MOMENTS IN FILM

AN ESSENTIAL UNDERSTANDING

Ron Newcomer

KENDALL/HUNT PUBLISHING COMPANY
4050 Westmark Drive Dubuque, Iowa 52002

Book Team

Chairman and Chief Executive Officer *Mark C. Falb*
Senior Vice President, College Division *Thomas W. Gantz*
Director of National Book Program *Paul B. Carty*
Editorial Development Manager *Georgia Botsford*
Developmental Editor *Angela Willenbring*
Vice President, Production and Manufacturing *Alfred C. Grisanti*
Assistant Vice President, Production Services *Christine E. O'Brien*
Prepress Editor *Angela Puls*
Permissions Editor *Renae Heacock*
Designer *Jenifer Chapman*
Managing Editor, College Field *David L. Tart*
Associate Managing Editor, College Field *W. Ray Wood*
Acquisitions Editor, College Field *Jay Hays*

Background image courtesy photos.com.
Filmstrip image courtesy Corel.
Moon image courtesy PhotoFest.
Gollum images courtesy New Line.

Contents

To Diane
The Nora to my Nick Charles

Acknowledgements and Resources

A very sincere thank you goes to Betty Shannon, Pat Kennedy, Caryl Terrell, and especially Kathy Buster, for their generous help and candid, forthright, unflinching advice on the preparation of the final manuscript. Also to Gus Edwards and Jim Newcomer for hours of pleasant chat about the movies, The American Film Institute for the special research information they provided, and Robert Wise, Richard Edlund and the fond memory of Max Youngstein, Stirling Silliphant, Vincent Price, Arthur Loew, Buddy Ebsen, Ray Waltson, Philip Dunne, Edward Anhalt, and Mary Louise Newcomer for their advice and wonderful stories over the years. Also grateful appreciation goes to Howard Mandelbaum and the wonderful, extremely helpful and extraordinarily patient people at PhotoFest in New York; and Chris LaMont, Robin Zlatin, and New Line Cinema for permission to use material from *Lord of the Rings: Return of the King* on the cover. And to James Burke whose "trigger effect" theory was one of the inspirations to begin this journey.

The research on this book began with a Stan Laurel and Oliver Hardy short projected on a sheet many years ago, and continued with thousands of films seen since then. This book was originally dictated as a series of lectures without the use of notes or research material, pulling entirely from the memory of these films. This process began during seven years as the curator and historian of the Classic Cinema at the Scottsdale Center for the Arts, and from more than twenty years as a writer and development director in the movie industry. The objective was to let the films tell their own history in an effort to recognize the changes in directing and production over different time periods. Also to observe how political, social, and entertainment shifts during these years affected the look and content of motion pictures.

The book was then written using the transcript of these lectures, and referring to the following resources for accuracy of dates and events: *Cinema Year by Year 1894–2000*, A Dorling Kindersley Book; *The Timetables of History*, Third Revised Edition, by Bernard Grum, A Touchstone Book; *The Film Encyclopedia*, Third Edition, by Ephraim Katz, HarperPerennial; *The Compete Directory to Prime Time TV Shows*, 1946–Present, Fifth Edition, by Tim Brooks and Earle Marsh, Ballantine, the Internet Movie Database (*IMDb.com*), and The Academy of Motion Picture Arts and Sciences (*Oscars.org*). Although there was no material taken directly from these periodicals and newspapers, the issues of Daily Variety, Hollywood Reporter and American Cinematographer since 1984, and all the issues of Premiere and Entertainment Weekly, helped provide an ongoing understanding of the business and changing trends of motion pictures. However, the biggest source of research has been fourteen years of students at Arizona State University, whose honest opinions, pro and con, and enthusiasm for movies provided insights to significant changes in the cinematic arts.

Introduction

The biggest problem facing film today is not preservation, but appreciation.

Classic films are being rescued from decay and near oblivion in an international campaign for film preservation. Recent heroic efforts have managed to save some great examples of film-making, which date back over a hundred years. Still, it is estimated that we have lost over 90 percent of the movies made between 1895 and 1928. Many of these "silent flickers" were simply tossed into bonfires by studio executives to clear shelf space for the more popular sound films that were quickly stacking up.

If it had not been for a second life given to the vintage films of the 30s and 40s by the arrival of television (the same tiny screen archrival that Hollywood originally believed would destroy the motion picture business), it is highly conceivable that only a small number of films might have endured. This would have been the modern equivalent of what befell countless volumes of literature from ancient antiquity that were destroyed by the fire of the Library of Alexandria during the time of Cleopatra. Without a good financial reason to preserve our early film heritage, we might have ended up with a pitifully small representation of films from the Golden Age of Hollywood, very much the same way we now only have a handful of tragedies and comedies from the Golden Age of Greece.

Undisputed masterpieces of cinema art like *Citizen Kane, The Wizard of Oz,* and *It's a Wonderful Life* were box office disappointments when they were originally released, and only found an admiring audience on television and revival cinemas decades later. What masterpieces of light and sound would have been lost if there were not some way to bring films from musty vaults to a new audience? Yet, the permanent loss that befell the brittle strips of silent film celluloid is now happening to the very films that have been patiently preserved. This time the destructive force is not a physical endangerment—rather it is purely symbolic, a result of modern apathy.

Preservation means nothing if no one watches the old films that have been rescued. But the question arises, *who has the time anymore?* Each week two or three major studio films open, after being unmercifully promoted for months. And that same week at least three films come out on DVD with fabulous special features that are often twice as long as the film itself. Films that were overlooked in their original release and were lost in the ruthless box office shuffle are now pounding the marketing drums for a born-again share of the world audience on home box office. Plus there are the increasingly complex interactive video games that take dozens of hours to complete, and have lately become the inspiration for big budgeted summer releases. So, who has the time to pop in *It Happened One Night* with Clark Gable and Claudette Colbert, settle back, and munch on microwave popcorn with a gathering of that endangered species—old movie enthusiasts?

But the real problem is that *It Happened One Night* is in black and white, *without* Dolby Digital Sound, and has a leisurely editing pace to allow

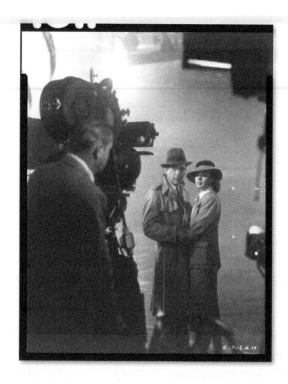

Casablanca (1942) *Humphrey Bogart and Ingrid Bergman being directed in the famous final sequence by Michael Curtiz. The movie has endured as one of the treasured examples of the Old Hollywood Studio System.*

for something called character development. Worst of all, it has deceased movie stars. As disrespectful as this may sound, it is very important for audiences this side of the twenty-first century to know all about the tabloid lives of their screen idols. Sure, Clark Gable was also in *Gone With the Wind,* arguably the most famous movie ever made, but it is a safe bet that most people under thirty years old have never seen it.

Film is the only art form where the incredible pioneering efforts of thousands of exceptionally creative actors, directors, writers, and designers seem to diminish in the eyes of each new generation. The wonders of the pyramids, the Sistine Chapel, Bach's Brandenburg Concertos, and Shakespeare all have the ability to inspire centuries later, remaining timeless in a respected cultural cocoon.

But films are treated differently. Like Merlin, films appear to go backwards in time, starting out ancient, then growing younger with each

year. A courageous first-timer might command him or herself to appreciate the historical significance of *A Trip to the Moon, The Battleship Potemkin* or *The Cabinet of Dr. Caligari,* but it is a daunting task. The images are faded, the music is monoton, the acting is on the stilted side, the violence is bloodless, and there is no apparent bridge to the vibrant visual styles of *Saving Private Ryan* or *The Lord of the Rings.* Yet, both of these films would not have been possible without the cinema magic discoveries of Georges Méliès, the editing theories of Sergei Eisenstein, or the freedom of the motion picture camera reintroduced to the world by the directors of the French New Wave.

As for highly significant impact on world history, it would be hard to argue that D. W. Griffith's perfecting of "the grammar of cinema," as Lillian Gish referred to it, is more important to know and appreciate than world-changing events like the invasion on D-Day or the sinking of the

Titanic. But by using Griffith's cinema grammar, which has evolved tremendously over the last eighty years, these events can be made to appear so real that audiences have the momentary sensation of being there in the midst of all the horrifying, spine-tingling action. It is all part of the art of illusion, a kind of smoke and mirrors at twenty-four-frames-per-second, where thrills and chills are achieved by the perfectly timed trickery of editing, the manipulation of light, and the reactions of actors to make-believe circumstances.

With the exception of religion, no subject has been written about or discussed more than the film, and film is just a little over a hundred years old. Every country has its own cinema heritage, in addition to importing the latest action blockbuster from Hollywood. On an average, as a global influence, film or television is watched 3.5 hours per day. With the rise of the Internet, along with the video game explosion, this statistic could eventually double. But this barrage of perpetually moving images has lost its wonder over the decades. In 1895, the image of a train moving rapidly toward the camera caused audiences to flee the theatres in panic. Today it would take a perfectly executed hologram of a train breaking down the walls of the multiplex to create the same excitement, and then, by the following week, even this would seem old hat.

Movies are the combination of all the arts. Within two hours movies can entertain with words, music, dance, painting, photography, design, and performance. Individually these artistic forms of expression attract lesser crowds. Think about how often you go to the live theatre as opposed to the movies, or an art opening, or a symphony. Separately, each of these are celebrated with brief visits a few times a year (maybe), and thus become occasions to dress up and go out to dinner at a fine gourmet restaurant.

With movies we arrive in casual attire, then consume a bucket of oozing buttered popcorn and giant Coke in a refillable souvenir cup. But within these two hours we have been exposed to some of the most stunning work of the greatest artists alive today, all interacting fluidly, scene after scene, in an almost impossible undertaking that took two years to make. And we have ultimately reduced this Herculean effort to an indifferent thumb up or a thumb down.

In the 1960s, Pauline Kael, the critic from the *New Yorker* magazine and arguably the most influential film critic ever, christened the new batch of young directors and writers as "the film generation." Indeed this was the first generation that grew up surrounded by film. As baby boomers they were the first to see old movies on television. This was followed by years of attending revival theatres and special film festivals on university campuses, all of which amounted to a sort of do-it-yourself film degree before there were film degrees.

Films that had gathered dust on studio shelves for decades were discovered and became the topics of endless late night discussion about styles and how certain scenes were shot. Actors who had been forgotten became stars again. And directors who had never been known by the general public were suddenly elevated to the stature of gods, with dozens of their old films being shown and debated like lost chapters of the Bible. Names like Lang, Stroheim, Murnau, Ford, Hawks, Kazan, Lean, Hitchcock, Cooper, Bogart, Cagney, the Marx Brothers, Mae West, and W. C. Fields were tossed about in everyday conversation.

During this time it was easy to look back and identify the major filmmakers. Many of them were still alive, and those that had just passed away had left a remarkable canon of work that was being shown over and over again in rundown art house theatres and on late night television. But then the Film Generation eventually made their movies. And now the current generation is making movies, whose heroes were part of the

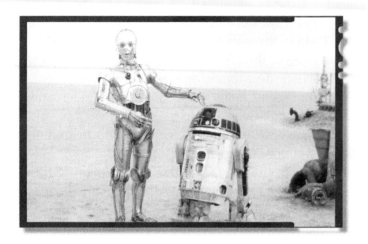

Star Wars *(1977) C-3PO and R2-D2 were inspired by the bickering characters in Akira Kurosawa's **The Hidden Fortress**. George Lucas borrowed from Old Hollywood serials and Westerns to create a film that revolutionized the motion picture industry.*

Film Generation, like Coppola, Spielberg, Friedkin, Scorsese, De Palma, Lucas, Cameron, Hopper, Fonda, Pacino, Nicholson, De Niro, and Streep.

Early film history is loaded with examples of the "trigger effect," meaning that one person's discoveries triggered new innovations. Today it is a technique or style that is used widely without any acknowledgment of where it began. But the great thing about film, unlike all the other arts, is that it is possible to look back and discover the individuals that created, literally out of thin air, the stepping-stones of modern filmmaking. The goal of this book is to examine the individuals, trends, and world events that shaped film over the past hundred years. For example, the very first comic strip in newspapers, *The Yellow Kid,* came out the same year film was invented. Continuing from this point, all during the twentieth century, there has been an astonishing evolution of visual language that people all over the world have grown up with. As Sergei Eisenstein and other Soviet directors in the silent era predicted, the written word is gradually being replaced by visual language.

Film is at a turning point, like a sequel that can only be described as Film History, Part Two. The point has been reached in the examination of film that will never be repeated as long as film continues. This is because film has gone full circle in this first phase of its evolution. The first narrative film in 1902, *A Trip to the Moon,* was a complete fantasy, full of groundbreaking special effects, which seem delightfully quaint and obvious to the modern eye. The Holy Grail of filmakers has always been to make fantasy believable in film. Each decade, from the creation of *King Kong* to *Star Wars,* special effects continued to improve in great leaps, but it was not until the *Lord of the Rings* that fantasy has become overwhelmingly real on the screen. Thus the circle is complete. Anything that follows represents a standard of filmmaking that borrows from the past, but from this point on film is in an entirely new territory. In fact, modern innovators like George Lucas have been pushing the digital envelope with the concept that *film* will not exist in a few decades, gone the way of the vinyl record and the crystal radio.

This book will explore the essential history of film and how films have been made over the decades. Time will be spent on important developments in film history with the aim of bringing these events alive so they can be appreciated by future generations. Like with any great occurrence in the arts or science, the path to modern filmmaking was the result of many happy acci-

dents and a cavalcade of creative individuals who just happened to be in the right place at the right time. A good place to start with this look at film history is to realize that the early pioneers did not have a map to follow. They did not have one book to read about filmmaking, or classes at a university, or commentaries on a DVD, or a documentary to watch on Turner Classic Movies. To borrow a phrase from Indiana Jones, they made it up as they went along.

It is hard to imagine what film, or any form of visual experience, will be like in the future, especially considering that when *Star Wars* came out in 1977 the concept of digital filmmaking was looked upon as a mad dream. But we can take a look at the essential movements and individuals that got us to this turning point in film history. After we explore this first phase in the filmmaking experience, then perhaps some predictions, no matter how incredible, might be in order. After all, the impossible in film has always been obtained, only to eventually become old hat.

About the Author

Ron Newcomer has produced more than 470 musicals, festivals, and concerts, and has been involved with more than 1,700 stage, film and television productions in his professional career. He received a Bachelor of Arts degree from the University of California, Los Angeles and Arizona State University in arts management and directing; he also earned a degree as a lab technician and worked at St. John's Hospital in Santa Monica, California. As a news correspondent he covered the Vietnam Peace Movement and later the conflict in Northern Ireland; for six years he served as a special feature writer for *The Hollywood Reporter.* In motion picture, he worked in story development for Max Youngstein Production (United Artists), Bungalow 78 Productions (Universal Studios), Dark Horse Productions (Warner Bros.), and New World Pictures. His screenplays **Full Moon Lover** and **New West** won top honors in the Arizona Screenwriting Competition. He was appointed to the Arizona Film Commission Advisory Board by Governor Bruce Babbitt, and later founded the Scottsdale Film Festival, producing **The Art of Special Effects** with Robert Wise and Richard Edlund, plus a series of film workshops with The American Film Institute, The Academy of Motion Picture Arts and Sciences, The Sundance Institute, and Walt Disney Productions. In theatre, he was the first playwright-in-residence for the Arizona Commission on the Arts; twelve of his plays and musicals have been produced, including the Playwright's Award Winner **Vladimir's Waterloo, The Return of Mata Hari,** and **The Incredible Adventures of Doktor Thrill,** based on the paintings of Earl Linderman For Barry Kemp Productions and Mirage Digital he the adapted the Howard Koch and Orson Welles radio drama **The War of the Worlds** into a live virtual reality production. As a producer he has staged productions with the San Diego Old Globe Theater, John Houseman's The Acting Company, The Royal Shakespeare Company, The Arizona Theater Company, Theater Under The Stars in Houston, Ballet West, the Ashland Shakespeare Festival, and The Nederlander Organization. He was Artistic Director for Shakespeare & Co. and Musical Theater of Arizona; General Manager of the Scottsdale Center for the Arts and Western Star Productions; and a founding member of The National Alliance of Musical Theater Producers. He has had written six books including **The Films of Glenn Close** (Carol Publishing Group), **Mary, Mary, Mary: The Complete "Mary Tyler Moore Show" Companion,** with Nick Toth (Carol Publishing Group), and **Indian Poker: A Wildcard History of Native American Gaming** (Birch Lane Press). In 2002, he established The Movie Magic Foundation for new technology research to be used for visual education; the foundation is working with the Alfred Hitchcock estate on an interactive educational program for film studies. At Arizona State University he has been honored with the Distinguished Teacher of the Year Award from the Herberger College of Fine Arts. He currently teaches screenwriting and film production at Arizona State University.

EARLY PIONEERS— EXPLORERS WITHOUT A MAP

1894–1914

32,000-YEAR JOURNEY TO THE FIRST MOTION PICTURES

In the caves of Grotte Chauvet, in southeast France, there exist the world's oldest known rock paintings, going back in time an estimated 32,000 years. High up on the walls of these dark, damp caves are carefully etched herds of prehistoric beasts with five or six intertwining legs. This could lead to speculation that there were strange mammals with more than four legs archaeologists have not yet unearthed. But most likely these paintings are early artistic attempts to show motion. The flickering light from the campfires that danced on the walls of these caves might have created an irregular strobe effect, causing the legs of these fleeing beasts to appear to be galloping away from the two-legged hunters that steadfastly pursued them.

The perplexities of movement have fascinated and frustrated artists for centuries. Since the earliest days of civilization there has been a kind of holy obsession about the inanimate breaking the bounds of reality and taking on a separate life of perpetual motion. The ancient Egyptians depicted solar boats in their hieroglyphics that took the dead on a final journey through undiscovered countries fraught with perils and unearthly dangers that only Ray Harryhausen could recreate. In fact, the language of hieroglyphics is entirely visual, made up of strips of two-dimensional figures in frozen motion, very much like a storyboard for a big budget special effects movie.

Greek mythology is full of these tales. Oedipus visits the winged Sphinx, who comes to life to recite her riddle. Pygmalion wishes that his heavenly statue be transformed into a real woman, and then lives to regret it. And Medusa reverses this process by turning mortals into stone with her stare. Sophocles and the other great dramatists of the Golden Age of Greece wrote their tragedies to take place from sunrise to sunset, allowing nature to provide the ideal lighting effects for each play in the trilogy. In *The Republic,* Plato writes about a mysterious Cave of Shadows where flickering images are rear projected on the walls for bemused spectators.

Michelangelo is believed to have wept because he could not make the marble eyes of the Madonna he had passionately sculptured come to life. Leonardo da Vinci made detailed drawings of perpetual motion machines and experimented with a camera obscurer. Rembrandt studied the effects of direct source candlelight

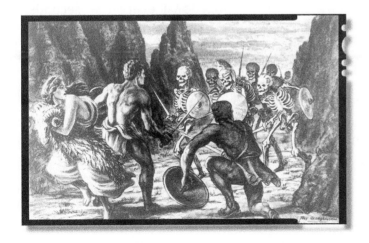

Jason and the Argonauts **(1963)** *Drawing of Ray Harryhausen's innovative special effects for the climactic clash with the skeleton army. The artwork imitates the romantic imagery found in adventure books in the early 20th Century.*

on his models just to capture the mood of a single second in his paintings. Samuel Pepys wrote in his diary on August 19, 1666, about a magic lantern that projected "strange things" on a wall to his utter fascination. And coinciding with the discovery of the motion picture camera, the Impressionists broke with classical traditions and used swirls of color to give the sensation of motion to casual scenes of everyday life.

Henri Langlois, founder of the Cinémathèque Français, passionately preached that movies have always been around, like an undiscovered continent or the formula to cure a rare disease. However, the means to create this visual magic was not possible until 1891 when Thomas Edison's Kinetograph camera was invented and billed as "an instrument that does for the eye what the phonograph does for the ear."

Langlois' abstract reasoning is certainly a backdoor approach to the truth. For centuries it has been natural for artists to experiment with ways to create the illusion of motion, because in our lives we are constantly aware of uninterrupted motion every waking hour. The fact is *we are movies.* We see things move around us exactly like a camera, and record the best action with our selective memories like strips of film. When we walk from one place to another we catch images like a Stanley Kubrick tracking shot. When we put on sunglasses we create a day-for-night special effect, the same way a cinematographer adds a filter or changes the f-stop. If we get bored during a tedious conversation with relatives or a lecture by a monotone professor, we excuse ourselves, thus literally editing someone out of our movie, and figuratively leaving these unwanted scenes on the cutting room floor. And when we sleep we see movies inside our head in the form of dreams. Film is simply an organized extension of what we see and experience every day of our lives.

PERSISTENCE OF VISION

The fascination of watching pictures that have only a slight degree of difference spin around, thus giving an illusion of motion, begins with the discovery of a distinctly human characteristic known as persistence of vision. This is a peculiar gift that humans have evolved with since prehistoric times, and appears to have no practical use or purpose except to watch movies.

Persistence of vision is something that caused a trigger effect in the 1800s, was studied in earnest by the best and brightest scientists of the age, and eventually lead to the discovery of the motion picture camera by the end of the century. Scientists diligently studied the movement of light, fascinated that two objects spinning around at the same time would create a singular vision. This phenomenon was studied in great earnest. At first, there was no real understanding of why people had this extraordinary gift, but persistence of vision obviously has been part of the human makeup for centuries.

Persistence of vision is simply that an image stays on the retina of the eye for a fraction of a second. This means there is always a slight overlap in what people see from one moment to the next. Humans have evolved with this to see without interruptions when they blink. Otherwise everyone would experience little blackouts, like a curtain coming down every few seconds, which would be a real handicap while driving or cutting up vegetables for dinner.

Blinking allows for moisture to coat the eye, otherwise the sensitive retina, which is like a highly developed lens of a camera, would dry out. To prevent this painful experience, people blink 17,000 times per day, or roughly 12 times per minute! (Only no one notices this repetitive action, unless, of course, someone brings it to their attention because of persistence of vision.)

For the fraction of a second it takes to blink, the last image seen before the eye closes remains on the retina, and thus fools the brain into believing that there was no momentary blackout.

If prehistoric man would have experienced these blackouts while hunting, even for a fraction of a second, they could have gotten pounced on by one of the many-legged beasts they immortalized on the cave walls. But there is an additional reason why the beast might have been drawn in that fashion. Another factor of persistence of vision is that light mixed with speed can literally pile up images on the retina, confusing the brain as to what it is actually seeing. If a candle is quickly moved around in the darkness, the light from the flame seems to leave a trail, so a circle of light could be completed, or somebody's name written in thin air.

This rapid action creates a visual bridge from one bit of motion to the next. In Western films, wagon wheels moving quickly sometimes appeared to be either going backwards or look as if they were not moving at all. So, to prehistoric man (and all their ancestors ever since) a running beast would actually appear to have more than four legs. Eventually a large money wager related to this illusion would result in the first experiments with cameras to *stop motion* for a split second, and then these photos would be used to create the first moving pictures.

Watching a film is like blinking twenty-four times-per-second. Any image repeated at sixteen times-per-second will cause the uninterrupted illusion of movement. Most silent films were shot at eighteen frames-per-second (fps), which created a slight flickering effect when projected, and thus they became known as the "flickers." When sound arrived, films where shot at twenty-four fps, and this speed had to be maintained for synchronization of sound and action. In actuality there are twenty-four separate photographs, with almost an indistinguishable difference between them. Between each photograph there is a small black frame, meaning that when an audience sees a film, almost half of what they see is complete blackness. But because persistence of vision has allowed people not to notice blinks, the interruption between each still photograph disappears and leaves a continuous flow of movement, or the illusion of life.

The study of the amazing science related to persistence of vision became the rage during the eighteenth century, a time period when people were beginning to probe for answers to everything possible or impossible. This was the age of the Industrial Revolution, and Science, which had conflicted bitterly with the religious doctrines of the Middle Ages, now ruled supreme in the popular imagination. A young French novelist named Jules Verne wrote *From the Earth to the Moon* in 1865, and suddenly there seemed to be no limit to what could be conquered by scientific endeavor. Thirty-six years later, Vern's fantastic vision would come true, not in reality, but as the first narrative film. But before this historic event happened, people amused themselves endlessly with stroboscopic toys, which were the video games of the eighteenth century.

STROBOSCOPIC TOYS

The slightest sense of continuous movement, even for a few fleeting seconds, fascinated people of the eighteenth century for hours. This created a boom market for portable devices that created this illusion. They became known as stroboscopic toys, since the main purpose in this early stage was the amusement of the leisure class. One of the first-and the most popular-was invented by John Ayrton Paris in 1825. He made a very simple toy that became

one of the first great visual gimmicks. It was comprised of two straps that held an image of a parrot on one side and a cartoon cage on the other side. When spun very quickly these images melded together, and thus the parrot ended up in the cage. Paris called his toy a *thaumatrope,* which is Greek for "wonder turn."

Names based on ancient Greece were the fad at this time, giving an air of respectability to these nonsensical gadgets. It was a sign of the times for just about everything, since scientists and artists alike felt they were rediscovering a new renaissance as part of the modern age, and looked back to the Greeks for the answers.

The most famous of these stroboscopic toys was invented by William George Horner in 1834 and called the *daedelum zöötrope* or *zoetrope* from the Greek for "life turning" or "wheel of life." This was a circular drum, like a large cake pan, with thin vertical slits along the side for the curious viewer to look through as it spun around on a metal shaft. Inside were exchangeable paper strips containing drawings, or an object that varied slightly in composition, like a jack-in-the-box jumping up. What the viewer ultimately saw was an amusing and enthralling example of sequential motion. As the slits flew by, the black covering fabric created little blackouts as it spun around, the same effect as film going through a projector. This name was borrowed over a century later by a group of ambitious young filmmakers, headed by Francis Ford Coppola, with the assistance of George Lucas, who named their San Francisco-based company American Zoetrope.

In 1932, Joseph Antoine Ferdinand Palatau made a stroboscopic toy called the *phenakistiscope,* again from the Greek meaning "deceptive viewer." There were several designs, but the most familiar used a circular board with a handle, that when spun in front of a mirror caused the images to change very quickly. Palatau is credited with determining that 16 fps caused continuous motion, whereas 12 fps or less created pronounced and annoying flickers. In the silent era, cameramen, with remarkable consistency, learned to crank at this particular speed, sometimes increasing or lowering the speeds to slow down or accelerate the action.

From 1834 to 1853, Baron Franz von Uchatius played with several designs that combined the stroboscopic toy with a magic lantern, until he eventually perfected the projecting *phenakistiscope.* It was able to actually project an image onto a wall or to a sheet. To see a moving image shot through air was awe inspiring in this time period. Von Uchatius' projecting marvel caused great fascination in parlors, and was immediately incorporated into many magic acts.

Many of these stroboscopic toys were so intricate in design and construction that many still exist and work today. The very early toy of a simple band with a parrot and a cage became more complicated within a few decades. The push toward finally having a motion picture camera was unstoppable, but first the still camera had to be perfected so a rapidly moving image could be captured-like a horse at full gallop.

THE CIVIL WAR AND THE ARRIVAL OF THE CAMERA

The Civil War was the first major conflict that was recorded by photography. Mathew Brady and other early photographers took emotionally charged still photographs of the battlefield with a wet plate process. This was achieved by covering a glass plate with a syrupy inflammable collodion solution that left a thin transparent film. When the plate was dipped into a bath of silver nitrate solution, it became sensitive to light. Once this time consuming process was completed, Brady had less than an hour to use the plates while they were still damp. Silver

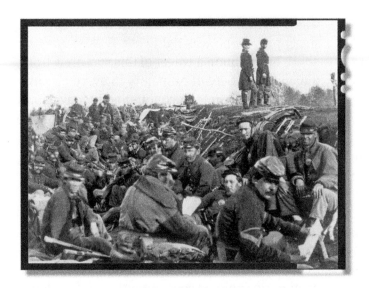

Mathew B. Brady's haunting photographs of battlefields brought home the horrors of the Civil War conflict to millions of people worldwide.

nitrate was used in motion picture film throughout the Studio Era and has caused problems for preservationists for decades, since it decomposes and is dangerously combustible. But the look of the black-and-white films done in this process is stunning, creating the expression "silver screen."

In order for Brady to take a photograph, he would remove the lens cap, and depending on the available light, expose the subject for fifteen to thirty seconds or longer. This is why the vast majority of his famous images depict the aftermath of war showing the lifeless carnage, or soldiers somberly staring at the camera. Any kind of movement in this time frame would result in a whiplash effect. Since it takes more facial muscles to smile, the person being photographed was told to relax and not show any expression; if they did, their lips might be blurred from the twitching motion. Thus the stoic expression in these old photographs, especially those of married couples, might imply an unhappiness or displeasure to the modern eye, but this ridgid posture was necessary to insure a perfectly focused reproduction of the actual subject.

A similar process was done with thin sheets of japanned iron and became know as tintype.

The cameras using this process had multiple lenses and could yield six photographs for the relatively low price of two bits, or twenty-five cents. Within a few short years photo galleries sprung up all over the country, and traveling photographers went from one small town to the next, dressing the local residents up for austere family portraits. With such popularity and public demand, innovations in still photography evolved quickly until better lenses and faster emulsion chemicals had a rendezvous with history.

IT ALL STARTED WITH A HORSE BET

Over the centuries, the purpose of art was almost of a spiritual nature, with the intention to inspire and lift human thought to its loftiest heights. The Greek theatre had tragedies about the divine deities and the earthly troubles that befell them, thus teaching the citizens of Athens the refinements of poetry and philosophy. Through the bloodshed and political turmoil of the Italian Renaissance, Michelangelo painted the ceiling of the Sistine Chapel, and

Leonard Da Vinci used his genius to create the beguiling *Mona Lisa, The Last Supper,* and sketches of bird-like machines intended to help man to conquer the boundaries of Earth. The great cathedrals were built by anonymous architects and laborers, all united with the single purpose of bringing humankind closer to the Almighty. Grand opera celebrated the glory of the human voice in lofty tales of Norse mythology and the frailty of unrequited love.

But motion pictures came to be because of a sensational wager that was heatedly debated in every capital and seaport of the world, over the dispute about *if all four hooves of a horse left the ground at the same time.* The irony is that the birth of motion pictures came about out of the necessity to find a way to stop a horse in mid-stride for one-twelfth of a second.

ENTER EADWEARD MUYBRIDGE

In 1872, Leland Stanford, railroad baron and governor of California (who would later have a distinguished university named after him), got into an argument with colleagues by declaring that all four hooves of a racehorse completely left the ground while at a full gallop. His jesting opponents declared this was against the laws of nature, and that the poor beast would plummet straight down if at least one of its hooves was not touching the good earth. This horse debate took place in the years following the California Gold Rush and when overnight millionaires gambled in wild excess and a glass of pure drinking water might sell for a hundred dollars. But when Stanford announced that he would put up twenty-five thousand dollars to prove his undeterred faith in this theory, the wager made headlines around the world. In a time when, in most places, a dollar would buy a thick steak dinner and large glass of beer, this

was a fortune, but there was no way to conclusively prove who was right.

The attention a wager of this sort drew from the widest variety of humanity in every country is nearly impossible to comprehend today, since everyone, without hesitation, knows the ultimate outcome. The fact that it is now common knowledge that all four hooves leave the ground while a horse is at a full gallop is only possible because people have seen pictures of horses stopped in mid-air by pushing the pause on a remote control. But there was no simple end to this debate back then, because no one had the power to freeze frame time. For thousands of years it had been impossible, except in myths, and perhaps it would take a god-like intervention to resolve this debate.

What finally transpired shows how dependent modern audiences are on Muybridge's hard-earned discoveries, combined with the almost unlimited financial resources of a man who truly admired the beauty of racehorses in action. Stanford was a devoted horseman who sought prestige and used his money to bring attention to himself, while at the same time solving a visual puzzle that was impossible for the human eye to determine in a split second. In all probability this is an argument that had been going on since people began to ride horses. But now at the dawn of the Industrial Age this issue had gathered the serious attention of scientists, artists, plus the vast general public, who for the first time in history were bombarded with daily news from dozens of local newspapers and tabloids.

The problem was proving beyond a shadow of a doubt if the hooves left the ground. The first attempts had men lying down along the homestretch of a racetrack, but the number of positive sightings were contradicted by fellow observers who swore they saw at least one or two hooves remain steadfastly on the ground. The only way to end this heated speculation was

to photograph the animal in action, but the tin-type process resulted in badly blurred and unrecognizable images even if someone moved only slightly.

Then Stanford heard about Eadweard Muybridge, a vagabond Englishman noted for his eccentric behavior, who had built a reputation as an excellent photographer and inventor in San Francisco. Learning that Muybridge had developed faster methods to photograph objects in motion, Stanford hired him to resolve the wager. Thus began a pursuit to get one perfect photograph of a horse with all hooves off the ground, which ultimately took hundreds of attempts over five years, interrupted by a sensational murder trial and costing nearly fifty thousand dollars—twice the original wager.

Born Edward James Muggeridge, he later changed his surname to Muygridge, then to Muybridge. Not satisfied with this incomplete reincarnation he altered his Christian name to Eadweard, which is how Anglo-Saxon Kings had spelled their names in ancient times. But even this appears to have changed since many accounts referred to him as Eadward. He might have been one of Charles Dickens' outlandish characters, with untamed white hair, a long tobacco-stained beard, and penetrating eyes. He was once appropriately referred to as "Walt Whitman ready to play King Lear."

Muybridge's first attempts at photographing a horse in motion were unsuccessful, but he pushed on with great determination. Stanford wanted a photograph so focused that the tip of the jockey's whip could be clearly seen. This required a faster lens that could let in enough light in less than a second to perfectly capture one frame of a horse going thirty miles an hour. Muybridge's first photographs were not decisive but showed great promise and further fueled the debate.

But in 1874 an incident occurred that postponed the outcome for two years. Muybridge shot dead his wife's supposed lover. He was imprisoned for five months until his trial for murder. His lawyer argued that Muybridge had found out that his newborn son might have been the result of an affair between his wife, a former divorcee named Flora Shallcross Stone, and a gentleman of questionable manners. In a brilliant defense, his lawyer attempted to convince the jury that Muybridge was not guilty by reason of temporary insanity. The jury rejected the insanity plea, and instead turned in a verdict of not guilty as a result of justifiable homicide, establishing a long tradition of unexpected verdicts from California juries. Within days after the sensational trial, Muybridge left on an expedition to Central America for a year on a "working exile."

THE BIG DAY FOR MUYBRIDGE FINALLY ARRIVES

All during this, Stanford stood by him and is rumored to have arranged for his defense attorney. When Muybridge returned he continued working on the photographic project as if nothing had happened. The next attempts to get the conclusive photograph failed in part because a single camera was being used, requiring the photographer to quickly remove the lens cap when the horse galloped past. On June 15, 1878, Stanford and Muybridge had arranged for a dozen of the most advanced cameras to be shipped from New York, including newly perfected lenses from London. Only a few years before, an exposure might take a minute; now Muybridge had twelve cameras side-by-side, aimed down the homestretch of the Palo Alto Stock Farm that clicked off like a loud drum roll in less than a half second. To insure an unencumbered image of the

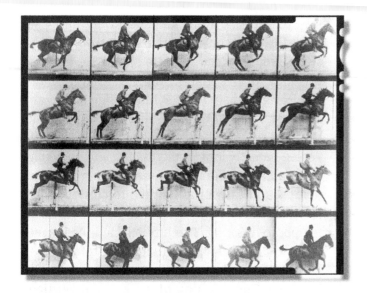

Eadweard Muybridge's photographs settled a high stakes wager over the debate whether all hooves of a galloping horse left the ground at the same time. This is one of many serial photographs by Muybridge that led to the invention of the motion picture camera.

horse, a rigged white backdrop was set up behind the inside fence of the track.

In twenty minutes Muybridge had developed the dozen plates, and with an air of absolute self-assurance displayed the photographs for the noisy throng of newspapermen, horse enthusiasts, and curious spectators. In the sequence of photographs Stanford's favorite trotting horse, Abe Edgington, is seen completing three full strides. In the middle of each stride is the indisputable evidence that all four hooves left the ground at the same time.

In an instant Muybridge's photographs changed forever the concept of art as an intensely personal vision to one that was a pursuit of realism, thus finding the truth in the tangible, instead of the private imagination. In fact, the images of Abe Edgington at full gallop caused French critic Paul Valery to write that these photographs "laid bare all the mistakes that sculptors and painters had made in their renderings of the various postures of the horse." Painter Edgar Degas and others studied the photographs to make their work truer to real life, while Auguste

Rodin roared in disgust, "It is the artist who is truthful, and it is photography which lies, for in reality times does not stop."

Rodin could have been correct, and the high-profile interest in the wager and Muybridge's photographs might have quickly disappeared if it had not been for an unexpected development that happened when the photographs were displayed for the public. Generally people stop and admire and briefly study each painting or sculpture when visiting a gallery or museum; instead people hurried past each of Muybridge's photographs, trying to view them all in within a few seconds. The curiosity about a single image of a horse suspended forever in mid-air quickly had faded away; now the viewer was intrigued by the phenomena of what were essentially the first motion pictures.

MUYBRIDGE MEETS MAREY

Muybridge was well aware of stroboscopic toys that deceived the eye into seeing continuous motion. He took the

principle of the Zoetrope, combined it with the magic lantern, and projected his now world famous photographs for public demonstrations. He called his invention the Zoopraxiscope, from the Greek meaning "life-construction viewer." For the next twenty years Muybridge perfected his multiple camera technique, eventually increasing his battery of cameras to forty and shooting hundreds of subjects. He called his photographs "serial pictures" because each one was shot with a different camera, but this cumbersome process of capturing moving images was about to change.

Muybridge traveled in Europe to give several exhibitions of his serial pictures of horses, elephants, tigers, men wrestling, couples dancing, and naked women strolling (which caused a sensation to sold out audiences). During Muybridge's visit to Paris, he met Etienne-Jules Marey, who invented a camera that closely resembled a shotgun, with a rotating circular plate that took twelve exposures. It is Marey's invention that arguably coined the expression "shoot," like in shooting a movie. Instead of dozens of cameras to set up and worry about, which is what Muybridge used with his technique, Marey used one camera, taking multiple images called *charonophotographs,* once again from the Greek meaning "writing time with light." He perfected his camera with faster lenses and coated paper instead of glass plates, thus swinging opening the door to the motion picture camera.

THE LITTLE CAMERA THAT CHANGED THE WORLD

In America, a man named George Eastman began his experiments with celluloid and paper film. By 1888, the same year Marey began to use coated paper instead of glass for his photographs, Eastman perfected a simple box camera called the Kodak, which sold for twenty-five dollars and held one hundred exposures. The Kodak suddenly made photography something that became everybody's passion and pastime. This meant that photography was not just the expensive, methodical craft of professionals. The little Kodak literally changed the ancient concept of art overnight. Now the common person could be an artist, because with the click of a shutter there was a fixed black-and-white moment of personal creative expression. Everyone could be Muybridge, who just a few years before froze the impossible in time. Art was no longer the exclusive trade of the elite or snobbish intellectuals. Almost overnight, all that was needed to create art was a little square black camera and some sunlight; not paintbrushes, typewriters, grand pianos, and the other tools of traditional artists.

The profound effect the Kodak camera—and eventually the motion picture camera—had on every part of society is unimaginable today, since it is mind boggling to anyone born in the second half of the twentieth century to conceive a world without photographs or moving images. Art had always been painstakingly time-consuming, with the goal of achieving perfection. This endeavor of mind and spirit goes back to the ancient Chinese and Egyptians when only certain individuals in each community or city expressed the artistic ideas of that particular era.

A BRIEF LOOK BACK AT THE ARTS

The earliest form of artistic expression is the live performance, which, of course, at one point had to do with the conquest of large beasts for dinner. These performances evolved in terms of language and movement, becoming increasingly more structured over the centuries. Dances evolved through older traditions passed down from generation to generation

that expressed something to please the gods, and to entertain everyone there that had traveled to watch it, creating the first paid performances. With those traditions that evolved over the centuries, special costumes and makeup were worn.

Theatre

The early tales of hunts, battles, and conquests became highly structured in the Golden Age of Greece when Sophocles, Aristotle, Euripides, and other Greek playwrights established a structured format: three acts with a beginning, middle, and end, usually lasting for the duration of two hours. These plays became the basis of interest in the Renaissance and began to expand the interest of people of expressing themselves within this very structured format. There was always an almost religious separation between the tragic and the comedy. Those two forms of theatrical expression existed independently for almost a thousand years. Then in the sixteenth century, William Shakespeare and other playwrights of the age began to mix tragedy with low humor for the common folks, who stood near the front of stage armed with rotten vegetables and pig bladders to express their discontent if they were not amused. During Hamlet, for example, in the midst of a great tragic moment, two rustic gravediggers, referred to as First Clown and Second Clown, pop up and exchange comic barbs with Hamlet, eventually holding up the skull of the court jester Yorick. Hamlet laments on "poor Yorick," and then is dead at the end of the next scene. This appeasement of the common man and woman was unthinkable in the days of Sophocles. It would be tantamount to having Oedipus suddenly transforming into Groucho Marx and exchanging one-liners with the Sphinx.

The Printing Press

The Guttenberg Press has been called the single most important invention of all time, allowing for the written word to be put down so that everyone could experience tales of great writers, going back to Homer. From the earliest days these books were of epic proportions, telling stories of great fantasy, with the Cyclops, ships torn apart at sea, outlaws that robbed from the rich and gave to the poor, and flying carpets in far-off lands. All of these things created rich images in the reader's mind, and by the nineteenth century, the novel became the primary form of escapism for millions of people, with inexpensive editions and newly formed libraries. The careful placement of a few adjectives by skillful writers could suddenly make people see the battle of Troy or the clever adolescent con job of Tom Sawyer, who got all his friends to whitewash a fence for him. The novel began to take on a new refinement as the fascination with stereoscopic toys and large theatrical productions became increasingly popular. The wheels began turning to see these stories on a large scale, but no one could imagine how big this scale would actually become.

Charles Dickens and the Novel

This was the era of Charles Dickens, who wrote for fashionable magazines; his novels were serialized, where every few chapters always ended with a cliffhanger. Thus the reader did not know from month to month what would happen to unfortunate, young Oliver Twist, or if Mr. Micawber would avoid debtor's prison in *David Copperfield,* or what would be the fate of honorable Sydney Carton in *A Tale of Two Cities.* Dickens' novels were interwoven with complex storylines, jumping back and forth between several adventures and full of rich characters—some noble, others

were outright thieves and scandals, but all drawn with an underlying sense of humor. Dickens loved the theatre, but his efforts as a playwright consistently failed. However, the theatrical flair appeared in his novels. There was inter-cutting suspense set against historical backdrops, bigger than life characters, plots that keep the reader on the edge of his or her seat for hours, and a cast of hundreds. Dickens' novels were far too big for the stage, but they were perfect for the movies. He died in 1870, never knowing that unofficially he had become the first great screenwriter.

Visual Art

For centuries, paintings were symbols for religious expression or an effort to capture the essence of real life. The great court painters of the centuries were able to have their royal subjects motionless for hours and days at a time until an idealized likeness of them was completed that dutifully immortalized the regal splendor of the subject. Eventually artists like Francisco Goya and El Greco began to let their passions dictate their brush strokes, creating portraits that gave a disturbing sense of horror and anguish to themes of religion and real-life events that befell the average citizen. With the first photographs, artists became fascinated with what might be considered the mistakes: blurred images that give a sense of movement, the rich dark tones brought about by under-exposing, and the hazy forms seen on foggy or overcast days.

Music

Music is perhaps the most interesting of all the arts, in terms of its evolution toward film, because music—as it matured over the centuries—began to conjure up visual images in the mind. Beethoven and later Richard Strauss and Modest Petrovich Moussorgsky composed symphonies and tone poems that told musical stories and encouraged images in the listener's imagination, like the Pastoral Symphony, which Walt Disney later animated in *Fantasia*. By the nineteenth century, music started to sound like film scores, only without any movies.

Events Leading Up to Motion Pictures

By the end of the nineteenth century, all of those forms of artistic expression were available on large scales to mass audiences in Europe and America. The fascination of seeing movement against a giant backdrop had been something that audiences always enjoyed, going back to the Roman Coliseum and the Greek Olympics. The reenactments of Civil War battles, with picnickers watching from grassy hillsides, were enormously popular events. Huge theaters would stage live versions of Lew Wallace's *Ben-Hur*, with actual chariot races at the climactic moment of the play. Horses going around on a revolving stage at full gallop in front of an audience had to be thrilling. In fact, a young actor in *Ben-Hur* playing on Broadway was a man named William S. Hart. He traveled west to California on a visit, became enamored of the West, and traded his toga for authentic Western attire, becoming one of the first actors who abandoned the theater for the thrill of the movies.

Admittedly, summarizing the great achievements of art over hundreds of years is a shortcut to showcase the events that were rapidly falling into place at the end of the eighteenth century when the Kodak camera was marketed to the world. To abridge the history of all the arts so quickly, is, of course, an invitation to heated debates, but the one consistent pattern that falls into place during the nineteenth century is the popular appetite for things to be done on a grand scale. The Industrial Revolution had allowed the

average work person discretionary money to spend—that is if they still had the energy after long, grueling workdays. Theatres could not be built large enough to hold the enthusiastic crowds that attended plays, operas, the ballet, the symphony, and even public readings by famous authors. Certain actors played the same role for most of their careers, touring cities around the globe, like James O'Neill, playwright Eugene O'Neill's father, in *The Count of Monte Cristo,* or William Gillette as *Sherlock Holmes.* All this interest in the arts centered in the new metropolises, with skyscrapers and rails that lead across continents. The big cities were the industrial centers where thousands of people poured into each week from all parts of the world. But even the rural towns had touring plays and opera with Edwin Booth and Lilly Langtree, and the biggest of them all, Buffalo Bill's Wild West Show with a cast of a hundred, including Annie Oakley. All of this cried out for a way that every city, comprising millions of people, could see the same show without having to wait years, and then perhaps risk being turned away. Everything was leading inevitably to film—only film hadn't been invented yet.

THOMAS EDISON, THE MAN WHO LIT UP THE WORLD

By 1889, George Eastman and a chemist by the name of Henry M. Reichenvace had managed to produce and market strips and rolls of celluloid film. The film was transparent, strong, thin, and the same width and quality from one batch to another. With this new advancement the Eastman Dry Plate and Film Company was renamed what it is still known as today, the Eastman Kodak Company. These long strips of film became a fascination of the great American inventor, Mr. Thomas Edison.

In 1888, Edison had already invited Muybridge to his lab, and the man who had

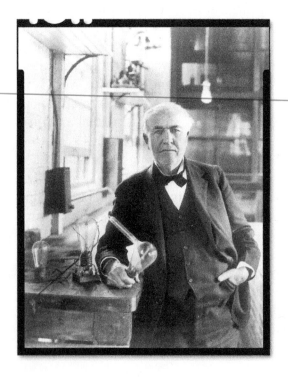

Thomas Edison changed the world with his invention of the electric light. The one invention he had very little faith in was the motion picture camera. He saw no financial future in the movies and did not pay for a European patent.

resolved the internationally famous horse wager entertained him with the zööpraxiscope in action. Edison was intrigued by this projecting machine, as were most of the people in the country. He knew that people were fascinated by the magical toys that showed simple movement, and he was playing with the idea that with Eastman's long strips of celluloid film a repetitious series of images lasting a second or two could possibly be extended longer, maybe as long as twenty seconds. Remarkably this is as far as he anticipated film going. To him it was simply a fad with which he could perhaps make a few bucks until the public's interest wore out.

The astounding thing is if Edison had seen the true potential of film the same way he saw the necessity for incandescent light, the electric generator, or, his favorite project, the phonograph, he would have been much more tenacious in solving some of the early problems that prevented film and sound from merging together. But if Edison had been able to peer into the future and see what film would eventually lead to, then the world would have had a very different experience in the twentieth century, and it is possible that even today the look and nature of film could be very different. Edison's blind eye, so to speak, about the possibilities of film lead him to ignore securing a European copyright, which in turn allowed France, Germany, England, Finland, and the Soviet Union the opportunity to develop a rich visual language and early masterpieces of the silent cinema that still endure and educate today. Then when Edison saw his mistake, he tried to create a monopoly on film in America, which ultimately created a mass exodus from New York, the newly evolving cultural capital of the world, to far away Los Angeles where Edison's attorneys could not reach the early film pioneers. Thus film grew up as a free, popular art form, and not under the disdainful influence of Broadway playwrights and directors.

Edison did see film as something that might compliment his phonograph, of which he did try to maintain total control (a great irony, since Edison was almost completely deaf in his old age). For this marriage to ultimately take place, there was the necessity of not only inventing a workable camera, which took years to resolve, but also the creation of an amplifier and speakers to carry the sound in a large hall.

In this time period the amplification in all concert halls and theatres was done through architectural design, plus the lungs of the performer. Enrico Caruso could sing to an audience of 3–4,000 people, and everyone in the back row could hear perfectly. This is the way performers were trained. The idea of having sound and music sent through a bunch of wires and out of a primitive box that would distort the voice certainly did not seem essential for audience enjoyment. But if the problems of amplification had been pursued vigorously along with the perfection of a motion picture camera, then there would never have been a silent age; without the innovations in this remarkable era, film would have been a prisoner of the spoken word, used probably to photograph plays in New York and London, and the look of film as we know it today might have taken another century to evolve.

INVENTING THE FIRST MOTION PICTURE CAMERA

By the end of the 1890s, America was experiencing an influx of immigrants coming from all points of Europe and Asia. Streets were filled with a cornucopia of languages. Most people who came to America would have to learn the English language very quickly, but there were no schools for the poorer people, and certainly no audiotapes. The great majority of the new immigrants learned English

on the streets, which resulted in the bastardization of phrases that became a unique vernacular of colorful slang terms. Earlier in American history there was debate on whether English or German should be the common language, based on the number of German citizens at that time. At this time Spaniards, Russians, Jews, and Asians were coming in. And in the beginning they had nothing in common to associate with. The silent films gave America its common denominator, and eventually crystallized the concept of the American Dream for everyone.

If Edison could have seen what his early experiments with film would lead to, even in the simplest way, he might have put his focus on finding a way to marry sound with film. The earliest phonographs had a big horn placed over the top, and sound would come through this device and very nicely fill a small living room or parlor. But to have that amplification in the Hippodrome in New York was not even in the realm of possibility at that time. But the man assigned the task by Edison to invent a motion picture camera believed there was a way. William Kennedy Laurie Dixon was given the job of making a camera that would expose the long strips of celluloid film that George Eastman was producing, perhaps enough film for an entire minute to go through the camera.

This was a task that was almost insurmountable. Dixon played with various inventions from 1888 to 1893. The major problem is the most obvious. Film is a series of still photography. Dixon knew that at least sixteen frames must be exposed every second to achieve fluid movement without the flickering effect. This meant there had to be a complicated inner working inside the camera to allow a frame to stop, the shutter to open, the film to be exposed, the shutter to close, and then advance to the next frame. Sixteen tiny pictures every second, or 960 pictures for one minute.

To solve the problems of advancing the film, he asked Eastman to create sprocket holes in a strip of film with a gauge of thirty-five millimeters, which is still the standard of most film shot today. Dixon eventually perfected a gate that allowed the film to advance, pause, and advance again using a hand cranking device. Each time the film advanced, a shutter had to block out the light coming in from the lens until the film was in place, or else light would blur the image if it were moving. This was an astounding feat of workmanship and creative ingenuity, especially considering he had nothing to use as a model except for the Kodak camera.

There has always been speculation that Dixon at one point exhibited an early synchronization of picture and sound called the *kinetophonography*, from the Greek meaning "motion sound writer." If Dixon had invented such a device, there would be some evidence of it. However, he had talked frequently about a machine that would show motion pictures with sound, but probably began the rumors that he was attempting such an ambitious project.

Edison had already taken the world out of the dark ages. Up until 1879, all nighttime activities, at any corner of the globe, were conducted under the flickering illumination of candlelight, gaslight, or whale oil lamps. When Edison invented the incandescent light bulb, he lit up the major cities of the world and changed forever how people went about their lives. After thousands of years the setting of the sun did not dictate people's routines; now things could go on twenty-four hours a day. Edison was thirty-two years old when he invented the light bulb and had achieved all the fame any man could want, but he kept searching for something that would eventually top his earlier achievements. Ironically the motion picture camera was that new victory, but he was blindsided by its early limitations.

1894

Here are some of the events that were shaping the world: Nicholas II becomes Czar of Russia. Captain Alfred Dreyfus is arrested and after an infamous trial is sent to Devil's Island. Baron de Coubertin forms the committee to organize the modern Olympic Games. In literature, George Bernard Shaw's comic play *Arms and the Man* is produced. Anthony Hope writes *The Prisoner of Zenda,* and Rudyard Kipling's *The Jungle Book* is published, both of which will be made into motion pictures many times. Robert Louis Stevenson, the writer who gave us *Treasure Island* and *Dr. Jekyll and Mr. Hyde,* passes away.

CAMERA! ACTION!— FRED OTT'S SNEEZE

The earliest example we have of Edison's experiments with motion pictures comes in 1894 and is called *Fred Ott's Sneeze,* lasting five seconds, it becomes the first film to be copyrighted. Ott was an employee of Edison at his laboratory who had a theatrical flair. One of the things he would do to amuse his fellow employees was to fake a sneeze on cue, and ultimately perfected a variety of sneezes. Edison filmed this, and it became the first film registered with the Library of Congress.

Once this landmark film was completed, there was the problem of what to do with it. How do you get the public to see the final product? There were always two choices. The ability to project an image had been around for decades, already employed with many of the stroboscopic toys that were able to project across large rooms. The projection of an image ultimately conjures up the same thoughts as watching a play, the experience of seeing something larger than life.

But Edison felt that this was a fad, a novelty that would soon wear off. To give him the benefit of the doubt, he was in many ways correct. The first motion pictures lasted about twenty-two seconds. To get people to file into a room, settle down, and then watch something for less than half a minute would certainly lose its appeal very quickly. Edison's approach, being a keen businessman, was to have one person at a time pay a quarter and peep through a small window the size of a pair of field glasses. This machine was called a Kinetoscope, and showed a continuous loop of film that went around various rollers and then passed in front of a viewing screen. Patrons would walk up and look into a peephole, an attendant would turn on the motor, and the fascinated viewer would be amused by

An assistant in Edison's workshop became immortalized in early film history as the star of the Kinetoscopic recording titled "Fred Ott's Sneeze." Lasting two seconds, it became the first copyrighted motion picture.

moving images of a man sneezing, a woman doing a belly dance, or two people kissing in a close-up, which caused a small scandal and brought people in by the thousands. Today it is inconceivable that someone would pay to watch the latest Hollywood blockbuster by bending over a machine and peeping through a hole for two hours. But in 1895 Kinetoscope parlors took the country by storm, surprising all of Edison's humble expectations.

NICKELODEONS—THE MELTING POT OF AMERICA'S HUDDLED MASSES

Edison was content with his Kinetoscope machine, patented in August 1881, as being a novelty of temporary appeal. When Edison was asked for an extra $150 to cover the copyright in England and France, he reportedly replied, "It isn't worth it." This is a phrase that has gone down as being one of the great mistakes in film history, right up there, perhaps, with George Raft turning down the lead role in *Casablanca*. But there was no reason to think the interest in motion pictures was something that was going to continue to spread. The world was fascinated by the music hall; vaudeville and burlesque were in their glory days. Why would someone want to watch something over and over again for less than a minute when they could see a live performance for two hours?

In 1893, a gentleman by the name of Norman Raff heard about the kinetoscope invention that was gathering dust in a New Jersey workshop and pressed his way into partnership with Edison (who was happy to get the contraption out of storage and put it to practical use). So, under Edison's name, the first kinetoscope parlor opened in April 14, 1894 at 1155 Broadway in New York. There were less than a dozen machines made for the astonishingly low price of $250. Immediately people flooded in and word of mouth caused long lines to wind outside the parlors and down the streets as people paid twenty-five cents to watch the brief shows at their pleasure over and over again.

Edison, seeing that this was something that he could turn a quick profit with, set about creating machines that would play for a mere five cents without the assistance of an attendant, thus establishing the nickelodeon. One of the few

Nickelodeon parlors sprung up in major cities in the late 1890s. For twenty-five cents customers could stroll down the line of machines and see a variety of short films (usually less than twenty seconds). The crowded parlors became a true melting pot of humanity during a time when millions of immigrants were coming to America.

places left in the world to see these machines, which were eventually manufactured in the tens of thousands, is on Main Street in Disneyland or Disney World. These machines do not use a continuous loop of film; instead they have cardboard cards that click past in rapid succession giving the same illusion of movement. The continuous photographs are developed on cardboard and then flipped like a deck of playing cards. This was a rival approach created by William Dixon, who eventually left Edison and began his own company in an effort to reap in some of the profits in this wildcat industry.

THE FIRST STUDIO AND THE POPULARITY OF THE NICKELODEONS

Edison did foresee that the success of these parlors was going to require revolving product for people to watch. But he quickly realized he needed a place to make his shorts. He built his own no-thrills motion picture studio in East Orange, New Jersey in 1895. The studio was affectionately dubbed the Black Maria, so named because it resembled a paddy wagon, the police vehicles that would nightly take intoxicated customers from the Bowery to jail. The Black Maria was designed to be able to rotate and follow the sun, allowing light to come in during the morning and afternoon. Inside, under the open roof, there was a small stage on which people would perform. There was no attempt to create scenery, since the movement of the human body was all the scenery spectators were interested in.

At first the performances were "gags," as they say in vaudeville, meaning a short solo specialty act, or a comic pantomime with another party. The performances quickly became more elaborate, and eventually extend to a minute or longer. The sensation of peep show amusements had lines literally around the block, especially the ones that showed something amusing and comical, or even risqué, which naturally became the favorites that people wanted to see over and over again.

The temperatures in these crowded parlors, combined with the impatience of standing in line, often resulted in fisticuffs because someone was viewing a show four or five times. But these scuffles only added to the excitement of the parlors. The money began pouring in and it

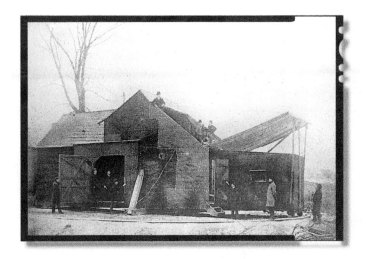

The Black Maria was built in West Orange, New Jersey in December 1892 and was the first motion picture studio. It was given this name because the odd-shaped building resembled a police patrol wagon.

soon became evident that the first motion picture franchise was necessary to keep up with demand. The expansion of the parlors happened very rapidly in Chicago, San Francisco, and Atlantic City. All were met with tremendous public activity. People from foreign countries visiting America stopped in to see the peephole wonders and then returned to their own countries and created similar parlors in England, France, and faraway St. Petersburg, Russia. This was completely legal because Edison did not pay the $150 for a European copyright.

Interest in the nickelodeons was fueled by the occasional scandal. When someone said these were lewd or unsuitable shorts for the eyes of children or young women, the concern about censorship sprang up over night. The controversy was further fueled by such performances as the legendary Little Egypt doing her internationally famous belly dance with unbridled passion. In the short viewers saw all of the glory of her body and movement, the same rotating movement of the hips that would make Elvis Presley equally famous years later when he appeared on the Ed Sullivan Show. Not surprising, Little Egypt was considered too offending for innocent eyes. So each frame of her salacious dance was stamped with a gate-like impression across her wiggling midriff, thus censoring out the exposed anatomy. That did not deter the lines, because people would watch the dance countless times in an effort to see what they were not allowed to see. Thus word of mouth made Little Egypt the first box office sensation.

To appease the art lovers, a short was based on Sandro Botticelli's early Renaissance painting, *The Birth of a Pearl*. An enormous oyster shell opens, an attractive young woman slowly rises, apparently completely naked, with her hands and arms posed in strategic locations. Upon close examination it is obvious that the woman is in a skin-tight flesh colored leotard, but it took the public many close examinations to be convinced of this fact.

And there was one short that caused a popular trend in courtship. *The Kiss* had two rotund individuals wooing cheek to cheek. Then the man, just as he began to embrace the woman and plant a kiss on her fair lips, pulled back and twirled his moustache. That became the fashion. Any respectable gentleman thereafter twirled his moustache before he engaged in amore with his

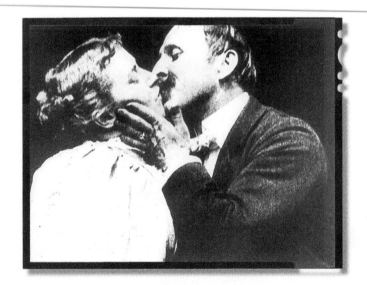

Edison's "The Kiss" (1896) lasted less than one minute and became the first runaway hit in motion pictures. Made at a time when kissing in public was illegal in many cities, the public outcry against the lewd short generated a word-of-mouth campaign that resulted in millions of customers.

sweetheart. *The Kiss* was shot as a close-up, with two average people, certainly not glamorous and worldly, in an age when kissing in public would have lovebirds arrested. The outrage of this short resulted in it becoming arguably the most popular attraction of the nickelodeon era.

THE PROJECTED IMAGE

The next logical stop to Norman Raff and many others was to project an image on a screen for larger audiences, instead of one at a time. Edison was still against this, thinking the bubble would eventually burst on this fad, even though it had exceeded well beyond his original predictions. The problems maintaining the nickelodeons forced this change. The Kinetoscopes were breaking down constantly because of constant use. The heat of the light inside slowly burnt the images so they could only be used a hundred times before being replaced. On most occasions they were replaced on a daily basis. The popularity of certain shorts was so high that the strips of film were brought dripping wet from the darkroom to thread into the machines.

A key obstacle to overcome with projecting an image was minimizing the stress on the film as it was stretched around and passed in front of a light bright enough to force the image thirty to forty feet onto a screen. William Dixon, finally out from under Edison's shadow, began an association with the Lathan family, a father and two sons who had been experimenting with a device to project images on a screen. Working together, within three years they had most of these basic problems solved, they came up with a way to have slack at the top and bottom of the film so the stress factor on the celluloid film would not be as great.

Meanwhile, another inventor stepped in, Thomas Amark, who made an observation that the clockwork-like mechanism in a camera would also apply to a projector, thus allowing the image to stop for one-sixteenth of a second to project each frame, a reverse of what the motion picture did to capture the image. This meant that the intense light would hit only one frame at a time, not a series of frames, to reduce the heat element. In September 1895, in Atlanta, Amark demonstrated the projector, which, despite working crudely, proved that the project was possible.

THE LUMIÈRE BROTHERS CONQUER THE WORLD

The real turn in this race to project film happened three months later. The Lumière brothers, Louis and Auguste, opened a picture parlor in Paris. Because of Edison's slow draw in understanding the potential of the camera and people's increasing fascination of films, he missed out on controlling the expansion of the newborn industry in Europe. All of this played into the hands of the Lumière brothers, who by 1895 had created their improved version of Edison's Kinetoscope they called the Cinématographe, which the Greek means "motion recorder" or "kinetic writer."

With the help of their father they created a factory and turned out the very best equipment of the day. Their version had great advantages over Edison's camera, which is battery operated and cumbersome to move. The Lumière brothers' camera could be hand cranked, which made it lightweight and portable, able to be picked up and placed almost anywhere. Being supreme mechanics, and very dedicated to their goal, they also invented a way to project the images onto the screen that gave a remarkable clarity of image.

The Lumière brothers' first film was appropriately titled, *Workers Leaving the Lumière*

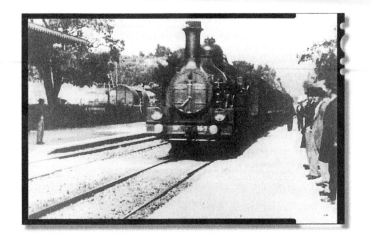

"Arrival of the Train in Ciotat Station" (1895) by Auguste and Louis Lumière caused many early patrons to flee the theatre in terror at the sight of the oncoming train.

Factory, and was a great success. The short that is tied forever to the Lumière brothers is *The Arrival of a Train.* The camera was positioned almost directly head on with the train as it steamed into a station. Members of the audience, especially in the first rolls, leaped up and ran from the theater, frightened that somehow a train had broken through the back wall. Stories of this incident abounded all over Paris.

Not only was the reality of something moving so remarkable at this time, there was no frame of reference in people's minds to understand the effects of film. It would be the same today as going into a fun house and having something leap out. In the darkened confines of a theatre, people's imaginations work overtime, and the patrons at this showing had no earthly experiences to tell them that a real train was not coming directly at them. Undoubtedly, within a few seconds everyone exploded into laughter. And then, most likely, people proceeded to invite their friends to come and sit in the front rows, as they waited in gleeful anticipation for the train to arrive.

It was a very strange but natural kind of relationship between the public and the screen at this time. Things were framed in a proscenium, much as a play would be, but the images suddenly went out of the frame. They disappeared. That caused all sorts of curiosity. Very much like a cat looking at his image in the mirror, then peeking behind the mirror to see if something was there.

The Lumière brothers have been compared to the legend of Johnny Appleseed, who went around America planting the seeds for future apple groves. The Lumière brothers did the same thing, only with film, and they did it around the world. They saw very quickly that audiences were fascinated by not just motion but also how people lived. They envisioned a way to open up the world to everybody. Soon they had photographers out with their hand-cranked lightweight cameras all over the globe. Suddenly people were sitting in these theaters looking at the Taj Mahal, East Indians passing by in elaborate costumes, Chinese junks slowly sailing past, and strange beasts called camels carrying turban-headed guides up to the Great Pyramids.

All of this was a huge fascination, because for hundreds of years, only the very wealthy were among the privileged few able to travel from one continent to the next. Unless called into military service, people spent their entire lives

in a radius of 50 to 100 miles from where they were born. To suddenly see the rest of the world was a marvelous realization of what the world really was, with its menagerie of different customs and people. In 1973, Jules Verne had made the astonishing prediction that someone could-with balloons, trains, and ships-actually travel around the world in eighty days. The Lumière brothers made this possible with their short documentary films. Eventually the novelty of simply seeing people move about, no matter how compelling the backdrop, began to wear away. But before this happened, not only did the Lumière brothers bring the world alive for people, they turned millions of people on to motion pictures.

Back in America, still frustrated with Edison's inaction regarding the creation of a movie projector, and well aware of the huge success of the Lumière brothers, Norman Raff turned to Armat, who by now had perfected one of his own. The men then approached Edison and guaranteed him a fee for the use of his name. Something that Edison had resisted, and had little interest in, became Edison's latest marvel, the Vitascope. Edison did not have a hand in the creation of the invention, but in America his name was gold and gave credibility to the process. The Vitascope opened in New York on April 23, 1896 at Koster & Bail's Music Hall. In all aspects it was the prototype of the modern projector. The screen was twenty feet wide, and the program included moments from a prizefight, several dance acts, and Rough *Sea at Dover,* which had audience members rushing from their seats to avoid the waves.

THE SLOW DEATH OF VAUDEVILLE

Most of the vaudevillian performers spent their entire lives perfecting one act. That was the whole approach in vaude-ville. If you had a comedy routine, you did that comedy routine all over the world. If you had a song, that became your trademark. Vaudeville was the craziest combination of performers with juggling acts, trained seals, slapstick comedy routines, the balcony scene from *Romeo and Juliet,* arias from Puccini, musical saws, and beautiful chorus girls. To cash in on popular names, motion picture companies would pay entertainers twenty-five dollars or more to perform their act in front of the camera. The physical comedy acts were the ones that amused audiences. Suddenly audiences everywhere were given the opportunity to see the routines of classic vaudeville. But it began to backfire on a lot of the performers. Since performers kept the same act and traveled from city to city, the act was always fresh because it was the first time most individuals had seen it.

Suddenly, with the ability to make multiple copies of someone's performance, it was used as one of the shorts in hundreds of motion picture parlors everywhere. When the actual vaudevillian performer got up on stage, quite often there was no interest since audiences had already seen the act several times. As with the constant turnover of shorts, people began to expect something new every time they sat down. The very nature of vaudeville made it hard for people to think of a new act. Years were spent perfecting one routine, and now, in a few weeks, everybody in the next town had seen it three or four times already.

Slowly many of the great performers of vaudeville began to lose their freshness, and only the smart ones who saw motion pictures as a friend and not the enemy, began to make adjustments. They hired writers to create new gags, and got composers from Tin Pan Alley to make up songs no one had heard before. But the performers that did not go with the flow, and looked upon motion pictures as the death of vaudeville,

sadly ended up as acts to fill in the lull while new reels were being threaded through the projectors. And the most heartbreaking ones became "chasers," whose job it was to make sure everyone cleared out of the theatre so the next group of paying customers could find seats.

But then the same thing began to happen to the motion pictures. Audiences began to get bored of just watching something moving across the screen, or seeing full figured action, usually without an edit or any attempt at a narrative structure. The initial thrill had dissipated. It looked for a while like Edison was right. Indeed the public was becoming tired of this little toy that made things move for a minute or two.

GEORGES MÉLIÈS—THE LITTLE MAGICIAN WHO WENT TO THE MOON

What happened next is credited to one individual. A French magician by the name of Georges Méliès is credited with creating the first narrative film. This is something that was inevitable. Filmstrips were becoming longer, and shorts were running regularly five to seven minutes. By 1902, Méliès had already made over 280 shorts, and would direct an unbelievable 559 mind-bending fantasy shorts in his lifetime, all in just eighteen years. But it is one little motion picture that he is best remembered for, *Le Voyage dans la lune,* or *A Trip to the Moon,* very, very loosely based on Jules Verne's novel, *From Earth to the Moon.* Considering that a Frenchman created the science fiction genre, it is only appropriate that a little Frenchman would complete the circle by making the first full fantasy film. In the process Méliès also created most of the visual language for film, including stop-motion animation, dissolves, double exposures, matte shots, and the first effective use of editing to condense time. Thus earning the rightful title of Father of Special Effects. And if this is not enough for one film, he also told a linear story with a neatly constructed beginning, middle, and end.

There are several different versions of how Méliès came to create what we now consider the art of special effects. One is while he was shooting on the street, his camera jammed. Once he was able to repair the problem, he continued cranking. When he developed the film he discovered that the bus that was in front of him suddenly turned into a hearse. There are other stories that he was shooting an internal scene, stopped momentarily, and someone removed a few flowers from a vase. He continued to shoot, and again, when he developed the film the flowers had disappeared.

To someone of a theatrical background, or just novice working with film, these incidents would have been considered a mistake. A stage manager might have cursed under his or her breath, then re-shot the scene thinking it was a mistake—something shot out of continuity that would confuse the audience.

But, Méliès was a magician. He did not see these things as a mistake, but as something magical. And in this instant was one of the greatest leaps in film pioneering that ever took place. A process that could have very gradually happened over years, suddenly changed overnight. Méliès examined all of the "mistakes" and applied his thinking as a magician. One of the tricks of the trade for the magician is to make the people in audience look exactly where he wants them to for an instant, while in a different part of the stage an exchange happens. Méliès must have known he had the perfect trick. He could let the audience stare right at the object and *still have it disappear* before their very eyes. And he could do it with storytelling.

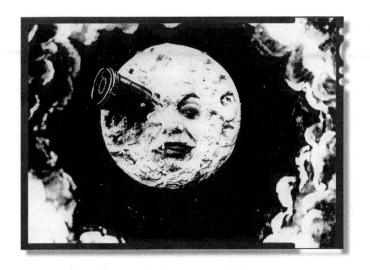

A Trip to the Moon (1902) by French magician Georges Méliès introduced dissolves, double-exposures, and stop-action animation into cinema language.

A TRIP TO THE MOON

This was the great age of magicians, with legendary names like Houdini, Harry Blackstone, Dante, Howard Thurston, Harry Keller, and Carter the Great. Méliès was a very prominent figure during this time. He was curious about the camera, like many of the magicians had been since the discovery of stroboscopic toys. His mind was very open to the camera's little idiosyncrasies. The public was fascinated by magic. Magic was always included in vaudeville acts, but the world famous names in magic would perform an entire evening and astonish audiences with their abilities to catch bullets in their teeth, or be tied in chains upside-down and be put into a glass cage of water and escape from it. Everyone was talking about these seemingly impossible feats of pure illusion.

The perfection of this art was at its high point. Méliès began to think of a story for which he could use the camera techniques with which he had been experimenting. Since one Frenchman had created the science fiction genre, it was only appropriate that another Frenchman would create the first full fantasy narrative motion picture. Many of his early shorts showed the progression to what eventually became *A Trip to the Moon,* which is *very* loosely based on Jules Verne's international bestseller, *From the Earth to the Moon.* Novels with illustrations were very popular with readers in this time, and both Jules Verne and Charles Dickens oversaw the artwork for their books with a very careful eye. Certainly these elaborate illustrations influenced Méliès. Since the planning of magic tricks is its own art form, he would carefully design each of the sets for *A Trip to the Moon.* Méliès became the first to use scenic sketches and storyboards, which became the blueprints for hundreds of his stories. Sadly, Méliès destroyed most of these drawings when he abandoned motion pictures after the first World War began. What has been preserved is a large collection of his shorts, which are a testament to his outstanding gifts as a visual artist.

To tell a narrative tale, especially one about space travel to strange worlds, required visual cues so the audience did not become disoriented by the changes in location and time. For this

he decided to use a process that became know as a dissolve. Dissolves were very easy to do with the old hand crank cameras. The cameraman would crank forward and slowly iris out, blocking the sunlight gradually as the image faded from the lack of light. Then the cameraman would back-crank the camera and slowly open up the iris until it reached its full exposure. In between, the two different images would overlap and fade in or out, or dissolve from one scene to the next. This was an important step in early narrative storytelling, since it allowed audiences who were accustomed to the theatre not to become confused. A dissolve was like a curtain coming down briefly to change the scenery. It told the audience that they were going to a new location, or that time had passed.

The blackout, followed by the fade-in, was another way to say, in theatrical terms, that this was the end of one scene, here is the next scene a little bit later in time or at a new location, only there were no overlapping images. Dissolves ultimately were used to signify a change in time and location throughout the silent era. This process became difficult to do twenty-five years later when sound arrived, since it was not as easy to back-crank the camera. Also, by then audiences were familiar with "scene changes" and did not need this visual road marker. Dissolves became to mean something very meaningful in a story with talking pictures, like a long duration of time, someone passing away, or two people walking toward a bedroom, then the scene dissolving into the next morning—all audiences knew what had transpired during that brief interlude.

The true genius of Méliès was the development and playful experimentation of double exposure and stop-motion animation. Early shorts by Edison made limited use of what became known as stop-motion. Whether Méliès saw these shorts or not, his inventive use of this process was revolutionary and highly original.

Using stop-motion in *A Trip to the Moon*, Méliès created what is arguably the most famous movie icon of the silent era. A rocket ship with the space explorers is loaded into a cannon, the barrel of which seems to stretch for a mile, by French maidens in skimpy skirts and sailor tops. As the rocket ship heads to the moon, the audience sees several brief scenes with dissolves as it gets closer and closer, until eventually the face of the moon comes alive. Méliès achieved this by stopping the camera, moving it closer to the miniature of the moon, and starting the camera again. Each time, the audience was visually drawn closer to the moon, as if they were in the rocket ship, until they saw the eyes of the moon flicker open. At this point the image of the moon is replaced by an actor with a craggy, round moon glued to his face. The audience grows closer. Méliès stops the action one more time and glues a miniature of the rocket ship to the right eye of the actor (which must have been miserably uncomfortable) and with makeup has tears flowing from his other eye. When the camera rolls for the last time, the audience sees the rocket ship wedged in the eye of the moon, causing the poor heavenly body to weep uncontrollably.

Once the explorers have landed on the moon they quickly settle down for a nap as snow falls. This is performed on a small stage with cutouts of moon rocks in the foreground, while upstage, where the sky would be, is a black curtain. When Méliès developed the film, this area would for all practical purposes be unexposed and remain completely black. He then would shoot other images against just the black curtain, like an attractive lady sitting in the cradle of a crescent moon waving. These images would be exposed in the area of the curtain, giving the impression the sky had come alive. The explorers awake and react to these celestial beings. But actually the actors playing the explorers were pantomiming to the black curtain, having no

idea, except for what they saw in Méliès' sketches, what the final effect would look like. To the audience this became a magical transformation. A hundred years later this same process is used in *The Lord of the Rings,* except the actors are performing against a green screen, and their images are dropped into a computer for a final rendering of hundreds of different elements.

The explorers then go into a moon cave. One of them puts down his umbrella, and immediately the umbrella grows from the fertile soil a dozen feet into the air like a giant mushroom. Méliès would have stopped his camera momentarily as the umbrella was replaced with another umbrella on a long staff that slowly grew up. All the actors were told to remain absolutely immobile, and not to move or wink for several seconds until this transfer was made. On stage the magician would have gone to great lengths to have the audience look away from the transfer, but Méliès was able to do it while the audience stared at the very spot it was going to take place. When the camera rolls again the actors act startled and amazed, putting the final touch to the miraculous sprouting umbrella.

Starting the great tradition of changing the original story of a novel to make it more exciting for the movies, Méliès has the explorers captured by small, demonic moon creatures. These creatures forcibly take the explorers to a throne room in the bowels of the moon. Dressed in Victorian costumes, the explorers are confronted by a strange King in traditional African garb who starts to pronounce a deadly sentence. Suddenly, an inspiration hits one of the explorers (played by Méliès), who seizes the Moon King and plummets him to the ground, where he violently explodes. This time Méliès uses stop-motion in synchronization with an electronic theatre flap pot and a dummy dressed as the King. When the actor playing the explorer grabs the King, the camera stops; everyone freezes, the king is re-

placed by the dummy, the camera starts, and the explorer plummets the dummy to the floor as the flash pot ignites, giving the breathless 1902 audience the impression that the king has been blown to atoms. The same stunt processes are used today, only the dummies have gotten much more realistic.

The explorers make their escape by violently thrashing the understandably irate moon creatures, who in turn are blown up one by one until the explorers are safely inside the rocket ship. Then, using the logic that the moon is up above, the explorers inside the rocket ship fall back to earth, splashing down in the ocean. The whole journey takes only fourteen minutes, telling for the first time a story in purely cinematic terms, with no spoken words.

Throughout *A Trip to the Moon,* Méliès uses a scenic design technique called forced perspective. At the launch, when the French maidens push the rocket ship into the cannon, the barrel appears to stretch out, almost touching the moon. In an earlier scene, men meet on the rooftop to discuss the ambitious project, and in the distance is seen the crowded Paris skyline with bellowing smoke stacks. In actuality the actors are only a few feet from the cutout of the skyline.

Forced perspective has been used by artists for centuries, and reached a high point in theatre during the time of Renaissance and *commedia dell'Arte,* as seen in opera sequences in the film Amadeus. This effect is achieved on stage by having different levels of scenery on a racked stage, with each section scaled down from the full set on the front of the stage. A favorite moment to use false perspective would be during a tearful farewell in a drama, where the actors pretend to be going on a long journey and ride off stage on a horse. The travelers would reappear on the next level upstage, which is painted to look like it could be a hundred feet away; only the actors are now midgets on a pony. When the

travelers reached the final level, they would be stick puppets bobbing in the horizon.

There is a scene like this in *Yankee Doodle Dandy*, where James Cagney says good-bye to his sweetheart on a full-scale ship. The ship moves off stage, and another ship appears that is half the size and steams midway across the stage. Finally a tiny model of the ship is seen out at sea, giving the impression that it is miles away. From the ship, fireworks go off, and Cagney launches into his famous tap number. Perhaps the most subtle use of false perspective is in *Casablanca*, when Humphrey Bogart is saying his final farewell to Ingrid Bergman. The men working behind them to ready the airplane are actually midgets milling around a scaled down cutout of an airplane painted silver.

Méliès simply brought this technique to motion pictures, along with stop-motion animation, dissolves, and double-exposure. But in reality *A Trip to the Moon* is a photographed stage play, with all the actors shot full-figured, and no internal editing during the scenes. Each scene is done as a master shot, with the actors entering and existing as they would on stage. What makes *A Trip to the Moon* a true motion picture is that Méliès made the camera the star. There are moments that could not be done on a stage. By stopping and starting his camera, he is able to make things disappear without misdirection or slight-of-hand. With double-exposures, he overlaps two scenes that were shot at different times, but giving the illusion they are taking place at the same moment.

Narrative motion pictures were inevitable, but they would have evolved from theatre and looked like photographed plays for probably a very long time. What *A Trip to the Moon* did was signal to the world that motion pictures were a separate art form which could combine all the other arts, but still be entirely unique, with a special bag of tricks that were purely cinematic.

Within less than a year after *A Trip to the Moon* was released, directors around the world were finding new ways to use the camera, freed up without the need of sound, to find methods of telling stories in a visual language that could be understood by anyone in the world.

Almost all of the shorts that Méliès made were high adventure about travelers to strange unexplored lands. This was a topic that interested audiences greatly at the turn of the century. There were still large parts of Africa and islands in the Pacific that were unmapped. It was perfectly conceivable to people that these "dark spots" on the globe might still have prehistoric beasts roaming around or some wondrous powers of enchantment—all the stuff of mythology that still exists in modern times. Tales of science being able to conquer the forces of nature were the themes of novels by Jules Verne and H. G. Wells who wrote about travel under the sea and invaders from Mars. Then later in the Tarzan and John Carter of Mars stories by Edgar Rice Burrows and Sir Arthur Conan Doyle's *The Lost World*. But to see these fantastical events come to life on a screen was an extraordinary experience on the eve of the twentieth century. Undoubtedly in the dark theatres watching Méliès' magical shorts were the future writers in this new genre of science fiction. And audiences, for a short while, could not get enough of them.

A Trip to the Moon was shown in almost every theatre or parlor around the world, and seen by millions of people. It started a stampede to create narrative films, and this is both the great success, and ultimate sadness of Méliès. He initially made a lot of money from the licensing of his films, but it got completely got out of control. Bootlegged, or, to use the modern term, pirated copies began to pop up all over. There was no way at this time to monitor widespread distribution. Exhibitors ran off endless copies, and when these wore out they made their own

versions and passed them off as shorts by Méliès. And only seven years before audiences were entertained by a sneeze.

But Méliès' eventual downfall was that he never stopped making the same motion picture. The stories were consistently about travelers going to strange new lands, and there was never any attempt at characterization, just broad brushstroke caricatures. The magic in these shorts at times got to the point of annoyance, because there were so many tricks that the storytelling almost completely disappeared. But his imagination was amazing and sometimes exhausting. He would take images, put them against an early version of a green screen, turn them around on an easel, and a different image would come to life on the far side. Méliès often tinted or hand painted frame by frame his shorts to give the illusion of color. They were rich in composition and amazingly playful to see, and to audiences they were like large bowls of chocolate ice cream.

His motion pictures became increasingly more surrealistic, taking images from childrens' books and personifying them into large creatures, like the Giant of the North Pole, who devours explorers, regurgitates, and spits them out on the ground, laughing as they get up and scurry away. In one of his more elaborate productions, *The Conquest of the Pole,* a woman falls out of a balloon, and explodes when she is punctured on the spiral of a church. He enacts a terrible Turkish execution. And in a short lasting almost twenty minutes, a train sets out to explore the unknown parts of the world, climbing mountains, and finally plummeting into the ocean. In the train is a small submarine, which begins to topple around with all the travelers trapped inside. The effects are mesmerizing, but a constant bombardment.

Like many of the early pioneers, Méliès never tried to expand beyond his short motion pictures to attempt something on a larger format. He became a prisoner of his own special effects, and instead of using characterization and suspense to build up to a fantastical moment, all of his moments were fantastical. Later directors like Fritz Lang and Alfred Hitchcock would become masters of this tight wire act between audience anticipation and the payoff with effects. By the time technology evolved to tell a full story, Méliès had lost interest in moviemaking.

When the war began, the innocence of Méliès' magical shorts, that had mesmerized the world for almost a decade, faded away. He

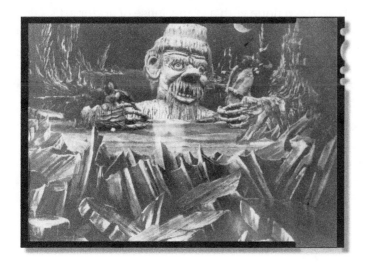

The Conquest of the Pole (1912) was one of the last movie magic films of Méliès, who made more than 560 experimental shorts in just sixteen years.

stopped production after over five hundred shorts, and in his discouragement he destroyed many of the original elements of his motion pictures. In 1914, he was forced to declare bankruptcy, and after this, a man who had once entertained millions of people seemed to fade away. Ironically, the French surrealism movement of the 1920s discovered Méliès' shorts and conducted a search for him. He was found selling toys and candy in a kiosk at the Gare Montparnasse. The French government in 1931 recognized Méliès' great achievements and gave him the Legion of Honor. By then he was a tired old man. The motion picture industry had changed so remarkably that his frolic with special effects seemed a distant memory. Méliès would live until 1938, having made his last film in 1914. Perhaps his greatest tribute came from D. W. Griffith, who simply said, "I owe him everything."

EDWIN S. PORTER, THE AMERICAN MELODRAMA, AND THE WILD WEST

Edwin S. Porter was a true American character. He had been everything from a sailor to an electrician, until he ended up at the Edison studio as a jack-of-all-trades cameraman, many times doubling as the director. Like everyone else at the time, Porter became spellbound by Méliès' short magic films and immediately started to imitate them. Porter's films were never as smartly crafted as Méliès', but he pulled off several interesting shorts with split screens, one with devils dancing above an actor's head. He created a miniature set of a bedroom and had the bed fly around, then with a double exposure made it appear to sail over the ocean.

Porter's camera tricks and the painted scenery were more realistic, and seemed less magical than Méliès' elaborate three-dimensional sets.

Quite often there were no backdrops. This allowed him the ability to do double exposures and make the subject clearer, as in *Pipe Dreams* where a seemingly tiny figure is being held in the palm of a lady's hand as she smokes.

These magical little films were a gold mine. A short ten minutes long with a variety of special effects would cost roughly three-hundred-and-fifty dollars to shoot, which was a sizable investment at this time. Edison's company would then sell the film outright to all exhibitors. Anybody who wanted to show the film simply bought a copy and ran it as long as they wanted to (or as long as the film lasted). By distributing in this fashion, the prints brought in close to thirty thousand dollars each. With huge profits rolling in, the company had the ability to take chances and expand its scope.

What happened next is a perfect illustration of the cultural differences between what is appropriately referred to as the Old World and the New World, especially at a time when innovations in filmmaking were jumping back and forth across the Atlantic Ocean. Méliès took his stories from myths and literature, with elaborate three-dimensional sets that brought these mythical worlds alive. From the start, European films were more philosophical, endeavoring to mold a new art form out of the infancy of moving pictures, often done with a grand sense of art for art's sake. American films were down and dirty, inspired by the wing-and-drop touring shows that were the rage of the country at the time; these have since become unfairly referred to as melodramas.

The melodrama was, and still is, the key ingredient in what would eventually become known as the "Hollywood movie." Traditionally, melodramas are frontloaded with characters on a collision course, and the outcome depends on a single individual who is forced to take aggressive measures. At the time motion pictures began simple narratives, America was receiving millions of

immigrants. Most of these immigrants wanted to get away from cultural traditions they felt were forced upon them and start their own. Melodramas were the common people stories, unlike Shakespeare, whose plays were full of kings and conniving queens. Melodramas were simple-designed to get the blood stirred up or to bring a tear to the eye as the final curtain descended.

The flint of melodramas is action. The principle character in the story becomes entangled with a problem that can only be resolved by direct confrontation. Modern films still have this dramatic spine, whether it is John McClane in *Die Hard*, Ellen Ripley in *Aliens,* or Frodo Baggins in *Lord of the Rings.* The folklore of the American West had all the ingredients for unabashed melodramas. There were gritty tales of good verses evil, one man fighting against overwhelming odds, shootouts at high noon, women in distress, colorful characters with an earthy sense-of-humor, and a showdown that resulted in a bang-up final act.

It is a mistake to think that all melodramas are like the modern day gaslight theaters, where the actor's mannerisms are overly exaggerated with outturned palms to the forehead, or holding the heart as the actor delivered his lines. The early melodramas had complicated stories and were considered highly realistic for the age. Touring shows like *Uncle Tom's Cabin* were considered so true to life that tough, hard-working coal miners were brought to tears.

This was also the era of the dime novel, where every month wide-eyed readers would get a new adventure about Wild Bill Hickock, Jesse James, or Billy the Kid. These ripping yarns were part of the popular legend of the Western, spun out of pure imagination with a dash of truth. Many of the folk heroes being written about were still alive, like Wyatt Earp and Buffalo Bill. John Ford, a director associated with Western movies his entire career, believed that when the truth is confronted by the legend then "print the legend." The first half of the twentieth century can be looked upon as a time of myth making, and the second half as a time when many of these myths were torn apart. Film played a major role in both movements, first allowing myths to be bigger than life on the screen, and later peeling back the curtain on these fictionalized tales to reveal a bitter truth.

From the very beginning, audiences were looking for stories that inspired and gave a sense of reality to ballyhoo about the American Dream. And film could bring these folk legends flicking to life. The hard-knock world was just outside the theatre doors. What the average person wanted was identification with people like themselves who had overcome adversity. The mixing of real people in melodramatic plots would become the bread-and-butter of early American cinema. In truth, the real west could never live up to the mystique of the movie west. And it all started with Porter's twelve-minute reenactment of a train robbery.

THE GREAT TRAIN ROBBERY

The narrative structure of *A Trip to the Moon* immediately caught Edwin S. Porter's attention, and he began to search for his own story. Borrowing from recent newspaper accounts of train robberies—in particular the hold up of the Great Northern Flyer by the Wild Bunch, with Butch Cassidy and the Sundance Kid—Porter put together a simple tale of daring. *The Great Train Robbery* was shot on location in New Jersey in 1903, and became the first Western, a genre that was purely American, which would have an incalculable influence on motion pictures for the next seventy years. The story was less fantastical than Méliès' journey to outer space, but *The Great Train Robbery* ignited the public's imagination in

a different way. It brought to life the wild adventures of cowboys and train robbers, the good guys and the bad guys.

In a novel, the events in *The Great Train Robbery* would comprise no more than a short chapter. Four ruthless men tie up a defenseless station agent, and then board the train while it has stopped for water. Two men make their way to the mail car, where they shoot the guard and blow open the safe (the explosion was hand-painted red and orange to heighten the effect). Meanwhile, the two remaining men overwhelm the train engineer and fireman, and the violent conflict ends with one of the men ruthlessly throwing the fireman from the speeding train (a moment of stop-motion photography borrowed from Méliès' explorers blowing up moon men).

The bandits have the passengers at gunpoint line up and proceed to relieve them of any valuable items, shooting one nervous dandy as he tries to escape. With their ill-gotten loot, the bandits ride the train to a prearranged point, and make an escape on horseback. Luckily a small girl discovers and unties the station agent, who quickly alerts the townspeople at a nearby hoedown. A posse is quickly formed to capture the bandits, and the first movie chase is underway, ending with a desperate shootout and the victorious recovery of the money. In the last scene of *The Great Train Robbery,* actor George Barnes aims his six-shooter directly at the lens of the camera and fires, which undoubtedly had hearts pounding in the front rows.

The Great Train Robbery had several cameo appearances by an actor known as Gilbert M. "Bronco Billy" Anderson. He plays with great dramatic flair the frightened passenger that attempts to flee and is shot in the back. Another time he is a tinhorn at the hoedown that is confronted by bad guys who fire at his feet until he does a little jig before he makes his successful escape. "Bronco Billy" Anderson (he would drop the first part of his name after the film) remembers going to the first showing of *The Great Train Robbery* and hearing the announcement to the crowd that they were going to see something different that night—something a little longer than usual. The audience was at first reportedly uninterested, in fact mumbled in discontent because their show had been interrupted. Within the opening minutes the audience became involved with the action, until by the chase they were rooting for the posse and cheering during the shootout. By the end of it, the applause was deafening and the cries of "more" resulted in it being shown several times that historic evening. The movie became the first blockbuster, and anyone who went to a theatre or parlor saw it over and over again.

Overnight "Bronco Billy" Anderson saw opportunity knocking and traded in his Eastern city clothes for a cowboy outfit and ten-gallon hat and became the first cowboy star. In total, he made over three hundred short Westerns from 1903 to 1916, swinging open the doors for William S. Hart and Tom Mix. Clint Eastwood even pays homage to the name in his motion picture *Bronco Billy* (1980).

And even with revisionist Westerns that began to appear in the 1960s and eventually changed the genre, the one feature that has never altered since the days of "Bronco Billy" Anderson is the theme of one man against large odds who ultimately succeeds. The basic structure of the Western has been used as a blueprint for almost every action film that has followed. George Lucas acknowledges the influence of the Westerns he saw when he was growing up in Modesto, California, on *Star Wars.* Clint Eastwood would hang up his six-shooters at times for a magnum, but still fought the same lawless criminals, only in the big city. And Akira Kurosawa talked about the impression that John Ford's cavalry films depicting the traditions of the Old West had on the

making of his samurai epics *Yojimbo, Seven Samurai,* and *The Hidden Fortress.*

EDWIN S. PORTER AND HIS CONTRIBUTION TO VISUAL STORYTELLING

The final moment in *The Great Train Robbery* (which is as famous today as Méliès' icon of the moon with a rocket in its eye) is often credited as being the first motion picture close-up, but technically this is not true. *Fred Ott's Sneeze* was shot entirely as a close-up, as was the loving couple in *The Kiss.* But Porter used his close-up for dramatic effect. Throughout the short film all the action is captured as full figured shots, but the closing shot was designed to give the audiences a momentary jolt. Thus the planned use of a close-up, which would later be perfected by D. W. Griffith, was added to the evolving grammar of movie making.

Porter's contributions also include the first pan shot, or the vertical movement of the camera on its tripod following the bandits racing past on horseback during the shootout. This simple movement of the camera broke the boundaries of the proscenium stage. Instead of framing every shot like a bit of theatre, complete with entrances and exits, the ability to pan the camera literally made the whole world a stage. The camera could pan 360-degrees, without a wall to inhibit the action. The confinements of dramatic conflict, which had been around for hundreds of years, were now blown wide open by the movement of the camera.

The Great Train Robbery is also credited with the first *matte shot.* A matte shot exposes a piece of film at least twice, except the images do not overlap like in a double exposure, they are instead carefully combined to give the impression that everything the audience sees was shot at the same time. In the scene where the bandits blow up the safe on the moving train, outside the open door, trees are seen flashing past. But the action is really taking place on a stage in New Jersey. The space behind the door on the train set is painted black, which is not exposed when the dramatic scene is shot. Then everything

The Great Train Robbery (1903) by Edwin S. Porter was America's first narrative film; influenced by Méliès, the 12-minute short was a huge hit and established the Western genre. It was reportedly seen several times by Butch Cassidy.

around the door and window is masked so that the exposed portion of the film does not get any additional light. Porter would have then carefully back cranked the film in the camera to expose the area of the door with footage of actual trees shot from a moving car.

The designs of matte shots and matte painting became highly complex over the next twenty years, reaching the height of perfection with the production of *King Kong* (1933) and with *Gone With the Wind* (1939), where over half of the exterior scenes are matte paintings, including the famous final shot of Scarlett O'Hara next to the sprawling oak tree with Tara in the background. Another form of matte shot was achieved by creating a perspective painting on glass that was strategically placed in front of the camera to fool the eye into believing it was seeing a castle on a distant mountaintop. This allowed for the effect and the master shot to be done at the same time, saving the problems exposing the film twice. In the silent version of *Ben-Hur* (1925) this process was used during the chariot race to give the impression that the uppermost walls of the coliseum actually existed.

In addition to its other achievements, *The Great Train Robbery* demonstrated the influential power of motion pictures. For a short while after its release, the hugely popular little film became a kind of visual instruction manual for outlaws in the art of holding up trains. When the film came out, train robberies were almost non-existent. Trains were faster, safes were better, there was more security, and people became cautious of what they took with them on long trips, thwarting the glory days. But *The Great Train Robbery* allegedly inspired a last hurrah in this illegal endeavor.

The greatest example of the influence of motion pictures came twelve years later with *The Birth of a Nation*. At the time of its release there were only a few thousand known members of the Ku Klux Klan. Within two years after a firestorm of controversy, the membership grew to over three million.

RESCUED BY ROVER

Another little motion picture that changed the boundaries between stage and screen was *Rescued by Rover* (1904, and remade in 1905), directed by in part by Cecil M. Hepworth, one of the founders of the British film industry. It was a film that broke a tradition done out of necessity, going back to the very first stage performance. *Rescued by Rover* is the kind of short action film that became extremely popular, leading the way for super animal stars like Rin Tin Tin and Lassie. It was one of the earliest films to feature an animal as the center of attention. Animal acts were always extraordinarily popular in vaudeville and circuses, dating back to the ancient Romans and before. But in films they could carry the story by themselves, with humans as the secondary leads. Because of the process of editing from one image to the next, animals appeared to have the ability to understand completely what people were saying to them, or having a way through barks and body language of getting a message to humans.

The story opens with a nurse taking a baby out in a perambulator for a morning stroll. She inadvertently insults a gypsy woman, who naturally vows revenge due to this slight. The next scene shows the nurse chatting merrily with a potential beau. During this interlude the camera pans from the preoccupied couple to the baby carriage, revealing the gypsy menacingly stealing the infant. This movement of the camera is the first of what would eventually become known as a *planned sequence,* or an intricately designed shot that has multiple facets, so camera work must be precisely executed. In *Rescued by Rover*

the movement of the camera tells two stories in one shot, the flirtation and the kidnapping.

Another extension of this technique is called *blocking in the camera,* where during a single shot the actors are blocked into different configurations within the framework of the scene, thus at different times they will be in a close-up, medium shot, or a long shot. John Ford does this in almost all of his films, since it allows the acting momentum to continue without the interruption of an edit. Steven Spielberg used these techniques in films like *Schindler's List* and *Saving Private Ryan* to create a documentary feeling. The movement of the camera almost becomes the eyes of the audience, looking around, and, as is the case with *Rescued by Rover,* seeing something the characters in the film do not.

But this is not all this seven-minute film achieved. What happened after the gypsy disappears with the baby is revolutionary, and would become an essential part of filmmaking forever. On stage there would be a moment out of necessity where the nurse turns and discovers that the baby is missing, and then spends time talking with her beau as she becomes more frantic about the situation and eventually hurries off into the wings as the curtain comes down to change the scenery. In the theatrical world, actors must get on and off stage, and there is usually dialogue to cover entrances and exits. In this particular case, we did not see that in the audience. Instead the next shot has the nurse running into the house in a panic announcing that the baby has been abducted.

As the nurse delivers the terrible news to the parents, Rover, the faithful family dog, listens knowingly, obviously understanding every word the distraught nurse is saying. Then Rover turns and leaps out the window, fully resolved to bringing this matter to a happy conclusion, and unquestionably knowing exactly where to go. A popular phrase for editing in this fashion

is "cutting to the chase," and it perfectly shows the differences between plays and movies. What has been cut out are the unavoidable stage transitions, and instead there is a sense of perpetual forward movement, cutting to the high point of every scene, which builds suspense and tension.

On Rover's self-appointed journey, he dashes down a street, headed straight toward the camera, quickly turns a corner, and swims across a stream, shaking himself off on the other side. Then Rover searches several doors of Shantytown, and eventually discovers the wicked gypsy prematurely celebrating with a bottle of booze. When the gypsy woman titters from the room, Rover hurries inside, and nudges the baby as a reassurance that help is soon to come. Rover then runs out the door and proceeds back home, following the same route, with the same camera setups, so the audience is never lost in the action. This creates a very linear trip, beginning with the action going from the audience's left of the screen (or what is called "stage right" from the standpoint of an actor looking out at an audience) to the right, then repeating the action with Rover going from the audience's right to the left.

Rover leaps back through the window of the house, and dashes about, barking, until his master instinctively understands what he is "saying," and decides to follow. The journey is repeated, with the duration of the shots shorter this time, ending with the safe recovery of the baby. The film ends peacefully with the baby safely out of the clutches of the gypsy, and mistress, master, and Rover all happily in their living room. Hepworth did not show the retreat back to the family home, knowing that the emotional high point was the audience seeing a sense of domestic normality restored to the family.

Not only did Hepworth cut the film to the essential action of each shot, eliminating any business or movement that would diminish the tension of the rescue, he gave the audience visual

Rescued by Rover (1905) by Cecil M. Hepworth is the first example of a planned sequence in motion pictures; here showing the abducted baby and faithful dog happily reunited.

landmarks so they know the direction the wise dog is headed each time. This process has become the basis of all filmmaking. One location at a time is shot for complete coverage. Each location that Rover visits is shot once with him coming toward the camera as he searches for the baby, then shot again with him moving away from the camera going home for help, and shot a third time with his master in hot pursuit. This is called *shooting out of continuity,* where each scene in a script is shot in its entirely, no matter what the effects or time of day, then the next scene is shot. Sometimes the last scene might be shot first, depending on the production schedule. This saves an enormous amount of time and money, since it is possible for one camera setup to be used several times; most importantly, the cast and crew do not have to return to certain location after the initial shooting takes place.

Another feature of *Rescued by Rover* is the use of the 180° rule. Action in film usually goes from "stage right" (the actor's right facing the audience) to "stage left," the right part of the screen being the most powerful since the eye instinctively goes there. This continuity of action will continue through out the other scenes, creating a sequence that tells a small story, like in *Rescued by Rover.* If the camera stays within a radius of 180° for each shot going from the right to the left of the screen, then the audience feels everything is headed in one direction. However, when the camera is placed on the opposite side of the 180° line, when edited with the others that shot will appear to be moving in a different direction. The action in film has always been done by staying within the 180° boundaries and not jumping the action. However, this is nearly impossible to achieve in documentaries, especially war footage. Starting with some of the directors in the French New Wave Movement, deliberately breaking the 180° rule gave a documentary feel to a movie that, if done correctly, could heighten the sense of reality.

THE MOTION PICTURE PATENTS COMPANY

By 1908 there were over 5,000 nickelodeons, attracting over 80 million people each week. This is a startling figure con-

sidering that the entire population of America at this time was 100 million people. These were mainly immigrants, the lower working class, and wives that could find an hour out of their day to get away from the drudgery of kids and cooking. Almost 100 million dollars was raised through nickelodeons yearly, five cents at a time. Still they were located in the lower parts of cities and not taken seriously by the upper class or sophisticates of high society.

In many ways going to a nickelodeon was almost an unthinkable visit. Since most of them were converted stores, they were tightly packed with no ventilation or air conditioning, causing many women to "swoon" during the showings. The rooms were perpetually hot and stuffy, even in the dead of winter. The chairs were usually on loan from funeral parlors, made of hard wood and creaking constantly. In an effort to isolate the movie projector and projectionist from the curious masses, tin sheets were put around the projector, leaving the projectionist to sweat as he tried to put these little pieces of film together for the next show. The stench of bodily odors was unimaginable in an age when bathing was a weekly chore, if that regularly. Owners would have the help roam the aisles spraying cheap perfume between shows, but mist would linger in the air, unable to penetrate the foul atmosphere. Men would smoke, creating a dark brown cloud that the projector light cut through like an early laser beam. Fights were a nightly occurrence. The language was a verbal smorgasbord of different tongues, cursing, arguing, insulting, and cheering if the little movies were any good.

But when the little films worked with their silent pantomime performances, the excitement took everyone out of the cramped, muggy surroundings. Suddenly they were in the middle of a Bronco Billy western, or laughing at the parade of comedians that began to leave vaudeville and music halls and try their luck in the flickers. A piano player on a rinky-dink upright would underscore the action on screen, or, when the film broke, bang out a popular Tin Pan Alley song and encourage the rabble to sing along. A big night was the prizefights, which were brutally realistic in a time period when athletes fought with bare fists for forty or fifty rounds in sweltering heat.

There was no arguing that motion pictures were a giant business and not just a passing fad, which was Edison's original assessment. The ownership of equipment and the rights to make movies became a giant court battle for over ten years, with over 500 legal disputes filed, and ultimately 200 of these lingering in courts for years. By 1908 the two biggest companies were Edison and Biograph, but there was a growing number of others including Vitagraph, Essanay, Lubin, Selig, Kalem, and two French companies that were producing in America, Méliès and Pathé. Biograph's films were becoming the more popular, in part due to an actress known simply as the Biograph Girl, and a new director by the name of David Wark Griffith.

Realizing the court system was only delaying bigger profits and bleeding money to lawyers, Edison made a move to Biograph and the other movie companies joined forces with Edison in what became known as The Motion Picture Patents Company. The first course of action under this unified legal umbrella planted the seeds that would eventually result in the movie industry relocation to California. What the Patents Company sought was an ironclad legal justification to have a weekly tariff levied against the bustling nickelodeons. Each owner would be expected to pay two dollars for every theater that was showing films from a Patent Company, and this was over and above the film rentals they were being charged. The Patent Company was clearly taking this action as a legal maneuver to stop others from making or exhibiting films. It was an

outright attempt to form a monopoly on motion pictures.

This was at a time when American capitalism was at its peak and monopolies in oil, trains, ships, and banking were coming under scrutiny by the newspapers. In order to achieve this total control, smaller motion picture companies were only allowed to use cameras that were made by the Edison Company, or to be hit with legal actions. To present any potential end-runs around the demands of the Patent Company, Edison and other members approached George Eastman and struck up an agreement where Eastman would supply them *and them alone* with the negatives for the film. For all effective purposes, this was a ball-and-chain that any company interested in the motion picture business had to live with. It took a 5′3″ man with the determination of a giant to fight back.

Carl Laemmle, who had been a distributor, saw that producing his own movies was the only way to challenge the newly formed Patent Company. His first movie was *Hiawatha* in 1909, loosely based on Longfellow's poem. Laemmle became the leader of the Independents, and would relocate to California by 1915, creating Universal Studios. Another distributor turned producer was William Fox who likewise started his own company in California, which eventually merged with Twentieth Century to create Twentieth Century-Fox. Laemmle and Fox were able to align themselves with the Lumières in France and received film stock to make movies, avoiding Eastman and his exclusive agreement with the Patent Company. Eventually Adolph Zukor, with Famous Players-Lasky, which later reorganized as Paramount, joined the fight against the Patent Company.

While the ensuing legal battle raged in the courtrooms, a move took place to separate the actual process of filmmaking from the devastating visits of strong-arm people from the Patent Company that had become known as "Edison's thugs." Gangs would unexpectedly show up at companies that were resisting the strong-arm techniques from the Patent Company to license equipment, and proceed to shoot bullet holes in cameras, wreck sets, and rough up actors. There quickly became a limit to how much the Independent companies would suffer for their art. The smaller companies packed up what was left of their equipment and boarded trains to sunny California, 3,000 miles away from Edison, the Patent Company, and the legal obsession to control motion pictures in the United States. This migration west by the Independents changed films forever.

THE BIOGRAPH GIRL

Perhaps there is no better single example of the power of film and how it impacted audiences quite so rapidly as that of "The Biograph Girl." Her real name was Florence Lawrence, but there were no credits for actors in the early years. Often actors did not want their names to appear, because making the flickers was considered a big step down from the legitimate theatre, but mostly because no one thought the general public would have the slightest bit of interest in knowing the names of these images in shadow and light. The four leading companies that were supplying films on a daily basis to the nickelodeons were Edison, Vitagraph, Kalem, and Biograph, all located in New Jersey and New York. This was during a time period when there were laws stating that a theater could not be within 200 feet of a church. Since acting traditionally was considered a lowly profession by religious groups, there was no reason to think that the name of these performers was of any consequence, unlike the names of honorable statesmen, presidents, and royalty.

Enter the The Biograph Girl who changed the public's concept of what it meant to be famous. She became known with this title because she was making pictures at the Biograph Studio. Florence Lawrence had been working on stage since she was three-years-old, and at twenty was cast by the Edison studio for a production of *Daniel Boone*. She moved to Vitagraph and then to Biograph, where by 1909 she had made over one hundred short melodramas, many of them with the new director on the lot, D. W. Griffith. Suddenly, this unknown actress was getting hundreds and ultimately thousands of letters from fans that knew no other way to correspond with her except as "The Biograph Girl." These letters would extend invitations to dinner, requests for lovelorn advice, and eventually proposals of marriage. All of a sudden someone that had no public name except for "Anonymous," with no royal pedigree, and who had done nothing remarkable in terms of art or inventions, was the subject of letters by the bagful begging for her attention. Very quickly the studio heads took notice of this phenomena. Here was an unknown actress hired to be the innocent, wide-eyed heroine in a few quick shorts, and suddenly she was getting unprecedented attention from men and women all over the United States. Everyone wanted to know her real name.

The elaborate plot that was conceived to bring her name to the clamoring public's attention is something that could only happen in Hollywood-in this case, even before there was a Hollywood-and sadly had one of the first tragic endings to a story about fame of the silver screen. Desiring to be recognized by her own name, Florence Lawrence left Biograph, but the Patent Companies immediately blacklisted her for her ambitious actions.

Carl Laemmle, seizing upon an opportunity, proposed a sure-fire publicity stunt that would bring her real name to the public's attention: a story was released that The Biograph Girl had been tragically struck down and killed during a trolley accident in St. Louis. Overnight, the newspapers picked up the sad news and the nation went into mourning. Here was a vibrant personality that people could still see in her old movies who was now gone forever—or so it seemed for the moment. This must have been one of the most baffling experiences in the early years of cinema, to see the image of an actor in a state of perpetual motion after the actual person has passed away. This form of immortality had never been possible before.

Then in a flurry of news it was announced that Florence Lawrence, formerly know as The Biograph Girl, had actually been rushed to a hospital in a state of amnesia but had now made a remarkable full recovery. Her first guest appearance in St. Louis after the miraculous news had more people attending than the President of the United States, who was there the following week. But the mystique of The Biograph Girl did not translate to the success of the real life Florence Lawrence. She made motion pictures until 1914, but her popularity began to wane quickly as a parade of new female stars caught the public's attention, like Blanche Sweet, Dorothy and Lillian Gish, and Mary Pickford. Her roles became fewer, and she was forced into retirement in 1914 after a serious stage accident injured her back. A few years later she attempted a comeback, but audiences had all but forgotten the woman who had dominated headlines as The Biograph Girl. She continued to step in front of the camera but was reduced to minor roles as the flickers grew into an international industry. On December 28, 1938, after years of illness and despair, Florence Lawrence committed suicide.

What is significant about the sad tale of Florence Lawrence is that a completely anonymous person, by some indefinable presence on a stained white sheet in a nickelodeon, could

suddenly cause an international sensation. This was during an age when great moments in science and discovery were happening almost weekly, and yet it was the pale moving images of nameless actors that fascinated people the most. The star system had been born.

GO WEST, YOUNG FILMMAKER

Edison's first assumptions about the early flickers were nearly correct. Film had indeed almost died a slow death early on because of the static, repetitive nature of the shorts. Méliés and Porter invigorated moving pictures with visual twists that would have been impossible to imagine before in any other art form. These men took the one-note fascination of cinema and turned out innovative pantomimed stories for a huge audience. No one could have foreseen these simple but ingenious changes. By ignoring the prospects of a European patent, and later trying to force a motion picture monopoly, Edison made two critical mistakes that allowed film to grow and break away from the boundaries of theatre.

From the beginning, one of the things distributors of motion pictures wanted was a certain respectability that was only found in theatre. These men wanted this for two reasons. Most presenters were recent or second-generation immigrants and were fascinated by the famous actors of theater, which represented a glimpse into the world of high society that they were not allowed to participate in. For the most part, distributors were Jewish, with such names as Adolph Zukor, Carl Laemmle, William Fox, Louis B. Mayer, Irving Thalberg, Harry Cohn, and the Warner Brothers. These men would later become known as movie moguls. Once in America these men discovered that many doors were closed to them in a predominately Protestant country. They could not get into most universities to study medicine or business, and country clubs and wealthy homes were closed to them. But they could attend the theatre along with the snobby social elite. They wanted to be a part of the glamorous world behind the footlights, but not a small part. These men wanted to bring about a way of presenting the arts to the masses, and they saw motion pictures as the way to achieve this.

On July 12, 1912, Adolph Zukor opened a theatre on Broadway and premiered a forty-minute feature production of *Queen Elizabeth* with the world-acclaimed French actress Sarah Bernhardt. At the time, this was considered the first feature length motion picture and proved that audiences could sit still for more than a few minutes if the subject was compelling. *Queen Elizabeth* was done as a straight stage production with artificial scenery, no effective lighting moods, and no effort to use the film language that had begun with Méliès and Porter. It is a perfect example of what motion pictures might have become for decades if many of the distributors had not relocated to California and begun to produce on an elaborate scale.

Over in Europe a group of artists formed the Film D'Art, which was comprised of actors from the Comédie Française, composers like Camille Saint-Saëns, and writers like Edmond Rostand, the playwright of *Cyrano de Bergerac*. They banded together for the purpose of bringing art to the infant cinema that they envisioned could enrich the masses. In Italy there were several productions over two hours long including *Quo Vadis?* (1912) and *Cabiria* (1913), depicting the burning of Rome. All of these productions were elaborate plays, done against theatrical sets, and with a style of acting intended to reach the last row of the theatre, missing the subtleties that were possible performing in front of a camera only a few feet away. These epics were remarkable in scope, with beautifully color-tinted scenes, but they never fired the public's attention.

Quo Vadis? (1912) this Italian made epic directed by Enrico Guazzoni runs for two hours and is a remarkable example of how cinema storytelling advanced in just ten years.

Anticipating that feature length films were the next logical trend, Jesse L. Lasky and Samuel Goldwyn formed the Lasky Feature Play Company with a young actor and writer named Cecil B. DeMille. The company would later become Paramount Pictures. For their first venture they decided to adapt the successful stage play *The Squaw Man,* written by Edwin Milton Royle. DeMille's experience with motion pictures consisted of a one-day apprenticeship at the Edison Studio, but from the very beginning he wanted to make the melodramatic potboiler into something spectacular, with wide open plains and majestic mountains that audiences had not seen before. This appetite for things on a grand scale would become his trademark with epics like *The Ten Commandments* and *The King of Kings.* DeMille also wanted to get away from the potential rough-housing and gunplay of the agents with the Patent Company, so he set out for Flagstaff, Arizona.

This might have been the new home of motion pictures, but unfortunately history played a dirty trick on Flagstaff. When DeMille arrived with his crew and actors, it was during one of the worst storms on record. It was almost impossible to get from the train to the station to send a wire back to New York. The message from Lasky told the freezing film company to keep going west. DeMille and his company ended up in a small town surrounded by orange trees called Hollywood. They rented a barn at Vine and Selma Street to use for interior shooting, which became the first studio stage in Hollywood; it can still be visited today across from the Hollywood Bowl.

The Squaw Man was released in 1914 and ran for seventy-eight minutes, making it technically the first full-length feature film in the United States. It was a huge hit, primarily because of the magnificent, uninterrupted landscapes. The motion picture started a second California gold rush, except this time it was for the diverse scenic terrains and the distance from the legal wrangling and brutal methods that Edison had resorted to. Los Angeles was a perfect spot. It was sunny most

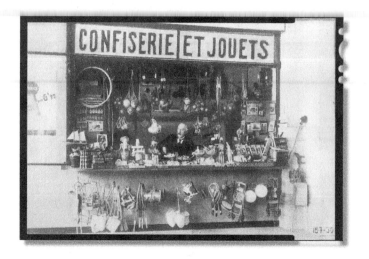

Georges Méliès is discovered in 1930 selling toys at the "Confiserier et Jouets" in Montparnasse; the following year he was given the French Legion of Honor for his contributions to the art of the cinema.

of the time, and within a couple hours drive a company could be in unspoiled mountains, deserts that looked like the Sahara, or the ocean, with beaches that stretched for miles without anything in sight—a scenario which only lasted for a few years after the invasion of filmmakers. It was a perfect haven for making films all year round. And if Edison did send a few of his strong-arm agents to practice what they did in New York and New Jersey, film crews would disappear across the Mexican border for a few days until things cooled down. This newfound land of Hollywood was a perfect environment for motion pictures to grow unimpeded by legal clashes and the restrictive cultural attitudes of the New York theatre scene.

The kinds of motion pictures that began to come out of California over the next decade had a different look, feel, and excitement. The word from the home offices of studios, which would remain in New York, was that audiences wanted more films with action, and less with actors waving their arms in funny costumes from a time period that most immigrants could not identify with. The new motion picture companies made the word *Hollywood* represent glamour, excitement, overnight fame, and a carefree crazy living style. People began flooding in from around the world. The car was making its appearance in large numbers, and trolleys could take someone all the way from the ocean to downtown Los Angeles. It was an invigorating time, and, most importantly, land was cheap.

The Squaw Man proved that audiences could sit still for over an hour if they were entertained, but the most attractive feature of DeMille's horse opera was the landscape—not the story or the acting. And except for the outdoor shots most of the film was shot like a stage play with very little variety in camera setups. What was rapidly becoming a major industry still did not have a definitive vision that separated it from the theatrical world.

There were comic car chases and shootouts, but the bits and pieces of visual storytelling that Porter and Méliès had pioneered had not been put together in one film. There needed to be someone that understood what all these separate little discoveries were and could assemble them into one motion picture—someone who understood everything that had happened for the first twenty years of film and put a defining mark on it. That gentleman was David Wark Griffith, and he was about to change the American cinema in such a way that even today the motion picture industry is still using the "visual grammar" he created.

Chapter 2

An International Visual Language

1915–1927

AN AGE OF DISCOVERY

No single invention changed the world as completely and rapidly as Edison's incandescent light. Invented in 1879, by the turn of the century, the major cities of the world were brightly lit up at night. This dramatically altered the pattern of the way people lived. Before incandescent light there was gaslight, which at best could only illuminate a few feet of darkness, and before this there was candlelight or the glow of the fireplace. The daily routine of the world had always been to get up early with the sun and go to sleep shortly after sunset. Very few people could afford the luxury of candles throughout their homes to illuminate evening gatherings. Even gaslight was inconstant, fluctuating in intensity, as well as being a very dangerous thing to live with. Faulty gas lines were constantly causing catastrophic fires during the early years of the Industrial Revolution.

The light bulb was safe, and it quickly improved over the years, becoming brighter, lasting longer, and able to throw out considerably more light evenly. Big cities became a flurry of social life in the evenings. People were able to stay out late and find their way home safely, whereas the pitch darkness of alleyways and back streets of the gaslight era were intimidating with the possibilities of danger and vice.

The incandescent light seemed to trigger a burst of modern discoveries, which in turn influenced the traditional nature of music, literature, and plays at the turn of the twentieth century. It was a time unlike anything the world had ever seen before, where traditional things were taken apart and put back together in incredible new ways. The Wright brothers flew at a remote spot called Kitty Hawk. Composers like Igor Stravinsky, Richard Strauss, Claude Debussy, and Sergei Prokofiev revolutionized the sound of music. In literature, James Joyce redefined the novel, and August Strindberg wrote plays about the alienation of modern man in a forsaken universe, foreshadowing Expressionism that would heavily influence German cinema. Sigmund Freud

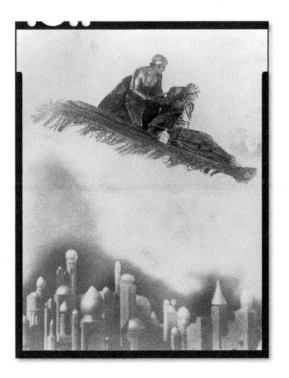

Thief of Bagdad (1924) directed by Raoul Walsh, this elaborate production stars Douglas Fairbanks, the first internationally famous action star of the movies.

began to unravel the mysteries of the mind, and his interpretation of dreams as a path to the subconscious triggered the Surrealist movement. The classical forms of art fell into the hands of a generation that would bring a new vitality to these disciplines, unlike anything that had been seen or heard before. And film was immediately at the center of this experimentation.

Joseph Pulitzer and William Randolph Hearst rammed heads in the bloody newspaper wars, giving the name of "yellow journalism" to an era of questionable reporting. Both men believed the masses wanted sensationalism, and that sometimes the truth was not always the most direct path to a newsworthy headline. Immigrants coming to America by the tens of thousands every week, often given names upon their arrival that sounded more American, found it easier to read newspapers peppered with sensational photographs and cartoons. Ironically, Pulitzer's name would come to represent the height of literature and journalism with his yearly prizes for excellence, and Hearst would become forever linked with *Citizen Kane* and the lonely last utterance of "Rosebud."

Henry Ford put America on wheels, with his Model T's backfiring black fumes of smoke into the increasingly sooty air. Horses, the prime form of transportation since the dawn of civilization, were now endangered in the streets, quite often panicking when the pitter-putt of automobiles raced past at 15 m.p.h. Small towns began to lose population as sons and daughters moved to the big city to seek out their fortunes. The fictional Horatio Alger stories of the American Dream suddenly became a reality. Trains ran daily from rural communities to New York, Chicago, and Los Angeles, and within ten days or less someone could cross the country, seeing the vastness of America. People began to look for excitement in every way.

Queen Victoria passed away in 1901, living long enough to be captured on film. Mark Twain was still very much alive, commenting that stories of his death had been "greatly exaggerated." It was a time of nervous splendor, when the royalty of Europe wore their crowns slightly askew, perhaps in the anticipation that centuries of control were about to vanish in a few short years with the onslaught of the Great War. It was a period not only of great inventions, but also of medical strides. Yellow Fever was eradicated in the Panama Canal Zone. The miracle of aspirin was discovered and became a daily remedy to cure headaches and other short-term ills. And tooth powders and mouthwashes added new pleasures to intimate relationships.

Motion pictures fit this age of discovery perfectly. The stories were told in pantomime, accompanied by music, often with large orchestras, and the prints were often tinted or hand-painted. However, the mechanics of movie making were improving faster than the visual storytelling process. Cameras had faster lenses that could shoot in almost any conditions. An understanding of the principles of cinematography developed at a remarkably fast pace. Within the first decade of motion pictures there was already a sophisticated sense of composition, and pioneer cameramen were experimenting with lighting techniques to reinforce the dramatic mood in scenes. But movies were still being directed like stage plays, even after the breakaway to California. Most shots were full figured, and there was very little use of inserts, close-ups, reverse angles, or rapid editing. What happened next is the equivalent of giving an infant who has just learned to crawl all the letters of the alphabet, only to return a short time later and find the child has created a brand new, fully realized language that everyone in the world can instantly understand.

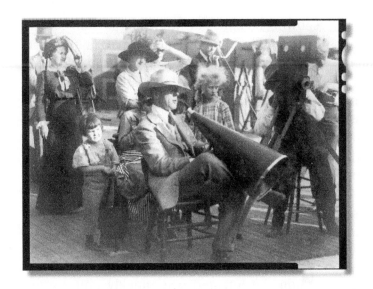

D. W. Griffith directed more than 530 shorts and features, many with cinematographer Billy Bitzer, and developed the "visual grammar" of the movies.

ENTER MR. GRIFFITH

No single individual can be credited with doing more for putting the pieces of the modern motion picture together than David Wark Griffith. As Lillian Gish has fondly pointed out, Griffith was the father of film, the great visionary that gave us a *film grammar* that is as essential to early filmmaking as the Rosetta Stone was to translating ancient languages. Griffith took all those happy accidents that occurred in film over the first decade and made sense of them—a jump in creative comprehension unparalleled in any art form. Griffith was able to understand the power of film and how to visually manipulate an audience into feelings of anger, fear, love, and laughter. As his contemporary Cecil B. DeMille would later say, "He taught us how to photograph thought."

D. W. Griffith was born on January 22, 1875 in Oldham County, Kentucky, ten years after Robert E. Lee's surrender marked the end of the Civil War. He came from a very poor background. His father, who would mesmerize him as a child with stories of the Civil War, had lost all of his

fortune in this great conflict. Jacob Wark Griffith, who had been a doctor, a statesman, and a slave owner, was never able to recover financially and died in 1882, leaving his wife and seven children in great poverty. Young David received an elementary education, not graduating from high school, and began to fancy himself as an actor and writer when he joined an amateur touring theatre group at the age of twenty.

Griffith read ferociously, especially the novels of Charles Dickens, who shared a similar bleak childhood of hardships. He wanted to be part of the theater world in front of the footlights. In sound documentaries he reminisced about his early days on stage and the inspiration to make moving pictures. He speaks in a full throttle voice, with mannerisms and gestures adding extra timbre to every word. He had a force and presence that reflected the naturalistic acting style of Edwin Booth and Charles John Kean, but ironically would have been considered overacting in his own movies.

Performing under the name Lawrence Brayington and Lawrence Griffith to protect his family's proud reputation, he traveled from

Portland, Oregon to Boston, Massachusetts, giving performances in stock companies. During these years Griffith invented his most memorable character—himself. To cover up the fact that his father was a disillusioned and heart broken member of the confederacy, he began to embellish his family history with hair-raising tales about the war that pitted brother against brother. But his love affair of the stage was very short lived, resulting in a meager income.

Griffith knew of the silent movies of course, because by 1907 everybody was talking about them. He had visited nickelodeons many times and felt there was really nothing there for an actor who was serious about his craft. But, like everybody else, he had a fascination with these flickering bits of light on the screen. As someone that understood the underdog, the immigrants, and the poor people that he had seen in the south growing up, he appreciated that they too, for their nickel, could have some form of escape and enjoyment.

Griffith met with Edward S. Porter, who was still working as a director with the Biograph Company on 14th Street in Manhattan. Griffith's first assignment was to appear in Porter's short *Rescued from the Eagle's Nest,* a preposterous film that has Griffith with his larger-than-life mannerisms, doing battle with an unconvincing looking eagle who had stolen a baby. Griffith appeared in a few more films but had much more luck selling story ideas to Biograph, which eventually offered him the chance to direct.

He was leery of this opportunity to begin with, fearing that his failure as a director might ruin his success with Biograph, but he was reassured that no matter what happened, his talent as a writer would still be welcomed at the studio. His first film was *The Adventures of Dolly* (1908), with a scenario about a plump little girl kidnapped by gypsies (a very popular theme in early silent films). It is a routinely shot film, showing no hints of Griffith's future innovations, but remarkably this one-reeler has survived, where over 90 percent of the films made during this period disappeared. Griffith's genius for directing evolved over the next five years where he made hundreds of short films, most of them with pioneer cameraman G. W. "Billy" Bitzer.

BILLY BITZER AND GRIFFITH TEAM UP

In 1908 at the Biograph Company, Giffith was introduced to "Billy" Bitzer, who had been on the lot, and was quickly able to give Griffith some lessons in how to direct a film. This began a partnership that changed the look of motion pictures. Bitzer was the first man to really study and understand the techniques of cameras, and among his accomplishments he invented the iris that helped focus the audience's attention on certain characters during fade-ins and fade-outs. He helped perfect the dissolves, cross fades, and blackouts. Like the great artists, Bitzer constantly studied the dramatic influences of light at a time when most American films were shot with bright, full stage coverage. And he is credited with doing one of the first movies in artificial light "The Prizefight," the heavy weight championship bout between Jim Jeffries and Jim Starkey.

Bitzer had started his career as a newsreel photographer, and among his assignments was the inauguration of President McKinley and the Spanish Civil War in Cuba. By the time he began working for Biograph, he had already perfected the matte shot and a great number of special lighting effects. Bitzer was always experimenting with different reflective surfaces, using new kinds of filters and gauze, or any type of material that would give the exposed film a distinctive look. If Bitzer couldn't achieve something with existing equipment, he would go out and build it himself.

The first collaboration between Griffith and Bitzer was a short called *A Clamorous Elopement,* which is noteworthy because of the use of the close-up. This collaboration would continue for the next sixteen years, and the full influence of Bitzer on Griffith can never be measured. As a stage performer, Griffith's instinct was to shoot a scene as if he was a member of the audience. But as a storyteller, with an almost inborn affection for melodrama, Bitzer's constant experimentation with camera techniques opened Griffith's eyes to new ways to show dramatic moods, especially with the close-up, a window to the inner thoughts of an actor.

"Billy" Bitzer loved to work fast, at a highly accelerated pace. From August 1908 through August 1911, he had completed an astonishing 326 one-reel films, most of them with Griffith. During this intensive process, both director and cameraman quickly grew bored of the traditional limited routine of camera setups. Most scenes were shot in one long take, usually full-figured, and occasionally with a medium two-shot. The editing was typically from one scene to the next. Internal editing going from long to medium to close shots within a scene to underscore dramatic action was rarely used. And the close-up was employed to show off the attractive features of an actor, instead of showing the character's internal reflections.

The relationship between a cinematographer (or cameraman, as they were originally called) and a director has had a powerful impact on films throughout motion picture history. The collaboration that might be best known is between Gregg Toland and Orson Welles on *Citizen Kane.* But since audiences do not go to movies because of a cinematographer, most people are not aware of these long-term collaborations. Toland also shot some of John Ford's best films, including *The Long Voyage Home* and *The Grapes of Wrath,* and did amazing work with William Wyler on *Dead End, Wuthering Heights, The Little Foxes,* and *The Best Years of Our Lives.*

Another remarkable collaboration is between Alfred Hitchcock and Robert Burks, who made twelve films together, starting with *Strangers on a Train,* and then *Rear Window, To Catch A Thief, Vertigo,* and *North by Northwest.* David Lean and Freddie Young collaborated on three films together, *Lawrence of Arabia, Doctor Zhivago,* and *Ryan's Daughter,* all winning Academy Awards for best cinematography. Gordon Willis teamed up with Francis Ford Coppola on the *Godfather* trilogy, and with Woody Allen on eight films, including *Annie Hall, Manhattan,* and *Zelig.* And recently Steven Spielberg and Janusz Kaminski worked together on a remarkable variety of films, like *Schindler's List, Saving Private Ryan, Minority Report,* and *Catch Me If You Can.* Plus Spielberg made three Indiana Jones films with Douglas Slocombe. It is evident that great cinematography will push and inspire a director to try new things, from camera angles to the development of shot footage. This is the equivalent of two great tenors on stage, each sharing the creative ecstasy of a musical moment.

THE CREATION OF A NEW LANGUAGE

Griffith was also someone who would sit and study and offer very didactic advice to the actors on how to play roles, or at least put them into the proper frame of mind. And by sitting next to the camera he was able to observe the minute expressions on their faces. It would be fascinating to know when Griffith realized that a close-up of an actor thinking in the context of his or her character would allow for two story lines to occur at the same time. But the process of this realization is evident in the films he was turning out every five days or less.

The equivalent of a close-up on stage is a follow spot that irises down on an actor's face, perhaps during a soul searching soliloquy, but the audience is still thirty to a hundred feet away. And for an actor to stop speaking and just stare and think is singularly unexciting on stage; but in a movie, if done at the right moment, this is mesmerizing. Steven Spielberg talks about how he likes to see a character deep in thought at a key moment, and directors like John Ford and David Lean were masters at letting the camera study an actor's face while deep in thought.

Griffith was working in an art form where there were no spoken words, but the wonderful part about letting the audience see the contemplation on an actor's face during a close-up is that each individual person begins to invent their own dialogue. This was the appeal of silent movies from the very beginning; each person would hear in their mind words in their own language and dialect. Thus the dialogue in silent films (unless, of course, someone could read lips) was always perfectly tailored to each person watching. What Griffith gradually discovered is that a character could be saying one thing, but thinking something else entirely. An actress like Lillian Gish could be saying how proud she is that her true love is going off to battle, but her eyes betray the feelings that she might never see him again. In film audiences can see these two conflicting actions happening simultaneously and feel how realistic a moment like this is.

D. W. Griffith's partnership with Billy Bitzer began to evolve to a more complex standard of filmmaking and gradually a new way to tell stories. To a director like Griffith, the idea of doing the same camera setups over and over again would have been extraordinarily aggravating. Griffith began to experiment more with these short films, realizing that he could be telling two or three different stories at the same time. Follow spots and other lighting instruments had the ability to divide the stage into different quarters, in effect editing in an open space. One scene could be lit while scenery moved behind them, or someone could be revealed on the far side of the stage as a surprise to the audience. This dual storytelling with fast scene changes intrigued him.

Griffith began to use medium shots closer to his subject. He would then cut back and forth. So, instead of following the current tradition of having someone come into a room then shooting the whole scene, occasionally panning the camera to follow the action, Griffith would cut many times within a given scene. In fact, his multiple cuts led to grumbling from members of the audience. In an article published in *Motion Picture World* it was noted that Griffith was using far more edits than the standard one-reeler of that era. This caused some patrons to complain of headaches and confusion as to what was actually happening.

But Griffith grew more stylized in how he approached each scene. Borrowing from rules that began with shorts like *Rescued by Rover*, Griffith and Bitzer very carefully planned their shots based on the interaction of characters, increasing the rhythm of the cuts to build tension. They planned scenes within the confines of theatrical staging, where characters made entrances and exits within a 180-degrees radius. This was to avoid jump cuts and establish a continuity that was easy to follow. But then Griffith would cut for effect within each scene using many camera setups. *The Sands of Dee* (1912) contained almost seventy different cuts in just seventeen minutes. This rapid editing must have seemed chaotic to certain audience members, the early equivalent to MTV music videos in the 80s, except the editing by then had increased to two- to three-hundred cuts within a three-minute song.

Perhaps the single most important technique Griffith developed is a process called cross cutting, or intercutting. An early example is *The*

Lonedale Operator (1911), a one-reel potboiler about ruthless robbers trying to break into a remote railroad station. Inside the station house is the defenseless heroine, played by lovely Blanche Sweet, who has taken over the duties of the telegraph to help her ailing father. Meanwhile, the hero of the story rushes to get there before the dastardly ruffians can steal the payroll on the train and take unfair advantage of the Daughter of the Lonedale Operator (as she is listed in the credits). At one point she holds the men at bay with what appears to be a gun; however, Griffith uses an insert shot to reveal to the audience that she is actually gripping a monkey wrench.

This is the stuff of standard melodrama, which relies on a last-minute rescue, but Griffith cross cuts between the stories at a kinetic pace, pumping up the excitement. The robbers break into the station house, just as word gets to the hero, who immediately leaps into action. The lines are carefully defined, with the two separate stories headed on a collision course. There is no confusion about the direction the hero is headed, racing from left to right on the screen, or the layout of the house where the heroine flees from one room to the next in a fruitless attempt to hide.

By putting his camera in a moving vehicle, Bitzer follows the hero, slightly under-cranking to heighten the sense of speed, and letting trees flash past in a whiplash effect. Griffith then edits back and forth between these scenes of pursuit and rescue, trimming out a few frames each time to intensify the action as the peril of the heroine grows more intense, and the hero appears to be a hopelessly long distance away. Will he be able to make it in time? Well, by pure determination and perseverance, he arrives at the last possible moment, the bad guys are severally dealt with, the payroll money saved, and the handsome couple tenderly embraces. Fade out.

Audiences found this film, and many others just like it, exhilarating and breathtaking. The acting for this style of unabashed melodrama is surprising natural and controlled. And as the decades have rolled past, the acting has become intensely more real, but the cross cutting between opposing elements in a high stakes chase have not changed. They have become longer and more dangerous, with hundreds of more edits and multi-track sound effects, but the structure still follows the visual blueprint that Griffith established at the turn of the last century.

The effects of cross cutting can only be achieved in cinema. On a stage, having two opposing forces seemingly headed towards a showdown would mean having lights go up and down, stage right and stage left, until the audience felt like they were watching a tennis match. In literature, the descriptive passages would have to be extremely sparse, peppered with highly colorful metaphors, or else done with extraordinarily short chapters. In film an audience can absorb a huge amount of visual information in only a few seconds, including the direction the action is moving, the recognition of actors, the dramatic conflict within the scene, and if elements of a scene are repeated, like a car speeding to a certain destination, then less time is needed to comprehend the visual information. In fact, the rule of thumb for most special effects is to hold the shot for three seconds or less, otherwise the human eye begins to perceive the faults with the model or process shot.

If sound had been married to the motion picture camera from the beginning, then this form of exciting filmmaking might not have appeared for decades. But the absence of words and the challenge of creating thrills beyond the pantomimed expressions of actors lead Griffith to experimentation with dual storytelling and precisely planned camera placement. He literally let the camera, the eyes of the audience in a movie, be the star. With the basic alphabet of his visual grammar, he began to envision a motion picture

that would last more than two hours and hold the audience spellbound. But the Biograph Company, and in fact everyone else in the movie industry, thought this was complete folly. The only ones who truly believed in him were his actors.

THE GRIFFITH STOCK COMPANY

Griffith was really the first to turn actors into movie stars. He discovered as many major talents as David O. Selznick, Louis B. Mayer, and Irving Thalberg, and no one else came close to him during the silent era. Among the stars that got their start with Griffith are Dorothy Gish, her sister Lillian Gish, Mary Pickford, Lionel Barrymore, Blanche Sweet, Mae Marsh, Donald Crisp, Richard Barthelmess, and even Mack Sennett, who began by writing stories for Griffith. Many continued with long careers, and others faded into obscurity after sound came in. Lionel was the brother of John and Ethel Barrymore, the Royal Family of theatre in America, and the great uncle of Drew Barrymore. Sennett would go on to create the Keystone Kops, the Mack Sennett Bathing Beauties, and discover Charles Chaplin. During the silent era there was the custom of giving titles to many of the stars. Lillian Gish became know as "Our Lady of the Constant Sorrows," and Mary Pickford became "America's Sweetheart."

Every actor who ventured into the motion pictures at this time wanted to work for Griffith. He was someone who got real performances out of his actors, showing for the first time that being in the movies could be an honorable profession. He made actors very aware that they had to feel the emotion. This was long before the Stanislavski method of trying to immerse into a character. Griffith's approach was just common sense. An actor did not need all the hand and body gestures required in theater to project emotions to

*The first great lady of the American cinema, Lillian Gish was a devoted member of Griffith's stock company of players; shown here in **The Wind** (1928), directed by Victor Sjostrom, her last film of the silent era.*

the very last row. With a close-up, the audience could see thirty feet high emotions ranging from love to fear in the actor's eyes. Griffith learned by making hundreds of films that a slight movement of the eyes can depict far more information about a character than the histrionics of flinging arms into the air or covering the heart in dread anticipation.

During the summer months, when the New York theaters were closed, actors would go out and make flickers, and they all wanted to work with Griffith at Biograph. They became extremely loyal, and his reputation as a director grew immensely. He knew exactly what he wanted to see from an actor, and he knew how to use his natural theatrical skills to get them into the right frame of mind. The image of the aristocratic director, sitting stately beside the camera in a canvas beach chair, with a megaphone within an arm's grasp started with Griffith. He was very sparing with his praise for actors, but when he did compliment someone it was something special.

Money was never the reason that actors wanted to work with Griffith. The respect he had from actors was extraordinary. His films were becoming longer and more ambitious, and there was undoubtedly the sense that he was about to do something remarkable. And everyone wanted to be part of it. Blanche Sweet said that all she needed from Griffith after a take was "a nod and a 'That's good.'" Lillian Gish recalled that when *The Birth of a Nation* finally went into production Griffith asked all the lead actors to waive their salaries to help pay for the supporting cast. All of them agreed. No other director came close to achieving what Griffith was doing, and slowly a form of naturalism emerged in his movies.

Griffith's experimentation with film was astounding in just the terms of pure numbers, but his genius was that he retained the fruits of these efforts as a kind of mental visual encyclopedia. In *A Corner in Wheat* (1909) he cross cuts between a banquet of the affluent eating and drinking to extreme, and a bread line of the poor struggling to stay alive. Griffith played with different genres. *The Musketeers of Pig Alley* (1912) is credited as being the first gangster film. In it, a gang leader walks toward the camera until his face fills half of the image on the screen with a close-up, looking menacingly around to see if his rivals are going to fall into the trap he has set. And Griffith was good with comedy. He allowed his actors a free rein at times, understanding from the great masters of literature, that sometimes relief is needed before a storm. With a moment of humor, the audience could be impacted even more because they were ready for the next wave of dramatic action. These are very simple and obvious tricks of the trade in movies now, but as the adage goes, "All clichés start with an original idea." Many of these things were purely original when Griffith tried them, and then he was ready to create a symphony out of these bits and pieces.

It is inconceivable today for an audience to watch only shorts, and then leave without a feature presentation. But this was the nature of movie going before Griffith. He grew to passionately believe that the right story could hold an audience's attention for two hours or longer. This was the destiny of motion pictures. Later Walt Disney would likewise be accused of folly for dreaming that the seven-minute cartoon format could be expanded into a feature length presentation, but *Snow White and the Seven Dwarfs* proved he was right. But Griffith had a harder fight because in 1915 only a few Italian epics had been made that were over an hour, and none of these had made a profit.

Griffith began to argue more and more with the front office at Biograph about making longer films. The management had already seen what had happened to one of their actresses, who suddenly drew popular attention as "The Biograph

Girl." They were hesitant to recognize actors in fear that production costs would rise. And here was Griffith turning out one short after another with his stock company of players, just like a theatrical repertory. Griffith's response to this argument was that if audiences liked an actor they were more likely to see a movie because that performer was in it. As it turns out, both sides were right; stars did drive up costs, but they brought a fortune into the box office.

Griffith's battle with the front office finally ended after they allowed him to make the biblical drama *Judith of Bethulia* (1914). It was four reels, four times longer than any American motion picture, except for DeMille's *The Squaw Man* that came out the same year. But *Judith of Bethulia* did not have the artistic vision Griffith had hoped for, and the film struggled to break even. Griffith left the studio after a falling out over the funding for his next project. All he had was his ensemble of actors, who loyally left the security of Biograph with him, and the rights to a play, based on the novel by Thomas F. Dixon Jr., titled *The Clansman.*

1915

This was a remarkable year in world history. Here are just some of the events that were taking place: The Great War, which would eventually become know as World War I, was in its second year and terribly bogged down on the Western Front, where the fighting would remain in a murderous deadlock for the next three years. A German submarine sank the Lusitania with American citizens on board. The first Zeppelin bombed London, opening the future to aerial attacks on capital cities. Anglo-French forces landed at Gallipoli, which Winston Churchill, the First Lord of the Admiralty in the British War Cabinet, planned as a way to bring a

quick end to the war, but instead turned into one of the worst disasters in military history. The British merchant ships lost over one million tons of badly needed supplies.

In literature, John Buchan wrote *The Thirty-Nine Steps,* which Alfred Hitchcock turned into a gripping spy thriller twenty years later. W. Somerset Maugham's autobiographical and controversial *Of Human Bondage* was an international best seller, and was later made into a movie that made Bette Davis a star. Joseph Conrad, D. H. Lawrence, Ezra Pound, Rupert Brooks, Edgar Lee Masters, and Hermann Hesse all published major works. And playwright Arthur Miller was born.

In the world news, Albert Einstein postulated his Theory of Relativity. Alexander Graham Bell in New York made the first transcontinental telephone call to Thomas Watson in San Francisco. Henry Ford mass produced his one-millionth car. Jess Willard defeated Jack Johnson after 26 rounds to take the heavyweight crown, which would become the subject of the play and motion picture *The Great White Hope.* Margaret Sanger was put in jail for writing *Family Limitation,* the first book on birth control. And Gil Anderson broke the automobile speed record at Sheepshead Bay, New York at 102.6 m.p.h.

BIRTH OF A NATION

The *Birth of a Nation* is the first motion picture to be told in the new language of the cinema. Because of this, the action on the screen became absolutely real to everyone who saw it. It is estimated that everyone that had access to a movie theatre saw *The Birth of a Nation,* which means that in America alone it was seen by over half of the population. This makes it the most watched and talked about event in the history of the world up to this point. It ran for years

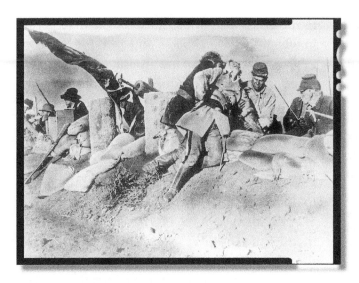

The Birth of a Nation (1915) directed by D. W. Griffith is the first feature length film to recreate the excitement of Civil War battles that had only been hinted at in Mathew B. Brady's photographs.

in some cities, bringing in so much money at the box office that the true amount will never be known, in part due to the fact that accounting practices were far from regulated at this time.

What is known is that distributors like Louis B. Mayer, the Warner Brothers and others made so much money they formed their own studios and began production. Thus the feature length film, the studio system, the star system, and the movie mogul were all born as a result of Griffith's Civil War epic. For these things alone *The Birth of a Nation* should be as revered and respected as the plays of Shakespeare. But the motion picture also has an unfortunate and enduring side effect. It showed for the first time the power of the cinema to create racial stereotypes that were unquestionably accepted by the general public as being a true depiction of an ethnic group. The first true Hollywood blockbuster will forever remain the center stone of motion picture history. And at the same time be responsible for tarnishing the image of an entire race of people, the African-Americans, and beginning what Anita Loos, one of the most success women writers in Hollywood who got her start with *Musketeers of Pig Alley,* called "a racist problem in the United States."

It is not easy to study Griffith and truly understand the man, and at the same time be able to separate the troubling images of his great masterpiece. This movie would change the course of motion pictures forever, plus create a controversy that might be a source of outrage as long as movies exist. Sixty-five years later, student filmmaker Spike Lee would do a satire, "The Answer," about a black screenwriter hired to do a remake of *The Birth of a Nation.* An honest depiction of the African-American on the screen had to wait until the late 1950s with actors like Harry Belafonte, and especially Sidney Poitier, who almost single handedly changed the persona of the black male to the world public. Even a film like *Glory* (1989) is still trying to set the record straight almost seventy-five years later.

And Griffith himself tried to defuse the firestorm of controversy about *The Birth of a Nation* with his next film *Intolerance* (1916), arguably his greatest motion picture, which ironically became the first major box office disaster. *Broken Blossoms* (1919) is not only the most beautifully shot motion picture that Griffith ever made, it is one of the most heartfelt films of all times. This story is about prejudice toward Asians, ending with brutal violence. Decades later in *The*

Searchers, John Ford, who had learned from Griffith and been one of the riders in the climatic scenes of *The Birth of a Nation,* explored the same prejudicial theme toward the Native Americans. But as Adolph Zukor predicted, "It isn't commercial. Everyone in it dies." Thus Griffith's second attempt to bring a motion picture to the screen that shows he was deeply aware of the destructive force of prejudice was mostly ignored by the public. His legacy as a director of more than 530 films will probably never escape the negative racial image stereotypes found in the second half of *The Birth of a Nation.*

With Griffith's love of classic literature, he might have considered making *A Tale of Two Cities* as his first feature length movie, or turning to the Bible like DeMille did later on. He was certainly fascinated by the French Revolution, as reflected in *Orphans of the Storm* (1921), which was done on a grand scale, full of exciting plot twists and large crowd scenes. But it did only modest business at the box office. The success of *The Birth of a Nation* has nothing to do with being first, which it was not, and everything to do with the combination of the story and the inspirational visual storytelling. Every motion picture since *The Birth of a Nation* owes a debt to it in terms of filmmaking. The editing, cross cutting, camera placement, and the variation of shots all added up to what Lillian Gish referred to as the grammar of cinema. Combined with an arousing musical underscore during the Civil War battle scenes and the grand finale rescue, plus the recreation of the assassination of Abraham Lincoln, *The Birth of a Nation* is a textbook on how a motion picture can manipulate an audience.

Only a handful of films have truly captured the world's attention, including *Gone With the Wind, Psycho, Jaws, Star Wars, E. T., Titanic, Lord of the Rings,* and *The Birth of a Nation.* Each of these has the perfect story for the time period in which they were made, and each is exceptionally well crafted, taking filmmaking to a new level. But the most influential factor of each of these motion pictures is that they opened the floodgates to a level of box office attendance that had never been achieved before, and consequentially became the blockbusters that both filmmakers and studio executives desperately tried to duplicate for years afterwards.

As for the timing of *The Birth of a Nation,* in 1915 the Civil War was still being fought in the hearts and minds of most Americans (as it appears to still linger in some minds today). The conflict had ended fifty years before with General Lee's surrender at Appomattox, so this was the year of a major anniversary. Old veterans put on their time worn uniforms and marched proudly down main streets. Undoubtedly, this was a period of reflection for Griffith, who recalled hearing as a child stories from his father and other relatives about the damnable humiliation of the Southern gentleman at the hands of the carpetbaggers. There is little question that if Lincoln had lived, the South would have been treated more benevolently in its recovery. And the irony that an actor had been the cause of this great President's death was not lost on Griffith.

So the emotions Griffith was experiencing were at a high pitch, and the scenes that he created for the screen must have been playing in his head almost from the time he could remember. Here was an opportunity to set the record straight. After seven years of unparalleled cinematic experimentation, Griffith and Bitzer had developed the way to bring this epic American tale of the fall of the Old South vividly to life. What they achieve has influenced every feature film since.

*Watching **The Birth of a Nation,** audiences felt they were eyewitnesses to history and wept during the assassination of Abraham Lincoln.*

GRIFFITH'S FILM GRAMMAR

Lillian Gish remarked about Giffith's directing of *The Clansman,* which after its premiere was renamed *The Birth of a Nation,* that he did not invent the close-up and other camera techniques. But he did bring all these innovations together into what Gish called "film grammar," or the basic ABC's of visual storytelling that are still used today. It was a remarkable leap in thinking, representing an understanding of how to edit together a series of seemly related shots to manipulate an audience to tears, laughter, and sweaty palm excitement. The movies were only twenty-one years old.

There are three ways to use a camera to tell a story in a movie: omniscient, subjective, and third person. Omniscient is the most common approach, unfolding the story in a god-like fashion where all events are seen by an all-knowing neutral eye and there is no interaction with the characters. The subjective is where one character is the focus of the story and all events revolve around him or her. Since this character cannot see around corners, like with the omnis-

cient approach, there are events that come as a complete surprise, since the character had no knowledge when and how something would occur. Voice-over narration and point-of-view shots are used to put the audience in the place of the character. Almost any Alfred Hitchcock film uses this approach.

The third person is when the audience feels like it is one of the minor characters in the movie who is witnessing extraordinary events. This is the sensation for most of *The Birth of a Nation.* The audience follows Col. Ben Cameron, a gentleman from the genteel South before the Civil War, through the hardships of battle, where he becomes a genuine war hero, and back to his home town, which is being ravished by greedy politicians and carpetbaggers. Cameron comes from a well-to-do family that ends up losing most of their worldly possessions because of the war, very much like what happened to Griffith's father. He is the one character that the audience gets to know the best, so when he takes action to rid his community of corruption there is an understanding of why he is forced to take extreme measures. Unfortunately for modern

audiences, his actions result in the formation of the Ku Klux Klan, and they become the heroes of this melodrama.

Griffith uses intercutting throughout *The Birth of a Nation* to heighten the suspense and tragic elements of the story. The most affective sequences are the battle where Cameron leads his soldiers in a gallant but futile charge against the heavily fortified Northern line, and at the climax of the film when citizens are being overrun by the black military, the KKK races to the rescue. In the midst of battle, Griffith cuts away to families gathered around the dinner table reading the Bible in anticipation of the great conflict about to befall their loved ones. This intercutting gives a sense of familiarity to the soldiers that are about to fight, giving additional tension to the actual conflict. In the end sequence, Griffith shows the hooded riders meeting at daybreak, growing in numbers as they gallop to save imprisoned and terrorized townspeople. He cross cuts between a half-dozen different events, dramatically showing people fighting for their lives, all seeming hopeless since the enemy in great numbers has surrounded them.

In the moments before the battle, soldiers are given a small ration of corn. Inserts of rusty metal bowls and earth stained hands are shown as the corn is proportioned out. A close-up of a hungry solider's face reveals how precious even the smallest amount of food is. When the battle begins, there is a wide panoramic shot of the battlefield as pillars of smoke rise up from the canons. Then Griffith cuts to Cameron in the center of the conflict, using his camera as the third person. For the first time in cinema on a large scale, the audience feels caught up in the bombardment and frenzy of battle. All of the action is shot using the 180-degree line, so there is never any confusion as to the direction of the action or the activities of the two armies. During the charge, Cameron and his fellow soldiers rush for-ward toward the camera, which is mounted in the back of a moving automobile, giving the moment a dynamic sense of energy. Time and again, Griffith cuts to a long shot, then back to Cameron, centering the attention on one person, each time reducing the number of frames, accelerating the meeting of the two sides.

The assassination of Abraham Lincoln in the Ford Theatre by John Wilkes Booth was an astonishing reenactment for American citizens in 1915. Here was an event immortalized for decades in drawings, newspaper articles, and word of mouth, but Griffith brought this moment in history alive so effectively that people watching the scene reportedly cried out warnings to the great president. It is moments like this that undoubtedly led President Woodrow Wilson to remark, "It is like writing history with Lightning. And my only regret is that it is all so terribly true." But his comment was not directed at a certain moment but the entire motion picture, which unfortunately includes the racist showdown between White and Black and the ultimate victory of the Ku Klux Klan.

In the rescue sequence, Griffith uses intercutting, inserts, a mobile camera, and personalizes each of the characters, but this time his canvas is much larger and the distances greater. Lillian Gish's character is being held against her will, fearing for her life. Families have gathered in a small log house in a clearing, surrounded by armed soldier. They prepare for their final fate, holding the ends of rifles over the heads of women and children, ready to bash them so they will not fall victim to the rabble outside. These scenes are tinted blue, red, and yellow to literally give the audience a color code. Blue for innocent families, red for the battle and riots, and yellow, passing for gold, to heighten the nobility of the men riding with determination to the rescue. All of the action was underscored with dramatic music, ranging from *Dixie* to Wagner's *The*

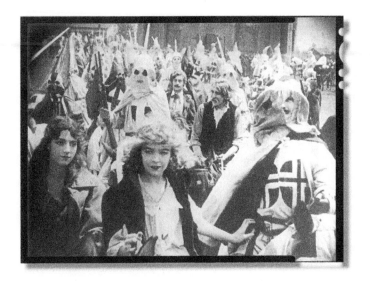

The Birth of a Nation is a double-edged sword in film history: Griffith's innovative use of motion picture techniques heralded the beginning of modern cinema, but his demeaning depiction of African-Americans stirred up a controversy that continues to exist today.

Ride of the Valkyries, and played on opening night by the full Los Angeles Philharmonic Orchestra. These final moments were a visual intoxication to many citizens, a rallying cry from the distant past, and within two years the membership of the Ku Klux Klan grew from a few thousand to over three million.

On opening night, Lillian Gish recalled that she was seated at the end of a row of men, and the entire row was shaking as they wept uncontrollably. The one scene in particular that affected these grown men, many of whom would be caught up in the Great War in a few years, was when Gish's character visits a hospital full of wounded Southern soldiers. As she waits in the hallway in her summer dress and bonnet, a sentry leans on his rifle watching her as if she was an angel from heaven. Without a word needing to be spoken, the audience understood clearly the soldier's private thoughts about home and loved ones. By the cutting of two images, Griffith perfectly captured the emotional toil that accompanies the hardships and sacrifices of war for everyone.

If *The Birth of a Nation* had ended with the defeat of the South and the return of the soldiers to their ravished homes, it would be considered a great epic and shown widely today. But Griffith's mission was to depict how the Old South rose out of the ashes, and the word "birth" has a double meaning. It is the birth of a new nation, as Lincoln referred to in the Gettysburg Address, and of the new South under the watchful guard of the hooded clansmen. The profound irony is that the second half of the motion picture is Griffith's greatest achievement as an innovative filmmaker, and it is the part that comes under the most controversy because of the melodramatic racist plot device. It is literally a conflict in Black and White, good versus evil, so that the two sides of the conflict are represented in pure visual terms.

The lead actors playing adversarial characters are in blackface, and are shown lusting after white women, drinking to excess, and given to sudden fits of violence. Because white actors wearing blackface makeup perform these scenes, they seem almost surreal today, and thus more debasing to African-Americans. And without question it is impossible to ignore these derogatory images and admire Griffith's brilliance as one of the most innovative filmmakers ever. Critic

Roger Ebert summons it up best when he wrote, "*The Birth of a Nation* is not bad because it argues for evil. It is a great film that argues for evil. To understand how it does so is to learn a great deal about film, and even something about evil."

There were riots and bloodshed in many cities where *The Birth of a Nation* played. The NAACP held mass protests, and the term "racism" became part of the American vernacular. But controversy makes for big headlines, and the old marketing adage "there is no such thing as bad publicity" proved especially true with *The Birth of a Nation*. It started the fortunes of the men that became moguls in Hollywood, and overnight the feature-length motion picture became the preferred form of entertainment. Hollywood had now become the archrival of Broadway, and for the first time in America the flickers were taken seriously as an evolving art form. And the film grammar that Griffith forged from the bits and pieces of earlier movies was immediately imitated by every director, and has been ever since. It is now almost impossible to look at *The Birth of a Nation* and appreciate his considerable genius, because what was once so astonishing is now elementary filmmaking. Perhaps his most enduring contribution was the action sequence, with the inter-cutting of multiple stories. The only thing that has changed over the decades is the adversarial character. In *Stagecoach* it was the Indians. In war movies set in the South Pacific it was the Japanese. In *The Magnificent Seven* it was the Mexicans. With *In the Heat of the Night* it was Southern rednecks. And in *Training Day* it was a corrupt black cop.

Griffith continued to make motion pictures until the early 1930s, and was one of the founders of United Artists, along with Charles Chaplin, Mary Pickford, and Douglas Fairbanks. Arguably his greatest achievement was *Intolerance,* made the year after *The Birth of a Nation*. It was a production that went considerably over budget, foreshadowing future box office disasters like *Duel in the Sun, Cleopatra,* and *Heaven's Gate*. But *Intolerance* was a masterpiece of filmmaking that was perhaps eighty years ahead of its time. Four different stories of human intolerance are woven together in an almost stream of consciousness. The morality tales stretch from the fall of Babylon to the crucifixion of Christ, to the St. Bartholomew's Day Massacre in Paris in 1572, and conclude with a contemporary story of social reformers that nearly destroy the lives of a man and the woman he loves.

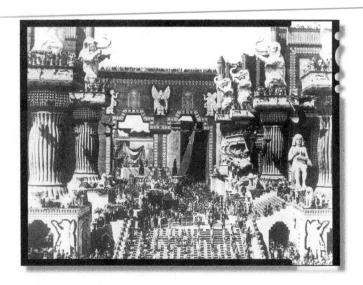

Intolerance (1916) is Griffith's masterpiece of epic storytelling that intercuts between four historic events. The giant set for Babylon, designed by Walter L. Hall, took almost a full year to construct. Despite the film's grandeur, it became the first major box office disaster.

Griffith was passionate about the theme, since he thought it would answer the harsh criticism aimed at him from *The Birth of a Nation*. The steps of Babylon, with its giant elephants, was one of the largest and most expensive sets ever build. The location is only a few miles from the Kodak Theatre, the home of the Academy Awards, which recreated the elephants as part of the façade. But the production proved to be too costly and overly ambitious to audiences. *The Birth of a Nation* struck a common cord with Americans with a linear story line that built up to a rousing conclusion. *Intolerance* left audiences confused and indifferent. Once a story started to take off, the image of Lillian Gish symbolically rocking a cradle would be seen, then a different story would continue. Audiences expected Griffith to give them excitement, and *Intolerance* was like four different sermons.

Broken Blossoms (1919) again took on the subject of prejudice. This time the story is between a Chinese missionary, who travels to England to share the teachings of Buddha, and a beautiful white girl who is beaten by her prize-fighter father. *Broken Blossoms* is exquisitely photographed by Billy Bitzer, but the somber mood and the tragic climax did not appeal to audiences that were just emerging from the devastation of the Great War. But Griffith would have one last box office triumph in his career. *Way Down East* (1920) is absolute melodrama about the shame of a woman who has a baby out of wedlock. The movie ends with Lillian Gish wandering in a snowstorm and collapsing on a sheet of ice on a half-frozen river leading to a seemingly giant falls. The race to save her is Griffith at his best. The cutting from wide shots to close-ups heightens the action, which takes place on an actual ice flow. Just before Gish plummets over the falls she is rescued and taken to safety. Audiences cheered.

Griffith never adjusted to sound, or perhaps just refused to be part of something that diminished the purity of silent movies. He made his last film in 1931 at the age of fifty-six, but would live in Hollywood, the glamour town he helped create, until his death on July 21, 1948. He was an almost forgotten man when he passed away, living close to studios that were turning out one motion picture a week. It was through the loving efforts and writings of Lillian Gish that Griffith's achievements were rediscovered. She bestowed upon him the fitting title of Father of the Motion Picture.

IN OLD HOLLYWOOD

The Industrial Revolution had become the epitome of wealth and disdain in terms of the money barons who had a monopoly on the railroads and factories of mass production. This kind of demand for product had not been known before in mass industry. Eli Whitney revolutionized the cotton industry with assembly line production where individual workers had a special function, but only one foreman in a vertical integration structure managed the overall operation. A practical understanding of the laws of supply and demand in terms of mass marketing and production was the modern day holy grail that brought certain people to great power in business.

Within this formula for success there was a growing group of people who were either recent immigrants or the sons and daughters of immigrants that had come over looking for a promised land. The immigrants were escaping the atrocities of the Czar's soldiers in Russian, and the brutalities of territorial war that were lighting cities up all through Europe and stirring up age-old bigotry, especially against the Jews. The idea that America was free and that the American Dream was something that was attainable for everybody ironically came about through the movies more than it did through the actuality of what people

W. S. Hart began as a Shakespearean actor but one visit to California started him on a career to becoming one of the most popular cowboy movie stars of the silent screen. Hart demanded authenticity and the dusty images of the Old West in his short films thrilled fans around the world.

were experiencing when they first came to this new land.

Most of the men that later became movie moguls were of Jewish heritage. They began in businesses where they would sell goods in mass production. Adolph Zukor was in the fur trade and Louis B. Mayer was highly successful in the scrap metal business. By coincidence these were men in businesses that had everything to do with the distribution of a large number of goods and making sure these goods reached various outlets across the country or internationally. So the distribution of motion pictures was the same kind of business as making sure that every respectable fur shop in the country had a fox stole waiting for customers, no matter which store they walked into. The other appeal of movies, as Zukor reportedly recalls, was that "it is the only business where people will pay money before they see the product."

Most of the immigrants that came over, especially the Italians and the Irish with their Catholic upbringing, were outsiders and not part of the closed-door Protestant "ethic club" of this time period. It was because of this elitism that unspoken rules were obeyed as to who got jobs, who went to certain schools, and who interned at certain businesses. So these outsiders looked for opportunities where doors were not closed—often opportunities that the other people thought were beneath them.

Most Jewish and Irish immigrants were not accepted into medical or law colleges at major universities. They were forbidden to even participate at certain banking jobs and excluded from country clubs and social events. The theatre and later the flickers became a natural outlet. Here were people in a new country who had no formal education and no direct ties with the arts or formal artistic training. But a big part of the Jewish and Irish cultural upbringing had always been storytelling, which was something richly embedded in their heritage and second nature to them.

The move from New York to California was something that was not only necessary to avoid the lawsuits that continued to linger in the courts; it also allowed these recent immigrants the chance to create their own small empires. In New York they had been generally relegated to certain neighborhoods and occupations. Now they began to create an industry that was entirely their own. Because land was so inexpensive, huge areas were suddenly bought up, literally creating almost feudal systems within the area of old Los Angeles.

Within a few short years after Griffith finished *The Birth of a Nation*, the people who would later become the major players in the motion picture industry had already relocated to California. Adolph Zukor, Samuel Goldfish (later changed to Goldwyn), Louis B. Mayer, William Fox, and Jack Warner were all true-life stories of the American Dream in action—people who had started out with a few pennies in their pockets had suddenly become the wealthiest people on the face of the earth. They lived in millionaire homes with luxury and respect that never could have been imaginable had they stayed in their Old World countries.

Thomas H. Ince created Inceville in Santa Monica and began a system of production that made the producer king, overseeing each stage of a motion picture from script to release. Carl Laemmle's Universal City opened in 1915 and had rows of shooting offices, stages, and a huge back lot for outdoor sets. All the major studios exist to this day, including Warner Bros., 20th Century-Fox, Paramount. Even the MGM studio still stands in Culver City, despite the fact that MGM as a motion picture company has not been located there for decades. There were even ranches that many of the studios owned with cattle herds, and with trees and rivers running through them that could be used for anything from Westerns to medieval forests.

The motion picture industry was broken up into distribution, production, and exhibition. The corporate bosses stayed in New York where the parent offices of the studios existed, to oversee the financial management and be near the Stock Exchange. Quite often the heads of the theater chains ended up creating their own production companies, like Marcus Loew with Metro-Goldwyn-Mayer. The production of motion pictures fell to the heads of each studio in Los Angeles, who quickly followed Ince's formula of mass production.

The studio heads instinctually understood that the only way motion pictures could be mass produced was to bring the best workmen, in this case meaning writers, directors, scenic designers, costumers and, of course, actors, all of which were assigned to their own specialty. Writers were hired for their various talents. Some were good at sight gags or plot twists. Others were good at creating new stories for the screen and others at adapting an established work. Many of the earlier motion pictures were based on great novels or short stories to add credibility to the concept that movies could be art.

MOVIE STUDIOS

The major Hollywood studios that were formed in the 1920s and became part of what is referred to as the Golden Age of the Studio System were Paramount, MGM, Warner Bros., Columbia, 20th Century-Fox, United Artists, and RKO. Since most of these studios were ruled by the same mogul for decades, some like Darryl Zanuck and Jack Warner who stayed in power until the late 60s, the studios developed a certain cinematic personality, especially during the first two decades of their existence.

The most powerful studio in the early days of Hollywood was run by Adolph Zukor, who

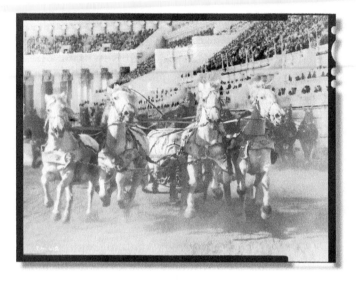

*The chariot race in **Ben-Hur** (1925) was shot in a replica of the Antioch Coliseum, a set even more massive in design than Babylon in **Intolerance.** More than 40 cameramen were placed at every possible angle, some in speeding automobiles to keep pace with the galloping horses.*

absorbed a distribution company called Paramount Pictures, which eventually became the name for his large conglomerate. Paramount included Famous Players-Lasky, Edwin S. Porter's company, Rex Pictures, and Lewis J. Selznick's (the father of David O. Selznick) motion picture company. Paramount had Mary Pickford and William S. Hart as part of its contracted players. Because of this early star power Paramount began the practice of "block booking." This was a practice where if a theater wanted the prestige features it had to accept a contract to get a package of other Paramount movies sight unseen during the year, just for the right to show a Pickford comedy or the newest Hart Western. Paramount became known as a director's studio with Cecil B. DeMille epics, Preston Sturges comedies, and Billy Wilder dramas like *Double Indemnity* and *Sunset Blvd.* When the Depression hit, the star who is credited with saving the studio was Mae West with her naughty movies like *She Done Him Wrong;* this same movie made a star out of Archibald Leach, who had wisely changed his name to Cary Grant.

Marcus Loew, to guarantee product to his national chain of theaters, bought the Metro Picture Company and the Goldwyn Company. Loew proceeded to name Louis B. Mayer the head of the company, and eventually brought in a brilliant young production manager named Irving Thalberg, who had been at Universal. This formed Metro-Goldwyn-Mayer, which would become known as the Home of the Stars. Samuel Goldwyn immediately had a falling out with Louis B. Mayer and left, though his name remained, and became the first of the independents with Goldwyn Productions. MGM would proudly announce that it had "more stars than there are in the heavens," and as far as matinee idols this was no mere boast. MGM was for decades the Royal Rolls of studios, envied for its impeccably made motion pictures and its thoroughbred stable of movie stars like Greta Garbo, John Barrymore, Joan Crawford, Spencer Tracy, Myrna Loy, William Powell, Clark Gable, Jean Harlow, Judy Garland, and eventually Katharine Hepburn.

Carl Laemmle formed the Independent Motion Picture Company and merged with smaller companies to create Universal Film Company, which opened Universal City, which it literally was, with its own fire department, police force,

and post office. Universal Studio is right over the hill from Warner Bros., and a dozen miles from Paramount. But it took the Man of a Thousand Faces, Lon Chaney, to really put Universal on the map with *Phantom of the Opera* and *The Hunchback of Notre Dame.* Despite the fact the studio made classics like *All Quiet on the Western Front,* it will be forever associated with gothic horror movies like *Dracula, Frankenstein,* and *The Wolf Man,* made famous by Lon Chaney Jr.

William Fox changed the name of his company from Box Office Attraction to Fox Film Corporation. In 1916, he set up a studio in Los Angeles. Like Zukor, Fox also put out quality productions and brought in some of the first of the European directors to work on his lot. Fox's company eventually merged with Darryl F. Zanuck's Twentieth Century Film, which Zanuck formed after leaving Warner Bros., to become 20th Century-Fox, as it is known today. Starting as a writer, Zanuck's trademark became movies made from solidly crafted scripts, often telling stories that pulled the curtain back on social problems of the day. John Ford made some of his best movies at 20th Century-Fox, but the studio also turned out classy musicals with Alice Faye and romantic adventures with Tyrone Power.

The Warner Brothers—Albert, Harry, Sam, and Jack—had opened their first Nickelodeon in 1904, and began producing their own features in 1917. They moved their independent operations from New York to Hollywood in 1919, creating Warner Brother Pictures. In the beginning, Warner Bros. was always on the edge of financial collapse, but it was probably one of the most courageous studios with regard to experimenting with the new techniques. In 1923 they bought Vitagraph and began experimenting with sound. Warner Bros. eventually took over First National.

First National was formed in 1917, by a group of theater owners that felt they were being unduly pressured by Zukor in block booking of his movies. They created the First National Exhibitors Circuit, which was managed by W. W. Hodkinson, who was at one point forced out of Paramount by Zukor. (Revenge has been a remarkable career incentive in Hollywood history from the very beginning.) First National contracted with individual stars like Charles Chaplin and Harry Langdon to make pictures just for their theatres. They gave these performers great freedoms, and consequentially the stars gained great independence and financial backing. The theatre owners ended up with huge profits by

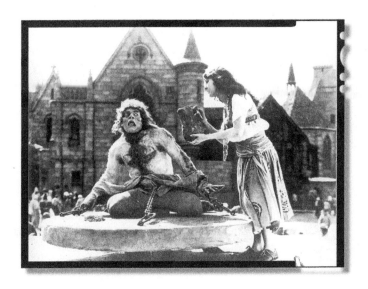

Lon Chaney was known as "The Man of a Thousand Faces" because of his incredible skills with make-up and character portrayal. As Quasimodo in **Hunchback of Notre Dame** *(1923), he contorted his body with a special harness that could only be worn for fifteen minutes, at a time.*

establishing stars. This concept was so successful that First National was among the three greatest powers during the 1920s. When Warner Bros. took control, the company signed up James Cagney, Bette Davis, Humphrey Bogart, George Raft, and eventually Errol Flynn, specializing in tough gangster movies and swashbucklers.

Wanting even more control over their movies, which meant a great share of the profits, Chaplin, D. W. Griffith, Mary Pickford, and Douglas Fairbanks formed United Artists Corporation. This became the first company run by artists and was a driving force in the film industry in the early years. But as the careers of these individuals declined, so did the studio. Griffith, Pickford, and Fairbanks never made the transition to sound motion pictures, though each tried the talkies, they felt that the silent pantomine was the true expression of film and watched almost broken-heartedly as an era passed. Only Chaplin continued to make silent films, but his productions eventually took three or four years to make. When the Little Tramp finally spoke in *The Great Dictator* (1940) silent movies were officially laid to rest.

Among what were referred to as "the poverty row studios" was Columbia Pictures, run by Harry and Jack Cohn, along with Joe Brandt. Harry Cohn holds the dubious reputation as being the toughest of all the studio moguls, which was quite an accomplishment in a very crowded field that included Louis B. Mayer, Jack Warner, Carl Laemmle, and others. Columbia was a studio that was always floundering, never really able to make the transition to a major player until a young director that had been recently fired by baby-faced comedian Harry Langdon walked on the lot. The director was Frank Capra, and within a few years Capra's movies like *Lady for a Day, It Happened One Night,* and *Mr. Deeds Goes to Town* propelled Columbia into one of the great powers.

The Radio-Keith-Orpheum Corporation, or RKO Pictures, was formed from the merger of the Keith-Albee-Orpheum (KAO) theatre company, Joseph Kennedy's Film Booking Office (the father of John F. Kennedy), Pathé, and the Radio Corporation of American (RCA). David O. Selznick initially ran RKO before he made his move to MGM, overseeing productions like *King Kong* and *Dinner at Eight.* During the 1930s, RKO would be the source of some of the greatest entertainment that Hollywood had to offer including the Fred Astaire and Ginger Rogers musicals,

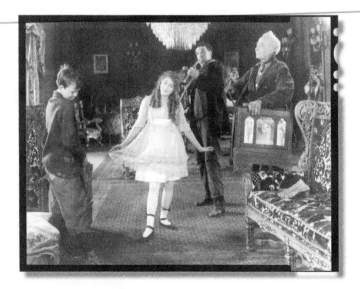

Mary Pickford became know as "America's Sweetheart" because of playful comedies like **Poor Little Rich Girl** *(1917). Because of her huge popularity she was able to produce many of her own motion pictures and in 1920 founded United Artists with D. W. Griffith, Charles Chaplin, and her husband Douglas Fairbanks.*

and the early films of Katherine Hepburn, many of them directed by George Cukor, and was the distribution company for Walt Disney Productions. Ultimately RKO would become known for one film that almost bankrupted the studio, *Citizen Kane*, by the boy genius Orson Welles, and eventually for being run into the ground by the mismanagement of Howard Hughes, who allegedly never stepped foot on the lot.

The blanket term of "Hollywood" captured the popular public imagination even though MGM, Warner Bros., Universal, and Columbia were in different parts of Los Angeles. Hollywood became synonymous with the concept of movie magic. Its name conjured up a world of fabulous make-believe, divine luxury, beautiful movie stars, grand hotels, fine dining establishments like the Brown Derby, racetracks where the glamour people gathered, and a freedom of living that was unlike any other place in the world. Hollywood became a point of destination for anyone who wanted to break the chains of obscurity and believed that with the right look and the right audition with the right producer they too could be up on the silver screen and driving around in the latest model Duisenberg. After all, the men who built the studios did exactly this with only a little money in their pockets. Out of the tens of thousands of men and women who caught the train or hitchhiked to Hollywood, a few ended up living their dreams. But judging from the credits of movies past and present, most did not. Hollywood became more than a location, it became a state of mind.

THE MOVIE PALACES

Less than a dozen years had passed since movies were shown in nickelodeons and seedy little parlors in the worst parts of town. The idea that the movie-going experience had to be something grand, something more spectacular than going to a stage production, took hold early. One of the first movie palaces built was the Strand Theatre that the Mark brothers opened on Broadway on April 11, 1914, with crystal chandeliers, plush carpet, high gold-leafed ceilings, and beautifully framed art hanging in the lobby. For this touch of high society a patron would pay twenty-five cents, but what a show they got. There was an orchestra, glimmering new prints of the latest star-packed features, and uniformed ushers trained like audience-friendly soldiers who greeted people and showed them to their seats. Samuel Lionel Tothapfel, best known as "Roxy," turned New York theatres into movie palaces, including the Capitol, the Realto, and the Rivoli.

These grand movie palaces were almost religious experiences designed in extreme art nouveau, with plush padded chairs for 2,000 people at a time. The music would begin to play, the lights would slowly go down, and plush red velvet curtains would rise. And then the black-and-white images would flicker on the screen. The use of silver nitrate in early motion pictures brought about the expression "on the silver screen," where images seemed to glow in the darkness, almost like a laser beam of light from the projection.

This was a time when many of these movie palaces might have been the only true luxury that many of the people in the audience were able to afford, living in great extravagance for a few hours. These were places of worship. The worship of seeing god-like faces thirty feet high spectacularly photographed. It was a daily event that brought people together and for awhile there was kind of a harmonious peace within the confines of these large ornate cathedral-like palaces designed especially for pure enjoyment and escapism.

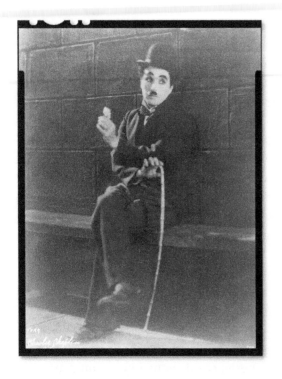

Charles Chaplin was the first motion picture superstar and his character of the "Little Tramp" was beloved by millions of people everywhere. Unlike most silent comics, in his later films Chaplin subtly pantomimed the inter-feelings of his character in close shots which played on the emotions of the audience. In **City Lights** *(1931) he lovingly remembers a blind girl from whom he bought a flower.*

A FEW WORDS ABOUT MUSIC

The greatest disservice done to silent movies is the music that was inflicted on them. Major motion pictures opened in the grand movie palaces where there were orchestra pits that held thirty or more musicians. These films had special scores written for them, often freely borrowing from the classics and popular tunes of the day. But many of the scores were original compositions and still exist. In the 1960s when many of the classic silent films were rediscovered they were shown with full orchestras underscoring the action. The combination of a pristine print in a beautiful old theatre with an orchestra was what was popularly referred to at this time as a *happening.*

To see a silent movie with an orchestra playing is a singular experience. In fact, silent cinema can never be fully appreciated until a person is able to see a classic under these conditions, which is sadly rare. People have gone in reluctantly to theatres where a silent movie is going to be shown with an orchestra and have come out enthusiasts. This is what audiences in the big cities experienced all the time and is one of the primary reasons the silent cinema flourished for so long. The overnight rush to talkies was a result of music. *Don Juan* with John Barrymore had a lush orchestra score that was recorded, complete with sound effects. And *The Jazz Singer* was a hit because of the songs and the hot jazz accompaniment.

When silent movies were released on VHS, most producers were too cheap to find the original score and hire an orchestra. So, pizza parlor piano music was done instead. Sometimes synthesized music was used, which was a terrible marriage, and often the music was improvised, with no attempt to research the original score. This would be like taking *The Wizard of Oz* and replacing all the words and music with just an

organ and the adlibs of someone who had never seen the movie before. Generations of children have been forced to sit and watch a silent movie with a piano player banging out repetitive tunes and have immediately been turned off to the experience forever.

The preservation of motion pictures should include the restoration of the musical score. The score for Abel Gance's *Napoleon* has been found and the music gives the movie an entirely new dimension, because the dramatic images were intended to be reinforced by a very carefully thought out orchestration. Charles Chaplin is the only silent director that instinctively knew that the wrong music could destroy his comedy, like what happened to Buster Keaton, who had no control over his movies. Chaplin composed his own music, and movies like *The Gold Rush* and *City Lights* are still popular with audiences because the subtle comic moments are perfectly underscored. But sadly, Chaplin is the exception.

SILENT CLOWNS

To many people the point of least resistance with silent movies are the clowns, since most of the action is pantomime.

There are not long scenes like in serious dramas where actors talked and then the title cards pop up with the words. This seems artificial to many people, but that was never a problem with the silent clowns. The best clowns worked only with body language and facial expressions. This is probably why their performances are still amusing to modern audiences. The best of these clowns seem almost timeless, part of a bygone era. But because of the everyman quality of their characters, the situations they get themselves into still have a ring of truth: Trying to impress a sweetheart. Dealing with an impossible boss. Or attempting to find a safe refuge in the middle of a hurricane. Well, this last one only happened to Buster Keaton in *Steamboat Bill, Jr.*

The Commedia dell'Arte had stock characters like Pulcinella that are still imitated or have become the basis for other comic characters. In vaudeville and burlesque comedy teams were popular. One member played the straight man to his partner's absurdities. A straight man is someone who sets up a joke, but timing is everything in comedy. In vaudeville certain teams did the same routine for years, with three shows a day, never changing a word. But the silent movies altered all that, because it was impossible to get

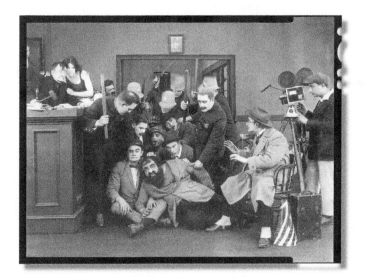

Producer Mack Sennett said the essence of his comedies was the chase. The slapstick antics of the Keystone Kops thrilled and amused moviegoers with madcap car chases that seemingly defied the laws of gravity and often ended in a free-for-all pie fight.

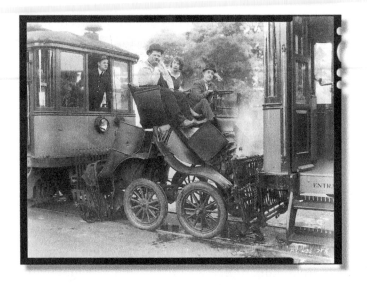

Laurel and Hardy were the movies' original comedy team and among the very few silent comics who transferred successfully to the talkies. "This is another fine mess you've gotten us into," was Oliver Hardy's familiar catchphrase to the perpetually bewildered Stan Laurel.

a laugh on a punch line if the audience had to wait for the title cards with the words.

With the flickers the humor had to be sight gags. The silent clowns invariably got themselves into situations that seemed to multiply problems. The situation comedy, or sitcoms as they are known on television, came out of the silent era. Most of the comedies were two-reelers, about twenty-five minutes long. This was the ideal time to setup a situation and then to milk the humor without wearing out the novelty. The idea of doing a feature-length silent com-edy was almost unthinkable. The concern was that the humor would go stale after the first half hour. But two silent clowns did their best work in the longer format.

There will probably always be a debate about who is the greatest silent clown, Buster Keaton or Charlie Chaplin, but it all boils down to personal preference. Both men came from theatre backgrounds. Keaton was literally born in a truck while his parents were touring in a vaudeville show. Chaplin's parents were music hall entertainers in England. Both were stars at an early

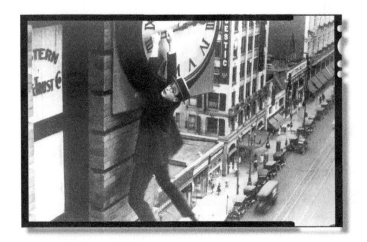

*Harold Lloyd started out impersonating Chaplin until he gave up the baggy pants for a pair of round glasses. His best comedies were story-driven, advancing from one improbable situation to the next. In **Safety Last!** (1923) a bet goes wildly astray, leaving him literally hanging from the side of a building. Most of the effects were cleverly designed camera tricks, but many audience members passed out from the suspense and had to be revived by spirits-of-ammonia carried by ushers.*

age. Buster was one of The Three Keatons, who headlined the vaudeville circuit along with W. C. Fields, Eddie Cantor, Al Jolson, and Bill "Bojangles" Robinson. (He was given his first name by Harry Houdini who saw the tot tumble down a flight of stairs and get up unhurt, remarking that was a real "buster" which is a term for a comic pratfall.) Chaplin was touring in a musical when he was eight and appearing at the London Hippodrome when he was barely eleven. And both men had tragedies in their childhoods. Keaton's father was an incurable alcoholic and the act broke up when his father became too unsafe and unpredictable on stage. Chaplin's mother was diagnosed as insane and spent years in an asylum.

But their comedy styles were very different. Keaton played his character with a poker face, or with a deadpan expression, and only showed hints of emotion, no matter how crazy the action. He was a physical comedian who took increasingly more dangerous risks to get a laugh. In *Steamboat Bill, Jr.* (1928), the front of a two-story house weighing over a ton falls toward him but he is unscathed because he had positioned himself perfectly where the tiny upstairs window was located. In *Sherlock, Jr.* (1924) he hurries across the top of a moving train, then grabs the rope of the waterspout and hits the ground with water gushing down on him. (Years later he visited a doctor with complaints of persistent back pains, and the doctor informed him that he had cracked a vertebra while performing the stunt.) Keaton's sight gags became bigger and more elaborate, until in *The General* (1927) his co-star is a real locomotive.

Keaton used very few close-ups, shooting mostly in master shots. Since he played everything deadpan, his body movements were especially important to his comedy. He was an extraordinarily physically gifted man. The legendary Olympic winner Jim Thorpe once said he was the greatest athlete he had every seen. Consequentially, Keaton's movies became bigger and ultimately more expensive. *The General,* considered his masterpiece, lost money and the studio became reluctant to produced future films. Keaton could never let go of a vision, and to pull these giant rabbits out of a hat became almost absurd at the time. He had a cutaway hotel built that went up three stories just so he could run down one staircase too many, do a double take, and run back up a flight—a twenty-second sight gag that cost a small fortune.

*Buster Keaton was a deadpan comedian, who greeted all predicaments with a permanently perplexed expression. In **Sherlock, Jr.** (1924) he is a projectionist who falls asleep and dreams he is a detective that can step into a movie and solve the mystery.*

Sherlock, Jr. is a perfect example of Keaton at his very best. He plays a projectionist who is studying to be a great detective and impress his sweetheart. While he is watching a movie he falls asleep and dreams he can leap into the screen and interact with the characters. He becomes Sherlock, Jr., hot on the trail of thieves and kidnappers. It is full of one incredible stunt after another. Keaton trained himself to ride on the handlebars of a speeding motorcycle and steer it by himself. The driver gets bumped off but Keaton unknowingly carries on a conversation, warning that they might be going too fast. All the time Keaton is doing the actual driving as he goes across bridges that collapse and through a picnic where a tug of war is taking place. In the end he wakes up and gazes at the screen with his sad-eyed fixed expression of disillusionment, realizing it was all just a dream.

Chaplin was also a physical comic but he was a minimalist compared to Keaton. His character was the Little Tramp, which became the first great and enduring movie icon. Audiences around the world loved the Tramp, probably because everyone knew someone like him. He was small but ready to fight for what he believed in. He was a bit of a troublemaker, but was always there to help the underdog. He had a mischievous side and fancied himself a lady's man, but, like Keaton, rarely ended up with the girl of his dreams. The biggest difference between these two comedic giants is that Chaplin showed emotions and knew better than perhaps any screen actor before or since how to subtly play to the camera. Chaplin could show his inner feelings of love or disappointment or take the audience from slapstick to unabashed melodrama. He added to the mystique of his character of the Tramp. He had human fragilities but no matter how downcast he became, he always endured and continued on. A favorite image was the slightly bow-legged Tramp going down a deserved road into the sunset.

Chaplin ended up making thirty-five films a year with Mack Sennett and ended up make a movie about every three years. Not because he demanded big sets and props like Keaton, but because he was so protective of the Little Tramp that every move had to be perfection. He was the only silent star that continued to make silent movies after sound came, and audiences stood in line by the thousands to see his movies. On *City Lights* (1931) Chaplin was confronted with how to make a blind girl think he was a millionaire without words. He closed down production for weeks at a time, keeping everyone on salary, until he reasoned out how to do this on screen. *City Lights* is the quintessential film about the Little Tramp. He falls in love with a blind girl and sacrifices everything to help her, including an attempt at boxing which turns into an amazingly choreographed sequence, prompting W. C. Fields to proclaim that he "was a [censored] ballerina." The end of *City Lights* is one of the most heartbreaking and sincere moments in any of Chaplin's films, giving a lasting image of personal victory in the face of adversity.

THE ROARING '20s AND HOLLYWOOD SCANDALS

Because of this freewheeling lifestyle of wild parties, endless sunshine, and warm Pacific beaches, the specter of trouble befell this new Eden. A series of scandals broke out that created not only national but international attention. The kind of events that even by today's standards are remarkable in the number of newspapers they sold and the number of gossip columns that began to spring up almost overnight. The effects of yellow journalism were in full-bloom. The muckrakers at the beginning of the century planted the idea in the collective mind of the American public that everything needed to be reformed. Hollywood became a target.

Roscoe "Fatty" Arbuckle was one of the most popular silent comics. Then, in 1921 he was accused of the manslaughter of young starlet Virginia Rappe at a wild Hollywood party. The Hearst newspapers made the incident front page news and, despite the fact that Arbuckle was eventually acquitted of the charges, his career was destroyed.

Many newspaper stories that became big news involving scandals in the corporate world always played themselves out quickly and became dull reading to the average citizen. But with this carefree land of motion pictures, newspapers began to realize that juicy stories about celebrities could hold the public's attention almost indefinitely. It was a time period when audiences were still naïve about what they were looking at on the screen. Most people believed that the actors continued to exist in the lifestyles they portrayed in the movies, even after the camera stopped rolling. This was their everyday persona. Charlie Chaplin was always the Little Tramp. Fatty Arbuckle was always the good-natured fat guy that kept trying to get a kiss off of Mabel Normand. And Rudolph Valentino was perpetually the lover extreme, always in the midst of a tango, a cigarette dangling from his lips, with the smoke curled up in front of his face. These were images of extravagance for a few hours.

Movies that had hints of sexuality to them were always popular with audiences, and condemning them only made people pull their hats down over their foreheads and sneak in while the lights were dimming down. The idea that married couples could have infidelities, that the wealthy were not happy with all their capitalistic luxuries, and that women would use their sexual charms to gain a foothold in a man's world were tantalizing subjects popular with audiences but shocking to the religious community. These melodramas showed things that the clergy and religious groups became fearful of. This was also a strong time period for the churches and synagogues, because with trouble in the world, people develop a need for worship. And the Roaring 20s were full of headlines about gangsters, killing

on the streets, speakeasies, and the moral corruption of America's youth by bathtub gin and wild parties.

By 1920, a series of scandals began to unwrap in Hollywood that were immediately targeted by the major newspapers, especially the Hearst papers. The first of these scandals was that America's sweetheart, Mary Pickford, who made a career playing young, rascally ingénue parts suddenly had a quickie divorce in Nevada and within two weeks married the dashing Douglas Fairbanks. The newspapers heated up quickly because here was a pigtailed actress that had made America laugh and cry with all of her antics in *Pollyanna* and *Rebecca of Sunnybrook Farm* who was suddenly not that righteous child people had been seeing on the screen. But this was just the beginning.

Two scandals hit the newspapers the same year involving Fatty Arbuckle. The silent comics had always given the impression that they were as fun and pure as their slapstick characters. But this was about to change in a major way. The first scandal took place in Massachusetts at a party that Arbuckle had thrown. The District Attorney of Massachusetts County had received a $100,000 gift shortly after the party. The public began to wonder, with help from the Hearst newspapers, what happened at this event to justify such a large sum of hush money.

Then a few months later, Fatty Arbuckle threw another party in San Francisco, at the St. Francis Hotel. The next morning, Virginia Rappe, a guest who had crashed the party, was found dead in her hotel room. The story exploded in headlines. Arbuckle's image as an obese comedian was against him. A sexual relationship with the frail woman in the photographs was a repulsive idea considering his body weight and his stately stature. Arbuckle was tried in the newspapers and accused of assaulting and raping this young starlet.

The truth of the matter is that Virginia Rappe ended up dying because of a botched abortion and other preexisting medical problems resulting from a very active lifestyle. But these facts did not come out in the paper. What appeared were the accusations that Arbuckle had done something terribly naughty to this starlet, who had appeared in early Valentino movies, and then tried to hush it up. There were pictures of Arbuckle in the newspapers that were actually publicity photographs of him in one of his comedies holding onto the bars of a jail cell. Stories began to run rampant accusing Arbuckle of using a Coke bottle and other obscene devices as assault weapons. Newspapermen rushed to Hollywood to interview anyone who had ever met or seen Arbuckle at a party. The trial lingered on and on, but the headlines never went away. After two mistrials, Arbuckle was finally acquitted based on the evidence about Virginia Rappe that the newspapers ignored during the first trials.

Arbuckle's studio and the Hollywood community barred him from making any films until the case was proven one way or the other. But these were the kinds of charges that would not go out of the public's mind. Trying to imagine what happened that night became intriguing and shocking and the event was in everybody's thoughts. Fatty Arbuckle's career was over. At the time of the incident he was the third most popular comedian in the world, next to only Chaplin and Keaton. He would eventually direct under the name of William Goodrich. In 1932, he signed an agreement with Warner Bros. that would give him a lucrative salary to appear in six comedy shorts.

Allegedly, the contract was backed by William Randolph Hearst, the man who had led

the most damaging newspaper attack against him. Arbuckle once met Hearst and asked, "Why are you doing this to me?" Hearst reportedly replied, "It's just selling papers." Nevertheless, it looked like Arbuckle was going to make a recovery and return to the screen. He went home the night he signed the contract, got into bed, and never woke up. The next day the headlines mourned the loss of one of Hollywood's greatest clowns.

Two other scandals preoccupied the public in 1922. The first was about tall, ruggedly handsome Wallace Reid, who had appeared in *The Birth of a Nation.* He had made over sixty motion pictures and was most popular as a daredevil in action movies that highlighted thrilling auto races, like *Excuse My Dust.* After a train accident, a doctor put him on morphine so he could complete the movie he was shooting in Oregon. He became addicted and turned to alcohol as his health quickly declined. Reid died in a sanitarium at the age of thirty-one. Posthumously, a scandal broke when it was discovered he died of an overdose of booze and drugs. In his movies, he had always been physically active, which compounded the shock to the public when they learned of his death. Reid was the first well-known movie star to make an exit this way, very similar to the loss of John Belushi and River Phoenix over sixty years later.

Later that same year, director William Desmond Taylor was found shot in the chest, fully dressed inside the front doorway of his bungalow. Within hours after this discovery representatives of the studios, friends, and other unidentified people invaded the house. If there was ever a crime scene that was disturbed, it was this one. Boxes were carried out and taken to the studio and places unknown. Whatever these people were afraid the public and the news would get their hands on rapidly disappeared in the early morning hours. But a few provocative clues were left behind. In the closet was a negligee that belonged to young starlet Mary Miles Minter, and it was believed that perhaps her jealous mother had shot him. He had been a good friend and mentor to Mabel Normand, who was seen leaving his house only a few minutes before he was fatally shot. Suddenly, Normand was scooped up in the investigation, which permanently damaged her career.

Taylor was considered a first-rate director with a very high reputation as a professional. His funeral was a showcase of every prominent personality in the motion picture industry. To this day the case is still open on the books in Los Angeles. It might have been a former employee, a spurned starlet, or, as the investigation deepened, it might have been something unspeakable in the Hollywood community, an idea which still exists today in tabloid speculations. Taylor might have lived a double life. But no one knows for sure, and the murder of William Desmond Taylor remains a web of speculation.

People read and talked about these scandals on a daily basis. The image of Los Angeles as a place of innocent fun, where the great actors mingled together like they did in the movies, was suddenly torn apart forever. The image of Hollywood now was as a mecca of sin, and the churches knew that this wave of immorality in such a short time period signaled there were more stories that had been covered up. And there were, of course. Publicity men were constantly giving the police tickets to movies or premieres if they would give a bad boy actor a break. And there was the implication that the studio moguls did not care about the high standards of living and morality in America. And that they would do anything to make a buck and thus bring about the moral decline of the children across the country.

Something had to be done. The churches began to threaten and then enact their own censorship. On Sunday mornings church-goers were often given a sermon from the Bible followed by a list of films to stay away from for the moral good of the family. Comics like Fatty Abruckle and Mabel Normand only a few years before delighted members of the clergy; now these silent clowns were proof that Hollywood was the new Babylon.

WILL H. HAYS AND HOLLYWOOD CENSORSHIP

Just as the baseball owners brought in the reputable Judge Landis after the Black Sox scandal, the Hollywood moguls decided to take action before matters got completely out of hand. In 1922, they found a man of slight stature but of true grit by the name of Will H. Hays. He had been President William G. Harding's campaign manager and had dealt with the scandals of that presidency. He had been the Post Master General of the United States, a Presbyterian Elder, and was a good stern Republican. Hays became the president of the Motion Picture Producers and Distributers of America (MPPDA). This organization financed and supported all the major film companies in America. It became known as the Hays Office and Will Hays headed it for twenty-three years. There have been only a handful of people to head this organization. In 1945, the MPPDA became the MPAA, i.e., the Motion Picture Association of America. Eric Johnston, who headed the organization until 1996 succeeded Hays, and then Jack Valenti became its president.

In Europe, scenes of sexuality never became a lightening rod issue like they did in America. They were treated openly and without any kind of shocked reaction from audiences. It was usually the violence in films that disturbed European moviegoers far more than seeing a naked body moving freely and uninhibitedly. But in America it was very different. The whole idea that the body could be used for great pleasure was attacked by the Church, which believed these scenes encouraged a moral breakdown.

The objective of the Hays office was to have the studio producers send in a script that would be reviewed for any material that might not be considered proper for public viewing. At first this was handled very loosely by Hays and his people, and ultimately did not deter films with mature subject matter from being made. The moguls said they respected the Production Code, but their movies did not reflect this lip service. Will Hays made speeches to reassure the public that this was a new process and it would take a while to have everyone participate, but the goal was to have all movies that all people in America could go see.

The scandals continued to emerge. Stories about Clara Bow, the "It Girl," emerged about her relationships with everything from man to beast that were more shocking than anything seen in the tabloids today. Outrageous tales crept into the newspapers, and of course the newspapers were swept up immediately. Every large city had four, five, and sometimes six newspapers. There was something coming out everyday, and almost every hour. So in order to beat the new edition by a rival paper the next story had to be more sensational.

The Production Code spelled out the "don'ts" about language, sex, and crime. It prohibited nudity or the suggestion of nudity, suggestive dances, and, not surprisingly, the ridicule of religion. It forbade the use of illegal drugs, profanity, the suggestion of abortion or venereal disease, and even the depiction of childbirth. The sanctity of marriage and the home had to be strictly upheld. Any scenes that had to do with adultery and illicit sex could not be explicated, thus planting the seeds of wrongful behavior. The

*Clara Bow became America's first sex symbol during the Roaring 20s and was known as the "It Girl" to her fans. Her private life was made very public with a series of scandals but it was the arrival of sound that ultimately ended her career. She was very self-conscious about her Brooklyn accent and developed "mike fright" to the point of having breakdowns. She is parodied in **Singin' in the Rain** as the character Lina Lamont.*

Production Code did allow for a hint of adultery in movies, since it would be almost impossible to tell any story without the "other woman" theme, but whoever tempted a husband's attention had to end up unhappily alone.

After the gangster genre became so popular in movies, they came under attack by local law enforcement and eventually government agencies, especially J. Edgar Hoover's F.B.I. The most important demand of the Production Code related to crime in the movies stated that no action would be depicted in a way that allowed au-

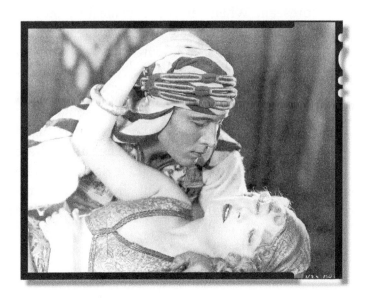

*Rudolph Valentino reached international stardom as a screen lover after dancing the tango in **The Four Horsemen of the Apocalypse** (1921). He would make only fourteen more movies, dying suddenly after the hit **The Son of the Sheik** (1926) of complications from a perforated ulcer. The attention of his death by millions of fans and his legend that followed made studio moguls recognize the potential power of movie stars.*

diences to sympathize with criminals. Brutal murders could not be shown, and in the same frame of film a gun could not be fired with someone falling down, implying he or she had been hit by a bullet. No one could glorify violence so that it would be imitated, especially by young children. (Oddly, there was nothing that prohibited graphically shooting Indians in westerns.) Crime could never pay. The bad guys had to be caught, put on trial, and severely punished for their illegal actions.

The Hays office did not have enough muscle in the early years to enforce the Production Code. It would eventually take the Great Depression, the threat of boycott by religious groups, and a staunch Catholic by the name of Joseph Breen to make the studios obey the rules. On June 13, 1934 the Production Code Administration was established that required all Hollywood produced motion pictures to obtain a certificate of approval before they could be released. Breen was brought in to oversee this department after the eleven studios signed off on the agreement. Heavy fines were imposed for studios if they broke the rules. Finally the Production Code had teeth and would become something that was fixed in stone for the next thirty-some years in Hollywood.

The strict obedience to the Production Code by the studio moguls changed the nature of what was happening in Hollywood. This will always be debated since it was ultimately a form of self-imposed censorship, and without question serious women's issues that were just beginning to be explored in motion pictures disappeared for decades. But the trade-off had an equal value. Women in movies became respected partners in work and marriage, and were wooed instead of portrayed as quick and easy conquests for men. The stars after the implementation of the Production Code showed that women could be reporters, lawyers, detectives, doctors, and even wear pants like men. In short, a woman could have a career and make it on her own, and have a good time in the process.

The Production Code also forced Hollywood to focus on great storytelling, which in turn increased the star system with actors that audiences wanted to see over and over again. Sex and violence were exchanged for charm and charisma. (Of course, sex and violence never disappeared, they just became implied, which became a game by many directors like Howard Hawks and Alfred Hitchcock, who found amazingly clever ways to skirt the Production Code.) These changes in the Hollywood produced movie became more evident when stars began to speak. The silent stars had personas much larger than life. This was the age of gods and goddesses on the silver screen. Once this image was tarnished by the scandals then it took a folksy quality from the next generation of actors who could speak like real people to begin the change in public interest and create a new kind of screen idols.

The Production Code also had another impact on motion pictures that no one could have foreseen. When television came in almost a quarter of a century later Hollywood felt it would ruin the studios. Free entertainment right in everyone's living room? How could motion pictures compete with this? It turned out the studios had thousands of movies they could sell to the networks, all of which were perfectly suited to any member of the family. The sale of these vintage motion pictures to television gave the studios extra capital, and introduced great directors and actors to what would become known as the Film Generation.

THE GOLDEN AGE OF EUROPEAN CINEMA

The years after World War I represent the greatest advancement of artistic experimentation in motion pictures internationally. If nothing else, just by the sheer number of films being produced at one given time. It was a time period unlike anything that had happened before, and in many ways anything that has happened since, all leading on a collision course to the arrival of sound. But the main purpose of films during these years was to tell a story as purely as possible with visual images, not having to use title cards with bits of dialog or explanations of what was happening. This became a finely tuned visual language where new ideas and techniques could be traded between filmmakers in different countries without the interference of words.

In all European countries, masterpieces of this lively art form were being produced. Sweden, Denmark, France, England, and especially Germany and the Soviet Union were devastated after the war, but ironically one of the first things that began to emerge out of the ashes of this prolonged battle that had taken over ten million lives was the cinema. Motion pictures were actually being produced during the war. At first many countries completely stopped film production altogether, thinking that it was not right to be making movies about trivial life matters in the midst of such hardships. But it became very evident, very quickly that this was not going to be a short war. As the conflict wore on for years and years movies were invited to take the people's minds off of what was happening on the Western Front and other parts of the world that were deadlocked in battle. It was typical near the front that in burnt out little theaters, which had been bombed the night before, portable projectors still managed to be set up and a new sheet was stretched across the back wall for the soldiers to watch and forget for a few hours.

The most popular kinds of films for the soldiers were the comedies, especially Charlie Chaplin's, and hard riding Westerns. War films were also surprisingly in demand because what was happening in the movies and what was happening in the real battles were so completely different. These movies seemed to give kind of a spiritual uplifting that eventually the war would work out in the same way the movies were depicting, with parades, hot meals, and faithful sweethearts waiting. In England the military made sure these movies were being shown in every remote little township so that the spirit of the people supporting the war effort was always being reinforced.

Up until the war, the motion picture industry in Italy, Germany, France, and Denmark had large studio complexes. Italy had over 200 studios that were producing three major full-length features each week. As soon as the war was finally over, people returned to what was left of their studios. The equipment was broken and completely out-of-date, but each of these countries immediately began to make movies. It became a necessity to revive the spirit of the country, and even though great lip service was given to the motion picture industry by leaders like Mussolini, very little financial reward came from the military or the government itself. Most of the support came from private investors who saw that audiences seemed to grow when times got hard.

New kinds of motion pictures were being made, each reflecting the individual directors, writers, designers, and cameramen in each country. The improvements in cameras and new lenses were beginning to change the look and

dynamics of movies that crisscrossed the ocean from Europe to America so quickly that one innovation would quickly be copied only a few weeks later on another film. One successful epic would suddenly spur on two or three epics with similar themes. In particular, the look of these movies from different countries was beginning to be the dividing point between what is known as the Hollywood film and the foreign film.

It has been said that the difference between the European and the American motion pictures was that in America the actors were lit and in Europe the scenery was lit. This seems an almost trivial way to separate the two different kinds of filmmaking, but it is fundamentally a very accurate description, especially in Germany. A movement was taking place in Europe called Expressionism and the surroundings of the story were part of the story itself. The look, the feel, and the intensity of the lighting, or the absence of light, became almost a character within the storytelling. Freud's writings had opened up a dark new frontier—the human mind. Certain directors tried to capture the twists and turns of the mind on film, especially the troubled mind.

This was a time of phenomenal changes in the art world, where the old forms of realistic art were scrapped and replaced by all the new "isms." Surrealism, Expressionism, Impressionism, Dadaism—all of these movements began to compound, and immediately the leaders of these movements saw film as a natural extension of the visual art form, whereas in America film was treated as a stepchild to the arts, a latecomer without a historical pedigree, primarily because the purpose of the American cinema has always been to entertain within the structure of a melodrama. In Europe film was embraced and used as an extension of the creative imagination. Even the finest artists of their days were beginning to make films that were shocking, revolutionary, and sometimes immensely beautiful.

THE GERMAN CINEMA

The technology of film and the understanding of how to make movies had become highly sophisticated in less than twenty years from the first moving pictures shown against the milky screens by the Lumière brothers. After the war, there was one country that had an amazing burst of creativity, producing some of the greatest technicians, directors, and actors of its era. This was Germany. The innovations from the close of the Great War to the rise of Nazism still influence filmmaking today. The German film industry would lose everything in World War II, only to have its filmmakers re-emerge in the United States to create a different style of film, which began in Berlin during the silent era. The directors include Fritz Lang, F. W. Murnau, Ernst Lubitsch, Billy Wilder, Fred Zinnemann, Robert Siodmak, Douglas Sirk, Josef von Sternberg, and Alfred Hitchcock.

Toward the end of the war in 1917, the German military realized that it was fighting two battles. One was the propaganda battle, which it was losing. The other was the battle on the field. The propaganda film showed the German soldier in a more positive light in an effort to offset the bleak images coming out of Hollywood of the evil Hun, played as villainous and murderous with no hints of redeeming qualities. The German character had become a cliché, which is always the fate of the losing side. So it was decided by the German government to make films that would at least try to win the propaganda battle, even if the one in the field was already lost.

The short movies showed German soldiers coming into occupied countries being kind and

The Cabinet of Dr. Caligari (1920) directed by Robert Wiene is one of the classic films that most people have heard about but few have actually seen in its entirety. The most famous example of German Expressionism, the film uses abstract scenery to unfold the tale of murder as told by a madman.

courteous to the people that they visited in their homes, teasing with the children and trying to put the adults at ease. A series of movies also were made depicting glorious moments of German history, suggesting that what happened once can happen again. To produce these movies, the German government in November of 1917 created a private company that soon would begin to buy and merge with other studios, forming a single large film-making facility called Universum-Film AG, which became known to the rest of the world as Ufa. The first order of business was to build up the spirit of the German people. It never had a chance to succeed. The war came to an end less than two years later, and it had only begun to put everything into motion.

What happened then was something quite extraordinary. Through the grips of financial hardship, Germany became an isolationist coun-try. Germany was in the midst of a crippling depression where literally a wheelbarrow full of marks would buy a loaf of bread. The value of the mark was so low that it was not feasible to import films. To fill the void Ufa produced its own films and thus began a flurry of filmmaking unprecedented in any other country. Ironically the influences of the American cinema had a major impact. The German directors had loved the motion pictures by D. W. Griffith, especially the later movies like *Broken Blossoms* in which the mood and the atmosphere define the characters in their inability to function within a given part of society.

The motion picture that is most closely identified with the German cinema and introduced Expressionism to the world was *The Cabinet of Dr. Caligari. Caligari* is a film that is extreme in what it depicts. Most of the Expressionists films never took the same broad steps that *Caligari* did.

It is the sheer power of the imagery that makes *Caligari* a masterpiece. Expressionism is counterpoint to Impressionism, which was the rage in France with artists like Picasso, Monet, Chagall, Cezanne, and Renoir, who gave the external feeling and the immediate interpretation of what they saw. Expressionism works from the inside out, exploring the psychology of the characters, and was part of a major theatrical movement. Surrealism takes this exploration further into the subconscious mind, where images clash together in a symbolic nightmare. It is most closely associated with the work of Salvador Dali.

The Cabinet of Dr. Caligari was made in 1919, directed by Robert Wiene and written by Hans Janowitz and Carl Mayer. The cast includes Werner Krass as Dr. Caligari and Conrad Veidt as Caeaer, a somnambulist that awakes from a deep sleep to predict the future, thus setting into motion a series of murders. Mayer, when he heard the concept of the movie, replied "this is madness, this is crazy, the whole movie should be this way." As a result the story takes place inside the mind of a madman, telling the events leading up to his downfall, depicted as a madman would see them in forced perspectives with buildings and streets that zigzag off into infinity. The streets look like a child's drawings of lightening bolts. The mood is a nightmare of abstraction.

But Expressionism is not simply the look of the sets, but all aspects of the film. The performances by Warner Krass and Conrad Veidt are instrumental in making the movie work. Warner's Caligari is a man that appears almost comically deranged, with his round tortoise shell glasses, sneaky side-glances, and his menacing way of moving, almost as if he was a ballerina gone insane. Conrad Veidt's performance of Cesare, the Somnambulist, perfectly fits the concept of the story. At times he crawls along the edges of the scenery, almost becoming part of the exaggerated painting. (Conrad Veidt will be best remembered as Major Strasser in *Casablanca* twenty years later, as the Nazi who tries to stop Humphrey Bogart at the airport and pays the price with his life, prompting the line, "Round up the usual suspects.")

There has always been a debate on who is ultimately responsible for *Caligari*. It was made on an extraordinarily low budget. The backdrops and scenery were painted on cardboard, but the mesmerizing look of this deranged carnival world is the work of the production designers Walter

Werner Krauss plays the sinister Dr. Caligari. In German Expressionism the lighting and design of the scene create a physiological environment for the actors to perform in. Alfred Hitchcock was trained in Germany during this era and used this concept in his suspense films.

Reimann, Walter R(hrig, and Hermann Warn, and cinematographer Willy Hameister. Their contributions to the scenic atmosphere of this movie is profound, creating the images that have become legendary. That does not in any way take away from the remarkable achievement by director Robert Wiene (who would be the only German director that did not ultimately venture across the ocean to Hollywood). His use of the actors may seem overly exaggerated in today's eyes, but was a perfect style compliment to the environment these characters were living in.

Starting with *The Cabinet of Dr. Caligari,* German cinema became highly influential and the envy of other countries. It is not true that the Germans had the most advanced studios or the better cameras. Though the equipment was quite superior, many of the cameras that they used were brought over from America. But it was the way the atmosphere was defined by light and the manner in which the scenery became an embodiment of the entire story. This is what intrigued directors and designers from around the world.

Since the German mark was so low, motion pictures could be sold to other markets for a profit, which was enormously beneficial to the industry. Within only a few weeks after a premier in Germany a movie was being shown to American audiences, who looked upon these dark, abstract tales with great fascination. Studio moguls like Mayer and Zukor made periodic raids on Europe for new talent and offered lucrative contracts to German directors to make movies in Hollywood. Countries that had an impoverished film industry like England sent promising directors to apprentice in Berlin.

YOUNG ALFRED HITCHCOCK

Alfred Hitchcock's experience in Germany during the height of the Expressionist movement is an incident where the right man was in the right place at the right time. It is unimaginable to study film history without Hitchcock, whose career extended from 1922 all the way to 1976. He arguably influenced more filmmakers than any other director, being recognized a true *oeuvre* by the French New Wave movement as someone who made films that had an immediately identifiable personal touch throughout the producer-controlled Studio Era. However, Hitchcock may never have developed his distinctive style without his early experience in Germany at the height of the Expressionist movement.

Hitchcock was aggressive about getting into the motion picture industry in England, which was extremely poor after the war. He began to work for Gainsborough Pictures, which had just come under contract with Lasky as a cross-training facility to make more films and hopefully open up the English market. The studio eventually launched a co-apprenticeship with the Germany film industry. Hitchcock was sent to Berlin during the time of the notorious cabaret night life, where the social atmosphere was something very new and exciting for a man young who had been raised by strict Catholic parents and attended Saint Ignatius College. He had gone over to study design and to be an assistant director. He had already made a name for himself as a skilled artist with title cards, and had mastered an understanding of screenwriting. But he had no ambition to be a director.

In Germany he was able to closely observe the man he would later call Master. F.W. Murnau was directing *The Last Laugh,* a landmark film where the camera is in almost constant motion, making the audience identify with the character's inner feelings. Through a precise visual language the story is told without the need of title cards. The influence of Expressionism on Hitchcock was immense and all consuming. Because of Murnau, he was able to witness how

a director could preplan shots and move the camera to create a mood that would surround the character and ultimately penetrate the character's habits and way of life.

The great moments in any Hitchcock film are usually silent montages where the camera tells the story. He told actors before shooting began that the one thing that he insisted on from them is to allow him to move and place the camera where he wished. His distinctive visual style was born in Germany and had a life changing impact on young Hitchcock. Back in England, when he made *The Lodger* (1926), the motion picture that began his lifelong association with the suspense genre, it looked very much like an Expressionist film. When Hitchcock came to America in the early 1940s, he brought this influence from Germany with him. Throughout his career, he continued to develop a visual language where the lighting and atmosphere were essentially important to understanding the minds and actions of his characters.

METROPOLIS

In 1926, Fritz Lang produced his most elaborate production, which became one of the most influential motion pictures of all time, but almost ruined the German film industry when it was not received well by audiences. *Metropolis* was inspired when Lang came to America to visit Hollywood. Upon landing in New York, he looked up at the buildings and the blinking lights and suddenly the images that would be the massive Tower of Babel in *Metropolis* began to form in his mind.

On his return to Germany in 1927 he began work on *Metropolis,* which was built on a scale unlike any other film at this time. It was a marvel of innovative special effects, creating images that sometimes took frame-by-frame animation. The other effects were painted on glass, then reflected in mirrors. Sections of the mirrors would then be scraped away and through these transparent openings, actors more than fifty yards away could be seen marching through the great abyss of the city in a forced perspective.

Metropolis (1927) directed by Fritz Lang is an example of a film that was a box office disappointment, but the power of its visual imagery has endured and still influences modern movies. Considered the first great science fiction film, **Metropolis** is the dark story of a futuristic society where the marvels of engineering and architecture are made possible because of the toil of zombie-like workers in a deep underground factory.

Metropolis is the story of oppressed people who work the machines in the bowels of the city, and the people that take advantage of this human suffering to live in great luxury at the top of the great skyscrapers. It is a world that envisions airplanes as flying taxis. Into this harsh reality workmen wearing the most humble black clothes and caps descend like zombies into the depths of the city in elevators that seem to drop forever. Above all this, the aristocrats of this futuristic world run races in coliseums built on the top of the skyscrapers and frolic with scantily dressed women in a recreation of Eden.

Into this world of extreme wealth and moral decay comes Maria, who has brought up children from the depths to show the son of the Industrialist and appeal to him for sympathy for their lives. She is quickly ushered out, but her wholesome appearance and sincerity attracts the son who becomes obsessed and ventures into this underworld trying to find out where she lives. Opposed to this union is the father figure, who runs this great empire without sympathy, knowing full well that his people are suffering but that is what they are meant to do. These worthless souls are there only to run the machines and being killed is all part of the daily experience. Knowing that his son is attracted to Maria, he visits a scientist with a mechanical arm—the prototype of all mad scientists, right down to Dr. Strangelove. The scientist has become obsessed with creating a robot that can change into the image of his lost wife. The Industrialist convinces him to turn the robot into the likeness of Maria, then let her go down and wreak havoc, thus ending the revolution that has already started.

The film was criticized for its obvious symbols and metaphors. But that is not what the film is truly about. It is an attempt to create a futuristic society that works within the realm of the Bible and the story of the Tower of Babel recreated in a heartless metropolis. The cinematography was by Karl Freumd and Günter Rittau, and the work on *Metropolis* has had an enormous impact on every science fiction movie since. Freumd went over to America, like many of the German cinematographers and designers, and became highly influential with regard to the great horror films at Universal Studios in the 1930s, lending his style to such movies as *Frankenstein* and *The Mummy.*

The reviews on *Metropolis* were disastrous when it first opened. In order to secure a release to regain some of the money put into it, the producers allowed the film to be re-cut from its original 153 minutes down to 93 minutes, and in some instances down to 80 minutes. In America a new screenwriter was brought in to look at the footage and write a new version in what became almost an entirely different story. What survives in *Metropolis* are the great scenic designs and "visual philosophy." Even in the extremely edited versions of *Metropolis,* what is seen on the screen has a tremendous impact that stays with the viewer—images that refuse to go away and that have been imitated countless times by filmmakers since its release over 75 years ago. It is one of those instances in which a film met with failure and harsh reviews on its premiere, yet continued to grow in reputation because it was seen by cinematographers, scenic designers, directors, and writers who studied it and marveled at this feat of filmmaking. Only a few films have had this distinction. Orson Welles' *Citizen Kane* is certainly one of them.

The impact of *Metropolis* makes it impossible for any film about the future not to be influenced by Lang's vision. The decisions to go with his vision and enhance it are seen in movies like *Blade Runner* and *The Matrix.* It was the first fully developed vision of what life may be like

Blade Runner *(1982) by Ridley Scott is one of the many films that owes a debt to the scenic design of* **Metropolis.** *Other movies include* **THX 1138** *(1971),* **Logan's Run** *(1976) and* **The Matrix** *(1999).*

in a futuristic society, and it has put a stamp on these images that have endured to this day. In 2002, on the seventieth anniversary of *Metropolis,* the Murnau Foundation restored what was available of the original print. Going back to notes on the director's cut and restoring the original score, the film was pieced back scene by scene, though tragically there are thirty minutes that have been lost forever. *Metropolis* had become almost a wastebasket for other composers to score, everything from hard rock, to jazz, to synthesizers. The original score with its full orchestration gives the film a magnitude and presence that makes the images fit perfectly with the neoclassic themes.

Some critics have compared *Metropolis* to the Gutenberg Bible because it opened the doors to the power of early cinema. Fritz Lang's *Metropolis* created the science fiction genre and put an indelible mark on it, forging a piece of cinema that has created a vision which has re-

mained intellectually intoxicating to viewers over the decades.

SOVIET CINEMA AND *THE BATTLESHIP POTEMKIN*

Shortly before he passed away, director Billy Wilder was asked what he thought was the greatest film of all time. Without hesitation he replied, *"Potemkin."* Coming from Germany, where Expressionism was the primary force in movie making, this is a telling statement. It shows that after almost eighty years the powerful impression this single film made on him had not gone away. The German cinema had a reputation for being slow moving. The focus was on creating visual moods with light and scenic design, and the films sometimes unwind at a very leisurely pace. Though highly respected, many of the German movies were re-edited when

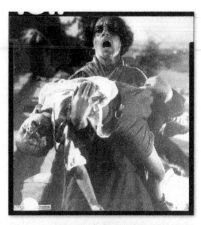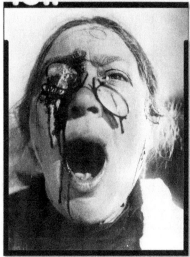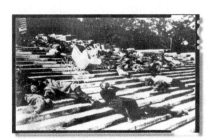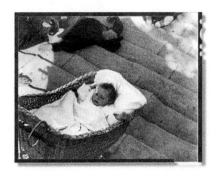

Potemkin, or *The Battleship Potemkin* (1925) directed by Sergei Eisenstein is perhaps the most studied film of all time. Originally made as propaganda to justify the reasons for the start of Russian Revolution, the massacre sequence on the Odessa Steps took the principles of montage to a level that has influenced every film since.

released in America to speed up the stories for audiences. So, when *Potemkin* (1925) premiered in Berlin, it must had been like a bulldozer knocking down the back wall of the theatre and letting a whole new vision flood in. *Potemkin* changed the concept of filmmaking for everyone.

The single most studied moment in any motion picture is the massacre on the Odessa Steps. This sequence is made up of hundreds of separate shots edited together to assist the viewer to the terrible realization that the soldiers of the Czar were unemotional killing machines. After watching the brutality that the military inflicted on the innocent citizens, there is not a second of doubt that the Revolution was justified and absolutely necessary. *Potemkin* is the first effective propaganda film, and it is so perfectly crafted that the audience never knows how much it is being manipulated in its idealized thinking. But the lasting impact of *Potemkin* is in the art of montage.

Sergein Eisenstein has been referred to as the Griffith of Soviet cinema, and there is a lot

of truth in this. Both directors experimented with rapid editing techniques and were able to tell complicated stories in purely visual images. Griffith introduced intercutting to this process and opened up the number of dynamics in each sequence. Eisenstein took what Griffith had done and effectively multiplied it by a hundred. The major difference between these two filmmakers is that Griffith used montage to tell a cohesive episode in a movie, and Eisenstein used it to assault the senses.

Eisenstein was part of the Soviet film movement that believed the montage would replace the written word—a theory that might have proven itself generally true in today's visually oriented society. Eisenstein had labored in the Red Army after the fall of the Czar and Vladimir Lenin's rise to power. He joined the Moscow Proletkult Theatre and studied under Vsevolod Meyerhold, who was changing the nature of theatre with his concept of biomechanics or the conditioned spontaneity, which would become the foundation for method acting in America. Eisenstein applied these principles to the cinema, believing that edited images should collide together, keeping the audience in a state of hyper suspense as to what was about to happen next. He called this the "montage of attractions," and believed that a sequence of photographed images has a greater emotional effect on the viewer than the sum of its parts.

Eisenstein realized how quickly a person could see an image and absorb information. And even if images bombarded the viewer every few seconds, if the individual images related to a story, there would be complete comprehension. What he referred to as the "intellectual montage" would include the use of metaphors and symbolism. He put these theories to use in *Potemkin*, the true story of a mutiny on a battleship that was a prelude to the Russian Revolution. The film is broken into chapters, beginning with the sailors on the Potemkin who are served meat swarming with maggots. After the ship's doctor declares the vile meat suitable to eat, Vakulinchik, one of the sailors, incites others to riot over the miserable conditions. During the uprising Vakulinchik is killed, and early in the morning his body is taken into Odessa harbor and placed on the dock for the townspeople to see. The citizens of Odessa rally to the aid of the starving sailors, beginning the sequence titled "The Odessa Steps."

Here Eisenstein literally introduces his cast of characters that will be swept up in the massacre. The citizens are first seen in a state of joy, waving to the sailors as dozens of small sailboats take food out to the Potemkin. There is a mother and her son, a student with glasses, a lady with a lace parasol, an elderly woman with spectacles, a man with no legs that zigzags through the crowd using just his hands, and others. This is a celebration of good will, and for a moment it appears that the mutiny has been a success.

Then suddenly at the top of the steps, soldiers appear in a regimented line and begin firing their rifles into the crowd. Panic ensues and Eisenstein begins cutting rapidly, going from master shots to close shots of the citizens he has introduced. In the chaos each of the individuals ends up in a different place on the steps, caught in the line of fire. Eisenstein has worked out the geography carefully so the audience is never confused about the location of each citizen. The faces of the soldiers are never seen; they are impersonal, moving like deadly toys. In counterpoint, the innocent, frightened citizens that huddle together for protection are given close-ups, making the viewer identify with their peril.

Eisenstein then shows the death of five people. The young boy trips on the steps and is brutally stepped on by the fleeing citizens. The mother picks up his lifeless body and approaches the soldiers. For a moment everything grows still, and there is the brief hope that the soldier

will let her pass to seek medical aid for her son. But instead they open fire and continue their deadly march down the steps. The Cossacks appear at the bottom of the steps, trapping the citizens and slaughtering them as they try to escape. The next incident is the most famous. A nurse has taken an infant out for a stroll in a white baby carriage and has accidentally gotten caught up in the mayhem. She is shot, and as she sinks down, her body bumps the carriage, sending it down the steps. Everyone watches helplessly.

At the bottom of the steps, when the carriage with the child appears to be safe, Eisenstein cuts to a close-up of a Cossack with a pure evil expression. The Cossack pulls back his sword and then slashes the body. The final shot on the steps is an elderly woman with a bloody eye socket—her mouth open in a silent scream of horror. Eisenstein then cuts to the Potemkin as the gun turrets revolve toward the camera and fire. Intercut with each blast is the image of a stone lion. The first one is asleep, the next one awake and standing, and the third roaring.

The number of shots cut together for this sequence can only be compared to modern films that have hundreds of camera setups for one action sequence. Eisenstein's influence on editing and his theory of montage were immediately used by directors everywhere, but the kinetic style of cutting that overwhelmed the audiences with clashing images was short lived. By the time *Potemkin* reached America, sound was only a year away, and the construction of this kind of montage was all but impossible with the limitations of the new cameras. Like so many films that became lost to the public, Potemkin was rediscovered in the 1960s and studied by students in newly emerging film schools.

The most imitated moment in *Potemkin* is the baby carriage bouncing down the steps. Woody Allen parodied it in *Bananas,* and Brian DePalma paid homage in *The Untouchables.* But the principles learned from the Odessa Steps sequence is used constantly. In *Clear and Present Danger* the massacre is treated in the same fashion. Make the audience identify with the good guys with close-ups and keep the bad guys as faceless murderers. Then cut between multiple stories of the people caught up in the violence, and hit the audience with hundreds of images, giving them a sense of disorientation.

Like Griffith, Eisenstein had redefined the art of visual storytelling with one motion picture. The silent cinema had reached its high point as an international language. For the first time in world history, countries were almost instantly sharing astounding innovations in art, the new art of the cinema. But by 1927, twelve years after *The Birth of a Nation,* it would all come to an abrupt end when Al Jolson opened his mouth and sang.

The Arrival of Sound and the Pre-Production Code Era

THE JAZZ SINGER

O n October 6, 1927 the world literally changed overnight. Warner Brothers' production of *The Jazz Singer* opened in New York, and within two hours the silent era passed away and talkies were the rage. The impact of *The Jazz Singer* is almost unparalleled throughout history. Military operations have taken over cities in days, but the change in life took months and years and sometimes was never fully reflected. After the first audience saw *The Jazz Singer,* everyone knew that sound was the only way to go from this point on.

Sound, in some form, had been around from the very beginning. The nickelodeons had music playing, usually in the form of piano rolls. Edison had experiments where a stethoscope connected to a phonograph underscored the moving images. But this had a tendency to breakdown, and the sound was usually quite muffled. Besides, the movie parlors were always active with noises of people coming and going. The theaters had orchestras, or at least a piano playing to accompany the action on the screen. There were even sound effects from backstage to imitate the sound of thunder, gunshots, and the stampede of horses, with large pieces of sheet metal, blanks, and men clapping coconut shells together.

The year before *The Jazz Singer* became a sensation, the Warner Brothers, who staked the future of their studio on the popularity of sound, premiered an elaborately produced motion picture of *Don Juan,* with the actor known as the "Great Profile," stage legend John Barrymore. Though enthusiasm for *Don Juan* was great it did not create the overnight sensation that *The Jazz Singer* did. The synchronized music and sound effects let the audience hear the clashing of swords and the richly orchestrated score highlighting the dramatic action, but there was no dialogue or singing.

At this time no entertainer was as popular as Al Jolson. This cannot be emphasized enough. Jolson was considered the greatest music performer of his era. Few singers in the entire history of show business have had as much energy on stage as Jolson. He could hold an audience for three to four hours, having them applaud and stand after almost every number. In a stage play, he often stopped the production and moved to the footlights to sing a few of his popular songs

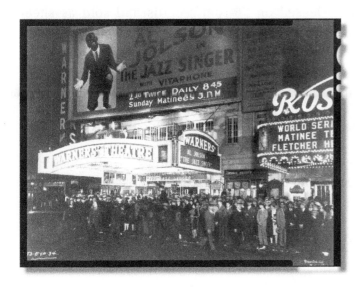

The Jazz Singer (1927) directed by Alan Crosland was Warner Bros.' big gamble into sound that changed the movie industry literally overnight. The film's best asset was Al Jolson, who was the biggest star in vaudeville and the most popular singer of the era. He adlibbed the first spoken words in a movie, "You ain't heard nothin' yet."

to the delight of the audiences, and probably to the weary look of the cast members that had to stand there until the production resumed. Jolson was a scene-stealer of the first order. In the Jazz Age, no one sold a song with more feeling, and his records sold out within the first few hours. His sentimental *Sonny Boy* sold twelve million records in just four weeks, which is incredible even today.

Jolson's stage persona was in the tradition of the minstrel performer. The irony is that his blackface appearance in *The Jazz Singer* became the first time the public got to see the depiction of an African-American as a benevolent, loving human being, healing some of the wounds of the stereotype image propogated by *A Birth of a Nation.* Only in the early years of the motion pictures, when audiences were still highly impressionable, could a Jewish performer in blackface influence people's beliefs about an entire race.

In *The Jazz Singer,* Jolson plays a cantor in the synagogue, where his father is the rabbi. But it is his secret dream to go to Broadway and break with some of the Old World traditions. This was a time period where this theme caused great concern. One of the longest running plays on Broadway was *Abie's Irish Rose,* a very broad comedy about the marriage of a Jewish boy and an Irish girl and the problems it causes with the two families. Many immigrants felt their children might be abandoning ancient traditions for the promise of success in the big cities.

The enthusiasm for sound came with Jolson's exuberant performance. *The Jazz Singer* is still a silent movie with a few episodes done in sound. Jolson's natural enthusiasm resulted in the ad-lib, "Wait a minute, wait a minute; you ain't heard nothin' yet," which must have been painful to the ears of English teachers. But true to his words, he sings "Toot-Toot-Tootsie," *Goodbye,* with his trademark hand whistles, and brings the house down. The audiences on the screen and in the theater went wild. The movie depicts Jolson briefly giving up the bright lights of Broadway to appease his father on his deathbed. But *The Jazz Singer* ends when Jolson returns to the theatre and in blackface sings "Mammy" to his teary-eyed mother in the front row. The impact of this moment is that each member of the real audience was as close to this living legend as the mother in the movie. With a close-up and synchronized sound everybody has the best seat in the house.

THE PHONOGRAPH AND TIN PAN ALLEY

As Edison had predicted, the gramophone and the phonograph had become almost household fixtures. By the time *The Jazz Singer* opened almost every home had one. Listening to great performers on phonograph records was affordable to the workaday people. And music was going through a glorious time period. What was referred to as Tin Pan Alley was in full swing. Irving Berlin and the Gershwin bothers were composing one hit after another, the kind of memorable songs that people could stand around and sing. These hit tunes were released on 78-rpm records and sold as sheet music by the millions. Berlin made his songs easy for people to sing, since he composed almost everything in the key of E. Broadway was the place that showcased new songs, especially in the days of George M. Cohan, but when Al Jolson opened his mouth and words came everybody went Hollywood.

Early Broadway shows usually had very rambling stories, and actors broke into song without any attempt to integrate these showstoppers into the story line. The books of the shows have not aged well, but the music has endured. The music that was really the pulse of the Roaring

Twenties was jazz. The idea of being a jazz singer was very appealing. There was something emotionally intoxicating about the music, the same way that in the 1960s rock 'n' roll caught the popular attention and scared adults into thinking that the youth had gone wild—and they had.

This was the last hurrah of the vaudevillian era. All kinds of music, from classical to jazz to romantic ballads, had become part of the daily existence. Radio was coming in, and the popular comedians and singers that once did overnight-hops from one town to the next were now in everyone's living room. Listeners tried to keep a steady frequency as they fussed with their crystal radio sets to get the wavering of the radio to stay constant throughout the program. When *The Jazz Singer* opened, it had everything going for it. It had popular music and it had Jolson at his vivacious best. Just the right note at the right time.

THE TRANSITION FROM SILENT MOVIES TO TALKIES

As the great cinematographer, Vilmos Zsigmond, observed, the sudden arrival of sound was really a great catastrophe to movies. This might seem overly stated and perhaps somewhat pessimistic, but in truth overnight panic to install sound in all theatres almost destroyed all the complex visual language of silent films. The wild enthusiasm for all singing, all dancing, all talking motion pictures became so absolute that the heads of the studios were taken off guard by the immense popularity of the *The Jazz Singer*. Everyone began to lose sight of what the visual power of film was all about. The Roaring Twenties had certainly opened up the avenue for feature-length motion pictures, and almost everybody in America was going to films at least once a week.

Everyone threw out a form of movie experience that had been developing since 1894, without a single thought as to what film was all about—visual storytelling. Sound had been kept on the backburner for many years because of the price that it would cost to rewire all the theatres in the country. The studios owned the theatres, and though they were going through a prosperous time, no one wanted to spend all the profits on the installation of an unproven technology. This would have been compounded drastically if anyone had known that two years later the whole

Singin' in the Rain (1952), directed by Gene Kelly and Stanley Donen, was a lovingly made spoof of the transition into sound. The events in the musical mirrored the many crazy problems that took place in Hollywood after the release of **The Jazz Singer.**

world would go into an economic depression. Many of these old theatres had only been recently wired for electricity and lights over the last decade.

But after *The Jazz Singer,* the theatres had to bring in bulky speakers, microphones, and a maze of new wiring. To speed up the process, some theatres had to close down for short periods, or have technicians come in after the last performance of the evening and work throughout the night. The new sound equipment was anything but secure in how it operated. There were flaws—many flaws. The sound was static. Buzzing noises seems to come out of nowhere, giving audience members headaches. It was a technology that a few people knew a little bit about, and no one knew very much about, but tens of thousands of theatres had to be changed quickly.

For over thirty-three years, audiences had gone to silent movies. Actors had moved their lips and were obviously speaking lines. But this never bothered anybody. Today, this is probably the one aspect that younger generations are disturbed most by, the realization that people are saying things and then having to wait for the words to appear on title cards. By 1929, silent movies were an art form where words did not matter. The images told everything. This changed absolutely with sound. The freedom of the camera, the variation of images to show emotions, and the abilities of certain directors to tell a story visually that could be understood by audiences around the world. Even D. W. Griffith made one talkie but refused to make another, saying "Why should I give up 90 percent of my audience for just 10 percent that can understand the English language?"

Silent films had been the right thing at the right time. From the turn of the century to the start of the Great Depression, the huge migration of immigrants who could not speak English had a common language. The biggest loss was the montage form of story telling, perfected by Sergei Eisenstein, and the scenery and lighting effects that came from German Expressionism. A few directors who learned their craft during the silent era, like Alfred Hitchcock and John Ford, would continue to use these techniques, but it would be almost forty years until the camera would be freed up again.

THE BIRTH OF THE HOLLYWOOD STUDIO SYSTEM

When sound arrived, everything was at the mercy of an individual commonly known as the sound engineer. He would sit at a control panel with a few dials and literally dictate the future of actors. Sets had to be built so a microphone could be strategically placed, such as actors sitting around a table with a flower pot, or gathering in a narrow confine without moving, so their voices could be picked up. If an actor was not heard or not speaking clearly, everything came to a complete stop. The sound engineer became more important than the director. He became the most influential entity in filmmaking for the next half dozen years, because to everybody else this was some type of electronic black magic.

Sound is what finally galvanized the Hollywood Studio System. The studios were originally open or had glass roofs so that sunlight illuminated sets. As lighting equipment was developed, studios were constructed like enormous blimp hangars with no thought for soundproofing. In *Singin' in the Rain,* Gene Kelly and Donald O'Connor walk through a studio with half dozen films being shot next to each other, which was not too far from the reality of shooting in the silent era. The studios were turning out at least one major feature each week, which continued through the end of World War II. In addition,

Cleopatra (1934) *starring Claudette Colbert was directed by the legendary Cecil B. DeMille, one of the few silent directors that transitioned successful into sound. He was able to skirt the censorship issues of sex and violence enforced by the Production Code by setting his lavish movies in ancient times or by bringing Bible stories to the screen.*

there were at least two or three B-features in progress, comic shorts with Laurel and Hardy, or other silent comedians, plus constant construction for the next motion pictures. Studios were a dissonant orchestra of noises. All this stopped with sound, where silence was observed like a religion.

The spoken word forced everything into the sound stages. Before this, most productions were done on locations where giant sets were built like small cities. Sound forced everything and everyone within the confines of sound stages and the back lot of studios. Before sound the producer had no way to oversee every aspect of a motion picture. Now they could go from one sound stage to the next and manage every aspect of production. Quickly, sound stages with thick walls began to mushroom as the old structures were torn down. Only one production could be done at a time, and this production might demand several sound stages.

Any kind of noise became a critical factor. Sound cameras had to use motors so they would record at exactly 24-fps, and these early motors were loud. To prevent the rattling of the camera motors from bleeding into the microphones, the camera was put into what became known as an icebox. It was basically a soundproof cage with a paned glass window the camera could shoot through. This padded cage was on wheels, so every time a different shot was needed several crewmen would have to roll the clumsy cage to a new setup. Inside, the cameraman was almost suffocating, like in an oven without ventilation. The silent cameras weighed less than forty pounds and could be easily lifted and walked away. The new sound cameras weighed three times this and had to be moved by several strong people. For one shot done with sound, a silent cameraman could have setup and done a half dozen shots or more. This meant that talkies took longer and had fewer shots to edit together for a

scene. And many simple in-camera techniques used in the silent era were lost or became too expensive to create.

It is remarkable how fast all this changed. Within the next few years, the cameras were slowly freed up again from the limitations of early sound recording and gained more mobility because of sound blimps that muffled the motors during a shot. But the trade-off was that sound blimps made the new cameras even heavier, especially when Technicolor came in; many were the size of a refrigerator and weighed as much. To put one of these cameras in an airplane or a fast moving car would be inviting disaster. Classic motion pictures of the late silent era like *The Last Laugh* by F. W. Murnau or *Wings* by William Wellman were completely impossible to do.

With sound, the studios became kingdoms for moguls. The back lots, which were sometimes hundreds of acres (all of Century City at one time belonged to 20th Century-Fox), were constantly busy with some of the best skilled carpenters and designers in the world. Seaports, ranch houses, New York streets, ramparts of medieval castles, and small town, USA all popped up next to each other. When the Great Depression hit, expert craftspeople headed to Hollywood. The money was good, though the hours were long. Most of the sound stages built in these years are still used today. And the back lot sets were constructed with such precision and skill, as with Universal City and Warner Bros., that they have been used in literally hundreds of movies and television shows and can still be visited today.

Having the ability to shoot all motion picture production on a single lot made the studios even more of a kingdom in the fact that the moguls offered long term-contracts—not only to stars, but to writers, character actors, designers, composers, cinematographers—almost everybody had long contracts with good salaries, but they had to work exclusively for the studio. Many stars talk about what a "close family" the studios were, and how busy they were kept, so that years went past before they had a chance to meet their counterparts from other studios.

FILM GENRES

The concept of genre films was very much like going into a factory at General Motors and picking out a Pontiac, Chevrolet truck, or a fancy Cadillac. It was very much the

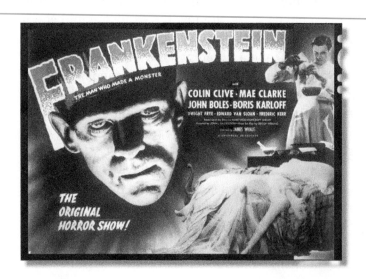

Frankenstein (1931) directed by James Whale made a star of British character actor Boris Karloff who was originally billed as "The Monster — ?" Made the year after Dracula, the success of these movies saved Universal and started the horror genre that is still identified with the studio.

same kind of mentality to the people that were running the studios. This sounds very nuts-and-bolts but it is not. The wisdom of the genre films is still very much in effect today. Early motion pictures were easily labeled Westerns, musicals, screwball comedies, romances, or adventure. Today genres get mixed together, like fantasy/action/adventure used to described *The Lord of the Rings.*

It has been said the early studios reflect the personalities of their moguls, and evidence of this can be seen in the genre films from these studios. A musical from MGM was lit more glamorously than the gritty backstage musicals from Warner Bros., and a Cecil B. DeMille epic from Paramount had a much different look than a costume adventure from 20th Century-Fox. For many years studios specialized in certain genres for their stable of stars. Warner Bros. had a lock on the gangster films with James Cagney and Humphrey Bogart. Universal was kept afloat with gothic horror thrillers like *Dracula* and *Frankenstein.* And Columbia had Frank Capra, who was his own genre.

All the studios put out a quota of genre films, based on audience research and the box office popularity of their stars in certain kinds of motion pictures. Errol Flynn was bounced between high adventure and Westerns. Cagney looked out of place in Westerns, but was terrific in gangster films and the occasional musical. Bette Davis' fans loved her in costume dramas. Surprisingly, Cary Grant did not do well in costume dramas, but was perfect for screwball comedies and romantic tearjerkers. And Spencer Tracy could do anything.

As the years went past, one genre would give birth to other genres. When the Production Code came down on the gangster genre, the hard-nosed detective drama became popular, which then turned into film noir with its cigarette-smoking anti-heroes. The horror genre turned into the psychological thriller, which after *Psycho* became the slasher film. The heroes of 7th Cavalry in the John Ford Westerns became the bad guys in the revisionist Westerns of the 60s. And the action-packed Western, with one man or a small group of men against impossible odds, traded firearms and become maverick cop movies like *Bullitt* and *Dirty Harry,* then went to a galaxy far, far away in *Star Wars* and *Aliens.* Other genres have not changed much, like the heist film, or even the fantasy adventure, which has instead become more realistic because of CGI special effects. And screwball comedies like *Bringing Up Baby* have become gross-out comedies like *There's Something about Mary* or action/adventure/music/comedies like *Austin Powers: International Man of Mystery.*

A direct trend in each genre can be followed from the first flickers to modern day, and the influence of genre filmmaking is obvious on television shows, and even the way bookstores are laid out. The moguls discovered a long time ago that people like to see certain genres of films over and over again; others only pay to see them under special circumstances; for example, a star they like is in the film. Thus there are genres for everybody's taste. It is almost impossible to name a film without thinking which genre it falls into, and those outside the envelope are given the blanket titles of foreign or independent films. There is a mind-set that happens when someone sees an ad for a Western or musical or film noir. There are certain expectations, and each genre has its own set of rules, which the writer and director must weave into the plot and even the look of the film. If done cleverly, these age-old rules can be broken on occasion, but this is becoming increasingly more difficult.

Members of the Hays Office with Will H. Hays seated in the center. These men administered the Production Code, or the "Hays Code" as it was popularly known, with the utmost seriousness as their expressions clearly denote.

THE PRE-PRODUCTION CODE ERA

The Production Code was originally presented on March 31, 1930 by Will Hays and became popularly known as the Hays Code, but did not have any cohesive affect until the threat of a Catholic boycott of motion pictures. An amendment was added to the code, which was formally adopted on June 13, 1934, establishing the Production Code Administration under the tenacious watchdog leadership of Joseph Breen.

One of the great ironies of Hollywood is that after the code was first announced and the Hays Office formed, movies actually became more violent and racier, peppered with sex, naughty wordplay, and stories about wild living. It had a complete reverse effect and Hays was constantly making public speeches apologizing on behalf of the studios, who had promised not to make any more movies that did not strictly conform to the guidelines of the code. But they did, simply because the movies made buckets of money.

This period when the Hollywood moguls thumbed their collective noses at the efforts of the Hays Office became known as the Pre-Code Era, also referred to as Forbidden Hollywood. It lasted barely five years, but since it signaled the arrival of sound, the beginning of the star system, and economic madness brought on by the Stock Market crash, this is perhaps the most eventful and tantalizing period in motion pictures. The movies learned to speak in a tough vernacular. New stars arrived that were fresh-faced and fearless, and the studios, which were shelling out a fortune to convert the theatres to sound, turned to Tommy guns and sex to stay out of red ink.

If *The Jazz Singer* had opened a year later then the hurried switchover to sound would have probably been much slower, taking years and perhaps a decade to complete. The studios simply would not have been able to afford the expense of installation in all their movie theatres. But at the height of the Roaring Twenties investors were literally dancing on Wall Street. Profits seemed to magically fall out of thin air. All businesses were booming: railroads, cars, luxury items for the home—everything seemed to be going straight up with no indication there was a major turn in the road about to happen.

The studios owned a majority of the theatres and had worked out deals with theaters in terms

of blocked booking, a process where theater owners would have to take a group of movies if they wanted to have a few with notable stars. Thus in order to get four films by a bankable star, the owners would have to take ten other films sight unseen to go along with it. One-sided negotiations like this continued until the late 1940s and quite often tied up the few independent theatres because they had long-term commitments with certain studios. It was a practice that was eventually outlawed but was very practical in the years after sound and the rise of the star system. Theatres would know for sure that the next motion pictures with Greta Garbo were definitely coming to their theatre and not to the theatre up the street.

Something astonishing is that even the smallest towns in America would have four, five, or even ten different theaters lined up on Main Street, quite often right across from each other. Some had banners announcing air conditioning, others simply that they had better prices or a live opening show. The number of movie theatres throughout America was increasing constantly. And after *The Jazz Singer* all of these theatres needed to be wired for sound as quickly as possible, and there were very few reliable companies that knew this kind of technology. It was difficult and confusing at times to work out deals to get the best prices, which was something that hung over a lot of the studios, especially after the Great Depression hit.

In 1927, the expensive switch over to sound was a reasonable move and something that needed to be done, and the studios poured their net profits into it. But if *The Jazz Singer* had opened in 1929, the Stock Market Crash that happened in October of that year would have prevented this kind of expansion, and films might have ended up being very different. The thoughts that the transition was so abrupt it took away much of the visual storytelling of the silent films is un-

questionably true. A gradual evolution from silent to sound would have been indeed a different kind of *motion* picture.

The only way to glimpse what might have happened is with the few films that Charlie Chaplin made after sound came in, which utilized sound without talking. In *City Lights* (1931) and *Modern Times* (1936), Chaplin occasionally uses musical instruments in place of people's voices and composed his own underscoring for the Little Tramp which fit perfectly. Chaplin kept the pantomimed tradition of silent films, then added sound for comic affect. These movies were highly popular with audiences. But Chaplin was the exception.

THE GANGSTER FILMS

A distinguishing factor of the Pre-Code Era are the movies that suggest what might have been if the studios did not give into the ultimate pressures to change the moral behavior of characters in the make-believe world. This is something that is still strenuously debated today, and something that will probably never go away as long as there is an artist with a unique idea that shows the world a different viewpoint.

The gangster film was born in the Roaring Twenties during Prohibition. If there had not been Prohibition there might never have been organized crime, especially on the scale that it rose to in the United States. It allowed bootleggers to network from city to city. Not only did Prohibition not limit alcohol input, it increased the desire for it. The crime of drinking was not considered a crime by many during the Roaring Twenties. It added a little adventure to people's lives, knocking on doors late at night, whispering passwords, and going into dens full of half-dressed women and loud jazz and alcohol that could take the paint off walls. The bloody battles

Scarface (1932) directed and produced by Howard Hughes, actor Paul Muni played Tony Camonte with a thick Italian accent, clearly suggesting real-life gangster Al Capone. The film was used by the Hays Office as an example of how graphic violence had become on the screen. Even Capone said the film had gone too far.

over bootleg liquor made headlines around the world and became part of the "anything goes" attitude of the 1920s.

It was only natural that Hollywood immediately began to make motion pictures about the gangsters. This immensely disturbed the religious community and parents because suddenly young children were not playing cowboys and Indians they were playing cops and gangsters, and most boys wanted to be gangsters and speak like Cagney. The dialogue in gangster movies might not have had colorful four letter words, but still was tough and direct, almost like little verbal punches. Gangster movies were instructing peo-

The Public Enemy (1931) directed by William A. Wellman continued the gangster genre at Warner Bros. that began with **Little Caesar.** James Cagney was originally cast as the secondary lead but after two weeks of shooting Wellman switched the roles around and Cagney emerged as one of the studio's biggest stars.

ple that violence was a part of something dangerous but the rewards of money and penthouses were worth the fight. The primary factor, and the one that is still under the shadow of censorship today, was that violence had reached a point of almost Wagnerian proportions in movies, fostering the concept that violence breeds violence.

SEX IN THE CINEMA

But, as always in American cinema, it was sex more than violence that deeply offended the religious community. The Pre-Code movies capriciously played with the theme that women could and would use their sexuality to achieve anything they set their determined minds to. The family environment is at the core of all religious organizations, and "bad girl" movies showed wandering-eyed husband could be at the mercy of modern day Jezebels. These movies depicted women as cunning creatures of behavior that used their "wherewithal" to get

any man they desired in exchange for a prominent place in society or the good-old-boy business world.

People kissing in public became scandalously commonplace after seeing movie stars doing so on the screen. It was the overt suggestion of sex in Pre-Code movies that troubled the churches. Part of the regulations in the Production Code Hays had drafted stated that women could not have extramarital affairs, and a kiss could be no longer than three seconds on the screen. The bedroom could not show a single bed but always had to have two beds visible and undisturbed, even if the characters were supposedly married. This two beds rule is something that continued through the early years of television with *I Love Lucy* and *The Dick Van Dyke Show*.

On screen women could not dress in attire that was not appropriate, thus the image of women in slacks was discouraged. And a woman could not show she took pleasure in any kind of sexual activity. The problem was that film has been and

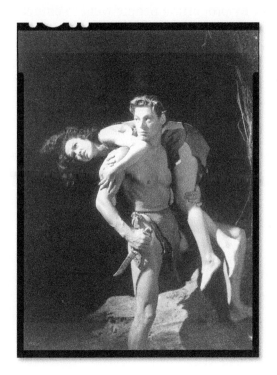

Tarzan and His Mate (1934) starred Johnny Weissmuller and Maureen O'Sullivan and was a huge hit for MGM, but even this high adventure did not escape the Hays Code. There were complaints that too much flesh was exhibited and that the happy couple, who lived in a tree house together, were not legally married.

always will be something that mirrors the time period in which it is being made. Trying to enforce these limitations on women characters at the height of the Roaring Twenties, when in daily life they dressed as flappers and did the Black Bottom in public, was almost ludicrous to try and impose. F. Scott Fitzgerald's tales of the Jazz Age about women who smoked and parties where people drank all night and paraded around in public fountains in the early hours of the morning, was the reality of the era before the curtain came down after the Stock Market Crash. To restrict this on the screen seemed preposterous. Women were setting records flying across the country and were beginning to do things in society that had been unheard of before. But in the movies these long overdue advances for women were taken as dangerous signs to the groups that wanted the Production Code enforced.

JOSEPH BREEN

The code, as all forms of censorship, focused on the negatives, or what were perceived as adverse forms of moral behavior, worrying that any kind of influence could be an adverse influence. There are a lot of good things to be said about movies, and quite often these are overlooked for the bad things. Remarkably, people have generally taken the good they have seen in movies and used those as shining examples of what they would like to become. Probably more people have gone into the legal profession because of Atticus Finch played by Gregory Peck in *To Kill a Mockingbird* than have (hopefully) turned to a life of crime because of Tony Montana played by Al Pacino in *Scarface.* There are certainly cases for both sides of the debate, but for the most part, motion pictures have taught more good behavior than bad.

Popular fashion is influenced by the movies. People travel to places because of movies. Certain actors almost become old friends, and audience members sometimes have difficulty separating Jimmy Stewart from his role in *Mr. Smith Goes to Washington,* or Julia Roberts from her character in *Pretty Woman.* From the Pre-Code era on, people spent more time in a movie theatre than going to church. By proportion people went to church for one hour but saw two, or with double features, four movies a week. On the other hand, many

The man who put the bite in Hollywood censorship, Joseph Breen was appointed head of the Production Code Administration in 1934. He strictly enforced all the rules of the Code, including the rule which stated married couples had to sleep in separate beds and that no screen kiss could last more than three seconds.

religious organizations have greatly benefited from images on the screen. *The Ten Commandments* (1923) directed by Cecil B. DeMille was highly praised because congregational church goers were able to see the Bible come to life and, through the power of special effects and movie magic, made them better people. It became the most attended film since *The Birth of a Nation.* Recently *The Passion of the Christ* (2004) directed by Mel Gibson astonished Doubting Tom critics by smashing box office records.

In 1934, when the Catholic Church declared it was going to boycott motion pictures, the studios rapidly figured out this meant literally tens of thousands of people in major cities. These people had, up until that point, been avid theatregoers, yet would stop buying tickets because their priest or their pastor forbad them to do so. Joseph Breen, a devout Catholic, arrived in Hollywood like a piece of red-hot steel to cauterize the wounds he felt movies and movie moguls

had inflicted on the world. So, all twelve studios did the only smart thing and agreed to abide by the Production Code down to the last letter. No one had any idea this would remain in force until 1966, when Vietnam, television, and foreign films made it a relic of the past.

Overnight, careers were ruined. Probably the best example would be Mae West, who was famous for her double entendres, like the scene when she checks in her fur coat and the girl behind the counter says, "Goodness, what a beautiful coat," and Mae West replies, "Goodness had nothing to do with it, sweetie." West's saucy comedies saved Paramount from bankruptcy when the stock market crashed, but once the studios signed off on the code her career was over and four-year-old Shirley Temple became a sensation. The woman of the world was out, and a child of complete innocence was in. All motion pictures immediately reflected this mandated morality, and thus a new era of Hollywood

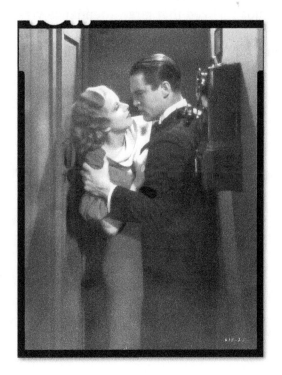

Red-Headed Woman (1932) directed by Jack Conway created loud outcries from the Church as an example of everything wrong in Hollywood, which was being referred to as the New Babylon. Jean Harlow plays, with great relish, the gold digger Lil Andrews, who uses all her feminine charms to reach easy street—and succeeds.

movie-making was born. Happily this change occurred coincidentally as filmmaking technology improved, allowing for some of the polish and high art sophistication of the silent movies to be restored.

THE EFFECTS OF THE GREAT DEPRESSION

When the Great Depression hit in October of 1929, over 8,700 theatres had been wired for sound to the considerable expense of the studios. Each theatre cost roughly $10,000 to wire, which included bringing in speakers and new projectors. Today this would probably be close to $100,000, which also happens to be the estimate to install digital formatted projectors. With this amount of money going out, and having to drop prices after the Depression hit to keep people coming into theatres, the studios were in big trouble. To make matters worst, many of the movies proclaiming, "all singing, all dancing, and all talking" were not holding the public's interest. The movies had become dull because the exciting filmmaking of the silent era had disappeared. The public could not articulate this, but there was a sense that movies were just not as interesting as they used to be.

By the early 30s the country had changed radically. The gaiety that was once part of the Roaring Twenties vanished with daily concerns of employment. It affected every aspect of life, which had been flipped upside down. The long lines for bread and soup were around every corner. People sold apples on the street or just sat on the curbs looking like they had become part of the cement they were resting on. Not only were jobs, even temporary jobs, difficult to find, there was almost no employment for women. The glamour so many women saw on screen and tried to emulate suddenly seemed part of another lifetime. Signs of the Depression were everywhere. The gloomy atmosphere was penetrating all parts of society, which a few years before knew no limits to the carefree enjoyments of life. Movies about the Great War and realistic tales of modern living with unhappy endings that were so popular when sound came in were no longer the kinds of things audiences wanted to pay to see.

Studios realized that large attendance was of primary importance. Most of the studios ran on annual budgets of less than four million dollars. Only MGM had a larger budget, and only

The Grapes of Wrath (1940) directed by John Ford with cinematography by Gregg Toland is the kind of movie the studios avoided during the height of the Great Depression. The moguls gave audiences uplifting entertainment, knowing that the bitter realities found in Ford's film were just outside the cinema doors.

MGM went through the Depression in the black. All the other studios were on the edge of bankruptcy. If a film that was expected to generate certain revenue did not do well at the box office, it affected every other film that was already in production. Cutbacks happened almost daily at the studios. With only two or three box office failures of A-list movies a studio could go under, and the way movies were marketed there was no quick way to bring in revenue. Today a movie can *open wide,* meaning in hundreds of theatres across the country on the same day, and be into profits after one weekend.

Opening a movie during the Studio System was very much like a traveling show or a circus. Films would open up in the larger cities, play for several weeks, and then go to the smaller cities. Each of these cities had to be monitored by someone hired by the studio that went each week, and sometimes daily, to count ticket stubs and reconcile revenues. Only one theatre could show a certain movie in a city, or within a radius of one hundred miles. The theatre had to keep the movie until it stopped generating a certain percentage of paying customers, then the next movie would replace it. This meant that if a movie was not doing well another movie had to be ready to fill the bill. So, for the studios to slow down production could spell disaster if one or two prestige releases began losing business. There would be no replacement and another studio could step in. Production had to be kept at the same level as before the Depression, but this demand kept the studios on the brink, especially with ticket prices being dropped to encourage business.

A motion picture could take a full year before it broke even or showed a profit. And if a movie was not performing well the ripple down effect might take months before the studio could assess the damages and adjust production budgets. This kept the stars busy promoting their latest movies, sometimes doing whistle stop train trips across the country for weeks at a time. They might have been stars but their bodies belonged to the studios, and they were worked six days a week. And when a star was not making a movie at his or her studio, he or she could be loaned out to a rival studio for a tidy profit, none of which the star ever saw.

A movie with big name stars would open in New York and Hollywood with giant premieres that were broadcast nationwide. All of the trappings of divine decadence and glamour were part of these premieres, just as in old newsreels or the opening scenes of *Singin' in the Rain.* Limousines would pull up with stars in their tuxedos and full-length furs (which, of course, is an unthinkable fashion choice today). Most of the stars under contract with the studio had to attend, even if they were not in the movie. Searchlights would light up the sky for miles, airplanes flew overhead with banners, and flashbulbs went off like Tommy guns. After the premieres, and hopefully good notices, the movie would then be released to other major cities, then eventually to the smaller communities. Sometimes movies had to be slightly re-edited to remove anything that might offend a certain demographic, like an all-black musical number in the South. Then the movie would be released in London or Paris and begin the international tour. In foreign countries, certain voice talent that dubbed the movies did the voice for the same actor for years and years, sometimes retiring if the star passed away. This kind of distribution of the movies continued for decades. By the late 1950s a motion picture might open nationally on the same day, but still the exclusivity clauses prevented another showing within fifty to a hundred miles. *The Godfather* (1972) was the first movie to open wide, appearing in several different theatres in New York. And *Jaws* (1975) began the modern distribution campaign.

HOW MOTION PICTURES WERE MADE IN THE PRE-CODE ERA

One of the most amazing things that happened in Hollywood when sound came in was the opinion held by the moguls that none of the silent directors knew anything about how to direct motion pictures that talked. Some of these directors had made fifty or more movies that had reached a high form of visual storytelling, but in the minds of the studio bosses they knew nothing about how to direct a movie where actors opened their mouths and words came out. The sound engineers who arrived in Hollywood with high-minded attitudes certainly encouraged this erroneous notion. This gave them a control factor, which allowed them to spook many people in the industry. In the middle of a shot, they would stop the production and let the studio director know he had blocked the actors outside the range of the microphone, or that the costumes were rustling too much. For a while the sound engineers ran the sets, with highly skilled directors as their assistants. But when the film got to the cutting room it was very evident that these dial-turners did not know how to make a movie.

To be fair, many of the American directors were frustrated and impatient with the limitations of sound. These men had learned to work fast, improvising scenes as they went. To have a couple of people sit down and talk for five minutes, without moving their heads in fear of losing sound, was not movie making to these veteran directors but bad stage plays. Many of the foreign directors were more apt at coming in and understanding the necessities of sound because the scripting in foreign films, even though they were silent, was very systematically put together. Many of these directors used storyboards and carefully planned each shot.

Initially, the biggest problem that actors had to deal with was working in a very defined space, where they had to talk toward a vase of flowers where the microphone was hidden. During the first years of sound every table setting seemed to have a large vase of flowers on it. Reportedly, to overcome this immobility problem took the ingenuity of a woman director named Dorothy Arzner. While she was in the middle of a scene trying to work around the restrictions of the microphone, she told an assistant to go out and bring back a fishing pole. She connected the microphone to the fishing pole and held it over the top of the actors' heads, creating in essence the first boom microphone.

The fears of the studio heads that all of a sudden they did not have actors who could speak properly, nor directors who knew how to work with talking actors, resulted in a mad rush back to New York. Only twelve years before studio moguls had left New York to get away from Edison and his lawsuits. Now these men scurried back to Broadway to find anyone starring in or directing a play or musical. Anyone who was quickly got a movie contract. If an actor could speak and be heard by an audience, he was considered star material.

The change in the look and style of the movies came about by bringing in Broadway directors who, at this particular time, were probably best suited to deal with the limitations that sound inflicted on films. These stage directors were good at working in terms of master shots, using a full stage approach and blocking actors into different positions to create dramatic effects. They were also used to working within a structure where the script was king. Aided by seasoned assistant directors, they quickly picked up a working knowledge of filmmaking and editing. Rouben Mamoulian became extraordinarily creative, finding ways to move the camera freely

again by shooting scenes in silence then adding dialogue and sound later. George Cukor became one of the best actor's directors that ever got behind the camera. And Busby Berkley saved the Hollywood musical by making the camera the star in numbers like "42nd Street" and "By a Waterfall."

From this tug-of-war for control behind the camera, many silent directors continued to prove their worth and made the adjustment into talkies. Directors like William Wellman and Raoul Walsh at first put blankets over the motors to muffle the sound and took the cameras outside again. They continued to work for another thirty years making classics in almost every genre. Directors who had recently arrived from Germany, like Ernst Lubitsch, Fritz Lang, and Josef Von Sternberg quickly adapted to sound and brought their distinctive touches of genius to movies that have endured the test of time. What is amazing to observe is how theatrical early sound movies were,

like the original Dracula (1931), then to see how far filmmaking advanced in just three years with *Tarzan and His Mate* or *It Happened One Night.*

THE STAR SYSTEM

Perhaps Louis B. Mayer put it succinctly when he said, "Stars can go through hurricanes but they have to look beautiful in their close-ups." This is a perfect definition of the star system, which in essence declares that there are a select few who light up the silver screen with that "unknown something" and even Nature's calamities cannot disturb their celluloid persona. This knowledge was the bread-and-butter of many great cinematographers and certain stars, who knew that their screen image depended on subtle lighting tricks.

In 1930, MGM announced in headlines around the world that "Garbo talks!" but no one knew for sure if *how* she talked would make a

*Backstage during the filming of MGM's **Grand Hotel** (1932) Greta Garbo and John ("The Great Profile") Barrymore take a break for an early photo opportunity. During the 1930s MGM proudly claimed it had, "more stars than there are in the heavens." During the movie Garbo said the famous line, "I want to be alone."*

difference to her fans. She was the studio's biggest star and had just made a fortune for MGM with her last silent movie *The Kiss* (1920) where her lips moved but only music underscored her words. Now, there was no avoiding it, she had to speak. But Garbo had a very pronounced Swedish accent and the fear was that audiences might laugh. It was decided to let her talkie debut be *Anna Christie*, the title character in Eugene O'Neill's Pulitzer Prize winning drama, adapted by the most successful screenwriter in Hollywood at this time, Frances Marion.

To help out an old friend, Marion added the character of an old, frumpy barfly played by Marie Dressler, who stole the movie. But Dressler, who won the Academy Award that year for her performance in *Min and Bill*, was instrumental in Garbo's successful transition into sound. Dressler reacted to each word that Garbo spoke as if it were pure gold. The audience in turn loved Dressler, so if she liked this character of Anna Christie, so did they. This is the unspoken duty of a character actor—make the star look good. In the opening scene of *Anna Christie*, Dressler is seated at a table as Garbo enters, dressed in almost rags and certainly not looking like the sex goddess audiences had just seen in *The Kiss*. She tells the bartender to, "Gimme a visky, baby," then talks with Dressler at the next table. Dressler carries the rest of the scene, and the audience thought Garbo was wonderful.

Like *The Jazz Singer, Anna Christie* is a motion picture that has not aged well but was immensely popular when it was released. It was directed by Clarence Brown, who made many motion pictures with Garbo, including *Anna Karenina* (1935), and would go on to make the MGM classics *National Velvet* (1944) and *The Yearling* (1946). *Anna Christie* was photographed by William Daniels, who became almost synonymous with Garbo, giving her the "Garbo look" in most of her major movies, including *Grand Hotel*

(1932) and *Camille* (1936). In fact, Garbo would insist upon having Daniels photograph her, and Garbo got whatever she wanted, which was the very best.

This story perfectly describes the star system in action. The very best talent was always available to make the star look and sound great.

Both Marlene Dietrich and Garbo, who both spoke the same year, were very conscious of the lighting and how they should be shot on film. Josef von Sternberg, who was very knowledgeable in the technical aspects of film production, always made sure that Dietrich had a high key light in every motion picture, which would soften her cheekbones. Garbo was very much the same way. She was afraid of a certain profile that Daniels was able to downplay; he also gave her that enduring image, sometimes using a dozen lights to bring out the sparkle in her eyes and muting any lines in her face by putting gauze over the lens for her close-ups. This attention to detail sometimes took hours but was immensely important in creating the image of a Movie Star.

There are many folk legends of what happened when sound arrived. To put it in proper perspective, only a few silent stars were given the heave-ho because they had speaking voices that were inappropriate. John Gilbert's voice was allegedly high pitched, implying that he was not a man's man. Clara Bow was from Brooklyn and still had a charming accent, but she did not have the voice of a great stage actress, which audiences imagined she would have. Bow, the first American sex symbol who had "it," was brilliantly mocked by Jean Hagen as Lina Lamont in *Singin' in the Rain*, and it is assumed that her career ended because of her voice.

Other people were devastated by what the microphone did to them. A lot of this had to be attributed to nerves. Having to face a microphone in a huge empty sound stage, an actor realized that when he left it might be his last visit. If word

got out, the silent star's chances of becoming an enduring Hollywood star would fade as quickly as a comet hitting the face of the earth. Nerves had to play a lot into someone suddenly having a high pitched voice or not being able to shed the accent they grew up with.

There are many cases where stars like Louise Rainer, who received two Oscars back-to-back for *The Great Ziegfeld* and for *The Good Earth,* had a very thick Austrian accent. In these two films she was able to either disguise her voice or to use it to a great effect. Ultimately, her popularity faded. Emil Jennings had a thick German accent that he never felt was necessary to try to Americanize and quickly returned to Germany after winning the first Academy Award for Best Actor, the same year sound came in.

Other people were able to make the transition. Another barrier that kept some silent actors from being able to make the transition into talkies was the very ability to memorize lines and to deal with very specific blocking. The new stars that were coming to Hollywood were actors that came from the theatre. Many more just got into the movies because of their background in vaudeville, or they happened to be at the right place at the right time. The movies in the silent era were very loosely hung together. Scripts were usually only paragraphs describing the action, and it was up to the directors and quite often the stars to figure out all the setups and what the action was going to be for that particular day.

When sound came in, actors had to learn their lines precisely. The screenplay, probably in the only time in its entire history, was a bible. The actors had to say the lines, which had been approved by the producer. Some of the greatest writers of the day were coming in to write dialog. This was something that very quickly changed within a few years. Actors had to give lines sometimes sitting down or standing in awkward positions so they would be facing the directional microphone. Many of the silent actors did not understand this process. The idea of going home at night to sit down with a script to go over lines or to rehearse lines with an acting coach or a fellow actor to be prepared for the next day was completely foreign up until this point.

Actors had to work in a very complicated fashion where the sound was omnipotent and the stage directors demanded very precise movement. In the past actors had great freedom to walk or suddenly light a cigarette. Silent actors had directors not unlike the stereotypes with a

Steamboat Willie (1928) introduced audiences to Mickey Mouse and started Walt Disney on the road to movie immortality. From this 8-minute cartoon to the Technicolor **Snow White and the Seven Dwarfs** (1937) represents the most remarkable period in the evolution of animation.

megaphone shouting to turn on the tears or to laugh with a brave heart or to turn away in repulsion at the man who was making advances toward you.

Suddenly, if an actor forgot lines one hundred people would let out a collective sigh, and the actor would be embarrassed and have to repeat the scene over and over again. If something happened with the lights or on a set, everything would have to stop. Any kind of noise, like someone accidentally knocking over a cup of coffee, suddenly became a high calamity on the set. Many of the silent stars just did not adjust to this.

Words also destroyed the most vivacious of all the silent genres, the silent comedies. Everything had to be based on the craziness of dialog, which is why the Marx Brothers, when they appeared with *Coconuts* and *Horsefeathers* were perfect for this transition. They still had the slapstick comedy routines and Harpo as a silent character, but they also had all the funny witticisms.

The same thing was true with Mae West and W. C. Fields. They knew how to use words to get a laugh, but most of the old comics from the silent days, like Harry Langdon, tried with a valiant effort to make the transition but never did. Harold Lloyd made a few talkies but was quickly forgot-

ten. A few like Laurel and Hardy still maintained their popularity, establishing catch phrases like, "This is another fine mess you've gotten us into." But even their films were still silent comedies with an occasional close-up of Ollie's berating of the poor sad-faced Laurel.

The silent movie stars were always shot, as most scenes are even today, at a slight up-angle, elevating them into kind of screen gods. Their ability to hold the audience was indeed almost divine, projecting every emotion. Those that were great in close-ups, like Lillian Gish and Charlie Chaplin, are the ones that have continued to be watched over and over again.

The sound pictures allowed for audiences to see people as they really were. On Broadway and in literature it was a time of the common man or woman that writers were beginning to understand better. It was a time when people in America spoke with so many different accents that it was only proper for this to be displayed on the screen.

The actors that survived quite often were the ones that had a unique style to them and had the ability to put across a performance that no matter what the material was like, they could transform it into something that was uniquely

My Little Chickadee (1940) with Mae West and W. C. Fields represents the end of an era. This was West's last major film; once the most popular star at Paramount, her career was now in decline because of the tough dialogue restrictions of the Production Code. Fields would only make two more movies before he retired. Both comedians were rediscovered by young audiences during the 1960s when their films became hits at the revival theatres.

their own. This is what producers were searching for. An actor could go in front of the camera, and perhaps be the greatest actor of his generation, but if the camera did not like him then, no matter what kind of effort he gave to his performance, the audience did not relate to him. Someone else could be in the background of a scene and all eyes would immediately go to that person. It is a phenomenon that if there were a way to bottle it, would sell unlike any elixir on the face of the earth.

The number of actors who were brought in and put under contract was staggering in the early days. But by 1929, when the Depression hit, going Hollywood was a very different thing. The theater still survived but it was a tough life and only a few shows managed to run more than a hundred performances. Even the best of actors in the New York theatre, like Paul Muni and eventually Spencer Tracy, had to consider being unemployed for half of the year as opposed to being employed full-time in the movies. Suddenly the long trip was not such a bad deal after all.

In the early years, before some of the unions came in, like the Screen Actors Guild, actors would end up working sometimes 14-to-16 hour days. By the time a star got home, showered, and ate, there were only a few precious hours of sleep. In the contract was the stipulation that if an actor was not doing well in the public box office they could be dropped at a moment's notice and their seven years' security would disappear immediately. An actor was happy with a contract that gave them ten times the money they were making in New York. But if the movie was a big hit, literally bringing in hundreds of thousands of dollars to the studio, the actor was stuck with that same salary line no matter how popular his or her movies became. Many actors rebelled and refused to work, like Bette Davis and James Cagney. But it was a very hard contract to break. And if the actors did protest the contract they would be sued and could not take on any other work until the lawsuit was resolved.

Looking back, the stars were treated well if they behaved, but they were working hard, with some stars making fifty or sixty movies, sometimes throughout a career of forty years or longer. Actors were being treated as a commodity, but they also had things written especially for them and had the most gifted cinematographers immortalize them with light. But a star had to be a star all the time. Some of the contracts, especially with the female stars, specified they could not even take their garbage out in the morning unless they were dressed like they were going to a premiere. Stars had to look at all times like movie stars.

What resulted from this rush to Broadway to find talking actors was a sense of American colloquialism. The concept anybody could make it big was a theme dear to the people's hearts during the Great Depression. Audiences enjoyed the kind of folk logic that if someone could endure a little bit longer they could hit the jackpot. This was evident in almost every kind of movie made after the Depression. In the dark theatres, audiences could be part of high society and live among fun people like Fred Astaire and Ginger Rogers. Or they could go to the Dark Continent of Africa and to come out wealthy. All of these messages were being sent by the movies. All of these ideas were things that the public fell for.

Feature-length movies were only a little over fifteen years old and each year were becoming more sophisticated. The sound was better. Movies were getting back into having more action on the screen, a practice that had disappeared for a while because of the problems with sound. And the ability to deceive the eye with matte shots, special effects, rear projection, second unit photography, and other visual tricks lead audiences to believe that whatever they saw on the screen was real. Today audiences have

become too knowledgeable in understanding filmmaking, and these effects might seem dated. It is the movies in this era that deal with human behavior, and stories that chronicle the moods of the time that have lasted.

BUSBY BERKELEY SAVES THE MUSICAL

Within three years after Al Jolson sang and opened the floodgates for sound, it appeared as if the Hollywood musical had run its course. Attendance began to drop rapidly, which scared the studios because this was one of the surefire moneymakers that they relied upon. The Great Depression had hit hard in 1929, and ticket sales fell dramatically. People were either homeless or afraid to spend even a dime to see their favorite star when they could buy milk and bread instead. But the movies had lost the excitement of the silent era. This was especially true with the musical that had become prisoner to the microphone. Musicals became elaborate stage productions with no imaginative editing. Just when the musicals looked like a short lived fad, Samuel Goldwyn brought in Broadway choreographer Busby Berkeley to do the musical numbers for Eddie Cantor's *Whoopee!,* which was done in the two strip Technicolor process.

Warner Bros. liked what they saw and recruited Berkeley to do the musical sequences of *42nd Street* (1933), directed by Lloyd Bacon and starring a young tap dancer, Ruby Keeler, who was the wife of Al Jolson. It also featured a young Ginger Rogers, who the following year would go over to RKO and team up with a slightly balding dance partner named Fred Astaire. With Berkeley's highly original staged and photographed choreography, *42nd Street* changed the concept of what a musical was and in fact opened up the possibilities for what movies could do. In the same year, *King Kong* took the old fashioned form of stop-motion animation and brought a doll-sized furry gorilla to life that seemed as frightening and as real as anything possibly could be. Movies were beginning to come alive with excitement again.

42nd Street concludes with the title song by composer Harry Warren, which turns into an almost twenty-minute long dance number where the camera becomes the star attraction. Berkeley

*Gold Diggers of 1933 quickly followed the highly successful **42nd Street,** both featuring musical numbers choreographed by Busby Berkeley, are credited with restoring public interest in the musical. After sound came in the camera became locked down with very little movement and audiences soon became bored of this static look. Berkeley freed up the camera by synchronizing the music with the action in post-production, allowing him to do kaleido-scope effects with "a hundred beautiful dames."*

puts the camera on a crane and pans down the crowed street, looking into windows, catching the human drama with all manner of humanity, with voyeuristic glimpses of violence and murder. The number ends with the dancers flipping over large parts of a puzzle, like the card section in football games, that ultimately turn into the Empire State Building with Dick Powell and Ruby Keeler at the top.

42nd Street is what was known as a "backstage musical" since it centers around the story of a Broadway production that was perpetually in financial troubles. But when everything seems lost, a fresh-faced member of the chorus line goes out on opening night and saves the show, making it a huge popular hit. Warner Bros. was the only studio that did not pull away from the daily events of the Depression outside the theatre doors. These musicals were an ideal match for the times, when people were living with the dream of a lucky break that could bring some good fortune into their lives. In *42nd Street*, Warner Baxter, who plays the producer of the seemingly ill-fated show, gives his heartfelt pep talk to big-eyed Ruby Keeler, and she goes on stage and saves the night with her flatfooted dance style.

The real star was Busby Berkeley, in the way he used the camera. Berkeley had no background in how movies were put together, which was probably in his favor since he did not know the rules; thus he did not know what he should not be doing. The first thing he did was to have all the musical numbers dubbed in afterwards, so he basically was shooting a silent film. He would yell out orders, with a small orchestra playing, as rows of dancers tapped in unison. The shooting lasted as long as sixteen hours a day. The final musical number was edited together then underscored with a full orchestra, giving audiences the impression that it all had taken place on a Broadway stage, doing things that no stage could possibility accommodate.

Even more spectacular were the two other movies Berkeley made that same year, in particular one that came under heavy fire from the Hayes Office called *Gold Diggers of 1933*. This movie had the famous musical ode to posterity, "We're in the Money," featuring Ginger Rogers and a chorus of scantily dressed girls with large coins covering key parts of their anatomy. *Gold Diggers of 1933* was a huge hit and started a series of Gold Digger musicals for Warner Bros., which were copied by MGM as the Broadway Melody musicals.

Busby Berkeley's trademark became large production numbers with scantily dressed dancers. In "Pettin' in the Park" from **Gold Diggers of 1933,** he teased audiences by showing what appeared to be nude silhouettes of women. This sequence immediately came under fire from the Church and the Hays Office and became one of the primary examples of why the Production Code needed to be strictly enforced.

Broadway Melody (1929) was actually the first backstage musical, going on to winning for MGM the Academy Award for Best Picture, but the dance routines were stilted because of the sound problems, completely lacking the spectacular camerawork that Berkeley brought to this concept. All the later Broadway Melody musicals reflected Berkeley's influence, and eventually MGM bought him over to work with the teenage team of Mickey Rooney and Judy Garland.

Gold Diggers of 1933 was even more visually inventive than *42nd Street,* with musical numbers that even today are astonishing to watch. A hundred or more women, shot from overhead in the giant sound stage, create the kaleidoscope effects that are Berkeley's trademark. One number in particular, "Petting in the Park," caused an uproar with religious organizations because of what the title of the song implies, combined with the voyeuristic approach Berkeley took with the staging. The term "petting in the park" is slang that still means the same thing today, necking or making love in public places. It is a playful number that changes from summer to winter and back to spring. It starts with Dick Powell and Ruby Keeler singing the song, followed by a long choreographed number featuring a midget dressed as a baby who shoots beans at the back of the heads of policemen. In the final episode of the number, a spring shower makes all the ladies run for shelter to change from their wet dresses. The audience sees the women in silhouette on a screen and as they remove their garments they appear to be completely naked. At this moment, the midget, now dressed as a young toddler, pulls the draw cord for the screen, leaving the audience to believe they are about to see something very risqué. But the women turn out to have undergarments, which, for the lack of a better term, are sheet metal chastity belts.

Another number is "The Shadow Waltz" that features a large chorus of young ladies wearing sheer evening dresses, with plunging backs all the way down to their tailbones, all playing the violins. When the lights go out the audience discovers the violins and bows are outlined in neon. To achieve this dazzling effect, the women had to wear battery packs in uncomfortable places to power the neon. Much of the wiring had minimal insulation, causing shocks every time the neon was switched on. This was just before the Screen Actors Guild came in with working regulations, and Berkeley took full advantage of rehearsing the dancers until they literally dropped. So the fear of being electrocuted or having pinches of electricity going through a dancer's sweaty body was nothing compared to the idea of having to repeat the number over again. "Shadow Waltz" had over fifty women all doing the same movement or counterpoint in perfect synchronization with the studio orchestra. One tiny mistake drew the eye, and the entire scene had to be redone.

The final number of *Gold Diggers of 1933* is a courageous bit of homage to the veterans of the First World War. The number sung by Joan Blondell is "Remember My Forgotten Man," and musically dramatizes the hardships these veterans, many of them with medals of honor, had to endure when the Depression hit and the pension fund was wiped out. With treadmills and a series of dissolves, Berkeley shows the young soldiers marching proudly off the war, then marching in the rain carrying the wounded, then lined up in bread lines with their heroism and sacrifice forgotten. In the final sequence, marching soldiers are silhouetted on art nouveau bridges, and then they flood out onto the stage toward the audience. It is a moving moment, showing what was happening outside the walls of the theatres in the midst of the Great Depression.

The other movie that Berkeley choreographed that year was *Footlight Parade*, starring Warner Bros.' newest star, James Cagney, who

had just shocked the world in *Public Enemy.* As was very typical during the Studio System, writers would come in for specialty work on a script. The same was true for directors. Berkeley later directed films like *Babes in Arms* and *Take Me Out to the Ball Game,* but mostly he came in for the specialty numbers. With these sequences he had complete control over camera placement.

In the musical number called "By the Waterfall" sung by Dick Powell, women dressed in bath attire that left little to the imagination, slipped down shimmering slides or leaped off waterfalls into the lagoon below. One shot has Ruby Keeler swimming through the bare legs of dozens of shapely bathing beauties. Berkeley's ingenious use of the camera and his surrealistic choreographed dance routines were rediscovered in the 1960s and were considered highly psychedelic by the hippie generation. But in 1933, the Hays Office and religious organizations were unimpressed with Berkeley's mind bending visions. They only saw the suggestion of nudity

and the encouragement of easy virtue. They were displeased with what they saw on the screen, and the following year when Joseph Breen enforced the Production Code, Busby Berkeley's musical numbers were cited as good examples of how immortal Hollywood was becoming. But even when the Code was firmly in place, Berkeley continued to slip obviously sexually suggestive images past the eyes of the Hays Office. In *The Gang's All Here* (1943), Carmen Miranda sings "The Lady in the Tutti-Frutti Hat" with a chorus of women holding giant bananas.

THE DECLINE OF EUROPEAN CINEMA

This was a time of "what ifs" in the Hollywood parade. If the Production Code had not come in even for a couple more years, or the studios had been able to work an agreement around the code that gave more flexibility

In Germany the depiction of complex sexual relationships heavily influenced American filmmakers during the Pre-Production Code Era. **Pandora's Box** *(1929) directed by Georg Wihelm Pabst is an uncompromising study of a woman who ruins the lives of every man that becomes involved with her. The film stars American actress Louise Brooks who became one of the most famous icons of the Jazz Era because of the success of* **Pandora's Box** *but drifted in almost complete obscurity when she returned to Hollywood.*

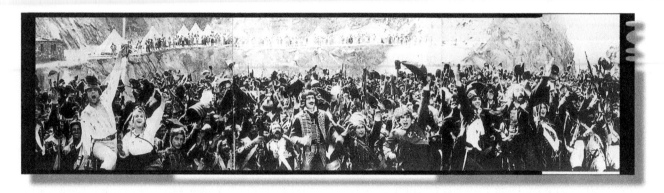

Napoleon (1927) directed by Abel Gance was an epic film decades ahead of its time. Gance used a three-camera technique called Polyvision (approximate aspect ratio of 4.00:1) that preceded Cinemascope and Cinerama. Hailed as a masterpiece in Europe, **Napoleon** had the misfortune of being released in American when sound arrived. Gance's film was drastically cut and might never have been seen again if it had not been for the untiring efforts of historian Kevin Brownlow who put together the first of several restored prints in 1981.

in the kinds of motion pictures that were being released in this era, there would undoubtedly be a different kind of movie today, especially regarding women's themes. This gives the impression that if they had gone "unchecked" for several more years it could have resulted in the same kind of renaissance that happened in the late 1960s when film was no longer under the pressure of the Production Code.

By 1933, very few films were coming out of Europe. The economy had gotten so bad that the few filmmakers that had survived journeyed to America. The political changes pointed to the coming of the Nazi party, which meant violence to the Jews in Germany. Besides, the money that could be made in Hollywood, as opposed to staying in Europe making movies that were constantly having their budgets cut, was certainly more appealing. The only major European director that would remain through the 1930s was Alfred Hitchcock, who used his movies as a calling card to set up a contract that he felt would be proitable for his entrance into Hollywood. Hitchcock's spy thrillers, which created a new genre, like *The 39 Steps* (1935) and *The Lady Vanishes* (1938) had been big hits with American audiences.

By September of 1933, the Third Reich had placed the German cinema under the control of the Nazis. At the head of this was the Minister of Propaganda, Dr. Joseph Goebbels, who, like Hitler, was a film enthusiast. Both men realized that the power of the cinema was something that could enhance the presence of a great authority figure that Hitler wished to present to his country. The Nazis wanted motion pictures that showed how they were the right cause trying to help the common people, but the Jews were depicted quite often as rats scurrying through the streets. There was very little doubt as to what was about to happen, but no one could imagine to what extent. Goebbels approached Fritz Lang, saying that he respected his movies, especially *Siegfried* and *Metropolis*. He asked Lang to become the new head of the German film industry. Lang politely requested to think about it overnight, and replied that he was appreciative of the honor presented to him, realizing he could not keep secret from the Nazis the fact that he

was half-Jewish. He and his wife caught a train for Paris that night, leaving behind almost all of their precious household goods and a wealth of paintings to escape to America.

The studio moguls were very supportive of the German filmmakers. They had brought a high quality of art to the cinema, and were welcome in Hollywood. For the most part they were given very respectful projects to do, but never to the grand scale achieved at the end of the silent era and height of the Expressionism movement. When Lang came over, the glory of the German cinema died.

THE DIRECTORS: THE START OF THE AUTEUR THEORY

Many of the directors who worked in silent motion pictures continued all the way through the late 1950s and 60s. At this juncture French critics of the New Wave began to look at the older movies and realized many of these movies had certain trademarks that were indelibly part of the director's personality and style. This began the Auteur Theory that declared the director was the author of the film, and that there was no individual that had greater control over the movies. Many of the directors praised by the New Wave leaders began during the changeover to sound, but learned their craft in the silent era, like William Wellman, Howard Hawks, John Ford, Lewis Milestone, and Alfred Hitchcock.

The debate over who is truly responsible for a motion picture is a precarious intellectual trap to get into. All through the Studio System and even today, a strong producer puts a mark on a film. So does the cinematographer, scenic designer, costume designer, screenwriter, and the star. During the Studio System the producer would get the material or hire the writers, approve the look of the sets, green light the cinematographer, approve the cast, and make changes in the scripts *before* the director started. The director quite often came in sometimes only a few days or a few weeks before production started, and he had to use the screenplay as a bible.

There are many stories where the screenplay was not quite finished and written along the way, or changes were made on the sets. *Casablanca* is the most famous example of this.

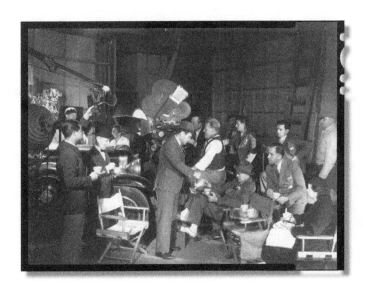

John Ford holds court on the set of **The Whole Town's Talking** (1935) as star Edward G. Robinson pours coffee.

And by the 60s this began to happen more. But most of the motion pictures that went into production had a good script worked out and it was the doing of the director to follow it. A lot of the scripts were skillfully put together by an assembly line of writers, each with a certain specialty in storytelling or character, that by the time it got to the director there was not a whole lot that could be improved on. Besides, the major studios had to turn out an A-feature movie a month, so there was no time to bring in other writers to play with scenes the star did not like. The vast majority of the scripts were melodramas, which was the most popular format with Hollywood audiences. The scripts, as they still do today, had well defined plot transitions and character types that were part of the highly structured formula. And during the 1930s most of the films had happy endings.

Most directors were studio men who did terrific work but it would be very hard to tell who did what movie. Most of Victor Fleming's work does not look that much different from W. S. Van Dyke's. Both did classics like *The Thin Man* and *The Wizard of Oz,* but these movies are more products of MGM studios than individual directing styles. The directors that put a personal mark on movies, despite the material they got, or fought for certain material, are the ones that qualify as true auteurs. Many of these directors had a great deal of freedom in what they did or wanted to develop, which often depended on the politics that they were willing to play with the moguls of the various studios.

The distinguishing traits of directors vary, and it is not always based on how they use the camera, which became the identifying factor of many directors starting in the 1960s. Some directors were more inventive in their styles, like Hitchcock with his psychological suspense films. Others used an ensemble of actors associated with a certain genre, like Ford with his Westerns. It is a misconception to say that because a director does not have the same techniques as Alfred Hitchcock, they are not part of the Auteur Theory. Hitchcock is the exception, since he developed his trademark style with complete freedom in England, and he did not have to work within the confines of the Studio System. After many successes with his mystery genre movies, Alfred Hitchcock, because of his distinctive style, was invited to work in America by David O. Selznick,

*With **Greed** (1924) Erich von Stroheim attempted to bring the entire novel **McTeague** by Frank Norris to the screen in an eight hour version. Believing that audiences would not sit through such a lengthy film, **Greed** was radically cut to just over two hours by Irving Thalberg at MGM. It would take television programs like Masterpiece Theatre to eventually bring expanded literary works to the masses.*

one of the notable maverick producers. Directors like Ford and Hawks worked within the system but still put their mark on movies with how they directed actors, the themes of their movies, and how they framed a shot. Ford would say that his camera was like a phone booth that people came to, implying with his Irish wit that he used a lot of master shots. But his eye for locations, like Monument Valley, are so striking, audiences could immediately tell this was "Ford's country."

Studio directors were expected to get *full coverage,* which was standard procedure so the producer had options to edit the film after production. Full coverage is when the director starts with the master shot, which is a full shot very much like watching a stage presentation with the actors. Then goes in for closer coverage, allowing for adjustments to the lighting. Every time the camera is moved there is a delay as the cinematographer makes slight changes and readjusts the focal lengths. The director then does medium shots, or two-shots of the actors, reverse angle shots over the shoulders of the actors, and finally close-ups. Then perhaps a series of inserts, which might not be with the same actors, showing a hand reaching into a jacket to pull out a gun, or a hand holding a watch to let the audience know the time. Full coverage on a simple scene with two actors might be as many as a dozen separate camera setups.

Old pros like Ford knew how to edit a movie in his mind and did not bother with full coverage. And Hitchcock planned his shots months in advance on storyboards. The close relationship and understanding between the director and the cinematographer about the visual style of each scene has always resulted in the most remarkable movies. The ability for a director to get across to the cinematographer a certain mood that he wanted really is the freedom that almost all directors have once they were able to start shooting.

Hollywood studios preferred seamless storytelling. This meant that audiences should never be conscious of the camera. Everything was shot in the third person, as if God was making the movie. Hitchcock and the German directors were the exception. With the French New Wave Movement the camera was freed up, like it had been in the silent era, and became the star. By the 1970s, directors began to overtly move the camera, using different lenses and making the camera one of the characters in the film. As cinematographer Conrad Hall observed, this kind of camera work would never have happened back in the "slick old days of the studios."

Studios would have second unit directors go all over the world and shoot locations in Africa, Europe, the Far East, or down in Mexico. These would become establishing shots or rear projection footage. A double for an actor might be seen going into a church in Mexico. Inside the church the audience was looking at a set in Hollywood with the real actor. During the Studio System, stars rarely went on location, unless it was to the back lot. The second unit would usually shoot enough footage for the studio to cut together a travelogue, which was immensely popular.

The Europeans

Fritz Lang was a director from the silent era who continued to have a long career. Arguably, Lang not only created the science fiction film with *Metropolis* (1927), he also put an indelible mark on the crime genre with *M* (1931), which introduced the world to Peter Lorre. He later became associated with film noir, which was a natural extension of Expressionism. He was a director who never achieved the same success in America as he did in Germany. This is a somewhat misleading statement, because despite the fact that *Metropolis* has endured the test of time, it was not a box office success when it came out. In

*Franz Lang can arguably be credited with the creation of two motion picture genres: science fiction with **Metropolis** and crime with **M** (1931) starring Peter Lorre. **M** is a dark suspense story of a child-murderer who is being pursued by the police and eventually the local criminals, who join in because the large manhunt is disrupting their illegal businesses.*

America, Lang never had the freedom to experiment on a large scale like he did with Siegfried and Kriemhild's Revenge, both in 1924.

When Lang came to America, like Hitchcock, he found a genre of film that became uniquely his own, and continued to find variations on the theme of mystery mixed at times with a touch of surrealism. One of his first films after relocating to Hollywood was *Fury,* a bitter tale of social injustice that helped launch Spencer Tracy's remarkable career. This is the story of a man wrongfully accused of a crime and put into prison. The townspeople turn into a lynch mob and try to burn down the prison. The man miraculously escapes, but everyone believes he burnt to death in the inferno. The man reappears to his family, but is now obsessed with seeking revenge on the people that tried to hang him. He wants them put on trial for his murder, despite the fact he is still alive. This is an ideal theme for Lang, especially after fleeing the Nazis, where an innocent man

is turned into a heartless murderer because of the injustice that befell him. It is a warning that even in a democratic society terrible things can happen if a few people misuse the justice system.

The most successful of the directors who came over from Germany was Ernst Lubitsch, who made a series of delightfully flirtatious sex farces. His motion pictures often had a bit of nostalgia for the Europe prior to the Great War. Lubitsch began his career as a popular comic actor in Max Reinhardt's Deutches Theatre. He made inventive comic shorts while still in his teens, then turned to large costume dramas like *Madame Dubarry* (1927). Lubitsch was on the same lot as many of the directors of the Expressionist movement, but his films never reflect this visual style. Instead he poked fun at contemporary mores. He was the first of the German directors to leave for Hollywood, probably because his films were playful, funny, and made money at the box office. In *Love Parade* (1929) and again

in *The Merry Widow* (1934) he teamed up Maurice Chevalier and Jeanette MacDonald in two whimsical musicals that are the height of high society elegance and humor, each one a perfect gem of that illusive thing called comic timing.

This was famously known as "the Lubitsch touch" and indeed there was something special about his movies that makes them quite unique from any other comedies made. Billy Wilder, who was mentored by Lubitsch and a close lifelong friend, said the best way to define "the touch" was a series of jokes building on each other. The first one funny, the second one being a little funnier, and third, as they said in vaudeville, was the topper. However, it was more than this; the humor worked because of the wonderful performances he got out of his actors. And actors loved working with Lubitsch, who gave the impression of being a large, cigar smoking teddy bear. Things done in threes is something that appears in comedy a lot, and it also can happen in drama with the reverse affect on an audience. Three things can go terribly wrong for a character, and the audience feels sympathy. In comedy, in its most simple definition, the first joke (or sight gag) puts the audience in the mood, the second is funny but now the audience begins to anticipate something else, so the third joke gets the biggest laugh. The only hard trick to this is to have extraordinarily clever dialogue, and Lubitsch's movies were unmatched in this area because of writers like Samson Raphaelson, Charles Brackett, and Billy Wilder.

The Little Shop around the Corner (1940) with James Stewart and Margaret Sullivan was later remade into *You've Got Mail* starring Tom Hanks and Meg Ryan. *The Little Shop around the Corner* is a charming example of a Lubitsch comedy, which often has a touch of the bygone innocence of Europe before the Great War. Two people who work in Matuschek's gift shop have a natural dislike for each other professionally, but at the same time each is carrying on a romantic correspondence with individuals they have never met, only to discover they are writing to each other. The owner of the shop is played to heartbreaking perfection by Frank Morgan, who the year before was the slightly befuddled wizard in *The Wizard of Oz*.

Lubitsch's comedies sometimes tackled political themes that were considered a little dangerous at the time. Like Mel Brooks, who was one of his greatest admirers, Lubitsch felt that if audiences could laugh at an individual or political ideology it would reduce the subject to the commonplace and begin the process of eliminating people's fears and phobias. Tough medicine for comedy but he twice made it work brilliantly. The posters and previews declared that "Garbo laughs" in *Ninotcha* (1939), and Lubitsch was the director behind this reinventing of MGM's biggest dramatic star. The subject was nothing less than Communism. Garbo plays Ninotcha, a no nonsense officer in the Red Army sent to Paris to find out why three male members of the People's Party had gone AWOL, only to discover that she was vulnerable to romance in the capitalistic Parisian night life.

Libitsch came under criticism when he made a parody of Hitler in *To Be or Not To Be* (1942), which Brooks remade forty years later. This would be the last movie that Carole Lombard, the reining queen of screwball comedies, would finish before her tragic death in an airplane accident while returning home from selling war bonds. Her finely tuned comic timing as the wife of a ham actor, played by Jack Benny, is a testament to how Libitsch brought out the best in actors, and sadly suggests what might have been if she had lived longer. *To Be or Not To Be* is remarkable in how it manages to debase the character of Hitler and all the trappings of Nazism, while maintaining a fine balance of backstage humor mixed with moments of Hitchcockian

suspense. Having to abandon his home country of Germany, Libitsch must have taken great satisfaction in reducing the little dictator to the tail end of a joke.

Josef von Sternberg made seven memorable motion pictures with Marlene Dietrich, starting with *The Blue Angel* (1930). He spent much of his career turning Dietrich into a screen goddess in impeccably photographed movies like *Morocco* (1930) and *The Starlet Empress* (1934). Von Sternberg's early motion pictures met with mixed success in America. *Underworld* (1927) foreshadows film noir and was one of the first of the gangster genre. It was made the year sound arrived, and written by the legendary Ben Hecht, who won the Academy Award that year. *The Last Command* (1928) is the moving story of an officer in the Czar's army who ends up as a Hollywood extra recreating a moment of his past personal glory. Emil Janning's performance is near perfection, winning him the first Academy Award for Best Actor, along with his performance for *The Way of All Flesh* (the first year of the Academy Awards leading actors received nominations for multiple roles).

Von Sternberg returned to Germany, unlike many of his fellow directors who, once they left they never returned, and shot what is considered his masterpiece, *The Blue Angel,* which introduced Dietrich to the world. The movie stars Jannings, who also returned to Germany when sound came in, realizing that his career in Hollywood would soon be over or reduced to character parts. The story is about a strict disciplinarian professor who visits a smoke-filled cabaret starring Lola Lola, played by Dietrich with the seductiveness of a purring cat, who enchants the professor when she sings *Falling in Love Again.* (This would become her signature song for the next fifty years.) His fall from grace is pure melodrama, with him ending up the clown in the cabaret. He then returns early one morning to his classroom to commit suicide. However, what von Sternberg was able to get out of his performers was incredible, truthful performances that transcended the predicable story lines and turned them into modern tragedies.

Von Sternberg was considered one of the most difficult directors to have ever worked in Hollywood, but the quality of his movies made his Prussian approach to directing worth the experience. Some of his later motion pictures might never have been made had it not been for the star stature of Marlene Dietrich, who after she

The Blue Angel (1930) directed by Josef von Sternberg is one of the first German films to be made with sound and the last masterpiece of the Golden Age of German cinema. Marlene Dietrich as Lola Lola sang "Falling in Love Again" establishing an endearing image of the smoky cabaret life. Dietrich and von Sternberg would make seven films together, including **Morocco** *and* **The Scarlet Empress.**

stopped making films with him stayed loyal to her mentor. Von Sternberg was interested in the psychology of his characters, which is one of the reasons his movies were rediscovered in the 60s by the New Hollywood directors. His intricate look at power struggles in the aristocratic domain reveals dark conclusions about human nature.

A perfectionist to the point of fanaticism, von Sternberg worked with the great cinematographer Bert Glennon. He would spend hours lighting the set and then Dietrich, always allowing her a few more foot candles so she seemed to pop out of the darkness, where the other actors were more muted into the surroundings. Von Sternberg discovered that a high key light would soften the features on Dietrich's face, something she insisted on for the rest of her career.

Many shots in von Sternberg's films could be stopped, a frame clipped out, blown up, and printed to make an incredible photograph. His patience and sometimes insistence to a maddening degree created some of the most perfectly composed movies with regard to lighting and scenery that had ever been done in the cinema. He was never able to match the successes of *The Blue Angel* and *Morocco,* and his career never re-

covered from the unfinished and highly controversial *I, Claudius* (1937) which starred a highly temperamental Charles Laughton. Only clips from that ill-fated production remain. Though Dietrich would go on to a career with many other directors, she always credited von Sternberg with teaching her just about everything that she knew as a performer in front of the camera. She obviously learned it extremely well.

One of the early tragedies in motion pictures is the death of F. W. Murnau. He had completed *Sunrise* (1927), a masterpiece of visual storytelling made the same year sound took over the movie industry. He had worked with and ultimately took over the production of *Tabu* from Robert Flannery who was the first great documentary filmmaker. Murnau was killed in a car accident on the Santa Barbara Highway, scarcely a week before the opening of the movie.

Probably out of all of the directors who died young in Hollywood, he is one of the greatest what-ifs, because no director was as esteemed and liked and studied as Murnau was during this time. He was just forty-four years old. Hitchcock credits him with influencing his directing style for his extraordinary use of the camera and his

Sunset (1927) directed by F. W. Murnau is an example of how fluid the visual storytelling had become in silent films, ironically released the same year as sound arrived. Murnau believed in the "unchained camera" as seen in **The Last Laugh** (1924), which young Alfred Hitchcock was able to observe during the filming. One of the most influential and admired directors of the silent era, he was tragically killed in a car accident in 1931 at the age of forty-three.

ability to make an entire film without the use of title cards. Murnau's motion pictures during the Expressionism Movement have become hallmarks of filmmaking. *Nosferatu* (1922) brought the legend of Dracula to life and horrified audiences around the world, leaving a lasting mark on the genre. *The Last Laugh* (1924) experimented with almost every possible use for a camera; it was a film that in many ways was forty years before its time.

If his ability to excite and guide directors like Hitchcock is any indication, then the movies that Muranu never had the chance to make represent a profound loss to the evolution of motion pictures. For example, if Hitchcock had died suddenly at the same age as Murnau, then he would not have made *Spellbound, Notorious, Strangers on the Train, Rear Window, Vertigo, North by Northwest,* or *Psycho.* To use a modern comparison, if Steven Spielberg had somehow perished at the same age as Murnau, audiences would

have never seen *Jurassic Park, Schindler's List,* or *Saving Private Ryan.*

In England, Alfred Hitchcock was beginning to experiment with what would become his trademark suspense film. Hitchcock says that as a young man he never intended to be a director. He was happy as an art director, drawing the title cards for dialogue sequences in silent movies. Fortunately for generations of moviegoers, he was sent to Germany to study. The British film industry was extremely poor at this time and arranged for promising talent to have apprenticeships with German filmmakers. Hitchcock was able to observe first-hand the man he later referred to as the master, F. W. Murnau, who was directing *The Last Laugh.* The influence of Murnau's montage techniques to tell a story purely in visual language, combined with the freedom of his camera movement, unquestionably galvanized Hitchcock's sense of what motion pictures could achieve. In addition, Hitchcock was in Berlin during the

*Alfred Hitchcock had learned the art of filmmaking in Germany during the height of the Expressionist movement. His early success like **The Lodger** (1927) and **Blackmail** (1929), the first British sound movie, reflects the dark, shadowy atmosphere found in films by F. W. Murnau and Fritz Lang.*

wickedly notorious cabaret period and the height of the Expressionism movement. Hitchcock became the direct descendant of German Expressionism and used what he learned during this brief period in his life in all of his future films.

The great moments in Hitchcock's motion pictures are scenes done in montage, purely visual story telling with very little dialog, and underscored with music and sound effects. As is the story with the careers of many directors, Hitchcock was asked to take over a production that had fallen behind schedule. His first movies proved to be box office disappointments, and his future as a director was in jeopardy. But these earlier silent movies did not provide stories that allowed Hitchcock to exhibit what he had learned in Germany. Then he found the ideal property that had all the elements of suspense and would ultimately launch his career.

The Lodger (1927) was made in England but in every respect looks like it was shot in Berlin. It is an prime example of the Expressionist influence, where the night and shadows visually define the suspicion and psychology of the characters. The story is about a man who shows up mysteriously on a foggy night seeking lodging in the area of London where the murders of Jack the Ripper were taking place. The question is, is he or is he not the infamous Ripper the police are searching for? Young Hitchcock knew instinctually how to play with the audience's emotions and fears. There are moments in *The Lodger* which are classic examples of Hitchcock's singular visual style. He had an entire ceiling made out of glass so the camera could shoot upwards through the ceiling past the chandelier. The audience, through the point-of-view of the terrified guests downstairs, see the character suspected of being Jack the Ripper nervously pacing back and forth in his room. Hitchcock makes his cameo appearance at the end of the movie as a member of the mob gazing down at the innocent man

hanging by handcuffs to a picket metal fence in the form of a crucifixion. This would become one of his favorite themes in his movies, a man wrongfully accused of murder who must run from the authorities in an effort to find evidence to prove he did not commit the crime.

There is a strong influence of Hitchcock's strict Catholic upbringing in the imagery and themes of his films, often creating a psychological descent into hell for his characters. He was especially attracted to the story concept that a good person could fall into the clutches of evil in the blink of an eye. *Blackmail* (1929) was the first talking motion picture made in England and is the simple tale of a seemingly nice woman who makes the mistake of going up to the apartment of an artist. A playful scene suddenly turns dangerous as he tries to seduce her. In order to protect herself, the woman grabs a kitchen knife and stabs the man. Horrified that no one will believe her story, she flees the apartment, but the deadly act is with her every second.

There is a scene at a breakfast table where Hitchcock demonstrates an ingenious talent for sound effects editing. The word "knife" is said, then repeated like an echo in the mind of the women until she recoils from the bread knife she has been using. In a typical Hitchcock plot twist, she has been dating a detective from Scotland Yard, who is assigned to the case. For most of *Blackmail* the camera is locked down because of the restrictions of early sound recording, but in a memorable sequence there is a chase in the British Museum that foreshadows similar moments in *The 39 Steps, Saboteur,* and *North by Northwest.*

The films Hitchcock made in England were enormously popular, but he became increasingly frustrated because the cameras and quality of filmstock were not equal to those being used in America at that same time or even in Germany. It was Hitchcock's ambition to eventually be able to use better toys in making his films. At

this particular point when he found the genre of film that he was most comfortable in he began to literally create a genre that would be known as a Hitchcock movie. He was cautious. He had enjoyed a great amount of freedom as a director, which he knew was not the case in the American studios so he wanted to place himself, which he eventually did, in a position of being so powerful a director that he would be invited over and still be able to literally call his own shots.

Hitchcock is the first of these directors that really began to have an immense influence. Because he was making films from the late 1920s all the way up to the mid 1960s, his influence even in his earlier films seemed to be a guiding light for many directors that followed. He was one of the first who really began to bring the public's attention to the technical aspects of movies, especially the camera movement. He would always talk to his actors and say "you must always do what I tell you, and you must always let me move the camera the way that I want to." Indeed it must have been difficult for some of the actors to realize that on occasions only their feet or their hands might be photographed in a dramatic scene, but no actor ever questioned that Hitchcock knew his stuff and knew where to place the camera for greatest effect.

American Directors

Incredibly, many of the directors that began their careers with silent pictures or during the Pre-Code Era continued to make movies for another thirty or forty years, many of them shooting more than sixty features. These directors had the unique ability to evolve with the time and create classics with almost every transition that Hollywood went through over the decades. Many of them felt at home with particular genres, but all of them learned their craft by making every kind of motion picture imaginable. These men made the movies and created the visual language that all directors continue to use today. Great filmmaking is always imitated, or as the French diplomatically put it, *homage* is paid to important directors. Modern directors have borrowed from Steven Spielberg, Martin Scorsese, or Akira Kurosawa, among many others. And these directors freely borrowed from John Ford, Alfred Hitchcock, Howard Hawks, and William Wellman, who in turn had learned how to put a film together from D. W. Griffith, Charles Chaplin, Sergei Eisenstein, and all the German directors of the Expressionist Movement. Since it is a common misconception that many of these directors only worked during the days of the Studio System, they will be introduced below, but their careers will then be followed over the next major stages of film history.

Cecil B. DeMille is best known for production on an epic scale, his movies had a huge influence on the way audiences even today perceive other parts of the world and bits of history. D. W. Griffith began this look at the Biblical world with *Intolerance,* but it was Cecil B. DeMille more than any other director who created the enduring Hollywood image of Cleopatra's Ancient Egypt and the Roman Coliseum. Even today it is hard for people to not think of these elaborate sets that were built for DeMille's spectacular motion pictures, realizing they might be historically inaccurate but there is still the lingering sense this is the way they should have been.

DeMille was first and foremost one of the great showmen. In the silent era his greatest success was *King of Kings* (1927) seen by millions and giving a lasting impression of the life of Christ. He was one of the few directors that used special effects in his movies throughout his long career. *The Ten Commandments* (1923) was a remarkable experience for early audiences with the pillar of fire and the parting of the Red Sea. *The Sign of the Cross* (1932) brought the vice and den-

igration of Emperor Nero's Rome to life, with Claudette Colbert's infamous milk bath, Christians being fed to all manner of wild beasts, and orgy scenes that were promptly cut out when the Production Code was enforced. DeMille's cinematic visions of the ancient world have left an indelible imprint on every epic since.

King Vidor's war epic *The Big Parade* (1925) made for MGM holds up remarkably well today. He experimented with editing to metronomes and having the actors move to the beat of drums, creating a sense of movement that was unique from other directors. His films tended to be ahead of their time in visual storytelling. *The Crowd* (1928) is about a man that sets out to conquer the Business Empire of New York but ends up lost in the crowd. It is a movie that uses the camera to great effect with shots panning over rows of desks that seem like they stretch for forever. Vidor was a director that made courageous movies with powerful ethnic themes like *Hallelujah* (1929), one of the first sound motion pictures that features an entire Black cast. And he was a director who found ways to free up the camera, even when early sound caused most cameras to be locked down and imprisoned on sound stages.

He liked to shoot on location whenever possible, such as with the unabashed tearjerker *The Champ* (1931), about a young boy and his ex-heavyweight champ of a father who tries for one last victory in the ring.

John Ford became the most honored director of all times winning four Academy Awards, and a director that lived by the belief his character *The Man That Shot Liberty Valance* put forth, "This is the West. When the legend becomes fact, print the legend." Ford is a mythmaker. It is hard to look at some of his movies and realize they are historically inaccurate. But the bottom line purpose of his motion pictures was to create a legacy on film about America's heritage, and this he did unlike any other director. His movies were important to the American people, giving them a sense of identity in troubled times. For almost five decades he was the ultimate filmmaker in everybody's opinion. In fact, when young Orson Welles was asked whom he considered the three greatest directors, he quickly replied, "John Ford, John Ford, and John Ford."

Ford began by making silent Western shorts starring Harry Carey, and later with Hoot Gibson, Buck Jones, and Tom Mix. His silent Western epic

Stagecoach *(1939) by John Ford was shot in Monument Valley, an area he would revisit many times to make his Westerns. During the Studio Era, Ford was one of the few directors that preferred to shoot on remote locations, in part, as he said many times, to get away from the nosy, interfering producers.*

The Iron Horse (1924) was about the building of the transcontinental railroad. Like many directors, Ford was influenced by German Expressionism. His early sound films began to reflect a more relaxed and personal style, and the spoken word gave him many opportunities to show off his Irish sense of humor. Ford was always at home with action films and began to form what would become known as the John Ford Stock Company, a group of actors who would appear in his films over and over again for thirty years. By the time he made *The Informer* (1935) he had already shot eighty-four films. But with this one motion picture about betrayal and the Irish Republican Army, which won him his first Academy Award, the legend of John Ford really begins.

Howard Hawks once remarked, "A good movie is three good scenes, and no bad scenes." And for most of his career, stretching from early talkies to the mid-60s, he practiced what he said. He came to Hollywood after being a racecar driver and a pilot. His love for aviation was apparent with his first sound film, *The Dawn Patrol* (1930) and later with *Only Angels Have Wings* (1939). But it was the Howard Hughes production of *Scarface* (1932) that put him on the map as a top director. Loosely based on Al Capone, and starring Paul Muni as the ruthless, trigger-happy gangster, Hawks directed *Scarface* to show the real-life violence of the mob underworld whose exploits had been splashed across the headlines for years.

The movie was a sensation but also stirred up controversy about the effects of violence on children. The Hays Office refused to approve the film unless the ending was changed. In the original climax, Muni's character goes out shooting and dies on his own terms. The new version had Muni's character begging for mercy and trying to escape when he was gunned down by the police. Even this was not enough for the Hays Office,

and a third ending was shot where Muni's character is captured, tried, and executed. Hughes took his case to the Supreme Court and had the second ending reinstated. Still church groups and mothers attacked the film and sent hundred of letters to the studio.

The sensation that surrounded *Scarface* and the popularity of the movie secured Hawks' ability to become that rare person in early Hollywood, the director-producer. Hawks never really worked for one particular studio and developed most of his own film projects. Perhaps no director was as versatile as Hawks, who directed classics in almost every genre, from Westerns to screwball comedies to gangster films to high adventure. Hawks respected the writer, especially if they were outdoor men, and personally had a great knack for dialogue that was sexually suggestive but somehow slipped past Joseph Breen and the Production Code.

William ("Wild Bill") Wellman was a director that has never been given the credit that he fully deserves. He was a man who was as fearless as his name implies. He was an aviator in the Lafayette Escadrille, surviving a terrible crash. Wellman understood the deadly art of aerial combat that he brought to *Wings* (1927). The aerial scenes shot outside of El Paso, Texas have a feel for the terrible beauty of dogfights. Wellman claims he had assembled the third largest air force in the world at that time to make the movie. The action was shot inside the cockpits of the biplanes as they dodged each other, and it is filmmaking at its most exhilarating. These kinds of action sequences would disappear from the screen for many years after sound came in. Wellman brought a tough-guy style to all his movies like *Public Enemy* (1931), where he injected a new energy into the gangster picture, making James Cagney a star in the process.

AMERICAN MULTICULTURAL FILMS

The great thing about motion pictures is that they can last forever. The terrible thing about motion pictures is that they can last forever. Looking back at how various multicultural groups have been treated negatively in early motion pictures certainly fits into this second statement. Again, the melodrama is the format of almost every American motion picture since *The Birth of a Nation*. The plot structure demands some type of adverse character. Since early films were in black-and-white, having the "bad guy" be part of an ethnic culture made for easy visual identification for audiences. Like children's games, Hollywood played Cowboys and Indians with many variations.

Motion pictures heavily influenced people's reaction to every ethnic group in America. Ironically, everyone in America at one point was considered an ethnic group. The only true Americans are the American Indians. But through conflicts, power struggles, and plain old politics the look of America as represented in the first one hundred years of motion pictures has gone through many changes. Today *most* of the negative stereotypes have been erased. But these old movies survive as a reminder of the unpleasant effects and aftermath of simplifying an entire ethnic culture.

Through the major time periods in film history, different cultural groups will be looked at. Each group's image went through remarkable changes, going from a negative betrayal to ultimately one that is positive, with ethnic filmmakers making movies about their own heritage and people.

African-Americans

African-Americans are the cultural group that without question has been the most maligned, but also the one that has gone through the greatest changes in films. It just took a long time evolving to what is seen today on the screen. Movies almost from the beginning treated African-Americans as children that quite often had to be taught over and over again, usually in a physical way, between right and wrong. The African-American was usually depicted as being unintelligent and was put into degrading stereotypes.

The most damaging depictions were of the male African-American who was often portrayed as a *coon* character, simply there for a dim-witted comic reply or a physical sight gag, and then they would disappear for the rest of the movie. These characters were slow talking and uneducated, usually shuffling aimlessly around in search of another place to hide and sleep. Another male stereotype was the aggressive *buck* character that was physically daunting, and someone who probably had unsuitable ideas about the white women in the town. This is the character that came under great protest when *The Birth of a Nation* was released, since audiences perceived him as the most dangerous and threatening.

With female African-Americans, the *mammy* character was the most common and lasted the longest in the movies. They usually were intelligent and within limits had integrated into a white household. The male servant is the counterpart to the mammy character, but in earlier movies he is not as bright or articulate, never accepted as fully into the community. The *mammy* character is quite often shown as being an intrinsic part of the family, often taking care of the children. This is somewhat based on reality in history. They were treated more favorably, but they also were always relegated to the kitchen or answering doors or serving tables or having some type of colloquial advice presented as if it was part of a folk tale.

And there was the *mulatto* character, which prescribed by Southern law, is a woman with one

drop of black blood in her, who often appears to be white. This is an issue of primary importance to the story line of the musical *Showboat,* and would become a theme used more and more in the transition period of the African-Americans after World War II. During the Social Film Movement starting in the late 1940s, each of these characters would go through radical changes, in a form of unprecedented revisionist history. But through most of the Pre-Code Era, after *The Jazz Singer,* the most common character was the contented slave who always found an opportunity to break into a spiritual song about a better place to come.

Asian Americans

The Asian character was usually depicted as a villain in movies or as brilliant Charlie Chan, the inscrutable detective with a large family. Charlie Chan became immensely popular with audiences as someone who was wise and talked with little sayings like Confucius or fortune cookies. He had the uncanny ability to piece things together, so he was smarter than the white policemen and detectives, and could always talk his way out of danger. This would seem to be a very positive Asian character, but the great irony in his forty-some year history is that Charlie Chan was never played by an Asian actor, but always by a white actor with slanted-eye make-up.

In fact, almost all Asian characters that had leading roles in movies were played by white actors who put on makeup and talked in a slightly high pitched sing-song voice. One of the most famous examples is *The Mask of Fu Manchu* (1932) with Boris Karloff playing the evil Overlord who is determined to suppress the white race and rule with his sexually active daughter, played by Myrna Loy.

Probably one of the most interesting portrayals of the Asian in America was in D. W. Griffith's *Broken Blossoms* (1919). Griffith actually made this film after *The Birth of a Nation* to show he

The Mask of Fu Manchu (1932) starring Boris Karloff as the evil genius Dr. Fu Manchu, with Myrna Loy as the spinster daughter, is typical of this time period with non-Asian actors playing the lead roles.

was sympathetic with the hardships and misunderstandings of ethnic individuals. The character played by Richard Barthelmess was very compassionate in his feelings toward a white girl who was abused by her father, but he was also someone who was helpless in everything he tried to do to change the terrible situation. Whatever worthwhile intentions Griffith had for this motion picture were lost because of limited box office returns. More people eventually saw *The Mask of Fu Manchu* than *Broken Blossoms,* which is the major reason that stereotypes get perpetuated. Popular films reach the largest audience, which in turn reinforce negative images in people's minds.

One of the problems audiences had with Asian characters, especially during World War II, is there was no clear distinction on the screen between the Japanese and Chinese, or any other group of Asian characters. They were all put into one big melting pot. Quite often Japanese actors, when they were allowed to act in supporting roles, played Chinese characters. Asian characters would often be shown with a certain amount of realism, but there was always a theatrical style to the characters.

This has a lot to do with the way writers approach material with ethnic characters, which is similar to the way a classically trained actor would approach a character. All make-up boxes at this time, and for decades to follow, had a variety of face paint and flesh color pieces that could be glued on to change an actor from one ethnic character to another. This is what an actor did—play a diversified number of roles. Writers used words instead of make-up, and traditionally each ethnic group had a certain way of speaking that audiences recognized immediately.

Thus all Asian characters talk a certain way, because that was the way they were written. The way certain character groups were depicted was behavior learned through centuries of literature and theater. They were often referred to as stock characters, very much like the Comedia Del Arte had certain characters that were instantly identifiable to the audience. If an Asian character came out and spoke in perfect English, this would have been unrealistic to audiences. It took Asian filmmakers that gained international attention after World War II to change all this.

Native Americans

The Native American was never treated with the same disdain in early films as were the African-Americans. Because Native Americans were relegated to reservations in the middle of deserts or places where most roads ended, they were treated almost like foreigners in their own country. In the same way African-Americans were depicted as wild, painted natives in Africa, Native Americans were shown as if they lived on a separate continent. The highlight of *The Birth of a Nation* was the climactic rescue by the Ku Klux Klan. Ironically, John Ford, one of America's great directors of Westerns, was one of the horsemen in the movie. There was something invigorating about the drama of having a group of people stranded, about to be massacred, and then help arriving at the last possible moment. This is the definition of action in movies, and it has never gone away. The chase and the final showdown became the stock and trade of Westerns. After the riots from *The Birth of a Nation,* the African-American was replaced by the Native American, and the "ruthless savages" attacked defenseless people in a stagecoach or wagon train. But instead of the KKK, audiences now saw the 7th Cavalry coming gallantly to the rescue, blowing the bugle that was somehow heard miles away.

Early motion pictures like *The Squaw Man,* or shorts with Hoot Gibson, William S. Hart, Tom Mix, and others always concluded in a showdown with the bad guys in town or with the Indians. This action was seen hundreds of times

without the violent protests that greeted *The Birth of a Nation,* and it continued for almost fifty years. The Lone Ranger with his sidekick Tonto started as a popular book series, then appeared in the funny papers, and ultimately found its way into movies, radio, and television. It was one of the few sympathetic looks at this culture. Most often Native Americans were played by Latinos, like Anthony Quinn, or by actors of a mixed blood, and even Italians.

What most people in the world know about Native Americans is from these movies, and within the brief era from the end of the Civil War to the 1880s. This is the narrow time period when settlers going west declared there was an "Indian problem," and General Sherman made the statement, "The only good Indian is a dead Indian." Naturally, the movies made General Custer an American hero, possibly the next President of the United States, massacred by an overwhelming gang of savages at the Little Big Horn. With the popularity of Westerns around the world, these images have become fixed in people's thoughts even today. It is almost as if the Native American only existed during the time period of the Old West, and this is because only a few movies about contemporary life on the reservation have ever reached international audiences. Not until the revisionist Westerns that began in the 60s was Custer presented as less than a military mastermind, and Native Americans were allowed to play themselves. Like the African-Americans in movies over the decades, the tone of Westerns gradually changed, ultimately presenting the Native Americans in the framework of historical truth. But even then, they remained strangers in their own land, locked away in time.

Latinos

The Latino male is generally depicted in early movies in two ways. There is the gentle peasant who loves the white man who comes into their community because it means money. These characters often have a touch of the con artist, trying to get a few extra silver dollars for any kind of service that might be required. These peasants are bright but very childlike, or least they pretend to be. As the evening approaches these peasants begin to sing and beautiful señoritas dance flirtatiously, with Mariachi bands that seem to pop out of thin air. It is an idyllic, picture postcard existence.

Or there is the bandito character. This is a time period when there were banditos in history, or at least characters that were part of the revolution in Mexico. The names of Zapata and Pancho Villa had been in the headlines. The images of these men quickly became stereotyped in movies. The bandito had gun belts that crisscrossed his chest, a big sombrero, a three-day-old stubble, and spoke in lusty terms with a thick accent. Invariably, he was given to heavy drinking, womanizing, and could never be trusted.

This was a stereotype that was still going strong in *The Wild Bunch* thirty years later. As with other ethnic groups, the Latino, and especially the bandito character, was performed by non-Latino actors, like Wallace Berry in *Viva Villa!* (1934), and later Eli Wallach in *The Magnificent Seven* (1960). This happened even when there was a serious attempt to dramatize Mexican history, like Paul Muni in *Juarez* (1939), with Bette Davis flashing her eyes as the Empress Carlotta von Hapsburg.

WOMEN IN FILMS

The studios did their research carefully and knew that women were the ones that usually brought the men to the movies. Women loved the films in this era. This was not an expensive night out. For twenty-five cents a

French born Alice Guy is considered the first woman director, making more than 240 shorts and features between 1896 and 1920. In 1910, she, along with her husband, Herbert Blache, built and opened a studio in Fort Lee, New Jersey. After a series of financial failures she returned to France but was never able to secure funding to make another movie. She eventually returned to America and died in 1968, only a few miles from where her original studio was located.

couple saw two features, newsreels, a comic short, a cartoon or two, and perhaps a live performance or sing-along. And when the lights went out they had a chance to cuddle.

There were few opportunities for women and most were housewives, or on their way to becoming housewives. And being a housewife was a tedious task. It was a full time occupation. There was no time to go out and find a job, not with a schedule that meant having children and raising a large family. So between childbirth and cooking three meals a day there was no opportunity to become a lawyer or a reporter.

This was long before supermarkets. Women had to go to two or three different stores and make sure the meat was not greenish and that the vegetables were fresh. Everything was done on a daily basis. There was no way to keep most foods longer than two or three days. The icebox had arrived but it was very inefficient. Milk would be delivered each day, which was one of the very few conveniences in an otherwise chore laden day. Women in the early years of the Depression were locked into a fixed routine and a night at the movies was a treat.

The biggest thrill had to be in seeing other women on the screen. Women who were free-spirited could occasionally tell the male in the movie to take a hike. These tough ladies stood up to men, often giving them a perfectly phrased piece of their minds. Most importantly, these ladies did not have to be married to be a part of society. Unless a woman was married by a certain age she would almost become an outcast in mainstream society, which had unspoken rules of conduct that frowned upon single women going out by themselves. There were community events single women could attend, but many doors to a social life were closed unless women were married. The 19th Amendment giving women the right to vote was not passed by Congress until 1920, after a long and bitterly fought battle.

Women were intended to marry, have children and care for the man of the family. If they did not, or could not marry, women were referred to as "wallflowers" and an unmarried women beyond the age of twenty-five was on her way to becoming an old maid. Except in the movies.

Norma Shearer in *The Divorcee* (1930) shocked the audiences when her character decided she had the same freedoms that men did and had an affair in retaliation for her husband's infidelities, then just for the pure pleasure of it. The Hays Office was bombarded with letters, ironically, mostly from husbands. The movies of the Pre-Code Era were groundbreaking, showing women who were not only aware of their intelligence but who used their sexual charms in exchange for a better lifestyle. History is peppered with women like Cleopatra who were famous for having many love affairs, but in stern, no nonsense Protestant America during the height of the Depression, to inflame the average woman's thoughts with these celluloid ideas was considered very dangerous. No telling what could happen. Jobs were scarce, so it was bad enough that the movies showed women working as reporters and climbing the business ladder; but when these screen ladies began to have extramarital affairs, then Hollywood had gone too far.

In Fritz Lang's *Metropolis,* Bridget Helm plays Maria, who is leading the revolution of the underground workers against the oppression of the capitalist tyrants. She is such a formidable threat to the status quo of how Metropolis operates that a robot is invented to take on her identity and through lusty means make the workers forget the purpose of the revolution. These were the two roles of women, either saints or objects of unholy desire.

Many of Hollywood's screen goddesses were literally imported in the early days of the silent movies and talkies, like Greta Garbo and Marlene Dietrich, who were from Sweden and Germany. These were women that were aggressive in their desires toward men and there was never any doubt what happened next when the camera faded out during a long embrace. It was great fun for women in the audience to watch these stars do their stuff on screen. Watching Marlene Dietrich flirt with handsome Gary Cooper in *Morocco,* only to make a fool of him to the point where he could not live without her must have been extremely liberating to workaday housewives.

Bette Davis, Joan Blondell, Mary Astor, and Barbara Stanwyck were stars that took chances with roles and were fearless in their approach to characters. Ann Dvorak in *Three in a Match* (1932) plays the ill-fated third woman who lights a cigarette with one match. Her character ends up leaving a wealthy marriage because of drugs, abandons her child, and ultimately commits suicide in order to bring an end to the misery she has caused everybody. In *Scarface,* that same year, Dvorak is a young woman who is overly protected by her brother, Tony Camonte, played by Paul Muni. It is strongly implied that the relationship between sister and brother is one of an incestuous nature.

These were strong themes that were new to audiences, so it is not surprising that the religious organizations and mothers were terrified at what they were seeing. At the same time women were seeing very complex characters who made it on their own in the big cities. And costume dramas were popular, which were often tales of the modern age done in hoopskirts about women who used every means possible to survive in a man's world.

The lessons from these Pre-Code films might seem stereotypical today, but emerging from a time period when role models mostly came from literature, like Becky Sharp in *Vanity Fair* or Dickens' *Little Dorrit,* to suddenly see women on the screen taking big risks was nothing short of

*Frances Marion is one of the most remarkable screenwriters, male or female, to have worked in Hollywood. She started out as a combat correspondent during World War II, then moved to Los Angeles and soon became the official writer for Mary Pickford. Under Irving Thalberg she took on serious themes, becoming the first screenwriter to win two Oscars for **The Big House** (1930) and **The Champ** (1931), which made a star of Wallace Beery. Her other films include **Anna Christie** (1931) and **Camille** (1936) starring Greta Garbo as well as **Dinner at Eight** (1933) and **Riffraff** (1936) with Jean Harlow. But after Thalberg's untimely death in 1936 she lost her major supporter and was given less than A-list assignments. She continued to write novels and plays until her death in 1973. Marion had over 160 screenplays to her credit.*

revolutionary. Mae West undoubtedly had a greater influence on the behavior of women than she did as a sex symbol for the men in the audience. She was a smart businesswoman who said what was on her mind without hesitating, and she looked for satisfaction the same way men did.

Women were in the headlines. Amelia Earhart flew the Atlantic Ocean. Pearl Buck won the Pulitzer Prize for her best selling novel *The Good Earth*. And movie stars like Katherine Hepburn, Myrna Loy, and Claudette Colbert were in the news daily. Most of it was coming from the pressrooms of the studios but it gave

the impression of a non-stop exciting life. It is no wonder these stories convinced women to go to Hollywood with the hopes of a screen test. It was either this or marry the poor guy who ran the small town filling station. There were now more options in the life of women, even if it meant only a brief moment of fame as one of the leggy beauties in a Busby Berkeley musical number. Even this was a moment of glory for the adventurous few who tried to change their lives; in the course of all this, it slowly began to drag the American women out of the Middle Ages. Even little Betty Boop did her bit to help.

THE GOLDEN ERA OF THE STUDIO SYSTEM

1934–1939

The Golden Age of the Hollywood Studio System only lasted five years. There will be individual debates on how long this era continued and what it encompassed. Some feel that it began with *The Jazz Singer* and carried on through the 1930s up until the end of World War II. Others may look at the fact that the studios really did not fall into the La Brea Tar Pits of prehistoric operations until the mid-60s and the Hollywood Studio System changed over to the New Hollywood. There is also the argument that the studio system never disappeared, but just reinvented itself with advances in technology and the way films were distributed.

For the sake of argument, all of these are true. But the few years from when the Production Code was officially enforced to France and England's declaration of war on Germany after the invasion of Poland, the studios produced a quality of motion picture entertainment that has never been matched or duplicated. During this highly productive era the finely organized Hollywood assembly line set a standard for filmmaking that will last forever.

Sound was the glue that brought the pieces of the Studio System together. When all production was done on sound stages and back lots, the moguls became the monarchs of these small kingdoms. Most of the major studios are still around. Warner Bros., Paramount, 20th Century-Fox, Disney, and Universal are parts of giant conglomerates; so is Columbia, which is owed by Sony; and MGM merged with United Artists to form MGM/UA, but was forced to leave its historical Culver City studio location. And the sound stages of RKO, Republic Pictures, and the Hal Roach Studio are still booked solid with film and television productions.

Working in the confines of the Code, the movies focused on storytelling with memorable characters, put together by an assembly line of the finest actors, directors, designers, composers, and writers that has been unmatched every since. Their collective jobs were to simply make the best entertainment possible for a Depression weary public, and to create roles for actors that could turn them into that elusive something called a star. This kind of control over talent with the use of long term contracts would become impossible by the end of the 40s. The purpose of movies changed when war broke out in Europe and then the Pacific. But from 1934 to 1939 the studios were doing what they will be best remembered for, creating perfectly conceived dream worlds thirty feet high.

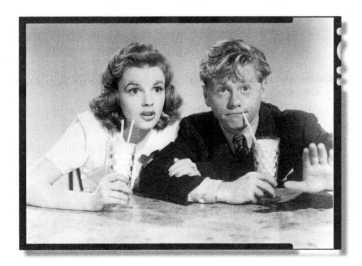

*By 1939, Mickey Rooney and Judy Garland were two of MGM's most popular stars and the first teenage couple to achieve such status in Hollywood. Mickey was riding high with the Andy Hardy series and Judy became America's new sweetheart after **The Wizard of Oz.** But they hit box office gold when they teamed up in a series of musicals directed by Busby Berkeley including **Babes in Arms** (1939), **Strike Up the Band** (1940), and **Babes on Broadway** (1941). The ongoing theme of most of these musicals was overcoming an adverse situation by putting on a big show—like in a barn.*

The Production Code became official on June 13, 1934. Joseph Breen, the man that would be the watchdog of the Code for the next thirty years, was a devout Catholic and privately felt that Bill Hays had been an expensive mouthpiece for the studio moguls. Hays had served a function but did not have the muscle or the grit to make the Code stick. The truth is the studios had reached a point that if they did not agree to the terms of the Code then they would have been met with a series of boycotts.

They had been losing audiences to horrified mothers, the Church, and other religious organizations. It was becoming more difficult to keep some of the carefree shenanigans of movie stars out of the press. Scandals were still going on, perhaps not of the same magnitude as the Fatty Arbuckle and William Desmond Taylor scandals, but in the minds of many citizens this was the new Babylon. Another factor was that Congress repealed Prohibition in 1933, and gangsters and free spirited women, after almost five years of the Depression, were distant memories of a bygone era.

The Code galvanized the processes of filmmaking. There was less diversification, but the kinds of motion pictures that were made in each genre became gems for the most part. The panicky search for stars had a happy ending and each studio now boasted of a stable of actors, many of whom would stay with a certain studio for almost two decades. The same was true with many of the directors. Only a few like John Ford and Howard Hawks had the ability to go to different studios and get on board with different projects.

Hollywood built up to 1939, which is the Golden Year of the Golden Era of the Studio System. In 1939 there were more masterpieces produced, which have endured the test of time, than in any other year. A majority of the motion pictures had a strong focus on women, like *Gone With The Wind, Wizard of Oz, Dark Victory, Love Affair, Wuthering Heights,* and *Mr. Smith Goes to Washington.* But after the war, the woman's film would change enormously.

In direct counterpoint to Hollywood's upbeat escapist motion pictures, the rise of the Nazi Party was shaking Europe, and in 1939 the war clouds burst and the world was at war again. America would not officially become part of this for two more years, but the war in Europe was a giant magnet that gradually pulled everything in its direction. Outwardly, Hollywood appeared to ignore the war, but, in fact, the moguls were told to avoid movies that might stir up more political turmoil. Most of the studio heads had relatives living in Europe. New German conquests were in the headlines of newspapers and newsreels on a daily basis. One of the factors that kept Hollywood from making anti-Nazi motion pictures was the threat of what might happen to these relatives. Ambassador to England, Joseph Kennedy, who had been a producer and well-known figure in Hollywood during the silent era, came and met with the Jewish moguls. They were told that movies that denounced Hitler or played favorites with the politics in Europe might go badly for the families and the loved ones that were over there.

Only a few foresaw how terrible events finally would get. It was suggested in no uncertain terms that since the heads of the studios and many of the producers were Jewish, this would be taken by the anti-Semitic movement in Europe, especially by the Nazi Party, as an excuse to widen the sphere of violence. Through subtle threats the Hollywood moguls were in effect being politically blackmailed into avoiding movies about the Third Reich. Warner Bros. was the only studio that made a few films that defiantly looked at the negative side of Hitler's rise to power. *Confessions of a Nazi Spy* (1939), starring Edward G. Robinson, is real-

ly an old-fashioned gangster movie in disguise about a G-man breaking up a network of Nazi espionage agents in America and Latin America. Warner Bros. was in production on *Casablanca* when Pearl Harbor was bombed.

STARS AND STUDIOS

This was a time period when little miracles of casting were happening in every studio. Each of the studios had found their specialty—the kind of motion pictures they did the best and have become identified with over the years. Almost all of these movies were a result of the star system. Movies were being written especially for the stars, and to secure the studio's investment, the stars were under long-term contracts. There are stories of legendary conflicts and walkouts with the heads of the studios due to salaries and the quality of material, but overall the studios were generous to their stars. After the Studio System broke down in the 60s, there were loud complaints on television shows and tell all books about the unfairness of the contract, but since then many of the old stars began to realize how special this time period was, de-spite the clashes. The studios certainly did not give stars profits in the films as stars get today, this would not happen for another twenty years, but they certainly allowed them to live like kings and queens in a city that was growing faster than any other in the country at that time.

MGM had the largest stable of stars, which justified the famous marketing ads, "More Stars Than There Are in the Heavens" and "The Home of the Stars." MGM was located in Culver City and had the largest back lot. Its most valuable asset was Greta Garbo who was put into lavish costume dramas from *Grand Hotel* (where she whispered her famous line, "I wish to be alone") to *Camille* to *Mata Hari.* Her roles were extremely popular, and she had a huge following in Europe, so the distribution of her movies reached the widest audience of any actress in Hollywood. But the war would change this overnight.

All punching in the clock at the same time were Joan Crawford, Lionel and John Barrymore, Jeannette McDonald, Nelson Eddy, Jean Harlow, William Powell, Myrna Loy, Robert Taylor, Spencer Tracy, and Norma Shearer. Louis B. Mayer was one of the first moguls to recognize the popularity of juvenile stars. Freddie Bartholomew was the

For over ten years Greta Garbo was queen of the silver screen in glossy entertainment like **Grand Hotel** *(1932),* **Queen Christina** *(1933),* **Anna Karenina** *(1935), and* **Camille** *(1936). She always insisted on having William Daniels as her cinematographer. Here she strikes a rather uncomfortable pose with Leo the Lion.*

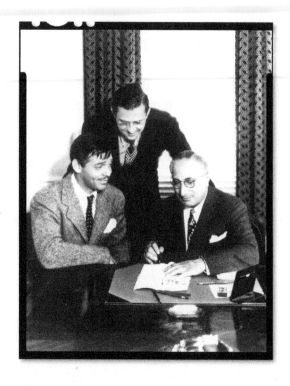

*Though he is smiling, Clark Gable was not happy about being loaned out by Louis B. Mayer to star as Rhett Butler in the David O. Selznick production of **Gone With the Wind**. Gable was afraid he would not live up to the public's image of the dashing Southern adventurer.*

model of the proper young English gentleman and was key to the success of *David Copperfield* (1935) and *Captains Courageous* (1937). But the two biggest stars were Mickey Rooney and Judy Garland, who made several of the Andy Hardy movies together and then a string of hit musicals that had the recurring theme of turning a barn into a theatre for a special show. By the end of this decade their little movies were among the most popular and highest grossing on the lot.

Of course, MGM had the king, Clark Gable. Gable got his royal title and only Academy Award when Louis B. Mayer loaned him out for being difficult and arguing about the quality of roles he was being given. He was sent to Columbia, which was considered the equivalent of Siberia in 1934. The name of the film was *Night Bus* and the director was a man named Frank Capra. Clark Gable had so little respect for Capra and his bus picture that he showed up stinking drunk at their first meeting. But he quickly got along with Capra. He certainly enjoyed working on this particular movie, which was retitled *It Happened One Night*, and it became the biggest hit of the year.

Capra also had another actress that was on loan, Claudette Colbert, except she came with a much higher price tag from Paramount Pictures. Like Gable, she did not think very highly of Frank Capra. Colbert did not care for Capra's style of directing and thought Robert Ruskin's screenplay was pure lowbrow comedy. Perhaps because of this attitude she brought to her character of the spoiled rich girl just the right touch, and she and Gable had screen chemistry.

It Happened One Night ended up winning the big five Academy Awards for Best Picture, for Best Actor and Actress, Best Screenplay and one for Capra as Best Director (the first of three he would win over the next six years). At the beginning of the movie there is a moment when the audience first meets Clark Gable. He is in a phone booth, drunk and telling his newspaper boss off.

He is fired, but keeps talking after his boss hangs up on him, pretending to have the last word. When he exits from the booth the small crowd that had gathered begins to jokingly call him "the King" and the title stuck. Clark Gable returned to MGM a major star and with an Oscar to prove it. He was given a much higher salary and ultimately had the pick of any motion picture he wanted and the right to work with any director he requested. So the punishment of sending him to Siberia certainly did not seem to work the way Mayer originally thought, but after *Mutiny on the Bounty* and *Gone with the Wind,* he ended up with the biggest box office star in Hollywood.

It must have been incredible to be able to walk through the back lot and sound stages of MGM and hear the Gershwins trying out a new song, John Barrymore rehearsing with Greta Garbo, Spencer Tracy and Clark Gable stealing scenes from each other, and dance numbers with Judy Garland and Mickey Rooney being worked out by Busby Berkeley.

Over at Warner Bros. Studio in Burbank the list of stars was quite different, and, at least on the screen, a lot tougher. There was James Cagney, Edward G. Robinson, George Raft, and Humphrey Bogart, who really didn't find a role that made him a star until the end of the decade. Bogart paid his dues in a number of movies playing second-banana gangsters and corrupt lawyers. He was the one that usually got "plugged" by Cagney, but he began to climb up the ladder with *The Petrified Forest* (1936) and *Dead End* (1937). He achieved stardom in 1941 and 42 by taking over three roles that George Raft turned down, *High Sierra, The Maltese Falcon* and *Casablanca.*

Also on the lot were Bette Davis, Olivia de Havilland, Joan Blondell, Dick Powell, Ruby Keeler, Errol Flynn, who had become the heir apparent to Douglas Fairbanks, and for awhile a dancer-singer named Ginger Rogers. And for prestige motion pictures there was Paul Muni,

who started out being an actor whose movies made Warner Bros. a lot of money, like *Scarface* and *I Was a Fugitive from a Chain Gang,* both in 1932. But as Hal B. Wallis, who was in charge of production, said toward the end of Muni's contract, "Every time [he] parts his beard and looks down a microscope, this company loses two million dollars." When he began to insist on being billed Mr. Paul Muni, he soon fell out of favor with audiences that felt he was too distant.

At Paramount Studios the big stars were Gary Cooper, Claudette Colbert, and Fredric March. Mae West was also a big star at Paramount, and her movies before during the Pre-Code era rained money at the box office, but with the all the restrictions the Code put on anything that hinted at sex her movies became too tame and her popularity faded. After a falling out, Adolph Zukor invited Cecil B. DeMille back to the lot, which began a series of epics about ancient Rome, *The Sign of the Cross* (1932) and *Cleopatra* (1934), both starring Claudette Colbert, and Westerns like *The Plainsman,* with Gary Cooper, (1937) and *Union Pacific* (1939).

On the opposite side of the hill at Universal Studios most of the stars were making the gothic horror films that were heavily influenced by German Expressionism. Boris Karloff scared audiences half to death as Frankenstein and The Mummy. Bela Lugosi gave people nightmares as Dracula. And Lon Chaney, Jr. followed in his father's footsteps when during the full moon he became the Wolf Man. But it was not a monster that saved Universal during the Depression, but a young singer that was given her walking papers from Louis B. Mayer. Allegedly, as part of Hollywood folk legend, Mayer said, "Get rid of the fat girl!" and instead of firing Judy Garland they got rid of Deanna Durbin. She ended up at Universal and starting with *Three Smart Girls* (1936) her teenage musicals kept the studio afloat throughout the Depression.

Twentieth Century-Fox had Henry Fonda, Don Ameche, Tyrone Power, Alice Faye, and through the height of the Depression they had the most valuable female star in all of Hollywood; a pint sized dynamo named Shirley Temple. Her uplifting, three-handkerchief movies were pure old-fashioned melodramas to the core and saved the studio from bankruptcy. With titles like *Bright Eyes* (1934), *Curly Top* (1935), and *Dimples* (1936), the day a Shirley Temple movie opened the lines would form around the block. Even legendary John Ford made *Wee Willy Winkle* (1937) with Shirley Temple. Between 1932 and 1940, from the age of four to twelve, she made forty-three shorts and features.

Her image was marketed everywhere. Her only competition was Mickey Mouse, and the Shirley Temple doll reportedly made as much as her movies. As an example of how popular she was, Louis B. Mayer wanted Shirley Temple to play Dorothy in *The Wizard of Oz* and offered both Clark Gable and Jean Harlow, MGM's two biggest stars at the time, in exchange for her to play the role. Harlow unexpectedly died before the deal could be finalized, and just getting Clark Gable was not enough for Darryl Zanuck, the

head of Twentieth Century-Fox, who turned down the deal. Shirley Temple went on to make *The Blue Bird* (1940) a big budget disappointment for the studio that signaled the end of her stardom. And over at MGM, Louis B. Mayer reluctantly gave his second choice, Judy Garland, the role of a lifetime.

RKO had some of the biggest stars, directors, and producers, but by the end of the decade lost many of them to MGM. Ginger Rogers left Warner Bros. to team up with a slightly balding dancer named Fred Astaire, and together they rewrote the Hollywood musical. David O. Selznick was in charge of production at the age of thirty and was around long enough to discover Katherine Hepburn, befriend George Cukor, and produce *King Kong* (1933) before marrying Irene Mayer, the daughter of Louis B. Mayer, and moving over MGM. Before the end of the decade, Hepburn, Cukor, and Astaire would also be at MGM. But the studio did have a distribution deal with another producer, that despite its ups and downs, proved to be very rewarding. His name was Walt Disney and all the *Silly Symphonies, Mickey Mouse, Donald Duck,* and *Snow White and the Seven Dwarfs* (1937) were released under the

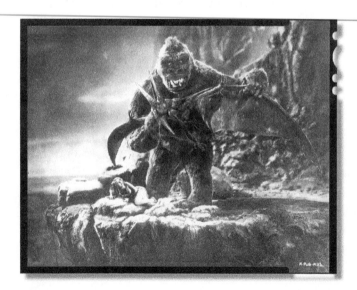

King Kong (1933) was produced by David O. Selznick before he went over to MGM. The film was a huge success, putting RKO on the map as one of the major studios. But eventually most of the stars, directors, and producers ended up at MGM, including Katharine Hepburn, Fred Astaire, Cary Grant, George Cukor, and Pandro S. Berman. Max Steiner's music for the film is considered the first great score of the sound era.

RKO banner. Ironically, Disney had approached MGM first, but was turned down.

Columbia had one major asset, a director named Frank Capra. One of the few big name stars was Jean Arthur, who was in Capra's *Mr. Deed Goes to Town* (1936), *You Can't Take It with You* (1938), and *Mr. Smith Goes to Washington* (1939). Harry Cohn, the head of Columbia, negotiated star deals and was able to bring in heavyweights like Clark Gable, Gary Cooper, Barbara Stanwyck, James Stewart, and Roland Colman for *Lost Horizon* (1937). But the reason these stars wanted to make pictures at Columbia was because of Capra. He single-handedly turned the studio from a struggling poverty row outfit into one of the majors, and won two Best Pictures honors for *It Happened One Night* and *You Can't Take It with You* during the most competitive time in the history of the Studio System.

SCREWBALL COMEDIES

The one genre of film that might typify this era more than any other is the screwball comedy. It is difficult to pin down exactly which comedy put screwball humor on the map. It is an attraction of opposites tale in a world that has gone slightly mad. The two people involved are perfect for each other but always start out as adversaries. The one that most likely introduced screwball humor, even though it does not have all of the ear markings of later comedies, is *It Happened One Night*.

The story deals with a brash newspaper reporter and a spoiled rich brat socialite. To spite her father, she jumps off a yacht, determined to get back into the arms of her social climbing lover. But she just happens to end up on the same bus with the reporter who has just been fired and looking for the story to get him back into the good graces of his boss at the newspaper. They dislike each other intensely, but, eventually nature takes its course during the long journey to New York. There is one scene in a shabby little motel where they are forced to spend the night together and they put up a blanket that they call the walls of Jericho. This undoubtedly was poking fun at the newly enforced Production Code, which became a kind of game with a lot of the screwball comedies.

The tone of *It Happened One Night* changed the direction of movies in Hollywood, at a time when studios were just beginning to struggle with life under the Code. Its enormous success showed that audiences were taken with this zany form of courtship. In fact, it demonstrated that relationships between men and women could be wildly enjoyable, which surprisingly was something of a new concept for the general public.

In later screwball comedies the rapid-pace dialogue became one of the signature ingredients, along with a lineup of madcap characters. Screwball comedies were popular with stars because they were a refreshing break from costume dramas and other standard studio productions. Howard Hawks directed three classics: *Twentieth Century* (1934) with John Barrymore and Carole Lombard, *Bringing Up Baby* (1938) with Cary Grant and Katharine Hepburn, and *His Girl Friday* (1940) with Cary Grant and Rosalind Russell. William Wellman, not known for his comic touches, made *Nothing Sacred* (1937) with Carole Lombard and Fredric March, about a women who thinks she is dying and becomes famous overnight from an outpouring of public sympathy, only to discover she is not dying after all.

That same year *It Happened One Night* came out, MGM released what would become on of the studio's most popular series, the comedy-mystery *The Thin Man* based on Dashiell Hammett's best selling novel. It is a clever murder mystery, but what tickled audiences was the rapport between Nick and Nora Charles played by William

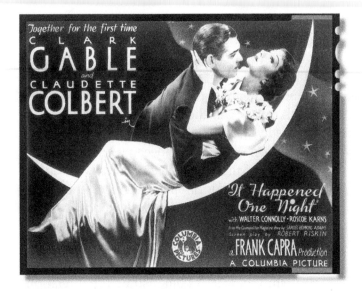

It Happened One Night (1934) directed by Frank Capra and starring Clark Gable and Claudette Colbert was a blockbuster sensation, winning the top five Oscars, including one for Robert Riskin's great screenplay. The movie jumpstarted what became known as the "screwball comedy." Made the year the Production Code was fully enforced, Capra's busy tale about the attraction of opposites proved that romance could be good, clean fun.

Powell and Myrna Loy. The playful antics and remarkable consumption of martinis, along with humor provided by their dog Asta, presented the idea that marriage could be fun. *The Thin Man* had a variety of characters constantly going in and out, most of them were either with the police department or shady Damon Runyon criminal types. But the real amusement was how Powell and Loy shook up the traditional concept of marriage. They made faces behind each other's backs and tossed out one-line zingers like two overgrown children. This screwball comedy literally began to change the expectation of what marriage could be like. A man's best buddy could also be his wife.

A TOUCH OF ENGLAND IN HOLLYWOOD

Partly because of better salaries and partly because they spoke so distinctly, a trait producers searched for when sound came in, a large number of the movies from the early 1930s through World War II were English. They brought a prestige with them to Hollywood, but also built an identification with everything that was good about England. From classic novels that were adapted to the screen to stories about the simple folks, all of this was part of the American movie going experience. Faraway England had a certain magic to it, which became an invaluable source of political support during the early days of the war when London was being bombed.

It would not be just the actors, but directors and writers were also part of this English colony in Hollywood, and as the storm clouds neared they were encouraged to keep up this image of England as a bright light of democracy that deserved to be saved at all costs. Winston Churchill and others saw the value of motion pictures and knew that when war came, which many thought could be avoided with diplomacy, that movies about noble and fun loving English people would be a strong influence against Hitler's lust for power. These motion pictures created a close identification with the American people's mind and ultimately were extraordinarily important in bringing America to England's

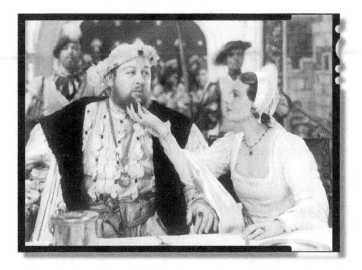

The Private Life of Henry VIII (1933) directed by Alexander Korda, the stately costume drama starred Charles Laughton, who won an Oscar for his robust performance as King Henry, putting a defining mark on the role for generations to come. Laughton become one of many Englishmen lured to Hollywood by bigger paychecks, but most of his major roles had a hint of homeland, like **The Barretts of Wimpole Street** (1934), **Ruggles of Red Gap** (1935), **Mutiny on the Bounty** (1935), and **The Canterville Ghost** (1944).

rescue in its darkest hour. As the RAF pilots in their Spitfires fought against overwhelming odds, Americans listened on the radio at night about the attacks on English soil with images from *A Tale of Two Cities, The Adventures of Robin Hood,* and *Goodbye, Mr. Chips.*

An amazing number of the English performers that came to Hollywood became legends of the golden age. Many of them arrived long before there were concerns about the Nazi party. The most famous was Charles Chaplin, but since the Little Tramp never spoke and all of his comic adventures were in America, audiences naturally did not think of him as English. But Chaplin would be the first to ridicule Hitler before America entered war in *The Great Dictator* (1940), and thereafter at every opportunity reminded audiences about his heritage when the war began.

If Chaplin was the most famous silent star, unquestionably the most famous English star of the sound era was a man named Archibald Leach, who wisely changed his name to Cary Grant. And what would the movies be like without Grant in *Bringing up Baby, The Philadelphia Story, Notorious, An Affair to Remember, North by Northwest* and scores of other that indelibly defined the ideal English gentleman?

Other stars include Charles Laughton, who won an Academy Award for *The Private Lives of Henry VIII* (1933) and became known to American audiences as Captain Bligh in *Mutiny on the Bounty* (1935). When Laughton played Quasimodo in *The Hunchback of Nortre Dame* he brought over redheaded beauty Maureen O'Hara to be Esmeralda. She later played leads in John Ford's *How Green is My Valley* and *The Quiet Man.* Leslie Howard played Professor Higgins in *Pygmalion* and Ashley Wilkins in *Gone with the Wind.* Ronald Colman was in some of the most famous English roles, including *A Tale of Two Cities, The Prisoner of Zenda, Lost Horizon,* and *Random Harvest.* Errol Flynn became the screen's leading swashbuckler starring in *Captain Blood, The Adventures of Robin Hood,* and even made a hero of General Custer in *They Died with Their Boots On.*

And then there were the character actors. Basil Rathbone, who quite often played the adversary in such films as *The Adventures of Robin Hood,* would have a long career in films and radio

as Sherlock Holmes, with fellow English actor Nigel Bruce. Claude Rains was one of the most versatile of character actors, able to go from *The Invisible Man* to Capt. Renault in *Casablanca* to a Nazi industrialist in *Notorious*. And one of the most famous voices in the movies, despite the fact the early audiences rarely got the opportunity to hear it, was Boris Karloff, who was the source of nightmares in *Frankenstein* and *The Mummy*.

England also gave Hollywood some of the finest child stars. Freddie Bartholomew won America's hearts in *David Copperfield* and *Captain Courageous*. Later young Elizabeth Taylor would begin her long career with *Lassie Come Home* and *National Velvet*. Roddy McDowall, a recent refugee from England, won the lead as the youngest son in John Ford's *How Green Is My Valley,* and became the most popular child star during the war in movies like *My Friend Flicka* and *Keys of the Kingdom*.

The number of English stars that won the Academy Award prompted a satirical remark that perhaps there should be two Oscars for acting, one for the English and another so that somebody else could win for a change. Joan Fontaine was nominated for Alfred Hitchcock's first American film, *Rebecca* and won the following year for the Hitchcock thriller *Suspicion,* with Cary Grant. Her sister, Olivia DeHavilland, was the love interest in many of Errol Flynn's films including *Captain Blood* and *The Adventures of Robin Hood,* co-starred as Melanie in *Gone with the Wind,* and won two awards for *To Each His Own* and *The Heiress*.

Laurence Olivier would become England's most nominated actor for such classics as *Wuthering Heights* and *Rebecca,* and winning for *Hamlet*. Olivier would be the first to successfully bring Shakespeare to the screen with *Henry V, Hamlet,* and *Richard III*. And Olivier's wife, Vivien Leigh, who appeared with him in *Fire Over England,* won for the highly sought after role of Scarlett O'Hara in David O. Selznick's *Gone with the Wind*. She would win again as the aging, unstable Southern belle in *A Streetcar Named Desire*.

The same year as *Gone with the Wind,* the versatile British performer Robert Donat, the star of Alfred Hitchcock's *The 39 Steps,* won for his remarkable portrayal as the lead character in *Goodbye, Mr. Chips,* beating out Clark Gable and James Stewart in *Mr. Smith Goes to Washington.* In the movie, Donat goes from a young man in his twenties to a very elderly professor in an English boy's school. *Goodbye, Mr. Chips* introduced Greer Garson, who would become one of the most popular stars during the war years, winning for the hugely successful *Mrs. Miniver*. Other winners include Victor McLaglen for *The Informer,* Ronald Coleman for *A Double Life,* David Niven for *Separate Tables,* Ray Milland for *Lost Weekend,* and George Sanders for *All About Eve*. Barry Fritzgerald won best supporting actor for *Going My Way* but also was nominated for best actor in the same role, the only time in the history of the Academy Awards this has happened. The rules were changed afterwards.

The British invasion of Hollywood left a lasting mark on motion pictures. These movies had strong English stories during the era that defined the concept of star power and had production qualities associated with the Golden Age of the Studio System. They can be generally described as dignified, romantic, with a mischievous subtle humor, and frequently centered around strong women characters. As an example, the following are just the motion pictures that were nominated or won best picture honors from 1933 to 1939: *Cavalcade, The Private Life of Henry VIII, A Tale of Two Cities, David Copperfield, The Barretts of Wimpole Street, Mutiny on the Bounty, The Informer, Midsummer Night's Dream, Captain Blood, Ruggles of Red Gap, Romeo and Juliet, The Life of a Bengal Lancer, Anthony Adverse, Lost*

Horizon, The Adventures of Robin Hood, The Citadel, Pygmalion, Wuthering Heights, and *Goodbye, Mr. Chips.*

Gone with the Wind, the best-known American novel during the Depression, could also be included among these motion pictures. The central characters are the O'Haras, as Irish as they come, and Scarlett's heretical stubbornness is a predominate theme in the book. And when the epic Civil War drama was made, three of the leads were British: Leslie Howard, Olivia de Havilland, and Vivien Leigh. David O. Selznick came under fire when he announced the most desired woman's role ever at that time was going to an English woman. He had originally passed Leigh over after seeing *Fire Over England,* feeling she did not have a strong enough screen presence to play Scarlett, but once he met her in person, when the night crews were filming the burning of Atlanta sequence, he knew he had found the right actress. When the motion picture premiered all concerns about his choice vanished overnight.

As a strong indication of the power and influence of these motion pictures, Winston Churchill commented to President Roosevelt after seeing *Mrs. Miniver* that the movie was worth several battleships for the good will it generated. *Mrs. Miniver* went on to win best picture honors and ran in some theatres for the duration of the war. The images of the English people were ingrained in the minds of Americans. *Mrs. Miniver* might appear overly sentimental to modern audiences, but when it was released it had an enormous impact, showing the sacrifices of a small band of people against terrible odds, perhaps the last holdout against Fascism in Europe.

Hollywood received another Englishman in 1939, this time a director who would fight the war with another kind of motion picture that had been unique to British novels and cinema, the spy genre. His name was Alfred Hitchcock, and his special use of the camera to create suspense would have a lasting influence on all motion pictures in the future.

THE GOLDEN ERA YEAR BY YEAR

1934

Once the Production Code was formally set in place, it changed filmmaking in all parts of the world. Sound had obviously done this by bringing in language to film, which in turn created a language barrier that was not there before. No one truly knew the difference between a German movie and one for the Soviet Union, because the only indication would be the title cards, and they would be in the language of the country the film was showing. The Motion Picture Academy recognized films from England, but all other motion pictures from countries that did not speak English were considered foreign. With only a few exceptions, like Jean Renior's *Grand Illusion* (1937), the Academy, and the American audiences for the most part, ignored this new species that became know as foreign language films. A special category would be created after the war, but by then the so-called foreign directors had begun to make motion pictures that were generic to their own countries. These films in turn would have a huge impact on American cinema after the war, changing the look of Hollywood movies.

By the time the Production Code was strongly in place, Europe was in turmoil. It was in a state of economic depression, with most countries struggling more than America was at this time. Only Germany and France to a lesser extent were showing signs of recovery. Germany was getting back on its feet because of political changes that were secretly offering jobs in factories to create a great war machine that would by the end of the decade attempt to conquer all of Europe. Many of Germany's innovative filmmakers had already left for America or crossed the

Silver Screen was one of many film magazines that showed the glamorous lives of the movie stars. Quotes from actresses like Joan Crawford were usually supplied by staff writers in the marketing department. After World War II magazines like **Confidential** began to dig up the dirt on the stars.

border into France, which would be a safe haven for only a few more years.

In England the film industry was extremely poor, which was the primary reason so many talented actors left for greener pastures in Hollywood. But England had two major successes, a director and producer that put their unique mark on film. Alfred Hitchcock had come into his own with a successful series of films so original they would eventually be labeled with his name as Hitchcockian, a distinctive genre of film. The movies were laced with wonderful bits of subtle British humor and demonstrated a conscious development of the elements of suspense. Hitchcock began to work with some of the major stars in England, like Michael Redgrave and Robert Donat, which allowed him to increase the dangerous situations in his carefully manipulated plots and heighten the fear factor for audiences.

The producer was Alexander Korda, who has been referred to as the Cecil B. DeMille of England. Many of his films, which he also directed, were often large historical dramas, laced with far more fiction than truth, but highly appealing to audiences. Alexander Korda, and his brothers Zolta and Vincent, were a group of filmmakers that were unique in Europe at this time because they were able to tap into the escapist vein of Hollywood films. Many of the motion pictures that Alexander Korda produced were very popular in the United States, like *The Private Life of Henry VIII*, *The Scarlet Pimpernel*, *The Ghost Goes West*, *The Four Feathers*, *The Thief of Bagdad*, and *The Jungle Book*. He also provided an early entrance into directing for Michael Powell, Laurence Olivier, David Lean, and Carol Reed. Alexander Korda was the only English producer during the golden era who was the equal to David O. Selznick or Irving Thalberg.

France would end the era with two remarkable films by Jean Renoir, *Grand Illusion* (1937) and *The Rules of the Game* (1939). These motion

pictures examined the crumbling aristocratic society and lamented the passing of Old European traditions. They focused on the common man that had now taken over and understood the use of power better than the aristocrats, who had frivolously lost control of how to govern and conduct themselves wisely in the face of rapid changes that were ocurring almost daily in the twentieth century. Needless to say, these films caused a controversy, were censored, and ultimately did poorly at the box office. As with many of the films that became classics of the foreign cinema, they were later rediscovered after World War II when their themes had an even greater significance.

In Germany the major filmmakers associated with its golden era before the coming of sound had left or fled for their lives, since most were Jewish. This marked the decline of a once great industry that influenced film around the world, and would still continue to with the directors that relocated in Hollywood. But for better or worse, there would be one final innovation in Germany— the perfecting of the documentary as a political tool for the Nazi propaganda machine. Without question, the best known example is *The Triumph of the Will* (1934) by perhaps the most famous, or now infamous, woman director, Leni Riefenstahl.

The Triumph of the Will forever changed the documentary. Before this, the documentary allowed a story to unfold naturally, catching the moments as a third person observer, like with Robert J. Flaherty's *Nanook of the North* (1922) and *Man of Aran*, which came out the same year as *The Triumph of the Will*. Riefenstahl shot and cut her documentary about the 1934 political rally of the Nazi Party in Nuremberg to influence and persuade the audience about the power and leadership abilities of Hitler. This documentary still creates controversy in how it portrays Hitler, who at this time the world was just beginning to know and many respected. There was no sense of his evil intentions and perverse personality to

audiences at this time. What they saw was a remarkable leader that was pulling his country out of the grips of financial ruin and had begun to give it a new energy.

Leni Riefenstahl had a team of over 120 people and an amazing 32 cameras that would be in every part of the city from buildings to moving cars to balconies, capturing the highly organized events of the rally in real time. It resulted in 130,000 meters of film that would be eventually be edited down to 114 minutes. Riefenstahl had crews filming Hitler's flight into Nuremberg and following him down streets packed with cheering people. The chilling brilliance of *The Triumph of the Will* is that there is no narrative over the images giving the audience background information. Instead Riefenstahl edited the shots of Hitler, other high ranking Nazi leaders, and the faces of the devoted and enthusiastic citizens and solider to create an almost god-like aurora around this new leader of Germany. By the use of pure montage, Riefenstahl cuts from Hitler to the children waving flowers, or to young boy scouts proudly presenting the Nazi flag.

These are the editing methods used in almost every political campaign today, but looking back at *The Triumph of the Will* gives a dreadful sense of how easy it is to sometimes manipulate people's hearts and minds. The staging of this political rally had the pageantry of Wagnerian operas with literally a cast of a million, torch parades at night, and huge searchlights shooting straight up into the sky. There were great pageantries of austere respect. Many prominent Americans who saw all this, like Charles Lindbergh, believed that Hitler was doing something that was remarkable for Germany and that perhaps some of his tactics should be used in America.

During the Depression in America many people began to fear that fascism could happen in America. Novelist Sinclair Lewis wrote *It Can't*

Happen Here on this subject, and later Robert Penn Warren won the Pulitzer Prize for *All The King's Men,* a fictional account of Huey Long. America was in turmoil. Many people felt that capitalism was a failure, and with the Depression not showing any signs of letting up there was good reason to feel this way. The philosophy of communism appealed to many intellectuals. No one knew about the trials and executions conducted by Stalin in the Soviet Union at this time, with his iron fisted control of the newspapers he was looked upon as a hero until the end of the war. This experimenting with other political forms would come back to haunt many people during the hearings conducted by the House Un-American Activities Committee (HUAC).

The sense that the American way was working was a constant theme in Hollywood movies, especially the films of Frank Capra and John Ford. The one thing that got many people through the Depression, and this probably cannot be overstated, was a sense of national identity found in the movies. A lot of this was because the Production Code literally forced the films to look at life through rose-colored glasses, but the studio moguls and their directors had a sense of purpose to show how good the American experience could be. Many of these men and women were immigrants or from families forced to flee the grown tyranny in Europe and knew that even in the midst of a Depression, America still had opportunities found nowhere else. They were proof of it.

Hollywood movies became more upbeat. The gangster films that ended with the annihilation of a central figure in a hail of bullets begin to disappear. The movies that depicted women using their sexual prowess to climb the social ladder, or showed the grim reality of war like *All Quiet on the Western Front,* were replaced with screwball comedies and musicals. If the audiences wanted movies that did not demean the traditions of family values and marriage, then Hollywood broke from the huddle and made one movie after another showing that the human spirit could overcome anything if everyone stuck together. At its best, Hollywood showed weary people that there was still a great deal of gaiety in the world that could be easily found at the drop of a hat.

The other thing the Production Code did was to restrict the kinds of films that could come in

All Quiet on the Western Front (1930) directed by Lewis Milestone had a long-reaching effect on Hollywood. The film is a masterpiece of cinema, made in the early years of the sound era when most movies had become very theatrical in appearance. It depicts the hardships of war with scenes of brutal power and won the Oscar for Best Picture. However, the production costs almost bankrupted Universal Pictures, and with the start of the Depression it took years to recoup the investment. After this studios steered clear of showing the agony of war and instead war movies became the stuff of high adventure. The honesty about battle would not be seen again until movies like **Saving Private Ryan** were made over sixty years later.

from foreign countries. This meant that all countries had to suddenly adhere to the rules of the Code or their films would not get a release in the most profitable marketplace in the world. Films by German director Georg Pabst, like *Pandora's Box* or *The Diary of a Lost Girl* starring Louise Brooks, that shocked audiences with their strong sexual content, could not be shown in American theatres without a certificate of approval. This caused many films to be drastically re-cut or not exhibited at all. But films made in England by Alexander Korda and Alfred Hitchcock, that mirrored Hollywood movies with their own unique approach, had no problems getting approval and ultimately finding large audiences.

Many moguls had seen that changes were inevitable and had begun to clean up their act after the controversy over movies like *Red-Headed Woman, Scarface,* and *Gold Diggers of 1933.* In many situations, the studios were in production by late 1933 with motion pictures that fit the mold the Code insisted upon. The Poverty Row Studios like Republic and Monogram never were known for films that pushed the envelope of sexuality or violence. Movies from these studios had always been quickly produced for popular consumption and were directed to younger audiences, especially the Westerns, the mysteries, and Saturday morning serials.

By 1934 almost every director that would later be identified with the golden age had hit his stride and found the themes and rhythms of movies that would become his trademark. The directors never had control of their material, though later the French New Wave would find certain fingerprints all over films by forceful personalities like John Ford, Howard Hawks, and William Wellman. Producers had an army of readers going through every magazine and proof galleys from publishing houses. There was not the freedom for a director to go into an executive office and plop down a screenplay or novel and insist this was going to be his next movie.

Hawks and Ford earned this right after they began wearing two hats in the 1940s, but even Ford, after winning three Academy Awards, had to wait almost twenty years to make his pet project *The Quiet Man* (1952). With only a very few exceptions directors were at the beck and call of the producers who had the final say on which stories and scripts were right for their stars. The one freedom stars had during this time period was insisting on working with certain cinematographers that lit them so perfectly, and occasionally succeeded in demanding a director for a film, like Bette Davis with William Wyler or Marlene Dietrich with Josef von Sternberg.

In 1934, the two studios that had the biggest hits were both in deep financial trouble and each had a film that transformed them from Poverty Row to a Major. One was RKO and the other Columbia. The biggest transformation was Columbia. *It Happened One Night,* to the rancorous joy of Harry Cohn, the mogul of Columbia, brought in so much money to the struggling studio it was able to green light a series of prestige films. Cohn had found the magic elixir in director Frank Capra. Capra, the year before delighted audiences with *A Lady for a Day,* based on a short story by Damon Runyon. He would later remake this movie, titled *Pocketful of Miracles,* with Bette Davis. Ironically, these two films would represent Capra's first major hit and his final film twenty-eight years later.

But no one could have predicted from *A Lady for a Day* what would take place when *It Happened One Night* opened up. People stayed in the theatres and watched the movie two or three times in one day. From word of mouth, lines began to form and stayed that way for months. It was the first comedy to really hit the mark perfectly in the sound era. There had always been

comedy, going back to Charlie Chaplin and Buster Keaton, but this was a different kind of comedy. *It Happened One Night* was reality and fantasy mixed up. There was something wonderfully genuine about Capra's lead characters. They were on opposite poles from each other, but opposites attract, and of course the audiences knew that. And Capra played with the would-they or wouldn't-they plot right up to the last minute of the film.

As another example of the power of early motion pictures, *It Happened One Night* has some memorable moments that did end runs around the Code. In one scene Clark Gable starts to undress in front of Claudette Colbert. But before she can retreat behind the hanging blanket called the Walls of Jericho, Gable takes off his shirt revealing no undershirt. This moment almost devastated the undergarment industry, whose sales dropped over 50 percent, just because if Gable did not wear an undershirt no real man would. Arguably it was not until *A Streetcar Named Desire* with Marlon Brando that T-shirts became fashionable again.

The other big surprise film phenomenon of that year was over at RKO's lot. The studio had done extremely well with *King Kong* the year before, but *Kong* was a highly expensive production and took almost two years to make, so the money it brought in was spent on some moderately budgeted musicals with a faster turnaround. The year *Kong* came out, RKO released *Flying Down to Rio* that teamed up an unlikely couple by the names of Fred Astaire and Ginger Rogers. They played the second leads in the movie but stole the show with their musical numbers. In 1934 they were given their own musical called *The Gay Divorcee,* which has a twenty-two minute dance number titled "The Continental" which caused a national sensation.

At first glance, Astaire and Rogers seemed an unlikely couple to create a Hollywood sensation. Astaire was a perfectionist's perfectionist. He would rehearse numbers incessantly until

Fred Astaire and Ginger Rogers are without question the most famous dance couple in the movies. Playing off the attraction of opposites scenario, their dance routines were often playfully competitive. It has been said that Ginger gave him sex appeal and Fred gave her class, and it has been noted that everything he did, she did backwards and in heels. But the real delight of their dancing is how they make the almost impossible seem effortless.

they were absolutely right. He made them look easy to do, but that was part of his style and it came out of a discipline that was unmatched by any entertainer in the movie business. Someone who has faded into the dust of Hollywood folklore wrote about Fred Astaire when he came to RKO, "Can't act. Can't sing. Balding. Can dance a little." If there ever was a kiss of death as far as an evaluation of a screen test, this was it. Fortunately, Pandro S. Berman, the chief of production at RKO, saw that Astaire had the star quality but he needed the right partner. Astaire's sister, Adele, had retired from the business but Astaire could not get the stardust out of his shoes. Berman had just lured away a feisty blonde from Warner Bros. and thought she might work.

Ginger Rogers had already made her mark in musicals. The year before she had been showcased in *The Gold Diggers of 1933* in the opening number of *We're in the Money* where she gets an extreme close-up as she sings a pig-Latin version of the song. But Rogers had to play second banana to Ruby Keeler, and she wanted lead roles in the future. The teaming of Astaire and Rogers was purely professional. They got along well and had a mutual respect for each other. But there was never any hint of flirtations or affairs; it was all pure business between the two of them (she was at the time involved with playboy millionaire turned movie producer Howard Hughes).

Rogers was bound and determined to keep up with Astaire, who was the master of the ballroom and tap. What evolved on screen was at times a competition between the two of them, which was written into their characters. It was very much like *It Happened One Night* where there were two opposites. In this case Astaire and Rogers used that viva la difference in their dance numbers, so that one would challenge the other until they ended up embracing and doing a series of almost impossible dizzying spins. This routine where much of the time they openly faced the camera seemed perfectly natural in the movies. It was something uniquely their own and it proved to be pure chemistry. It is said that Fred Astaire gave Ginger Rogers class, and that Rogers gave Astaire sex appeal and this is probably as good an analogy as any. It created a sparring partner not only on the dance floor but also in the kind of sophisticated comedies they became famous for, like *Top Hat, Roberta, Follow the Fleet, Swing Time,* and *Shall We Dance,* all made between 1934 and 1937. Fred Astaire seems to have been born in a tuxedo. No one, with the possible exception of Cary Grant, wore a tuxedo as well as he did.

The stories in the musicals usually took place in the madcap world of high society, peppering it with wonderful character actors like Edward Everett Horton and Eric Blore. Busby Berkeley had made the camera the star in his elaborate dance numbers with barelegged girls doing kaleidoscope routines. Fred Astaire and Ginger Rogers were shot full frame. What was seen on the screen were simply two people dancing divinely together in a full master shot. Since the dancing was of such quality and sophistication, with a touch of flamboyancy at times, there was never a dull moment about the way the scenes were shot.

1935

In 1935, the studios truly earned the nickname of dream factory. It was a year that showed a marked change from the films that were teeter-tottering on the do's and don'ts of the Production Code only a year before. The films this year all fit perfectly within the limited confines of the Code, but now terrific storytelling became the battle cry for all of the studios. Great production values and total escapism were the kinds of things Hollywood did best during the Depression. There was no political undermining of what

The Little Rebel *(1935) directed by David Butler and starring Shirley Temple and Bill "Bojangles" Robinson. It is almost impossible to imagine the popularity of Shirley Temple during the Great Depression. Her sugar sweet melodramas single-handedly saved 20th Century-Fox from bankruptcy. She made singing and dancing seem so easy it is often overlooked what a remarkable talent she was, a true natural that could turn on the emotions like a veteran actor. And during a troubling time in Southern history, her frequent pairings with tap master Bill Robinson showed audiences that good friends came in many colors.*

was happening in America, and human despairs stayed outside the doors of the Baroque movie palaces. On the screen men and women got along in peace and harmony, without ever having to go through the heartbreaks of illicit affairs or divorce that would tear a family apart. This is the only time in history this could have possibly happened. The studios owned the theatres and thus controlled everything the American public saw. When the studios signed off on the Code the public stepped into a perfect world when they visited the local cinema.

The superstar this year, at the ripe old age of six, was Shirley Temple. She was as marked a contrast to the sassy double entendres of Mae West as could be imagined. Mae West's career was finished by this point, and only two years before her films had saved Paramount from financial disaster. Shirley Temple brought new life to 20th Century-Fox, as had Rin Tin Tin a few years before. Darryl F. Zanuck was running Fox and had been doing the kind of hard-hitting social dramas he had written and produced over at Warner Bros. He had brought in directors like John Ford and some of the finest writers in the business. In fact, Fox under Zanuck was always

considered a writer's studio, over the years turning out clockwork screenplays. But it was a dog and a little girl that kept the doors open during the Depression.

The popularity of Shirley Temple reflected the optimism of the times even though the Depression still was a day-to-day event. There were certain signs that things were beginning to change, jobs were beginning to open up. The life on the road was not as difficult as it had been. People having nowhere to go were beginning to find work and settle down again. Shirley Temple with her as fresh as fresh can be image was someone that with songs and bright-eyed wisdom had the ability to bring together on screen a husband and wife that had drifted apart back into a family.

There might have been opportunities for another child star to be in her place, but there was something completely unique about Shirley Temple. The camera discovered her at the right time. What was happening in the world and the Production Code coming down presented a red carpet for her to enter Hollywood and the hearts of millions of Americans. She has a charismatic charm that still endures, and a certain kind of

hope needed in the country that had begun to lose its grip on hope. Shirley Temple made four feature motion pictures this year, *The Little Colonel, Our Little Girl, The Littlest Rebel,* and *Curley Top.*

Her dance partner in *The Little Colonel* and *The Littlest Rebel* was one of the greatest tap dancers of all time, Bill "Bojangles" Robinson. On stage he would dress in a tuxedo like Fred Astaire, but in the movies he usually played a servant or handyman that befriends the little girl, who is often neglected or misunderstood. On screen they became buddies and confided in each other. Robinson always had an opportunity where he could show his stuff, and the scenes where he danced with Shirley Temple were immensely popular. But the significance of these scenes had a subtle but amazing impact on audiences. Here there was a white girl and a black man who could be friends, hold hands with each other when they sang and danced, enjoy each other's company, and be treated as equals.

To show the amazing influence of Shirley Temple, she received a tribute from Franklin Delano Roosevelt when she was seven years old. He said, "During this Depression when the spirit of the people is lower than at any other time, it is a splendid thing that for just fifteen cents an American can go to a movie, look at the smiling face of a baby and forget its troubles."

It was also an incredible year for Charles Laughton, who had won the Academy Award just two years before for *The Private Life of Henry VIII.* He would also appear in three films, *Ruggles of Red Gap, Les Miserable* as Inspector Javert, and his defining role as Captain Bligh in *The Mutiny on the Bounty.* Ruggles of Red Gap is a charming comedy where he plays a proper English gentleman's gentleman, Marmaduke "Bill" Ruggles, who is lost in a poker game by his master and ends up in the wild west. One of the high points of the movies is when Laughton calms a noisy cowboy saloon by reciting from memory the Gettysburg Address. The people on screen (and at the time those in the theatre) were brought to tears with his heartfelt interpretation of Lincoln's immortal speech.

Laughton then turns around and plays a role in complete contrast, without an ounce of humorous compassion. His interpretation of Captain Bligh is one of the great performances in film and was the source of impersonations for decades. He played Captain Bligh in such a way that audiences loved to hate him. *Mutiny on the Bounty* is one of the last films put into production by Irving Thalberg, shot on exotic locations, and has a first-rate cast including Franchot Tone and Clark Gable as Fletcher Christian. This was Gable's first role after returning to MGM from making *It Happened One Night.* All three actors were nominated, but Laughton is the one that steals the movie. It has been said that everything anyone needs to know about screen acting they can learn by studying Charles Laughton in *Mutiny on the Bounty* (1962). In all Laughton made fifty-five films, and the last two were *Spartacus* (1960) and *Advise and Consent.* He also directed one motion picture, the suspense classic *The Night of the Hunter* (1955) with Robert Mitchum as the bloodthirsty preacher.

1936

The year marked the passing of two men, one almost entirely forgotten and the other immortalized as the very definition a great producer. They were John Gilbert and Irving Thalberg. Symbolically Gilbert represents the passing of the silent era. He died just eleven days after New Years, just three years after making *Queen Christina* with Greta Garbo, who had once been his lover and was engaged to marry him. Gilbert's greatest triumph was in King Vidor's epic *The Big Parade* (1925), a landmark film that

A Night at the Opera (1935) directed by Sam Wood and starring Groucho, Chico and Harpo Marx was supervised by Irving Thalberg who had brought the screwball comedy team to MGM with the plan to make their films more commercial. In the past the zany movies by the Marx Brothers had not been very successful and **Duck Soup** (1933) was a complete failure. Thalberg put **A Day in the Races** into production but passed away before it was released. Ironically, the Marx Brothers' biggest success happened in the 1960s when their films were shown on television and in revival theatres. The Marx Brothers were constantly poking fun at established institutions like university life, politics, the military, and grand opera. All this fast-paced horseplay was perfect for the rebellious Baby Boomers.

still has a powerful anti-war statement. In total, Gilbert made 101 motion pictures.

On the silent screen Gilbert had been Hollywood's most desired matinee idol after Rudolph Valentino, but his rumored high-pitched voice lead to a disaster when sound arrived. These rumors were allegedly started by Louis B. Mayer to deliberately harm his career and prevent him from marrying Garbo. The rumors stuck, despite the fact that he proved to have a pleasant voice when he made *Queen Christina*. Gilbert represents the first of many stars that were quickly forgotten by Hollywood, and presents an irony of switched possibilities. If he had died just before sound came in he might be remembered like Valentino; instead he ended his days alone and forgotten, his memory mixed up with false reports about the tone of his voice. He was a man that passed away with silent movies, only he lived nine years after their demise.

Also this year Hollywood lost Irving Thalberg at the age of thirty-seven. During his short tenure at Universal and MGM, he defined the role of the producer, or at least the producer that has a true sense of the artistic contribution to a movie. Producers quite often have the reputation of being metaphorical blackjacks hitting the skulls of fearful writers, actors, and directors. That they walk about looking for problems and being brutal in keeping things under budget.

A good producer has without question many of these characteristics, but he or she is also a mastermind at foreseeing what the public wants, how to get it on the screen, and having a god-like overview of every aspect of the production. During the studio system, a producer would know instinctively which directors, actors, and designers to assign to a film. He knew how to nurse a young actor into a start, and how to take a chance with only a feeling in the gut. Thalberg was there at the beginning of motion pictures and demonstrated how one man in a very short time period can make an almost never-ending contribution to something if he sets his standards very high.

Though he never put his name on his pictures, unlike his fellow rival at MGM, David O. Selznick, Thalberg produced more than eighty films in his short career. They include *The*

Hunchback of Notre Dame with Lon Chaney at Universal and the silent classics *The Big Parade, Ben-Hur, The Flesh and the Devil,* and *The Crowd* at MGM. And then he oversaw many of the early sound classics like *The Champ, Tarzan the Ape Man, Red Dust, Grand Hotel, Red-Headed Woman, Mutiny on the Bounty, A Night at the Opera, Day at the Races, The Good Earth,* and *Goodbye, Mr. Chips.*

Actors that became movie stars in his films, building MGM's reputation for having more stars than any other studio, were Jean Harlow, Norma Shearer (who he was married to), Greta Garbo, John Barrymore, Clark Gable, Lionel Barrymore, Wallace Beery, Maire Dressler. He also restored the careers of the Marx Brothers. In F. Scott Fitzgerald's final uncompleted novel, *The Last Tycoon,* the central character is based on Thalberg. He was the first to package stars together in big budgeted productions, like in *Grand Hotel.* He also secured the talents of the best writers he could find, among them Frances Marion, who wrote for Garbo, Harlow, and Lillian Gish, and James Hilton, whose novels *Goodbye, Mr. Chips* and *Random Harvest* became two of MGM's most memorable films.

Thalberg's enduring gift to the film industry was his pursuit of quality. In the earliest days of motion pictures audiences would have accepted almost anything on the screen and it would have been easy to cut back on production values. Thalberg loved literature and believed that movies could achieve the greatness of a superbly written novel. He brought many of the classics to the screen, but more importantly he brought them to life for audiences. He had costume and scenic designers research and make hundreds of drawings to capture the essence of the time period of the movie, and he was involved in every aspect of production with the writers and directors. When sound came in he secured the rights to best sellers and Broadway plays, realizing how important good dialogue was going to be in defining the movie stars of this new era. Whereas a producer like David O. Selznick was chaotic in his approach to film production, Thalberg was highly organized and knew the project perfectly. He set the standard for all other producers to follow, and his methods are evident today where the costs of motion pictures have become so extreme that a producer must have complete faith in the project and know every minute detail of it or become hopelessly lost in the process.

The big motion pictures this year were Frank Capra's *Mr. Deeds Goes to Town,* which dramatically increased the star power of Gary Cooper, and became the first in a series that were later referred to as "capracorn." Other movies that would later be added to this list are *Mr. Smith Goes to Washington, Meet John Doe,* and *It's a Wonderful Life.* Each of these films combine a strong melodramatic plot and a central character that is torn from innocence into harsh reality, or to be more exact a modern retelling of the story of Christ. All of them show a good man that is thrust into a situation that tests his faith in his fellowman, whether it be through earthly trials, money, politics, women, or the perception of failure. Audiences loved these films because at the core they were purely American, the success story that goes temporarily awry, then ends with a fairy tale ending. This is literally the case with *It's a Wonderful Life,* the only film in this series that was a box office disappointment when it came out after the war, but because of television has become Capra's most popular and enduring film. A plot twist that Capra would have liked.

MGM had two blockbusters this year, *The Great Ziegfeld,* a lavish biography of Florenz Ziegfeld, the legendary theatrical producer, and *San Francisco,* that ends, of course, with a truly spectacular reenactment of the 1906 earthquake, that even by today's standards is remarkable to watch. *San Francisco,* following in

the star-studded tradition of *Grand Hotel,* had Clark Gable, Jeanette MacDonald, and an actor that was finally looked on as a star, Spencer Tracy. Tracy had a dynamite year, appearing in two films with Jean Harlow, *Rifffraff* and *Libeled Lady,* and Fritz Lang's first American feature, *Fury.* In one year, he decisively proved there was nothing he could not do as an actor, from screwball comedy to heavy drama to stealing the screen from Gable.

Once asked what the secret was to acting, Tracy replied, "Come to work on time, know your lines, and don't bump into the other actors." Tracy is one of those actors that instinctually knew the essence of method acting long before it became the rage on Broadway and in Hollywood after the war. He inhabited each of his characters, his eyes were mesmerizing to watch, since they expressed more information to the audience than a full page of dialogue. If Charles Laughton is the actor to study for the classically trained approach to a role, then Tracy is the person to study for his uncanny ability to become the character. There is never a false moment in a Tracy performance, because, as his definition of acting implies, he simply figured out who his character was and then became that person. This might sound easy, but it takes a gift to be able to pull it off. Once asked about the Method, Tracy thought for a moment and said, "The kids keep telling me I should try this new Method Acting, but I'm too old, I'm too tired, and I'm too talented to care."

Tracy would win back-to-back Academy Awards over the next two years for *Captain's Courageous* and *Boy's Town,* and eventually be nominated nine times. He made several films with his buddy Clark Gable, but his most famous partner was Katharine Hepburn, with whom he made nine movies. When Irving Thalberg hired Tracy for MGM, Louis B. Mayer shouted, "Why do we need another galoot for? We already got Wallace Beery." But Thalberg was right and obviously Mayer forgave him.

1937

This is the year when the best film was not a film in the traditional sense but the first full-length animated feature, Walt Disney's *Snow White and the Seven Dwarfs.* Originally known as Disney's follies, taking four years in production at a cost of $1,500,000, which was an extraordinary amount of money, considering that two years later *Gone with the Wind* would be made for three million dollars. To look at *Steamboat Willie,* just nine years before, with Mickey Mouse in black-and-white and crudely animated with almost stick characters, and then at *Snow White* with its sense of pure magical realism, it has to be one of the greatest leaps in any art form ever.

Going from images that were almost primitive art to images that were highly sophisticated and three-dimensional in perspective, with characters that were as complex in their feelings as anything done in live productions, it was simply the impossible coming to life in glorious Technicolor. Disney had a vision of *Snow White* years before and to insure he had the right team of artists he used the *Silly Symphony* as a training ground, turning out hundreds of cartoons, increasing the length of many of them, and pushing for realism of motion. He was a master storyteller and would meet with his artists after dinner and unfold the next projects in precise details. Disney gave his animal characters real human feelings and fears to make the audiences identify with them more, and he experimented with exaggerated animation to give his characters a greater sense of movement and action, like a tortoise stretching its neck way out as it ran.

It has been said that there have been only three true geniuses in motions, Charles Chalplin, Alfred Hitchcock, and Walt Disney. To have the vision to see something so clearly that has never been done before, and to know exactly the steps to take to insure this vision comes to life, is a ex-

During production **Snow White and the Seven Dwarfs** *(1937) was referred to by Hollywood insiders as "Disney's folly." It has been said that there are only three true geniuses in movie history: Charles Chaplin, Alfred Hitchcock and Walt Disney. Today it seems odd to call* **Snow White and the Seven Dwarfs** *a visionary work of art, but that is exactly what it was. What is harder to imagine is a world without animated features. With one film Disney changed forever the concept of established movie entertainment.*

cellent definition of genius. *Snow White and the Seven Dwarfs* premiered on December 24th and was the perfect Christmas present for the entire world. Sergei Eisenstein called it the greatest motion picture ever made up. Disney would ultimately receive a special Academy Award plus seven miniature Academy Awards for his efforts. And since *Snow White* was a musical, it produced several popular hits that played day and night for months on the radio, including *Whistle While You Work, Some Day My Prince Will Come* and *Hi Ho, Hi Ho, It's Off to Work We Go.*

1938

Georges Méliès passed peacefully away at the age of seventy-eight on January 21, 1938. The ingenious magician made his last film in 1914, after completing 560 surrealistic shorts over a productive eighteen years. Through his abilities to turn around what might have been considered mistakes, he invented most of the tricks that are still used for special effects. He introduced the world to a narrative structure and proved that flickering bits of light could tell remarkable stories. Yet, like so many of the early pioneers, his incredible imagination could only focus on a spe-

cific area of filmmaking and he was left behind in the rapid-fire evolution of motion pictures. Still, there must have been hundreds of unfinished films going through his mind. His experiments in the cinema arts ended in a year that included Technicolor adventures, amazing animation, and a special effect, star-packed look at test pilots.

It was a wonderful year for all the studios. Attendance had been steadily increasing, and ticket prices were up to fifty cents at some first run theatres. And the clouds of the Depression appeared to finally be lifting. Despite daily radio reports about what was happening inside Germany, and the fears that Hitler was planning to go to war with his neighbors, most Americans were Isolationists, determined not to get dragged into another costly conflict three thousands miles away. The political problems in Europe would not put a loaf of bread on the table, and that is all that mattered to Americans. That and who would win the big race between Seabiscuit and War Admiral.

At the Academy Awards, Frank Capra took home his third Oscar in six years for the George Kaufman and Moss Hart Pulitzer Prize winning stage play, *You Can't Take It with You.* The movie

The Adventures of Robin Hood (1938) directed by Michael Curtiz and William Keighley and starring Errol Flynn, Olivia de Havilland, Basil Rathbone, and Claude Rains. One of the first films to be shot in glorious Technicolor, this movie was ideal for the Depression Era when bank robbers like John Dillinger and Bonnie and Clyde that were looked upon as modern day Robin Hoods. The rich musical score by Erich Wolfgang Korngold has influenced film music every since, especially movies like **Star Wars** and Titanic. But the movie's biggest asset was Errol Flynn, the only actor then or now that could pull of the roguish behavior of Robin Hood and make it seem absolutely natural.

also won Best Picture, beating out *Jezebel, Boys Town* and *The Adventures of Robin Hood.* The cartoon hit was *Brave Little Tailor* starring Mickey Mouse. These last two films are significant because they represent the biggest change since sound that *did not* happen overnight.

The Technicolor process, after several false starts, had triumphed with *Snow White and the Seven Dwarfs* but had not found a live action motion picture that immediately made it appealing to the general public, like *The Jazz Singer* had done for sound. Color has been part of film since the earliest days. Some sequences were hand painted, which was an incredibly challenging and time-consuming process, but tinting was very common and eventually used in almost every film. Tinting was easy to do, since the developed print was soaked in a color dye, so night scenes would be in blue and battle scenes in red. When the sound tract became part of the filmstrip, the tinting process was abandoned since it would have muted the volume of the sound.

In 1915, Herbert Klamus, a graduate from M.I.T., and his team invented a two-color process by alternately exposing green or red frames with filters. This was done on a single strip of film,

not two strips as is sometimes commonly believed. The result was attractive and proved successful in sequences of Cecil B. DeMille's *The Ten Commandments* and other motion pictures, but it had the appearance of a faded photograph and never caught on. Also, the problems with production were enormous and ultimately proved to be too expensive to justify the limited returns. When the Depression hit, and film budgets became very tight, Klamus' company almost went under.

Instead of giving up, in 1932 Klamus invented a three-color process that was shot in a huge camera built by William Young and cost $30,000, which was a fortune in a time when the average hourly wage was less than fifty cents. This process used three strips of film that ran next to each other in the camera and were exposed red, green, or blue. The look was sensational. The colors were rich and vibrant, a giant leap from the two-color process, and if the timing had been better and the expense was less, Technicolor would have the next natural step in film production. But this was the hardest year of the Depression and the use of Technicolor caused a budget to rise almost 50 percent. The studios were still paying for theatres to be wired for sound. The last thing they

needed was another innovation to drain the rest of their money.

This might have been the end of color film for years if it had not been for Walt Disney. The same year Klamus came up with the three-color process, Disney had begun production on his first Silly Symphony cartoon, *Flowers and Trees.* After seeing a demonstration, he stopped production and re-shot everything in Technicolor. His brother Roy, the man that had to find the money for all of Walt's ambitious ideas, reportedly hit the ceiling, believing that his younger brother had gone completely mad. But his anxiety abated when the eight-minute cartoon was being shown in almost every theatre in America. Later that year Disney released *The Three Little Pigs,* which was even a larger hit because of the song, "Who's Afraid of the Big Bad Wolf" that everyone was singing as the Depression showed signs of recovery. This started a long-term agreement with Technicolor, resulting in some of the most spectacular looking movies ever made, including *Snow White and the Seven Dwarfs, Pinocchio,* and *Fantasia.*

But there was a big difference in an eight-minute short and a two-hour live action feature. The cost was intimidating, but still the success Disney was having was attractive, if the right feature could be found. Louis B. Mayer decided to try out Technicolor and used it for a series of travel documentaries. In 1934, producer Jock Whitner took a chance and made a two-reel musical for the giant sum of $50,000, three times the budget if he had done it in black-and-white, with the unfortunate title of *La Cucaracha.* And finally in 1935, the first full length Technicolor motion picture was released, *Becky Sharp,* based on William Makepeace Thackeray's classic novel *Vanity Fair,* directed by Rouben Manoulian. This did not prove to be *The Jazz Singer* for Technicolor, and the movie was received by audiences with the enthusiasm of one-hand clapping. *The Trail of the Lonesome Pine* fared better at the box office, but only made a modest profit.

The problems with Technicolor were plentiful. In the early days three times the light had to be used because of the low ASA of the film and the filters that were used. This meant that the temperature of the sets would rise to over ninety degrees. The original cameras were the size of refrigerators, and with the sound blimp weighed twice as much. Delays were constant, and before every take tests had to be run, which meant the actors stood in the middle of the set with a chart for color balance called a pumpkin held in front of them for long periods of time while they were in costumes, something that Marlene Dietrich complained about in vulgar English on the set of *The Garden of Allah.* David O. Selznick was the producer of *Allah,* and he, like Disney, thought that Technicolor would give his films prestige and make them a step above other productions. Still he made his next motion picture, *The Prisoner of Zenda,* in black-and-white. And this decision was the result of the almost insurmountable problem with Technicolor, the cost.

Today audiences that grew up in a color world sometimes find it hard to watch black-and-white movies. It seems foreign to them. Music videos and films like *Manhattan, Schindler's List,* and *American History X* are shot in black-and-white but they are the exceptions. For over forty years audiences had grown up with black-and-white. It seemed perfectly natural, and with silver nitrate film the images on the screen were dazzling. But in 1938 there was one motion picture that almost caused another major change in Hollywood.

Warner Bros. took a chance and made *The Adventures of Robin Hood* in Technicolor, with an incredible cast including Errol Flynn, Olivia de Havilland, Basil Rathbone, Claude Rains, and Alan Hale. The original director William Keighley shot much of the film on location, then the

production was turned over to Michael Curtiz who re-shot many scenes and ordered the cast and crew out on more locations. This was not going to be a movie that had backdrops and artificial trees on a sound stage. To insure bright greens for Sherwood Forest, people would arrive before daybreak to spray paint the grass and hang fresh branches, flown in each day, on the trees. The costumes were rich primary colors, and the movie looked like a Howard Pyle painting come to life.

Robin Hood was a good bet for a big budget movie during the Depression. Outlaws like Bonnie and Clyde and John Dillinger were called modern day Robin Hoods, and with Errol Flynn the studio had the right actor for the role. Erich Wolfgang Korngold, the acclaimed Austrian composer who studied under Richard Strauss, was persuaded to score the movie, which he reluctantly agreed to do, fearing he could not compose to meet the grand scale of the movie. The end result is one of the best loved and most influential scores ever, winning Korngold the Academy Award.

The Adventures of Robin Hood was finally the right motion picture to generate excitement about Technicolor. People went to see it over and over again, making it one of the biggest hits of the year. It was not just the look of the film and the cast, *Robin Hood* was written with style and humor. In one scene Robin Hood is accused of speaking treason against King John, and Errol Flynn answers with fearless ease, "Fluently." The fight scenes, one of Curtiz's specialties, were, and still are, genuinely exciting to watch, with men being shot by arrows as the camera rolled. (Stunt men wore metal breastplates with light wood coverings clamped to them. They were given bonuses of up to fifty dollars, depending on how far back the archer was when he shot.) It had fun, romance, adventure, and has endured as one of Warner Bros. most popular motion pictures, and the one Errol Flynn will be best remembered by. Years later when Kevin Costner made his version of Robin Hood, he was asked if he was going to wear tights, and he replied that only Flynn could get away with that.

Because of the success of *The Adventures of Robin Hood* there was a rush to make Technicolor features. The following year produced some of the very best, including *Drums along the Mohawk* directed by John Ford, *Gulliver's Travels,* the full length animated feature by Max Fleischer, *Jesse James* directed by Henry King, and the two most famous, *Gone With the Wind* and *The Wizard of Oz.* But by the end of 1939 the studios were facing another difficult time with the war in Europe beginning and losing their second biggest market. War films and dramas replaced the escapist glamour of the Depression Era, and black-and-white suited the mood of these films. Early television was in black-and-white and did not change over to full color until the mid-60s. An Academy Award was given for black-and-white cinematography from 1927 to 1966. *Who's Afraid of Virginia Woolf* was the last to win in this category, but in 1993 *Schindler's List* won.

So, if the war had not broken out, then Technicolor might have been used more during the 1940s, instead of for the occasional musical. And if *The Jazz Singer* had opened a year later, on the eve of the Wall Street Crash, then it might have taken years for sound to replace silent movies. These are a few of the what-ifs that perpetually hover around film history.

Another significant event happened this year; rumors of a film festival in Cannes became a reality. There had been talks of having a festival for years, with the British and Americans encouraging an international festival somewhere in the sunny beaches of southern France. With the exception of the years during World War II, this sleepy little town would be invaded with moviemakers from around the world, creating controversies still today, turning unknowns into stars, and celebrating great films that reflect the art of cinema.

1939

This is the Golden Year of the Golden Age of the studio system. Whatever created such a remarkable and fruitful year, Hollywood has searched for the formula. Perhaps it was because of the continued unrest in the world, the threat of war which would erupt before the year's end, and the Depression now going into its tenth year that caused Hollywood to reach such heights. Whatever the reasons, 1939 produced more masterpieces than any other year in motion picture history. Here are just a few: *Goodbye, Mr. Chips, Mr. Smith Goes to Washington, The Roaring Twenties, Wuthering Heights, Dark Victory, Ninotchka, Of Mice and Men, Beau Geste, The Hunchback of Notre Dame, Only Angels Have Wings, Gunga Din,* and *Love Affair* (which was remade as An Affair to Remember). John Ford had a remarkable year with *Drums along the Mohawk, Young Mr. Lincoln,* and *Stagecoach.*

These films represent an excellence in storytelling that shows that just over ten years after sound arrived Hollywood had literally found its voice in motion pictures, which translates into a ideal balance between sight and sound. Movies had become photographed stage plays during the early sound days and the freedom of moment that was part of the silent area disappeared. But as technology incredibly increased the abilities to mobilize the camera, and still meet the demands of sound, the visual language of the silent movies returned.

The star system also became a key ingredient in telling stories in the movies. As Alfred Hitchcock once observed, he could save fifteen minutes in a motion picture by casting Cary Grant. This meant that the audience knew Grant and when they saw him in a certain role they already had a good impression of the character. Only a few more details were needed to fill in the

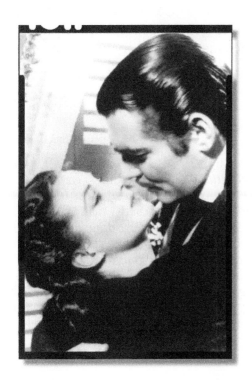

Gone With the Wind (1939) directed by Victor Fleming (with additional scenes by George Cukor and Sam Wood) was the crown jewel in what has been called Hollywood's Greatest Year. This Civil War epic is a quintessential romantic melodrama and the ultimate woman's picture of the Studio Era. The film mirrors some of the hardships that people were experiencing during the Depression which made the identification even stronger. There was a nationwide search for Scarlett O'Hara (who was almost called Pansy in the novel) that lasted for almost two years. There were outcries of protest when the role went to Vivien Leigh, an English woman who had never made a film in Hollywood, but when the lights went down audiences knew she was the perfect Scarlett.

character. A good example is Gunga Din, a film that changed the adventure genre and later had a great influence on the Indiana Jones movies. Once the audience knows that Grant's character has a incurable lust for lost treasures, nothing else needs to be said, and everything that follows seems natural for that character. The same is true with *Mr. Smith Goes to Washington;* once the audience knows that James Stewart is playing a character who is honest to the core, everything that befalls Smith later on fits perfectly with the public persona of Stewart. The best example is Clark Gable in *Gone With the Wind.* In one shot, as he looks up at Scarlett climbing the stairs, the world bought him as the dashing, mysterious Rhett Butler.

The movie that took all the honors was David O. Selznick's *Gone With the Wind.* In this year, to have one motion picture be notably the number one box office champion was unquestionably a major feat. If converted into today's dollars, *Gone With the Wind* by many calculations is the most successful film of all times. The story has influenced countless films since it release, and the look and scope of the film has endured as the primary example of Hollywood in its Golden Era.

And it was a motion picture plagued with problems that fit its epic scale and would have sunk any other production of that day.

There was no lead for the role of Scarlett O'Hara until filming actually began. The budget doubled by the middle of production, forcing David O. Selznick to turn to MGM for the extra capital to finish shooting and in the process gave away a large portion of its distribution rights. The first director and one of Selznick's closest friends, George Cukor, was fired a few weeks into production, and Victor Fleming was taken off the final weeks of shooting *Wizard of Oz* to take over the directing chores. Then because of the pressures of filming and Selznick's maddening ways of management, Fleming had a nervous breakdown and disappeared for several weeks. A third director, Sam Wood, was hired on to fill in for Fleming, and when Fleming returned Selznick kept both directors working.

The technical problems were staggering, and cannot be truly appreciated today when working with color and location shooting is much easier. William Cameron Menzies was without question the man that forged the concept of Production Design, which means that every aspect of a film

Gone With the Wind was originally going to be directed by George Cukor who, as close friends, had worked several times with David O. Selznick, but the early scenes lacked the dramatic punch of the novel. Clark Gable, who was very insecure in the role of Rhett Butler, was afraid that the women in the film would get all the attention, so he suggested bringing in action director Victor Fleming, who was in the final weeks of shooting **The Wizard of Oz.** *This is how Fleming ended up making two of Hollywood's most enduring classics in the same year.*

is designed and planned in advance by this person. This includes the sets, costumes, props, cinematography, matte shots, and special effects. Every aspect of the motion picture is overseen by the Production Designer, from the colors used in each scene, the choice of fabrics, the make-up, even finding the right red dirt for the carriage entrance to Tara.

Gone With the Wind was shot on the back lot of Selznick studios which was next door to MGM, and only a few full sets were made. Most of the Southern mansions were brilliant matte paintings. Even the path leading up to Twelve Oaks was a matte, as were most of the ceilings in the large buildings. But the biggest challenge for Menzies, and the most critical, was the color scheme for the Technicolor process. This was a brand new area for filmmakers, and it was being used on the most expensive motion picture ever made; it had to be perfect. To study each scene in *Gone With the Wind* is a crash course on color design. The colors were picked in each scene to compliment the dramatic action, to make a statement about the characters, or to contrast with scenes later in the motion picture. Tara, Scarlett O'Hara's plantation home, has three distinctive moods, from spacious and freshly painted white before the war, to somber tones and uninviting after the war, to almost dreamlike at the end of the epic tale.

But when it premiered, the only thing on the screen was the crown jewel of the studio era and a perfect motion picture for the times. *Gone With the Wind* is an example of a movie that takes place in another era but reflects all of the conflicts and human emotions of the year it was made. The story begins in a time of careless prosperity at the height of the Southern aristocratic lifestyle, then plummets down into Civil War, followed by a prolonged economic depression. It was very much like the Roaring Twenties that disappeared over night when the Depression hit. Scarlett O'Hara, with her desire to regain part of the glory of her past at any cost, is the center of the tale, making her one of the most interesting and complex screen heroines that ever came before the camera.

The search for the right actress to play Scarlett O'Hara was built into the promotion of the film itself, whether incidentally or with great foresight will always be argued. But the perfect Scarlett was someone that everyone was talking

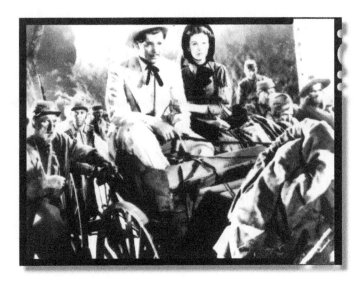

Gone With the Wind was shot almost entirely on the back lot of Selznick International in Culver City. William Cameron Menzies was given screen credit as production designer. He created conceptional drawings of all the major sequences and color coordinated the look of the sets and costumes in each of the scenes, which as a major task in the early days of Technicolor. Almost half of the movie has elements of matte paintings to block out modern city skylines or to expand the look of the interiors. Jack Cosgrove was in charge of special photographic effects and his job was to make all the matte paintings blend seamlessly into each shot. Today all of this would be done in front of a green screen.

about. City after city would hold auditions, with all the fine Southern belles showing up, each one convinced in her heart that she was perfect for the role. But Vivien Leigh was meant to play this role. In every scene as Scarlett, she is completely unafraid of showing a side of a woman that manipulates people, uses men to get what she wants, and has no compulsion about lying if it benefits her. In her pursuit to bring the past alive again, she ends up betraying her one opportunity for true love.

Gone With the Wind is the perfect Hollywood melodrama and over the decades has influenced every film that attempts to show the rise and fall of a family set against the backdrop of American history. *The Godfather* is often referred to as a modern *Gone With the Wind*. They both open with a celebration, one at a barbecue and the other at a wedding, and all the principle characters are introduced. Both families, the O'Haras and the Corleones are ruthless in their pursuit of success, and both stories are about the rise and fall of a powerful family. Both movies show how violence changes the family structure, and both are about children that must take over the leadership after the head of the family, a father that began life in America as an immigrant, falls victim to violence.

American literature has always been fascinated with the rise and fall of great men, undoubtedly coming from the true tales of capitalism and the sudden rags-to-riches exploits of many self-made millionaires. The gangster films in the early sound era embraced this theme with characters like Little Caesar and Tom Powers in *The Public Enemy*. Margaret Mitchell takes this theme and puts a strong-willed woman in place of the traditional male role, making Scarlett one of the most fascinating and most American characters in literature.

Both the novel and the motion picture of *Gone With the Wind* defined rules for any book,

movies, or television series like *Dallas, The Sopranos,* or any afternoon soap opera, that takes an episodic look at the misuses of money and power. The fascination with the Kennedy dynasty certainly reflects this. As Darth Vader observes, a character that ventures over to the "dark side" is captivating to audiences, and certainly *Star Wars* is about internal family conflicts and who will be the master, the father or son. Since Scarlett was very determined to get what she wants at any cost, she still seems as contemporary and complex today as she did for women back in the Depression.

And if all these exceptional motion pictures were not enough, this was also the year of *The Wizard of Oz*, the movie that probably has been seen by the widest audience of any film ever. This exposure is twofold, like *Gone With the Wind*, it looks and feels like no other film, thus no matter how many times it has been imitated it is still an original, and because of television. *The Wizard of Oz*, which might be the best salute to vaudeville every done, was not a big success when it was released. It was popular, but the war had broken out in Europe and the mood of America was beginning to change already.

Gone With the Wind fit the changes in the time almost as if by design, but *The Wizard of Oz* felt a little too old-fashioned even in 1939. Ironically the nostalgia it evokes today, like *It's a Wonderful Life* (another box office disappointment), is one of its enduring qualties. It was not until *The Wizard of Oz* began to be shown on television, originally every Easter, that it found a giant audience. Originally it was shown only in black-and-white, because color had not arrived yet on television, so it must have been a big surprise to audiences when Judy Garland opens the door and there is the brightly colored world of the Munchkins.

The Wizard of Oz has become legendary with the problems of creating some of its most

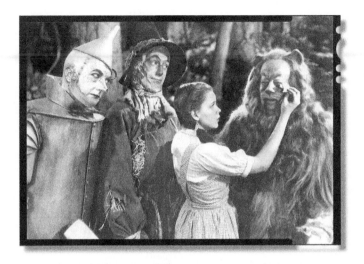

The Wizard of Oz (1939) directed by Victor Fleming, starring Judy Garland, Ray Bolger, Bert Lahr, Jack Haley, and Terry, as Toto, was MGM's big-budget musical fantasy and a box office disappointment when it premiered. By the end of 1939, war had been declared in Europe and the daily broadcasts on radio seem to dampen the American public's interest in stories about evil witches and cowardly lions. Also more than a third of MGM's revenue came from countries like England, France, Italy, and Germany, and overnight these markets were in turmoil. Greta Garbo's films depended greatly on her popularity in Europe. She would only make one more film, *Two-Faced Woman* (1941) and then retire. *The Wizard of Oz* would become an annual Easter weekend event starting in the late 1950s when it was rediscovered by millions. But no studio undertook a major fantasy film again until *Mary Poppins* twenty-five years later.

beloved images. First there was the acting call for hundreds of midgets to play Munchkins, then the constant problem of Technicolor and building massive sets painted with bright colors that were almost blinding. Buddy Ebsen had to be replaced as The Tin Man because the aluminum dust used for his make-up settled into his lungs. Louis B. Mayer did not want Judy Garland for the film and was trying desperately to get Shirley Temple. Margaret Hamilton, The Wicked Witch of the West, was almost incinerated in one take and fell off her broom during another, both times having to be rushed to the hospital. All of these add up to great folklore about the movie.

There was high vaudeville with actors like Bert Lehr as The Cowardly Lion and Ray Bolger as The Scarecrow, who captured the music, dance, and humor of this bygone era. And it gave Frank Morgan the role of a lifetime as the Wizard, or more appropriately, the *roles* of a lifetime, showing the talents of one of the most versatile character actors in Hollywood. Louis B. Mayer had wanted W. C. Fields for the part, but fortunately this did not work out either. Fields would

have brought the humor but not the heartbreaking sensitivity to the role that Morgan did. He made the Wizard his own. But ultimately, it was Judy Garland's performance that anchored everything into a marvelous sense of make-believe reality. Her emotions throughout were absolutely perfect and her ability to show joy or fear that struck a perfectly real cord made Dorothy Gale one of the most memorable women's characters in film. Like Orson Welles who will forever be identified with his character in *Citizen Kane,* Judy Garland's life will always be reflected in *The Wizard of Oz.* But even if someone does not know the sad story of Garland's career, it is almost impossible not to have an emotional surge when she sings *Over The Rainbow* to Toto. No one but a truly exceptional talent could have bought such feeling to a song, making it almost impossible for anyone else to sing it as well, even today.

One of the first behind-the-scenes books to come out was "The Making of The Wizard of Oz." It began the public obsession of peeling back the curtain of Movie Magic and seeing exactly what made it tick. In the case of *The Wizard of*

Oz, it seems to add a greater enjoyment to watching the motion picture. *Oz* was one of those rare films in the 1930s that had a lot of special effects and fantasy locations. But all the effects, sets, and costumes still enchant viewers, where so many of the other effects-oriented films from this time period have a tendency to seem very artificial. There is something perfectly natural in the artificial realm of *Wizard of Oz* that makes it a place of desire that children young and old would like fly to and step out into a glorious land of Technicolor.

All of these motion pictures hold up like vintage automobiles. They are fun to go back and see time and again. They still have the ability to entertain, and they have that first-class touch of quality that almost every movie made in 1939 seems to somehow magically possess.

THE DIRECTORS

To pick the outstanding directors of the Studio Era is a daunting task, because almost every director that was doing major work within the studios had at some point during this brief but exquisite era produced what is now commonly referred to as a four star movie. Many of the directors that would become noteworthy over the next two decades were beginning to put an early mark on films. And directors like John Huston, Billy Wilder, and Preston Sturges were writing scripts but had not yet been given the chance to direct their first movie. Other directors had learned their trade in the silent era making literally scores of films before sound came in, developing a craft and style that forged a visual language for all future filmmakers.

These directors often would direct two, three, and sometimes even four films a year, so there was the ability to have a director go from one project to another. Most directors locked their cameras down, meaning they would put it on a tripod, giving it a slight up-tilt from a low angle to allow the actors a strong presence on screen. The distinguishing characteristics of many directors were storytelling, pacing, the use of actors, and the relationship with the cinematographer, but not the complex camerawork associated with modern directors. This does not mean there are not scenes with remarkable tracking shots, but they were rare and extremely difficult to achieve due to the size and weight of the cameras. Since Hitchcock had complete freedom to experiment

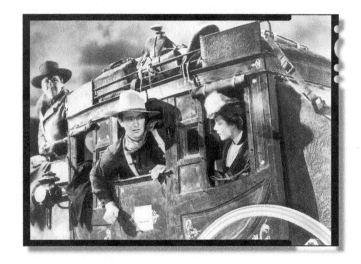

*Stagecoach (1939) directed by John Ford is the film that finally made John Wayne an A-list movie star. It has been assumed that Westerns died out when sound came in, and were not revived again until **Stagecoach**, but this is not entirely true. Poverty row studios like Republic turned out scores of B-movie Westerns during the 30s. Wayne was featured in more than sixty of them before he was given the star treatment by Ford. But after **Stagecoach** directors like Michael Curtiz, Howard Hawks, William Wellman, George Stevens and William Wyler all made classic Westerns.*

while in England, he is one of the exceptions that moved the camera to tell a story.

Directors like John Ford rarely took more than one take and knew instinctively how to piece a film together from years of experience on Westerns and other low budget features where there was not the time or money to get complete coverage. Other directors were at the mercy of the head of productions in the studios and were given the mandate to shoot full coverage, meaning long and medium shots, reverse angles, close-ups, inserts, and cutaways. These shots would give the producer plenty to look at in the editing room, usually while the director was off on another assignment.

Some directors preferred full coverage or covered their bets with endless takes. George Stevens, unlike Ford and Hitchcock, would shoot from every angle multiple times. William Wyler was very exacting about his camera angles, often working with cinematographer Gregg Toland, but he would shoot a scene over and over until the actors were sometimes begging for a bit of direction. He would just tell them to do it again, looking for that little bit of spontaneity that sometimes might be on take two of fifty-two.

The concept of a director communicating insightfully with each of the actors, giving them thoughts on the inner psychology of their characters, is not true. Actors were there because of their ability to work quickly and effectively in every possible genre. Lead actors were given lessons in movement, sword fighting, and singing, depending on their next role. And versatile characters actors were cast because of looks, speech patterns, or their simple ability to get a laugh from a reaction shot. Many of these character actors became as well known as the movie stars and beloved by fans for decades. Thomas Mitchell, for example, had a great year in 1939, appearing as Clopin in *The Hunchback of Notre Dame,* a hard-nosed reporter in *Mr. Smith Goes to Washington,* an over-

the-hill pilot in *Only Angels Have Wings,* Scarlett O'Hara's father in *Gone With the Wind,* and winning an Academy Award as a doctor that likes a shot of whiskey in *Stagecoach.*

This was one of those rare times when screenwriters were instructed to give a lot of character information and visual descriptions. Like character actors, screenwriters were often assigned to a project because of their flair in writing love scenes, action sequences, comedy bits, or for being able to take an eight-hundred page novel and cut it down to a two-hour feature. The screenplays had detailed information that the producer approved, and would become the bible for the director and actors to use for character background and the visual mood of scenes. They are very different looking scripts than those of today, which have a minimalist approach to screenwriting. Most of the major writers had their turn in Hollywood because of the lucrative paydays and wild weekends. Some survived like Ben Hecht; others like Herman Mankiewicz and F. Scott Fitzgerald were destroyed by it. William Faulkner took the money and went back home to write some of his best novels, and Ernest Hemingway just sold his novels but never became a writer for hire.

Some directors earned the right to insist upon certain actors, like what became known as the Ford Stock Company, which always have variations of Victor McLaglen, Barry Fitzgerald, Ward Bond, John Wayne, Maureen O'Hara, Ben Johnson, Mildred Natwick, Harry Carey, Jr., Jane Darwell, John Carradine, his older brother Francis Ford, and Henry Fonda, until they had a falling out over *Mister Roberts.* There were also few directors that moved from studio to studio, like Howard Hawks who worked with a wide variety of actors, but still had his favorites like Cary Grant, John Wayne, Walter Brennan, Humphrey Bogart, and Lauren Bacall. And these A-list directors could insist upon favorite writers. Ford

used Dudley Nichols, Frank S. Nugent, and Nunnally Johnson on many films, and Hawks liked Nichols and Jules Furthman, worked occasionally with Ben Hecht and Billy Wilder, brought William Faulkner to Hollywood, and wrote some of his best scenes himself. Alfred Hitchcock collaborated with Ben Hecht seven times and four times with John Michael Hayes.

In retrospective, the top of the list of the directors for this era would be would be Frank Capra, John Ford, and William Wyler. Capra was the director that in six years won three Academy Awards for *It Happened One Night, Mr. Deeds Goes to Town,* and *You Can't Take It With You.* He ended up the decade with *Mr. Smith Goes to Washington.* More than any other director, Capra created the enduring image of small town America. The best of Capra's films are time locked in the 1930s, even *It's a Wonderful Life,* made after the war. He knew of the hardships of the Depression and was not afraid to show them on the screen, turning them into fables about how one man could make a difference. They were uplifting and still ring true with the basic human belief that one good life changes many others. But when he returned from the war, his films reflected a different person. Capra's belief about one man making a difference had been shaken, because he had now seen that the wrong man could also change millions of lives in a terrible way. The faith he had for positive change seemed hopeful and old-fashioned in the post-war America of large industrial cities. Ironically, over the years it was Capra's depiction of old-time values that has made many of his films endure and find new audiences.

John Ford and William Wyler would make their greatest films over the next two decades, but each had exceptional motion pictures during this era, ending in 1939 with superb examples of what was yet to come. *The Informer* was a daring work done on a small budget. The mood and look of the film, especially the opening sequences, had the influence of German Expressionism. The images were dark, stylish, and symbolic, a departure from Ford's earlier films. By the time he made *The Informer* he had shot eighty-four shorts and features. He followed his actor brother Francis Ford to Hollywood and began his career as a jack-of-all-trades, including props and stunts. Ford proved more than capable of handling tough actors and working with cowboys. He was fast, cut the scripts (or notoriously lost pages) to keep the action moving, and loved working outdoors.

"It is no use talking to me about art," Ford once rebuked, "I make pictures to pay the rent." But even in his earlier films there was a natural sense of composition in his camera shots. He cut in the camera, meaning that he shot many of his earlier films in continuity, with usually only one take per camera setup. This meant he was always thinking about his next series of shots and how they would be edited together. Steven Spielberg once observed about Ford's style that it is an approach that might sound simple, but it can turn into a disaster for a director that is not perfectly organized. But like it or not, *The Informer* marked a turning point for Ford. He had become a true artist, something he would probably had punched someone in the eye for saying, but after his dark tale of the Irish Revolution his films began to take on a greater scope.

It has been said that Ford was a chronicler of the American heritage, but looking back on his films he was more the Hollywood Homer. A man who believed in the embellishments of oral tradition, Ford showed what American history should have been like, more than he attempted any faithful reenactment of events. He had displayed his Irish roots on the screen many times before, usually as comic interludes, but *The Informer* was different, this was a real taste of the Irish tradition he was eternally passionate about. The Irish Catholics had not been welcomed in Protestant America, and were resented

with the same intensity as Jews and African-Americans. Ford's films, along with the arrival of actors like James Cagney and Spencer Tracy, began to change this. He loved the rituals of military and family traditions, all with a touch of the Irish and old folk songs, and this became a galvanizing experience for many Americans during the Depression.

The Informer has a different look than most of Ford's later films, since he was experimenting with style, but in 1939 he made three motion pictures that were unmistakably his own and became landmarks: *Young Mr. Lincoln, Drums along the Mohawk,* and *Stagecoach.* With *Young Mr. Lincoln* he brings the early years of this great president to life, treating him as an ordinary person in search of an exceptional destiny. Lincoln had been played almost like a regal Shakespearean character in movies before this. Ford's Lincoln was a simple man with a country wit, who would use humor and common sense to outsmart his opponents. This would not be the last time he presented history in the disguise of a folk tale.

Drums along the Mohawk was in glorious Technicolor, and about the hardships and dangers of pioneer life in the years before the American Revolution. But Ford's most popular film this year was *Stagecoach,* which thrilled audiences with life on the frontier of the old West, with an Indian attack, a rescue at the last second by the 7th Calvary, colorful characters, outlaws, and a shootout at the end. This was the first big studio Western since *Cimarron* eight years before and made a star of a young actor named Marion Michael Morrison, who had changed his name to John Wayne. Ford gave Wayne the star treatment in the movie, when from the point-of-view of the stagecoach a dark figure is seen in the twilight. As the horses slow down, Ford moves his camera in on Wayne, as if the sheer power of his presence is stopping the stagecoach, until the screen is filled with a close-up of the young actor's face. From that moment, Wayne climbed to the top of the Hollywood star list and stayed there for the next forty years.

William Wyler studied music in Paris, business in Switzerland, and somehow ended up at Universal making Westerns. Like Ford, he learned his craft making quick cowboy tales. "I used to lie awake at night," he once said, "trying to think of new ways of getting on and off a horse." Unlike Ford, he only made a few Westerns after sound

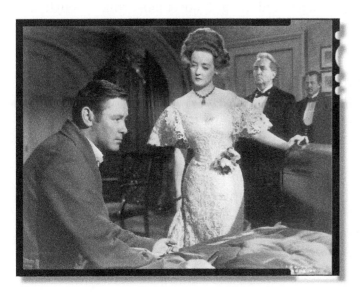

*The Little Foxes (1941) directed by William Wyler was the third, and last, film he made with Bette Davis. In a relationship that was often explosive on the set, the two had also worked together on **Jezebel** (1938) and **The Letter** (1940). Wyler was identified with Goldwyn Studios; his greatest period of creativity was from 1936 to 1946 when he directed **Dodsworth** (1936), **These Three** (1936), **Dead End** (1937), **Wuthering Heights** (1939), **The Western** (1940), **Mrs. Miniver** (1942), the documentary **The Memphis Belle** (1944), and **The Best Years of Our Lives** (1946). Wyler's favorite cinematographer was the remarkable Gregg Toland, who won his only Oscar for **Wuthering Heights.***

came in, but there was no genre of film he could not master, from dramas to comedies to epics like *Ben-Hur.* In 1936, Wyler began a long association with Samuel Goldwyn, starting with *These Three,* an adaptation of Lillian Hellman's controversial play *The Children's Hour,* which he remade twenty-five years later because he felt the Hays Office had censored the theme of homosexuality too much in the original.

Wyler's next film, *Dodsworth,* made the same year is based on Sinclair Lewis' novel about a middle-aged man's estrangement with his frivolous wife while on vacation in Europe. Many consider this Wyler's finest motion picture, which is an extremely difficult choice to make. Next he brought to the screen the Broadway hit *Dead End* by playwright Sidney Kingsley, about Public Enemy Number One, Hugh "Baby Face" Martin, played to perfection by Humphrey Bogart, who returns to his old neighborhood to see if he can recapture part of his past. This gave Bogart one of his first major roles and made famous the Dead End Kids, who went on to make dozens of B-movies together as the East Side Kids and the Bowery Boys.

In 1938, Wyler worked with Bette Davis for the first time on the motion picture *Jezebel,* which began a long and volatile working relationship. Davis won her second Academy Award as a tragic Southern Belle, just the year before Vivien Leigh won for her Southern Belle in *Gone With the Wind.* Wyler and Davis would make two more remarkable films together, *The Letter* (1940) and *The Little Foxes* (1941), but her arguments over how scenes should be shot caused them not to speak afterwards for years.

Wyler was a perfectionist, working a lot in master shots with long takes and blocking his actors so they created different configurations within the scenes. Gregg Toland, his favorite cinematographer, would set up a shot with an extreme depth of field, then block his actors to move from close-ups to long shots, effectively editing within the frame. One of the most famous is in *The Little Foxes,* where Bette Davis' character is seen in a close shot as her ailing husband, played by Herbert Marshall, leaves her side to get his heart medicine. Davis does not move an inch to help as the husband collapses behind the chair, and then reemerges a few seconds later trying to climb the stairs. When he falls, Davis knows the moment is right and rushes to the stairs calling for help, knowing her husband is now dead. This was all done in one take. Wyler would also have actors do many retakes of the same shot, which often lead to complaints, until the actor saw the final cut.

Like Ford, Wyler had a turning point in his career in 1939, which reflected the quality of films to follow. He directed an adaptation of Emily Bronte's gothic novel *Wuthering Heights,* which made a star of English stage actor Laurence Olivier and won Gregg Toland his only Academy Award for the magnificent black-and-white cinematography. *Wuthering Heights* shows Wyler's skills as a visual storyteller, without a single wasted shot, and with excellent performances from all of his actors. Wyler captures the mystery and passion of one of the greatest love stories of the ages, and brings a novel most critics thought impossible to the screen. Olivier credits Wyler for proving to him that the classics could successfully be transported to the screen, which he later did in his productions of *Hamlet* and *Henry V.* Three years later, Wyler would direct one of the most popular films of World War II, *Mrs. Miniver,* then leave for war service where he would make documentaries, including *The Memphis Belle.*

There are many directors who have been unfairly identified with the studio they worked longest with and are often overlooked as being true auteurs by members of the French New Wave, but an objective examination will reveal an original approach to moviemaking by each of

them. George Cukor started out at RKO, but his longest stay was at MGM. He directed Katharine Hepburn in her first film, *Bill of Divorcement,* and then *Little Women,* her biggest hit of the 1930s. Later at MGM he directed her in *The Philadelphia Story* and many of the Spencer Tracy and Hepburn motion pictures, including *Adam's Rib* and *Pat and Mike.*

Cukor worked with many of the giants of this era, like John Barrymore and Jean Harlow in *Dinner at Eight,* Greta Garbo in *Camille,* Cary Grant in *Holiday,* and just about every major female star in *The Women,* including Norma Shearer, Joan Crawford, Rosalind Russell, and Paulette Goddard. James Stewart, Ingrid Bergman, Ronald Coleman, and Judy Holliday all won Academy Awards under Cukor's direction, and technically so did Vivien Leigh in *Gone With the Wind.* Cukor worked on the pre-production of the Civil War epic with close friend David O. Selznick, then shot several scenes that remained in the motion picture, but was he fired a few weeks into the troubled production. Leigh was so upset about his departure that she continued to meet with him in secret as her dramatic coach. Cukor was an actor's director who really did give fine bits of characterization advice, unlike John Ford who often used intimidation, or Hitchcock who said an actor's motivation was his paycheck.

Michael Curtiz is a director who is never given enough credit for truly being unique in his directing style and who is often over looked. Perhaps this is because of his arrogant personality or the fact that most of his movies were in the adventure genre, which is never taken seriously by critics. Actually, Curtiz has worked in every genre, like Robert Wise and later Steven Spielberg, but too often during the Studio System this versatility got the label of "studio director," someone who only makes films for popular entertainment.

In 1938, Curtiz became the only director up until Steven Soderbergh in 2000 that was nomi-nated for two Academy Awards in one year, for the romance *Four Daughters,* that introduced the world to John Garfield, and the Cagney gangster classic *Angels with Dirty Faces.* He certainly made action adventures movies, some of the best with Errol Flynn, including *Captain Blood, The Sea Hawk,* and *The Adventures of Robin Hood* (which was also shot in '39). In 1942, he changed gears and directed the flag waving musical *Yankee Doodle Dandy,* which got Cagney his long overdue Academy Award. And the following year Curtiz made *Casablanca,* one of the most popular movies of all time and usually way up on everyone's top ten list of the greatest films.

But still Curtiz has not become a legend like Ford or Hawks, who both made films for popular public consumption. Steven Spielberg talks about Curtiz's camerawork, which, like Hitchcock, is sometimes astounding as to how he found ways to follow the action with a camera the size and weight of a refrigerator. One of his trademarks is large, looming shadows on the wall, like in the duel to the death in *The Adventures of Robin Hood* or when Humphrey Bogart opens the safe in *Casablanca.* Curtiz also made *Mildred Pierce* (1945), considered one of the first and best in the film noir genre, and won Joan Crawford her only Oscar, but never became a darling of the French New Wave.

Victor Fleming is another director that is overlooked in the sands of critical film history, though many of his motion pictures are among the most popular ever made. He started his career as a successful cameraman. As a director he brought a sense of rugged sexuality to movies, like *Red Dust* (1932) with Jean Harlow and Clark Gable. And, like Curtiz, he was a master of adventure movies. Fleming's adaptation of Richard Kipling's *Captain Courageous* (1937) won Spencer Tracy his first Academy Award, and featured an all-star cast that included Lionel Barrymore, Mickey Rooney, Freddie Bartholomew, and Melvyn

Douglas. A favorite among leading men, he worked with Tracy on *Test Pilot* (1938), *Dr. Jekyll and Mr. Hyde* (1941), and *A Guy Named Joe* (1943), which Steven Spielberg remade as *Always* (1989). Gable called his friend in to take over the directing duties on *Gone With the Wind* when George Cukor was fired, which meant that Fleming left before he completed *The Wizard of Oz*. This gave him the two most watched, honored, and remembered motion pictures in the Golden Year of the Golden Era.

There were many other important directors in this era. William ("Wild Dog") Wellman, who had made *Wings* and *The Public Enemy*, co-wrote and directed the original *A Star Is Born,* and made the screwball classic *Nothing Sacred,* both in 1937. In 1939, he made two of the great adventure films, *Beau Geste* with Gary Cooper and Rudyard Kipling's *The Light That Failed* with Ronald Coleman. Henry Hathaway, who was always noted for his action films, directed *The Lives of a Bengal Lancer* (1935) with Gary Cooper. Louis Milestone who directed the powerful anti-war film *All Quiet on the Western Front,* brought the John Steinbeck novel *Of Mice and Men* (1939) to the screen staring Lon Chaney Jr. in a role of a lifetime, before he became forever identified with the Wolf Man.

Leo McCarey directed the Marx Brothers in their truly zany comedy, *Duck Soup* (1933), then followed this with *Ruggles of Red Gap* (1935) starring Charles Laughton. McCarey won the first of two Academy Award for his screwball comedy *The Awful Truth* (1937) with Cary Grant and Irene Dunne. He then turned around and made the definitive Hollywood weeper *Love Affair* (1939), with Irene Dunne and Charles Boyer, which was remade eighteen years later as the four-handkerchief movie *An Affair to Remember* with Cary Grant and Deborah Kerr, the film that Meg Ryan is influenced by in *Sleepless in Seattle.*

In England, after the success of *The Man Who Knew Too Much, The 39 Steps,* and *The Lady Vanishes,* Alfred Hitchcock had packed his bags and was headed to the United States to work with David O. Selznick. They originally planned on telling the story of the Titanic, with the grand but financially mad scheme of sinking an actual ship around Long Beach. But ultimately they ended up making the Daphne Du Maurier international best selling novel *Rebecca,* a motion picture that won top honors for Selznick two years in a row, and gave Hitchcock the opportunity to make his first American suspense film.

AMERICAN MULTICULTURAL FILMS

African-Americans

The Production Code did not directly address the problem of ethnic stereotyping, and advances during this time were hard fought; but movies were beginning to show more of a variation on characters. With the exception of minstrel musical numbers in some musicals, black actors played black characters. This was not true with Asian, Latino, or Native American major characters, who would continue to be performed by white actors in make-up for another thirty years. Ethnic groups reject many of these characters today because of what the physical images implied to audiences at this time, some of which were profoundly negative.

After *The Birth of a Nation* there was an uneasy feeling over the depiction of the African-Americans. There were no longer scenes of drunken violence or attempts to rape young white women, and the use of blackface disappeared. The roles became simplified. They were shown as people who broke easily into song,

loyal servants that tapped danced up and down staircases, and were the comic relief for a sassy one-liner.

A turning point happened when Hattie McDaniel became the first African-American to win an Academy Award for her performance as Mammy in *Gone With the Wind.* No one could dispute she deserved the honor that year. As an accomplished actress, every moment she was on screen was a masterful bit of scene stealing, and her character was the glue that held all of the episodes of the epic motion picture together. It was a great performance that resulted in a memorable character.

Hattie McDaniel once remarked, "I would much rather play a maid than be a maid." Her performance brought a greater sensitivity and a sense of true dedication that were not always written into the dialogue. There was something deep about the character that she brought to the screen, especially in her close-ups. As a servant, Mammy overstepped the boundaries that had been laid out for the African-American in real life and on the screen for so many years. She spoke her mind whenever she pleased, even though with Scarlett she realized it was futile effort.

Many of the movies that tried to have all Black casts like *Hallelujah* and *Hearts of Dixie* both made in 1929, failed at the box office. This was undoubtedly due to the inability to market them properly. It was sad and frightening to realize that during this time period the racial divide was so strong that films with Black performers usually never played the South. *Gone With the Wind* was the exception because it fit the Southern attitude of the slave that a lot of the Southerners still clung to. Many musicals had Black specialty numbers that were put in but did not advance the plot and could be conveniently cut when the movies toured the Southern states.

The best known African-American to audiences was Stepin Fetchit who made over forty motion pictures from the first talkies to the late 30s. On screen he essentially played the same character that was slow-witted and perpetually lazy. Stepin Fetchit was his stage persona. His real name was Lincoln Theodore Monroe Andrew Petty and he became the first black actor to be a millionaire. He was a popular comic relief and he often made up his own lines. In life he had airplanes, twelve automobiles, and a small army of Chinese cooks.

Stepin Fetchit as an actor had remarkable moments of genuine humor. The problem was that on screen he represented almost single-handedly the entire African-American culture to audiences, perpetuating the belief that Black males were ignorant and childlike, lacking in ambition. An actor that is often confused with Stepin Fetchit is Willie Best, who appeared in over a hundred movies and had a career that lasted into the early television era. Best played a variety of characters and toned down the slow, sleepy-drawl replies that were associated with Stepin Fetchit over the years. His characters were often more involved in the plots of movies like in *Ghost Breakers* (1940) with Bob Hope, not just comic vaudeville bits intended for a quick laugh.

Next to Bill "Bojangles" Robinson the best-liked Black actor was Eddie "Rochester" Anderson, who was in over sixty movies, including a small part in *Gone With the Wind.* But he is best remembered as the outspoken and sarcastic butler on *The Jack Benny Show.* With his raspy voice, he worked with Benny for twenty-three years, first on one of the most popular and longest running radio shows, then on television. His character was quick and always a few steps ahead of Benny's various schemes. Audiences that listened to the radio would hear voices and have

no idea that white actors were playing Black characters, like *Amos and Andy*. Anderson was one of the exceptions.

Asian Americans

The Asian was usually treated with a certain amount of respect as far as intelligence in the movies, but the cliché was that this brainpower was often used for evil purposes, like with Fu Manchu or ruthless Japanese military officers. There was never any thoughtful attempt to distinguish between Chinese and Japanese characters, which had to be confusing to audiences. German actor Peter Lorre played Japanese detective Mr. Moto, and Scottish actor Sidney Toler was Hawaiian Chinese detective Charlie Chan. The Chinese were often seen as peasants, and during the Depression there was a close association between these hard working rice farmers and the American farmers that were forced to leave their homes because of the Dust Bowl. On screen they became metaphors for each other.

The Charlie Chan series was extremely popular but is now greatly maligned because there was always a white actor speaking in fortune cookie sayings and witticisms. Charlie is a highly intelligent individual, always respected by the other characters in the movies and often feared by the criminal element because they knew he was invincible when it came to the powers of deduction. No Asian actor every played the inscrutable detective, but Chan's sons and family members were Asians. The most popular was Victor Sen Yung who was Jimmy Chan, the overly anxious son. Yung made over eighty motion pictures and dozens of guest appearances on television, including in the long running series *Bonanza*.

The Good Earth (1937) was the last major production overseen by Irving Thalberg. It was based on the best selling novel by Pearl S. Buck

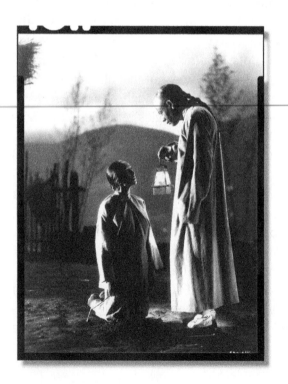

The Good Earth *(1937) directed by Sidney Franklin, starring Paul Muni and Luise Rainer, was based on Pearl S. Buck's acclaimed novel about the struggles of a family of Chinese farmers. As was typical in this era, non-Asians played the lead roles and Chinese or Japanese actors played the sons and supporting roles. Rainer, who was born in Dusseldof, Germany to a prosperous Jewish family, won her second Oscar as O-Lan, a Chinese slave sold into marriage. An Asian actor would not receive an Oscar until 1957 when Miyoshi Umeki won for* **Sayonara.**

and won both the Pulitzer Prize and the Nobel Prize. It was a natural for Hollywood, but the characters were Chinese. *The Good Earth* is a remarkable motion picture made on the grand scale. There are droughts, revolutions, betrayals, slavery, locust attacks, and a story that covers three generations. But there were no major actors in Hollywood that were Asian who were even remotely considered stars, and this was a movie that needed box office clout. Paul Muni the famous actor of the Yiddish Theatre in New York played the lead role, and German born actress Luise Rainer played the long-suffering wife. Rainer won her second Academy Award for the role, winning the year before in *The Great Ziegfeld.* So, a non-Asian actor wins for playing a celebrated Asian part. No Asian actor would actually take home an Academy Award until Miyoshi Umeki in 1957 for her supporting role in *Sayonara* with Marlon Brando.

Latinos and Native Americans

After the silent era, the Westerns faded away for several years. But Indians speaking only in monosyllabic phrases like "How" were still very much the standard cliché in the movies. The Lone Ranger series was very popular on radio and in large print novels with lots of dramatic drawings that were ferociously read by young boys. The loyal character of Tonto was played exclusively in later years by Jay Silverheels, who would eventually become a spokesman for better portrayals of Native Americans.

The motion picture that brought Westerns back was John Ford's *Stagecoach,* which made John Wayne a movie star, and featured a long action sequence of Indians in war paint attacking a defenseless stagecoach as it crosses the majestic landscape of Monument Valley. This scene would be recreated almost countless times over the three decades. It was a perfect example of

Sergei Eisenstein's principles of montage from *Potemkin,* where the attackers are played without remorse, and the innocent people are given endearing character traits, but now instead of Cossacks the opposing force was Indians.

If there were minimum attempts at depicting the differences between the Chinese and Japanese on the screen, there were no attempts at showing the many different Native American tribes. They were all given the same war bonnets and face paint, and the beat of tom-toms was heard in the musical score when they were first spotted in the distance. Many times actual Navajo riders pretending to be Apaches were used in the chase scenes.

When the war started there was a need to create a Good Neighbor policy with America's friends south of the border, and this is when the Latin Lover appeared on the screen. This was a total turnabout from the way Latinos had been portrayed. The old clichés continued in the movies if there were scenes that were supposedly shot in Mexico. There was the likeable old scoundrel, the easy-to-please, beautiful peasant girl, and the unshaven, quick-tempered bandito. Since the bandito would usually eat up the scenery with his performance, non-Latino character actors would smear on bronze make-up and blast out their lines written in comic broken English. These characters would continue to persist, and even today there are examples of these stereotypes in movies. But a whole new batch of romantic and comic characters were about to be added to the Latino experience in Hollywood.

WOMEN IN FILM

Women in this era should probably all be given a medal of valor, especially the ones that had enduring careers and fought like the hellcats for better roles. From this

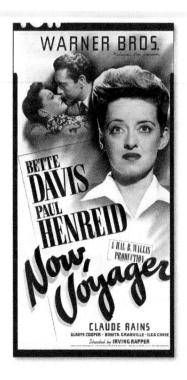

Now, Voyager (1943) directed by Irving Rapper, starring Bette Davis and Paul Henreid, ends with the melancholy couple lighting cigarettes and Davis saying, "Don't ask for the moon, Jerry, we have the stars." With her bulldog line delivery, no other actress in the 1930s was as highly respected by the average American woman as Bette Davis. Katharine Hepburn was high society, but Davis was made of common clay and well known for speaking up for her rights. She protested being cast in the melodramatic weepers by Warner Bros., but her bigger-than-life acting style fit the tone of these movies perfectly.

group, Bette Davis has to be at the top. Many of her films have not aged well for younger audiences, since they were often unabashed melodramas about women struggling to hold her own in a man's world. These potboilers were manipulations to drain the tear ducts of every last bit of moisture for the women in the audience. But by the end of this era Davis was playing stronger characters, under the direction of William Wyler and Edmund Goulding.

Bette Davis' ability to stand up to any and everybody and blow smoke in their face was pure magic to many of the women in the audience. Davis did everything they secretly wished they could. This Golden Age of the Studio System was Davis' special time. She delivered her lines with the force of a howitzer going off, tossing back her hair so the audience could see her famous Bette Davis eyes glaring at a person like Superwoman and telling them right to their face exactly how she felt. There was not a syllable that was not right on the money.

But this was also the Golden Age of Women's Films with stars like Katharine Hepburn, who shocked polite society by wearing pants, Jean Arthur who played the hard-nosed news reporter in many of Frank Capra's movies, and Vivien Leigh who was having an open affair with Laurence Olivier and still managed to capture arguably the greatest women's role ever, Scarlett O'Hara, making it completely her own. Other stars include Irene Dunne, Carole Lombard, Joan Crawford, Greta Garbo, Barbara Stanwyck, Shirley Temple, Judy Garland, Norma Shearer, and Greer Garson.

Perhaps because of the Production Code, or perhaps the time was just right, women were shown as intelligent, determined, professional, and not easily won by a handsome face. Especially in the screwball comedies, women could do incredibly outrageous things and audiences loved it. A woman could be tough, but still put her guard down and show her feminine side if she was sure it was the right moment. A great

majority of the motion pictures had women as the central characters or were entirely carried by a female lead. This began to change rapidly during the war years and never fully recovered when the action movie became the box office champ. This was a unique period in Hollywood. Women were romanced in the movies, and men would break into songs about their beauty and charms. The women stars had the best writers in world putting high-spirited, witty words in their mouths. And the women in the audience were taking pride in who they were and began in mass for perhaps the first time in history to feel they could have careers and lives of their own.

THE WAR YEARS

1940–1946

On September 1, 1939, while Hollywood was enjoying its greatest year ever, Germany invaded Poland. Two days later Great Britain and France declared war on Germany. President Roosevelt stated that the United States was neutral but that would only last for two more years. The news of war in Europe affected everybody living in Hollywood at this time. Many English actors, directors, and writers were living there, and most of the studio moguls had been turn-of-the-century immigrants and had close relatives in Europe. But Hollywood's hands were figuratively tied because of the mandate by Joseph Kennedy, who had been to Ambassador to England, not to stir up the political situation in Europe because it would have dire effects on relatives and friends living there.

After the surprise attack on Pearl Harbor, President Roosevelt declared that America was in a state of war with Germany and Japan. The policy of isolationism, which was supported by more than eighty percent of the American people before the attack, disappeared overnight. A feeling of patriotism swept the country. Politics had discouraged the studio moguls for years from making films showing the truth about the rise of Nazism in Europe. Now the Dream Factory was called upon to use all of its resources to support the war effort. But even with the predictability of happy endings in Hollywood films, it was going to be a hard fight. According to the daily headlines, it was obvious that Hitler and his generals were conducting a different kind of war. The *Blitzkrieg,* or lightning warfare, had allowed the Nazi army to quickly invade and defeat Czechoslovakia and Poland. Only Germany had significantly advanced its weapons of war. All other countries were still using the same armaments left over from the end of World War I. France had guns aimed across the border of Germany, assuming that tanks and the soldiers would take same route they did in 1914.

With this photograph, Betty Grable, known as the girl with the "million dollar legs," became the number one pin-up girl for soldiers in the military. Hollywood's chief objective during World War II was to give the men in combat an image of something to come home to. Stars like Rita Hayworth and Jane Russell felt it was an honor to have their photographs taped next to an army bunk or inside a sailor's locker.

Almost 90 percent of Americans were isolationists, not wishing to be drawn into a conflict, especially in Europe where they felt they had been so badly treated at the end of World War I and where so many American lives had already been sacrificed. Americans felt they had been slighted in the League of Nations and had never been given proper respect for the nation's contributions. Many were outraged that so many American lives were lost in that deadly conflict, yet they were being criticized for not coming into the war sooner. The average American citizen felt that no one in Europe could be satisfied, so let them fight their own battles and kill each other off—America was going to stay out of it.

The single factor that began to change the image of what was happening in Europe was Hollywood films. There were many British actors who had become matinee idols; it was almost impossible to go to the movies and not see a story representing England. So, the American public had been subtly conditioned to have a soft spot for the British way of life. They had seen *Wuthering Heights, The Tale of Two Cities, David Copperfield, The Citadel,* and *Goodbye, Mr. Chips;* all of these adaptations of English novels were huge successes in America. At least in the dark confines of movie palaces there was a positive feeling about England's fate.

In the midst of the production of *The Hunchback of Notre Dame,* Charles Laughton, the great British actor who had been in America since his Academy Award winning performance as Henry VIII, went to the set of Notre Dame cathedral. It was the day that England and France declared war against Germany. He then swung on the ropes, ringing the bells as a hopeful signal of a quick victory for England. According to Maureen O'Hara and others on the set, it was a profoundly moving sight.

America stayed neutral and Hollywood continued to make escapist movies right up until December 7, 1941, but there was no way to ignore the events all over the globe, and things were already beginning to change. By 1940, the themes in motion pictures began to reflect a darker feeling that the American people were beginning to distrust the idea that being purely optimistic in the vein of a Frank Capra movie could truly make a difference in the world.

OVERWHELMING ODDS

Hollywood was forced to be on the sidelines. The simplest explanation is that the ability to show something on film was so powerful that the U.S. Government was afraid of it. It is impossible now to look back in history and speculate what might have happened if America did not get into the war. With only a few situations that might have gone in Germany's favor, all of Europe very well could have fallen to Hitler; England might have been completely isolated and eventually overcome by a blockade. What was frightening was that the countries that represented democracy were losing so many battles and being quickly overrun at a terrible cost to human life. These tragic events were dramatized in every form of art. Japanese armies had taken over Singapore and Hong Kong, and devastated much of China. Newsreel footage showed the grim aftermath of these victories. Picasso's *Guernica* was a giant mural showing the devastation brought about by Stuka bombers that within a few hours completely wiped that small Spanish city off the map.

There were plays that were beginning to look at the rise of Fascism. The most famous example was Orson Welles' production of *Julius Caesar* set in a Fascist state. The impact when it premiered was enormous. One scene recreated a scene from the headlines when a lone Jew was brutally murdered by actors dressed as Nazis.

Mrs. Miniver (1942) directed by William Wyler, stars Walter Pigeon and Greer Garson, who won the Oscar for her performance as the valiant Kay Miniver. British actors and directors were encouraged to go to Hollywood and make movies based on English literature or heroes. The stars of this era included Cary Grant, Roland Colman, Laurence Olivier, Vivien Leigh, George Sanders, Leslie Howard, Olivia de Havilland, Charles Laughton, Robert Donat, Erroll Flynn, and dozens of character actors. *Mrs. Miniver* hit at the heartstrings of the American people with its dramatization of the miraculous rescue of soldiers at Dunkirk. But it was Garson's understated performance that gave audiences a face with which to associate all British citizens who were enduring the nightly bombardments from German aircraft.

This so aroused audiences that it was given a standing ovation for over thirty minutes on its opening night.

The fear was coming over the radio constantly. News broadcasts updating an anxious American public on the devastating war in Europe were at the top of the hour daily. The growth of the Nazi Empire and the realization of how strong it was becoming created panic waves throughout America. One of the most notable examples of the power of radio was Orson Welles' Halloween production of *War of the Worlds* in 1938. H. G. Wells did not give permission to use his entire book, only the story line of the invasion and the nature of the Martians' final demise. Welles decided to make his production seem like a live radio news broadcast. But that was enough. Because of fear that things were happening in the world that were so uncertain, listeners began to imagine the worst and for an hour thought there was an actual invasion.

Popular music began to reflect patriotic themes. At the Hollywood Bowl people stood up with tears rolling from their eyes. The whole concept of patriotism was beginning to be born. It is almost impossible today to imagine what it was like living in this devastatingly uncertain time period. American teens had spent their entire childhoods in great poverty, but as a country born in the philosophy of freedom, it had endured. By 1940, no matter how much Americans desired to stay out of this war, it looked more and more ominous that there was going be a fight. What no one could have imagined was what an important role Hollywood was going to play.

The only major studio film made in 1939 about the crisis in Europe was called *Confessions of a Nazi Spy*. It was put out by Warner Bros. and was inspired by a true story based on a Jewish representative of Warner Brothers who was killed by the Nazis. Ironically, there was no mention of the Jews in the movie. Warner Bros. was quickly advised to stay away from such themes. Warner Bros. had always been the studio most interested in social themes. A lot of their films featured children growing up in the ghettos and becoming

criminals, like in the James Cagney gangster films. These films had a certain realistic edge to them, and they were often taken from stories in the headlines. Earlier films like *I Am a Fugitive from a Chain Gang* showed that Warner Bros. liked to take on themes that were provocative for the times, instead of glossing over them like MGM had done so successfully.

The gate had now been opened, and the following year MGM made a movie called *The Mortal Storm* about a family that is torn apart by brothers who become Nazis. But the biggest film that ridiculed Hitler was *The Great Dictator* starring Charles Chaplin. Hitler had been a great fan of Chaplin and according to reports, had even trimmed his moustache to resemble the Little Tramp. Knowing this, Chaplin hurled the ultimate degradation at Hitler by playing the Tramp as a Ghetto Jew.

There are many "what ifs" that will always linger about what might have happened if Hollywood studios had been able to make films sooner which gave a negative image to Hitler's rise to power. If more motion pictures like *The Mortal Storm* and *The Great Dictator* had been made, could it have at least awakened countries to the horrors of Nazism earlier? But now that war seemed more certain, the studios were beginning to use the most incredible propaganda machine ever created. It was almost as if through the Depression era, and with the advent of the Production Code, that Hollywood had conditioned itself for such a moment in time. Its greatest contribution without question had been keeping the spirits of America and even the world up, and showing that things were headed in a positive direction in the troubled years from 1933 to 1939. To keep people's minds off of the Depression was one thing, but to suddenly be in a war where over an estimated sixty million people were killed, with atrocities that before this were unimaginable, took a different kind of movie. It was the ability of the Hollywood dream factory to shift gears and being to mass-produce movies that reflected a noble cause.

Hollywood played a spectacular part in giving people a vision of what they were fighting for. By this point in history, with so much uncertainty, there was the constant fear that Fascism could very quickly arise in America. What ensued in the early years of the 1940s was something that came terrifyingly close to ending all forms of democracy. Ultimately the fight was for the idea that people could be free and govern themselves. Hollywood fought the war machinery of Germany and Japan with star power. The idea that certain stars represented positive human values on the screen gave a unified vision to many people. As Churchill had said of the English people, World War II was their finest hour because everyone pulled together. This is also very true about what happened in America.

HITCHCOCK AND CHAPLIN

Alfred Hitchcock and Charles Chaplin are two Englishmen who have become icons and whose very names represent a certain kind of filmmaking. In 1940, Chaplin and Hitchcock symbolically passed the torch on from the old tradition of filmmaking to the new. Both men were total filmmakers—directors with unmistakable styles and absolute control over their distinctive motion pictures. When sound came in, Chaplin was the only silent star that continued to use pantomime exclusively in his movies, without spoken dialogue. The Little Tramp, he declared, was a man of action not words. But sound was embraced immediately by Hitchcock, who used dialogue and sound effects to heighten the suspense in his films. Sound brought in the Studio System and gave control to the Producer. Chaplin was the last star and director of

Alfred Hitchcock had become internationally known for his espionage movies going back to **The Thirty-Nine Steps** *(1935). David O. Selznick, who was responsible for bringing Hitchcock to Hollywood, never cared for the genre, feeling it was "too British" for American tastes. But when the war broke out in Europe, Hitichcock's spy thrillers were tremendously popular with audiences, including* **Foreign Correspondent** *(1940),* **Saboteur** *(1942) with its final encounter on the Statue of Liberty, and* **Notorious** *(1946). These films gave a glimpse into the shadowy underworld of secret agents and sowed the seeds for James Bond, the most famous British spy of them all.*

this era to have full control over his productions, and Hitchcock was the first director to take this control back and begin a new era in filmmaking.

After sound came in, Chaplin only made two movies, which are considered among his greatest, *City Lights* and *Modern Times*. Realizing that the end had finally arrived, in 1940 Chaplin made his final movie starring the Little Tramp, this time with words. *The Great Dictator* was a very courageous punch in the eye of Hitler when it came out. Though played for comedy, using long sequences of pure pantomime, the film ends with an emotional plea for the world to stand up against tyranny. Perhaps the most famous scene in *The Great Dictator* is when Chaplin, as Adenoid Hynkel, the dictator of Tomania, takes the globe of the world and bounces it around like a giant balloon in a dreamlike reverie of conquest. The scene ends when the globe pops. Simple symbolism, true to the traditions of Chaplin, that was highly effective in showing Hitler's lust for power.

The other character Chaplin plays is unmistakably the Little Tramp, but he is billed as a Jewish Barber. This was five years before full evidence of the Holocaust would be exposed to the world, but anti-Semitism was one of the rallying points of the Nazis and a brave topic for Chaplin to use. Though Chaplin was not Jewish, he had no personal concerns about presenting such an image if it would help expose Hitler's ruthless methods to the world. In an irony that could only happen in the movies, the Jewish Barber becomes a double for the dictator and gives a speech that is broadcast around the world. The speech today seems terribly overwrought and maudlin in its appeal, but in 1940 it served as a wake-up call and had a profound effect on audiences. It pleaded for peace, which was already an impossibility by the time the film premiered. After the war, Chaplin pulled the film from future release, feeling the slapstick comedy was inappropriate in light of the horrors that had happened to the Jews

and millions of others. Now the film can be looked at as one of the first few examples of Hollywood trying to warn people of what was about to happen.

Hitchcock also warned audiences, but in his own trademark fashion with spy thrillers. The mystery was born in England and is the genre from which spy stories evolved. *The Moonstone* by Wilkie Collins is credited with being the first mystery novel, followed soon after by Sir Arthur Conan Doyle's immortal detective Sherlock Holmes. In the 1930s everyone was reading Agatha Christie and trying to figure out whodunit. The characters in her page-turning novels, like Hercule Poirot and Miss Marple, were immensely popular with American readers.

The spy thriller was still new to audiences, but because of the thematic necessity of double role playing, it was a natural for the movies. The first novel was Joseph Conrad's *The Secret Agent*. This is a far cry from the James Bond style of espionage, but it set the ground rules for all spy films to follow. Hitchcock even made Conrad's novel into a film called Sabotage because he had done an earlier film with Peter Lorre and John Gielgud called *The Secret Agent*. In *Sabotage*, Hitchcock learned a lesson that in effect has changed every movie that has ever followed, very much like D. W. Griffith and F. W. Murnau and many of the people that created the innovative grammar of motion pictures. The concept of suspense has always been a part of movies, but it was never finessed, articulated, and finally developed the way Hitchcock did it. The discovery, like many, was a pure accident.

In *Sabotage* a young boy has been asked to return a canister of film. The man who has persuaded the boy is Mr. Verloc, who is a member of a group of foreign saboteurs that operates a small movie theatre as a front. In the canister of film there is a bomb intended for a landmark in London. With cutaways, the audience sees the bomb ticking inside. The cherub-faced boy is delayed time and time again, and Hitchcock constantly cuts to clocks throughout the city to remind the audience the boy is behind schedule and is not going to make it on time. The boy gets on a public bus, next to a nice elderly lady and her lapdog. What happens next becomes a turning point in Hitchcock's career. The bomb inside the canister explodes, killing the boy and apparently everyone in the bus. The movie was a complete flop when it came out, Hitchcock's first after a long string of box office hits. Hitchcock realized that audiences were upset because they anticipated that the boy would somehow miraculously be saved.

Despite the fact that the incident with the bomb is the most famous moment in Conrad's novel, Hitchcock became aware that in motion pictures the audience had different expectations. The audience could be surprised by having the bomb suddenly go off, but as Hitchcock points out in one of his many interviews about film, this only gives a few seconds of screen excitement. Suspense is achieved by letting the audience know there is a bomb, so they are drawn into the action. They might want to warn the people on the screen, but they cannot. So, if one lets the audience in on the action, they are held in suspense for ten minutes or more instead of a few seconds,. This form of storytelling is pure cinema. In a novel or play it is impossible to switch the reader or audience back and forth with brief inserts of vital information, like cutting away to a bomb inside a film canister. Hitchcock further realized that he could tighten the screws of suspense even more with movie stars.

Another key element of suspense that Hitchcock perfected in his British films is a device that has become known as the man-in-the-middle theme, despite the fact that in several films a woman is at the center of the action. This is a perfect exercise of Hitchcock's personal paranoia,

where both the police and criminals are chasing a man that has accidentally fallen into a web of spies or is accused unjustly of murder. *The Lady Vanishes* and *The 39 Steps* are clockwork gems that began to combine the words "Hitchcock" and "suspense" together in audiences' minds. Both movies have major stars of the British cinema. Robert Donat plays a man who is being chased by Scotland Yard and a group of cunning spies in *The 39 Steps*. He later won the Academy Award for Best Actor in 1939 for *Goodbye, Mr. Chips*.

What Hitchcock did not want to do was to come into a studio that was run like a factory. He realized because of his success in England and the popularity of his little British spy thrillers he would probably be given a certain amount of freedom, but he wanted to find a studio and a producer that he felt he could work with on his own terms. Ultimately, that producer was David O. Selznick. They were two completely opposite personalities. Even though there were clashes between them, what matured out of the relationship between Hitchcock and Selznick are arguably two of the greatest motion pictures of all time and one flawed classic. *Rebecca* was voted best picture in 1940 and was Hitchcock's most successful film to date. *Notorious* is one of the most influential motion pictures in the spy genre and remarkably increased the visual language of filmmaking. *Spellbound* at times feels like two different movies, in large part due to the disagreement between the two men, but it has some of Hitchcock's most famous moments, especially the Salvador Dali dream sequence.

For his second American film, Selznick loaned Hitchcock out to United Artists for *Foreign Correspondent*. Ironically, this spy movie was also nominated for best picture the same year as *Rebecca*, completing Hitchcock's grand entrance into Hollywood. One of the primary complaints by actors and directors during the Studio System was that a producer could loan out talent to other studios, which meant, in the case of Hitchcock, he would not make a penny more but Selznick collected handsomely. But after the giant success of *Rebecca*, no other producer was going to pull in the reins on the newly crowned Master of Suspense. Thus during these loan outs Hitchcock made a series of films that allowed him to test new waters and play with better toys, as he often referred to cameras and other equipment.

Foreign Correspondent is about a hotshot American newspaperman who is assigned to Europe to see what is happening and report back on the political changes. The bad guys are very clearly Nazis, even though they are not identified with Swastikas. They wear long trench coats and use menacing means of torturing a diplomat played by veteran actor Albert Basserman. The film is full of visual tricks designed by William Cameron Menzies, who had been the production designer on *Gone With the Wind*. Hitchcock is constantly replacing dialogue for visual storytelling. In one clever sequence, a car that is being chased suddenly disappears on a road with windmills. When the newspaperman stops and gets out of his car to figure out what happened to the vehicle he was pursuing, the audience sees that the sails on one of windmills is rotating in a reverse direction of the others.

Hitchcock realized he would not be able to return home once the war broke out. To show his support for the English people, he ends *Foreign Correspondent* with a radio broadcast while German bombs are falling on London. Hitchcock as the newspaperman read his story over the airwaves, concluding by saying the lights are going out all over Europe and that the American people will be their only hope. Because of the timing of the war, the spy thriller became a popular Hollywood genre overnight. Hitchcock continued with *Saboteur*, which ends with a chase that goes from Radio City Music Hall to the Statue of Liberty. In *Lifeboat*, as the

title suggests, the action takes place entirely in the middle of the ocean on a lifeboat with a cross-section of humanity representing America and Germany in the war. Hitchcock said that with good editing and the right choices of camera lens, an intriguing motion picture could take place in a closet. *Lifeboat* and later *Rear Window* are good examples that a confined space does not limit the possibilities of a motion picture.

These films planted the seeds for the James Bond series, with its double agents, men on the run, and fancy gadgets. If Hitchcock had made his journey to America in the mid-1930s his suspense films might never have been as successful or as influential. His style of filmmaking really became popular because of the timing of historical events. By the end of the war, Hitchcock had become the first motion picture director who was a household name. His distinctive camerawork in *Notorious,* his last spy thriller of the decade, set him apart from all other Hollywood directors. *Notorious* ushered in the *film noir* movement with its multi-layered characterizations and dark atmosphere. And people were becoming conditioned to look for his optical tricks and brief cameo appearances. With Hitchcock audiences were aware that a director and his camera, not some invisible deity, was shooting the movie.

HOLLYWOOD GOES TO WAR

At the height of the Studio System era it would take a year for a film to go through the writing phase into production, then finally post-production and release. In many cases the process was even faster than this, which is astonishing compared to what now could take anywhere from two to three years, even if the film is on the fast track. The movies of 1940 reflect this rapid turnabout in motion picture production. Audiences were seeing the tail end of the films started before the war began in Europe and the first movies that reflected the looming specter of this growing conflict.

Only the year before, there were only a handful of motion pictures that mirrored the problems in Europe. Now the list of popular films with this theme included *The Great Dictator, Foreign Correspondent, The Long Voyage Home,*

Yankee Doodle Dandy (1942) directed by Michael Curtiz, with James Cagney in an Oscar winning performance as George M. Cohan, was an unabashed flag-waving musical that audiences could not get enough of during the war. Cagney had started out in burlesque as a song-and-dance man, but after **Public Enemy** *he was kept busy playing gangsters and tough guys. Cohan had doubts about Cagney, but after seeing the film he had nothing but praise for his fellow Irishman.* **Yankee Doodle Dandy** *connects The Great War with World War II by having President Roosevelt inviting Cohan to visit him in the White House and with the use of flashbacks, the veteran songwriter tells his life story. The movie ends with Cagney leaving the White House and seeing a parade of young soldiers marching to the song "Over There."*

Waterloo Bridge, and *The Sea Hawk.* This last one was an Errol Flynn swashbuckler about England's defeat of the Spanish Armada but ended with a rousting speech by Queen Elizabeth that was aimed at the heart of Germany. On the flip side of this year was *The Philadelphia Story, Rebecca, Kitty Foyle, The Letter, The Mark of Zorro, Northwest Passage,* and *The Grapes of Wrath.* Many of the movies reflected darker moods, but it proved to be a vintage year for comedies with Preston Sturges' political satire *The Great McGinty,* plus three vintage screwball comedies staring Cary Grant—*His Girl Friday, My Favorite Wife,* and *The Philadelphia Story.*

The comeback story of perhaps all Hollywood comeback stories is Katharine Hepburn in *The Philadelphia Story.* Hepburn bought out her contract with RKO and left Hollywood after a series of flops, including the box office disaster *Bringing Up Baby,* which was later rediscovered and proclaimed a screwball comedy classic. She went back to New York and resigned herself to the fact that her acting career was over. Fortunately, this lasted only a few weeks, and she returned to the theater. A few years before, her appearance in *The Lake* received the infamous pan by critic Dorothy Parker, who wrote that she ran "the gambit of emotions from A to B."

This time Hepburn took no chances. She approached her friend, Philip Barry, who had written the play *Holiday,* which she and Cary Grant made the movie version of directed by George Cukor. She persuaded Barry to write a play for her, which turned out to be *The Philadelphia Story.* To insure her bet that the play would be a success, she approached Howard Hughes, another influential friend of hers, to buy the movie rights to *The Philadelphia Story.* The rest is legend. *The Philadelphia Story* was a huge hit on Broadway, and Hepburn was able to come back to Hollywood and call the shots. This time she signed with MGM and asked for Cukor to direct

The Philadelphia Story (1940) directed by George Cukor, starring Katharine Hepburn, Cary Grant and James Stewart, is a movie filled with ironies. Hepburn had been declared box office poison in Hollywood and retreated to New York. There she convinced her friend Philip Barry to write a play for her, which become **The Philadelphia Story.** A hit on Broadway, Hepburn persuaded another friend, Howard Hughes, to loan her the money to secure the movie rights, which she then took straight to MGM. Hepburn had asked for Spencer Tracy and Clark Gable, but had to "settle" for Grant and Stewart. Her last film with Grant, **Bringing Up Baby** (1938) was a box office bomb, so there were concerns about the two stars teaming up together again. The year before Cukor had been fired from **Gone With the Wind** and briefly everyone thought his career was over. A final irony is that James Stewart, in almost a supporting role, won the Oscar this year. It was a delightful performance, but many critics feel Stewart won because he had not received the award the year before as Jefferson Smith in Frank Capra's **Mr. Smith Goes to Washington.**

and Clark Gable and Spencer Tracy to star. She got her wish for director, but she had to settle for Cary Grant and James Stewart instead.

John Ford was the only Hollywood director that could have made *The Grapes of Wrath* and kept all the realistic intensity found in John Steinbeck's Pulitzer Prize winning novel about migrant farmers during the Depression. Ford was on a magnificent roll. The year before *Young Mr. Lincoln, Stagecoach,* and *Drums Along the Mohawk* were three of the highest grossing films of 1939. Ford would win back-to-back Academy Awards for *The Grapes of Wrath* and *How Green Is My Valley* the following year. Ford was known as a director who enjoyed and respected the common people of America. Largely because of this sensitivity (a word he hated) he was able to bring a rich but unvarnished look at the endless troubles of the Okies trying to stay alive and find work in California. By the time the movie was made, the economy was slowly recovering. Jobs were beginning to open up, in part because of Roosevelts's agreement with the English for ships and supplies. Nevertheless, *The Grapes of Wrath* had a powerful effect when it was released, being one of the very few major studio films to look outside the doors of movie theatres and see the hardships of the real world.

When Darryl F. Zanuck, the head of 20th Century-Fox, decided to make *The Grapes of Wrath* there was an outcry that what had been depicted in the book was pure fiction; such hardships in America did not really exist. To ensure that he could refute such criticism, Zanuck hired a private detective to go out and investigate the farmers that had traveled to California in hopes of greener pastures. This was four years after the best selling book about the Joad family was published. The weary private detective returned and reportedly said no, it was not that bad—it's worse.

This same year, Ford directed *The Long Voyage Home* based on the one-act sea plays by Eugene O'Neill. The cinematographer on both films was Gregg Toland, and each movie is stunningly unique and a masterpiece of lighting. *The Grapes of Wrath* is shot in a naturalistic style, almost a documentary approach, that evokes the work of the best photographers of the Depression

The Grapes of Wrath (1940) directed by John Ford, with Henry Fonda and Jane Darwell as Tom and Ma Joad. In later life Ford would introduce himself as making Westerns, but he won his four Oscars for very different kinds of films. His first one was for **The Informer** (1935) based on Liam O'Flaherty's tale of the Irish Revolution. He then he won back-to-back awards for **The Grapes of Wrath** and **How Green Is My Valley,** from Richard Llewellyn's novel about Welsh miners. Eleven years later he received his fourth Oscar for **The Quiet Man,** a Technicolor valentine to Ireland. When Orson Welles first came to Hollywood he was asked who he thought were the three best directors, and he replied, "John Ford, John Ford and John Ford." As a strange twist of fate, in 1941 Welles lost his Oscar for **Citizen Kane** to Ford.

era like Dorothea Lange and Walker Evans. *The Long Voyage Home* is closer to German Expressionism and is an excellent example of Toland's use of *deep focus,* which he developed with experiments with faster lens and light sensitive film stock. This allows the foreground and background of a scene to be in clear focus, so that an actor can be in an extreme close-up but the images or person in the distance is also clearly defined. This is a technique that Orson Welles especially liked, and Toland used it throughout *Citizen Kane* one year later.

It is fascinating to look at the kinds of films that had British themes from 1940 to 1943, many of them in living Technicolor. Obviously, Hitchcock's *Rebecca* and *Foreign Correspondent* took place in England. Greer Garson and Lawrence Olivier teamed up brilliantly for the delightful adaptation of Jane Austen's *Pride and Prejudice. The Letter,* based on Somerset Maughan's story about murder in the tropics of South America, was peppered with proper English traditions and performers. The tearjerker *Waterloo Bridge* starred Vivien Leigh in her first major role after catapulting to international fame as Scarlett O'Hara in *Gone With the Wind.* And master English producer Alexander Korda released the Technicolor adventure *The Thief of Bagdad,* introducing the world to Sabu, the first Indian actor to become a movie star. The movie is a magnificent marriage of fantasy and special effects, with genies popping out of bottles, flying carpets, and a creature that has six arms and attacks with curved swords. Because of costs, this kind of filmmaking would disappear for almost a decade once the war broke out.

Joan Fontaine who did not win an Academy Award for *Rebecca,* won it for the very English murder mystery *Suspicion,* also staring Cary Grant, in the first of four films he would do with Alfred Hitchcock. This year Fontaine was competing with her own sister Olivia de Havilland for *Hold Back the Dawn,* based on a screenplay co-written by Billy Wilder. They are cousins of the pioneer aviator designer Sir Geoffrey de Havilland. After losing against her sister, which created a long lasting feud, de Havilland had the ultimate revenge by receiving two statues for *To Each His Own* and *The Heiress.* She also sued Warner Bros. after being stuck in one overly sweet role after another—a gutsy move for an actress during this time, but she ended up winning in a landmark case that carries her name to this day.

John Ford's *How Green Is My Valley* was based on the best selling novel, the first to win the National Book Award, and movingly showed the hardship of miners in Wales. The movie served as an ode to the passing of time and of old traditions and had an enormous impact on audiences at the beginning of the war who were very conscious that this simple way of life might be obliterated forever. It won for best picture, and the following year *Mrs. Miniver* won, making a major star of Greer Garson, who first graced the screen in a brief but unforgettable role in *Goodbye, Mr. Chips.* John Ford was scheduled to be the original director on *Mrs. Miniver,* but because of delays it was taken over by William Wyler, who had ironically been developing *How Green Is My Valley.* The screenplay for *Mrs. Miniver* is by James Hilton, the author of *Chips* and *Random Harvest,* which was made into a movie this same year, again starring Greer Garson.

The role call of films continued with *In Which We Serve* directed by both Noel Coward and David Lean. This would be Lean's first major directing job. He had been an editor and caught the attention of the distinguished playwright Noel Coward, who became his mentor. Lean's next three motion pictures were adaptations of Coward's plays, including *This Happy Breed,* the comedy *Blithe Spirit,* and the story of a love affair, *Brief Encounter,* which was a huge international hit and brought great attention to Lean. At

the end of the war, Lean gave the world a marvelous dose of Charles Dickens when he directed *Great Expectations,* bringing to life the characters and the city of London during this era unlike any movie before.

Considered the tearjerker of all animal story tearjerkers is MGM's beautiful Technicolor production of *Lassie Come Home,* with newly discovered Roddy McDowall, who had also broken hearts two years before in *How Green Is My Valley.* The motion picture also featured another young British actress, Elizabeth Taylor, in her second screen appearance. The beautiful English and Scottish countryside was certainly not shot on location in 1943, but for years after the war, naïve tourists could get Lassie tours. *Lassie Come Home* would start a franchise that would move successfully into television. During the war, the wonder collie inevitability matches wits and courage against the Nazis and wins in *The Son of Lassie.*

There were many fronts that needed constant morale boosting during the war. There was the American home front, which received the most attention, and America's friends to the south, which was part of the Good Neighbor Policy to keep Mexico, and South America and the Caribbean Islands on the side of democracy and hopefully out of Nazi and Japanese control. Though Technicolor was twice as expensive as a black-and-white studio motion picture, and considerably more costly than the average B-movie, studios found that the vivid colors and postcard appearances of South American countries, the Old West, and the green fields of England had a great nostalgic effect on audiences. Many people had been torn from their homes and forced to journey to safety in America, but many more were troops who looked at these color films as a touch of home and a vision of what they were fighting for. At the height of the war, American people were going to the movies at least once a week, and overseas movies were run day and night for soldiers.

Some of the best examples of Technicolor for this era—or ever, for that matter—are *The Thief of Bagdad;* King Vidor's *Northwest Passage;* Cecil B. DeMille's epic *Northwest Mounted Police; The Blue Bird* with Shirley Temple; *Bittersweet* with Jeanette McDonald and Nelson Eddy; *Blood and Sand* and *The Black Swan,* both with Tyrone Power; Sam Wood's *For Whom the Bell Tolls;*

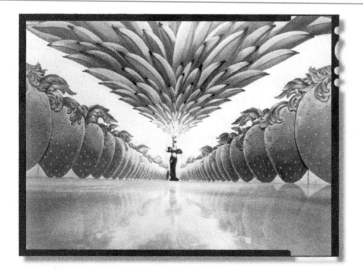

The Gang's All Here *(1943) directed and choreographed by Busby Berkeley, features Latin bombshell Carmen Miranda in this outlandish musical number, "The Lady in the Tutti Frutti Hat." How the number ever made it past the Hays Office is a mystery to many people, and it remains as one of the most surrealistic sequences in any Hollywood movie. When the war started there was great concern from the U.S. Government about Nazis setting up military operations in South America. Thus began the "Good Neighbor Policy" that encouraged films about friendly relationships south of the border. Miranda was a highly popular star during the war years because of her flamboyant dancing style, flirtatious singing, and hilarious comic delivery.*

Busby Berkeley's *The Gang's All Here,* Claude Rains' version of *Phantom of the Opera;* and *National Velvet,* which made young Elizabeth Taylor a star. There is no comparison to the bright, pure quality of Technicolor motion pictures in this era, and the images have not deteriorated like those with later color film. The richness of the colors was deliberate. These were make-believe movies in the best definition of the term, made at the pinnacle of the Studio System. The purpose of these movies was to transport the audience away from the realities of the war for a few hours, and they successfully achieved this goal for millions of people.

Down Argentine Way (1940) made at 20th Century-Fox is a very typical musical of this time. It starred Betty Grable, who was the number one pin-up during World War II, with the famous shot of her back to the camera in her white bathing suit, showing off her million dollar legs. Grable was a song-and-dance girl, back in a time period when terms like pin-up and girl were not considered politically incorrect. And her legs, according to the news releases from Fox, were insured

for a million bucks. Making her movie debut was perhaps the most flamboyant South American star to ever knock on the door of Hollywood—a woman born to be photographed in color—the Brazilian Bombshell, Carmen Miranda. No matter how hard the other actors tried, Miranda always stole the movie with her up-tempo Latin songs, sassy looks, and flamboyant hairdos and hats that had everything from apples to plums to bananas. *Down Argentine Way* also featured the Nicholas Brothers, arguably the best dance duo that every tap danced on a sound stage, doing amazing routines that made them appear lighter than air. This is not a film like *Casablanca* that will be hailed as an enduring classic. It is predictable, with only a hint of a plot that is really there to lead from one musical number to the next; but it was pure entertainment and gave a lot of people the idea of the good times that might be waiting when the war was over.

Walt Disney released three animated features during the early 1940s: *Fantasia, Pinocchio,* and *Bambi. Fantasia* proved to be a slight box office disappointment. Audiences were expecting a

Flash Gordon Conquers the Universe (1940), starring Buster Crabbe, has become the best known serial of all time, largely because it was an inspiration to George Lucas for **Star Wars.** Each episode opens with a summary of what happened the week before, going up the screen in an "infinity crawl." Flash Gordon and his friends in the rebellion to save the universe were usually dressed as Robin Hood characters. They were always outnumbered by the evil Emperor Ming, who had a formidable army that looked like German soldiers in operetta costumes. Serials go back to **The Perils of Pauline** (1914) starring Pearl White and remained popular with young audiences until the mid-1950s. John Wayne made **The Hurricane Express** (1932), and during the war **Don Winslow of the Navy** (1942), played by Don Terry, battled the Japanese. Each episode of a serial was about twenty-five minutes long, and, except for the first and last chapters, always ended in pulse-beating cliffhangers.

continuous story line and did not connect with the different musical episodes, finding them a bit too highbrow, perhaps. However, in the 1960s, during the Hippie Generation, *Fantasia* was rediscovered and found a very enthusiastic audience. One of Disney's dreams was to bring classical music to the masses, presenting it as almost pure montage. For his television program he broke the feature up into interludes, which worked nicely, except *Fantasia* was in Technicolor, which, like *The Wizard of Oz,* many viewers did not realize for years. The two most popular moments were prima donna hippopotamuses dancing with smiling-jawed alligators in the *Waltz of the Hours* and Mickey Mouse in his perhaps single most famous cinema outing as *The Sorcerer's Apprentice.* It was a film that was far ahead of its time in what it was trying to do combining images and music.

Pinocchio, with Jiminy Cricket singing *When You Wish Upon A Star,* about the misadventure of the wooden puppet that finally becomes a real boy, hit the right chord with audiences, as did *Bambi* two years later. Both features were shot on a specially designed multi-plane camera that produced an almost three-dimensional perspective to scenes and a spectacular depth of field to landscapes. One of the surprising criticisms of *Bambi* is that it looked too real and did not feel like a cartoon; indeed Disney in just fifteen years had turned animation into a major art form.

Disney also believed that a good story for adults and children had to teach a lesson and at times almost scare them to death. In *Pinocchio* there are two sequences; one is on Pleasure Island when Lampwick transforms into a donkey, which unquestionably prevented many children from playing hooky from school. The other moment comes in the middle of the ocean when the giant whale Monstro chases Pinocchio, Jiminy, and kindly Geppetto, trying to crush their raft. Since fire and water are the two most diffi-

cult things to animate, this sequence was the single most complex scene in any of Disney's features, but it was surpassed by the forest fire and storm sequences in *Bambi.* The most frightening moment in *Bambi* gave many future hunters doe-fever. It happens when the mothers whispers, "Man is in the forest."

THREE CLASSIC MOTION PICTURES

Citizen Kane

Citizen Kane has since the late 1960s, when it was rediscovered after almost decades of obscurity, been consistently at the top of critics' lists of the ten greatest films of all times. The thing about *Citizen Kane* is its uniqueness. To look at *Citizen Kane* is to look at a film that has had an immense influence on people behind the camera for thirty years. It was a film that was far advanced in its look, storytelling, and even its subject matter. And *Citizen Kane* is a film that will forever be interwoven with its twenty-five-year-old director, writer, producer, and star, Orson Welles, who once said about his movie career, "I started at the top and worked my way down."

Young Orson Welles' great love was Shakespeare. Many of the stage productions with the Mercury Theatre, co-produced with John Housman, became hallmarks of American Theatre. They include the so called "voodoo" version of *Macbeth, Julius Caesar* set in Fascist Germany, and a play of Falstaff, that Welles would later make into the film *Chimes at Midnight.* He describes *Macbeth* as perhaps the high point of his life. When he was just barely out of his teens, he cast untrained actors in Harlem and set the production in Haiti, with voodoo medicine men as the witches. The opening night of the play created such a sensation,

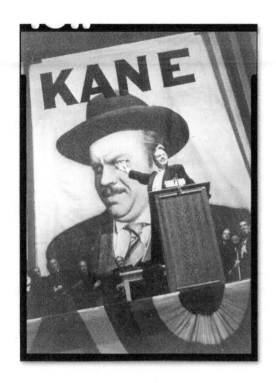

Citizen Kane (1941) directed by Orson Welles, and stars Welles, Joseph Cotton, Dorothy Comingore, Agnes Moorehead, Ray Collins, Everette Sloane, Ruth Warrick, and Paul Stewart. Because of high-profile Hollywood politics, *Citizen Kane* was a failure when it was first released, but its enduring impact was on cinematographers, who for decades have studied Gregg Toland's groundbreaking work, and the young directors of the New Hollywood who discovered the film in rival theatres. As Peter Bogdanovich observed, *Citizen Kane* "was forty years ahead of its time." Part of the greatness of *Citizen Kane* is its complete originality; there is simply no other film like it. In the character of Charles Foster Kane, Welles created a modern tragic figure worthy of Shakespeare.

Welles remembered that after dozens of curtain calls with standing ovations they finally let the audience come up on stage. The next day when Welles walked out of his hotel room, he saw a line of people trying to buy tickets that was the complete width of the street extending for blocks.

There is an old theatre legend about this production. As it turns out, only one elderly critic gave *Macbeth* a negative review. All the other reviews had praised every aspect of the play. According to the story, John Houseman had gone back to the theatre after the opening night when the reviews came out and heard the medicine men down in the basement chanting. Looking around, he saw they were obviously doing something over and above just rehearsing for the next day's performance and made a hasty retreat. The next day, as the critic was crossing the street he had a massive heart attack and fell down dead. Whether there is any truth to this tale or not, it is the kind of thing that attracts interest in Welles even to this day. It is one of the reasons that *Citizen Kane* is inseparable from the life of Orson Welles.

The meteoric rise of Welles and his tragic plummet is very much the stuff of Shakespeare. Like King Lear, he manages to reach the pinnacle of success only to see his personal flaws bring him down into the abyss. A bit dramatically stated, but this is the arc of his life, just like an extended stage production in three acts. By the time Welles was in his early twenties, he was as well known as President Roosevelt. He met his opportunity to make a motion picture by an event that at first he felt would demolish his entire career, something that even if it had been calculated the end results could never have been predicted. This was the famous radio broadcast of *The War of the Worlds,* written by Howard Koch, who later would work on such movies as *The Sea Hawk* and *Casablanca.*

Welles' fame as a radio star was enormous. Today it is hard to imagine how popular radio

Orson Welles is seen here during his 1938 radio show "War of the Worlds" on Halloween eve, which became known as the Panic Broadcast. Written by young Howard Koch (who would later co-write the screenplays for **The Sea Hawk** *and* **Casablanca**)*, the radio program made major changes to H. G. Wells' story. Wells has little respect for radio and knew his science fiction novel would be radically cut, so he only granted the Mercury Players on the Air the rights to the title, the physical likeness of the monsters, and the ending. In desperation, Orson Welles told Koch to write it like a live radio broadcast. The end result was that millions of listeners believed there was an real invasion. For days afterwards, Welles thought his career was over, but instead he was offered an exclusive contract to make two films at RKO.*

was, but radio shows were something that captured the public's attention during the Depression. It was everything from listening to sporting events to comedy shows like Jack Benny to programs that have become famous for the use of sound effects and creepy themes like *Inner Sanctum* and *The Shadow*. Among his radio personas, Welles was the voice of The Shadow. He also had his own company, The Mercury Theatre on the Air, who were an extension of his theatre ensemble. So while rehearsing and starring in plays, he would do the classics on the radio and be the voices of many of the characters. This stretched his time very thin. He found a loophole in the city ordinance regulating ambulances in New York and found that a person did not really have to be sick to be in an ambulance. So, Welles would hire an ambulance to take him from one radio station to another across town.

In October 1938, the circumstances surrounding *The War of the Worlds* broadcast were waiting for just such an event. The American public was getting daily information about the events in Europe and the build up of the Nazi war machine. There was a constant threat of invasion and war. During a live report there was the emotional eyewitness coverage of the Hindenburg disaster. Radio was relied on for its trustworthiness in news, especially during live broadcasts.

When the H. G. Wells estate only gave limited radio rights to the novel, Welles decided to create the impression of a live broadcast. There were calculations in how the radio show was timed out. From existing copies of the broadcast, it is very clear that audiences that listened to the beginning of the show understood what was to follow was a reenactment of *The War of the Worlds* as a Halloween treat. And after about thirty minutes, the radio show turns into very long monologue by Welles, who describes himself as perhaps the last person on the face of the earth, describing the carnage and the damage he sees.

It was the seven minutes after the opening of the broadcast that became a sensation.

The Mercury Theatre on the Air did not have a sponsor at the time, so they did not need to take commercial breaks. And the program was very low in the ratings, so it did not have large audiences tuning in at the beginning. Welles crafted the plan that about seven minutes into the broadcast there would be the first reporting of a Martians landing. He presented it with all of the mad confusion that might happen on a live location. There was confusion, awkward pauses, long silences after explosions with soldiers screaming, and then cutting back to a live orchestra playing. If someone tuned in during the commercials on other stations they would have heard complete pandemonium.

The trick worked perfectly. But even if it was calculated to give a momentary thrill, no one was prepared for the utter chaos that followed. There were stories of townspeople going out and shooting at windmills. A man was in the process of divorcing his wife in Nevada, but when he heard that Martians had landed he jumped into his car, hoping to get back to New York in time to rescue her. A man loaded his family into their car then in the excitement drove through the garage doors. People flowed into the streets in panic, wanting to know where to go and if they should breathe the air. Other people got wet rags and stretched them along the window frames to keep the gases from the invaders from poisoning them.

Welles refused to stop the broadcast even after repeated warnings that people were taking it seriously. After all, he later explained, it was a big Halloween hoax that was intended to scare listeners. The next day during a press conference he was asked why he would have done something that upset so many American citizens. There is a famous photograph of Welles looking as sheepish and as innocent as a newborn babe, swearing he had no idea that it would cause this kind of panic. In truth, this is one of the few times that Welles really exhibited any kind of fear. He felt because of the enormous reaction he very well could be banned from radio. In fact, a law was passed shortly after this stating that one could not pretend to be doing an actual broadcast without disclaimers all the way through it. It became illegal to do exactly what he pulled off, presenting fiction as the truth. In other countries, people that had duplicated *The War of the Worlds* broadcast were jailed, and in one instance the radio station was actually burned down with the announcer inside. But the luck of the Irish stayed with Welles, who became a bigger celebrity than ever.

Welles had done something so sensational Hollywood admired it and gave him the greatest and ultimately the most destructive gift of his career. He was given a contact that allowed him without any outside interference to pick what he wanted to make as a motion picture and do it completely within the realm of his own artistic vision. This kind of unconditional contract was unheard of. Directors that had been around for decades like Frank Capra, John Ford, and Howard Hawks never been given the kind of contract that "the Boy Wonder" was given, and it was greeted with great disdain by many people in the Hollywood community. RKO, who offered the contract, felt that the notoriety of the radio broadcast would insure that whatever Welles did next would be a hit. It was a very logical move. The studio had no idea of the seeds it was planting and that the end result would become Hollywood legend and almost break RKO.

Welles took Housman and the Mercury Players with him to Hollywood. The first project he was going to do was an adaptation of Joseph Conrad's *The Heart of Darkness*, shooting the movie from the point-of-view of the central character. The budget skyrocketed and the idea was eventually abandoned. Later it became a project that inspired a young film school student, John

Milius, to pick up the baton that Wells had dropped on *Heart of Darkness* and write his own version. The film eventually became *Apocalypse Now,* directed and greatly rewritten by Francis Ford Coppola. This has become typical with many of Welles' unfinished projects. His persona as a boy genius has given him the metaphorical status of being the fastest gun in Hollywood. Over the decades many of his aborted projects and unfinished films have attracted the interest of "young gunfighters" in the movie industry, who want to see if they can lick the problems and make a name for themselves.

Next Welles became fascinated by the idea of doing the story of a great American, but giving it the trappings of a modern tragedy. The possibility of newspaper tycoon William Randolph Hearst came up. This idea was proposed by Herman Mankiewicz, who had attended many parties at Hearst's castle in San Simeon. He had first-hand knowledge of Hearst, which immediately intrigued Welles. Mankiewicz was one of the famous early writers who went to Hollywood

for the quick buck and stayed drinking up the best years of his talent, but a man with an incredible wit. He was invited to every party. He was a man who had moments of astounding creative genius. Among his more than sixty screenplays are *Dinner at Eight* and a rewrite on *The Wizard of Oz.* He was part of the Mankiewicz heritage that seemed to pass down the writing gene for generations. His younger brother was Joseph Mankowitz who won back-to-back Academy Awards for writing and directing *A Letter to Three Wives* and *All About Eve.* Herman's son Don became a notable correspondent and a successful writer-producer on television, and his nephew was one of the early writers of the James Bond films including *Live and Let Die* and *Diamonds Are Forever.*

Over the years there has been occasional controversy about Welles' ultimate contribution to *Citizen Kane.* He insisted that the final credit on the film, the one usually reserved for the director, be shared with cinematographer Gregg Toland, and Toland's visual contribution to the

*For **Citizen Kane**, Orson Welles was surrounded with incredibly talented people that wanted to work with the "boy genius." Among them was Bernard Herrmann, who eventually created scores for Alfred Hithcock's **Vertigo** and **Psycho**. Editor Robert Wise would later direct such diversified classics as **The Day the Earth Stood Still** and **West Side Story**. The two men that created the distinctive look of **Citizen Kane** were cinematographer Gregg Toland and optical effects master Linwood G. Dunn. In the photograph, Toland is kneeling as he studies the light on Dorothy Comingore for the opera sequence. Welles is seen in a wheelchair, since he had broken his ankle in production and shot most of the film in a cast. Dunn's contributions were visual effects that combined several images, like the political rally and the opening montage. Welles was a magician and loved the idea that Dunn's optical printer could fool the eye of the audience and preceded to pepper little optical tricks throughout **Citizen Kane**. In his career, Dunn worked on **King Kong** (1933), **Cat People** (1942), **Mighty Joe Young** (1949), **West Side Story** (1961), and **2001: A Space Odyssey** (1968).*

film was undeniable. His lighting and use of depth of field is perhaps the single most influential example of cinematography in any single film. But Welles was partner in this and by all reports the two men were like children trying to discover new ways to use the camera, light a scene, or create a trick shot as a transition into a new scene.

Famed film critic of the *New Yorker* magazine, Pauline Kael started a battle over the screenplay credit for *Citizen Kane,* declaring that Herman Mankiewicz's script was entirely his own work of genius and that Welles took unfair credit. This was a double-edged sword, since Mankiewicz did most of the writing and came up with the idea based on his own experiences with William Randolph Hearst. But Welles did extensive revisions of scenes, worked on unique edit transitions with Toland, and, as a good director, cut scenes down to make them more visual. An example is the short sequence at the dining room table that with a brief series of scenes shows the total deterioration of Kane's first marriage.

But Mankiewicz had the inside track and was telling tales out of school about the parties, love affairs, and the happenings up in San Simeon with Hearst, his mistress, actress Marion Davies, and the elite Hollywood crowd. When *Citizen Kane* opened, Hearst and everyone else blamed Welles for the story and Mankiewicz got off scot-free for the most part. Perhaps there would not have been such a outcry about the film from the newspaper tycoon if the word "rosebud" was not used. Only Mankiewicz knew that "rosebud," which became the subject of the search into Kane's past in the movie, was the playful term Hearst used for Marion Davies' private parts. Naturally, he was upset, and it is doubtful that Welles had any knowledge of the source of the word until it was too late.

It is hard to judge how much Mankiewicz was trying to get away with by telling something that he knew was going to be a complete piece

of dynamite within the Industry, but Welles was immediately attracted to it. Shakespeare, Welles' idol, obviously enjoyed taking political figures, the modern kings and royalty, and bringing them to life on stage, either immortalizing them like *Henry V* or giving them marks of villainy that would never go away as with *Richard III.* Welles from his early years was able to quote Shakespeare fluently, and eventually put on stage productions that were revolutionary but still completely faithful to the bard. Welles tried to bring a national theater to America, and might have succeeded if he could have only focused on just this one thing in his life. He was very much the image of the bad boy genius, the Irishman that could not resist a practical joke and quite often had it backfire at his own expense.

So, when he began to get the pages of *American,* later to be renamed *Citizen Kane,* he saw it in way that Shakespeare would have written if Shakespeare were around in 1939. The story was the rise of someone from total obscurity who is corrupted by his own ambitions. It is also, more than anything else, a tale of loss of innocence. The bittersweet ending that shows the fate of the thing called Rosebud, which the movie audience alone discovers, is remarkable in its ability to create sympathy for a man whose downfall is tied in with his lost childhood. *Citizen Kane* is the story of a young boy being taken away from an idyllic life and thrust into a business world, which he despises and ultimately remains a child until he utters his last word. Charles Foster Kane's character flaw was his inability to grow up, something that Welles himself was accused of during his own life.

There are critical points that will be debated forever about the movie. What is phenomenal is that the screenplay tells a non-linear story. It is the kind of work that has now become fashionable. From the very beginning, the screenplay format took a story from point A to Z in a straight

narrative structure. A few films after the war began to play with time, like *Rashomon, Last Year at Marienbad,* and the film noir classic *Out of the Past*. In recent years, there have been many more, like *Memento, Run Lola Run, Pulp Fiction, Go* and *The Usual Suspects* that have begun to mix both the film genres past and present. Even the musical *Chicago* played with the idea that most of the movie was taking place in the head of the central character.

The great achievement of *Citizen Kane* is that it used the structure of an investigative reporter trying to solve a mystery. As the reporter tries to extract information from individuals that knew Kane, each pulls back a layer of onion from their own perspective, and with each episode the person injects his or her own personality. It is a very difficult trick to pull off, and the greatness of the script is that the audience is never confused for a second. The sequence with Bernstein, the faithful employee, is upbeat and optimistic, reflecting the character's true persona. The sequence with Leland, played by Joseph Cotton, has a tendency to be slightly slower and stuffy, because that is the trait of this particular character.

The fact that Welles was able to up the age-old structure of a screenplay, in an era where all movies had a story that moved from beginning to end in a straight line, and have it make perfect sense was a remarkable achievement. *Citizen Kane* could have been an immediate influence on other films, had it not been suppressed in an avalanche of controversy when it was released. Instead, it is a film that became popular with the next generation of filmmakers in the New Hollywood. They were the ones who began to look at playing with and cheating time in various ways. It was a film that had to wait almost thirty years for its power to be felt.

Citizen Kane can be looked at on so many different levels. Almost every single scene has a moment that is a slight-of-hand in some ways—

not in the sense there is trick photography, which many times there is, but because of subtle touches that were unique at this time. Much of these moments are the influence of Gregg Toland. To create strong dramatic upshots, Toland found ways to show ceilings, which were usually added in post-production by use of matte paintings. At one point, Welles enters a photograph and it comes to life with newspapermen at a dinner banquet. Toward the end there is the moment when Kane is walking down a hallway and his dejected figure is reflected countless times in large mirrors.

Since Welles came from radio, his use of music and sound in *Citizen Kane* can be examined scene by scene. This was Bernard Hermann's first motion picture score. He would go on to achieve musical immortality with Alfred Hitchcock films like *Vertigo, North by Northwest,* and *Psycho*. In *Citizen Kane,* Hermann composed all the music, including the opera sequences, and created musical bridges that connected story to characters, helping the audience with music cues to keep track of locations and events in time.

Welles plays with sound from the first scene. The film opens in complete silence, in a time when all studio pictures had a form of musical overture to get the audience's attention. The scene with Kane's death is very quiet, but a moment later the newsreel blasts to life on the screen, surprising audiences, like Josef Hayden did in many of his symphonies. And sound helps define the space in scene, symbolically establishing the distance between characters both physically and emotionally. In the giant hall of Xanadu there is a hollow sound to the room, and as Kane moves away from his second wife the two almost have to shout at each other to be heard. And like the dozens of puzzles in *Citizen Kane,* editor Robert Wise, who would go on to direct such classics as *The Day the Earth Stood Still* and *West Side Story,* spliced together all these fragmented

bits of film in a coherent story line. Many directors have taken *Citizen Kane* apart and put it back together again just to understand the dynamics of editing and to study frame-by-frame the art of cinematographic storytelling.

One of the definitions of greatness is that something is created once that cannot be copied, and it is impossible for another filmmaker to take the structure of *Citizen Kane* and not have people comment on its original source in the same way people immediately notice the telltale elements of a Hitchcock film. The movie is impossible to fit into a genre, like Western or murder mystery, and it is far more than a biography, because by the end of the film audiences in many ways know less about Kane as a person. *Citizen Kane* represents what might have happened to the nature of movies, had it been successful when it was first released. As it turns out it had a gradual influence that has increased over the decades. Toland's lighting is an entire course in cinematography. The screenplay by Mankiewicz *and*

Welles continues to have new surprises with every viewing. And Welles' interest in finding personalities plucked from the news that could be made into subjects of a modern Shakespearean tragedy had to wait until the 1970s with films like *All the President's Men*, *Dog Day Afternoon* and *The Godfather*. The fact is that almost every modern film owes a debt of gratitude to *Citizen Kane*.

Casablanca

Casablanca is a love story that was perfect for its time. It is also one of the most effective propaganda films of all time. There is any number of legendary accounts that the screenplay was incomplete and only in its early stages when production began. It was based on an unproduced one-act play called *Everyone Comes to Rick's* by Murry Burnett and Joan Alison. It was sold, but then there was uncertainty as to how to turn this vehicle into a motion picture, which even in its completed format seems very theatrical. Rarely

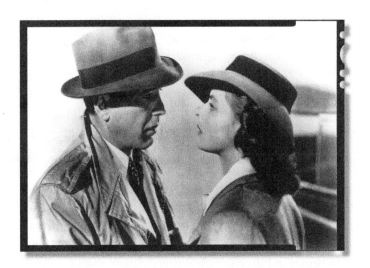

Casablanca (1942) directed by Michael Curtiz, stars Humphrey Bogart and Ingrid Bergman. Part of the powerful undercurrent of the film is the fact that a large number of the cast has been forced to flee Europe and relocate in California. Most had left behind loved ones they would never see again and personal possessions that were lost forever. Many of these actors were major theatrical stars in their own country, but in Hollywood they were happy to find work as character actors. S. Z. "Cuddles" Sakall, who plays Carl, the chubby café manager, was from Hungary. Peter Lorre (Signor Farrari), Madeleine LeBeau (Yvonne), Curt Bois (the pickpocket), and Conrad Veidt (Major Strasser) left their homes in Germany when the Nazis came to power. Leonid Kiniskey, who plays Sasch the bartender, came from Russia. Claude Rains (the humorously corrupt Capt. Renaut) and Sydney Greenstreet were from England, and Paul Henreid came from Austria-Hungary. Bergman had arrived from Sweden just the year before.

does the action take place outside of Rick's Café. What is important about *Casablanca,* and what makes Humphrey Bogart's final decision about his future with Ingrid Bergman, is the time itself. In production before World War II began and completed when America entered the war, *Casablanca* became the ultimate story of self-sacrifice in the face of a greater cause.

Jack Warner and head of production, Hal B. Wallis, had earlier tried to make films showing the brutality of the Nazis in Germany and had been politically slapped down. But world events were escalating to a point where it was inevitable that America would get into the war. It would only take one extremely violent act against America itself to set off that trigger. The sympathies of the American people were changing rapidly. Even though for many years it was a country of adamant Isolationists who did not want to get involved in any foreign conflict because of earlier humiliations in World War I, the political climate had begun to shift, to a large degree because of the movies depicting the English and their hardships.

To take a chance on a film about a divided city that is partially run by the Vichy government was a big gamble in the days before the war. When Nazi soldiers marched victoriously into Paris, a large section of France signed a pact with Germany to avoid a military invasion. The southern part of France, under the military leadership of Marshal Henri Philippe Petain, became know as the Vichy government. It technically became a separate nation that took orders from Nazi Germany. Thus, when *Casablanca* was being made, the Vichy government in North Africa was expected to stay on the side of Germany and fight the Americas on the beaches in case of a landing. The character of Capt. Renault, brilliantly played by Claude Rains, represents the slightly corrupt Vichy government. In terms of propaganda, the joining together of Renault, the Vichy mil-

itant, and Rick Blaine, the American isolationist (played by Bogart), sent a very powerful message of a "beautiful friendship."

Casablanca also had one of the greatest international casts ever assembled for a movie. Almost everybody in *Casablanca,* with the exception of Bogart, were people who had recently left or fled their homelands to come to Hollywood. Ingrid Bergman was from Sweden, Paul Henreid was from Austria-Hungary, and Claude Rains and Sydney Greenstreet, the owner of the other café in Casablanca, were from England. And the supporting cast was from all points in Europe. Conrad Veidt, who plays Maj, Strasser, and Peter Lorre were from Germany. Leonid Kinskey, the bartender, was from Russia, and S. Z. ("Cuddles") Sakall, who plays Carl, was from Hungary. They were individuals that in moments of passion changed what might have been pure melodrama to the highest level of patriotism. The French underground was active and in the news constantly, so the romantic images of a few men and women frustrating the great Nazi war machine was no fiction. It is no wonder that when the "La Marseillaise" was sung as an act of defiance to the German officers, there was a huge emotional charge on the set that spilled over to the audiences watching the movie.

No one in the movies at this time was more American than Bogart, who had finally become a major star in tough guy films. He is described as an Isolationist but with a past of being involved in noble causes. In *Casablanca* he is a tough, mysterious man with a broken heart. Like many Americans, he represented the disillusionment citizens felt about "being dumped" by the Europeans during the ill-fated League of Nations. So, when Rick has the showdown with Major Strasser (after which Rains delivers the immortal line, "Round up the usual suspects."), and he sends away the woman that he loves passionately in order to fight the Nazis, it is a call to action

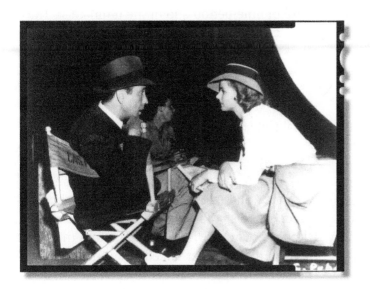

for the American people. *Casablanca* is a movie that works on many different levels. Because of this, and the timing of its release within months after war was declared, it hit audiences in the emotional gut.

Casablanca is a screenplay put together by four different writers. The original two writers were the Epstein brothers, Julius and Philip, who brought humor to the characters and wrote all the bits about gambling. They gave Claude Rains his wonderful one-liners, like being a "poor, corrupt official." The Epsteins were masters of sophisticated comedy, like *The Bride Came C.O.D.* and *The Strawberry Blonde,* but they were called off in the midst of filming when Pearl Harbor was bombed to go to Washington D.C. to write the *Why We Fight* documentaries. These propaganda shorts were under the direction of Frank Capra, who President Roosevelt considered the most American of directors and the one who could fashion these documentaries, to be shown in every theatre, about why it was necessary to fight Germany and Japan.

After the Epstein brothers left midway, Howard Koch was brought in. Koch had written

The War of the Worlds broadcast and recently the hit movie *The Sea Hawk* starring Errol Flynn, where he had worked with director Michael Curtiz. Koch politicized the character of Rick, giving him his background in fighting for lost causes. He wove into the script the importance of the underground's courage against the Nazis as something that could make an important difference. Koch remembers writing all night, delivering his pages to the studio that were to be shot that day, going home for a few hours sleep, and then hitting the typewriter again.

And then there was a writer that decided not to take credit. Casey Robinson was brought in to write the flashback between Bogart and Bergman. He was part of the assembly line of writers at Warner Bros., working on many of the Bette Davis weepers like *Dark Victory* and *Now, Voyager.* Deciding, from rumors on the set, that *Casablanca* was going to be a dog, he declined credit, an act which he commented later was the biggest mistake of his life. Robinson wrote all of the scenes in Paris, including when Rick pops a bottle of champagne as the Nazis arrive at the outskirts of the city and says, "Here's looking at

you, kid." Robinson also added the touch of Rick leaving Paris on the train, reading a letter in the rain with all the ink running down the page.

Director Michael Curtiz had this same year made *Yankee Doodle Dandy* and *Captains of the Clouds,* both with James Cagney. His skill at camera movement and placement and his ability to capture the style of a period, work fast with stars, and show complete versatility with any material tossed at him was exhibited this year. Curtiz never met a genre he couldn't handle, and this proved to be his biggest year, ending with an Academy Award for *Casablanca,* the movie everyone thought was going to be a disaster. There are only a handful of A-list directors that could jump around successfully to different genres like Curtiz could. Vincente Minnelli, Robert Wise, and Howard Hawks are just a few. Curtiz would continue making films for almost twenty years, completing the John Wayne Western, *The Comancheros,* the year before he passed away. After *Casablanca* a few of his other movies include the film noir classic *Mildred Pierce* with Joan Crawford, the gritty New York drama *Young Man with a Horn* with Kirk Douglas, and the holiday favorite *White Christmas* with Bing Crobsy and Danny Kaye.

The reason that *Casablanca* seems to endure is that it is the perfect example; it is the one motion pictures that connects with new audiences and shows them what a clockwork movie from the studio era is like. It is a film almost within a film, about people trying to get out of Casablanca to freedom in America, full of actors that had just made that same difficult journey to Hollywood. And at the start of the war, which would last for four more years, it unabashedly showed that America was the hope of everyone on the continent of Europe at this particular point in time. It was the kind of propaganda that was as powerful as anything could possibly be, and now looking at it decades later one still gets that great sense of time period and of the ultimate sacrifice of the characters for something that is bigger than all of them. It is a film that showcases all of the perfectly tooled efforts of the dream factory but is still able to look at the political climate and get a message across in a very entertaining and emotional fashion.

Notorious

Notorious, like most of the films in Hitchcock's career, was a spy thriller and pure entertainment. Hitchcock is one of the few directors that very early on in his career talked about the audience. His ultimate objective was to entertain an audience, and this was often appalling to critics, especially during the post-World War II era where there were strong social films dealing with racism and prejudice. The films of Hitchcock did not measure up to the in-depth analysis of *Citizen Kane* or even the sly propaganda and emotional charge of *Casablanca,* he was simply there to give audiences a good time. Hitchcock was the man behind the two-way mirror that laughed at people tripping over all of the little fun house obstacles in the darkness and the things that go bump in the night.

On the other hand, artists from the very beginning of time were there to entertain an audience. The definition of entertainment has changed radically since the ancient Greeks and the days of the Elizabethan Theatrer but the essence of what entertains an audience has not changed. Great plays had already been full of blood, murder, and evil plots, just like Hitchcock movies. The difference was that Hitchcock's poetry—his undeniable genius—was in visual storytelling, and for critics to appreciate this took almost eighty years. He was a true Auteur who wrote with the camera not the pen. His greatest moments were done with montage, the purest form of cinema and the depth of character he developed with

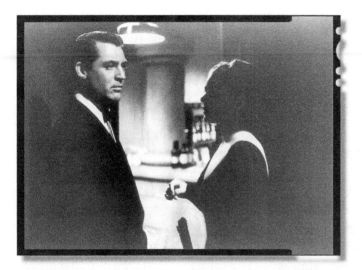

Notorious (1946) directed by Alfred Hitchcock, starring Cary Grant, Ingrid Bergman and Claude Rains, is unique to Hollywood movies because of the experimental camera work. Hitchcock was expanding the visual language of cinema through his use of point-of-view shots which allowed the audience to get into the psychology of the characters. Hitchcock took the metaphor of the spy to new and dark extremes, where the actions of the character are often in conflict with what is being said. In certain sequences, if the sound is removed, the characters seem to be plotting in one direction, but if only the dialogue is heard then a completely different impression is given. Traditional studio filmmaking made the operation of the camera invisible to the audience, but Hitchcock in **Notorious** used the camera to draw the audience into the center of the action.

camera angles, editing, acting, music, and without words was remarkable. *Notorious* is Hitchcock at his best-Aristotle with a camera.

Hitchcock's career evolved and changed from the silent era all the way to the wildly unpredictable *Psycho* in 1960. Professionally he went from highs to lows and through different golden periods in his own life. On the way he brought the general public into the appreciation of the well-made thriller and the motion picture that can manipulate an audience purely through visual images. He was a magician who loved to talk about how he created his tricks, and thus was the first major movie director that talked about the movies.

Notorious is by far a more influential film that *Citizen Kane.* This is a statement that might astonish or irritate many critics, but the fact is that *Notorious* was a massive success when it came out. *Citizen Kane* vanished for almost twenty years. The visual language in both films is revolutionary, but *Notorious* is far more complex in how this language is used. *Citizen Kane* is the inspired work of a great filmmaker, and *Notorious*

made some of the most important directors of the New Hollywood want to become filmmakers. Orson Welles by almost pure chance got total control over *Citizen Kane* and proceeded to scare executives to death, losing almost its entire investment and ruining the opportunity for other directors. Hitchcock earned the right to have total control on *Notorious* and made an art film that was also a cash cow.

All the way through *Notorious* Hitchcock was pushing the envelope of cinema language. In an early scene, Ingrid Bergman wakes up from a night of heavy drinking. With the camera from her point-of-view, audiences see a distorted Cary Grant walking to them, until he literally ends upside-down in a forced perspective on the screen. The audience immediately understands the hangover and her confused feelings, and they begin to sympathize with her character.

For a party sequence, Hitchcock had a specially designed crane made that would allow the camera to go from a full shot of a party and in one take end up in an extreme close-up of a key tightly clutched in Ingrid Bergman's hand. This

was twenty years before zoom lens. The key is slipped a few seconds later to Cary Grant in another close-up. Nothing is ever mentioned about the key, it is all achieved by close-ups and reaction shots, but the audience knows exactly what is going on, they are part of the intrigue. They key is used to discover what is stored in the wine cellar of the house, which is occupied by Nazi agents and scientists. In the atmosphere of World War II, Hollywood did not treat war in realistic terms, like *Saving Private Ryan* did forty years later, which would have devastated audiences who had relatives overseas, yet it was high adventure for most movies. It was feared that the Nazis were trying to develop the Atomic Bomb, so Hitchcock thought using Uranium-254 would make an ideal "MacGuffin." This is the thing in many of Hitchcock films that everyone in the movie was trying to get, but audiences could care less what the object actually was. They just enjoyed the pursuit of the object by the various characters that were trying everything possible to get the upper hand from each other. The idea that the Nazis were in South America working on an Atomic Bomb was the perfect story setup for the end of the war. Hitchcock claimed that J. Edgar Hoover had him followed, but this was never proven.

Notorious also pulled a fast maneuver around the Production Code with the story that Hitchcock and Ben Hecht came up with. It is about a woman, played by Bergman, who falls into social disgrace because her father had been a Nazi agent. She is living a life of pure decadent pleasure, obviously giving herself freely to older men who have money to spare. She appears to be a woman without any moral center. But then the audience learns that her self-imposed debauchery is really because of the terrible guilt she feels for being a part of a family that turned against the American way. In a recording of a telephone conversation with her father, that handsome FBI Agent, Cary Grant, plays for her, it is discovered that she is a true patriot.

Bergman's character is then asked to go to South America and work for Uncle Sam by having an affair with a Nazi agent, played by Claude Rains, which ends up becoming a marriage. Grant knows this is all done in the line of duty and is part of a spy's trade, but he secretly loves Bergman and is being torn apart by jealousy. Bergman loves Grant, and is literally trapped in a sex life with a man she is repulsed by. But because there was a war on, Hitchcock convinced the Hays Office that what was immoral in peacetime was a response to duty during war. It worked. *Notorious* is one of the most sexually frank films since the pre-Production Code era.

The visual language that Hitchcock perfected in *Notorious* was the complex use of the point-of-view shot {POV}. This opened up the ability of the filmmaker to shoot many different angles and to interweave two or three stories simultaneously, each from the POV of different characters. Most notably, in the party scene in *Notorious*, from the POV of Claude Rains the audience sees what he believes are Ingrid Bergman and Cary Grant about to have an affair. The audience knows they indeed would like to have such an affair, but the duties of Uncle Sam come first, and they only pretend to flirt with each other to lead Claude Rains astray. From the POV of Cary Grant the audience notices Rains constantly eyeballing him, and thus makes it difficult for him to disappear and check out the wine cellar. And from the POV of Ingrid Bergman the audience is witness to the fact that the champagne at the party is going fast, which is reinforced by the constant popping of corks. If the champagne runs out, then Rains will discover his key is missing and warn the Nazi guests, who have a way of making people mysteriously disappear. This is a simple sequence that is made highly suspenseful by manipulating the audience with three different

motivations, all done in montage. The dialogue in the scene amounts to play acting, in contrast to the real game of espionage. What might have been a static scene in a movie suddenly is full of dramatic action because of different POV's.

The point-of-view is something Hitchcock would continue to perfect over the years until it became a dominant feature in films like *Rear Window* and *Vertigo.* Hitchcock more than anybody changed the idea of what a director was in the public's mind. Because of his use of montage and carefully planned storyboards before production, he also changed the very nature of the production process. The point-of-view shot is something that was not part of the normal visual language of many films in the early studio era, because it broke the traditional rules of seamless filmmaking. Now with *Notorious* there were camera tricks, multiple stories within a scene, and dialogue that meant one thing but visual action that was counterpoint to what the words were all about. Without question, by the end of the war *Notorious* not only represented the movement into film noir, it also gave directors new tools and character motivations to play with.

HOLLYWOOD CANTEEN

Hollywood stars loved the public limelight and knew that they had a powerful effect at critical moments in America's history. During World War I, there was newsreel footage of stars like Mary Pickford, Douglas Fairbanks and Charles Chaplin rallying huge crowds for War Bonds, which was stock in the U.S. Government to build up the war machine. In World War II almost every star was there in force to do tours and talks, to make training films, and to start something called the Hollywood Canteen, which was the brainchild of Bette Davis. The Hollywood Canteen, and its counterpart in

Anchor's Away (1945) directed by George Sidney, with Gene Kelly, Frank Sinatra, and Jerry the Mouse. Studios quickly found out that men in the military took pride if a star played a sailor, marine, pilot, or foot soldier. The war years might have been Hollywood's finest hour. Stars were constantly making personal appearances at bases to build up morale, going on tour with the U.S.O., visiting hospitals, and stopping in at the Hollywood Canteen at night to sing a few songs, tell jokes, dance with the soldiers, hand out coffee and donuts, or just wash dishes.

New York, The Stage Door Canteen, were there for service men waiting to be called up, or returning from combat service. Every night for eight to ten hours sometimes, after stars had finished shooting for the day, they would go a small building that could house about two thousand GIs, sailors, and marines at one time. Outside there would be a line of another two thousand men waiting to get in. It ran regularly on two-hour shifts. Inside a GI could get a hot cup of coffee, donuts, maybe some soup, and listen to a band with the top performers of the day, from Ray Bolger to Bing Crosby to Betty Hutton. This was the Golden Age and the last hurrah of the Big Bands that traveled on miserable buses all day so they could perform for the troops all night. Harry James, Tommy Dorsey, Benny Goodman, Jimmy Dorsey, and Glenn Miller all were big as movie stars and appeared in motion pictures having their own solos. Movie shorts that were used as fillers in theatres were early versions of MTV music videos.

The enlisted men would come to the Hollywood Canteen and be greeted by Bette Davis, Marlene Dietrich, Betty Grable, or hundreds of other stars and starlets. Everybody eventually showed up. GI's wrote home that they danced cheek-to-cheek with their favorite movie star. Any number of soldiers went off to war with the images of this moment in their minds. Letters were being constantly written from GI's to these stars, and they were religiously answered as much as possible.

The Hollywood Canteen was something that night after night, without pay or consideration for the long hours, already exhausted from churning out films during the day, most stars never missed. The feeling that they were doing good in bringing a few hours of enjoyment to soldiers that were being sent out to fight all over the world was enough. It was Hollywood's shining moment.

THE RISE OF THE DOCUMENTARY AND ARMY TRAINING FILMS

When war was declared, one of the first phone calls President Roosevelt made was to Frank Capra to come to Washington, D.C. and to make a series of documentaries titled *Why We Fight* that would let the American people know what their enormous sacrifices were going to be for. His instinct was that Capra was the most American of all the directors, and would be able to tell the American people what America was and what freedom was, because at this point in history many citizens had lost sight of it. Now America had to go back into battle for something that did not seem like their fight until the attack on Pearl Harbor on Sunday, December 7, 1941.

For many countries Americans was like the Seventh Cavalry coming to the rescue to put an end to tyranny. But something Americans were not prepared for was how obsolete the military was because of funding cutbacks during the Depression and consequently unprepared to fight aggressive force, like the Japanese navy and the Luftwaffe of Germany. It was now time to galvanize a spirit of determination in the minds of the American people, which was the kind of morale building that the Hollywood studios had perfected over the past decade.

Since the silent era, newsreels were shown before the feature motion picture. Newsreels like "The March of Time" and "Fox Movietone News" were about seven minutes long and focused on important events in the world—fashion tips, sports, and usually a humorous anecdote, or a look behind-the-scene glimpse of Hollywood. During the Second World War newsreels grew longer, until there were times when a feature length documentary would replace the B-movie on a billing. Frank Capra's *Why We Fight* were a series of documentaries each about thirty min-

The Memphis Belle (1945) directed by William Wyler is one of the most successful documentaries to come out of the war. It follows a B-17 crew from takeoff to landing on their twenty-fifth bombing mission over Wilhelmshafen, Germany. Meeting with heavy fire from ground artillery and fighters, Wyler, who was operating one of the cameras, had his hearing permanently damaged from the noise of the 50-mm machine guns. During the war a documentary came to be expected on every cinema bill. Other directors who made documentaries were John Ford (**The Battle of Midway**), John Huston (**The Battle of San Pietro**), Frank Capra (**In Which We Serve**), and George Stevens (**Nazi Concentration Camps**). The process of making documentaries appears to have had an effect on these directors when they returned to mainstream filmmaking. Their movies became darker, both in lighting and story plots, and were often shot on location to give a heightened sense of reality.

utes long that were intended to give a unifying focus on why America was going to war, and to counteract the devastating effect of Leni Riefenstahl's *Triumph of the Will.*

Audiences were used to seeing blurred and jerky images in these documentaries. Most of the footage was smuggled out of countries and shot under very dangerous circumstances. It is, of course, impossible for a camera operator to shout "stop" to an invading army, like on a Hollywood sound stage, just because the lighting was not right. A photographer often held the camera up and hoped for the best, others got into the middle of the action, like the camera was a gun. The images bounced around, the cameras were always handheld, the 180-degree line was broken, different film stocks were edited together, and there were constant jump cuts, with little attempt at continuity in the images. But in documentaries, all this was acceptable because audiences knew intellectually this was real-life and the

rules were different. This technique became known as cinema vertie.

The camera was the key player in war documentaries; shooting through trees, the edge of buildings, or from inside foxholes, it could capture the aftermath of or occasionally the moment the fighting occurred. Frank Capra's *Why We Fight* and Leni Riefenstahl's *Triumph of the Will* represent the two sides of documentary filmmaking during this era. In *Triumph of the Will* the images are revealed naturally without imposing a godlike voice explaining the action. But in *Why We Fight* the images are deliberately cut to fit a script, with a narrator giving the viewer a guided tour of action. Capra brought in Walter Huston, who has a stern fatherly tone to his voice, as the narrator to talk about the world of light and darkness, or democracy and fascism.

Other directors joined the Signal Corp on the heels of Capra going to Washington, like John Huston, William Wyler, and George Stevens.

Disney's studio stopped production on several projects and got ready to send Donald Duck to war and to make cartoons to help the war effort. Many directors were given units that would shoot everything from training films to patriotic documentaries to informational films that demonstrated that loose lips could sink ships and the correct procedures during a blackout and air raid. There were educational films for soldiers on what to do and not to do if they are captured by the enemy, dramatizing the sly methods in which the Germans could extract, without the use of torture, innocent bits of information that could be pieced together to thwart a potential invasion. At the height of the war, there were literally tens of thousands of documentaries and informational films in some stage of production. One of the most popular was the cartoon series Private Snafu, which showcased the worst soldiers in the Army that did everything completely wrong, using humor to educate soldiers on correct methods. Private Snafu was started at Warner Bros., but it was so popular other studios were given contracts to keep up with demand. Most of these movies were destroyed after the war, but some vintage clips by Chuck Jones and other cartoonists still survive.

Walt Disney made his entire studio available for the war effort. Not only did he throw his army of animators entirely into making shorts that would promote the cause of fighting the enemies around the world, but also worked a deal with the U.S. Government to build sound stages that could be converted immediately into hospitals in case of invasion. This was a very real concern along the western seaboard for years after Pearl Harbor. Many of the buildings and sounds stages at the Disney Studios in Burbank reportedly still have outlets in the walls for oxygen. Disney's inept soldier was usually Donald Duck, with his short temper. The most famous cartoon is "Der Furhrer's Face," where Donald wakes up in Nazi Germany.

By the end of the war the documentary became a huge influence on the look of films, especially in foreign countries, becoming a deliberate style during the French New Wave Movement. A new generation of directors realized they could achieve a sense of realism with a mobile camera. The shaky almost amateurish look of a scene, sometimes with poor sound quality, could actually heighten the sense of realism in depicting characters, especially the anti-hero who lived in a darker more uncertain world that sprang up after the war. Documentaries began the process of an innovative style that would eventually change the look of movies by the 1970s.

It is incredible to witness how sophisticated the photography in war zones became as a result of lighter weight cameras and faster film stock. Dramatic scenes that would not have been possible at the beginning of the war became commonplace over the years of fighting. Cameras could shoot the action in rainstorms, twilight, and even the blast of cannons at night. These murky images, in complete contrast to the look of Hollywood studio movies, were deliberately recreated in the classics of film noir, where an alley or seedy hotel room was lit sometimes by a single source of light, engulfed by shadows.

Many Hollywood directors that went into the Signal Corp made documentaries that ended up as small masterpieces in this art form. William Wyler, who made *Mrs. Miniver* before he went into service, shot *The Memphis Belle,* one of the most highly respected documentaries of the war. *The Memphis Belle* is the name of a B-17, and the documentary follows the crew on their final bombing mission over Germany. If a crew survived twenty-five missions the men could stop flying. This number increased throughout the war, as reflected in the military insanity of *Catch 22* by Joseph Heller. On this mission, Wyler and a few cameramen flew with the Memphis Belle crew. Other cameramen at the airbase shot the

action from the early morning briefing, to loading the bombs, to the long wait for the B-17 crew to return home safely. During the mission that saw heavy resistance, Wyler lost part of his hearing because of the noise of the 50-MM machine guns. He came back from the war afraid that his career would be over. But his experiences inspired him to make a motion picture about the problems of returning veterans, *The Best Years of Our Lives,* with two key scenes that took place inside a B-17.

John Huston made two remarkable documentaries. One was *The Battle of San Pietro* about a mission that seemed to be a walk in the sun but turned out to be one of the bloodiest in the Italian campaign with over 1,100 Allied fatalities. Huston's other documentary, *Let There Be Light,* became a political hot potato and was ultimately banned by the US War Department for thirty-five years. The documentary showed returning soldiers that were completely disoriented, probably forever, by shell shock. This was a controversial subject that was completely ignored in the First World War and only began to be recognized late in the Second World War.

The famous incident when General Patton slaps a soldier for saying he cannot continue any longer because his nerves are shot began to open up this subject in the newspapers. Patton declared the soldier to be a coward, which was the prevailing attitude of most commanders throughout military history. One of the great myths of warfare was that real soldiers did not break down, but the truth were that they did in terrible ways that were always neatly hidden from the public. This was long before soldiers had social workers and psychologists who understood the trauma they went through. These men were treated as complete outcasts, as people that could not stand up to the pressures that others did and thus were lesser men in this respect. *Let There Be Light* is extremely difficult to find even today, but its

disturbing study of battle worn soldiers is still very effective. The first motion picture that Huston made after the war was *The Treasure of the Sierra Madre,* which just happened to be one of the most engrossing studies of a man descending into madness ever put on film.

The hiding of information from the public has been a flint stone for government conspiracy theories. Certain documents, films, and perhaps even spaceships have supposedly been stored in cavernous warehouses, like at the end of *Raiders of the Lost Ark,* until the American public was ready to see them. This was especially true of newsreel footage that was never shown to the public, of images so horrifying that it would have defeated any efforts to keep morale up on the home front. This is in total contrast to a 21st century audience that almost hungers to see graphic violence on the screen and television. A modern example of keeping upsetting images from the public was the Zapruder 8-mm film of the assassination of President Kennedy in Dallas in 1963. *Life Magazine*'s frame-by-frame layout stopped before the final shot to the head out of respect to the family, and it was believed that the public would be too distraught by the images. It was almost sixteen years after the event before these last seconds were finally shown to the public.

John Ford won two of his six Academy Awards for documentaries he made during the war. One was *December 7, 1941,* co-directed with cinematographer Gregg Toland. The other was *Midway,* which was actually shot during the fierce naval and air battle that became the turning point of the war in the South Pacific. Ford was wounded at one point while shooting the action with his handheld camera, something he rightfully bragged about for years. *They Were Expendable* was Ford's first film after the war about the courageous yet overlooked PT Boat commanders battling in the Philippines against a shortage of supplies and overwhelming odds.

There is a memorable scene where a small group of PT's helps General McArthur escape from Corregidor at the beginning of the war. The film is full of Ford's touches, with humor and patriotic music, but there is a certain understated pessimism that had not been seen in his earlier movies.

The only director that shot in color was George Stevens who followed the action in Europe from the invasion of Normandy all the way up through the evacuation of the concentration camps. Many of these images are extremely unsettling. Because World War II was exclusively photographed in black-and-white, the color in Stevens' footage brings a different sense of realism to the war, especially the horrific scenes in the concentration camps. The sight of emaciated bodies moving toward the camera in a sleepwalking state is something that lodges in the mind forever. Reels of this exposed footage was stored in Stevens' garage for years, and it was not made into a complete documentary until almost forty-five years after the war.

Many of the directors that ended up in harm's way to depict the war came back changed and their films had a turnabout in storytelling. Several of them embraced the Western, looking back at this era as a time of great significance in American history and one that brought a certain peace of mind to them as filmmakers. After the war John Ford turned to Westerns and rarely ventured out of this genre for the rest of his career. To him the settlement of the West showed America at its finest. His Cavalry Trilogy of *Fort Apache, She Wore a Yellow Ribbon*, and *Rio Grande* were shot in Monument Valley. They starred John Wayne and became the building blocks of the Ford Stock Company. Howard Hawks directed *Red River,* a tale of the first epic cattle drive, and ended up his career with his own trilogy of *Rio Bravo, El Dorado,* and *Rio Lobo,* all starring John Wayne.

The director that came back with the darkest change was George Stevens, who had seen first-hand the devastation of American soldiers during the Battle of the Bulge and later the evacuation of the concentration camps. Before the war his movies were notably lighthearted, like the musical *Swing Time* with Fred Astaire and Ginger Rogers, the grand scaled adventure *Gunga Din,* and the comedy *Woman of the Year* that teamed up Spencer Tracy and Katharine Hepburn for the first time. When he came back he also turned to the Old West with *Shane,* the most successful Western made to date. But his movies with contemporary themes had a much darker side like *A Place In The Sun, Giant,* and *The Diary of Anne Frank.*

Frank Capra seemed to become lost after the war, making only one film that was the stuff of the old Capra vision of small town America, *It's A Wonderful Life,* which was also James Stewart's first movie after he returned from war service. Capra's films during the Depression era were optimistic and played with the theme that one man could make a great difference in life, as shown in *Mr. Deeds Goes to Town, Meet John Doe,* and *Mr. Smith Goes to Washington. It's a Wonderful Life* is disturbing because for most of the motion picture everything goes against the central character, George Bailey, and for over half the story it appears that a single man really might not make a difference. In Capra's other films, the public or the common people, came to the rescue; however, in *It's a Wonderful Life* the character is pushed to the point of suicide and it takes divine intervention for George Bailey to realize his worth. After the box office failure of *It's a Wonderful Life,* the other films that Capra made did not have the feeling of the old "capracorn" that made him the most American of directors according to President Roosevelt. His last film was *Pocket Full of Miracles,* a remake of his earlier success *Lady for a Day,* but it too proved to be a financial dis-

appointment. Feeling that Hollywood had changed too much, Capra retired and wrote one of the first books about the film business, *The Name Above the Title,* which became a best seller and it is still worth reading for his insights into directing and the motion picture business of a bygone era.

DIRECTORS

With many of the major American directors gone into the service, like John Ford, William Wyler, Frank Capra, and John Huston, it was the foreign directors who had fled Europe that began to put their mark on Hollywood, a mark that would reflect by the end of the war the pessimism that many of them felt about the dark side of humanity. These directors were part of the German Expressionism movement, and were never into the Hollywood tradition of carefree song, screwball love stories, and upbeat endings.

These directors had always marched to a different drum when they worked in the studios during the 1930s. They realized the good medicine of escapist movies that kept people's spirits optimistic was important to dig out of depression. But they had seen and experienced a bitter sneak preview of the bleak reality of what World War II would eventually do to so many millions of people. Atrocities that seemed like something out of the worst stories of the Middle Ages became daily headlines during these dark years. The war had its lasting affect on the general public and what they wanted to see when the soldiers came home. Perhaps it was because of the terrible losses, or because of the realization there was no absolute good and evil, but people were composed of a bit of both under certain circumstances. Or perhaps because people collectively began to feel they had been lied to and a cancerous distrust started to grow that would lead into the Communist witchhunts by the end of the decade. After the war the "anti-hero" became the new movie idol, and di-

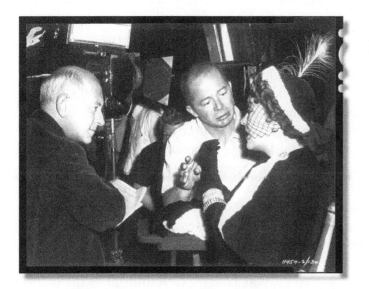

*On the set of **Sunset Blvd.** (1950) with director Billy Wilder, Gloria Swanson and Cecil B. DeMille. The film takes a hard look at the unglamorous side of Hollywood. Wilder was cursed at by Louis B. Mayer for making the film, but he had the last laugh when he and partner Charles Brackett won the Oscar for writing. Wilder started out as a reporter and then began to write for the German cinema during the Expressionist movement. His mentor was Ernst Lubitsch, who helped him come to America. Though he wrote comedies like **Ninotchka** (1939) and **Ball of Fire** (1941), when he got the opportunity to direct his films often examined the dark side of human nature. **Double Indemnity** (1944), considered one of the first film noirs, is based on the true story of a woman who lures an insurance salesman into a plot to kill her husband. **Lost Weekend,** made the following year, is the disturbing look at an alcoholic writer who hits rock bottom. Like with Fritz Lang, Jacques Tourneur, and Fred Zinnemann, Wilder was bringing a European influence into mainstream Hollywood.*

rectors that had come to America from Germany, France, and England were the architects of this character born during the darkest hour of night.

Ernest Lubitsch sadly passed away in 1947, having seen the end of the war and the destruction of Berlin, where he began his film career thirty years before. His *To Be or Not To Be,* along with Charlie Chaplin's *Great Dictator,* were the two notable movies that mocked Hitler. *To Be or Not To Be* was later remade by Mel Brooks, who was a fan of the German director and the famed "Libitsch Touch." Brooks, like Lubitsch, felt that if people could laugh at someone, it de-mythologized them and took away part of their threat, as he had also done with Hitler in *The Producers.* One of the first directors to come over from Germany, Libitsch was the exception to the rule. His films were superbly crafted musicals and delicate comedies. His style influenced many directors upon his arrival in America, and many of his comedies have nicely endured the test of time. Libitsch was one of those people whose wit never seemed to fail him. About directing he once said, "I sometimes make pictures that are not up to my standard, but then it can only be said of a mediocrity that all of his work is up to his standard."

Billy Wilder was the protegé of Lubitsch and looked upon him as a father figure. Lubitsch helped get him his first writing assignments in Hollywood. Wilder never really felt he had mastered the English language and always worked with other writers, Charles Bracket and ultimately a long collaboration with I. A. L. Diamond. The variety of films made by Wilder most often reflected his background in Germany, with his interest in becoming a lawyer, and later turning to work in journalism for one of the largest newspapers in Berlin. A writer and director that could remarkably go from farcical comedy to hard-hitting drama, his movies had a reporter's sense of finding a certain fundamental truth, and the dark side of a story always appealed to him. He was one of the first directors that was beginning to explore the previously untapped dimensions of the anti-hero character that became popular after the war.

Double Indemnity (1944) was a film that everyone close to Wilder said would ruin his career. This became a running theme in his life with most of his great successes, like *Sunset Blvd.* and *Some Like It Hot. Double Indemnity* became the touchstone of all film noir that quickly followed. Based on a true story, then turned into a scandalous novel by James M. Cain, it is about two people that meet by chance and connect with an animal attraction for each other. They begin to plot the perfect murder to bump off the wife's husband for the double indemnity on his insurance policy. But in the world of film noir there is no such thing as a perfect murder. The sadistic fun is watching everything gradually fall apart, like a house of cards in slow motion.

Shot in dark rooms with slashes of shadows, *Double Indemnity* was Wilder's first big hit, and is the only film on which he collaborated with the eccentric but brilliant writer Raymond Chandler. Wilder once said of Chandler, best known for his famous mystery novels *The Big Sleep* and *Farewell My Lovely,* that he could write complete nonsense all day, but there would always be one gem of a line that was used in the script. Wilder, like Hitchcock, enjoyed casting stars against type. For the icy blonde he used Barbara Stanwych, who up until then was known for her comedies, or the love interest in *Meet John Doe.* And for the sex starved insurance salesman he cast Fred MacMurry, who had always played the good guy, or the fellow that does not get the girl in routine studio movies. And making a bit of a comeback, as someone on the right side of the law for a change, was Edward G. Robinson as the insurance investigator with the sensitive stomach. This film also set the high bar for something that is linked with film noir, snappy dialogue full of

streetwise metaphors, wisecracks, and a richness of wordplay that has faded away from most film genres over the years. Later motion pictures like *Chinatown, L. A. Confidential,* and even *Pulp Fiction* owe a debt to *Double Indemnity.*

For Wilder's next film (another one he was warned against making), he teamed up with his old writing partner Charles Bracket. Together they did the screenplays for Lubitsch's *Ninotchka* with Garbo and *Hold Back the Dawn,* and then with Wilder behind the camera, the two had comedy hits with *The Major and the Minor* and *Five Graves to Cairo.* But their follow-up to cold-blooded murder is one of the most honest and grueling motion pictures ever about alcoholism, *The Lost Weekend* (1945). It also was one of the first films that set out to achieve a documentary look. Many scenes of Ray Milland, who would win an Academy Award for his performance, were shot while he wandered the early morning streets of New York by himself, with the camera hidden inside a van peeking out the back window. The sequences when Milland is locked in an alcoholic ward to dry out, and later when he returns to his apartment and has the delerium tremens are nightmares of cinema verite realism. Wilder walked home with two of his five Academy Awards this year, one for writing, along with Bracket, and the other for directing. In total he would be nominated twelve times for writing and eight times for directing.

Like his mentor Libitsch, Wilder was known for his "Wilder-isms." He once remarked, "My English is a mixture between Arnold Schwarzenegger and Archbishop Tutu." He also observed something that is sadly true about making movies, "A bad play folds and is forgotten but in pictures we don't bury our dead. When you think it is out of your system your daughter sees it on television and says my father is an idiot." Toward the end of his career he lamented, "today we spend 80 percent of our time making deals and 20 percent of our time making pictures."

Fritz Lang proved that he was a master of almost any genre by directing two Technicolor westerns *The Return of Jesse James* with Henry Fonda, who he had worked with earlier in *You Only Live Twice,* and *Western Union* with Randolph Scott. From 1941–45 Lang made a series of films that helped define the film noir genre, and equaled Hitchcock in the area of spy thrillers. Lang seemed to find his footing in Hollywood during these years, and it came to be argued that *M* was the first motion picture that studied the anti-hero and laid the ground work for film noir. *Man Hunt* is a highly suspenseful film about a British big game hunter that goes after the ultimate prey during the war—he sneaks into Germany to assassinate Hitler. It is rightfully referred to as a classic in its visual storytelling, showing Lang at the top of his form.

Hangmen Also Die is based on the true story of Nazi Reichsprotector of Bohemia "Hangman" Reinhard Heydrich who was killed by Czech resistance fighters and the brutal aftermath that followed. The screenplay is by Bertolt Brecht and one of few credits the famous German playwright ever received during his lotus days in Hollywood. Lang followed this with an adaptation of Graham Greene's espionage novel about a man who is released from an asylum and gets caught in the middle of spies in London. Lang's next two films are among his very best, showing his inventive skills as a director and melting his background in Expressionism into a fine mix of film noir to create a strange dreamlike quality. *The Lady at the Window* and *Scarlet Street,* both made in 1945, star Joan Bennett, Edward G. Robinson, and Dan Duryea, one of the great deranged bad guys of the noir period. Both films use irony to perfection, one of the necessary ingredients in this genre.

In *The Woman in the Window* a professor becomes enchanted by a portrait of a beautiful woman, only to actually meet the woman and be invited under innocent circumstances to her apartment for talk and a bit of champagne. But her boyfriend arrives and misinterprets why the professor is there. A struggle ensues, resulting in the boyfriend's death. Thus the irony that noir thrives on. What follows is a suspenseful blend of cover up, police investigation, and blackmail, with a suspenseful payoff ending.

Scarlet Street bring this trio of actors together again. This time Robinson plays a simple cashier who pretends to be a wealthy artist and helps a pretty woman escape her abusive boyfriend by letting her move into his apartment. Robinson is inspired to paint several incredible canvases, only to have boyfriend return and sell them under her name. Again everyone becomes involved in events that spiral out of control.

Film noir is a quick turn down a dark alley, compared to the ready-to-please studio motion pictures that lead up to the war. These dark tales of greed and intrigue that often lead to murder were still governed by the Production Code, where crime has to be wrapped up in a neat bow and punished by the final reel. The locations were usually big metropolises, the asphalt jungles of post-war society. Los Angeles and New York were the favorites, thus the genre was referred to as "dark city" films, places where an innocent man or woman could be corrupted in the blink of an eye by taking one step in the wrong direction. Lang, Wilder and Hitchcock made major contributions to film noir almost the same year, launching hundred of other films that were defined by one of the most inventive periods of cinematography since the end of the silent era.

Robert Siodmak was born in the United States but raised in Germany. He learned his craft under the leadership of Robert Wiene and F. W. Murnau, but like so many of the German direc-tors, Siodmak was forced to flee during the Nazis roundup of the Jews. He took any assignment he could get at Universal, like the *Son of Dracula,* but then directed *The Phantom Lady,* based on a novel by Cornell Woolrich, and for the next six years entered the realm of film noir.

The Spiral Staircase and *The Dark Mirror* prepared him for the adaptation of *The Killers* (1946) based on the Ernest Hemingway classic short story *Nick Adams.* Elwood Bredell's cinematography is almost a visual textbook on the lighting of film noir. *The Killers* introduced Burt Lancaster, and starred young and beautiful Ava Gardner, who added a whole new meaning to the term *femme fatale.* The story used a familiar plot device in this genre, where there is a murder at the beginning that resulted in a long flashback to uncover all the details, opening up a world of double-cross and long planned revenge. Siodmak followed the success of *The Killers* with *Cry of the City* and *The File of Thelma Jordan,* both taunt and superbly crafted examples of the noir style. He made two more movies with Lancaster, *Criss Cross,* and then in a complete turnabout the Technicolor high-spirited swashbuckler *The Crimson Pirate,* which was his last film in Hollywood.

Born in Vienna, Fred Zinnemann worked in the German film industry, meeting Robert Siodmak and Billy Wilder on the production of *People on Sunday,* then came to America in the early 1930s. His first job was as an extra in *All Quiet on the Western Front,* but out of pure determination he was able to apprentice with the legendary documentary director Robert Flaherty, which had a profound influence later on his feature films. Zinnemann made hundreds of short documentaries and won an Academy Award in 1938 for *That Mothers Might Live.* When he got his break into features, he used many of the techniques that he had learned to heighten the realism in his early motion pictures. Zinnemann

proved to be a versatile director from the start with films like *The Seventh Cross* (1944) starring Spencer Tracy, which was his first major break into the Hollywood system, and reflected his early influence of German Expressionism.

The Search (1949) was shot on location in post-war Berlin in a documentary style, about a GI trying to find the mother of a war orphan. Zinnemann was responsible for giving two actors that became giants of the Method Acting their film debuts. Montgomery Cliff was the star of *The Search*, which was shot before *Red River*, which reached the screens first. And Marlon Brando was first seen in *The Men* (1950), the story of a soldier paralyzed during the Korean War. Much of *The Men* was shot in a veterans' hospital with real soldiers recovering from disabling wounds. The screenplay was by Carl Foreman, who that same year wrote *High Noon* that Zinnemann directed, with Gary Cooper giving an Academy Award winning performance as the marshal of a town that would not help in his stand against a gang of outlaws. The movie was a western disguised as a criticism of McCarthyism and the witch-hunt trials of the 1950s. *High Noon* became controversial because Cooper throws his badge in the dust as the townspeople come out to greet him after the shootout. This action implied that people who are afraid to take a stand against the forces of evil do not deserve the protection of the law, which was a very courageous statement, even as a visual gesture, during this period.

Zinnemann would go on to win two Academy Awards for directing. One for *From Here to Eternity*, based on James Jones's best selling novel about army life in Hawaii before the war, and *A Man for All Seasons* about the religious conflict between Henry VIII and Sir Thomas More. Zinnemann's early experience in documentaries probably led him to shoot many of his films on location, especially if the subject was new and provocative in nature. He made *The Nun's Story* with Audrey Hepburn, *The Sundowners*, one of the first major motion pictures to be shot in the outback of Australia, the political assassination thriller *The Day of the Jackal*, and *Julia*, with Jane Fonda and Vanessa Redgrave, based on the story by Lillian Hellman about a friend who was lost in the Holocaust.

One famous story about Zinnemann is that later in his distinguished career, he met with a young, brash Hollywood executive in his plush office. The young executive obviously had not done his homework and flatly asked the multiple award-winning director if he had done anything of significance in his career. Zinnemann, always the European gentleman, smiled politely and replied, "Sure. You first."

Jacques Tourneur was born in Paris, and began at the age of nine working for his father Maurice who was a director. He worked on scripts and edited for his father's films and gradually began to get jobs as a director. He was hired by David O. Selznick to work the second unit shots for *A Tale of Two Cities* with Ronald Coleman. Then he teamed up with legendary producer Val Lewton at RKO Studios. Lewton had put together a series of horror films that were unique because they worked more on the imagination instead of just the fright factor of seeing scary monsters.

One of Tourneur's most highly successful films was *The Cat People*, a movie that works with shadows and suggestions, where darkness becomes almost a character in the story. The audience never sees the cat person as it transforms, leaving it up to their active imaginations. The film became a huge hit. Tourneur worked on other films in the horror genre including *I Walked with a Zombie* and *The Leopard Men*. In 1947, he did an adaptation of the crime novel *Build My Gallows High*, renamed *Out of the Past*, which is a masterpiece in the film noir genre with Robert Mitchum, Kirk Douglas, and Jane Greer.

All aspects of *Out of the Past* come together perfectly. Almost half of the film is done as a flashback, telling a story of a man played by Mitchum who becomes entangled with one of the most memorable femme fatales in cinema history, Katie Moffat, and how he thinks he has escaped his past in a small town. Then the story arrives back at present day where the past catches up with him and he is asked to do one final job to even the score. This is another popular theme in film noir. Nicholas Mussaraca's cinematography creates a dream world that descends into a nightmare. And crisp, tough guy dialogue, like when Mitchum tells Greer out of disgust after she double-crosses him, "You're like a leaf blowing from one gutter to the next."

All of these directors were forced to leave their countries for fear of imprisonment or probable extermination. They brought with them the lessons they learned in filmmaking and transplanted their styles and theories of lighting and editing into the Hollywood system, which began to take root during the long war. If there was any possibility, no matter how remote, that these directors could have stayed in Europe, then their unique approach to filmmaking might not have influenced the popular cultural of American motion pictures. But after the war the directors that began to be noticed and ultimately transformed the look of Hollywood movies by the late 1960s were those that did stay in their native countries, like Federico Fellini, Ingmar Bergman, Jean-Luc Godard, and Akira Kurosawa. These directors would make films that were very much associated with the culture, the background, and the artistic traditions they grew up with in their own countries.

The phenomenon of all of these directors coming to Hollywood in the years before the war without question created a true artistic melting pot, which altered the superficial nature of studio movies. This was a gradual process, as the events in Europe caught up with the American people. During the Depression motion pictures for the most part needed to be light and bright and full of gaiety, presenting an optimistic feeling of future prosperity. But war brought a different demand as the daily images coming from the fronts were like the damnation paintings of Hieronymus Bosch. There were photographs and documentaries of atrocities, genocide, and torture that shook the popular imagination, almost as if Orson Welles' broadcast *The War of the Worlds* had come true.

Much of the change in movies after the war came from returning soldiers who had been trained to kill and had done so, then were asked to put these dark memories away forever after the war. But the unthinkable happened—the memories remained, but good soldiers did not talk about the hardships of battle or the loss of close friends that stood beside them and then disappeared in a barrage of bullets or explosions. The naïve love affair with the movies had finally come to an end. The directors that came over to Hollywood were full of these images, because they knew full well many of their relatives and loved ones were caught up in the Nazi machinery. They were helpless to do anything about it, except to make films. And slowly these movies began to show the bleak feelings that so many of them had pushed aside for so long.

AMERICAN MULTICULTURAL FILMS

The films of this era are sometimes difficult to look at by today's standards because they are blatantly bigoted and racist against the enemies of America in World War II. Since there was no foreign film market at this time, the Hollywood films that came out were movies to keep the "fighting morale" of the citi-

Charlie Chan at the Wax Museum (1940) stars Sidney Toler as the famous Chinese detective and Victor Sen Yung, who appeared in fourteen of the series as Jimmy Chan and later Tommy Chan. Besides Toler, Charlie Chan had been played by Warner Oland and later by Roland Winters. The popular series lasted for over fifteen years. Though Chan was always shown with an Asian family, none of the actors playing the inscrutable sleuth were Asian. Victor Sen Yung was one of the most successful Asian actors from the late 1930s through the 1950s. He had roles in more than ninety movies and made forty-five television appearances.

zens and soldiers. In these films, the enemy, almost exclusively the Nazis and Japanese, were disgraceful beings, people that were stereotyped for quick identification, played as having no heart, and being called ugly derogatory names in the spirit of patriotism—names nowadays which are obviously politically incorrect. During the war they were used loosely. Since the Production Code would not allow swear words, slang words like "Kraut" or "Jap" or "Gook" are as close as actors got to profanity on the screen.

There was a distinction between the Japanese and the Chinese in many war pictures. The Chinese, which ironically were often played by Japanese actors, were the ones that were still trying to help American flyers and soldiers in movies like *Thirty Seconds Over Tokyo.* So this prejudice was not against the Asian people, but everyone was stereotyped as either very good or evil without compassion. The Japanese quite often were depicted with buckteeth, and sometimes they wore thick round glasses that magnified the eyes. Both the Nazis and Japanese were played as intelligent. Even in Hollywood movies the enemy were treated as advanced cultures, but the intelligence was used to torture or play with the

British or American captives, the same way a cat would keep a mouse alive for sadistic pleasure.

The enemy in these films were quite often the only jobs ethnic actors could find during the war, but this mainly applied to Japanese characters. Nazis were often performed with British accents, like with George Sanders in *Man Hunt,* or by German Jews that had escaped the Third Reich, like Conrad Veidt in *Casablanca,* which, of course, is the ultimate irony. War films were as melodramatic and culturally defined in terms of good and bad as the Westerns. Here were two cultures that audiences were conditioned to hate because of the color of their skin, the slant of their eyes, or their cool efficiency at eliminating innocent people.

What the general public really did not know were the atrocities that were happening in Germany. None of these things were depicted on the screen, and none of the movies showed Concentration Camps as they really were. There were depictions of prisoner of war camps, but even in movies like *The Great Escape* made twenty years later the conditions on screen are far better than they were in the real camps. There is no doubt, however, if these atrocities were known

during the war, then the racial stereotyping of the enemy would have been far worse.

Stereotypes allowed audiences to mentally boo and hiss, and since the war was always predictable in Hollywood movies, people knew that no matter how clever the enemy, or how efficient their army, the Allied Army would be victorious. It was very reassuring, even during times when the outcome looked uncertain. But it was a time that bred paranoia about what was happening in the world. Good Americans were not to trust people that became too talkative. In informational shorts audiences learned that even neighbors could cause damage if they did not turn out their lights quickly enough. And there are many stories that were not shown, even today, about what happened in America, perhaps because they still are too difficult to deal with.

Japanese-Americans were rounded up and put into Interment Camps. These camps were not formed as a way of eliminating people but to keep possible defectors from becoming spies. A person's property was seized, an act which to this day has never been satisfactorily rectified by the U.S. Government. But after the Japanese invasion of China and sneak attack at Pearl Harbor the resentment toward the Japanese-Americans was far more acute than it ever was toward the Germans, and this was only reinforced by the war movies pouring out of Hollywood.

Writer Studs Terkel described World War II as "the Good War" because it was a war in black-and-white, not just in the film stock but with the armies that were being fought and the purpose of the sacrifices. Every American knew the faces of Hitler, Mussolini, and Tojo, the bad guys in the story. War films have continued to be popular because of all the stuff that is so clearly defined like uniforms, airplanes, rockets, secret weapons, and even the music.

World War II themes popped up in almost every genre, especially in the early days when Hollywood was given free reign to go full blast after being held back for years. There were Westerns with Nazis in them. Sherlock Holmes outwitted the Nazis. Bob Hope and Red Skelton got mixed up with spies. Mr. Moto, who was a Japanese fictional character, was retired, but Charlie Chan continued to fight the good fight. And this was a golden era of comic books and newspaper cartoons. Captain America's archenemy was the Red Skull, the ultimate evil genius of the Nazi party. Batman, Superman, The Human Torch, Tarzan, and Terry and the Pirates all fought the enemy in full color panels month after month.

During the war the British began to take a backseat to the Latinos. Hollywood opened its arms to the Latin lover and the passionate spitfire. Ricardo Montalban, Caesar Romero, Carmen Miranda, and large casts from Mexico and South America began to fill the screen in glorious Technicolor as part of the Good Neighbor Policy. If someone had to be pigeonholed into a stereotype, then the persona of a Latin lover is a stereotype that most people would probably welcome. These Hollywood excursions south of the border gave audiences new, exciting music to listen to, and they opened up a different kind of romance on the silver screen. In Walt Disney's *The Three Caballeros* (1944) even Donald Duck fell head over beak with the beautiful Latin women that seem to always arrive at sunset fresh, lovely, and willing to dance throughout the night. After the war, tourism exploded to Mexico and South America with people searching for the idyllic life in this animated feature.

This was an era of unabashed sexism. Women were pinups, and in the call of duty, proud of it. Gorgeous half-naked Vargas girls adorned the sides of bombers. Betty Grable and Rita Hayworth photographs were taped up over every bunk. The big thing that began to change with women in film is that they became the ob-

Gilda (1946) directed by Charles Vidor has become Rita Hayworth's most famous film because of **The Shawshank Redemption** (1994), based on Stephen King's short story "Rita Hayworth and Shawshank Redemption." **Gilda** is an example of a motion picture that has endured several generations because of a few carefully crafted images, which last only a few seconds on screen. Hollywood entered World War II making Technicolor musicals and romantic comedies. By the end of the war the audience mood had changed and film noir with seductive femme fatales became highly popular. In this dark crime genre, Hayworth represented the new movie star, along with Gene Tierney, Jane Greer, and Lana Turner.

jects of desire, the gal the guys were fighting for. There were more women in pictures but less pictures about women. There were certainly no motion pictures about women on assembly lines making Sherman tanks or P-51 Mustangs, and by the end of the war almost half of the workforce on the home front was women. And by the end of the war the femme fatales began to scorch the screen in film noir movies. Teresa Wright in *Mrs. Miniver* was replaced by Ava Gardner in *The Killers* and Jean Arthur in *Mr. Smith Goes to Washington* had to step aside for Rita Hayworth in *Gilda*. Over the course of the war it became a man's world on the screen, and it stayed that way, with notable exceptions, for the next forty years. The respect for women in movies gradually eroded away, and the stars of Bette Davis, Joan Crawford, Greer Garson, and Ginger Rogers had faded. As it turns out, what men wanted before they went to war was not what they wanted when they returned—at least not at the movies.

After the war, an evening that must have been wonderful to be a part of was when everyone had returned home from whatever service they were in, whether it was the military, the USO, the Signal Corp or duty in Washington. That night most of Hollywood went into the famous Romanoff Restaurant. Because of saving food stamps, Romanoff was able to put together some of his famous delicacies for the first time in a long while. Everyone sat at tables or on the floor and listened to Bing Crosby sing and Hoagie Carmichael play the piano the entire evening. It must have seemed strange to realize that they had survived and were in a restaurant they had frequented when the world was a more innocent place. They recognized that the war was finally over, and they were back where they started, yet somehow sadly changed forever. So many of them had witnessed unimaginable tragedy, so it must have been a very poignant moment in Hollywood history.

Post-War Hollywood, Television and the Blacklist

1947–1959

The end of World War II played out like a big budget Technicolor Hollywood musical. The GIs came home. Their wives and loved ones were waiting for them. They were able to move into small suburban houses that were being mass produced and own a car that did not have machine guns attached to it. They had left this country during the Depression and had returned to find the most prosperous nation in the world. With a citizen army, America had defeated two of the most powerful military machines the world has ever known.

So far, things seemed to be going perfect. During the war the Hollywood studios had earned more money than in their entire history. By 1944, the five major studios had an estimated worth of over $750,000,000, a rise of over $145,000 from the year before. In 1946, the industry had reached $1,700,000,000, which was an incredible amount of money, considering the ticket prices were usually thirty-five cents. Two-thirds of the American people were going to the movies every week, and sometimes twice a week as the bills changed or to see the Saturday matinee specials. Approximately ninety million people enjoyed the latest Hollywood motion pictures. Things were so optimistic that it looked like the carefree movies of the 1930s had come true. America was out of the Depression. The economy was bounding forward. Jobs were plentiful. The GI Bill allowed soldiers to go back to school to pick up an education. Many soldiers were the first in their family history to receive a secondary education. Food was plentiful again. Everything that constituted the wholesome American dream seemed to finally, after the long years of the Depression and a horrible war, resolved itself into something where everybody could achieve a new lease on life. To continue the metaphor of the Hollywood musical, everyone could have stepped out of suburban homes and sung merrily the latest hit on the jukebox as a grand finale.

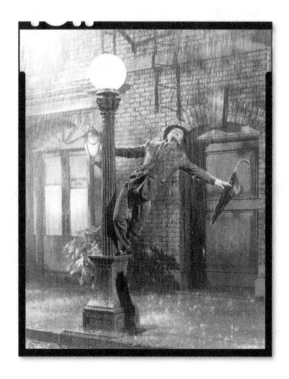

Singin' in the Rain (1952) directed by Stanley Donen and Gene Kelly, starring Kelly, Debbie Reynolds, Donald O'Connor and Jean Hagen, is considered the best example of the Old Hollywood style musical. Originally Kelly and the rest of the production team had serious doubts about the film's success. The producer and head of the musical division of MGM, Arthur Freed, wanted to make a movie based on many of the songs he wrote the lyrics for back in the 1930s. The feeling was that the material was hopelessly dated, but writing team Betty Comden and Adolph Green came up with the idea of doing a spoof about the havoc in Hollywood during the transition into sound. The combination of old fashioned musical numbers given the full Technicolor treatment resulted in a timeless musical.

But this was not the case. The fact is that a great number of soldiers returned home physically and mentally broken. The long war had left scars many of them could not begin to talk about. And the job opportunities for these soldiers were often remedial because the youngsters who were too young to enlist ended up with the good quality jobs that would afford advancement. The returning veterans had been trained in the necessities of war to drop bombs on enemy targets, stand guard duty on the front lines, or drive a truck in an endless supply line. Many fathers came home to children that they had never even seen and suddenly had to adjust to family life. The troublesome memories of war were something that began to change the family structure, especially in the 1950's when the internal workings of the American family started to break down.

The biggest difficulty was that it seemed that the war would not end. The destructive damage of "Fat Man" and "Little Boy," the nicknames for the two atomic bombs dropped on Hiroshima and Nagasaki, put a decisive end to the war, preventing a possible invasion of Japan that might have cost an estimated million lives and prolonged the war another year. World War II began with crude military tanks and biplanes and ended up with B-29 super fortresses and jets that almost reached the sound barrier. And most significantly, because of the top secret work on the Manhattan Project, America had the first atomic weapons.

The one weapon that was hailed as a deterrent to future wars was suddenly being called a terrible mistake by Albert Einstein and other noted scientists. These men warned that if splitting the atom was only going to be used for the expansion of war machinery, then it would be something that would plague humanity for ever. They were right. The atomic bomb ushered in the Cold War. In the days after the war, General Patton had been sternly reprimanded for making a statement that the America army should have continued the battle and gone into Russia, which, before it was fashionable, he saw as an enemy to democracy. The Soviet Union had been an ally during the war. Americans listened with horror at the tales of millions of people who died defending Stalingrad and Leningrad. Yet, as soon as the war was over, Stalin rushed to claim territory previously occupied by the Germans, round up scientists, and ultimately end up with the secret for the atomic bomb.

When Winston Churchill said the Soviet Union had brought down an "Iron curtain," the phrase stuck. America was no longer in a shooting war; it was in a war of threats and dire possibilities of using the atomic bomb and then the hydrogen bomb. The free world had feared that Hitler, and the German army would gain access to the Atomic Bomb and use it on London or New York. It now became a reality that the Soviet Union had this atomic weapon and was making the same threats. After the Russian Revolution and during the hardship of World War II, Communism had been romanticized, but overnight the term "Communist" became a label that stuck with anyone that had any association with this ideology and any affiliation with the term could permanently derail a career.

In 1947, the House Un-American Activities Committees (HUAC), under the gavel of J. Parnell Thomas, began hearings to investigate possible Communists that had spread the Red Menace to the shores of the United States. The easiest target that got the most exposure was Hollywood, which in 1946 had just celebrated its greatest box office year ever. The sad irony is that America had accepted in principle all cultures, so the search for Un-Americans initiated some of the darkest years in the country's history. A growing paranoia began. People began to suspect everyone of having some type of Communistic sympathies, especially in the intellectual Hollywood crowds. The obvious focus were the writers who

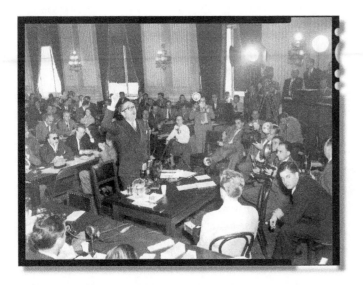

Hollywood became the focus of the witch hunt investigations during the years of Joseph McCarthy and the Red Scare that almost crippled the U.S. Government and started the blacklist that destroyed the lives of hundreds of actors, directors, and screenwriters. In retrospect, the televised hearings showed the same kind of bullying interrogation practices that Joseph Stalin had used during the secretive Moscow Trials. However, instead of losing their lives as millions had done in Russia, in America the people that were named as possible communists, or refused to testify before committees, lost their jobs without recourse. The only way to keep working was to name in public hearings the names of fellow associates that were known communists or "possible" communist sympathizers. Here Adolphe Menjou testifies before the Hollywood committee. Menjou said he thought about moving to Texas, because he knew that Texans would "kill communists on sight."

had expressed ideas that the capitalistic system during the Depression had failed and that Communism, at least in books and public speeches, advocated sharing the wealth so that everyone would be equal. It was a Utopian idea. After the end of World War II, the American people—especially those that had flirted with the Communist Party in the 1930s—finally saw what was happening in the Soviet Union. News was coming out that during the notorious Moscow Trials in the years after Lenin's death, Stalin had killed off more of his own people than Hitler.

Many high ranking military officers who Stalin suspected were plotting against him were sentenced to death. With the cream of his army gone, Stalin was under great stress when Germany invaded Russia. The American people saw that what was happening in the Soviet Union was the same thing that had just happened in Germany and Japan. The country was under a complete dictatorship, and the Communism of Stalin bore no resemblance to the writings of Karl Marx or Lenin, which had long ago been aban-

doned. Stalin had decided that an iron fist and not philosophies was required to govern an unruly mass of people. The war helped solidify the power of Stalin, which he immediately used to his advantage when peace was declared. Every effort by the Soviet army was made to find German scientists, especially those that had been part of the Pimiento Project and the creation of V-1 and V-2 Rockets that had poured down on London. Within months after the war the world was divided again. Overnight, one of America's chief allies had become its enemy, but this time it was a battle of nuclear threats.

This paranoia that Communism could be something that was contagious, and that a few words in a movie could somehow change a person's loyalty to America and turn them into a Communist agent, was a very real belief at this time. *The Manchurian Candidate* (1962), made after the blacklist officially ended, does an excellent job of showing the extreme and unreasonable paranoia of this era. Since there is no proof that a few well-chosen words could alter a

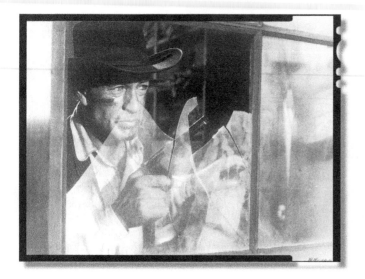

High Noon (1952) directed by Fred Zinnemann, starring Gary Cooper and Grace Kelly, was written by Carl Foreman who was blacklisted during the making of the film. Foreman took the popular Western genre and, like many films during the McCarthy era, gave it an undercurrent of contemporary politics. John Ford, Howard Hawks, John Wayne, and Ward Bond hated *High Noon* because they felt it tarnished the traditional values of a Western.

person's thinking during a motion picture, the mythical powers of Communism took on the aura of black magic, and the resulting HUAC investigations became know as "witch trials," referring back to the days of Salem in 1692.

The reason these hearing took hold of the public's interest is that they were the first major political event seen on the early days of television. The timing was perfect and unfortunate, since, like the first movies, what the average citizen saw on television they assumed was the absolute truth. This is long before Watergate and other scandals when people still believed in the honesty of politicians. It can be described as the first media circus, since people could see many of their favorite stars being sworn in and appearing very vulnerable. Celebrities like Gary Cooper, who had been Mr. Deeds and Sergeant York, said boyishly, that what he knew of Communism he did not like because it did not "sound on the level." Character actor Adolph Menjou announced that he would move to Texas, because he felt Texans would kill Communists on sight. The only way to wash away the specter of Communism was to name names. This process meant that if a person named someone *suspected* of Communist actives, which was a very wide net of gossip and bias, or if a man or woman admitted they had gone to Red meetings but then named others at these meeting, they were considered good Americans. Those that refused to testify were assumed to be Communist sympathizers and hostile to the court. Leading man, Robert Taylor turned in a fellow actor, Howard Da Silva (who later went on to play Benjamin Franklin in *1776*), because Da Silva always seemed like he had a little extra something to say on the set. The arrests of Julian and Ethel Rosenberg in the summer of 1950 for passing information that lead to the development of a Soviet Atomic Bomb proved beyond a shadow of a doubt there was a Red Menace loose in America. The Rosenbergs were executed by the electric chair on June 19, 1953, and doubts about their true involvement still linger.

As far as Hollywood was concerned, this was only one part of the triple punch that took the studios from the height of financial popularity into almost complete bankruptcy by 1950. The Federal Government, which had allowed corporations to act almost as monopolies to support the American war machine, and given Hollywood a free hand to get movies to theatres that would keep the morale of the people up, suddenly conducted an antitrust action against the five major studios. The result was that MGM, Warner Bros., Fox, RKO and Paramount were divested of their theater chains. The studios that owned and controlled the luxury theaters had been a source of controversy for years because most of the small, independent theaters were forced to deal with minor studios or second-run features. The independents rightfully felt they were not getting a fair shake with the profits. With a newly released A-list movie, the profits were coming in through the doors and then back into the studios. The antitrust suit effectively cut the Hollywood dream factory in half. Before this a studio would know exactly how many theatres a movie would open in based on years of research on the attraction of certain movies stars and the popularity of certain genres. A studio would be able to place certain movies into areas where musicals or Westerns were highly popular with a good calculation of how much money each film would bring in. It was a perfect arrangement that allowed major studios to grow into mighty powers. The major studios always had the best movie palaces to show first-run features. But the antitrust suit broke this up.

It ultimately took five years for studios to sell off the theatres. During this process it became very evident that the money made on production and distribution was sizeable, but the real profits were in exhibition. Under the new ruling, theatres did not have to run a movie under the commands of the studios. If a theatre manager felt that ticket sales were plummeting on a certain movie, then a feature could be quickly replaced with another feature, which might be produced by a different studio. The theatre owners could go with any studio they wanted to strike a deal for what they thought would be the movie with the highest potential gross. The theatres began to call the shots, even making suggestions to the studios on what kinds of films to make and who should star in them. This kind of supply and demand began to change the nature of the movies that were being made.

The theatre owners knew the territory, and the studios had to reluctantly listen. If a studio wanted a certain theatre in a city, it would now have to work out a short-term rental agreement with a sliding scale for the profits. The financial returns going back to the studios began to dwindle. During the height of the Studio System, movies would run as long as they were making a small profit; however, after the antitrust action, once box office receipts began to drop off, a theatre owner had the right to replace the movie. Studios still had first-run exclusive causes in the contracts, so an A-list film could only be shown in roughly a hundred mile radius. A big budget motion picture with stars still had clout in negotiating contracts with theatres, but the profits on small B-movies began to drop off. And for the first time since sound came in, studios began to feel the burden of keeping so many stars on long-term contracts.

Many theatres that had run down over the years repositioned themselves as art houses. They began to show revivals of the Hollywood classics and, ultimately, became the gathering places of curious and adventurous patrons as foreign films began arrive after World War II from Italy, France, Sweden, and Japan. Foreign film production had been devastated by the war, and Hollywood literally had no competition during these years. After all its years of loyalty, in an un-

expected turnabout that created great agitation, England announced a 75 percent import tax on Hollywood films. Soon other European countries followed. The foreign revenues from American films, which had been expected to skyrocket after the war, instead began to plummet because distribution became too expensive. In a repeat of what happened after World War I, filmmaking in European countries began to experience a second renaissance to fill in the void of imported films. When these films were exhibited in American art houses they attracted a younger audience that was becoming increasingly bored of the traditional Hollywood motion picture. Moviegoers found these foreign films different, provocative, and a little dangerous.

TELEVISION

By 1949, the Hollywood studios had lost their theatres, were facing embargo taxes in European countries, and hundreds of their earlier movies were being scrutinized by HUAC for any phraseology that might appear slightly on the "pink" side. Ultimately, however, the biggest wrench thrown in the Hollywood machinery was by something about six inches wide. The first batch of television sets had screens so tiny that families almost had to sit shoulder-to-shoulder to watch. They got very poor reception and had constant problems with keeping a horizontal picture. But television shows had one great advantage—they were free.

The earliest experiments with a system to transmit images goes back to 1831. The term "television" was first used during the 1900 Paris World's Fair. Philo Farnsworth put together the first electronic television system that in 1927 he patented under the name of Image Dissector, and in 1929 John Baird built the first TV studio. Television had its first big public introduction during the 1939 New York World's Fair when David Sarnoff with RCA televised Franklin Roosevelt giving the first live speech by a president. Four years later, Vladimir Zworykin invented the Orthicon, a camera tube that had enough light sensitivity to shoot outdoor events in the evening. At the end of the war, in 1946, Peter Goldmark invented the first color television, and by 1948 there were already one million sets in the United States.

In 1950, there were 8 million American families with television sets; by 1959 the number had increased to 42 million. The early sets had tiny screens, poor reception, and constant trouble with the horizontal control—but the shows were free. Families sat in the comfort of their living rooms, ate easy to cook Swanson dinners on a new piece of furniture called the TV tray, and laughed at shows starring Milton Berle, Phil Silvers, Sid Caesar, and Lucille Ball. The Hollywood studios had their greatest year in 1946, when people were going to the movies at least once a week, but by the early 50s, because of the influence of television, all the major studios were on the verge of bankruptcy.

This meant people's living rooms were suddenly filled with shows starting in the morning and continuing until midnight. Over the next decade this small box would change the entire structure of the American family. Millions of returning veterans who had spent every night in a different foxhole under terrible conditions for two or three years suddenly were able to sit down and watch something in the peace and quiet of their homes. However crude the early reception might have been or how uninspired the entertainment (the first big shows were professional wrestling events), television was a complete luxury. There was no getting in cars and finding parking places. No buying tickets and getting stuck in bad theatre seats. Early televisions were designed in wood consoles, like a piece of furniture, and quickly became a permanently invited guest at dinnertime.

But even free has its price. The early sets were a constant frustration to adjust. First, there had to be an antenna on top of the house with a wire running to the back of the television. Hopeful viewers would sometimes spend hours trying to pick up a clear signal, which would change when the sun set, or a brisk wind came up, or birds used the antenna to rest on and flutter about. Quickly there were so many antennas popping up it began to interfere with neighbors' reception. In places where there was a strong signal, "rabbit ears" could be used. These indoor antennas stuck up in a "V" formation that the viewer would constantly move around to get a good reception, which often was a snowy picture. Aluminum foil became a great conductor for these antennas. Sometimes, people realized their body chemistry would result in a reasonably clear picture and they would strike a very awkward position, holding the antenna during an entire show.

The first television star was a cowboy named Hopalong Cassidy, played by silent matinee idol William Boyd. He made his first appearance as Hopalong Cassidy in 1935, then over the next eight years starred in over fifty more features. These B Westerns were shot on location and were just over an hour long—the ideal time for a television show. In 1948, at the age of fifty-three, Boyd took a giant gamble by selling his ranch and buying all the rights to his cowboy character, which included motion pictures, radio, print, television, and merchandising. This was a move that was unheard of before this, but one that proved to be a gold mine. The Hopalong Cassidy of the movies was very different from the tough codger of the novels. He was the only good guy in movies that wore black. Cassidy did not drink, smoke, swear, gamble, was too busy for a love interest, and always let the bad guys go for their guns first. Boyd's trademark, besides his black costume, was his silver hair and infectious laugh. He always had a sidekick, usually a cantankerous character actor that became known as Gabby Hayes in the movies, and Edgar Buchanan on television.

Hopalong Cassidy hit the jackpot. It was a program made for television but shot like a movie. Here was a cowboy hero that adults had grown up on, and it was now a free weekly feature that a new generation of children could enjoy. Corporations rushed to sponsor Hopalong Cassidy, and the show became one of the first to be broadcast from coast-to-coast. Then Boyd began to franchise his character. Within a few years every child could buy Hopalong Cassidy cap six-shooters, milk, comic books, lunch boxes, bedspreads, records, rocking horses, watches, cereal, and hundreds of other products. The tie-in between television and the local department store was a marketing bonanza no one could have imagined. At its height, there were hundreds more Hopalong Cassidy items than Mickey Mouse or Shirley Temple.

The only franchise that ended up with a bigger catalog was *Star Wars*. George Lucas grew up

with Hopalong and knew from early experience about the financial success of franchising, which is why he took the option for merchandising in exchange for part of his salary on the original *Star Wars* movie. Most of the writers, directors, and actors that became part of the New Hollywood movement watched Hopalong Cassidy and his horse Topper each week, and had toy boxes full of Hoppy stuff. Quickly other cowboy heroes like Gene Autry and Roy Rogers stampeded to television and started their own brands of merchandising. By the time William Boyd retired in 1953 over half of the shows on television were Westerns.

The king of early TV, however, was not a cowboy, but a bigger-than-life comedian from the glory days of vaudeville and burlesque named Milton Berle. He was sponsored by Texaco and performed in front of a live audience. Uncle Miltie, as he was nicknamed by his fans, did comedy sketches that had been out of style since the demise of vaudeville. Berle was famous for his entrances at the top of the show when he appeared in outrageous costumes. His most popular gag with audiences was when he dressed as a woman, the kind of routine that burlesque was based on thirty years before. After his first years

he was given the title Mr. Television. When his variety show first aired there were roughly three million TV sets in the country. By the end of that season an estimated twenty-four million sets had been sold. Appliance stores left televisions on in the window overnight to attract customers. When Milton Berle was on, hundreds of people would mob the storefronts. Usually by noon the next day all the sets would be sold. And on nights when Uncle Miltie's show aired, movie theatres were almost vacant.

A lot of radio shows like the detective mystery *Boston Blackie,* the creepy horror program *Inner Sanctum,* the cop drama *Dragnet,* and soap operas like *The Guiding Light* switched over to television as entertainment. The poverty rows studios like Republic and Monogram had been turning out short B-features for decades. All the studios, especially Universal and MGM, had been making comedy shorts since the silent era. When television hit, it was like *The Jazz Singer* twenty years before, Hollywood was overwhelmed, but this time it had no control over the new craze.

Television was considered a step down for movie stars, an attitude that continued for decades. A quality motion picture would take

*Milton Berle became known as "Mr. Television;" his comedy-variety show **The Texaco Star Theatre** ran from 1948–56 on Tuesday nights and attracted up to eighty percent of the television viewing audience. Berle's program, along with **The Ed Sullivan Show,** has been described as the second life of Vaudeville. Berle became known for his opening entrances in outlandish costumes and for interjecting himself into the specialty acts of his guests. In 1951, with his popularity at its height, he was given a 30-year contract, for the then remarkable amount of $200,000 a year, if he would perform exclusively for NBC.*

months, and hours would be spent on the lighting and costumes for each single shot. Early television was mostly live, ranging from game shows like *What's My Line?* and *Name That Tune,* to talent searches like *Arthur Godfrey,* and prestige dramatic presentations like *Playhouse 90* and *Alcoa Presents.* Many of the live dramatic presentations were ninety minutes long and episodic in format, with a different story each week. Some of the most exciting writers of the post-war era were able showcase their talents with these programs. And many of these television specials were later remade into successful motion pictures. Paddy Chayefsky wrote *Marty,* a sensation on television, and the only American movie to win both the Academy Award as Best Picture and top honors at the Cannes Film Festival. Other television presentations that crossed over into movies were *Judgment of Nuremberg* written by Abby Mann, and *Requiem for a Heavyweight* by Rod Serling, before he created *The Twilight Zone.*

To make matters worse for the Hollywood studios, all these programs were done in New York with stage actors and directors, which was appropriate since the shows were effectively live theatre broadcast into millions of living rooms. Money flowed into television, especially productions aimed at the housewife, all in an effort to make her life easier. Procter and Gamble, Pillsbury, and General Foods spent millions in advertising, and Swanson made a fortune by introducing the TV Dinner, which was a complete meal on an aluminum tray that could be popped frozen into the oven and be ready for everyone's favorite show an hour later. There was no way to stop a movie every seven minutes to sell something, but no one cared if it happened on television, it just gave people time in their own homes to visit the kitchen or restroom.

The shows that were shot on film were done in a week, and often had tinny sound and bad special effects. But television audiences were not expecting the same artistic quality of *Gone With the Wind* or *Casablanca* when they turned on their sets and waited for the picture tube to warm up. The shows were free. Besides, if the last program was not very good there would be another one after a station break. Speed was essential in television. Many highly skilled second unit directors, technicians, cinematographers, and designers, along with a small number of character actors, who had been trained to work quickly on B-features, found green pastures in television. These talented individuals, who were often caught in the cogs of the major studios, did manage to instill a high level of quality in many of the early shows, like *Twilight Zone, Alfred Hitchcock Presents, Outer Limits, Perry Mason,* and *The Defenders.* Ironically, this Hollywood look is what has enable many of these shows to endure over the years.

One show that started a trend in television that has continued to this day was created by a redhead and her Cuban husband, known to audiences around the world as Lucille Ball and Desi Arnez. Never a big movie star, Lucille Ball had been in over eighty motion pictures, usually playing secondary leads, including *Follow the Fleet* with Fred Astaire and Ginger Rogers and *Stage Door* with Katharine Hepburn. So, when she turned to television it was assumed that her career was over in Hollywood. Instead, this new medium seen by almost a quarter of the population of America each day made her a superstar. With its catchy theme song and madcap misadventures of a not-so-typical wife, *I Love Lucy* was screwball comedy brought to the small screen. It was a comedy of endless situations, a format that became known as the sitcom.

I Love Lucy was filmed in front of live audiences. The early TV camera used for live shows gave a flat look to the images being broadcast. *Lucy* was shot on film using three cameras, and was in the tradition of the two-reel comedy shorts

that had been around since the silent era. Many studios that continued to make these shorts like the *Our Gang* series, also known as *The Little Rascals,* and *The Three Stooges,* had been reedited for TV commercials and were hits on late afternoons when children arrived home from school. *I Love Lucy,* like all sitcoms that have followed, was like a stage play. The actors performed full scenes, with the three cameras filming master, medium, and close-up shots. The only time the filming stopped was to change sets. The spontaneity of the audience's reactions to the comedy bits of Lucy and Ricky was real, but the look of the show had the feeling of the old-time shorts. The concept of using three cameras is credited to the great cinematographer Karl Freund, who was the director of photography for the *I Love Lucy* series. Freund was one of the great cinematographers, with motion pictures like *Metropolis, Dracula, The Good Earth,* and *Key Largo* to his credit, he also directed the Boris Karloff version of *The Mummy.*

Since *I Love Lucy* was shot on film, it became one of the first series made in Hollywood, USA. Joining their names together, the husband and wife team formed Desilu Productions and took over the historic RKO lot, which had fallen on hard times after Howard Hughes mismanaged the studio and sent it into a financial tailspin. To this day, the episodes when Lucy and Ricky drive to Hollywood with Fred and Ethyl Mertz, and the birth of Little Ricky are among the most highly viewed shows in television history. With the enormous success of *I Love Lucy,* Desilu produced such early television classics like *The Untouchables, Mission Impossible,* and *Star Trek.*

RKO was one of the first studios to sell its film library, which included the Fred Astaire and Ginger Rogers musicals, *King Kong, Gunga Din,* and *Citizen Kane.* Old movies had no life after the original release, and thousands of films were lost or deliberately destroyed to make room for newer movies. Most of these vintage films from the old Hollywood Studio System were stored in hot warehouses, with no thought of refrigeration to preserve them. They went untouched for sometimes decades at a time, slowly beginning to have a slightly rotten vegetable smell as they deteriorated in the canisters. With the exception of *Gone With the Wind,* or Walt Disney's animation features, that were re-released about every seven years, the studios considered their film libraries a useless form of capital. By this point in time, over 80 percent of the silent films had been lost. Old movies were like a car that had too many miles and was sold off for its parts. But television, which was being blamed for the death of Hollywood, brought an unexpected new life to the movie industry.

The idea that a studio could make money on its film library is very obvious today, but at the time it was quite innovative. By the early 1950s, television had three networks: NBC, ABC, and CBS. Each network had begun to produce their own shows, or gone into co-ventures with production companies that could supply programs. The problem was that television had taken off so quickly there were not enough programs for an eighteen-hour day. A typical weekday would begin early in the morning with children's programs, like *Captain Kangaroo,* then late morning go into a line-up of soap operas and game shows, then after school programs, like *Howdy Doody.* The evening news would come on around 6 P.M., followed by popular entertainment until 10 P.M. After this hour the networks felt it was financially unwise to produce shows, since most families went to bed by this time.

Showing old movies late at night seemed to be a good way to fill this empty time space until stations signed-off with the National Anthem around midnight. This began a major revival of Hollywood movies and was the genesis of what critic Pauline Kael calls the Film Generation. Most

It's a Wonderful Life (1946) directed by Frank Capra, starring James Stewart and Donna Reed, was a financial disappointment (not a failure, however), and quickly put an end to Liberty Films, the independent company founded by Capra, George Stevens and William Wyler. The film had the old Capra formula of one man making a difference in the lives of many, which was the theme of **Mr. Deeds Goes to Town** and **Mr. Smith Goes to Washington,** but *It's a Wonderful Life* is a much darker film than anything the director had done before. The film's major competition was **The Best Years of Our Lives,** directed by Wyler at Goldwyn Studios, which became the second highest grossing movie next to **Gone With the Wind.** Both films were about the importance of the individual, but Wyler took a serious, almost documentary approach to his story, and Capra used the trappings of a modern fairy tale. The fantasy theme is perhaps the reason the film did not fit the mood of audience at the end of World War II. Capra's movie was eventually discovered on television and is seen as the most original holiday story since **A Christmas Carol.** And by the late 70s, the pendulum had swung back and audiences were eager to swap reality for fantasy.

of these old movies had not been seen in a decade or more and were watched by adults with fond remembrances. However, children saw these motion pictures for the first time and became intrigued by them. With no planned intention, they became a random crash course in movie history, despite the fact that almost every one was butchered to reduce the run time for commercials.

Soon movies began to appear on Saturday and Sunday afternoons, and in the larger metropolitan cities stations would stay on until 2 A.M. or later. The studios began to sell their old movies in packages, so if a station wanted *Casablanca* they would also have to take several lesser-known Warner Bros. features. Because of this, television audiences began to see many films that were missed the first time around, including the thousands of B-movies that were wasting away in storage. Without question, if television had not come along when it did, a vast number of movies from the Golden Age would have been lost forever, much like what happened with the major-

ity of silent films.

The post-war era was a period when the process of filmmaking had not yet changed dramatically from the early talkies, plus many of the movie stars were still top box office attractions, like James Cagney, Katharine Hepburn, Spencer Tracy, James Stewart, Cary Grant, Bette Davis, John Wayne, Humphrey Bogart, and many more. There were no cinema books on film history or criticism, or guides with rating stars to tell viewers if they were watching a good or bad movie. Thus this cavalcade of old movies were seen without preconceptions or artistic prejudice. And films that were box office disappointments when they were first released suddenly became hits on television. Comedians like Mae West, W. C. Fields, the Marx Brothers, and Stan Laurel and Oliver Hardy who had begun to fade away had a whole new generation of fans.

Probably the best and most ingenious use of early television was by Walt Disney. His show first aired in 1954 and was called *Disneyland,* a

year before his Magic Kingdom opened to the public. Disney hosted the programs like a familiar family friend, and each week television audiences would visit Frontierland, Adventureland, Fantasyland, or Tomorrowland and see a short movie, wildlife adventure, or cartoon related to that kingdom. All of the Disney characters were suddenly in everyone's living rooms, and the excitement about the theme park captured everyone's attention like Lindbergh landing in Paris.

The hundreds of Disney cartoons now had a home on television and a new generation of children to watch them. Animated features that did poorly at the box office, like *Fantasia* and *Victory through Air Power,* were reedited to fit the hour-long program. It was one of the most visionary uses of marketing in early television. Not only was Disneyland the central subject, but each week audiences learned about new Disney books, records, and movies, plus sneak previews of future programs, like *The Mickey Mouse Club* and *Zorro.* Disney had learned during the war years to put together educational films by using animation mixed with moments of humor, and he often treated his program as a coast-to-coast classroom. There were lessons on science, American history, wildlife, mathematics, some of the first looks behind-the-scenes of movies and cartoons, and, of course, the building of Disneyland. These programs used animation, stop-motion and time-lapse photography, and guest speakers like Wernher von Braun. Disney's series on space exploration began one of the first marketing tie-ins when Richfield luxury filling stations gave away comic books that accompanied the series with the purchase of a tank of gas. This series started the 375 space fever for many children, which became a stepping stone to the ambitious proposal by President Kennedy to land a man on the moon.

NEW YORK, BROADWAY AND THE METHOD

For the first time in the history of the world, the center of an artistic revolution was not in European cities like Vienna, Paris, or London. New York was now the melting pot for all of the Arts, except for motion pictures, and even this would begin to change over the next two decades. On Broadway a new generation of playwrights were testing the limits of dramatic presentation, creating provocative plays perfect for the next generation of actors using the Stanislavski Method. These playwrights explored the myths of the American Dream, and looked frankly at the evolving sexuality between men and women. They were poetic and raw, using powerful language, and a far cry from the British plays by George Bernard Shaw and Oscar Wilde, or even American plays before the war by Eugene O'Neill and Robert Sherwood. These playwrights wrote characters whose psychological make-up often fell between the lines. What these characters said was often a cover-up for dark secrets and lies to divert the focus from unpleasant experiences. This demanded a new approach to acting that created these characters both externally, through dress and mannerisms, and internally, through veiled suggestions and a sense of anxiety.

The playwrights of this era included Thornton Wilder (*Skin of Our Teeth*), Arthur Miller (*All My Sons* and *Death of a Salesman*), Tennessee Williams (*The Glass Menagerie, A Streetcar Named Desire,* and *Cat on a Hot Tin Roof*), and William Inge (*Come Back, Little Sheba, Picnic,* and *Bus Stop*). This is also considered the Golden Age of the Broadway musical. Season after season the long running hits included *Oklahoma, South Pacific, The King and I, Kiss Me Kate, Guys*

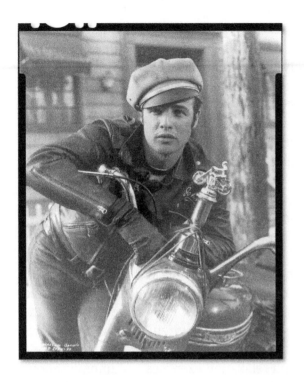

The Wild One (1953) directed by Laszol Benedek, turned Marlon Brando into an icon of the Hollywood Rebel. Made two years before **Rebel Without a Cause,** the image of Brando in black leather jacket riding a Triumph motorcycle instantly clicked with young audiences. Parents and church groups tried to get the movie pulled from release, and in England it was banned until 1968. **The Wild One** was based on a highly publicized incident in Hollister, California in 1947, but the impact of the film was Brando's coolly arrogant performance as an outlaw leader with a troubled soul. He touched a nerve with the youth of America, who until this point had no one to identify with in movies. Tapping into a trend that had already started; teenagers, after seeing Brando, began wearing leather jackets and white T-shirts. Parents had a right to be concerned, but the trouble was embedded in society and ready to explode. In the 60s, with **The Wild Angels** and **Easy Rider,** the biker genre became the equivalent of the modern-day Western.

and Dolls, Kismet, Damn Yankees, Pajama Game, Bells Are Ringing, My Fair Lady, The Music Man and West Side Story. All of these were successfully made into motion pictures, and reflect the influence Hollywood had on the stage musical in this era, where songs came organically from the story line, as they had in Meet Me in St. Louis and The Wizard of Oz.

Another big change came in literature and a group of angry writers that reinvented the American novel. The writers that can credited with starting this movement and putting their own indisputable mark on literature like F. Scott Fitzgerald, Ernest Hemingway, John Dos Passos, Booth Tarkington, and James Joyce were no longer the writers being read after the war. A new, outspoken generation that used language like carving knives wrote novels that readers grabbed off the shelf. Pocket Book made popular novels available in paperback format for only twenty-five cents, and J. D. Salinger's Catcher in the Rye

and Grace Metalious' anti-Frank Capra spin on small towns, Petyon Place, sold by the millions.

The war novel met with unexpected success. Naked and the Dead by Norman Mailer, From Here to Eternity by James Jones, The Wall by John Hersey, Battle Cry and later Exodus by Leon Uris, Tales of the South Pacific by James Michener, and Teahouse of the August Moon by Vern J. Sneider were all best sellers. These last two were turned into Pulitzer Prize winning plays and then made into movies. Following in the footsteps of Raymond Chandler and Dashiell Hammett, Mickey Spillane brought a sexually charged, no-punches-pulled realism to the mystery genre with his character Mike Hammer. When his steamy pulp fiction novels I, the Jury, and Kiss Me Deadly were optioned for motion pictures, they were reported by the Hays Office to have violated almost every rule of the Production Code.

The post-war plays and novels began to chip away at the lingering Puritan attitudes about

what was acceptable and what was obscene or unfit for popular consumption. Books were still banned in Boston, and the Catholic Church protested the moral corruption of certain Broadway plays, but all of these art forms had greater freedom than motion pictures. Taboo subjects about abortion, extramarital affairs, homosexuality, tainted bloodlines, incest, or rape which would become commonplace in twenty-first century American society were highly controversial during these years. Much of the tantalizing action, even in novels and plays, was implied in a language peppered with double meanings. The dramas of Tennessee Williams are perfect examples of this literary subterfuge. The characters in these plays are protecting deep secrets, and the traditional acting approach of putting on a costume and a putty nose would only scratch the surface.

The dialogue in plays from Sophocles to Shakespeare to Shaw gave a performer all the cues that were needed to understand the character. The words were poetry and philosophy about the misuse of power, revenge, greed, and other lofty subjects that still conformed to the principles of Aristotle's Poetics written in the third century B. C. Henrik Ibsen, Johan August Strindberg, Anton Chekhov, and Eugene O'Neill began to challenge the ancient disciplines of the drama, but Miller, Williams, Inge, and others explored subjects that were still figuratively in the closet. This called for a whole new kind of acting.

The Group Theatre in New York attracted actors and directors to the Stanislavski Method of acting. Members of this group were Lee Strasberg, Stella Adler, and Elia Kazan, and the early productions from The Group Theatre, like Clifford Odet's *Waiting for Lefty,* were explosive controversial dramas. The actors on stage had become their characters. There was a great sense of realism, as if ordinary people had stepped up on stage to tell their stories. Strasberg became the teaching force behind the Actors Studio, and Kazan became in effect the resident director for the company. Adler left The Group Theatre, studied privately under Konstantin Stanislavski, and then returned to form her own acting studio where she helped mold the talents of Marlon Brando, Warren Beatty, Robert De Niro, and many others. Kazan became the most visible member of The Group Theatre, but his "friendly" testimony during the McCarthy hearings when he named names of many members created a terrible falling out and bitterness that has never gone away.

The Method in its purest form is a process of becoming the character. It contrasts with traditional methods of acting where the character is approached from the outside, and is discovered through makeup, costume, movement, and the language of the playwright. The Method starts with the mental framework of the character, and through relaxation exercises and improvisations the actor begins to live the character. With improvisations the actor works outside the script, and comes to know the past and present of the character well enough to respond to any situation as that character. To immerse completely into a character, an actor might drive a taxi if that is the character's occupation, or become a worker on a shipping dock to understand the hardships the character has to endure day after day.

On stage every performance has a slight variation. An actor will not deviate from the lines, but as Stanislavski writes in his book *An Actor Prepares,* make the performance seem like the first time. The actor will go with the feeling of the character, perhaps feeling more anger one night and melancholy the next. This form of acting had always been part of the movies, because the major registration of any emotion is through the eyes of the actor. Stars like Cagney, Bogart, Hepburn, and Bette Davis were masters at working the camera during close-ups, where a wealth of information is conveyed with a simple lowering of the eyes. The Method focused on this in-

ternal acting. To prepare for emotional scenes, actors would have gone through exercises to recall similar moments from the past. If an actor had ever lost a loved one, or experienced outrage over an injustice, then the actor would remember this moment to stimulate feelings.

Without question, the play that brought the Method to the attention of the artistic community and the world was the landmark production of *A Streetcar Named Desire,* directed by Kazan and starring Marlon Brando as Stanley Kowalski. Brando took Stanley, who was written unsympathetically, and made him so that many people in the audience empathized with him. He is never despised for his inexcusable actions and is often the source of great amusement.

At one point, Stanley loses his temper and violently slaps his pregnant wife, Stella, yet she returns to him because of the pure animal lust between them. Instead of the audience being shocked, Brando turns the moment when he pleads "Stella" at the top of his voice into the pitiful cry of a lost soul who doesn't know any better. *A Streetcar Named Desire* is all about sex and yet any explicit moments are only implied in the staging—but it is obvious to anyone watching what is going on. Because the performances are so real the audience does not need the actions to be put into words. Brando was so convincingly Stanley Kowalski that if he had never performed in anything else audiences would probably believe he was not acting; he was just that character in real life. This is the ultimate definition of Method Acting.

CINEMA OF PARANOIA

The fears of the post-war era were reflected in the movies. The noir films were riddled with easy-takes going wrong and beautiful femme fatales that begged to be trusted, then set up a double-cross. Science fiction became the hot new B-picture genre, fueled by wild speculation about how atomic radiation could change ants in the middle of a test site or generate a giant creature that would attack Tokyo. The fear of things coming from outer space and mysterious unidentified flying objects became popular story lines in movies and on television.

Conflicting rumors that a flying saucer had crashed outside Roswell, New Mexico and that

The Invasion of the Body Snatchers (1956) directed by Don Siegel, with Kevin McCarthy and Dana Wynter, is the most famous example of the political paranoia that began to undercut many films, especially in the science fiction genre. Martin Scorsese calls this "subversive cinema," where a traditional storyline is undercut with a darker, deeper meaning. During the blacklist, friends were turning in friends in order not to lose their jobs, but, borrowing a movie metaphor, these people were collectively selling their souls. In *The Invasion of the Body Snatchers* pods from outer space have the ability to reproduce into exact replicas of human beings—except the individual no longer has the need for compassion or love.

the military quickly hushed up the reports would open the door to conspiracy theories about a shadow government. Russia had gotten the secret to the Bomb and was threatening to use it against the United States. Joseph McCarthy was on television with reports that Communists were working in the Defense Department. J. Edgar Hoover, the head of the FBI, wrote books about the Red Menace urging the public not to trust anyone that acted suspiciously. And in Hollywood, friends that had worked together on movies for years were suddenly turning on each other and naming names before HUAC or behind closed doors.

All of these events resulted in what has become known as the Cinema of Paranoia. What was happening in the news was twisted around and reflected in the movies that were being made. For the first time science fiction movies were popular, especially at drive-ins where couples could snuggle up to protect each other from the horrifying creatures that could destroy cities. There had been science fiction movies in the past, like *Metropolis, Things to Come, Frankenstein,* and the Flash Gordon serial, but the atomic bomb and strange sightings in the night sky around military bases sent this genre into orbit. Science fiction literature had started out being highly respectable with writers like Jules Verne and H. G. Wells, but for decades it was considered pulp fiction and not taken seriously by critics. Television became one of the first bases of operation with this genre with programs like *Science Fiction Theater* and *Outer Limits.* The biggest market was comic books that were read religiously by millions of wide-eyed children.

The public was told that science was their friend, but what most people saw in the news were nuclear tests on peaceful South Pacific islands. This was an era of incredible looking experimental planes, like the Flying Wing bomber, which were designed to carry atomic weapons.

There were television specials, like *Our Friend the Atom,* but the splitting of the atom, as Einstein had warned, looked like it would bring about the end of the world and did not appear to be a friend. It was also a time period of childlike naïvete and confusion about the power of the atom. There were serious proposals about seeding clouds with atomic particles to create rain in the desert. In Las Vegas tourists would stop gambling and go out on their balconies to watch bombs being tested less than a hundred miles away. And in Buster Brown shoe stores there were machines where children could stick their feet inside, push a button, and see a X-ray of their skeleton-like foot inside a new pair of shoes.

This paranoia was reinforced daily in society. School children were taught how to react if they saw a nuclear flash. Construction companies were offering specials on bomb shelters. Spies that had given away top secret information were caught and executed. And during the blacklist in Hollywood the fear that a screenwriter might be accused of being a Communist simply because he or she put together a string of suspicious words made paranoia a constant companion on the studio lot. The Bomb became the unbilled star of many movies. In Sam Fuller's *Pickup on South Street* (1953) a pickpocket lifts a wallet that has microfilm of top secrets intended for "the Commies" and has to go on the run. In Robert Aldrich's *Kiss Me Deadly* (1955) everyone is trying to get their hands on a suitcase that seems to contain raw nuclear energy, which leads to a very explosive end. (Quentin Tarantino paid homage to this mysterious power inside a suitcase in his post-modern film noir *Pulp Fiction.*)

In the emerging genre of science fiction, highly advanced aliens and The Bomb and its terrible repercussions seemed to be the catalysts for every story. In Robert Wise's *The Day the Earth Stood Still* (1951) earthlings are warned that the robot Gort is programmed to destroyed the earth

The Day the Earth Stood Still (1951) directed by Robert Wise, with Michael Rennie and Patricia Neal, was the first science fiction movie made by a first-class director. **Things to Come** (1936) by William Cameron Menzies, written by H. G. Wells, was a long sermon on the misuse of power, and the many serials based on the characters of Flash Gordon or Buck Rogers contained very little real science. It can be argued that modern science fiction began when the Atomic Bomb was dropped on Hiroshima. **The Day the Earth Stood Still** put into motion one of the most popular themes in science fiction: mankind is on the threshold of venturing into space but still cannot control the primeval urge to conquer and kill. Wise got excellent performances out of his cast, and his serious treatment of the story created suspense unique to a genre that until this time had been about ray-guns and spaceships.

if human beings cannot control their appetite for violence and war in the nuclear age: "klaatu barrada nikto." That same year, Howard Hawk's production of *The Thing from Another World* ended with the warning to "watch the sky." *Invaders from Mars* (1953) begins with a father investigating his son's wide-eyed story of a flying saucer landing, only to return with a strange needle mark on the back of his neck and a robot-like stare. The detachment of a child and a parent was another recurring theme in movies during this era, whereas on television the ideal American family ruled the airwaves, in shows like *Father Knows Best* and *The Adventures of Ozzie and Harriet.*

Them! (1954) uses the popular theme of atomic radiation mutating monsters that go on a rampage; in this case giant ants get into the sewers of Los Angeles. James Cameron overhauled this story line for *Aliens.* In *20,000 Leagues Under the Sea* (1954), when Captain Nemo blows up his secret island a giant mushroom cloud forms. And, of course, the Japanese had their own problems with *Godzilla, King of the Monsters* (1956), a giant irritable creature who had one atomic cocktail

too many. It would take most of the Cold War, continuing until 1977, before this cycle of wantonly destructive movie aliens came to an end with *Close Encounters of the Third Kind* and *Star Wars,* followed five years later by the kinder, gentler *E.T.*

The one movie that best represented this undercurrent of paranoia that crept into 50s popular culture is *Invasion of the Body Snatchers* (1956) directed by Don Siegel, who would later make several films with Clint Eastwood including *Dirty Harry* and *Escape from Alcatraz.* Siegel's film plays into the basic frailty of every person, the fear that love and compassion will suddenly go out of a relationship. There are a few special effects, like giant pods that ripen and from which unformed human figures begin to sprout. But the most chilling moments are created by the actors, who begin by playing reasonably happy citizens in a small California town, and then one by one all signs of friendship vanish during the night. Once a person goes to sleep his or her body is replaced by a new one, except this being is not burdened with human emotions like affection or

loyalty. The horror of the final scene in the cave is a moment that haunted many people in real life during this era. Someone would see a close friend, not knowing this friend had just given in to the unsympathetic demands of McCarthyism, and be greeted with the faraway stare of a total stranger. This was not paranoia, it was reality to many people who refused to name names and saw their lives ruined.

THE HOLLYWOOD TEN

The fear of Communism grew so quickly that no one was truly prepared for its ultimate impact. The accusations that Communist agitators had played havoc during strikes with Hollywood guilds and other trade unions throughout the country has been substantiated to a great degree. But the myth of how powerful the influence of Communism could be on the mind and how almost supernatural hidden persuaders that might have been slipped into movies could, within a few hours, convert normal citizens into Communist dupes is, in hindsight, pure exaggeration. Nevertheless, at the time many Americans believed this was possible and was actually happening. It is important to understand that during these years reason had been replaced by fear, which usually leads to superstitions. This is why in his play *The Crucible* Arthur Miller connected the dots from HUAC to the Salem Witch Trials, except the small isolated community had now become the United States of America.

Almost as soon as the war ended, America was in a war of nerves with one of its allies. The Berlin Airlift was started because by treaty part of that great city was under the military rule of England and the United States, but Russia had closed off all the borders, completely isolating it, and threatening to seize total control. Also, Russia refused to return sovereignty to territo-

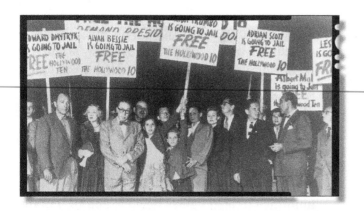

The Hollywood Ten, on the evening they left for prison after being convicted of contempt of Congress. In 1947 the House of Un-American Activities Committee (HUAC), chaired by J. Parnell Thomas, started a highly publicized investigation of the Hollywood Motion Picture Industry. HUAC interviewed 41 people from the motion picture community. These people attended voluntarily and became known as "friendly witnesses." During their interviews, these witnesses named nineteen people who they cited as having strong left-wing convictions. Eleven of these men were called before HUAC in Washington, D. C. They were Herbert Biberman, Lester Cole, Albert Maltz, Adrian Scott, Samuel Ornitz, Dalton Trumbo, Edward Dmytryk, Ring Lardner Jr., John Howard Lawson, and Alvah Bessie. Bertolt Brecht was also called, but after giving evidence he immediately left for East Germany. Eventually known as the Hollywood Ten, they refused to answer questions, claiming that the 1st Amendment of the United States Constitution gave them this right. But in one of America's darkest hours, the House of Un-American Activities Committee, and all other courts during the appeals process, disagreed with their position and found them guilty of contempt, handing out sentences from six to twelve months in prison. The Supreme Court refused to hear their case.

ries they had captured from the Nazis in Poland, Czechoslovakia, Hungary, and East Germany. Suddenly America had a new enemy—someone it did not know how to deal with—and since it happened so abruptly the whole concept of deceit became an issue. The assumption that a Communist agent could tantalize an unsuspecting person through clandestine meetings, which would then lead this person to drain the military of top secrets was in truth what Russian military leaders desired. This became a two-way myth. Russia had indeed gotten secrets from the United States military and wanted more. In turn, certain American politicians, along with J. Edgar Hoover, turned a few incidents into a nationwide epidemic.

Communism became a label that stuck to people. It was a black mark that would not go away. Communism was considered a cancer in the mind of people who had experimented with this ideology. Today it sounds fantastic that a country like America would have gone through this phase, especially following a war when so many people and nations had sacrificed so greatly for the principles of freedom. Indeed many of the people that were charged with being Communists had gone to meetings out of curiosity, had friends that were members of the Party, or had studied it as students. Donations to seemingly worthy organizations, which later were revealed as Communist fronts, came back to haunt people.

Director Edward Dmytryk, who was one of the Hollywood Ten, commented that a movie could show a hundred people getting shot *but* having one person talk about politics was considered dangerous. The fear was that some possessed the ability to change a person's thoughts by subterfuge. Thus anyone that had been exposed to Communism carried the disease. Ironically, it was very much like being exposed to radiation, where only a few seconds were sometimes irreversible. After all, politicians like McCarthy observed, the

citizens of Germany and Japan were fed the wrong ideas from the wrong people that ultimately led these countries on paths of destruction. Immediately following the war, this was a compelling argument that many Americans had come to believe though years of hardship.

In 1948, a group of twenty men working in the motion picture industry were called in front of HUAC in Washington, D.C. Only ten actually testified, and become known as the Hollywood Ten. They where Edward Dmytryk, who had recently been nominated for the Academy Award as Best Director for *Crossfire* (1947) that dealt with the hate murder of a Jew by a military officer. The producer of the film, Adrian Scott, was also called up. The others included producer/director Herman Biberman, and writers John Howard Lawson, Lester Cole, Alvah Bessie, Albert Maltz, Ring Lardner, Samuel Ornitz, and Dalton Trumbo.

They each were asked, "Are you now, or have you ever been a Communist?" The hearing quickly degenerated into a circus. The men refused to answer the question and challenged the right of the committee to even ask such a question under the Bill of Rights. John Howard Lawson said, "I'm not on trial here . . . the committee is on trial here before the American people." Ring Lardner Jr., who won an Academy Award for *Woman of the Year* (1942) and would go on to win a second award for *M*A*S*H* (1970), said in his statement, "I could answer that question but I could not live with myself in the morning." This became the title of his autobiography. The men and their attorneys were denied the right to call witnesses or cross-examine anyone who had presented evidence against them. One by one, they were asked to leave the stand, and some were forcibly removed.

The appearance of these ten men in front of the HUAC hearings was strongly supported in presence by Humphrey Bogart, Danny Kaye,

Lauren Becall, and other prominent celebrities of the Hollywood community. In fact, that night Bogart went on the radio to tell listeners of his negative opinion of the HUAC committee he had witnessed. The hearings were suspended before the other ten men could testify. The belief going into the hearing by these men and their legal advisors was that the charges of contempt of Congress would be overturned in the Supreme Court under the right of the First Amendment. But all of their appeals were denied, and the case never reached the Supreme Court. The men were sentenced to prison terms of up to one year and were given a hero's send-off as they boarded the train.

Thus, what became known as the Hollywood Blacklist began and would continue over the next twelve years. The blacklist was a system that has always been bitterly debated since none of the studio moguls publicly confirmed there was any such thing as a blacklist enforced. Under contract, employees could be released without explanation of any sort. So, one day a writer or actor could show up on the lot and be told they had one hour to clean out their office or dressing room and be escorted off the lot. Hundreds of people were out of work without any way to define themselves. If they tried to challenge the dismissal they were simply told their work was no longer good enough.

The moguls stated publicly they would not hire or continue to employ anyone who was a known Communist, but no one was officially fired for their political beliefs, whether assumed or actual. A small booklet with a pink cover called *Red Channels* was circulated to the studio brass that had a list of names that was allegedly updated each week. If a person's name appeared in *Red Channels* they were dismissed without explanation. As an example, actress Lee Grant was twenty-four when she was nominated as Best Supporting Actress in *Detective Story* (1951). That same year she attended a funeral of an old fami-

ly friend who had died of a massive heart attack and said that he would probably to alive today if he had not been called up constantly before the committee. Her name appeared in *Red Channels* and she could only find work in television or B-movies under different names for the next sixteen years, but she did not work again in a major motion picture until Sidney Poitier had her cast in *In the Heat of the Night* (1967). Grant went on to win her supporting award for *Shampoo* (1975) and became a successful director, but, like many others that unfortunately did not make a comeback, she lost of the best years of her acting career to the blacklist.

As the blacklist continued certain writers that had not fallen prey to McCarthyism became "fronts." A front was someone who helped out a friend or fellow writer that had been blacklisted. Often fronts were not exceptionally good writers, but miraculously overnight their talents improved remarkably and they were suddenly able to turn in clockwork scripts to the studios. The front would receive a percentage of the sale and get his name in the credits. Studios, since they needed good scripts quickly, turned a blinded eye to this arrangement, unless it somehow was leaked publicly. Restoring the rightful names to screen credits became a briar patch of problems that is still being sorted out by the Writers Guild of America today.

Two of the most notorious incidents of using fronts are associated with Dalton Trumbo and Michael Wilson. Trumbo kept files on any subject he thought would make a good movie. While he was waiting on his appeals, realizing that matters did not look favorable, he had the foresight to write a long treatment for a movie, also known as "the Bible," which is like a short novel of seventy pages or more outlining the story in detail. Trumbo felt at this time there was a keen public interest in royalty, especially with young Princess Margaret in England who wanted to married a

Roman Holiday (1953) directed by William Wyler, starring Gregory Peck and Audrey Hepburn in the role that won her an Oscar. The movie was shot on location in Rome and has remained a favorite romantic comedy with audiences since its release. *Roman Holiday* also won an Oscar for best motion picture story by Ian McLellan Hunter. In 1991, the year of his death, Hunter confessed that Dalton Trumbo was the actual writer and he was the front that had been sworn to secrecy. Trumbo, under the alias Robert Rich (this time he used a name of someone who did not exist), also won an Oscar for *The Brave One* (1956).

commoner. So, he devised a story about a princess who decides that she can no longer take the stress and strain of being so prim and proper and decides to run away. The treatment was *Roman Holiday* and it was sold for enough money to tide Trumbo and his family over during difficult times. The front was a close friend and fellow writer, Ian McLellan Hunter, and the agreement was that neither man would ever reveal the truth about the original story treatment. The movie became a huge hit and introduced Audrey Hepburn, and Hunter won the Academy Award that year. Before his death, almost forty years later, Hunter made the story public, allowing Trumbo, who had passed away years before, to finally receive full credit on the DVD edition.

But this was not Trumbo's only brush with the Motion Picture Academy during the blacklist. While living in Mexico he wrote a screenplay called *The Brave One* (1957). Unable to use his own name, the screen credit was given to Robert

Rich, who did not exist. Robert Rich won the Oscar for the movie, but no one came up to collect the award. Years later, before his death, Trumbo was given the award in a special ceremony. Trumbo was fortunate to have kept working, and in 1960 his name (and not that of a front), appeared on *Spartacus* and *Exodus*. There were no protests about his dual screen credits, and almost overnight the blacklist came to an end. To give credit where it is due, this was in large part because of the courage of Kirk Douglas and Otto Preminger, the producers of these two films, who had no idea what the repercussions might be on these expensive productions. It was a sublime irony that Trumbo, who became the most famous member of the Hollywood Ten, would be the one who officially broke the back of the blacklist.

Michael Wilson was one of the twenty men called before HUAC, but the hearings were dismissed before he could testify. Wilson is credited with one of the rewrites on *It's a Wonderful Life,*

A Place in the Sun (1951) directed by George Stevens, starring Elizabeth Taylor and Montgomery Cliff, won six Oscars, including best screenplay by Michael Wilson and Harry Brown. Wilson was nominated the following year for **Five Fingers** and then for **Friendly Persuasion** (1956). He had been one of the nineteen people named by friendly witnesses, but was not among the original Hollywood Ten. Nevertheless, he found himself blacklisted, and, in order to find work, went to England. There, along with blacklisted writer Carl Foreman, he wrote the screenplay for **The Bridge on the River Kwai.** Wilson continued to work with director David Lean, writing a large part of **Lawrence of Arabia,** but sole credit for the epic went to Robert Bolt. The Academy Board of Governors voted in 1995 to include Wilson's name, seventeen years after his death. Over 320 people were blacklisted in the entertainment industry, including Stella Adler, Leonard Bernstein, Charlie Chaplin, Aaron Copland, John Garfield, Howard Da Silva, Dashiell Hammett, E. Y. Harburg, Lillian Hellman, Burl Ives, Arthur Miller, Dorothy Parker, Joseph Losey, Anne Revere, Pete Seeger, Gale Sondergaard, Zero Mostel, Clifford Odets, Paul Jarrico, Orson Welles, Sidney Kingsley, Paul Robeson, Richard Wright, and Abraham Polonsky.

and in 1951 he won the Academy Award for Best Screenplay for *A Place in the Sun,* along with Harry Brown. He was nominated two more times, for *Five Fingers* (1952) and for *Friendly Persuasion* (1956), which he had actually written several years before. The problem was that between the time he wrote the script and when the film was made by director William Wyler, he had been blacklisted. With the realization that Wilson would receive the well-deserved nomination, the Motion Picture Academy called an emergency session and created a by-law that made him ineligible. His name did not appear on the voting ballot and for years it was not listed in resource books, just the disclaimer that the writer was ineligible under Academy by-laws.

In 1954, Wilson, Herbert J. Biberman, Will Geer, Paul Jarrico, and others who had been blacklisted in Hollywood decided they would start their own independent film company. They went to New Mexico and produced *Salt of the Earth* about Mexican-Americans who went on strike against poor living conditions and slave wages, based on the true story of a strike against the Empire Zinc Mine. The film was shot on location and used many local residents as actors, very much like what was happening in Italy with the Neo-realism movement. The real heroes in *Salt of the Earth* were the women who marched in the picket lines and continued the effort when most of the male workers had given up hope. The film was shot on a very low budget and probably would have made a small profit if marketed to a few major cities, thus allowing the group to rollover the money into another film. However, the combination of the film's subject matter and the fact it was made by controversial figures, gave the distribution companies reasons to turn it down. It ran in New York at a single theater and did extremely well, but ultimately it proved to be a failure, and the hopes of having a second Hollywood front were over.

Wilson then was put in touch with an English director who was struggling with the adaptation of a novel. The director was David Lean and the book was *The Bridge on the River Kwai*, written by the French author Pierre Boulle. Carl Foreman, who had written *High Noon*, worked briefly with Lean on the screenplay but their collaboration was short-lived. Lean enjoyed the company of Michael Wilson, and they worked well together. With only a scattering of pages from Foreman, Wilson effectively wrote the entire screenplay for *Bridge on the River Kwai* (1957), which was the release title. Wilson knew his name could not be on the credits, but it is reported that at the premiere when he saw Pierre Boulle's name as the sole writer he broke into tears. There was a great irony at work, that Wilson was fully aware of. When Boulle was given the Academy Award for his remarkable screenplay, one of the most intelligent scripts to ever come out of Hollywood, he thanked the audience in French, because he could not speak a word of English.

Wilson continued to work with Lean on the production of *Lawrence of Arabia,* in which he wrote and constructed the first half of the epic motion picture. Lean was notoriously slow when it came to the screenplay, and Wilson finally returned to the United States when signs the blacklist were lifting. When *Lawrence of Arabia* premiered, once again his name did not appear in the credits. (In this case, or a motion picture the American Film Institute would vote as one of the ten greatest.) Wilson eventually found work back in Hollywood on another Pierre Boulle novel, *The Planet of the Apes* (1968), along with writer Rod Serling. He had only one writing credit after this and died nine years later. Almost a decade after Wilson passed away his family was finally presented with his Oscar for *Bridge on the River Kwai* in a private ceremony. But it would not be until the release of the DVD edition of *Lawrence of Arabia* at the turn of the millennium that Michael Wilson would finally receive his rightful screen credit for that masterpiece. This is just one of the many tales of how people were affected by the blacklist.

SOCIAL REALISM AND THE HOLLYWOOD REBEL

This was an era associated with young movie stars that came from the Method School of Acting, including Marlon Brando, Montgomery Clift, James Dean, Paul Newman, Sidney Poitier, and a long list of others. It was the time of beat poetry, rock 'n' roll, and the rebel, someone who shook up the image of the Hollywood movie star and made serious films that exposed the underbelly of the American Dream. The films were part of the Social Realist Movement, very much akin to Italian Neo-realism, but these films were aimed at the social consciousness and dealt with subjects that needed reforming, like racial prejudice, dysfunctional families, the corruption of the judicial system, street gangs, and poor education. It can be argued that this era produced more great films than any other time.

Many of these motion pictures were a balance of outstanding performances, strong dramatic content, exciting contemporary stories, and the undercurrent of messages about social reform. They both entertained and educated, or to use an eighteenth century term, they *enlightened* audiences about things in society that needed fixing. This, of course, has never been an aggressive goal of Hollywood producers. The columnist Hedda Hopper is credited with the quip, "If you want to send a message, call Western Union." But for a while in post-war Hollywood, filmmakers like Elia Kazan, Stanley Kramer, Fred Zinnemann, Sidney Lumet, and Nicholas Ray made films

From Here to Eternity (1953) directed by Fred Zinnemann, starring Montgomery Clift, Burt Lancaster, Deborah Kerr, Donna Reed, and Frank Sinatra. Clift was already a movie star in 1948 after **Red River** and **The Search,** for which he received the first of his four Oscar nominations. This was two years before Marlon Brando made his screen debut in **The Men,** also directed by Zinnemann. Clift was the first actor audiences began to associate with Method Acting. When he made **From Here to Eternity** he had already worked with William Wyler, George Stevens, and Alfred Hitchcock. His tremendous performance as Pvt. Robert E. Lee Prewitt turned out to be the high point of his short career. Clift would not make another film for four years and by then his self-destructive nature began to take its toll. During the filming of **Raintree County** he was in a car wreck that ruined his handsome features. Though he continued to work until his death, ten years later at the age of forty-five, he became dependent on drugs and never emotionally recovered from the accident.

about social ills that were massively popular with audiences, in large part because they featured these charismatic rebels who had a dangerous and unpredictable edge.

These movies also tapped into a large segment of the population that was often ignored or pandered to by studios, teenagers and college students. Unlike the war years where harsh reality was disguised as uplifting propaganda, this small group of directors and producers found ways around the Production Code and somehow managed to put realism on the screen. Many of the films have become part of Hollywood folk legend, like *The Wild One, On the Waterfront, East of Eden, Rebel Without a Cause, The Blackboard Jungle,* and *The Defiant Ones.* Films of the Social Realism Movement were made with a passion and a sense of purpose; they were like newspaper editorials typed directly on the screen. In England a similar movement began starting in the late 1950s and produced "Kitchen Sink" dramas. This movement produced *Saturday Night and Sunday Morning, Look Back in Anger,* and *The Loneliness of the Long Distance Runner.* The tone of reality in all these films was often due to the improvisational nature of Method Acting mixed with the use of real people as extras or character parts.

These films were shot on location, breaking free of the studio look, often using young, inexperienced actors, and made on very low budgets. The camera was still invisible, without the handheld feeling of documentary filmmaking that became popular with the New Wave Movement in films like *The French Connection* or *Dog Day Afternoon,* but there was the sense of immediacy in action and performance. Studio moguls, who were spinning in circles about how to combat television, began to look at their box office totals and found these films were pulling in more revenue than their prestige features with vintage stars.

Even today many of these films have a unique quality about them, because the arc of Social Realism lasted up to the 1960s. After this many of the movies became more mainstreamed, or to borrow a phrase from Tom Wolfe, "radical chic." The moment co-inhabited the same time period as the blacklist and McCarthyism. It took guts and a real commitment to make some of these films, especially with the attitude of bringing about positive changes in race relations. Many of the writers, actors, and directors who made films that exposed a few unsightly smudges on the American way were called up in front of a committee to answer questions. By the end of the 50s motion pictures were wide-screen spectaculars and naughty but nice sex comedies.

The post-war era was a time when tens of thousands of young people in America were without fathers, because they never returned from the war, or they returned, took one look at a family they were not ready for, and split. Women who had been half the workforce during the war were given their walking papers and were unemployed. Marriage soared sky high, but this meant that many children found themselves with stepfathers they did not get along with, or new sisters or brothers that were much younger and stole all the attention.

Gangs began to form, replacing families for many tough kids w ho were left on their own. Neighborhoods in New York, Chicago, and Los Angeles became hellholes for juvenile delinquents who politicians and newspaper reporters began to refer to as "young savages." Even small towns were not safe from outlaw motorcycle gangs wearing leather jackets. In *The Wild One* (1953), produced by Stanley Kramer, Marlon Brando is asked what is he rebelling against, and he flippantly replies, "Whatya got?" Parents and older adults were shocked and outraged by the film, afraid it would spark copycat violence, which it did, but it cleaned up at the box office. When *Blackboard*

Jungle (1955), directed by Richard Brooks, was released there were riots in theatres when the younger audience heard Billy Haley and the Comets blast out *Rock Around the Clock*. Again there were protests, this time about how rock 'n' roll music caused immoral conduct in teenagers, which it undoubtedly did for that time period. But the one thing this younger age group did not have was their own rebel movie star.

In the 1930s, when the Studio System was in full swing, the first actors who became box office sensations put an indelible mark on the concept of a movie star. The same thing happened in this era when the tone of movies changed radically from the years of the Dream Factory into darker films where anti-heroes elbowed their way onto the screen. Being first in the movies is never a guarantee of immortality unless the talent is truly exceptional. This kind of enduring effect has only happened a few times in movie history, and unfortunately sometimes evolves around a star's early death. The very concept that a mere movie star could have such a profound effect on popular culture fifty years later is certainly open to debate.

Director Mike Nichols has observed, "When a great actor occurs it changes several generation because human nature is redefined." There are only a small number in this exclusive club that get this kind of lasting attention from people all over the world. It would be safe to guess that only a tiny number of people today have seen a Valentino silent movie, but almost everyone knows of Valentino, associating him with great screen lovers. And he died in 1926. When the topic of just a "regular guy" comes up, James Stewart usually springs to mind. An actor's actor would be Spencer Tracy. The definitive sophisticated leading man is Cary Grant. The "Blonde Bombshell" is Jean Harlow. And the fearless leading lady with a chip on her shoulder is Bette Davis.

Marlon Brando

The 1950s produced four movie icons who will perhaps forever be identified with this new phrase of Hollywood that gave birth to the Method, the Rebel, the Sex Goddess, and the shattering of old facial boundaries. There is no way to know who was the first person who made acting a tradition or the first artist who discovered primary colors. But Marlon Brando will always be the brooding prophet of the Method. Considering that acting is among the oldest professions, and arguably could be the first considering that a tribal leader or medicine man possesses natural acting skills, to racially change this century-old approach to performance is a staggering concept. Brando was not the first to practice the Method but he was the first to hotwire into the movies. From that moment forward, the most visible art form in films—acting—was changed. Every actor who followed owes a certain debt to Brando, not so much by becoming disciples of the Method, but for taking big risks with character development.

Marlon Brando was an actor whose screen life and real life became intertwined in the public's mind until it all seemed like one perpetual improvisation. He was completely unique, which is the main requirement of an icon. Another important element is to be part of something that lasts. When Orson Welles was asked how many films constitute a legacy for a great director, he replied "One." Brando created three vastly different characters who are impossible to associate with any other actor, in three films that continue to grow in acclaim over the decades.

A Streetcar Named Desire is probably the most famous American play, and Brando was the centerpiece on Broadway where he flipped the Theatre World upside down. Next this testament to Method acting was brought to the movies, and Brando reprised his character of Stanley Kowalski, an unpredictable beast of a man who tears apart the last vestiges of cultural refinement from a desperate Southern belle seeking her last chance at some form of happiness. In *On the Waterfront*, which was voted one of the top ten greatest American films of all times, Brando is Terry Malloy, an ex-prizefighter in the pocket of the Mob who is forced to think on his own. Made during the height of the McCarthy Era, Terry Malloy has to decide whether to inform on the racketeers living off the sweat of the overworked underpaid

On the Waterfront (1954) directed by Elia Kazan, starring Marlon Brando, Eva Marie Saint, Karl Malden, Lee J. Cobb, and Rod Steiger. Without question Brando's performances have influenced every actor that has seen them. Whether it was by luck or pure cinema fate, Brando made the three films that represent the pinnacle of Method Acting to audiences and critics: **A Streetcar Named Desire, The Godfather,** and **On the Waterfront.** His portrayal of ex-prize fighter Terry Malloy is arguably the most important screen performance ever given because he is able bring the inter-turmoil of the character alive with a minimal number of words and a resounding sense of truth. If greatness inspires imitation, then there is a little bit of Marlon Brando in every actor working today.

dock workers or to remain silent and be a by-stander to murder and violence. And in *The Godfather*, voted in the top five movies of all time by critics around the world, Brando *is* Don Vito Corleone, the head of a Mob family who makes offers no one can refuse. Brando introduced the Method with these first two films and literally became the father figure to the next generation of Method actors in *The Godfather*. But the true genius of Brando was Brando, who could be imitated but never equaled, and who took delight in tearing down the importance of acting, yet gave some of the most personalized performances ever seen on the screen.

There was an absence of young actors in the 50s, especially in comparison to films of the post-*Animal House* generation. Brando was already thirty when he made *The Wild One*. The typical Hollywood leading man was Gregory Peck, Jimmy Stewart, John Wayne, or some of the new British crop like Laurence Olivier and David Niven. There were newcomers like Burt Lancaster, Robert Mitchum, and Kirk Douglas, but they stepped into the film noir genre playing men with dark pasts who were old enough to legally carry a gun. In the 1930s, Mickey Rooney was one of the biggest stars at MGM and was often teamed up with Judy Garland. They played teenagers with teenager problems, like who to take to the prom or getting a first kiss. There was the group that became known as the Dead End Kids, from the production of *Dead End* (1937) that made movies until most of them were in their forties. They were modeled on the gangs that came out of Hell's Kitchen, but they wound up making only B-movies with lots of slapstick.

James Dean

It was not until an actor named James Dean came along that someone was able to suddenly connect with the enormous young audience. Dean's performance in *East of Eden* (1955), directed by

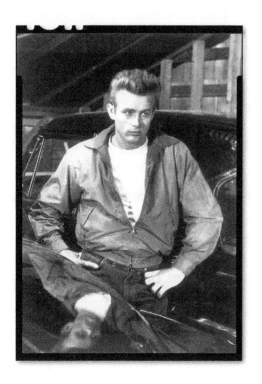

Rebel Without a Cause (1955) directed by Nicholas Ray, starring James Dean, Natalie Wood, and Sal Mineo. Dean became the first movie star that young audiences could truly identify with. He was not a clean-cut Andy Hardy or one of the tough-talking Bowery Boys. In three films made over two years, Dean, with his boyish looks and bare-all acting style, came to personify the anguish and confusion of adolescent youths in the 50s. After his death Warner Bros. was flooded with letters from mothers begging the studio not to make any more films like **East of Eden** or **Rebel Without a Cause** that would adversely affect teenage kids. But it was too late. His rebellious behavior has left a lasting mark on movies. Even today the media will speculate whether a promising young male actor is going to be "the next James Dean."

Elia Kazan, was startling because here was someone who teenagers could identify with. He was going through a period of rebellion on the screen and in real life. Dean's persona was that he did not understand the world he was living in or why he did some of the crazy things he did, and he was looking for someone to help him. Every kid in the audience understood these things.

The film that will forever be associated with James Dean is aptly titled *Rebel Without a Cause* (1955), directed by Nicholas Ray. It was made the same year as *The Blackboard Jungle* and the year after *On the Waterfront.* The film was the first real study of gang violence in Los Angeles and took a hard look into urban homes, revealing that the American family was in trouble. *Rebel Without a Cause* became one of the defining films of the 50s and a huge box office hit, but James Dean never lived to see it, or the legend he left behind.

He saw the long lines outside theatres for *East of Eden* and was childlike in his enthusiasm. He swore he would be a greater actor than Brando, and with his intensity he very well might have achieved this. He wanted to direct movies, years before actors like Clint Eastwood, Dennis Hooper, Jodie Foster, and Mel Gibson made this transition. But James Dean was killed on September 30, 1955 in a two-car collision on an almost deserted highway outside Cholame, California in his Porsche Spider christened "Little Bastard." He was killed two weeks before *Rebel Without a Cause* opened, and a year later *Giant,* the movie he just completed before his accident premiered, starring with Elizabeth Taylor and directed by George Stevens. As soon as a young audience had found its hero, he was gone. His biggest movie opened after the crash.

The movie going public had not experienced a shock like this since Rudolph Valentino died unexpectedly and Will Rogers was killed in an airplane crash trying to fly around the world. However, Dean's death set two major events in motion. There was the expected outpouring of grief by young people, who quickly turned him into an almost religious icon. But parents, especially mothers, wrote thousands and thousands of letters begging Warner Bros. to pull his three films and for the Motion Picture Academy *not* to give Dean an award (he was nominated twice after his death for *East of Eden* and *Giant*). Studios became afraid to do other films about youths because of the madness over Dean's death from the adult community. Dean, in less than two years, changed the concept of the leading man in movies and set into motion the rebellious films that followed a decade later, beginning with *Easy Rider* (1967), directed and starring Dennis Hopper, who had been Dean's buddy and appeared in *Rebel Without a Cause* and *Giant.*

Almost immediately, movie and television actors were being cast because they looked like James Dean. Unlike the almost mad craze of Elvis Presley impersonators that followed "The King's" death (who was offered the lead role in *Rebel Without a Cause* but his manager turned it down), actors began to seriously imitate Dean, or to put it another way, they forged the career he never had. The next movie that Dean was scheduled to make, *Somebody Up There Likes Me,* went to Paul Newman, who had lost out on playing the role of the brother in *East of Eden* because Kazan thought he was too close to Dean in his pretty boy looks and acting style. In physical looks and mannerisms, Dean has been more influential than Brando, especially in light of the new generation of young actors starting with the "Brat Pack" in the 1980s. But on the other side, there are very few actors in modern cinema that are identified with the leading man image of the Studio System, like Cary Grant, Clark Gable, Errol Flynn, or Gregory Peck.

The post-war era was generously peppered with sex and gnawing on the leash of the Production Code. Pure American values were in for a

shock when research reports suggested what was really going on behind the manicured lawns and closed doors of suburbia. There was the astounding realization that many teenagers were having premarital sex, that women actually enjoyed having sex, and that people were having sex at alarming rates, some openly admitting their attraction to same sex partners. It was something that was almost earthshaking at the time but seems by today's standards almost amusing because these statistics are common knowledge. But this era lit the fuse under the Puritan façade of Americans who wished to keep the S-word locked away in a bottom drawer. This would finally explode a decade later. The 1950s were charged with racy novels, beat poetry, Jazz, Playboy Magazine, rock 'n' roll, make-up, foreign cinema, television, two-piece swimming suits, push-up bras, and movie stars that oozed sexual charisma.

Marilyn Monroe

The Platinum Blonde has been around since Jean Harlow, and having "It" was a particular physical attribute that started with silent screen goddess Clara Bow. Both of these stars put their mark on movies in the Pre-Code Era. Harlow continued to make movies after Joseph Breen clamped down, but suddenly died three years later. The deliciously scandalous movies she is remembered for, like *Red-Headed Woman, Red Dust* and *Dinner at Eight,* were made before the Hays Office got its muscle. After this, Harlow's characters lost their sexual edge, Mae West's career was over, and with studios getting hefty fines for violating the rules it appeared that Bombshells and Sex Goddesses were things of the past. But under the blanket of the Production Code in the 1950s sex was stirring and what would happen next would eventually topple the Code.

Early in her career, Marilyn Monroe posed nude for a calendar for photographer Tom Kelley,

because she "desperately needed fifty dollars to get [her] car out of hock." A few years later, after she appeared in *All About Eve* and *The Asphalt Jungle* and was beginning to have her name appear in lights, a man threatened to blackmail her. She would either have to comply or he would tell the press that she was the unnamed woman stretched out on the red velvet. This was something to worry about, since the careers of many aspiring young movie hopefuls had been ruined for only implications of lewd behavior. This was an era when too much cleavage was censored, and Marilyn had shown a lot more than cleavage. But instead of giving in, she beat the man to the punch and told the press herself. At this same time, Hugh Hefner bought the photograph for $500 and made Marilyn the first centerfold, under the title "Sweetheart of the Month," in a new magazine called *Playboy.* As a result, the public forgave her, and she became a bigger star than before.

The problem was, after this the public could not get enough of Marilyn Monroe, whose real name was Norma Jean Mortensen. The image she created on the screen became her real life persona. The blonde hair, the breathy girlish speech, the abused childhood, the insane mother, the marriages, the delays coming on the set, the affairs, the Actors Studio, the Kennedys, and the endless search for happiness—she became the first fully public domain movie star. After *The Seven Year Itch* was released, she looked up at Time Square and saw the poster with her skirt flying up her legs, turned to a friend and said, "See, that's what they think of me." Her movies were fun, like *Gentlemen Prefer Blondes,* directed by Howard Hawks, co-starring the other sex symbol of the era, Jane Russell, where she sang *Diamonds Are a Girl's Best Friend.* She only made eleven motion pictures after she became a superstar in 1953 with the release of *Niagara* and *Gentlemen Prefer Blondes.* And of these films only

Marilyn Monroe in a publicity shot for "Diamonds Are a Girl's Best Friend" from **Gentlemen Prefer Blondes** *(1953), directed by Howard Hawks. Monroe would undoubtedly be astonished at people's obsession with her more than 40 years after her death, and she would probably laugh at the idea that she is considered a screen rebel. Over the years there has developed a media obsession with the early prophets of Method Acting, like Cliff, Brando, and Dean, where the search for the inner demons of their private lives has been scrutinized more than their performances. With Monroe, the public interest in her personal life has gone to excess, unfairly overshadowing her singular gifts as an actress. Method acting is not generally associated with musicals or gold digger comedies, but Monroe managed to make her characters in* **How to Marry a Millionaire, The Seven Year Itch,** *and* **Some Like It Hot** *delightfully unique while giving each one a little touch of herself. The problem is that most people think they are seeing the real Marilyn Monroe instead of a brilliantly crafted illusion.*

one seems destined for movie immortality, *Some Like It Hot,* which director-writer Billy Wilder tailor-made for her—or rather the image everyone has of Marilyn Monroe.

Part of her lasting appeal is that people are still reaching back in time to try to help her solve the mysteries in her life. Celebrated novelists Norman Mailer and Joyce Carol Oates have written books about her. The dress she wore when she sang "Happy Birthday" to President Kennedy sold for a million dollars. Yet when she died there were boxes that had not been unpacked and no pictures were on her bedroom wall. But most of the time she enjoyed the power she had as a star, which helped turn public opinion against the HUAC when her future husband Arthur Miller refused to testify. She was so unique as a personality that she broke the mold for Hollywood Sex Goddesses and no one has been given that title since. With comedy she was a true genius with her timing and natural sense of delivery. In

the end, like Orson Welles, it only takes one great movie to take someone into the hall of fame. Without *Some Like It Hot,* it is conceivable that the collected public memory might have turned off the lights. But like she said, "A career is wonderful, but you can't curl up with it on a cold night."

Sidney Poitier

Perhaps the bravest rebel of this era, and a man who almost single-handedly proved that film used as a lightning bolt for social change could reverse the negative images of the past, is Sidney Poitier. No star in Hollywood's history has had such a compelling influence in reversing the terrible clichés that had befallen the African-American in motion pictures, starting with *The Birth of a Nation* forty years before. Poitier was in a series of films made by outstanding directors like Joseph Mankiewicz, Richard Brooks, Stanley Kramer, and Norman Jewison that took

A Raisin in the Sun (1961) directed by Daniel Petrie, starring Sidney Poitier, Claudia McNeil, Rudy Dee, and Louis Gossett, Jr. There was a movement after World War II to use film as a means to expose the imperfections of society and thus jumpstarting a process of that would eventually change attitudes toward civil rights, ethnic prejudice, and anti-Semitism. Many African-American actors made groundbreaking films in these early years, like James Edwards, Brock Peters, and Harry Belafonte, but none of them had the intensity and sheer screen presence of Sidney Poitier. Starting with **No Way Out** (1950), there was something compelling about his performances. There was the sense that his characters were real men, with flaws and good points, like everyone. Because of his natural born talents as an actor, he created complex individuals on the screen, and eventually the collective number of these characters caused people to see all African-Americans differently.

him to stardom in a white dominated industry. He became the first African-American to win the Academy Award for Best Actor in *Lilies of the Field* (1963). In his early days he remembers there were only two black men on the studio lot, an old man shining shoes and himself. There were a few other African-Americans getting parts during the 1950s, like Harry Belafonte in *Carmen Jones* (1954); but as playwright Gus Edwards observed, Poitier became a star on the pure raw energy of his acting talent, not because he was a singer or sports figure to start with. His first film set the tone for many of his motion pictures that followed over the next two decades. In *No Way Out* he plays an intelligent young doctor with a strong sense of pride who is brought into a racially charged situation. His professional ethics are challenged when he faces the problem of keeping a white criminal alive who is a hateful bigot and has accused him falsely of malpractice. By this point in the movie everyone in the audience wants the man to die, but Poitier's character saves

him because he wants the man to live a long life and always remember who gave it to him.

After this breakthrough film he could only find a few character roles over the next five years until writer-director Richard Brooks cast him in *Blackboard Jungle.* To put *Blackboard Jungle* in perspective for this time period, Brooks had originally been asked to develop and direct *Ben-Hur* but turned it down for the opportunity of making a film that he felt would have a real impact on audiences. Poitier plays a student in a rough integrated high school who the other students respect and listen to, a natural born leader in a sea of young hoodlums, which was the popular expression of the day. A new white teacher, played by Glenn Ford, quickly sees that a way to open the doors of education for the other students is through Poitier, which creates an uneasy and dangerous alliance. In Poitier's most notable films, victory over prejudice is never easily won.

The role that got Poitier his first Academy Award nomination, and the first ever for a Black

male actor in a leading role, came three years later in Stanley Kramer's *The Defiant Ones.* The plot of the movie might seem something of a cliché today, but in 1958 it was original and daring. Poitier is being transported to a prison handcuffed to a white man, played by Tony Curtis, who hates Blacks as much as Poitier's character hates Whites. There is an accident, and they must try to escape through a wilderness handcuffed together. The film transcends the obvious symbolism because of the riveting and completely believable performances of the two stars. Curtis achieved movie immortality the following year when he donned a dress in *Some Like It Hot,* but in *The Defiant Ones* he gave an outstanding dramatic performance and credited it with the intensity with which Poitier assaulted his role.

A bitter irony about shooting on location during *The Defiant Ones* is that at night Poitier had to drive an extra hour to a motel that took Black people, and during the day he was making a film that would turn him into a star. The 1960s would be his greatest era with *A Raisin in the Sun, Lilies of the Field, A Patch of Blue*; and in one year, 1967, he would make *To Sir, with Love, Guess Who's Coming to Dinner,* and *In the Heat of the Night,* which won best picture. It must have been very satisfying to Poitier to achieve in Hollywood what so many White movie stars had enjoyed over the years, to have scripts by some of the finest writers especially developed for him. Like Brando and Dean, Poitier also has a generation of actors who have followed in his long shadow, like Louis Gossett Jr., Cuba Gooding Jr., and Denzel Washington.

WAR MOVIES

Like the social issue films that emerged after the war, war films began to look at the psychological damage caused by war and problems of returning vets trying to adjust to peaceful civilian life. One of the biggest surprises to many of the old studio moguls was the popularity of the war films. The war movies showed audiences during the war how important it was to fight the evil enemies of Japan and Germany, but it was assumed that no one would care about the war when it was finally over. One of these conflicts in opinion lead to a major shift of power at MGM when Dore Schary, who was in charge

Twelve O'Clock High (1949) directed by Henry King, starring Gregory Peck as Brig. Gen. Frank Savage. After six years of world war, the last thing the studio moguls thought the public wanted to see were war movies. **Twelve O'Clock High** *and* **Battleground,** *by veteran director William Wellman, came out the same year and were tremendous hits. Both films received Oscar nominations for Best Picture. The depiction of combat was not as graphically violent as seen in* **All Quiet on the Western Front,** *instead the post-WWII films began to focus on the psychological stress of war. Peck as Frank Savage plays a commanding officer that refuses to show his inner feelings toward his men, until he finally collapses from the burden. Savage is a direct influence on Tom Hank's Captain Miller in* **Saving Private Ryan.**

of production at MGM, fought hard to make a film called *Battleground* (1949), directed by William Wellman. This was a gritty depiction of the Battle of the Bulge using Hollywood stars in non-glamorous roles.

Louis B. Mayer had been the most successful of all of the moguls and had run MGM in the black during the Depression and War Years by making musicals and the Andy Hardy series. He opposed the green light of *Battleground,* believing, as always, that what America public needed was a little "R & R" from the violence they had seen in real life for five years. This clash of the titans reached all the way to the corporate office in New York, who gave Schary the okay to go into production. *Battleground* ended up being one of the five biggest moneymakers of the year. The screen version of World War II was far from over.

That same year 20th Century-Fox made *Twelve O'Clock High,* staring Gregory Peck and directed by Henry King. Considered one of the best war films ever, *Twelve O'Clock High* used a wraparound plot where a retired officer visits the abandoned airbase where he served in England and flashes back on the events of America's daylight bombing raids that took a huge toll. There is only about fifteen minutes of actual war footage; the main focus of the story is about the commander who is in charge of training young pilots in their late teens and twenties to fly missions where the odds were fifty-fifty. It is one of the best studies of the emotional stress of war ever put on film.

The motion picture that began this hard look at war was not about the war but dealt with the difficult readjustment of three returning veterans. *The Best Years of Our Lives* (1946) was directed by William Wyler, who had not made a film in Hollywood since *Mrs. Miniver* four years before. He had been part of the Signal Corp making training films and documentaries, including *The Memphis Belle. The Best Years of Our Lives* told the story of three soldiers returning to a small town in America, a sailor who had lost his hands, a bombardier, and an officer in the army. One was obviously physically handicapped, the other two were emotionally scarred. One compensated with a little too much to drink and the other found he was too old for most jobs, especially considering his only trained skill was dropping bombs on Germany.

The Sands of Iwo Jima directed by Allan Dwan and starring John Wayne, came out in 1949 and was a major box office success. Wayne received his first Oscar nomination as tough-as-nails Sgt. John M. Stryker, another commander that kept his real thoughts about his men inside. At this time the Marines were facing possible elimination as a separate military unit because of government cutbacks. Marine chief officers approached Wayne to make a film about the hard-won victory at Iwo Jima. The film was so popular that all talks about phasing out the Marines disappeared and recruitment immediately shot up.

The Best Years of Our Lives was picketed by the Veterans of Foreign Wars because the popular position was that returning veterans were not having problems adjusting to normal life. But the motion picture was a huge box office hit, partly because it is brilliant filmmaking tackling a subject that has rarely been done before or since. And partly because the lives of the three men on screen rang true to tens of thousands of vets who were having nightmares and adjustment problems, feeling they had lost the best years of their lives. In many ways the film set the standard for all other films that followed in this era, aiming the camera at the truth instead of make-believe. It was the last time that Wyler and legendary cinematographer Gregg Toland would work together. Toland would die two years later at the age of forty-four.

War films kept reinventing themselves over the decades. The genre returned to the concept of high adventure with *The Guns of Navarone*, *The Dirty Dozen*, and *Kelly's Heroes*, and was seen on television with programs like *Combat*. Then in the 1970s war films took two different paths. In 1970, both *Patton* and *M*A*S*H* were released; one was a big budget salute to a great general and the other was a satirical attack on the madness of war itself. By the end of the decade *Coming Home*, *The Deer Hunter*, and *Apocalypse Now* confronted the problems of Vietnam. With the belief that no genre ever disappears, the war films morphed into science fiction with space battles in *The Last Starfighter*, *Star Wars*, and on television with *Battlestar Galactica*, and in the near future on earth with *The Terminator*. The in the 1990s, Steven Spielberg brought back World War II in *Saving Private Ryan*, this time with an unflinching look at the brutality of combat in a war that had always been romanticized and treated as games with the Nazis. Then war became medieval with *Braveheart*, and its Middle Earth counterpart, *The Lord of the Rings*. The continuing fascination with war seems to reflect perhaps the oldest of human follies, the periodic need for wholesale carnage on the screen—and in life.

THE WIDESCREEN ERA

Hollywood literally waged its biggest battle against small screen television by going huge. The first film to use Cinema-Scope was 20th Century-Fox's *The Robe* (1953), declared by Darryl F. Zanuck as being a modern miracle, and starring Richard Burton, who would later scandalously team up with Elizabeth Taylor in *Cleopatra*, the big screen epic that almost broke the bank for the studio. But *The Robe* was a giant hit. It was an event, with reserved seats and souvenir books like a traveling Broadway show. It was based on an equally gigantic best selling novel by Lloyd C. Douglas, recreating the era of Christ and the power of his divine robe that was won by a Roman solider whose life changed forever. The unlikely combination of the Bible and a giant movie screen brought people out of their homes and away from television. But then the Bible and Hollywood had before been a marriage made in box office heaven, going back to Cecil B. DeMille's *The Ten Commandments, King of Kings*, and *The Sign of the Cross*.

CinemaScope is a process that owes it origins to Abel Gance's Polyvision created in 1927 for his failed epic *Napoleon*. The widescreen CinemaScope had an aspect ratio of approximately 5 by 3, meaning that for every three vertical feet there were five horizontal feet of screen, giving an image in some movie palaces that extended 30 feet by 50 feet. Later formats like Cinerama, Todd-AO, and VistaVision were 2.5 times the vertical dimension of the screen, sometimes wrapping a quarter of the way around an audience. The movies were shot with an anamorphic lens that compressed almost 180 degrees of

Ben-Hur (1959) directed by William Wyler, starring Charlton Heston, Stephen Boyd, Jack Hawkins, and Hugh Griffith, was shot in Ultra Panavision 70 with an aspect ratio of 2.76.1. Thus, audiences saw the chariot race 30 feet high and 82.80 feet wide. Though Wyler won his third Oscar for the film, the chariot race was directed by legendary stuntman Yakima Canutt and his son Joe. The shooting cutting ratio was 263-to-1, or there was 263 feet of film shot for every 1 foot used in the final sequence. The story that a stunt double was killed during the film is not true—mere Hollywood myth.

sight by 50 percent. When the film was projected, another lens spread the image across the screen. Early the 3-D process brought people out for movies like *Bwana Devil* (1952) but within two years this faded away. The reasons for this were uncomfortable paper glasses with plastic color lenses, poor projection of image, but mostly because the movies went for cheap thrills with monsters and madmen and were just plain awful. The decision from the very beginning with widescreen movies was that they would be high quality entertainment.

Over the next ten years studios turned their attention to lavish widescreen productions, like DeMille's own remake of *The Ten Commandments*, Michael Todd's *Around the World in 80 Days,* and musicals including *The King and I* and *South Pacific.* The most successful epic of this era was *Ben-Hur*, directed by William Wyler, which grossed MGM over $80 million dollars, an amazing feat that was only second to *Gone With the Wind.* The high point of *Ben-Hur* was the chariot race that lasted for almost twenty minutes and for many production managers and cinematographers it is considered one of the greatest achievements in moviemaking. The problem was that it raised the brass ring too high for future motion pictures.

The age of the widescreen epic was a time period of remarkable coordination. Many of these movies were so large they could not simply be built on the back lots of the motion picture studios. They had to be shot on location, which began a series of lucrative international deals where Hollywood would begin to partner up with money that would come from England, Italy, France, and other countries. The sets for these movie were literally monumental feats of construction, forty years before CGI effects could recreate the Roman Coliseum, pyramids, and full-scale sea battles. The movies began to have international casts as part of the ensemble, so that the studios had the ability to market them to most counties. Sophia Loren, Frank Sinatra, and Cary Grant starred in *The Pride and the Passion* (1957); Charlton Heston and Sophia Loren made *El Cid* (1961); and Kirk Douglas, Laurence Olivier, Tony Curtis, Charles Laughton, Jean Simmons, and Peter Ustinov were just part of the cast for *Spartacus* (1960).

Lawrence of Arabia (1962) directed by David Lean, starring Peter O'Toole, Alec Guinness, Jack Hawkins, and Omar Sharif, is an example of filmmaking as high adventure. Shooting for over a year, temperatures reached 120-degrees in certain desert locations, hundreds of camels had to be trained, caravans of trucks brought food and supplies to remote locations, and a city was built next to the sea. Lean is seen here preparing a tracking shot for an action sequence. The cinematographer was Freddie Young, who worked with Lean again on *Doctor Zhivago* (1965) and *Ryan's Daughter* (1970), winning Oscars for all three films.

Director David Lean became the undisputed master at the movie spectacle, and his films really mark the beginning and the end of this grand style of filmmaking. Lean was a modern Renaissance Man that in many ways made small movies on a giant screen. His greatest films focused on the intellectual conflict of a single individual, but he disguised these kitchen sink dramas with some of the most magnificent movements ever created on film. There is an expression that when a scene is absolutely perfect in its composition, lighting, and dramatic mood it is a "David Lean shot," because many of the images that he created have never been even remotely duplicated. Of the sixteen films he made, five of them won for best cinematography.

The motion picture that really created an epic adventure for audiences was Lean's *Bridge On the River Kwai*, which was shot entirely on jungle locations away from studios and had a look that was completely unique from the forced make-believe sound stage worlds of *The Robe* and DeMille's epics. Lean's follow-up was a motion picture that is a pure masterpiece of visual storytelling, *Lawrence of Arabia* (1962), which was in production almost two years, with one full year in remote deserts that many outside visitors had not seen in a century. With an army of extras, hundred of camels that had to be trained, an entire city had to be build on a far away sea coast, and desert storms had to be created with giant wind machines. *Lawrence of Arabia* used the widescreen format unlike any film ever made. Lean then made *Doctor Zhivago* (1965), combining the horrors of the Russian Revolution with a tragic Tolstoyian love story, which became his biggest box office hit. The movie once again saved MGM, so when he wanted to make *Ryan's Daughter* (1970) the studio backed the expensive project with hopes of another miracle. But the movie failed with audiences and critics, and opened up the studio to a takeover. Pauline Kael, the movie critic for *The New Yorker* verbally attacked Lean over the film, causing the great director not to make any motion pictures until *A Passage to India* fourteen years later.

DRIVE-INS

One of the cultural phenomena's that exploded after the war were the drive-ins. American fell in love with their cars,

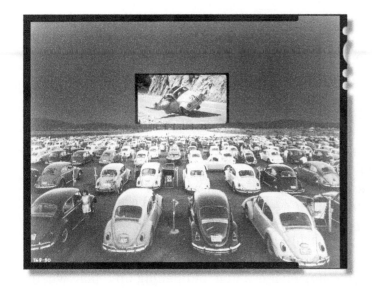

The first drive-in theatre opened in Camden, New Jersey the summer of 1933, but it was after World War II that drive-ins became a destination for family outings. Between 1948 and 1954 there were an estimated 3,775 American drive-ins, but by the early 1970s the acres needed for drive-ins, which were usually located on the outskirts of cities, became valuable land for real estate investments. The summer blockbuster **Jaws** represented the last big hurrah for drive-ins. By the 1990s more than 3,000 drive-ins had disappeared.

which because of rubber and gas shortages during the war they could only use for necessary trips. People would go out on Sundays just for a drive in the country, a little outing to have a picnic and return. Drive up restaurants had carhops on roller skates who served hamburgers and malts on special trays that clapped to the side windows. Car radios allowed teenagers to cruise or park and listen to the hottest new tunes. Drive-ins were ideal since entire families could watch a movie and go home without ever leaving their car—well, expect for visits to the snack bar.

Richard M. Hollingshead in Camden, New Jersey created the first drive-in in 1933 that accommodated four hundred cars. But the golden age of the drive-in did not happen until over twenty years later, reaching a high point in 1958 where there were five thousand drive-ins across the country. The drive-ins had their own commercials for the snack bar with dancing boxes of popcorn and hot dogs with legs and arms. There was a community feeling where families would bring lawn chairs and talk to the neighbors next to them. Kids would sit on the hood of the car resting back against the front window. Under the movie screen there were little playgrounds for

kiddies. There were raffles and auctions and sometimes a monster in a rented costume. It was a way to meet people and share ideas and, of course, scream loudly as *The Beast from 20,000 Fathoms* crawled from the ocean.

Science fiction and horror movies grew up with the drive-ins. They gave couples a chance to cuddle up to protect each other from monsters, giant spiders, and Martians with ray guns. Small motion picture production companies that specialized in B-features found a special market. Drive-in movies were often major releases that were shown in the local theaters, but quickie low-budget movies were made designed especially for teenage crowd.

American International began to make movies that were directly aimed at the teen market. Scream feature *I Was a Teenage Werewolf* and the movies that became associated with producer-director Roger Corman were made on the cheap, sometimes in just a few days. They were not trying to make another *On the Waterfront;* they had tapped into a giant market of young kids that wanted something off-beat and a little crazy. The entire canon of Vincent Price movies from *The Fly* to *The House of Usher* to *Pit and the*

Pendulum played perfectly at the drive-ins on double bills with *Little Shop of Horrors.* Hammer Films in England began to produce Technicolor remakes of Frankenstein and Dracula, starring Christopher Lee and Peter Cushing.

In the 1960s, the beach movies, starting with *Where the Boys Are* and later with *Beach Blanket Bingo,* starring Frankie Avalon and Annette Funicello, were racking in more money than most studio prestige pictures. Then the biker films became hot, like *The Wild Angels* with Peter Fonda and Nancy Sinatra, and *Hell Angels on Wheels* with a baby-face Jack Nicholson. With the studios cutting back, working on a Roger Corman quickie feature became a complete education in film production, which was otherwise impossible for this new wave of young directors, writers, and actors. Just a few of the directors, writers, and actors who eventually got their starts on Corman's one-week wonders were Francis Ford Coppola, Robert Towne, Martin Scorsese, Dennis Hopper, Peter Fonda, Bruce Dern, Jonathan Demme, Peter Bogdanovich, Joe Dante, James Cameron, and Nicholson. In fact, these names represent most of the major players who became associated with the New Hollywood in the late 1960s and 70s.

Almost all of the drive-ins are gone now, because as the cities grew the land became so valuable and the large acreage of drive-ins made way for shopping malls and housing complexes. One of the many complaints by the Paramount studio executives about *The Godfather* production was that Gordon Willis' cinematography was too dark and could not be seen in the drive-ins. But the drive-ins were on the way out by then and it did not make any difference to the box office. Starting with *The Godfather,* the concept of opening movies wide meant that A-list features would play for weeks at indoor theatres before they went to the drive-ins. Then by the 1970s, the remaining drive-ins were often long distances outside city limits or in bad neighborhoods. The last big year of the drive-ins was the summer of 1975 when *Jaws* was released. This was the perfect movie for people to sit on the hoods of their cars under the warm night sky and scream in utter terror.

DIRECTORS

Many of Elia Kazan's landmark plays, like *Death of a Salesman* and *A Streetcar Named Desire,* are cinematic in the use flashbacks and mixing up timelines. The film version of *A Streetcar Named Desire* is a phenomenal example of opening up a play where the action takes place in a very confined apartment in New Orleans. Kazan was able to isolate intimate moments with a short camera lens and create mini-scenes that gave a variety of conflicting dramatic moods and intonations of performance. Kazan was a director that was able to marry his Broadway and Hollywood careers and cross-pollinate his personal innovations into both of these art disciplines. Later, Bob Fosse would be able to achieve this with *Cabaret* and *All That Jazz.* Sam Mendes would continue this tradition of going from stage to screen with films like *American Beauty* and *Road to Perdition,* and John Madden with *Shakespeare in Love.*

Kazan's essential films are about reform and, as actress Lee Grant observed, even after he gave testimony to the HUAC Committee he still continued to use motion pictures for social change. *Gentleman's Agreement* looked at the prejudice against the Jews when most of the studio moguls were afraid of the theme. *Pinky* was about racial prejudice. *On the Waterfront* told the story about the Mob ruling and ruining the lives of the longshoreman by not giving them a fair deal. *Wild River* weighed the issues of bringing power to a remote part of country, even if it meant the loss of personal property. And *America,*

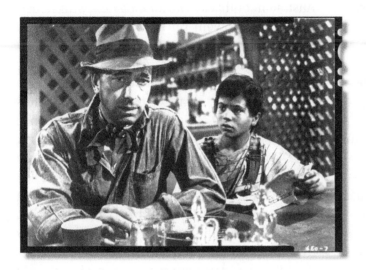

Treasure of the Sierra Madre (1948) *directed by John Huston, starring Humphrey Bogart, Tim Holt, and Walter Huston (John's father), was shot in Mexico. Huston, along with directors John Ford, David Lean, George Stevens, and Fred Zinnemann, insisted on making films on location, getting away from the glossy studio look that had been part of Hollywood features since sound arrived. Huston's most productive period were the ten years after his service in the Signal Corps during World War II when he made* **Key Largo, The Asphalt Jungle, The Red Badge of Courage, The African Queen, Moulin Rouge, Beat the Devil, Moby Dick,** *and* **Heaven Knows, Mr. Allison.** *Bogart made six films with Huston, winning his Oscar as Charlie Allnut in* **The African Queen,** *with Katharine Hepburn.*

America was the story of his grandfather immigrating to a new country.

John Huston's first film was *The Maltese Falcon* set in the dark world of the criminals. His best films redefined this genre on his own new terms. He was a director like John Ford and David Lean who wanted to get away from a studio back lot, and make rough-edged films in the spirit of the documentaries he made during the war, like *The Treasure of the Sierra Madre* and *The African Queen.* Houston was attracted to stories that had a terrible sense of irony. His characters are often thrown into a simmering Existentialist soup to see if they would drown or survive.

In *The Maltese Falcon,* Sam Spade philosophizes that the lead black bird is "the stuff that dreams are made of" and promises the beautiful double-crossing femme fatale that he will wait for her, providing they don't hang her first. In *Treasure of the Sierra Madre* a huge dose of gold fever overtakes Bogart's character, which leads him to a terrible, lonely demise with the wind claiming a great fortune. And *The Asphalt Jungle* is about a perfectly planned heist, which, one threat at a time, comes unraveled, ending with

the guy who was going to pull just one last job to buy a little ranch away from the poison of the big city driving to the country with a gunshot wound and dying in a pasture where horses are running free.

Fred Zinnemann directed classics in almost every genre of film and became noted for giving many of the new breed of Method actor their first screen roles, like Montgomery Clift in *The Search* and Marlon Brando in *The Men.* Because of his background in documentaries, many of his films in this era had a sense of immediacy and caught-in-the-moment realism. *High Noon* is probably more true to the historical west than most films in this genre had been before this time. As a reflection of McCarthyism, it sent Westerns in a new direction by using the metaphor of a sheriff in a dusty town trying to find townspeople to help him stand off a gang of killers arriving on the noon train. In the end he must fight alone and is contemptuous of the townspeople that congratulate him after the showdown. He throws his badge in the dirt and leaves.

From Here to Eternity is supposedly the film that the Mob put the head of a horse in the bed

of the producer to get Frank Sinatra his Oscar winning role. It is all Hollywood myth. The film became a landmark because it achieved the almost impossible during the Production Code of bringing James Jones' no-punches-pulled tale of Army life faithfully to the screen, and some of the finest acting ever seen in a film before this. As an example of some of the exciting, and at the time revolutionary, camera work that Zinnemann became associated with, during the attack on Pearl Harbor there is a point-of-view shot of a Japanese pilot mowing down the soldiers as they fly over the barracks lot. This quick editing and the mobility of the camera were unique in movies at this time.

The most famous scene is when Burt Lancaster and Deborah Kerr are embracing and passionately kissing on the beach, fully clothed in their swimsuits, as the waves wash in. The moment is three seconds long, but the essence of the scene was far more sexually charged than what audiences had seen in a long time. Zinnemann, to illustrate his versatility during this era directed the big budget musical *Oklahoma, The Nun's Story* with Audrey Hepburn, and was one of the first to shoot a major motion picture in the Australian outback, *The Sundowners* with Robert Mitchum. He went on to make *A Man for All Seasons, Julia,* and *The Day of the Jackal.*

When John Ford returned home after the war he settled in by making Westerns. This would be his fourth decade as the most respected director in Hollywood. *My Darling Clementine* looked at the legend of Wyatt Earp and the shootout at the OK Corral in a marvelous fashion that is the favorite of many connoisseurs of John Ford. It gave a sense of realism about life in the small towns and the petty feuds that happened there. He claimed that the gunfight was exactly the way that Wyatt Earp had described it to him, and indeed Ford had met Earp many times when the old marshal lived in California. This very well could have been the version that Earp would have preferred to see on the screen, instead of the one that actually happened in twenty seven seconds, with eight men standing a few feet from each other shooting it out. Ford was a believer of the oral tradition, and Earp was obviously a master of it.

In rapid succession Ford made what is known as his Cavalry Trilogy, *Fort Apache, She Wore a Yellow Ribbon* and *The Rio Grande,* which began what became known as the Ford Stock

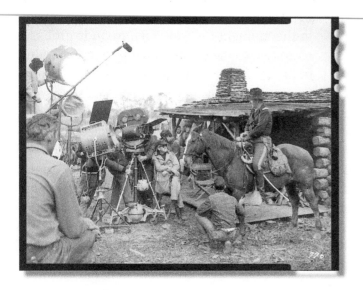

John Ford on location in Monument Valley with John Wayne, where in the late 40s the director made what became known as his cavalry trilogy: **Fort Apache, She Wore a Yellow Ribbon,** *and* **Rio Grande.** *These films were about military life on the frontier, showing the traditions and customs of the cavalry during the last years of what is described as "the Indian uprisings." The movies starred the members of the Ford Stock Company and were full of rough humor and traditional songs. Akira Kurosawa talked about how he enjoyed these films and how he saw a similarity between the cavalry soldiers and the samurai warriors.*

Company. He also directed *The Three Godfathers* with John Wayne and *Wagon Master* with Ward Bond, creating the groundwork for the successful television series *Wagon Train* that Ward Bond starred in for many years. His non-Western films include *Mister Roberts, The Long Grey Line,* and *The Quiet Man*, which is his Valentine to Irish traditions, full of song and feuds and humor, ending in a great donnybrook of a fight. This would win Ford his fourth Academy Award, making him the only director to be so honored. *The Quiet Man* is the film that E. T. is watching when he is drinking the beer and watching the man and woman kiss.

At the age of sixty-two, Ford made what many considered his greatest motion picture, *The Searchers.* This picture really was the first of the revisionist Western movies, looking at the fact that both sides of the battles between the Indians and the settlers had people that were equally obsessed with hatred and bigotry. At the center of it there is a great performance by John Wayne, who holds nothing back when playing a character that has been eaten away by revenge. This is a favorite movie of Martin Scorsese and one of the films that Spielberg watches before he begins a new production.

Ford would end up making over a dozen other movies after *The Searchers,* including *The Man Who Shot Liberty Valance* in 1962, which would be a box office disappointment but later considered a classic. By the end of his life, Ford had moved into a generation where Hollywood was suspicious of history. The Vietnam War was seen nightly on television, and the Watergate scandal had torn down what was left of the wall of privacy between Washington politics and the public. Books like *Bury My Heart at Wounded Knee* showed the obsession of General Sherman and General Custer in their attempts to commit genocide on the Native Americans and the barbaric actions at times of the Seventh Cavalry, a

unit that Ford had celebrated in his movies. His favorite belief that the legend was more important than the truth was at odds with a new generation of moviegoers. But the family traditions, the humor, the patriotism, and the way he shot parts of the American Southwest still endure at the core of all of his films.

The ultimate director who never really left his roots as a German filmmaker was Billy Wilder. Wilder's films very much expressed his background as a journalist. He liked to dig for the story. They also showed the influence of his mentor Ernst Lubitsch who he unabashedly praised throughout his entire life. Later in life, Wilder had wanted to direct *Schindler's List* because after leaving his home in Vienna his mother and most of his family were lost in the Holocaust. The black mood this must have put him through might be part of the reason he was attracted to material that was dark, dealing with taboo subjects—things considered untouchable by most directors in Hollywood. Wilder started out as a writer on such movies as *Midnight, Ninotchka,* and *Ball of Fire.*

As a director his major success was *Double Indemnity,* a film that jumpstarted the film noir movement. Wilder cast actors who had always played the nice roles, like Barbara Stanwyck and Fred McMurray, and turned them into cold-hearted killers. Many critics were outraged that there were scenes inside a supermarket, which was no place for glamorous movie stars, but *Double Indemnity* offered up many sacred cows. It is based on a true story about a scheming insurance salesman who falls for a married woman and almost gets away with the perfect murder. Instead of the traditional format of having a detective investigate the crime, Wilder stays with the two characters as they plot the murder and kill the husband, always playing with the audience until people are nervous they might get away with it. And, of course, with the Production

Code, they can't and they don't, which is obvious from the first scene. In *Double Indemnity* and later in *Sunset Boulevard,* Wilder uses a wraparound story, where he opens with present day, then flashes back to reveal the sordid details, and ends up in present day. With *Double Indemnity,* McMurray arrives at his office dripping blood from a gunshot wound and begins to give the ugly events of his story into a Dictaphone. But Wilder tops this with *Sunset Boulevard,* where during the opening scene the audience sees the corpse floating very dead in a Beverly Hills' swimming pool, and then the corpse begins to talk and tell how he got there, a perfect device that captures the madness of Hollywood.

Wilder took a long look at the ugly side of alcoholism in *The Lost Weekend,* the extent a reporter will go to get a front page story in *Ace in the Hole,* survival tactics in concentration camps with *Stalag 17,* and the affair between a young girl and an older man in *Love in the Afternoon.* Wilder worked with Marilyn Monroe twice, on *The Seven Year Itch* and the movie she will be best remembered for, *Some Like It Hot. Some Like It Hot* was based on a German movie that he had seen years before while living in Berlin and the concept about two men dressed up as women through the majority of this film was something everyone felt might ruin Wilder's career. Instead, it was voted the number one comedy of all time by the American Film Institute.

Some Like It Hot is an affectionate nod to the gangster films of the old Studio System. Wilder even puts in a gag with George Raft about flipping a coin being a "cheap trick" (which had been Raft's trademark in his early films) and Pat O'Brien playing the tough cop, which he did for scores of movies, when he was not playing a priest. *Some Like It Hot* is full of actors who had been in gangster films way back when, and Wilder somehow managed to get away with bloody murder with all the sexual implications throughout the film. No one has every equaled Wilder in the ability to create classics in serious drama, and then turn around and make outrageous screwball comedies.

After *Notorious,* Alfred Hitchcock made several box office flops in a row, including *The Paradine Case* and *Rope,* which he tried to show in one long continuous take. But the Master of Suspense hit his stride again with *Strangers on a Train* (1951) which became the start of his golden years. Over the next nine years he was his most ingenious and creative with films like *Rear Window, To Catch a Thief, The Man Who Knew Too Much, Vertigo, North by Northwest, Psycho,* and the *Alfred Hitchcock Presents* television series, in which he directed many episodes.

Strangers on a Train continues Hitchcock's fascination that had begun with *Shadow of a Doubt* eight years before, and would culminate with *Psycho,* and that was the study of a seemingly kind, gentle man who turns out to be a cold-blooded murderer. Hitchcock's own personal paranoia allowed him to turn commonplace activities, like being stopped by a policeman for a speeding ticket, into a sheer nightmare for the common person. In *Strangers on a Train,* a casual conversation proposes the idea of the perfect murder, which has two people who are complete strangers switching murders, where no one would be able find them, because each has man has own separate alibi. The problem is that one of the men is not joking and commits the murder, expecting the other man to do the same.

Rear Window is a Hitchcock experimentation, where, as with *Lifeboat,* he declared he could make a suspenseful film in a closet; however, his set was sizably larger, being one of the biggest indoor sets ever built at the time. The lighting go so hot that the first day the emergency sprinklers came on and production had to be shut down. He proceeded to put Jimmy Stewart in a wheelchair with a broken leg and a camera with

North by Northwest (1959) directed by Alfred Hitchcock, starring Cary Grant, Eva Marie Saint, James Mason, and Leo G. Carroll (who appeared in six of Hithcock's films). Screenwriter Ernest Lehman said he wanted to make the ultimate Hitchcock thriller, but when he met with the Master of Suspense they could not devise a plot to get the story started. Finally, after several meetings, Hitchcock said he always wanted to do a chase on Mount Rushmore and have Cary Grant hide inside the nose of Abe Lincoln—and when the bad guy approached, Grant would sneeze. This gave Lehman the inspiration he was looking for to write his screenplay.

long lenses and a pair of binoculars in one of the largest sets ever built at that time, looking across at different windows. The lead character is a photographer, played by James Stewart, who is confined to a wheelchair because of an accident. To kill some time he becomes a peeping tom who keeps track of the newly married couple next door, "Miss Torso" across the courtyard, a composer who can never finish his love ballad, a Miss Lonely Hearts, and a man who may or may not have killed his wife and hacked up her body into small pieces. As a bit of revenge on his old boss, Hitchcock deliberately cast Raymond Burr and gave him gray hair to look like David O. Selznick.

A French director, Henri-Georges Clouzot made a film called *Les Diaboliques,* a murder thriller starring Simone Signoret and based on a novel by Pierre Boileau. It is the story of two women who plot to murder a man. Once the murder takes place, the body of the man is put into a swimming pool overgrown with vines. But the body mysteriously disappears, thus creating a nightmare for one of the women who believes the man will somehow miraculously come back to kill her. It was a huge success, and Clouzot borrowed freely from Hitchcock's techniques. In reviews Clouzot was declared the new Hitchcock, which the old Hitchcock took great exception to and set out to prove he could create a movie just as eerie and full of the same sexual tensions, which would not be easy under the Production Code.

So Hitchcock bought a novel by Pierre Boileau and Thomas Narcejac and gave his film the name *Vertigo. Vertigo,* by many critics, is hailed as Hitchcock's masterpiece, but it is a difficult film in comparison to the intrigue audiences had come to expect from Hitchcock's films like *The Lady Vanishes, Notorious,* or *Strangers on the Train.* What is fascinating is the way Hitchcock got past the Code. *Vertigo* is the most written about film of the most written about director. The dialogue tells the story of a man being hired to

follow a woman who might be going mad and thus possibly suicidal, but Hitchcock's visual language unfolds a tale of a man becoming sexually obsessed by the woman he is following.

The attraction to another man's wife was forbidden territory. Yet it is obvious that Stewart's character begins to covet the woman he is following. At one point he retrieves her when she attempts to commit suicide by jumping into the San Francisco Bay. When she wakes up, she finds herself obviously naked in the bed, and he is hanging up her undergarments in the bathroom. Thus while she was passed out, he has obviously completely undressed her.

Vertigo is a remarkable film for what Martin Scorsese described as subterfuge, a method popular during the Production Code, where the story seemed conventional but the underlying meaning, symbols, and visual language told a completely different tale, like writing in invisible ink. The second half of *Vertigo* seems more like a nightmare than real, which is why the film has been so analyzed over the years. Movies today do not have to go to this extreme, but toward the end of the Code certain directors had become highly skilled with camera angles, editing, and music to put film together that could mean one thing with the sound on and something completely different with the sound off.

MULTICULTURAL FILMS

After the war there seemed to be a genuine interest in correcting some of the social wrongs that had existed in America for a long time. In the past, the stereotyping of ethnic characters was encouraged and perpetuated by the movies themselves. The efforts to change social thought through film came from a handful of people in the industry who were allowed to make movies with a social consciousness that could reach a large audience. It is mistakenly assumed that since Hollywood is a large industry that many executives, producers, directors, writers, and actors backed the majority of films that were being released. In fact it might have been one or two stubborn individuals who pestered

The Defiant Ones *(1958) directed by Stanley Kramer, starring Sidney Poitier and Tony Curtis, is a film that was extremely powerful and important when it came out in the years just before the Civil Rights Movement. Today the drama seems dated because so much has happened regarding African-Americans in American society since its release. What holds up remarkably well are the performances by the two leads, who play escaped convicts that are chained together and violently hate each other because of the color of their skin. Poitier received his first Oscar nomination for his role.*

and persisted until whoever was in charge of production approved a very meager budget, almost as a dare to make a movie with it. Yet these films got made and reached a much larger audience than anyone expected.

Stanley Kramer was one of these producers, who later began to direct his films and took on subjects like racial intolerance, the prize fighting racket, nuclear warfare, and the Nuremberg war trials. Kramer was in association with United Artists, the one studio at the time that co-ventured with producers and was looking for films that were an alternative to the major studios. Instead of newsprint, Kramer used celluloid to make editorials about reform, yet he was a filmmaker at heart and knew the value of a strong, entertaining story to make his case.

Champion (1949) looked at the corruption in the boxing world. *Home of the Brave* (1949) dealt with racial prejudice in the army. *The Men* (1950) was Marlon Brando's movie debut and dealt with the trauma of veterans who returned from war paralyzed and disabled. *High Noon* (1952) created what became known as the adult Western and used this American genre as a metaphor for the paranoia of the McCarthy era. Directors like John Ford and Howard Hawks hated *High Noon* and openly criticized it, but the film changed the nature of Westerns, starting with *Gunsmoke* on television. *The Defiant Ones* (1958) became one of the most influential films on racial prejudice. Kramer also made *The Wild One* (1953), *On the Beach* (1959), Inherit the Wind (1960), *Judgment at Nuremberg* (1961), and *Guess Who Is Coming to Dinner* (1967). He worked many times with actors Spencer Tracy, Sidney Poitier; writer, Carl Foreman; and director, Fred Zinnemann. Kramer began as a one-man movement for social change but soon there were many that joined in, and gradually the harm that early movies created was being corrected.

African-Americans

The American public was beginning to see in the movies a process of integration that did not exist in real life. When the African-American soldiers returned home, they were treated the same way as if the clock on segregation laws had held still while the rest of the world had advanced by years. African-Americans were still expected to sit in the back of the bus, drink from separate fountains, sit in the balcony during movies, and use separate restrooms. The movies began to heal some of the stereotyping wounds that began long before *The Birth of a Nation*. With dynamic actors like Harry Belafonte in *Carmen Jones* and *Island in the Sun* and Sidney Poitier in *No Way Out, The Blackboard Jungle,* and *The Defiant Ones*, the image of the African-American changed into someone who was intelligent, exciting, and not in the least dimwitted like the characters Steppin Fetchit had played only a decade before.

Dorothy Dandridge became the first African-American actor to be nominated for an Academy Award in *Carmen Jones;* she also starred in *Island in the Sun* and *Porgy and Bess* (1959). But sadly there were few roles for Black female leads, and her life became full of frustrations and went into a tragic tailspin. She died at the age of forty-two. As a kind of poetic justice, Halle Barry portrayed her in the television movie *Introducing Dorothy Dandridge* (1999) and went on to become the first Black woman to win the Oscar for *Monster's Ball,* forty-seven years after Dandridge's nomination.

As Diahann Carroll observed about the recognition that African-American actors were finally receiving in the 1950s, "it was a long time coming." Other actors that made important contributions to the change of stereotypical images were Brock Peters, James Edwards, and Pearl Bailey. The outcry that greeted *The Birth of a Nation* began a revolution that caused changes in Hollywood in the post-war years and brought

attention to old prejudices that erupted in the 1960s. Because of film people throughout America began to see the injustice of the segregation laws in the American South and the meaningless hatred over someone's skin color. Reform, though long overdue, was finally in motion, and it started with just a few stubborn, committed, and brave individuals.

Asian Americans

In 1957 two films broke the standard stereotypes of the Asian on the screen. One was *Bridge on the River Kwai* that afforded actor Sessue Hayakawa an Academy Award nomination as the commander of the Japanese prison camp. Hayakawa had been a leading man back in the silent era but had returned to Japan because of the scandal caused by the Cecil B. DeMille movie *The Cheat*. His performance was extraordinary in *The Bridge on the River Kwai,* and for one of the first times the cast was comprised entirely of Asian performers, not like the Charlie Chan mysteries that had gone out of favor by this point, or the caricatures that were created in movies like *The Good Earth* and *Dragon Seed*. Sessue Hayakawa's

character was ultimately a foil for the British commander, played by Alec Guinness, to outwit and occasionally use as a comic target. But here was a major Japanese character played by a Japanese actor, not a movie star with eye make-up. The traditions of the Japanese were observed, which gave the film its power as two diametrically different cultures clashed together.

The other film was *Sayonara,* directed by Joshua Logan, starring Marlon Brando, and based on James Michener's short novel. Miyoshi Umeki won the Academy Award for Best Supporting Actress for her role as a charming Japanese woman who marries an American G.I., played by Red Buttons, who also won supporting honors. Umeki was the first Asian actor to win the award. The movie was shot on location and made an effort to faithfully capture the traditions of Japanese life. The story deals honestly with the American military prejudice about the Japanese people and interracial marriage.

The film offers an on-screen kiss between Brando and his Japanese lover, played by Miiko Taka, years before a similar kiss between a white and a black couple. Sadly, the only oddity is Ricardo Montalban, a well-known Latino actor,

Sayonara (1957) directed by Joshua Logan, starring Marlon Brando, Miiko Taka, James Garner, Red Buttons, and Miyoshi Umeki as Katsumi Kelly. Based on the James Michener novel about the prejudice against interracial marriages after World War II, **Sayonara,** shot on location in Japan in Technicolor, is an odd mixture of casting. The lead female roles are played by Taka and Umeki (who won the Oscar for supporting performance along with Red Buttons) and all the supporting players are Japanese. But obviously there was still concern about a real Japanese actor playing the love interest to Patricia Owens, so Ricardo Montalban was cast as Nakamura, a master Kabuki dancer.

who is cast as a Japanese love interest to Patricia Owens. He wears Japanese attire with the slanted eye make-up, portraying the star of the Kabuki Theater. This was undoubtedly a result of the Production Code that relaxed its rules to let the male movie star kiss his supporting actress, but the idea of a Japanese man doing the same might have created a stir. Otherwise the film succeeds as a serious look at prejudice and its tragic repercussions.

Miyoshi Umeki only appeared in a few other films after this. She was on television in *The Courtship of Eddie's Father* and was delightful in the movie version of *Flower Drum Song.* But the prestige of winning an Oscar never gave her the career she deserved. This same thing happened to Hattie McDaniel, who won and then went back to work playing maids and character parts. Umeki played the lovable housekeeper on *The Courtship of Eddie's Father,* but in *Sayonara* she gave a truly heartfelt performance and by the end of the movie had most of the audience members in tears.

Without question, the films that caused the greatest change in the stereotyping of Asian characters were those by director Akira Kurosawa. His films were extremely popular in art houses. *Rashomon* (1950), *Seven Samurai* (1954), and other Kurosawa films were very important to the understanding of the Japanese culture, populated by characters vastly different from American heroes but all perfectly drawn and real. Since one of the influences on Kurosawa were the westerns of John Ford, the connection in traditions between the gunslinger and the samurai warrior were quickly embraced in Hollywood, resulting in movies like *The Magnificent Seven* and *A Fistful of Dollars.* Through the films of Kurosawa the ancient traditions of the Japanese, which had remained a mystery in books and greatly maligned during the war in the Pacific, were seen by audiences around the world and opened a door of understanding to this ancient culture.

Latinos

The Latino took one step forward but the other foot was firmly in the past. On screen the Latinos were divided into old stereotypes south of the border, and the Latin lover from South America, ironically, often played by actors from Mexico like Ricardo Montalban, who co-starred with Esther Williams in *Neptune's Daughter.* And there was Caesar Romero and Carmen Miranda who in the movies dressed in evening clothes and sang in fancy nightclubs. They were often the comic relief in pictures like *Weekend in Havana* and *Springtime in the Rockies.* These Latin characters were charming, bright, romantically charged, and welcomed as part of the gang in these movies, which were usually musicals and light-hearted comedies. Latinos played these characters, not a movie star in bronze makeup.

But in Westerns time had stood still. The bandito character was still used, and very often, they were over-the-top characterizations played by non-Latinos. However, Mexican actors filled out the rest of the ethnic cast, very similar to what had happened with Asian characters in many of the big studio pictures. When Kurosawa's *The Seven Samurai* was remade into the epic Western *The Magnificent Seven,* the role of the head bandito went to Eli Wallach, a brilliant character, but a non-Latino born in Brooklyn, New York.

Wallach played the character with great relish and humor, following it six years later with a more outlandish performance in *The Good, the Bad and the Ugly* with Clint Eastwood. In later years with movies like *The Wild Bunch,* Latino actors played the stereotype that had been established of the bandito character, often, it would appear, using Wallach's performances as their guideposts. In Sam Peckinpah's *The Wild Bunch,* the bandito character, who in this case is a high ranking offer in the military, is played by a Latino, but the character has reached an all time low as

a drunken, heartless, womanizing outlaw who will sadistically kill on a whim. The rest of the Mexican characters in these westerns were humble, soft-spoken peasants, fiery-eyed women who were perpetually swinging their brightly colored skirts, and likable con-artists who were either children who looked like cutouts from tourist posters or old men full of ancestral sayings.

Anthony Quinn was the most successful Mexican actor in this era, but he rarely played a Mexican and made a career of creating a wide variety of ethnic characters from Paul Gaugin in *Lust for Life,* Zampano in *La Strada,* Auda ahu Tayi in *Lawrence of Arabia,* and his most famous role, *Zorba the Greek.* He won one of his two supporting actor Academy Awards as Eufemio in *Viva Zapata!,* directed by Elia Kazan and written by John Steinbeck. Marlon Brando in bronze makeup played Emiliano Zapata. Perhaps because it was one of the few times that Quinn got to play a character of his own heritage, he gave an incredible performance and stole the movie.

Native Americans

The Native American character was portrayed as more sympathetic at times, but still they were time-locked in the decade after the Civil War following the massacre at Little Big Horn. The Indians would attack but the Cavalry would win. It never changed. If there were speaking roles it was usually done by a Hollywood character actor in red makeup: Anthony Quinn in *They Died with Their Boots On,* Henry Brandon in *The Searchers,* or Sal Mineo in *Cheyenne Autumn.* John Ford's Westerns began to show respect for the traditions of the Native American and their skill at fighting. This shows up in *Fort Apache* and *She Wore a Yellow Ribbon,* and is the heart and soul of *The Searchers.* Ford depicted Indians, who did not just attack stagecoaches and innocent settlers like painted savages. Ford began to develop

back stories in his Westerns that got into tribal politics and religious customs. Many times Ford, who had become sympathetic to the plight of the Native American after years of making movies in Monument Valley, gave Native Americans their first speaking roles.

But it was not until 1970 that *Little Big Man,* directed by Arthur Penn, would tell the Native American side of the story and introduce a wonderful actor named Chief Dan George. Ford's *Cheyenne Autumn* was suppose to tell this version of the story but it was badly cast and the director was too old and too much into his cups of Irish whiskey by that point. At the same time the theme of Westerns turned south to Mexico and there were fewer Indian attacks, especially after *High Noon* when Westerns became metaphors for the ills of modern society. As Westerns moved away from stories with Native Americans, there was nothing to fill the void. There were no modern movies about reservation life, or, like what was happening with African-Americans and Asians, social issue films about the injustice of the American government's treatment of different tribes. Native Americans gradually disappeared from the movies by the early 1960s.

WOMEN IN FILM

The way women were depicted in film changed radically after the war. In film noir women, known as femme fatales, were looked upon as sexual objects more than they had ever been in the past, even in the Pre-Code Era. The Production Code was still an iron thumb on movies' morals, so body language and overt behavior of what was referred to as naughty women was toned down. But film noir used lighting, costume, and the close-up to fill in the gaps, and what was implied was cinematic dynamite. The femme fatale got back one of the

Anatomy of a Murder (1959) directed by Otto Preminger, starring James Stewart, Lee Remick, Eva Arden, Ben Gazzara, and Kathryn Grant. The scope of what women could do in films was still greatly restricted by the Production Code. Based on a true story and best selling book, *Anatomy of a Murder* is a landmark court room drama about rape and murder. But there was also a major confrontation off screen: Preminger had to fight the Hays Office to use the word "panties" in the dialogue. Six years earlier he had a similar battle over the word "virgin" in *The Moon Is Blue*.

weapons taken away from women characters when the Code came in, the double entendre. In these dark movies everything was about murder, greed, a big knockoff, and sex. And behind every greedy, dumb man there was a femme fatale looking for her cut of the action. To borrow a phrase, movies weren't in Kansas anymore.

But during this era moguls operated in a redline panic mode. The studios were constantly fearful of who their audiences were. During the 1930s and war years women were the primary moviegoers. But after the war the studios could not predict that women were always the motivating factor in ticket sales. With television, husbands and wives did not go out as often. The man started to call the shots with movies, wanting to go to Westerns, not musicals, and crime dramas, not screwball comedies, which had almost disappeared. But the biggest reason was there were not as many films about women to go to. During the war the focus had shifted to the problems of men facing battle or other hardships.

Movies about women in the workforce, flying bombers to the front or the difficulties of raising families without sufficient income just did not exist. Hollywood did not want to make movies about women on the assembly line of an aircraft factory, first probably because it would be top secret, but mainly out of pure male ego. Movies showing that women were half of the workforce making weapons to be used against Germany and Japan would imply that America was in trouble. Besides, there was no romance, because in the movies all good wives waited faithfully for four years for their husbands to return. Women waited, and men were busy saving the world. But this was true. There was a war going on and until the invasion of D-Day no one knew for sure what was going to happen. So, the problems of a couple of people did not amount to a hill of beans. But through the necessity of supporting the war the women's picture of the 1930s took a backseat.

The idea of a "woman's film" is a concept forced upon a past era from a modern day perspective. These films were not referred to this way back during the Studio System. Each studio made films that everyone wanted to come to, and a man would just as readily see *The Philadelphia Story* as he would *Gunga Din*. There was something magic about the movies, and it had everything to do with star power. Women were changing during the 1930s, and men were just as fascinated

by movies with Katharine Hepburn, Bette Davis, Joan Crawford, or Greta Garbo as women were themselves. These movies were fun, unpredictable, and offered a crash course in the psychology of women. This evolution of the modern woman was put on hold when the war started. And afterward like men, women did not talk about their war experiences. Life just went on. For women the second part of their transformation had to wait until the 1960s.

Two women carried the star system for women on their shoulders into the 1960s—Elizabeth Taylor and Audrey Hepburn. Elizabeth Taylor without exception was the female star of this era, and she was completely unique. In the past there had been sex symbols, like Clara Bow and Jean Harlow, who effectively were only allowed to play themselves on screen (or the studio's carefully manufactured version of the star). And then there were stars who got the good comedy or dramatic roles, like Katharine Hepburn, Bette Davis, Joan Crawford, and Garbo. Elizabeth Taylor was a sign of the times; she was both a sex symbol and serious movie star. She did not make the kinds of films Clara Bow or Jean Harlow did; instead she appeared in *A Place in the Sun, Suddenly Last Summer,* and *Cat on a Hot Tin Roof.* No one was like her, and she got all of the juicy roles that Hollywood had to offer at this particular time.

Taylor was one of the first female movie stars who began to live outside the envelope of the Studio System. She lived her own life and sold copies of *Photoplay* magazine by the thousands. The tragedies of her life vicariously became the woes of the world. Taylor was a product of the Dream Factory, but she was very much her own person. And as the years went on she became a one-woman revolution for sexual freedom, getting top dollar in a man's world, and becoming a champion of making unfashionable causes fashionable, as with her dedication to AIDS research.

Audrey Hepburn had a purity and innocence about her characters. They were often deeply and passionately in love with someone who usually did not know she existed, like *Sabrina* or *Love in the Afternoon.* But she almost single-handedly kept alive the image of the old studio movie star with movies like *Roman Holiday, Funny Face, Breakfast at Tiffany's,* and *Charade.* Hepburn managed, for the most part, to keep her personal life private and not let it spill over into the movie magazines and gossip columns. But in public she looked every inch a movie star and was known for always wearing the latest fashions. Hepburn was bright, lit up the screen, when she was on, and was an incredible actress. But when she realized that movies were changing in the late 1960s, she knew her era had passed and she left without looking back and began a whole new life as special ambassador to the United Nations UNICEF fund to help children in Latin American and Africa. She was always a lady of quality.

There was a dark center to many of the outstanding women's roles during this era. Anne Baxter and Bette Davis stole scenes from each other and showed the underbelly of Broadway in *All About Eve.* Gloria Swanson was a faded movie star living in a dream world in *Sunset Boulevard.* In *A Place in the Sun,* Elizabeth Taylor fell in love with a man who commits murder for her, ruining both of their lives. Katharine Hepburn was an old spinster in *The African Queen,* and a jealous mother who would do anything to keep a terrible family secret in *Suddenly Last Summer.* Vivien Leigh was Blanche Dubois, a wilted southern belle with a dark past in *A Streetcar Named Desire.* Joan Crawford realized her husband was out plotting to kill her in *Sudden Fear,* and Joanne Woodward gave a devastating performance in *The Three Faces of Eve,* based on the true story of a woman with multiple personalities.

Movies were opening up to an international market, like they had been before the war. The

women's roles that were beginning to excite audiences were coming from Europe, and the movies were often provocative and controversial. Anna Magnani caused a sensation with her unguarded realistic performance in *Open City,* directed by Roberto Rossellini. Magnani would win her Academy Award for *The Rose Tattoo,* opposite Burt Lancaster. Simone Signoret won all the top honors in *Room at the Top,* playing a lover who is driven to suicide. Bibi Andersson was in *Smiles of a Summer's Night, The Seventh Seal, The Magician,* and *Wild Strawberries,* the classic films of Ingmar Bergman that everyone was talking about. Sophia Loren caught the whole world's attention when she emerged from the Mediterranean in *Boy on a Dolphin.* And Brigitte Bardot shocked American audiences and immediately earned the name "sex kitten" when she bared all in *And God Created Woman.*

Whether in a literal or symbolic fashion, the film that changed the role of women drastically for the next decade was *Psycho,* directed by Alfred Hitchcock, which starts out being a woman's film but with an unexpected twist. It is told from the point of view of Janet Leigh, who steals money to be with her lover; however, she never makes it past the first third of the film. She is violently killed while helpless and fully naked in the shower in a remote motel off the main highway. She had unknowingly triggered forbidden emotions in a man who was slowly being taken over by the personality of his overly possessive mother. The runaway popularity of *Psycho* spawned rip-off movies shot on microscopic budgets with women as victims during vulnerable times. The body count grew, the murders became grotesquely graphic, and any effort for a compelling story line, character development, or carefully crafted suspense sequence somehow must have been lost in the cutting room. Of course, these films became far more popular than they ever deserved to be. *Psycho* was the turning point in how women were portrayed in movies over the next two decades.

Neo-Realism, the New Wave and International Cinema

Unfortunately, it is impossible for people who were born after the second great renaissance in international cinema, between 1944 and 1961, to appreciate today the powerful effect these films had on audiences, particularly on the young creative minds of future filmmakers. They quickly became known under the general title of "foreign films" and played in art houses, which is a poetic term given to rundown theatres that could not afford first-run features. Many of these art houses were near college campus or areas of cities where rebellious members of the Beat Generation hung out. Foreign films fit perfectly within an era of social protest.

Today some of these films might seem unpolished, with poor sound quality and grainy film stock. Others were as carefully crafted as any Hollywood A—feature, with a revolutionary approach to cinematography that had an immediate influence on filmmaking everywhere. All of these films have subtitles-sometimes unreadable against white or pale backgrounds—and the vast majority of them were shot in black and white. Compared to the "slick old days" of Hollywood (as cinematographer Conrad Hall describes the impeccable look of the Studio System) foreign films have a certain kind of crudity. Everything about them was in complete contrast to Hollywood.

A great number of these films had the appearance of elaborate home movies, and in a sense that is exactly what they were. Each film has the indelible marks of the director and cinematographer who made them. They were personal statements, made on astonishingly low budgets, and they broke the old studio practice of keeping the camera invisible. Almost every motion picture made today owes a debt to the foreign films made during this era in terms of visual storytelling. What then was innovative in experimental camera techniques, editing, improvisation, and mature subject matter, is commonplace today. They are now part of the visual

The Bicycle Thief (1948) directed by Vittorio De Sica, with Lamberto Maggiorani as the father and Enzo Staiola as his son Bruno, and written by Cesare Zavattini, who was De Sica's frequent collaborator. After World War II, directors throughout Europe began making beautifully crafted movies about the people and traditions of their countries. In Italy the movement was known as Neo-realism. For the only time in film history these directors remained in their own countries and were not lured away to Hollywood.

pallet of every director, but when audiences first saw these films they were literally mind changing. They blew open doors to daring and provocative new worlds and began the death knell for the Production Code. What can never be recaptured is the rich, highly personalized filmmaking style practiced by so many remarkable directors. These films are the canvases of individual artists, and for the first time since the silent era, the customs, traditions, and people in countries like France, Italy, England, Sweden, and Japan were shown truthfully and without the hard varnish of the Dream Factory.

The foreign films that were exhibited in America were unlike anything younger audiences had seen before, especially a generation that had grown up on splashy musicals and cowboys and Indians. Art houses were ideal locations, since they provided an out-of-the-way sense of adventure, and films that struggled to break even in their own countries were big hits with American audiences. The films that have become legendary—those that many critics bow to in great reverence—are films that had a profound effect on the future filmmakers growing up in this era, who saw in them the unlimited potential of cinema.

The only other time foreign films challenged the Hollywood assembly line feature was during the silent era. With silent films the impact was much quicker because they went from one country to another without the necessity of translating lengthy subtitles. They had the advantage of an international visual language unencumbered by words. Foreign films after the war were an acquired taste because for almost two decades audiences had grown up on a steady diet of Hollywood features, cartoons, shorts, and newsreels. Today there is a concern with distribution companies that large audiences will not come to see films with subtitles. This was not the case with the foreign films of the post-war

era, since most people read two newspapers a day, wrote lengthy letters, and, because of paperback books, were reading more than any generation in history.

One of the biggest resistance factors to foreign films that were exhibited in America after the war was the Church, which considered many of them obscene because the depiction of sexual relationships was explicit, and violence was treated graphically. But inevitably, the ban put on some of these films only sparked curiosity and attendance. The main dividing line for many people was that foreign films were often downbeat, showing bitter truths about life, and the over-thirty generation had seen enough of this over the last decade. Television had dramatic programs like *Playhouse 90*, but by far the most popular shows were geared for belly laughs and humorous visits with wholesome all-American families. The largest audience for foreign films was the next generation, in their early twenties, who did not buy into the pasteurized treatment of life presented in Hollywood movies and on television.

PERSONAL FILMMAKING

Films that came out of Europe and Japan at the end of the war were immensely personal, like a novel or poem, and the directors used the camera like pen and paper. The 1970s were a time of personal filmmaking in America, but the trend started in the 1950s through this incredible wave of foreign films. They were films that came from the gut about the hardships of the common people, or they were autobiographical. For the first time, filmmakers found the most intriguing subject was themselves (or at least a slightly romanticized version of themselves). Writers like Ernest Hemingway and F. Scott Fitzgerald had used the novel as veiled autobiographies in *The Sun Also Rises* and *Tender*

Is the Night. Now directors like Francois Truffaut and Federico Fellini put scenes from their own lives up on the screen in *The 400 Blows, La Dolce Vita,* and *8½.* All of the major filmmakers of this movement like Ingmar Bergman, Vittorio De Sica, Jean-Luc Godard, and Akira Kurosawa worked from life experiences which gave a sense of truth and realism about their films that had disappeared in cinema after the Production Code and the rise of the Nazi Party. As the Auteur Theory would later claim, these directors were truly the authors of their films. Like any great movement, at the heart of this renaissance were only a handful of directors who became legendary and mesmerized audiences with films that were compellingly original.

Since the mid-1930s, Hollywood escapist movies had dominated the world's marketplace. As great as many of these movies were, the style was still based on a melodramatic story structure. The best of these movies could bring tears to the eyes, but they stopped short of holding up a mirror to real life. In the past, raw reality had proved disastrous at the box office with films like Greed and *All Quiet on the Western Front.* There was a security in Hollywood motion pictures. Women could go see *Gone With the Wind* repeatedly with the hope that Scarlett O'Hara might finally wise up and realize who the true love of her life really was, and then weep each time Rhett Butler leaves her. In *The Wizard of Oz,* Dorothy always wakes up to see that it was just a big Technicolor dream and there is no place like home. And each time in *Casablanca,* Rick makes the ultimate sacrifice by giving up one of the most beautiful women in the world to fight the good fight. These Hollywood movies had a carefully calculated emotional impact on audiences but still did not have the pulse of reality that films coming out of the Italian neorealism movement, the French New Wave, and the Japanese cinema had on audiences.

The films of the Italian neorealism movement had a documentary feel, since they were shot on location with available light. There was nothing glitzy about them at all. What was attractive to young Americans who were beginning to looking for ways to break the barriers of the Hollywood Studios was that these foreign films were made on tiny budgets, with small crews and mostly untrained actors. The directors went into the streets and began shooting. When Anthony Quinn, Academy Award winner, expressed an interest in starring *in La Strada,* the director Federico Fellini asked what his salary would be, and Quinn quoted his usual salary for a Hollywood film. Fellini went white in the face and for an uncharacteristic moment was silent. He then replied that Quinn's salary was the entire budget for his movie.

The foreign directors of the post-war era must have had an instinctive awareness that the freedom to make films on their own terms had everything to do with not taking the journey to Hollywood like so many fellow directors had been forced to do earlier. It is exceedingly difficult to find films by Billy Wilder, Fred Zinnemann, or even Ernst Lubitsch made in Germany before they came to America. Their films certainly reflected the influences of Expressionism and often paid homage to Europe in the years before the war—especially those by Lubitsch. But their major films had the trappings of the old Studio System and worked within the restrictions of the Production Code.

A SENSE OF HERITAGE

Directors like Bergman, Godard, De Sica, Fellini, and Kurosawa are inseparable from their countries. To think of Bergman trying to make a Western, like Fritz Lang did, is impossible (though it might have been one of

The Rules of the Game (1939) directed by Jean Renoir, represents the end of an era in two ways. Renoir's cynical look at French bourgeois life before World War II is also a melancholy farewell to an age that would vanish forever when the Nazis entered Paris. *The Rules of the Game* was greeted with protests and banned for many years, and Renoir left for America shortly after its premiere. He was among the last great directors of Europe forced to leave this country, bringing an end to a remarkable period of film-making that had lasted for two decades.

the most philosophically enlightening Westerns ever made). Fellini attempted a science fiction movie and failed miserably, which resulted in the surrealistic masterpiece *8½*. And Kurosawa was hired to direct the Japanese episodes of the attack on Pearl Harbor in *Tora! Tora! Tora!* but was fired for taking too much time and reportedly going over budget. Though these directors might have been tempted to take lucrative studio contracts, there was a feeling of a deep sense of obligation to tell stories about their own countries, as if they were tied to their own people and heritage for inspiration.

After 10 years of war and social upheaval, the filmmaking process in most European countries was almost a blank slate and had to be entirely remade. All of the major German directors had literally fled to America. Rene Clair and Jean Renoir had left France for the safety of Hollywood. Carl Theodor Dreyer left Denmark for Sweden, to distance himself from the rising storms of the Nazi conquest, and he had a terrible time finding financing after the war. Alfred Hitchcock had managed to work out a deal to come to America and work for David O. Selznick, arriving shortly before England declared war on Germany. And

in the Soviet Union, Sergei Eisenstein died of a massive heart attack after completing the second part of his projected *Ivan the Terrible* trilogy in 1948 at the age of fifty. So, there was very little left of the genius of the European cinema from the silent era. Perhaps this is why the next generation of European directors felt such a strong obligation to make films in their own countries.

England has always been tricky to fit into an exact category. It is certainly located in Europe, but, as George Bernard Shaw aptly puts it, America and England are two countries "separated by a common language." Since there have always been British actors that have become Hollywood stars, and so many studio motion pictures have been set in England, it may be reasonable to think the films from there are not foreign. However, the post-war films from this tiny country were "very British"—quirky, offbeat, a little naughty at times, and they celebrated the literature and heritage that makes England great. Directors like David Lean, Michael Powell, and Carol Reed filled the gap left by Alfred Hitchcock. There were the enormously popular Alec Guinness comedies, the "kitchen sink dramas" that explored the English working class, the "Carry On" series that opened

the nonsensical doors for Peter Sellers and Monty Python, and ultimately the great screen epics associated with Lean. It was cheap for American studios to shoot in England, so over the decades the financing of many films made in England were co-ventures, like Sam Spiegel's productions of *Bridge on the River Kwai* and *Lawrence of Arabia.*

Preston Sturges sold his screenplay for *The Great McGinty* in 1940 for one dollar with the provision that he could direct it. His success paved the way for John Huston, Billy Wilder, and other writers to become directors to protect their work and consequently have a greater influence on the kinds of stories they wanted to tell. They were still shot in ways that looked like the back lots of movie studios or elaborate sound stages. Most of the foreign directors either wrote or collaborated on their screenplays. And directors like Godard and Truffaut often had actors improvise their dialog within the framework of a story—a technique that Robert Altman and Sidney Lumet would use in many of their films.

These directors lived to make movies. They used film to explore relationships like a novelist, to probe the psyche like a psychologist, to search for universal meaning like a philosopher, and to bring history alive. They would go out on the streets with hardly any money and make films about people with simplistic problems of survival, like trying to find a bicycle to secure a better job with a slightly higher wage. Or the tale of a knight returning from the Holy Wars to be confronted by the personification of Death. All of this was powerful stuff to the generation that began to see these films at an early age, and at the same time watching classic motion pictures from the Hollywood Golden Age on television.

Most of the foreign directors also loved these old Hollywood movies. Thus began one of the greatest recycling acts in cinema history. Di Sica was a great admirer of Charles Chaplin, as seen in his casting of the young son in *The Bicycle Thief.* Godard and Truffaut were big fans of the Warner Bros. gangster films, especially those starring Bogart. Kurosawa reinvented the Westerns of John Ford as Samurai films. And they all had great affection for the silent comics.

Many of the foreign directors had an affinity with B-movies, the offbeat dramas of film noir that began to push the envelope of linear storytelling, or the Westerns, which were really crime films on horseback. The carefully crafted A-features were not always the main attraction with foreign directors, though they all seemed

Sullivan's Travels (1941) directed by Preston Sturges, starring Joel McCrea and Veronica Lake, is about a commercial Hollywood musical comedy director who really wants to make a movie of the Depression novel "O Brother, Where Art Thou?" (the Coen brothers used the title for a film sixty years later). Sturges was raised in Europe before he settled in Hollywood for a short but spectacular career. His fast-paced, screwball comedies have an undercurrent of satire aimed at the foibles of society, which reflects the influence of directors like Rene Clair and Jean Renoir. Like Billy Wilder, Sturges is an example of a writer-director that transplanted a little bit of Europe into his American movies.

to have an undeniable enjoyment of musicals from the Busby Berkeley era. The B-movies in post-war Hollywood often slipped under the radar of the studio and the scissors-happy censors. Martin Scorsese talks about the "subversive" nature of many B-movies that were carrying dual messages to audiences, symbolically playing tag with the forbidden subjects of the Production Code. American directors like Sam Fuller, Robert Aldrich, and even Alfred Hitchcock made tightly woven films that implied far more than what was actually spoken.

POST-WAR CHANGES

What is astonishing is that one of the first industries to get started up again in many of the war-torn countries was motion picture production. The exception was Germany, the one country that had been the major driving force in European cinema before the war. Germany had lost 80 percent of its studios and theatres during the bombardment, and it took almost three decades to show signs of recovery from its devastation. Despite the loss of so many innovative directors, Germany still produced movies until almost the last weeks of the war. Joseph Goebbels, the Minister of Propaganda for the Nazi Party, found ways to produce escapism movies for the German people, like operettas, light comedies-ironically in the Lubitch style-and historical epics depicting great German victories of the past. These movies attempted to keep the morale of the German people up, the same way movies like *The Sea Hawk* and *Mrs. Miniver* did with English and American audiences. However, German citizens had to sit through manipulated newsreels showing how the German Army was winning the war, but blaming any setbacks on the Jews. As an ultimate irony, the last scene of Fritz Lang's *M*, when Peter Lorre's character at-tempts to defend his murder of innocent children, was reedited into these newsreels to show how treacherous the Jewish people were. A decade before, Goebbels—after seeing *M*—had praised Lorre's performance and offered Lang the opportunity to run the German film industry.

During the war, American movies were shown everywhere possible for the Allied Armies, either in makeshift tent theatres or in the remaining movie houses, to keep up the good will of the English people and to uplift the spirits of lonely soldiers. Certain camps had movies running twenty-four hours a day. Often the same musical or Western was shown over and over again, but it did not matter. These movies were a relief from the terrible tedium and boredom between battles.

Hollywood had a huge hold on what was seen during the war. No other countries could afford the expense of producing on such a high level, especially when more and more studio films were being shot in full Technicolor. Film production never stopped in countries like England, France, or Italy, but instead of turning out entertainment movies, informational shorts and documentaries were made—and occasionally a war film to celebrate a victory or to showcase heroism. These films provided the training for the directors, actors, writers, cinematographers, and producers that would emerge after the war.

At the end of the war over twenty million people were homeless. Large numbers of cities no longer existed but were just rubble heaps. Most of Germany was in smoldering ruins. London had to be rebuilt. Entire sections of Poland and other countries suffered terrible damages and poverty. The war killed as many as one in every five fathers. Getting back into a basic daily routine that allowed for survival was a struggle for every person. The Black Market flourished and to get even the simplest of luxuries like soap, linen, shoes, chocolate, and make-up was a complex and often

dangerous process. Going to a grocery store and getting exactly what everyone wanted for dinner was a distant memory. It was always dependent upon what was available on that particular day. The kinds of profound hardships that people throughout the world were going through were things the American public had never experienced to such a degree. As bad as the Great Depression was, in other countries it was far worse and lasted years longer. There was sacrifice in America during the war, but none of the cities on the mainland were bombed. There was a food shortage but never widespread starvation.

One of the terrible after-effects of the war was that with so many millions of people dead it was almost impossible to focus on the day-to-day struggles of a single individual. Film changed that. The makeup of these countries and how each dealt with the devastation of war seem to give filmmakers a certain kind of freedom that never existed before. Each country developed its own personality. The surviving artists in each country knew each other and began to work and support each other. One would write a film, which would then open up the opportunity for someone else to direct. Federico Fellini started as one of the writers on *Open City,* direct-ed by Roberto Rossellini. The films from each country represented a way of life in that country that had never really been seen before by audiences on a large scale. In the past this had always been filtered through the looking glass of the Dream Factory.

FOREIGN FILMS IN AMERICA

By 1949, when the Hollywood studios were forced to sell off their movie theatres, there was a burst of foreign films coming into America. These films were often sensual in nature and sometimes shocking in terms of violence or the portrayal of hardship. They often went afoul of the Production Code and were sometimes shown with a condemned rating, which, of course, provided excellent word of mouth. Things would happen that were completely unexpected in these films. They were fresh and tantalizing. The films created discussion—lots of discussion. Even the things that are so simple in films today were dramatic breakthroughs in these post-war foreign films. These films were carefully analyzed by the future generation of directors, critics, intellectuals, and just

Sunset Blvd. (1950) directed by Billy Wilder and starring William Holden and Gloria Swanson. Twice foreign directors put an indelible mark on Hollywood pictures. The first time was when Wilder, Ernst Lubitsch, Fritz Lang and other directors left Europe during the rise of the Nazi party and worked in the studios. Their movies continued the kind of filmmaking they had learned in their countries. The other time was during the post-World War II era, when foreign directors began to radically experiment with film styles, creating a new visual language. The young directors of the New Hollywood grew up watching these films.

the average person that bought a ticket for this new cinema. Films like *La Strada, Breathless,* or even *The Seventh Seal* never reached millions of people. They attracted respectable numbers in the larger cities but did not play well in small towns. It would have been very unlikely to walk down a street anywhere in Nebraska and see Fellini's *Nights of Cabiria* playing.

Ten thousand people seeing a foreign film could make it a hit. By the early 1950s an average Hollywood feature would cost two million dollars, and if it grossed seven million it was considered highly successful. During this same time, a typical film from Italy or France had a budget of less than 50,000 dollars, or half of the cost of a standard B-movie. This became a rallying cry for the next generation of filmmakers. For a fraction of the cost of a Hollywood A-list motion picture, Fellini, De Sica, Bergman, and others were making films of superior quality that seemed to have a cinematic soul, which was certainly not a characteristic anyone expected from a MGM musical.

When John Cassavetes made *Shadows* (1959), he was following the path Rossellini had started a decade before. The reality that a French critic named Jean-Luc Godard, who had never made a feature film before, could shoot a movie in a few weeks with a small crew and actors that improvised most of the dialogue, and then find distribution was an impossibility in Hollywood. A director would typically have to work his way up the studio ladder, working on documentaries, then shorts, then B-movies, and—if lucky— finally work on an a big feature with stars. In Europe people were picking up cameras, getting their friends together, and making movies. What's more, companies like United Artist were distributing these films, and ultimately producers like Joseph E. Levine were distributing these films, and they were making profits.

Many of these films had a sense of freedom, which gave a documentary feeling to what was happening on the screen. Often the camera was off the tripod. Out of necessity during the war, lighter weight cameras were designed. This changed the process of shooting with a huge cumbersome piece of equipment that might weigh seventy pounds. Lens and film stock became faster, allowing for interiors to be shot on locations with existing light instead of on sound stages that would take hours to setup. For the first time since sound came in, the equipment to make a film was lightweight and manageable by a few skilled people, not an army of technicians.

The foreign films had a sense of realism that has become associated with the Method and training at the Actor's Studio in New York. But most of the actors from Italy, France, and Japan did not practice the Method with the fever that was happening in America. The philosophy of the neorealism movement, with directors like De Sica, was that every person had one great performance in them. It was up to the director to cast the right person and bring out that performance. The films were made with the intention of certain actors being a part of them from the very beginning. They were tailored-fitted for the personalities of the actors, and capturing this spontaneity of the actors often meant that scripts were being written as the camera rolled.

There was a burst of philosophy that took place after the war. The Existential Movement became the best known. There was questioning about Man's fate, the essence of women, and if there was a God, or was everybody walking an eternal tightrope without a net. Everything was questioned. The war stripped away all illusions. Throughout history, there had been conflicts that were devastating, and had lasted even longer, but nothing was as terrible as what happened in World War II. Everyone was affected. And it was the first war to be filmed from beginning to end, as a permanent reminder of the depths of madness to which people could sink. To come out of

this nightmare and return to a fantasy existence was impossible, and these were the spiritual and psychological wounds that philosophers like Albert Camus and Jean-Paul Sartre were exploring. This sense of isolation and abandonment spilled over into foreign films.

Suddenly, from countries around the world, films were being released in America that gave authentic insights to what different traditions and people were like. This began the slow eradication of Hollywood stereotypes, a process that still continues, but was changed significantly by directors making films about people of similar faith and ethnic heritage. Films by Fellini, De Sica, and Rossellini presented real Italians, not cliché gangsters with thick accents and violent tempers. The films from England showed audiences the working class, instead of the suave leading men that played detectives or royalty, and introduced British humor to tickle American audiences. And films from Japan by Kurosawa and Teinosuke Kinugasawas became a cure for deep resentments that lingered after the war. These films introduced customs of Japan that were new to most audiences. Film in a few years achieved what literature could not do in a thousand years. It showed a culture that was endlessly fascinating, and revealed similarities with American history.

With these films coming into America, there was an immediate influence on the way studio movies were being shot. This was not surprising, since American directors who were starting to affect a change were Billy Wilder, Fred Zinnemann, Robert Siodmak, Alfred Hitchcock, Fritz Lang, and others who had relocated to Hollywood. Suddenly there was an exchange of cinematic ideas that had not happened since the 1920s. There was a sense that the combination of these foreign films and American films by foreign directors were purposefully being made to challenge not only human emotions but to also jumpstart the intellect after a decade of one-sided international propaganda. They made people think.

What the members of the French New Wave would later call the Auteur Theory was already in full swing within a year after the war ended. Films were being made by directors in Hollywood that were completely unique from another director on the other side of the world. All these directors had a distinctive style about their work-a kind of personal signature that was immediately identifiable. None of these films looked like they came off an assembly line, and it was intoxicating to people who were looking for film as a catalyst for their own thoughts. The names of directors were being tossed around like those of playwrights, novelists, and philosophers.

It is fascinating to look at the number of American directors in the late 1960s and 1970s who were influenced by these foreign directors. Martin Scorsese admires De Sica, Fellini, Michelangelo Antonioni, and especially Rossellini. Steven Spielberg said that David Lean's films were an inspiration to him as a teenager. George Lucas and Francis Ford Coppola were huge fans of Kurosawa, and served as executive producers for *Kagemusha* (1980). William Friedkin, Dennis Hopper, and Arthur Penn were attracted to the films of the New Wave, especially Godard's sense of realism and freedom of camera movement.

And Woody Allen, Spielberg, and almost everyone else came under Ingmar Bergman's spell at some point. Bergman might be the only true philosopher who instead of writing on paper put his visions, thoughts, fears, doubts, and anxieties on the screen in a series of films that are unique and individually quite remarkable. He disguised these heady themes in tales of medieval knights, Swedish folk tales, magicians on the verge of insanity, and theatrical intrigues. Bergman balanced his projects between theatre and film, like Elia Kazan in America, and later

used television to create mini-series, like *Scenes from a Marriage* (1973). He collaborated with the great Swedish cinematographer Sven Nykvist on over a dozen films.

Like many of the films by Stanley Kubrick, including *2001: A Space Odyssey, Clockwork Orange,* and *Full Metal Jacket,* foreign directors of this era told stories on their own terms. Each film made by one of these directors had its own personality, like a member of an eclectic family. This personal approach to storytelling, which made these films so riveting when they were first released, is sometimes treated with impatience by audiences who expect the thrills of a mainstream motion picture. The innovative camera techniques these directors introduced now seem a little simplistic, mainly because they have been assimilated into almost every film made today. But the dynamics of filmmaking used by these directors were not intended to impress or dazzle but to underscore a greater meaning.

Like anything that causes massive change, what was once original is often reduced to a cliché or something that has become overly familiar to audiences. It is difficult to appreciate the genius that created a spark in a void. To put this in perspective, there are many Hollywood movies that might not have been made or would look profoundly different without the crossover influence of these foreign films. A few of these movies are *Bonnie and Clyde, Easy Rider, The Graduate, The Wild Bunch, M*A*S*H, The Godfather* (Parts 1 and 2), *Taxi Driver, Chinatown, Dog Day Afternoon, Annie Hall, Raging Bull,* and even *American Graffiti,* and *Jaws.* These films have obviously had an impact on the next wave of motion pictures, including *Amadeus, Silence of the Lambs, The Unforgiven,* and *Schindler's List.* And fifty years later there is the sensation of going full circle with independent films like *The Usual Suspects, Fargo, Memento, Boys Don't Cry, Requiem for a Dream, Shakes-peare in Love,* and *Lost in Translation,* which are kindred spirits of the films that came from the New Wave and the neorealism movements.

Unquestionably, the greatest potential of film is as conductor of original thoughts to a vast number of people. Any individual given the equipment and money could create a style of filmmaking that is distinctively unique from anything that has been seen before. And most likely, the majority of these individual films will not look like typical Hollywood blockbusters, but would reflect a personal odyssey to be shared with others. With the marriage of digital arts and the Internet, personal filmmaking might become as commonplace as Hallmark greeting cards.

Directors like De Sica, Fellini, Godard, Truffaut, Bergman, Kurosawa, and others started this personal odyssey and a remarkable number of their films have endured because of their originality in theme and style. Like *Citizen Kane,* a movie that is impossible to imitate without evoking a comparison, many of the films by these directors also possess this timeless quality and touch of genius.

THE GOLDEN YEARS OF FOREIGN CINEMA: THE FILMS AND DIRECTORS THAT CHANGED HOLLYWOOD

To appreciate the diversification of these directors and their films, it is best to examine them individually by year to understand the immediate influence they had on the American film industry. In fact, the international cinematic sharing process during the years between 1944 and 1960 was extraordinary and can only be compared to the height of the silent era from *The Birth of a Nation* to *The Jazz Singer.* Any selection of foreign films or directors from these seventeen remarkable years will immedi-

ately open a philosophical can of worms about who received too much attention or who was omitted. This was such a fruitful period of innovative film production—rich in small gems and major discoveries—that anyone who experienced this era will always find some difficulty in attempting to isolate the truly important films.

This reaction is usually based on purely personal choice, which is correct since each of these films was made on a very personal level by the directors, writers, cinematographers, actors—everyone involved. Such a debate is based on emotions, because someone will declare the film that most affected them was *The Bicycle Thief*, whereas others will say *The Seventh Seal or Breathless*. There might also be the feeling that films from England should not be included; but the British cinema in the post-war years was very different from Hollywood. During the golden age of the studios, English actors made up a large portion of the star system. But starting during the war, the English filmmakers began producing films that were unique to their country and heritage, identical to the movements in Italy, France, Japan, and other parts of the world.

Ultimately, this book is a search for films and filmmakers that had a "trigger effect" on the growth and development of cinema. It is in this light that the following films were selected. There is also the sad realization that for any number of irrelevant reasons (the films are in black-and-white, there are subtitles, the acting is different, or the stories are sometimes confusing, etc.) most of these films are not seen, and thus appreciated, as much as they should be to modern audiences. So, here is the singular hope that the following will encourage a greater viewing of these essential classics.

As an example of the personal impact these directors had on the filmmakers that became part of the New Hollywood, Producer Ismail Merchant wrote this in 2004:

Imagine if the films of Sergei Eisenstein, Jean Bunuel, Rene Clair, Marcel Carne, Louis Malle, Francois Truffaut, Ingmar Bergman, Federico Fellini, Luchino Visconti, Satyajit Ray and the other giants of cinema had been made, but never seen. It seems unimaginable. Yet, if these directors were working today, the chances of their films being made would be very slim, and the opportunities for seeing them would be virtually nonexistent. The cultural climate that allowed these helmers to create their masterpieces has virtually vanished, and with it any expectations of cinema to exist as anything other than the basest form of entertainment.

Merchant's final comment may appear slightly fatalistic, but to have been part of the original discovery process of these films does leave the impression that at the very least the variety of films has diminished over the years.

1944

The Rebirth of British Cinema, Laurence Olivier, and Henry V

Laurence Olivier's *Henry V* was made while German B-2 rockets were still dropping on London. William Shakespeare's historical drama of the legendary king and his victory against overwhelming odds at the Battle of Agincourt in 1415 went into production as the tide of war was turning in Europe. Shot in Technicolor, *Henry V* was an inspiration to war-torn audiences, depicting a battle against a foreign enemy in a different age but reflecting modern times and the current crisis in the world. At the time, it was the most expensive British film ever made, but Churchill and others had seen how motion pictures had given courage to the English people in their darkest hours and helped forge an indispensable alliance with American audiences. Perhaps the greatest source of pride of the English people is

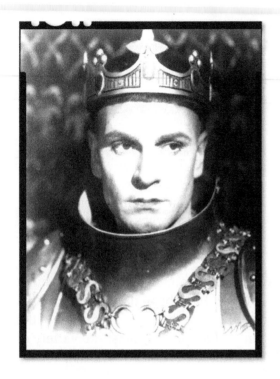

Henry V (1944) directed by and starring Laurence Olivier, is also known as **The Chronicle History of Henry Fifth with His Battell Fought at Againcourt in France.** *Made to inspire the citizens of Great Britain in the last year of World War II, the film marks a turning point in world cinema. Directors in different counties began to pull from the literature, folk tales, music, and traditions they had grown up with and use this wealth of material for personal movies. It was almost as if each country wanted to reclaim its identity through the art of cinema. Olivier's* **Henry V** *has been called the first successful movie adaptation of Shakespeare.*

their literary heritage, and *Henry V* was a magnificent celebration of the greatest playwright the world has ever known.

Henry V was released in the United States after the war and was greeted with tremendous enthusiasm. It received Academy Award nominations for Best Motion Picture, Sir William Walton's majestic musical score of the year, color art direction, and Laurence Olivier's performance. Olivier also received a special Oscar for "his outstanding achievement as actor, producer, and director for bringing *Henry V* to the screen." *Henry V* is a production that has the polished appearance of a mainline Hollywood feature but actually represents the start of a film renaissance in England.

For decades British films were targeted toward the tastes of American audiences (even those of Alexander Korda and Alfred Hitchcock) and during the 1930s and throughout the war, movies with English themes and actors were highly popular in the United States. But Shakespeare had always failed miserably at the box office, mainly because the films were overblown, dull, and performed with measured voice and a portentous zest. Olivier was the first to see that Shakespeare was writing screenplays 300 years before moving pictures were invented. There were large casts, duels and battles, dozens of locations, heroes and villains, special effects, a narrator to act as theatrical dissolve between acts, and comedy bits for the masses. The impoverished theatres of Shakespeare's era were typically bare stage, allowing for audiences to imagine the scenery. Thus there was a freedom of time and place in Shakespeare's plays since the moving of large sets was not a necessity.

Olivier realized that the prudent trimming of lines and shooting on actual locations was the key to bringing the Old Bard to the screen. Like what would eventually happen in Italy, France, Sweden, and Japan, Olivier used *Henry V* to give

a renewed sense of identity to the English people though a cinematic experience. In this sense it is very much in the tradition of Ingrid Bergman's *The Seventh Seal* and Akira Kurosawa's *Seven Samurai.*

Henry V opens with a pan shot over the top of Elizabethan London, descending into the Globe Theatre, and ending up backstage as the actors strut about nervously, running lines and checking on the size of the audience. In the next scene, Olivier takes the movie audience out of the theatre and into the full scale, three-dimensional recreation of a medieval painting. Each scene after this introduces additional touches of reality, concluding with the Battle of Agincourt, which is shot on an actual countryside location with hundreds of extras comprising the opposing armies.

Henry V was significant because it made possible all future movies of Shakespeare's plays, including *Hamlet and Richard III,* produced, directed, and staring Olivier; *Macbeth* and *Othello* by Orson Welles; Franco Zeffirelli's *Romeo and Juliet;* Roman Polanski's *Macbeth,* and those by Kenneth Branagh. Olivier had been in a movie version of *As You Like It* (1936), which was actually a lifeless and ponderous photographed stage play, reinforcing the basic fear of audiences that Shakespeare was difficult to sit through.

Olivier, along with Ralph Richardson and John Gielgud, represents the last of the great classical performers on the English stage. This was the golden age in theatre when Shakespeare was revived enthusiastically, representing the glory that once was England. It was a time period when aspiring actors had to play Hamlet as the ultimate challenge of their talents.

After his bad experience with *As You Like It,* Olivier felt that it was impossible to bring Shakespeare to the screen. Ironically, it was through his working with William Wyler on *Wuthering Heights,* a film that he did not initially want to make, that changed his mind. Writers Ben Hecht and Charles MacArthur used only a third of Emily Bronte's gothic novel for the movie and pared it down even further into cinematic moments. Wilder's approach was to have the actors treat the dialogue naturally, like in a modern day conversation, getting rid of the studied, forced approach to delivering lines that had been the tradition in theatre for decades.

Henry V represents the reinventing of classic literature and the rethinking of age-old theatrical traditions, starting a movement that quickly spread to counties around the world, like Poland, France, Spain, Sweden, Japan, Austria, and Mexico. Hollywood would eventually capitalize on this movement to bring a modern sensibility to ancient history and the great works of literature with full-blown CinemaScope epics about the Bible and the Roman Empire with motion pictures like *The Robe, The Ten Commandments, Ben-Hur,* and *Spartacus,* which starred Olivier as Marcus Licinius Crassus.

1945

Marcel Carné and The Children of Paradise

If one film signals the revival of the European cinema, it is Marcel Carné's *The Children of Paradise.* The film is often referred to as the French *Gone With the Wind,* because it follows the lives and loves of its characters over many years, is set against a backdrop of changing history, and runs almost four hours. *The Children of Paradise* was made during the last two years of the German occupation, and many of the tales about the making of the film are legendary. The Gestapo was looking for several of the principle actors. To avoid being shut down and having equipment seized or cast members imprisoned, locations were changed constantly during the

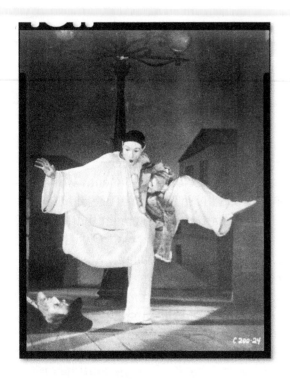

The Children of Paradise (1945) directed by Marcel Carné, starring Jean-Louis Barrault and Arletty, was shot during the occupation of France and released to great acclaim immediately after the war. It is an epic tale of ill-fated lovers that first meet on the Boulevard du crime. *The movie has been called the French* **Gone With the Wind.**

filming. The entire company would disband for weeks or months and then get back together to shoot more scenes. Jews were hidden on the sets until they could be taken to a safe place. *Children of Paradise* is based on a true story set in the theatre world of the 1840s, and reportedly there were two different versions of the screenplay—one to show the German authorities and the other for the actual shooting script. All of this intrigue seems to have added a deeply felt passion to every aspect of the film.

The title refers to the poor patrons that can only afford cheap tickets and must sit in the back of the balcony, which is nicknamed "paradise" because it is so far away from the stage. But Carné also refers to an age of innocence and invites the movie audience to watch his children at play. He tells his story on a large canvas full of inspired characters. The central character is the most famous mime of the 1800s, Baptiste Debureau, who falls in love at first sight with a beautiful woman,

Claire Reine (who calls herself Garance), when he witnesses an incident that causes her to be falsely accused of picking a man's pocket. From their first encounter, Baptiste believes his life will never know happiness without her. Garance realizes she will destroy Baptiste's gentle heart, and despite her feelings of love for him she becomes involved with the three other men: Lacenaire, a flamboyant criminal who fancies himself a poet; Frederick, a conceited actor who desires to play Othello but has never experienced jealousy; and Edward, Count de Monteray, who can offer her wealth and security, regardless of whether she loves him or not. And there is Natalie, an actress who becomes Baptiste's wife, living her entire life with the realization that he loves someone else.

The Children of Paradise is a classic romantic melodrama, in the tradition of *Cyrano de Bergerac,* but is transformed into a sublime reality by superb performances. At times it becomes a play within a play, recreating a bygone era of

French theatre. There is a touch of poetry in the dialogue and an overall sense of tragic longing for an age of romance and elegance that had been destroyed by two world wars.

The Children of Paradise had a spectacular effect on audiences in Europe after the war ended. People were mesmerized that such high artistic quality was possible during the long barren period of occupation and Nazi-imposed censorship. It became the source of inspiration—a guiding light that an important cinema could literally rise from the ashes. For over five years American motion pictures had been forbidden in France. With the success of *The Children of Paradise* and the reopening of revival theatres, young French critics and future filmmakers became almost intoxicated by films, examining them like precious works of art, setting the stage for the New Wave Movement.

The Italian Neorealism Movement

In Italy a new kind of cinema was about to be born known as neorealism, or "new realism." When Benito Mussolini seized power in 1922, one of the promises he made was to restore the international prestige of the Italian film industry to what it had been in the early silent era, when it had influenced such directors as D. W. Griffith and Cecil B. DeMille. It took thirteen years before Mussolini established the Centro Sperimentale di Cinematografia, a national film academy under the supervision of Luigi Chiarini. The ultimate problem was that the Fascists controlled the content of films and the number of films made, greatly limiting any adverse dramatizations of politics or the working conditions of common laborers. Despite a very short leash, Chiarini encouraged free thinking in his students, which included Roberto Rossellini, Luigi Zampa, Pietro Germi, and Michelangelo Antonioni. Meanwhile, most of the movies that were released were poor-

ly produced spectacles and "white telephone" movies that were pale imitations of Hollywood high society comedies.

The neorealism movement was given its title in 1943 by Umberto Babrero, a critic and professor at the Centro Sperimentale. He attacked the Italian cinema throughout the war years as being artificial and trivial, never attempting to get into the soul of the characters. Babrero championed the French cinema of the 1930s, citing the films of Jean Renoir, like *Rules of the Game* and *The Grand Illusion,* and those of Marcel Carné. But under the iron thumb of Mussolini's Fascist dictated government, films with a humanistic voice had to wait until after the war. Whether Babrero's influence was ultimately that powerful is debatable, but he set a challenge for future Italian filmmakers that could not be ignored.

At the end of the war, films immediately began to come out of Italy with realistic characters that became etched in the minds of future generations around the world. With such a large outpouring of these films, it is more logical to believe that the devastation of war affected the hearts and minds of the directors and writers at the core of this movement. Neorealism expressed the tangible feelings of grief for the common individual of a once great country. The filmmakers saw what was happening on the streets around them and caught life in the moment with their cameras.

Roberto Rossellini, Anna Magnani, and Open City

The film that brought world attention to the neorealism movement and jumpstarted a new style of filmmaking was Roberto Rossellini's *Open City.* Based on a true story about the execution of a priest during the last days of the German occupation, *Open City.* has no linear structure but is a series of vignettes about the people of Rome in a time of crisis. The primary focus is on a woman

named Pina, played by Anna Magnani, and her efforts to find a safe refuge for a resistance leader from the Gestapo. The film blurs the line between a documentary and the re-creation of actual events. Rossellini, who had made documentaries during the war, is said to have started shooting when the Nazis were evacuating the city.

All but the principal actors were amateurs, and despite writing credits by Sergio Amidei and Federico Fellini, most of the dialogue was clearly improvised. The film was shot on pure energy, with no time for rehearsals, capturing the moment in one take. Rossillini used what was available to him, which meant he shot mostly with available light and cheap newsreel film stock that was grainy when processed. This added to the sensation of reality and is the flip side of a Hollywood feature. Because *Open City.* felt like it had captured "the truth" of actual events, it caused a sensation everywhere it was shown.

Anna Magnani was in her late thirties when she made *Open City.* Although she had made more than twenty films prior to *Open City,* she was plain. She was plain by the Hollywood definition of a movie star, not like the glamorous Italian sex symbols who followed, such as Sophia Loren, Gina Lollobrigida, or Claudia Cardinale. She was earthly, volatile, completely honest in her performances, and, in a time period before political correctness, she would have been considered "all woman." Critic Pauline Kael said she was "the actress who has come to be the embodiment of human experience, the most 'real' of actresses." Because of *Open City,* Magnani became the first actress in a foreign film to achieve international stardom since Marlene Dietrich in *The Blue Angel* fifteen years earlier.

Before Marlon Brando, Montgomery Clift, or James Dean, everyone was talking about Anna Magnani, who was not associated with the Method, but gave performances that were astonishingly powerful and moving—a seamless blend of acting and complete realism. She did not become Americanized like so many of the foreign stars that eventually came to Hollywood, from Greta Garbo to Ingrid Bergman. Like the majority of post-war foreign filmmakers, she stayed in her own country to make most of her films, working with all the leading Italian directors. She only made three films in Hollywood.

Tennessee Williams was a great admirer of Magnani and wrote the play *The Rose Tattoo* for her. She turned down the Broadway production, fearing her lack of spoken English would hurt the production. She became a close friend with Williams, and a few years later, in 1955, she made the movie version, co-starring Burt Lancaster, and won the Academy Award. She did not attend the ceremony, believing she had no chance of winning, and when a reporter woke her up in Italy to tell her she had won, she threatened to kill him if he was lying. Her last Hollywood movie was opposite Marlon Brando in the bizarre but utterly fascinating *The Fugitive Kind* (1959), directed by Sidney Lumet and based on Tennessee Williams' play *Orpheus Descending.* As an example of the fickle nature of the movies, after *Open City* no actress was more admired and respected than Magnani, which remained true until her early death in 1973. But her films are rarely seen now, and none of them have captured the enduring popularity of *On the Waterfront* or *Rebel without a Cause.* Today, without this visual piece of the puzzle her enormous influence on the post-war revolution in screen acting is lost.

David Lean and Brief Encounter

On viewing, David Lean's *Brief Encounter* (1945) does not appear to have anything in common with *Open City.* There is no handheld camera work or attempt at a documentary approach and the actors stay absolutely faithful to the dialogue in the screenplay, based on the short play *Still*

Life by Noel Coward. Robert Krasker's cinematography is a masterpiece of black-and-white lighting, full of beautiful images of trains leaving the station with the white billowing smoke against the night skyline. The richly orchestrated musical score is Sergei Rachmoninov's "Second Piano Concerto," which became a huge hit on the radio and in nightclubs for years afterwards. Lean put together an impeccable film that looked better than most Hollywood features, and received his first of seven Academy Award nominations for directing.

Brief Encounter is an unabashed three-handkerchief tearjerker which became a huge sentimental favorite with American audiences, making so much money it almost single-handedly resurrected the British film industry. But despite the technical differences, it has many similarities with *Open City.* Both films were about average men and women, sans movie stars, against a backdrop of everyday locations, with very real problems with which people in the audience could identify. *Brief Encounter* is about an ill-fated affair told from a women's point-of-view. The two leads, Celia Johnson and Trevor Howard, are brilliant and absolutely convincing in their performances, but are made of common clay, with faces that would be lost in a crowd.

This was not *Random Harvest* with Roland Colman and Greer Garson. *Brief Encounter* is about an unremarkable couple who fall in love with all the passion and feeling associated with Hollywood weepers that have A-list stars. The film plays cat-and-mouse with the Production Code. For starters, they are both unhappily married. However, what makes *Brief Encounter* so sadly real is that the couple's one chance at intimacy never happens, but there is certainly no mystery about the their desires and intentions. This film, in its small way, foreshadows the changes in casting that would finally happen in mainstream motion pictures in the late 1960s, where actors that would normally play supporting parts found themselves in lead roles.

1946

Jean Cocteau and Beauty and the Beast

Jean Cocteau, one of the most versatile artists who ever lived, was fifty-seven years old when he wrote and directed *Beauty and the Beast.* He had not made a film in sixteen years, since the surrealistic *The Blood of the Poet,* which was savaged by the critics. In his self-imposed exile from the cinema, he was not idle. Cocteau was an accomplished playwright, novelist, philosopher, poet, sculptor, painter, composer, scenic artist, and actor, and was highly respected in all of his artistic endeavors. Being a master at so many disciplines, he became a great innovator, believing that for a true artist there was no difference between poetry and film—a revolutionary bit of thinking at the time that would eventually become the flash point for the Auteur Theory.

Cocteau's use of fantasy in *Beauty and the Beast* became a profound influence on a great number of films that followed, including the Disney animated feature. He used simple theatrical tricks and surreal images that looked elaborately beautiful on the screen. When Beauty enters the castle of the Beast for the first time, arms were sticking out of the walls of the long, narrow corridor holding candelabras that follow her with flickering light as she passes. Josette Day, who plays Beauty, was on a special dolly, which gave her the appearance of floating, dream-like, down the hall. Without a word, the audience knew they were in an enchanted castle.

Cocteau experimented with a personal tone in his films that was intended to bring out the inner thoughts and desires of the writer or director on

Beauty and the Beast *(1946) directed by Jean Cocteau, with Jean Marais and Josette Day. Like all great fairy tales, this exquisitely made film has layers of hidden meanings. Cocteau, who is considered the father of the French New Wave, uses simple theatrical magic to create spell bounding images.*

the screen. He believed that every film should be the personal expression of the artist. This is something that ignited the imaginations of the young French critics and filmmakers and led to the New Wave Movement. Decades before something similar happened when Sergei Eisenstein said that the visual image would replace the written word, which sparked an excitement about film montage. Cocteau felt there should be a complete freedom in storytelling when it came to film, and that a true artist must not follow traditional paths, but should mix the real with the surreal, breaking away from the linear story structure. The artist had the right to baffle and confuse an audience, because it is good for people to think about what they have seen, instead of just reacting to what they see on the screen like mindless cattle.

Cocteau made only ten films. Most are considered avant-garde, always with a touch of surrealism, like *The Blood of a Poet* (1930) and *Orpheus* (1949). His films quite often contain homosexual themes, which was daring and dangerous for their time. These themes are hidden to the general audience by the use of metaphors and symbolism, though to the jaded eye of a modern moviegoer they seem obvious. *Beauty and the Beast* on the surface is a tale about magic. But Jean Marais, who plays both the Beast and the Prince, and also starred in *Orpheus,* was Cocteau's longtime lover. Thus this simple tale becomes an allegory about the prejudice of people who only accept others at face value.

Great Expectations

David Lean's *Great Expectations* (1946) was the first of his two screen adaptations of novels by Charles Dickens and the first motion picture without his longtime mentor Noel Coward. Lean had co-directed *In Which We Serve* (1942) with Coward, and then directed three adaptations of Coward's plays, *This Happy Breed* (1944), *Blithe Spirit* (1945) and *Brief Encounter.* Since 1930, Lean had been an editor, working on such classics as *One of Our Aircraft Is Missing* (1942) and *Forty-Ninth Parallel* (1941), both directed by Michael Powell; and two adaptations of George Bernard Shaw's works, *Major Barbara* and *Pygmalion.* His apprenticeship was with two of England's greatest playwrights and wits, and with the finest directors and cinematographers in the British film industry. When Coward asked

if he needed his assistance as co-director on later films, Lean politely refused, saying it would not be necessary.

Great Expectations became Lean's second international hit in two years. It is a film of unbelievable beauty with Guy Green's black-and-white Academy Award winning cinematography. The remarkable quality about *Great Expectations* is that it brings to life the look and manners of Dickens' characters, like the illustrations originally commissioned for the novel had stepped off the page and began to move. There was not a theatrical tone about *Great Expectations,* as there had been in previous movie versions of Dicken's novels, like *A Tale of Two Cities* and *David Copperfield.* The audience could almost feel the dampness in the air and get caught up in the mood of candlelit rooms. *Great Expectations* was so successful it launched J. Arthur Rank and Pinewood Studios on a succession of now legendary hits including *Odd Man Out, The Red Shoes,* and *Kind Hearts and Coronets.* The trademark of a J. Arthur Rank production was a muscular man ringing a giant gong.

Great Expectations also introduced the world to a young British actor named Alec Guinness, who appeared briefly as a friend of the lead character, Pip, played by John Mills. This would begin a longtime relationship between Guinness and David Lean—one that had its rocky moments (such as when Lean off-handedly told Guinness at the start of production for *The Bridge on the River Kwai* that he originally wanted Charles Laughton or Cary Grant to play lead role) but nevertheless endured throughout both of their careers. In Lean's production of *Oliver Twist,* Guinness plays Fagin. He then plays *Colonel Nicholson* in *The Bridge on the River Kwai,* Prince Feisal in *Lawrence of Arabia,* Yevgraf in *Dr. Zhivago,* and finally an eccentric East Indian, Professor Godbole, in *Passage to India.*

Vittoria De Sica and Shoe Shine

In Italy, Vittoria De Sica made *Shoe Shine,* one of the most powerful examples of neorealism, which follows the lives of two young boys who have been reduced to living on the streets and shining shoes to make a meager living. Their simple ambition is to save enough money to buy a rundown horse to ride. In order to get quick money, they take a chance in dealing black market goods, but they are caught and end up in a reform school. There they are separated and tragically turn against each other.

An official category for foreign language films was not introduced as part of the Academy Awards until 1956, but starting in 1946, and each year thereafter, one film was given a special honor. *Shoe Shine* was the first, and the citation read, "the high quality of this motion picture, brought to eloquent life in a country scarred by war, is proof to the world that the creative spirit can triumph over adversity."

The Cannes International Film Festival

This was the year that the International Film Festival at Cannes became an established event. It had been held once before but was more of a gathering than a competition. The decision to create an International Festival was in deliberate contrast to what was happening in the Academy Awards, which since its conception in 1927 did not have a best foreign film category. This was not remarkable since the major studios created the glittery Oscar ceremony to honor their own motion pictures at a time when they were under attack by religious groups for making movies containing too much sex and violence. This night of high honors was an attempt to bring prestige to Hollywood and show the world that each year it could produce at least five films that qualified as

art. The doors were not open to foreign films because this was very much a yearly gathering of the major studios. The promotional strength of the Oscar was to determine the best American film.

The judges at Cannes were searching for the most exceptional films from nations around the world. Film festivals were new in this time period. There had been small ones over the years in various countries, but to pull together an international competition and give the Grand Palm Award to just one outstanding film was a huge breakthrough. Over the years it became a showcase for the beautiful people in the film industry—grand parties, deal-making in hotel rooms overlooking the Mediterranean Sea, and passionate arguments over the winners and who should have won. The Cannes Festival quickly became a melting pot of the entire world and took the focus away from Hollywood to show how important film had become in all countries following the war.

1947

Sergei Eisenstein and Joseph Stalin

No matter how restrictive the Production Code might have appeared, there were systems that were far worse. In the Soviet Union, Sergei Eisenstein finished the second part of *Ivan the Terrible,* but the depiction of Ivan as a despot in a court where he cruelly ruled was scrutinized heavily by Joseph Stalin. Thus started a long nightmare of cuts and rewrites that Eisenstein was forced to do against his will. This constant pressure from Stalin and his censors caused Eisenstein to have the first of a series of heart attacks that would leave him dead before the third part of *Ivan the Terrible* was put into production. The sad course of this projected trilogy represents the end of a remarkable period in Russian cinema—one which was started by the revolution and ultimately killed by the revolution—which had deteriorated into Stalin's brutal rule that had cost his country millions of lives. Going from *Potemkin* to *Ivan the Terrible,* Eisenstein used the cinema to show the cruelty by which the idealistic principles of Communism had been twisted into a dictatorship.

Carol Reed and Odd Man Out

In England a suspenseful film came out that made an international star of James Mason. *Odd Man Out* was directed by Carol Reed and was done in what was becoming known in America as the Hitchcockian tradition. *Odd Man Out* deals with a man who is part of a clandestine organization, obviously modeled on the Irish Republican Army. He is wounded during an ill-fated robbery in Belfast and pursued the rest of the evening by British soldiers. The story takes him from hiding place to hiding place, from one group of eccentric characters to the next, down narrow dark alleyways, into smoky pubs, and eventually into a loft where a self-absorbed artist attempts to capture his fearful expression as he slowly dies from his wound. He finally meets his end in a snowstorm near a street where he would have been safe.

Odd Man Out is a dark journey though Belfast that shows the underbelly of Irish culture, full of offbeat characters, bits of dark humor, and a touch of film noir. But Reed is not playing by the rules of noir, he has taken his own side street and is more interested in showing the nature of human folly than focusing on a story about a heist that has gone bad. *Odd Man Out* is told in vignettes that move from one suspenseful episode to another, against the backdrop of a citywide manhunt. It is all held together by exceptionally fine performances, especially by Mason and Robert Newton, one of the great

movies scene-stealers. Since Mason plays a character who is working outside the law, the film was destined to have a tragic final curtain because of the demands of the Production Code.

Odd Man Out, like most of Hitchcock's movies, is designed as a kind of sideshow of cinematic expressions. Carol Reed was a master of visual style. He explored unexpected ways to frame a shot, used Dutch angles to create moods that border on the surreal at times, and experimented with different ways to light scenes that still have a modern look to them. *Odd Man Out* was highly popular in the United States, which is slightly ironic. After *Notorious,* Hitchcock ended up making a series of fascinating but forgettable box office duds over the next five years. During this time Reed made three outstanding films, all reflecting Hitchcock's influence: *Odd Man Out, The Fallen Idol,* and *The Third Man.* But once Hitchcock returned to form with *Strangers on a Train,* Reed never made another suspense thriller to equal these. He did, however, win the Academy Award as Best Director in 1968 for the musical version of *Oliver!*

1948

The Death of Sergei Eisenstein

On February 11, 1948, Sergei Eisenstein died of a massive heart attack just two weeks after his fiftieth birthday. His early death was unquestionably brought on by the constant changes inflicted on his production of *Ivan the Terrible* by Joseph Stalin. Eisenstein was fortunate to have worked within the narrow window of opportunity in the early years of the Soviet film industry, when Vladimir Lenin enthusiastically supported film as means of propaganda for the revolution. It can be argued that the romantic conceptions of the revolution to people outside of Russia come from Eisenstein's films. His dynamic use of montage

literally changed the course of early cinema. Stalin had seen how Eisenstein's films were able to put a positive profile on the revolution and rightfully feared that film could also reveal the terrible secrets he had hidden from the world. Consequentially, even to this day, the Soviet film industry has never fully recovered from Stalin's paranoid control. Stalin died five years after Eisenstein. It would be fascinating to know, if Eisenstein had lived, the kind of films he might have made after the dictator's death, especially the third part of *Ivan the Terrible.*

The Decline of Roberto Rossellini

Roberto Rossellini made *Germany Year Zero* on location among the bombed out ruins of Berlin. It was his third film about the sufferings of war, which was preceded by *Open City* and *Paisan* (1946). *Germany Year Zero* ignited a controversy that the neorealism films were reflecting Italy in a poor light to the outside world. Without question, it is one of the bleakest films of this movement, telling the gruesome story of a young boy trying to find food for his starving family, who ultimately kills his gravely ill father to relieve the burdens and hardships on his family. Not able to live with his actions, he commits suicide. *Germany Year Zero* received very limited box office success and was overshadowed by *The Bicycle Thief,* made the same year. The film also did not have the same natural flow as *Open City,* which had the emotional impact of a story unfolding on the screen as captured bits of reality. *Germany Year Zero* feels like Rossellini is deliberately manipulating the audience and breaking away from the objective point-of-view, which is the strength of films by Vittorrio De Sica.

During this time, Rossellini began a scandalous affair with Ingrid Bergman, who had just broken the hearts of moviegoers as the nun in *The Bells of St. Mary's* and had given the public

appearance of a happily married woman. The affair made national headlines in America. Incredible as it might seem today, Bergman was denounced on the floor of the U.S. Senate as unfit to live in America, which led to her banishment from Hollywood for six years. She made several films with Rossellini, all of which failed and received limited release in America.

The decline of Rossellini's career has been blamed on the media circus surrounding his affair and eventual marriage to Bergman. This might have some truth in it, but, despite Martin Scorsese's passionate defense of Rosselini's later films, he was attracted to stories that had increasingly darker themes, with, at times, heavy-handed symbolism.

Eventually he began to lose his audience to other Italian directors like Vittorio De Sica and Federico Fellini. Gradually he separated from neo-realism as his style became increasingly romantic. He never again experienced the success of *Open City,* but this film had a trigger effect that has influenced directors for decades.

The Bicycle Thief

The film that won over the critics in 1948 was Vittorrio De Sica's *The Bicycle Thief.* It is a film that continues to appear on many lists as one of the top ten greatest films of all time, along with *Citizen Kane, The Godfather,* and *Casablanca. The Bicycle Thief* has become the one film that, to most people, perfectly represents the principles of neo-realism. *The Bicycle Thief* was written by De Sica's frequent collaborator, Cesar Zavattini, who also wrote *Shoe Shine* and would later provide the screenplays for *Umberto D.* and *Two Women.* It is the simple story of a man who has the opportunity to make more money for his wife and young son by going around the city putting up movie posters, but to get the job he must have a bicycle. The man does not own a bicycle but says he will have one to begin work the next morning. When he tells his wife, she without hesitation sells the bed sheets that were given to her as a wedding present-the only possession they have of any value.

The man starts his job with the proud feeling that his life has changed for the better. But the film's title clearly suggests that this will be a fleeting moment of happiness. De Sica plays with the emotions of the audience like a master conductor. Early in the film there is a scene when the man leaves the bicycle without locking it up and everyone watching immediately fears it will be stolen. But the actual theft happens suddenly,

The Bicycle Thief (1948), directed by Vittorio De Sica, has continued to appear on critics top ten film lists since it was released. Perhaps no film so clearly defines the difference between foreign cinema and Hollywood movies. The story is simple: A man gets a better job because he has a bicycle to ride around Rome putting up movie posters—but his bike is stolen, so, along with his son, he sets out to find it. The real story is about the lives of these simple people, who by the end of the film have become fixed images in the mind of the viewer.

when the man is putting up posters only a few feet from the bicycle. The rest of the film is the search for the bicycle. The misadventures that follow ultimately provide a double meaning for the title.

At the heart of *The Bicycle Thief* is the relationship between the father and his son as they spend a long day looking for the stolen bicycle. Enzo Staiola plays the young boy and Lamberto Maggiorani is the father. Both were non-professionals in their first film, but working together they gave two unforgettable performances. De Sica believed that every person has one great performance to give, and it was up to the director to find the right actor to play the character. This was never truer than in this film. After the enormous international success of *The Bicycle Thief*, neither actor found another starring role and both disappeared from the screen very much like the characters they played in the film.

Before he turned to directing, De Sica was a highly popular actor in Italy, and this give him personal insights when working with untrained actors. He was a huge fan of Charles Chaplin, and, like the Little Tramp in *The Kid* and *City Lights*, there is a mixture of melodrama offset by unexpected moments of comedy in his films. Chaplin and Steven Spielberg are often singled out as having a gift for directing children. De Sica deserved to be on this short list. The performances of Enzo Staiola and the two boys in *Shoe Shine* is testimony to his gift for working with young, inexperienced actors. Staiola in *The Bicycle Thief* has some moments that are pure Chaplinesque, as in the scene when he is trying to find a place to relieve himself in the middle of a chase or when he falls down in the rain without his father noticing.

De Sica did not use camera movements to create a documentary look to his films, but is more of a traditionalist like Chaplin or John Ford. His scenes were performance driven, but what makes many of them linger in the audience's mind is the way he framed a master shot or blocked the actors to capture the heart of the moment. The last scene in *The Bicycle Thief* is a perfect example of this technique. Without a single word being spoken, De Sica lets the body movement and expressions of the father and son foreshadow their uncertain future in a moment that is haunting and unforgettable.

Hamlet

From England, there were two films that became major box office hits and one that was a surprise failure that almost bankrupted the British film industry. Laurence Olivier's *Hamlet* was the follow up to *Henry V* and was quite controversial to Shakespeare purists. Serving as director and star, Olivier trimmed almost half of the script and gave the brooding Dane an Oedipus complex right out of Freud. There are rather obvious implications that Hamlet had an incestuous desire for his mother, which was quite shocking for audience members who picked up on these bits of business. These scenes only passed the Production Code because this was Shakespeare.

Shot in black and white, *Hamlet* has the look of German expressionism, like Fritz Lang's *M*, and deliberately plays off of the murder mystery theme of the play. Olivier uses sweeping camera movements, deep focus, and shadowy lit castle interiors that capture the emotionally stressed psychology of Hamlet. The film is told from the point of view of Hamlet, with scenes that become surreal in depicting a man on the brink of insanity. And to give the film movement, many of the speeches were cut down to a famous line, like "the play's the thing wherein I'll catch the conscience of the king," and then a quick transition into the next scene. Olivier took home the Academy Award for best performance and *Hamlet* was voted the best picture of the year,

and, since it was shot entirely in England, it became the first foreign film to be so honored. However, Olivier did not win for director; the statue went instead to John Huston for *The Treasure of the Sierra Madre.*

Michael Powell and The Red Shoes

The Red Shoes, directed by Michael Powell and Emeric Pressburger, was one of the most strikingly beautiful films ever made up until this time. It that ran for years in some American theatres. The art design by Hein Heckroth and Jack Cardiff's Technicolor cinematography has a dark, dreamlike mood, very unlike earlier Technicolor productions that are bright with absolute colors, such as *The Adventure of Robin Hood* or *The Wizard of Oz.* Based on the fairy tale by Hans Christian Andersen, *The Red Shoes* tells two stories that collide together until it is impossible to tell reality from fantasy. Moira Shearer plays a ballerina torn between two possessive men—a young composer and a demanding dance impresario—that try to control her life. The centerpiece is the "Red Shoes" ballet, where a magical pair of ballet shoes takes control of the ballerina with tragic results (making a good case that most of Andersen's stories probably have devastating effects on young children). The ballet sequence, which actually takes place in the mind of the ballerina, has a magnificent score by Brian Easdale, and is a masterpiece of modern surrealism. It is one of the most gorgeous dance sequences ever filmed, with dazzling production values and an elaborate color scheme ranging from rich blood reds to midnight blues, creating a mood that is both sinister and mysteriously captivating.

But there is more going on in *The Red Shoes* in terms of the relationships between the characters. Michael Powell is one of the directors to which Martin Scorsese refers in terms of creating a subversive cinema-meaning he visually underscores moments in the film that hint at subjects that were taboo at the time, like male sexual identity, obsessive love, voyeurism, and mental cruelty. Set in the world of ballet, this was an ideal backdrop for Powell's dual meanings camouflaged in his visual language, very much like Alfred Hitchcock's method in his suspense films. Powell's career would end in a storm of controversy twelve years later with the release of *Peeping Tom,* an offbeat thriller about a murderer that enjoys filming his victims as they die. *Peeping Tom* was banned for years and created a scandal that focused on Powell, and not the character in the movie, as a person with degenerate thoughts. (As long as he was making films like *The Red Shoes* that cloaked some of these taboo themes he was considered an innovative director.)

Oliver Twist

David Lean's *Oliver Twist* was a giant production for the British film industry to undertake, but after the success of *Great Expectations* with American audiences the undertaking seemed like a sure thing. But what happened next only goes to prove that there is no such thing as a sure thing in the motion picture business. *Oliver Twist* is an impeccably made film, with incredible cinematography by Guy Green, who won the Academy Award for his work on *Great Expectations.* At great expense, enormous back lot sets were constructed to recreate Dickens' London. Everything about the film suggested it would be a hit. It was a brilliantly conceived, exciting, funny, and a faithful adaptation of one of the most popular novels ever. But this last part, as the expression goes, was the rub.

Alec Guinness, in his first major movie role, plays Fagin, and his makeup, speech, and mannerisms are almost exactly as Dickens describes his loveable rogue-plus Guinness looked identical to the original drawings in the novel. But after

the war there was a huge outpouring of sympathy for the Jewish people because of the terrible events of the Holocaust. The newsreels of the concentration camps seemed unbelievable, and in America for the first time anti-Semitism was being exposed in films like *Gentleman's Agreement* and *Crossfire.* The stereotype of the greedy, cunning Jew, which had been part of literature and the theatre for centuries, was no longer amusing or acceptable. It made no difference that Fagin was the most likable, interesting, and complex character in the film; the portrayal of Fagin became a firestorm of controversy. In America, theatres refused to show the film, so it was pulled from distribution and disappeared for a decade. Ironically, *Oliver Twist* was rediscovered in American art houses in the 1960s and proclaimed as a lost masterpiece of British cinema. However, at the time, the costly failure of the film, which did not even break even, almost caused the complete collapse of J. Arthur Rank and the British film industry. What prevented this near catastrophe was partly due to the success of *Red Shoes,* but primarily because of the unexpected hit of a little sleeper black comedy that came out the following year starring Alec Guinness.

1949

Ealing Studios, Alec Guinness, and Kind Hearts and Coronets

Kind Hearts and Coronets features Alec Guinness as eight different characters who are all murdered in despicable and hilarious ways. Dennis Price portrays the ambitious social outcast of the stuffy upper crust D'Ascoynes family who decides to eliminate the relatives who stand between him and the dukedom to which he feels that he is rightfully entitled. Guinness plays all of the ill-fated D'Ascoynes in a tour de force of comedy acting that made him an international star. His various doomed characters range from a senile minister, to an admiral, a playboy, and a suffragette. *Kind Hearts and Coronets* had audiences rolling in the aisles each time Guinness got bumped off, and because his gallery of characters were silly relics of the past, all of this comic mayhem became a tonic for the post-war years.

Guinness ushered in a major change in comedy acting, going in a complete counterpoint to Hollywood humor where slapstick, one-liners, and stereotypical characters were mined for

*Kind Hearts and Coronets (1949) directed by Robert Hamer, starring Alec Guinness in eight different roles. After the war, Ealing Studios outside London made a series of droll and wickedly mischievous comedies intended to cheer audiences up. Guinness had already appeared in David Lean's **Great Expectations** and **Oliver Twist,** but his versatile portrayal of seven men and one woman that are hilariously bumped off made him a household name long before **Star Wars.***

laughs. Guinness underplayed his characters with a slight Stan Laurel expression that was meek and genuine, a milquetoast who was constantly planning something big. Often he became the straight man for little old ladies, gangsters, and nosy policemen, but always stole the scene with his precisely timed reactions. Though he was classically trained and never associated with Method Acting, he was admired by Marlon Brando and the members of the Actors Studio, and was a friend and mentor to James Dean. Ultimately, much of this is overshadowed in later years because of his enduring image as Obi Won Kenobi.

Kind Hearts and Coronets started what became known as the Ealing Studios comedies, which launched the careers of Peter Sellers, Herbert Lom, Terry Thomas, Joan Greenwood, Alastair Sim, Stanely Holloway, and Margaret Rutherford. These zany, very British comedies were a kind of variation on the American screwball comedies, but were subtle in terms of acting, and the characters often had a dark complexity about them. They also had a slightly naughty, disrespectful attitude toward social customs, which fit the mood of the younger generation in many counties at this time, and were delightfully sadistic in the demise of characters that represented authority.

The Ealing comedies became a refreshing change to American audiences and were enormously popular since they made fun of subjects that most Hollywood studios avoided, like cold-blooded murder, unions, religion, politics, unethical business practices, and, of course, sex. By the use of implications, double entendres, and body language, these comedies were often a very dignified spit in the eye of the Production Code. *Kind Hearts and Coronets* began a chain reaction that lead to the Carry On series, the Miss Marple murder mysteries with Margaret Rutherford, Monty Python, Black Adder, Mr. Bean, Absolutely Fabulous, and Inspector Jacques Clouseau, to name a few. Over a decade later, Peter Sellers, who got his film break in *The Lady Killers* starring Guinness, carried on a tradition by playing multiple characters in *Lolita* and *Dr. Strangelove.*

The Third Man

The Third Man has one of the most famous plot twists in any suspense film, where hereafter any film or novel that throws such a curveball in the plot will always be compared to this movie, very much like the unexpected revelations in *Psycho, The Sixth Sense,* or *The Empire Strikes Back.* Based on a screenplay by Graham Greene and directed by Carol Reed, *The Third Man* was recently voted the number one British made film by the British Film Institute. It was shot on location in Vienna, which was an exceedingly difficult task since the city was still recovering from the war and occupied by the British, Americans, and Russians. This made getting shooting permits very tricky with all the bureaucratic red tape. Location shooting, other than second unit work or Westerns, was almost non-existent after sound came in during the golden age of the Studio System. Using the streets, graveyards, labyrinth sewer system, and interiors of Vienna gave *The Third Man* a sense of authentic intrigue that made it stand out from other films of this period; and, as the years have elapsed, a timelessness by capturing a moment in history that has vanished.

To add to the production problems, most of the film was shot outdoors at night in the freezing cold. Robert Krasker won a highly deserved Academy Award for his brilliant black-and-white cinematography, remnant of Gregg Toland's experiential work with deep focus and unusual camera angles. In fact, *The Third Man* is celebrated for its extensive use of Dutch angles, where the framed images slope to the right or left of the normal vertical and horizontal axis, giving

The Third Man (1949) directed by Carol Reed, written by Graham Greene, and starring Joseph Cotton, Alida Valli, and Orson Welles. The character of Harry Lime, played by Welles, is one of the most intriguing villains in movies—an indicator of how dark anti-heroes would become in the future. Lime is a charmer who can make the most appalling action seem like smart business. The other star of the film is the dramatic nighttime cinematography by Robert Krasker. European patent.

a playful psychological uneasiness to suspenseful moments in the film. This technique had been used by many directors, especially Hitchcock and David Lean, but never to the stylistic extent that Reed and Krasker did in *The Third Man*. This was an ideal approach to shooting the dark and decaying grandeur of Vienna, and to subtly show the mental confusion of the lead character, a naïve American visitor, thus a stranger in a strange land.

The lively but haunting zither score by Anton Karas, who Carol Reed found performing in a smoky Vienna café, captures the mood of the once glamorous city and perfectly accents the dark, mysterious action on the screen. The decision not to use a full-blown orchestra, but instead use a single instrument that represents the faded gaiety of old Vienna, was a departure from Hollywood movies and opened up possibilities for future scores. There was also a financial bonus. "The Third Man Theme" became a hit sin-

gle, and one of the first musical spin-offs in the movies, encouraging producers to have a catchy song composed for the opening credits with the hopes of giving birth to a popular tune that would be heard on the radio.

What lifts *The Third Man* out of the traditional realm of film noir, and gives it a singular identity, is the love story. Going back to ancient literature, there have been love triangles with dangerous and deadly repercussions, but Graham Greene gives this old plot device a new spin. The triangle in *The Third Man* is between a man, a woman, and a corpse. Holly Martins, played by Joseph Cotton, is a writer of pulp Western novels who has traveled to Vienna to meet his boyhood friend, Harry Lime, who has cabled him about the prospects of making some easy money. But Martins arrives the day of Harry Lime's funeral. He finds out from the British military that his old pal was killed in a freak hit-and-run accident. Stuck in Vienna with time to kill, he visits

Lime's mistress and immediately proceeds to fall in love. But she is overcome with melancholy and is still obviously in love with the memory of a dead man.

Alfred Hitchcock had popularized the spy drama in his Hollywood movies, treating these tales of espionage as complex, highly entertaining cat-and-mouse games. In comparison, *The Third Man* is a realistic look at the European black market that flourished after the war and the rather dirty business of bureaucratic intrigue. In many ways, it foreshadows the clandestine activities of the Cold War as later depicted in the novels of John Le Carre, more so than the high-pitched action of Ian Fleming. Nevertheless, Reed knew how to play the suspense card, and *The Third Man* is full of memorable action sequences, like the final chase in the gothic sewers that run for miles under Vienna.

Carol Reed's use of famous Vienna landmarks actually assisted in the financial recovery of the city. There is a scene with Orson Welles and Joseph Cotton on a giant Ferris wheel, which still exists to this day. After the film came out, tourism picked up tremendously, since people wanted to take a ride on the Great Wheel, as it was called. For this scene, Welles, in his most famous role next to *Citizen Kane,* decided to give his characters a few extra lines, so he wrote a little speech that has become one of the most famous in movie history. "I'll meet you any place, any time," he tells Holly Martins. "And when we do meet, old man, it's you I want to see, not the police . . . and don't be so gloomy. After all, it's not that awful—you know what the fellow said . . . In Italy for thirty years under the Borgias they had warfare, terror, murder, bloodshed—they produced Michaelangelo, Leonardo da Vinci, and the Renaissance. In Switzerland they had brotherly love, five hundred years of democracy and peace, and what did that produce . . . ? The cuckoo clock." Welles also said that his role in *The Third Man* was the ultimate leading man part despite the fact that Welles is seen in less than half of the movie. As he points outs, the only thing that everybody does is to talk about his character.

Silvana Mangano: Fifteen Minutes of Fame, Italian Style

As an illustration of how a single image can turn a movie into a big hit, in Bitter Rice, a neorealistic drama directed by Giuseppe De Santis, there is a moment when nineteen year old Silvana Mangano is seen wading in a rice paddy. Just the still publicity photograph of Mangano looking defiantly at the camera caused a huge sensation and even inspired a satire on *I Love Lucy.* This was the kind of sensual stuff that was hard to slip into American movies. Despite the fact that any sexual activity was in the mind of audience members and not seen on the screen, all it took at this time was the image of Mangano to cause long lines at the box office.

In a review published in Rome (and one that would certainly be met with objections today), the critic writes, "There is no doubt that *Bitter Rice* will make Silvana Mangano, Miss Rome of 1946, into a star. The voluptuous Mangano in thigh-revealing shorts and torn nylons, her ample breasts thrust forward, her seductive head held high, standing in a rice paddy, is the film's most memorable image and the one that audiences will take with them. Ostensibly a neorealist exposé of the exploitation of women workers, the steamy film in reality exposes more of Mangano than its subject." But despite the glowing press, her producer-husband, Dino de Laurentis mishandled her film career, and her star quickly faded. Seven years later, Sophia Loren, who looks almost identical to Mangano, climbed out of the sea in the movie *Boy on a Dolphin,* struck a defiant pose in her wet dress, and caused a similar sensation. Sophia had better luck with becoming an international star.

1950

Changes in American Cinema

This was the first year that clearly showed a transition in the studio films coming out of Hollywood. *The Asphalt Jungle, D.O.A.,* and *Gun Crazy* would become three classics of film noir that defined the heist caper and explored the connection between the two most popular themes in movies: sex and violence. To avoid becoming a victim of the McCarthy witch hunts, director Jules Dassin, after his success with *The Naked City* two years before, moved to England to make *Night and the City,* which focused on the criminal underworld of London. The Western began a long period of revisionism, examining the psychology of violence and the treatment of Native Americans in *The Gunfighter, Winchester 73,* and *Broken Arrow.* Billy Wilder turned the spotlight on the dark secrets of Hollywood in *Sunset Boulevard,* and Joseph Mankiewicz would show the bumpy nights and backstage back stabbing of the theatre world in *All About Eve.*

Max Ophuls and La Ronde

Max Ophuls returned to France after eight years in Hollywood to make a film version of Arthur Schnitzler's scandalous social satire *La Ronde,* about ten people from different levels of society who meet and have affairs, ranging from the streetwalker to the aristocrat. Set in nineteenth-century Vienna, and using a merry-go-round as a metaphor for these sexual encounters, *La Ronde* is a stylish film with an outstanding cast. It features Simone Signoret, who would became an major star as a result of her alluring and intelligent performance and would go on to win the Academy Award ten years later for *Room at the Top.*

The film was greeted with its share of controversy. In New York the state censor refused to grant a license to the film because it showed "adultery not as a fall from grace, but as a game." In a vintage year of Hollywood comedies, like *Father of the Bride, Harvey, Cheaper by the Dozen,* and *Born Yesterday,* the satirical bite of *La Ronde* brought back the capricious fun of the battle of the sexes that had been lost in movies after the Pre-Production Code era.

La Ronde became the most prestigious film done in France since the release of *Children of Paradise* and a triumphant homecoming for Ophuls, one of the few directors to return to his country after the war. However, his decision to leave Hollywood was due to the failure of his elegant valentine to bygone Vienna, *Letter from an Unknown Woman* (1948), beautifully photographed by Franz Planer. This was a film that was expected to be highly successful since it was the kind of romantic drama that was so successful during the Depression and the early years of World War II. The disappointing box office showing threw many studio moguls into a panic, and the film came to symbolize the end of the golden age.

Luis Buñuel and The Young and the Damned

In Mexico City, Luis Buñuel would direct his first movie since *Espana,* fourteen years before, and thus begin one of the most remarkable returns in cinema history. The film was *The Young and the Damned,* or *Los Ovalidados* as it was released elsewhere. Buñuel had come to the world's attention in 1929 with *Un chien Andalou* and the following year with *Age d'or, L',* made with fellow Spanish surrealist Salvador Dali. *The Young and the Damned* is about street children growing up in the violence and neglect of the slums. Buñuel's depiction of the youth gangs, mixed with his trademark surreal dream images, was so shocking that the press and many politicians denounced the film as an "insult to the Mexican

nation" and began a campaign to have him exiled from the country. He made the film at the age of fifty and would continue making a series of provocative, highly original films, which were often greeted with outrage and scandal, over the next seventeen years. His films were admired by many directors for their dark attacks on the hypocrisy of society, like *The Exterminating Angel* (1962), *Belle de Jour* (1967), *The Discreet Charm of the Bourgeoisie* (1972), and *That Obscure Object of Desire* (1977). Alfred Hitchcock, who was a great fan of surrealism, said that Buñuel was his favorite director. Hitchcock had also worked with Dali on the dream sequence in *Spellbound*.

Akira Kurosawa, Toshiro Mifune, and Rashomon

This was the year that the world was introduced to Akira Kurosawa, and his favorite actor, the magnificent Toshiro Mifune. The film was *Rashomon* and introduced audiences to the fascinating and complex traditions of Japanese culture. It became an immediate sensation and was given the special Academy Award that year. Kurosawa was to become associated with the legends of the samurai in later films, but *Rashomon* is the telling of a single incident from four different points of view. It is the tale of a rape and murder, but from each person's retelling of the violent circumstances there are important differences that are either added or omitted, primarily to save face and uphold a sense of personal honor. The players in this twisting tale are a wife, her husband, a bandit, and a chance observer. The husband is murdered, so a special priest must be summoned who can communicate with the dead.

Rashomon unfolds in a series of flashbacks, so it is a non-linear story that plays with time. The pieces of the puzzle are nearly put together by one observer, but the next person mixes up the pieces and starts over, each time adding new

pieces. The audience never knows the exact truth, so with each person's spin on the incident there is renewed interest because the audience has become involved in the mystery. This shell game with time has since influenced many directors, like Stanley Kubrick in the *The Killing*, Bryan Singers in *The Usual Suspects*, and almost all of Quentin Tarantino's films, including *Reservoir Dogs, Pulp Fiction, Jackie Brown*, and *Kill Bill*.

Rashomon would be the first of several classic films Kurosawa made with Toshiro Mifune, including *Seven Samurai, Throne of Blood, The Hidden Forest*, and *Yojimbo*. The films they made together became as famous as the teaming of John Ford and John Wayne, Frank Capra and James Stewart, or Alfred Hitchcock and Cary Grant. They complimented each other's styles. Kurosawa was a master at framing a shot, and the images he captured compare to those of David Lean or Ingmar Bergman. Mifune was an actor of almost uncontainable exuberance, yet there was never a false note in his performances. His characters were bigger than life but completely real.

The American directors that became part of the changeover to the New Hollywood all had their favorite foreign directors in a long list that included De Sica, Godard, Bergman, Fellini; however, almost everyone said that Kurosawa had a profound influence on them. Most directors since have unabashedly borrowed the elements of Kurosawa's filmmaking style, whether they are aware of it or not. There is the rapid editing to heighten violence, slow motion to show death, long tracking shots, point-of-view shots from different characters in an action sequence, and the fluid movement of the camera. Kurosawa usually locked down his camera and did not use the jerky documentary style of Rossellini in *Open City* or the style that Godard would later use in *Breathless*.

His movements were smooth, carefully planned, with an absolute purpose-even on the

shortest takes to create a tension throughout the sequence. There is not the random movement that gave the impression a passerby picked up the camera and started shooting, which eventually became a stylistic choice of directors like Godard and John Cassavetes. His use of slow motion to prolong the moment of death, which is used subtly, became legendary in *Bonnie and Clyde* and *The Wild Bunch,* and has been overused ever since. The reason Kurosawa's use of the camera still feels contemporary fifty years later is because his techniques are reflected in the movies of Steven Spielberg, Tony Scott, John McTiernan, David Fincher, and Peter Jackson.

Perhaps Kurosawa's single greatest achievement was his incredible skill and obvious passion to show the culture and traditions of Japan. There were very deep international wounds to heal after the war, and since the sneak attack on Pearl Harbor on December 7, 1941, the depiction of the Japanese people had become an ugly stereotype for the express purpose of wartime propaganda. Japanese women disappeared from Hollywood movies, except for the voice of Tokyo Rose. The military men were played as stoic, heartless, barbaric, and without any sense of honor toward their enemy. The concept of the samurai code has been blurred into the flaming planes of the kamikaze pilots. With *Rashomon,* Kurosawa opened a door to the truth about the Japanese people, steeped in medieval mythology, with strange, fearless warriors that somehow resembled the gunfighters of the old American West. Because of the vast differences between the Japanese and Western cultures at this time, all of the literature, artwork, architecture, and theatre of Japan would never have achieved the immediate and lasting effect that one film started. Today the influence of the samurai warrior on Hollywood movies, ranging from Westerns to science fiction, is fully acknowledged by audiences everywhere. All of this is testimony to the power of motion pictures to change embittered opinions and introduce new worlds.

1951

Changes in American Cinema

This was the year that Hollywood invaded Europe and parts of Africa. One of the dubious benefits of the war was that the newsreels allowed audiences to see actual locations, whereas in the movies only a small proportion of the scenes were not shot on soundstages and back lots. People were responding to films that looked authentic, like *The Third Man, The Treasure of the Sierra Madre,* and even parts of the Gene Kelly and Frank Sinatra musical *On the Town.* For almost twenty years, studios used masterfully painted but lifeless backdrops, which if the camera stayed on them for more than a few seconds the eye would detect. The newsreels had spoiled audiences, and the glossy romantic recreation of far away places had lost its appeal. With smaller, lighter cameras and faster lenses and film stock, location shooting was not the near impossible task it had been before the war. Plus by this year, the bigger-is-better race was in full speed with television.

This was the year John Huston took Humphrey Bogart and Katharine Hepburn to Africa to shoot most of *The African Queen* and MGM headed to Rome with Robert Taylor and Deborah Kerr and a seven-million-dollar budget to make the epic *Quo Vadis?*—which, ironically, was originally filmed in 1912, in the early glory of the Italian motion picture industry, and inspired D. W. Griffith to make his own full-length epic three years later.

But there was more than just the look of the locations that started to lure Hollywood production to other countries. Then, as it is today, it was cheaper to film outside the United States. Movies

A Place in the Sun (1950), directed by George Stevens, starring Montgomery Clift and Elizabeth Taylor, shows how quickly Neo-realism films like **Open City** and **The Bicycle Thief** began to change the look of Hollywood features. Cinematographer William C. Mellor's use of "short lens" and natural lighting gave the film a documentary look.

that required massive sets and armies of extras could fill up the screen in Italy, which was one of the first counties after the war to welcome the Hollywood film industry. Soon Italian production companies would hire movie stars like Anthony Quinn, Orson Welles, and Kirk Douglas to appear in their movies.

The films coming out of studios this year had a very different quality about them. This was the year of *A Place in the Sun; Strangers on a Train; A Streetcar Named Desire; Ace in the Hole* (a.k.a. *The Big Carnival*), Billy Wilder's cynical but prophetic look at news reporting; and *The Day the Earth Stood Still,* the grandfather of alien invasion films. The way these films were photographed was a departure from the picture postcard studio look of A-features. There was an experimental feel about them, where light and shadow played a greater role in the visual storytelling.

But change did not come easy to some of the old Hollywood guard. The bright, breezy, Technicolor MGM production, *An American in Paris,* starring Gene Kelly, took home the Academy Award as Best Picture, and Humphrey Bogart beat out Marlon Brando as best actor. In Paris a group of young critics from the defunct *Revue du Cinema* joined together to create a new cinema magazine, *Cahiers du Cinéma,* which started a revolution in filmmaking with something they called the Auteur Theory.

England

Another reason that Hollywood journeyed to Europe to make movies was because several countries, including England, had imposed a high import tax on American films; one way around this was to shoot films using the studio facilities of these countries. And the technical crews were often highly trained; in fact, many American directors looked forward to working with cinematographers who had not been brainwashed with the "studio look" and were making exciting changes. The interior scenes for *The African Queen* were shot on the stages of the famous Pinewood Studios, twenty miles west of London.

The British film industry was getting into high swing. *The Tales of Hoffmann,* directed by Michael Powell and Emeric Pressburger, was the follow-up to their enormously successful *The Red*

Shoes. And Alec Guinness graduated from character actor to leading man in two comedies, *The Man in the White Suit* and *The Lavender Hill Mob,* which were so popular that he became as well-known to American audiences as Cary Grant and John Wayne. Every director suddenly wanted to work with him. Billy Wilder spent years trying to get Guinness to agree to make a film with him, but was always politely refused. In *The Man in the White Suit,* bearing an uncanny resemblance to Stan Laurel, Guinness plays a misunderstood genius who invents a white fabric that never wears out. This immediately causes a panic in the garment industry, especially within the worker's union, because miracle clothing that never deteriorates means factories will close down. *The Man in the White Suit* is a form of comedy that was almost non-existent in American movies but was common in English films during this time. The dilemma of the story centers on the problems of management and labor, with Guinness' character caught in the middle.

In *The Lavender Hill Mob,* he plays a mild mannered, proper, trusted banker who has been secretly plotting for years to rob a large gold shipment, melt it down, and smuggle it out of the country as souvenir toy Eiffel Towers. *The Lavender Hill Mob* took home the Academy Award for best screenplay, only the fifth English film to be so honored, and, besides *Pygmalion,* the only comedy to win. Much of the popularity of *The Lavender Hill Mob* is that it is a perfectly concocted parody of film noir heist thrillers, like *The Asphalt Jungle.* Once again, this brand of humor was uniquely English. Screwball comedies poked fun at high society, but few American films had ever put a humorous twist on an entire genre. Mel Brooks, in a far less subtle manner, would do this later with movies like *Young Frankenstein* and *Blazing Saddles.*

1952

Changes in American Cinema

This year was one of the last hurrahs for old fashioned Hollywood entertainment with Cecil B. DeMille's *The Greatest Show on Earth,* John Ford's *The Quiet Man,* and Gene Kelly and Stanley Donen co-directing *Singin' in the Rain,* the delightful musical salute to the silent era. But overall it was a very low year for the studios. Production was down, and everyone was running scared because of the blacklist and HUAC hearings. Many of the films that were released had a political or social undercurrent to them that questioned traditional American values Hollywood once dutifully sugarcoated to audiences. No one wanted to be suspected of waving a red flag at this time, or playing with ideas that might seem slightly off center, so these underlying themes were subtly woven into the story lines. In *Sudden Fear,* with Joan Crawford, a woman stumbled on a plot by her husband to have her murdered. Vincente Minnelli showed the dog-eat-dog side of movie making in *The Bad and the Beautiful,* one of the best Hollywood films about Hollywood, loosely based on the life of producer David O. Selznick. And Elia Kazan went down to Mexico with Marlon Brando to make *Viva Zapata!,* based on a screenplay by John Steinbeck, a movie that is openly anti-Communist. On April 10, he named fifteen of his colleagues to the Washington HUAC committee.

Fred Zinnemann directed two remarkable films: *High Noon,* written by Carl Foreman, who would be blacklisted during production, and an adaptation of Carson McCullers' *A Member of the Wedding,* about a young girl growing up in the Deep South. Zinnemann had shot *The Search* with Montgomery Clift on location in Germany two years before, and had gotten into the industry

making documentaries. He was familiar with what was happing in Europe, especially with the neorealists, and his films begin to reflect a freer movement of the camera and greater use of natural lighting. *High Noon,* considered a turning point in Westerns because of the use of psychological themes, is about a town of people who are too afraid to stand up against the bad guys and actually encourage the sheriff, played by Gary Cooper, to run away. *A Member of the Wedding* looks like a film that Vittorio De Sica might have directed, especially in the handling of the two children played by Julie Harris and Brandon de Wilde, who would be cast as the young boy in *Shane* the following year.

Europe and Japan

Children and old men would be a recurring theme in many of the films coming out of different countries this year. French director, Rene Clement made the highly emotional film, *Forbidden Games,* about two children growing up among the ravages of war who try to make a game of the death all around them. The performances by Georges Poujouly and Brigitte Fossey are heartbreaking to the extreme. Made as Cold War tensions were escalating in Europe, *Forbidden Games* was given the honorary Academy Award as best foreign film. This film stays in the mind because it shows the innocence of two children being destroyed by adults thoughtlessly making war on each other. The theme of children caught up in the chaos of war has been used many times since, in such films as *The Bridge* by Bernhard Wicki and *Empire of the Sun* directed by Steven Spielberg.

Two of the most powerful films about growing old and facing death were made this year. One is *Ikiru,* by Akira Kurosawa, starring Kanji Watanabe, who would play the leader in *The Seven Samurai* two years later. The other film is *Umberto D.,* directed by Vittorio De Sica, written by Cesare Zauattini, with Carlo Battisti, a nonprofessional actor who is flawless in the lead role. In *Ikiru* (To Live) a man learns he is dying of cancer and realizes that he has misspent his life. In his final journey to give some meaning to his life, he decides he wants to create a park where children can play. *Umberto D.* (short for Umberto Domeniko Ferrari) is a man without income, whose only true companion is his little dog, Flag. He considers suicide, but is uncertain about what to do with Flag. Then, in the tradition of Charles Chaplin, his fortune changes. Both of these films are heartfelt testaments to life that are directed with remarkable insights, beautifully shot, and with unforgettable performances.

The United States Supreme Court vs. The Miracle

Roberto Rossellini's *The Miracle,* the second part of *L' Amore* (1948), literally changed movie history when the Supreme Court ruled against a ban that had been forced upon it by the film board of New York and various religious figures lead by Cardinal Francis Spellman. *The Miracle* stars Anna Magnani, and was co-written by Federico Fellini, who plays a major role in the film. The story is about a simple peasant woman who has a chance meeting with a vagabond (Fellini) who she believes to be Saint Joseph. She is seduced by this careless man and later discovers she is pregnant, which she proclaims to be a miracle to the village people, because she is about to give birth to Jesus Christ. *The Miracle* in no way mocks the Church or pretends to be about the Second Coming. The film is a simple tale about Faith, but it was met with a firestorm of controversy in England and America, propelled almost entirely by people who had not seen it.

The case was appealed to the Supreme Court, and for the first time it was ruled that films

are "a significant medium for the communication of ideas." Up until this time American motion pictures were regarded as "a purely commercial venture," without the rights granted under the constitution for freedom of speech. Such a case would not have come to the attention of the court if it had been an American film, because a screenplay that violated the rules of the Production Code would never have been given the green light to be made. This could only have happened with a foreign film produced in a country where such a powerful code did not exist. For over twenty years, motion pictures had been declared a business, thus could be regulated by corporate guidelines and have penalties enforced upon them. Now, with this ruling from the Supreme Court, they were allowed the same privileges as all other art forms, which had always enjoyed such freedom.

1953

Changes in American Cinema

Joseph J. Green was given an Honorary Academy Award "for his conscientious, open-minded and dignified management of the motion picture Production Code." Ironically, this same year, *From Here to Eternity,* directed by Fred Zinnemann, based on James Jones' raw, no-punches-pulled novel about army life, won Best Movie. Marlon Brando, because of his motorcycle riding character in *The Wild One,* had kids imitating him by buying leather jackets and saying they were rebelling against everything. But the big battle being fought by the Hays Office this year was over the word "virgin" in Otto Priminger's *The Moon Is Blue,* which was ultimately released without the Code's seal of approval. These films reflected the slow loosening of the reins of Hollywood censorship. Foreign films only hastened this demise. People were lining up outside of art houses to see *Summer with Monika,* the first successful import of Swedish director, Ingmar Bergman, about two teenagers who spend the summer making love on an island, with the girl, played by Harriet Andersson, becoming pregnant.

This was a safe, conservative, and profitable year for the studios. The output of fatalistic film noir has decreased, and comedy, Westerns, and musicals were on an upswing with *Shane, Roman Holiday, Gentlemen Prefer Blondes, Calamity Jane, The Naked Spur,* and *The Bandwagon.* Cinema-Scope had theatres packed with *The Robe,* based on Lloyd C. Douglas' giant best seller, and starring new acting sensation Richard Burton. Marilyn Monroe steamed up screens in the murder thriller *Niagara. The War of the Worlds,* one of the first big budget science fiction movies in almost two decades, was a big hit. A star-studded *Titanic* sank to audience's delight. And, in a complete turnabout, Brando followed in Laurence Olivier's theatrical footsteps by playing Marc Antony in Joseph L. Mankiewicz's *Julius Caesar.*

France

Two totally different films came out of France this year, both becoming classics of their genres. *Monsieur Hulot's Holiday* was a comedy soufflé, starring Jacque Tati, that was a loving tribute to the silent clowns, like Charles Chaplin and Buster Keaton, yet, in its own understated madcap way, it was very original. Set in a sleepy seaside resort in France, the peace and tranquility of the guests are turned upside down when Hulot arrived in his strange little car. *Monsieur Hulot's Holiday* (or *Mr. Hulot's Holiday,* as it was retitled in America) was a series of interwoven comic episodes, with scattered bits of dialogue and accented with inspired sound effects, that literally explodes in fireworks at the end. With his funny walk and complete oblivion to the mayhem that follows him, Jacque Tati became an inspiration for Peter Seller's Inspector Jacques

Clouseau and many of John Cleese's characterizations on Monty Python, including Basil Fawlty in *Fawlty Towers*.

Henri-Georges Clouzot and Wages of Fear

The Wages of Fear was an action film with a brain, and was ultimately responsible for jump-starting the contemporary action-adventure genre. What was unique about Henri-Georges Clouzot's *The Wages of Fear* is that it was shot on location in the south of France, in what was, according to members of the cast, a very grueling and physically demanding shoot. The film starred matinee idol Yves Montand, who was married to Simone Signoret, and together they were considered the royalty of French cinema. *The Wages of Fear* is a hard-luck tale of four men who are desperate for money and agree to take nitroglycerin to a burning oil field 300 miles away over rocky mountain roads. In large part, because of the realistic settings, the film creates a tension at the beginning and keeps tightening the screws until the last scene.

The Wages of Fear* unanimously won the Grand Prix at the Cannes festival, where Jean Cocteau was president, and was acclaimed by the future leaders of the New Wave Movement for its visionary direction. The film shows the influence of American film noir, with the tough, uneasy relationship between the characters (who all qualified as anti-heroes), and the unpredictable circumstances of the seedy dark world. What was new territory for *The Wages of Fear,* and has become very old hat since, is the bringing together of a diverse group of characters to perform an impossible mission. In 1977, it was remade by director William Friedkin as *Sorcerer.*

Also, in Paris this year Sergei Eisenstein's *Potemkin* was finally granted a general release. The silent classic about the Russian Revolution had been banned in France due to political censorship since its original release, twenty-eight years before.

1954

Changes in American Cinema

Several films that have endured as classics came out of the Hollywood studios this year. Elia Kazan's *On the Waterfront* had the look of films coming out of England and Italy at this time, thanks to the brilliant black-and-white location work of Polish-born cinematographer Boris Kaufman. The film was unlike anything from a Hollywood studio and very much in the tradition of neorealism with the use of non-professional actors and shooting on the streets where the real events that inspired the screenplay actually took place. Alfred Hitchcock's *Rear Window* proposed the sinister possibility that our neighbors might be capable of anything, including cold-blooded murder. This taunt thriller became a favorite of the "hot head" New Wave directors, especially Francois Truffaut. Otto Preminger directed *Carmen Jones,* the first all-Black musical made by a major studio in over a decade, starring Harry Belafonte and Dorothy Dandridge, who became the first black actress to be nominated for an Academy Award. And Billy Wilder served up a charming, if unlikely, love affair between Audrey Hepburn and a much older Humphrey Bogart, proving that the director of *The Lost Weekend* and *Sunset Boulevard* also had the "Lubitch touch."

The success of CinemaScope spun off rival widescreen systems. Irvin Berlin's *White Christmas* was shot in VistaVision and the Gary Cooper Western *Vera Cruz* used the new Superscope. Movies in 3-D were a big attraction at the start of the year and a passing fad by the end. Hitchcock, with his favorite blonde Grace Kelly,

On the Waterfront (1954) directed by Elia Kazan, starring Marlon Brando and Eva Marie Saint, is a high water mark for the social issue films that began in American cinema after the war. Cinematographer Boris Kaufman was born in Russian and trained in France. For years he supported himself by making documentary shorts. *On the Waterfront,* which he won an Oscar for, is credited with bringing the Neo-realism style to American films. He also worked with Sidney Lumet on **12 Angry Men** and **The Pawnbroker.**

shot *Dial M for Murder* in 3-D, but the murder mystery was released in standard format. Walt Disney took a major gamble on a first-class adaptation of Jules Verne's *20,000 Leagues under the Sea* and the beauty-and-the-beast theme was taken underwater in the drive-in hit *The Creature from the Black Lagoon.*

As an example of how serious the young critics of *Cashiers du Cinema* were about the art of film, Francois Truffaut attacked Robert Bresson's *Diary of a Country Priest* and concluded with the statement, "Of what value is an anti-bourgeois film made by a bourgeois for the bourgeoisie?"

Japan

This unarguably was one of the greatest years of Japanese cinema, part of what has been referred to as the Golden Age. Leading up to this year were a remarkable group of films, starting with Akira Kurosawa's *Rashomon,* then Kimisaburo Yoshimura's *The Tale of Genji* (1952), and Kenji Mizoguchi's *Tales of Ugetsu* (1953). This year Mizoguchi made *Sansho the Bailiff,* a remarkably beautiful film set in feudal Japan. It told a story of injustice about the son from a noble family who is kidnapped, and then, years later, is re-

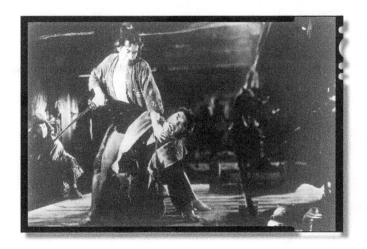

Seven Samurai (1954) directed by Akira Kurosawa, with Toshiro Mifune, had a huge influence on the directors of the New Hollywood. William Friedkin, Francis Ford Coppola, Steven Spielberg, George Lucas, and others have all talked about the impact Kurosawa's use of slow motion, rapid-editing, and camera movements made on them. What is sometimes overlooked is Kurosawa's remarkable sense of composition, especially in his action montages. Every frame is symmetrically balanced and lit, like a carefully arranged photograph.

united with his mother who is living in poverty. Also this year Teinosuke Kinugasa made *Gate of Hell,* the first Japanese to use the new Eastman color process. *Gate of Hell* is the tale of a twelfth-century warlord who saves a woman during an attempted coup. When he asks his lord to marry the woman as his reward he learns that she is already married and refuses to leave her husband. The samurai's jealousy and insistence that she leave her husband and submit to his demands ultimately leads to tragic consequences. *Gate of Hell* won Academy Awards for best foreign film and for Sanzo Wada's gorgeous costumes. It became the first Japanese film to win the Palme D'Or at the Cannes Film Festival, where the jurors were Jean Cocteau, Luis Bunuel, and Andre Bazin.

The Seven Samurai. Akira Kurosawa never enjoyed the respect as a great director in his own country as he did in Europe and America. *Rashomon* was poorly received in Japan but won the Oscar and the Golden Lion Prize at the Venice Film Festival. Kurosawa enjoyed American films, especially the Westerns of John Ford, and his plots often had the dramatic structure of this familiar genre. Perhaps because of this mixing of cultural elements, his films were slightly out of place in mainline Japanese cinema. By using the metaphor of the last gunfighters caught up in a changing world, brought about by the Industrial Revolution, Kurosawa developed the image of the master warrior in the sunset of his era. He found similarities in the legends of medieval Japan, after the decline of the power warlords, in an age when skilled samurais were forced to wander and offer their services for a bowl of rice. *The Seven Samurai* was one of those very rare films that actually forged new myths. It was the epic tale of a group of samurais who were the best of the best but had fallen on hard times. With no other prospects, they agreed to train and defend a group of farmers against bandits who outnumber them, own horses, and had acquired firearms. It was an impossible mission, and the majority of them would not survive.

The Seven Samurai was a perfect example of how films cross-pollinated the cinema experience of diversely different countries to create a new genre that had a comfortable sense of familiarity to many different audiences. Because of this, *The Seven Samurai* is arguably the most influential foreign film ever made. It reflects the themes of American Westerns translated into samurai legends, which would then be remade into Westerns that completely changed the old cowboy movies

Shane (1953) directed by George Stevens, starring Alan Ladd and young Brando De Wilde, is based on the best selling novel by Jack Schaefer. The most successful Western ever made when it was released, the story involves a gunfighter that defends peaceful homesteaders who are being driven off their farm land by ranchers. The concept of a gunfighter who has outlived his time, in the sunset years of the Wild West, had an influence on Akira Kurosawa, who used this metaphor for his samurai warriors.

of good vs. evil and made the outlaw the hero, or the anti-hero to be more accurate. *The Seven Samurai* became *The Magnificent Seven,* which later became *Butch Cassidy and the Sundance Kid, The Wild Bunch,* and all the Clint Eastwood Westerns, ending up with *Unforgiven.* Since the appeal of Westerns was so widely enjoyed by world audiences since the silent era, they created a trigger effect that influenced crime films, cop movies, and finally science fiction, completely redefining the action-adventure genre. Eventually this cycle went full circle with *Enter the Dragon* (1973) in Hong Kong and "Kung Fu" (1972–75) on American television. And fifty years later, it continues with *Kill Bill, Vol. 1 and 2* and *The Last Samurai.*

1955

Changes in American Cinema

If there was ever a year when the lines became blurred between American cinema and foreign films, 1955 was the year. *Marty,* directed by Delbert Mann and written by Paddy Chayefsky, was originally presented on live television then made into a film that went on to win the Academy Award for Best Picture and the Palme D'Or at the Cannes Film Festival. The Europeans applauded the low-budget film because it had the look and feel of neorealism, except with a uplifting ending.

The Blackboard Jungle, written and directed by Richard Books, followed on the heels of *On the Waterfront,* tackled the subject of inner-city violence and juvenile delinquency. Otto Preminger directed Frank Sinatra in *The Man with the Golden Arm,* the first Hollywood film about drug addiction, also featuring the first jazz score for a major film by Elmer Bernstein. Mickey Spillane hit the screen in *Kiss Me Deadly,* directed by Robert Aldrich—a violent, gritty film that was praised by the critics in *Cahiers du Cinéma. The Rose Tattoo,* directed by Daniel Mann, and starring Anna Magnani, resulted in an Oscar for Magnani's performance. And *The Night of the Hunter,* starring Lillian Gish and Robert Mitchum as a truly evil preacher who had l-o-v-e tattooed on the fingers of one hand and h-a-t-e on the fingers of the other hand. This is the only film directed by the great actor Charles Laughton, and is done in the style of early German Expressionism.

All of these films were shot in black and white and looked nothing like the studio movies even five years before. The camera was becoming more of a star, with movement, naturalistic images, and the sense of a prying eye on raw human drama. This was the year that Stanley Kubrick shot *Killer's Kiss,* a very low budget film noir that helped launch the independent revolution. Even the Technicolor films this year took on daring subjects: *Rebel without a Cause,* with James Dean; *Love Me or Leave Me,* with James Cagney giving his last great performance as a two-bit gangster trying to break into Hollywood; and Billy Wilder's *The Seven Year Itch,* with Marilyn Monroe, a comic look at marital infidelity (or at least the suggestions of it after the Production Code took the red pencil to the screenplay). And this was the year that Disneyland opened.

Europe

From Sweden, Ingmar Bergman scored his first major hit with American audiences with *Smiles of a Summer Night,* an eloquent period comedy of manners about love affairs among high society and the peasant class. Bergman's film owes a small debt to Jean Renior's *The Rules of the Game.* In fact, when Stephen Sondheim was searching for a story to adapt into a musical he was torn between these two films. He finally settled on *Smiles of a Summer Night,* which became the Broadway hit *A Little Night Music.*

From England, Lawrence Olivier delivered his third Shakespearean production, *Richard III,* which he produced, directed, and starred in. Alec Guinness donned a set of false crooked teeth to play the creepy but hilarious mastermind of a gang of inept robbers in *The Lady Killers,* who all meet their comical doom because of a sweet little old lady. A young Peter Sellers is a member of the inept gang, along with Herbert Lom; they would later appear together in the Pink Panther series as Inspector Clouseau and the perpetually frustrated Commissioner Dreyfus.

David Lean's *Summertime,* released in England as *Summer Madness,* gave Katharine Hepburn one of her finest roles as a spinster schoolteacher visiting Venice, who falls in love with a married man. It was shot entirely on location in beautiful Technicolor by Jack Hildyard, who had worked with Lean on *The Sound Barrier* and *Hobson's Choice,* and would be the cinematographer for *Bridge on the River Kwai. Summertime* became Lean's most successful film up to this point and allowed him to work with a major studio star, who praised him as a director. This became a turning point for Lean, who truly enjoyed the adventure and challenge of shooting in foreign countries. All of his future films became identified with remote locations that were incredibly shot, like *Lawrence of Arabia* and *Doctor Zhivago,* a look that not even the best Hollywood movies could match. *Summertime* give Lean the opportunity to work with American producers on large budget projects-the first English director to break into the Hollywood studios since Alfred Hitchcock.

Henri-Georges Clouzot and Les Diaboliques

Two excellent thrillers came out of France this year. Jules Dassin had gone into self-imposed exile in 1950 because of the HUAC hearings. He made *Night and the City* in London, then moved to Paris, where he took over the directing reins on *Rififi,* a film noir about a jewel caper that goes wrong. The highlight of *Rififi* was a twenty-two minute suspense sequence of a jewel robbery done in complete silence. Dassin was well-known by French critics for his earlier efforts in this genre, especially *The Naked City,* and now he was doing quality work in Paris. The timing of this had an influence on the future directors

Les Diaboliques (1955) directed by Henri-Georges Clouzot, with Simone Signoret and Vera Clouzot, based on the novel by Pierre Boileau and Thomas Narcejac. Two years before Clouzot rose to international attention with the action thriller **The Wages of Fear,** now with a suspense film of murder and betrayal he was called the "new Alfred Hitchcock." This set into motion a series of events that lead to **Vertigo** and **Psycho.**

of the New Wave who were big fans of the American crime film.

Henri-Georges Clouzot was called the French Alfred Hitchcock and his *Les Diabolique,* based on the novel by Pierre Boileau and Thomas Narcejac, had a surprise twist that even the Master of Suspense had not been able to pull off. This bizarre tale of sexual intrigue and murder is about a sadistic headmaster at a school for boys who makes life a living hell for his wife, Vera Clouzot, and his mistress, played by Simone Signoret. The two women join forces in a plot to kill him and make his death look like an accident. They are successful after a near bungled attempt and sink his body in the school swimming pool that is overgrown with vines. When the pool is cleaned for the new semester the women discover that the body has disappeared. From this point on *Les Diabolique* becomes truly frightening, building up to a climax that left audiences screaming. The final credits end with the cautionary request, "Don't be diabolical yourself. Don't spoil the ending for your friends by telling them what you've just seen. On their behalf—Thank you!"

Les Diabolique has become a classic that has held up remarkably well over the decades, becoming one of the best Hitchcock films that Hitchcock did not direct. The film was low budget and shot in black and white, with the use of dark shadows creating an uncomfortable sense of reality. At this time Hitchcock had started using Technicolor, and though he was at the top of his game, movies like *To Catch a Thief* and *Rear Window* had the studio look of perfection, whereas *Les Diabolique* was uncharted territory. Since there was a challenger to his suspense title, he decided to make a film that would be even more frightening.

Hitchcock bought the rights to *d'Entre les Morts,* written by the same team that wrote the novel *Les Diabolique* was based on, and renamed it *Vertigo*. But the cinema gods threw Hitchcock

a strange curveball: *Vertigo* was a box office failure when it was released and did not scare the wits out of audiences. Vertigo would become the Hitchcock film that has been written about the most, and considered by many critics as his greatest, but at the time it looked like the master had lost his touch. So, Hitchcock kept looking for a twisted tale of murder that he could do in the same style as Clouzot's little thriller, but with his own special surprise that would shock audience into a screaming frenzy. In 1960 he found the right film and reclaimed his title with *Psycho.*

1956

Changes in American Cinema

This was a year that foreign films and B-movies racked up some of the biggest box office totals and some Hollywood efforts were flops. Otto Preminger's screen version of the best selling novel *Bonjour Tristesse* by Francoise Sagan was killed by critics and ignored by audiences. Despite an all-star cast including Audrey Hepburn and Henry Fonda, King Vidor's *War and Peace* was a big-budget disappointment. And John Ford's *The Searchers,* which would become his most praised Western, left some of his fans cold because of the dark psychological theme of prejudice. The widescreen spectaculars that pulled in audiences were Cecil B. DeMille's remake of *The Ten Commandments* and *Around the World in 80 Days,* produced by the great showman Michael Todd.

Don Siegel's low-budget science fiction thriller *The Invasion of the Body Snatchers* had people afraid to fall asleep. Robert Wise's *Somebody Up There Likes Me,* based on the life of prizefighter Rocky Graziano, made a star out of Paul Newman (this was to be James Dean's next movie). Elia Kazan's *Baby Doll,* written by Tennessee Williams, ran into trouble with the

Roman Catholic Church and the Legion of Decency. And Stanley Kubrick attracted the attention of Hollywood with his film noir heist film *The Killing.*

Three of the biggest hits this year were all distinctly different from each other. The low-budget special effects thriller *Godzilla—King of the Monsters* from Japan was a smash at the drive-ins. The lumbering, fire-breathing creature from the depths of the sea that almost destroys Tokyo was the destructive result of atomic bomb testing. The one country that had experienced the horror of nuclear radiation had a strange love affair with Godzilla in the many sequels that followed. Eventually this indestructible, bad tempered creature became a hero that saved the people of Japan from even stranger monsters.

In complete contrast, the most talked about movie was from France. Roger Vadim's *And God Created Woman* introduced the world to "sex kitten" Bridget Bardot and filled the art houses night after night. But this was one foreign film where most men in the dark theatres did not read the subtitles. The scandalous reaction to B. B. (as the press referred to her) was unlike any foreign actress ever. No actress had ignited the screen with such a sexually charged presence since Louise Brooks in *Pandora's Box* or Jean Harlow in *Red-Headed Woman,* twenty-five years before on the eve of the Production Code. For months Bridget Bardot knocked Marilyn Monroe off the front covers of the movie fan magazines and quickly became the main attraction in Playboy.

But the surprise sleeper was *The Red Balloon,* a thirty-four minute film from France by Albert Lamorisse, shot almost like a silent movie, about a little boy who is followed around Paris by a large, bright red balloon. The ending had audiences weeping with tears of joy. *The Red Balloon* became an enormous hit with American audiences and was shown over and over again in some theatres for years. As a bit of irony, this was the first year that the Motion Picture Academy nominated three foreign films for writing: *The Lady Killers, La Strada,* and *The Red Balloon* were all competing with each other. *The Red Balloon,* the short film with only snippets of dialogue, was the winner, a true indication of how popular it was.

Frederico Fellini and La Strada

The neorealism movement came to a memorable crossroads this year. Robert Rossellini, who was at the forefront of the movement, had not had a successful film with audiences or critics for years. The press focused on his scandalous relationship with Ingrid Bergman and not on his directorial efforts. *Miracle in Milan* and *Umberto D.* were Vittorio De Sica's last films to attract international attention. He spent four years looking for funding in different countries without making a film, returning to Italy in 1960 to make *Two Women.* The examination of life's bleak realities by neorealism directors had begun to create a pattern that movie audiences were familiar with and thus associated these films with sad endings. The visions of people disappearing into crowds in the final shot, like De Sica's *The Bicycle Thief,* left little room for hope. But then Frederico Fellini made *La Strada* ("The Road"), and a new kind of cinema was born.

Fellini is one of the few filmmakers whose name has become identified with a certain style of movie, like Chaplin, Disney, Hitchcock, and Spielberg. Fellini had been one of the writers on Rosellini's *Open City* and *The Miracle,* and had minor hits with *Variety Lights* (1950) and *The White Sheik* (1952), but *La Strada* brought him overnight international fame. It has all the trademarks of Fellini's later classics, including circus themes, episodic storytelling, realism mixed with unexpected touches of surrealism, and is brutali-

ty counterbalanced by moments of tenderness and humor. These elements are brilliantly tied together with an infectious musical score by Nino Rota, which has the mood of 20s' jazz but can be best described as Felliniesque. The association between Fellini and Rota, who is best known for his score to *The Godfather Trilogy,* is surprisingly unusual in movies. Only Hitchcock and Bernard Herrmann, and Steven Spielberg and John Williams have had similar long-term relationships as director and composer. Rota's music give Fellini's films a sense of childlike magic that created a separate, slightly whimsical world that was part real and part make-believe.

La Strada is the story of a circus strongman, Zampano, played by Anthony Quinn, who buys a simple-minded girl, played memorably by Fellini's wife Giulietta Masina, from her impoverished family for a few lira. Together they travel from town to town performing for handouts. At first Zampano uses the girl to introduce his one-trick routine, but quickly she becomes the star attraction with her big-eyed clown act. Together they achieve a small proportion of success. *La Strada* is one of the most unusual love stories in the movies, yet one of the most tragic. The ending left audiences brokenhearted, talking about the symbolic significance of the characters, and yet with Masina's performance and Rota's music there is an overall underlying feeling of joy. Rarely had movie audiences been so uplifted by melancholy. *La Strada* was made in 1954 but not released in America until two years later. It became a box office phenomena, grossing more than any other foreign film up to this time, and became the golden goose for producers Dino De Laurentiis and Carlo Ponti. *La Strada* was the first film to win the year the Academy Awards created a separate foreign language category; it was the first of four Fellini films to take home this honor.

1957

Changes in American Cinema

Screen legend Humphrey Bogart died of cancer. This same year saw the loss of the aristocratic director/actor Erich von Stroheim and the great composer Erich Wolfgang Korngold. Playwright Arthur Miller was found guilty of contempt of Congress for refusing to name names in front of the HUAC committee, but humorously jabbed that the only thing on his mind was his upcoming marriage to Marilyn Monroe. Ingrid Bergman was forgiven for her carnal sins and makes a remarkable return to Hollywood features in *Anastasia,* winning the second of her three Academy Awards. Elia Kazan and *On the Waterfront* writer Budd Schulberg teamed up to mount an attack on the influential powers of television, which, from a contemporary viewpoint has proven to be incredibly perceptive. And features like *The Pride and the Passion, Saint Joan, Funny Face,* and *A Farewell to Arms* are being shot on location in Europe, with international casts, foreign crews, and investors from Italy, France, Spain, England, and other countries.

This was a year when foreign directors and new American directors, most of which were emerging from television, put a defining mark on Hollywood. Sidney Lumet who had directed dozens of live television shows, made his film debut with *Twelve Angry Men,* shot on a single room set over twenty days. Lumet pulled off a small miracle by giving this claustrophobic setting a sense of immediacy in a realistic drama about the difference that one man can make in the name of justice. Stanley Kubrick directed Kirk Douglas in *Paths of Glory,* a film heavily influenced by the techniques of the foreign cinema. Shot on location, Kubrick used long tracking shots, a mobile documentary look to the camera work, and natural lighting to tell a devastating

anti-war story about men who are executed to cover up the blunders of their commanding officers. *Paths of Glory* was banned in France and many other European countries, and on all U.S. military outposts and theaters.

British director Alexander Mackendrick, best known for his comedies *The Man in the White Suit* and *The Lady Killers* with Alec Guinness, made a blistering attack on the Walter Winchell world of gossip reporting in *The Sweet Smell of Success*. The film starred Burt Lancaster as the black-hearted J. J. Hunsecker, and Tony Curtis as his scrambling gofer. *The Sweet Smell of Success* was one of the first films to have a foreign director put a personal dark spin on the American way of life. Films that followed this tradition included *The Loved One* by Tony Richardson, *Midnight Cowboy* by John Schlesinger, *Deliverance* by John Boorman, and *Once Upon a Time in America* by Sergio Leone. Lancaster was one of the first actors to produce his own films and throughout the 50s balanced his action films, such as *The Crimson Pirate* and *Vera Cruz,* with movies that broke the Hollywood mold, like *The Sweet Smell of Success.* A great admirer of European directors, Lancaster did some of his best work on *Trapeze* with Carol Reed, *From Here to Eternity* with Fred Zinnemann, *The Leopard* with Lunchino Visconti, and *Atlantic City* with Louis Malle.

Foreign Cinema

Federico Fellini's next film, *Nights of Cabiria,* also starred his wife, Giulietta Masina, and for the second year in a row won the Oscar as best foreign language film. Cabiria is good-hearted but hapless prostitute in Rome who has never given up hope of finding the right man and true love. The film was turned into the Broadway musical *Sweet Charity.* In Paris, Claude Chabrol, a critic for *Cahiers du Cinéma* shot his first feature film, *Bitter Reunion.* Two years later, Francois Truffaut would be the next critic from the magazine to turn director with *The 400 Blows.* Also, in Paris, Charles Chaplin made *A King in New York,* which is in part a satirical attack on the House Un-American Activities Committee. After the devastation of World War II, the Polish cinema slowly came back to life, lead by Andrzej Wajda, whose second film, *Kanal* was about the heroes of the 1944 Warsaw uprising. The films by Polish directors would begin to chip away at the suppression of Communism, in much the same way the social films in America were tackling the issues of race. In *Throne of Blood,* starring Toshiro Mifune, Akira Kurosawa set Shakespeare's *Macbeth* in medieval Japan. This is one of the most visually haunting films of the master director's career, with an action climax that is still unrivaled in most modern movies.

The Bridge on the River Kwai

Perhaps the single defining motion picture that shows the crossover influence of English and European films on America cinema is David Lean's *The Bridge on the River Kwai.* Shot on location in Ceylon for over ten months, the film had a look about it that is still unequalled in movies. After this, no film could call itself an epic without matching the challenges that Lean and his cinematographer Jack Hildyard faced and conquered. *The Bridge on the River Kwai* was made despite the adversity of jungle heat and humidity, the construction and destruction of several bridges, and the task of creating a supply line that was the equivalent of a major military operation. There was even a short-lived mutiny by the crew and part of the cast because of the almost intolerable working conditions. Produced by Sam Spiegel, following his successes of *The African Queen* and *On the Waterfront,* the film was purely British except for William Holden and the two screenwriters, Michael Wilson and Carl

*David Lean shot **The Bridge on the River Kwai** in the jungles of Ceylon over eight grueling months. Since he worked slowly and would take days to set up shots, his crew almost mutinied against him. The end result changed the look of future movies.*

Foreman, who did not receive credit because of the blacklist.

But it was not the use of locations and the sense of realism that made *The Bridge on the River Kwai* a turning point in films, it was the psychological war and not the physical one that dominated much of the action. Epics up to this point had attempted to bring the stories of the Bible to life, or were two-dimensional adaptations of classics like *War and Peace,* that used the source material as a backdrop for battles, races, romance, or the conflict of religious faith. The characters often talked in a watered-down imitation of Shakespearean prose, and generals would wear metal helmets all day but their hair would be perfectly combed when they removed it.

Lean's film is a mental battle between two stubborn men over the issues of self-respect and personal glory, and the only real action happens in the last ten minutes after a two-hour build up. Alec Guinness' Colonel Nicholson is an insanely proud man who plays by the rules of war to the point that his heroic efforts causes him to collaborate with the enemy on building a bridge that will stand the test of time instead of collapsing when the first Japanese train crosses it. Coun-

terpoint to Nicholson's story are the efforts of an elite small group on an impossible mission to blow up the bridge. The excitement of *The Bridge on the River Kawi* comes from complex characterizations and the carefully crafted elements of suspense. After this there was a change, where epics focused on people and not solely on events and special effects, as in *The Guns of Navarone, Spartacus,* and Lean's *Lawrence of Arabia.* This redefining of the Hollywood epic has continued over the years, with *Gandhi, Dances with Wolves, The Last Emperor,* and *Braveheart.*

Ingmar Bergman, The Seventh Seal, *and* Wild Strawberries

Ingmar Bergman had been directing films since 1946, and scored minor hits with *Summer with Monika* and the chamber comedy *Smiles of a Summer Night.* But with *The Seventh Seal* and *Wild Strawberries,* two diversely differently films, Bergman-mania began in art houses, coffee shops, and college campuses. Bergman's transformation into a great filmmaker was simply extraordinary. There were hints in his early films, and he had been, from the beginning, an

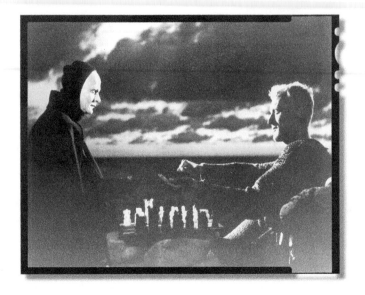

The Seventh Seal (1957) directed by Ingmar Bergman, with Max von Sydow, Bibi Andersson, and Bengt Ekerot as Death. Bergman had made over a dozen films in his home country of Sweden, but starting with this tale of a knight who challenges the Grim Reaper to a game of chess during the Black Plague he became one of the most studied directors in foreign cinema.

expert stylist in the cinematic arts, but suddenly in one year he wrote and directed two films that were highly original and profound. They were the ideal movies for a time period when poets tapped into the unrest of the younger generation and philosophy was being read like it was pulp fiction. Bergman's films were *about something,* and the agony of the artist trying to find meaning to life was brilliantly displayed on the screen.

Arguably the most famous Bergman film is *The Seventh Seal,* the story of a knight, played by Max von Sydow, and his squire returning to their homeland in Sweden after the Crusades only to be confronted by the personification of Death. The knight challenges Death to a game of chess, and as long as he is winning he can stay alive. In the Middle Ages touring plays depicting Heavenly Angels, Death, and the Seven Deadly Sins were enormously popular, and often sponsored by the Church to win over souls. Bergman captures this era in its customs, lifestyle, rich language, bawdy humor, and the pursuit of religious salvation. The film looks like a Renaissance tapestry that has come to life. But the true strengths of the film are the magnificent performances that bring a sense of reality to these classically drawn characters and leave the audience with the feeling they have stepped back into a different age, far removed from Cecil B. DeMille and Technicolor Hollywood. One of the tests of greatness for a film is the ability to remain unique over the decades. *The Seventh Seal,* despite the fact that the figure of Death has been parodied in Woody Allen's *Love and Death,* Monty Python's *The Meaning of Life* and many other films, remains an unparalleled singular vision.

Wild Strawberries is the story of a journey by an aging professor to Lund University to receive his anniversary title. He decides to drive the long distance, which triggers memories of his past. All of Bergman's films are about something, whether characters are questioning the existence of God, examining the complexity of personal relationships, or searching for a purpose in life. In *Wild Strawberries,* the professor, wonderfully played by Victor Sjostrom, begins to see that his life is full of lost opportunities. The film was very popular when it came out, during a time when a leisurely pace was not considered a major flaw, but its enduring impact is because of the cine-

matic tricks Bergman played. He opens with a dream that turns into a nightmare about death. On the journey, the professor sees visions from his past and he interacts with them. The present is blurred with the past, and time becomes confused like old memories returning to life.

Many of these techniques go back to the silent era and German Expressionism, but they had not been used successfully by directors for decades, except in horror movies or three-hand-kerchief romances. In *Wild Strawberries* these dreams and tricks of time give the audience a deeper understanding of the character without resorting to long passages of dialogue. Soon afterwards other directors began to experiment with the cinema techniques that Bergman had dusted off and revised. The following year, Alfred Hitchcock created a Technicolor nightmare for James Stewart in *Vertigo*, and John Frankenheimer masterminded the ultimate surrealistic reoccurring dream for Frank Sinatra in *The Manchurian Candidate* (1962).

1958

Changes in American Cinema

This was a year that began to blur the lines between foreign cinema and American movies. More big budget Hollywood features were shot in Europe, like Vincente Minnelli's *Gigi*, *The Young Lions*, based on Irwin Shaw's best-selling novel, starring Marlon Brando as a morally conflicted Nazi soldier, and *The Inn of the Sixth Happiness* with Ingrid Bergman. Complex sexual desires steamed up the screen between Paul Newman and Elizabeth Taylor in Tennessee Williams' *Cat on a Hot Tin Roof*, directed by Richard Brooks. Susan Hayward played condemned murderess Barbara Graham in *I Want to Live!*, shot in documentary style by director Robert Wise.

And Alfred Hitchcock made *Vertigo*, the French novel by Pierre Boileau and Thomas Narcejac, the same authors of *Les Diabolique*. Unfortunately for the Master of Suspense, his film about obsessive love proves to be a box office disappointment. American audiences had expected a cat-and-mouse spy thriller and were uninterested in the dark tale of a man who tries to transform a woman into the living image of his dead lover to arouse his sexual desires. Not surprisingly, the critics of *Cahiers du Cinéma* declared the film a masterpiece, and long lines formed outside Parisian movie houses.

The greatest irony of this year has to be given to Orson Welles, who directed *Touch of Evil*, his first American movie since *The Lady from Shanghai* and *Macbeth* over a decade before. Besides Welles, the film starred Charlton Heston, Janet Leigh, and Marlene Dietrich. It was Heston who talked Universal Studios into letting Welles direct, which the creator of *Citizen Kane* did for free, simply for the opportunity to get behind the camera once more for a major studio. For years Welles had lived in self-imposed exile in Europe, going where the work was to raise money for his own film projects. He became the reverse of European directors like Billy Wilder and Alfred Hitchcock. Welles was the brilliant young American director forced to leave his own country and become part of the cinema revolution going on in Italy, France, and England. *Touch of Evil* is full of handheld camera work, long tracking shots, and gritty, unglamorous locations. It is by all appearances a foreign film shot within the Hollywood studio system.

Welles, under the noses of the executives, made a dark and bizarre film about crime and corruption in the tradition of film noir; in fact, *Touch of Evil* has come to represent the end of the road for the noir movement. The film opens with an incredible tracking shot that follows a car with a bomb inside the trunk as it cruises

down the streets of a Mexican border town (which is actually the deteriorated city of Venice, California) before it explodes. There is a brutal murder shot entirely by a lightweight handheld camera brought over from Germany. Welles later joked that he was not trying to be innovative, these techniques allowed him to shoot fast on a very low budget.

Universal was not impressed with Welles' cinematic tricks and felt that *Touch of Evil* was a disaster and could possibly harm the box office potential of its stars. The film was re-edited and finally released as a second feature in the drive-in circuit. But as often happens in the unpredictable world of cinema, *Touch of Evil* became a hit in Europe, winning top honors at the Brussels film festival. Despite the fact that Welles publicly disowned the film after it was re-cut, *Touch of Evil* became almost a visual textbook for members of the French New Wave, including Jean-Luc Godard and Francois Truffaut, who saw it as a confirmation of the Auteur Theory.

Foreign Cinema

In England, Alec Guinness followed up his triumph with *The Bridge on the River Kwai* with *The Horse's Mouth,* based on Joyce Cary's novel about a volatile mad genius of an artist. Guinness played the robust central character with obvious great affection, and received another Academy Award nomination, this time as the screenwriter. Hammer Films released the Technicolor *Horror of Dracula,* starring Peter Cushing and Christopher Lee, which followed on the heels of *The Curse of Frankenstein* made the year before. These gruesome films put the horror back in horror movies and played for months at almost every drive-in in America. They were the start of one of the most successful series of films to come out of England. The two stars of Hammer Film would find an admirer in George Lucas and enjoy late career popularity in the *Star Wars* franchise. And Peter Jackson would give Christopher Lee the pivotal role of Saruman the White in *The Lord of the Rings* trilogy.

Arguably the most influential movie 1958 was *Carry on Sergeant,* the first in the long line of "Carry On" comedies that were enormously popular and beloved in England. These cheerfully irreverent comedies were a poke in the eye to what would be later referred to as the Establishment. Very English in nature, the "Carry On" comedies played well in art houses near college campuses when they crossed the Atlantic. The British always had a knack for satire, and playwrights like George Bernard Shaw and Oscar Wilde made a high art form of it. But in America satire usually fell on its face or became dark and mean-spirited. Only a few American directors mastered it, like Ernst Lubitsch, Preston Sturges and Billy Wilder, but these men had been raised on European culture. The "Carry On" movies arrived when college students considered Mad Magazine and the Harvard Lampoon required reading. *Carry on Sergeant, Carry on Nurse, Carry on Teacher, Carry on Constable* and all the others unquestionably planted the seeds for future American comedies that used barbed humor and broad satire to make fun of society's sacred cows. These playful satires put a new twist on the concept of the lunatics running the asylum. The beneficiaries of the "Carry On" movies include *M*A*S*H, Animal House, Airplane, National Lampoon's Vacation, Police Academy,* and literally hundreds of others.

From France, Jacques Tati won an Academy Award and international praise with *My Uncle.* Tati was the comic mastermind behind *Mr. Hulot's Holiday,* and this time used his eccentric madcap character to satirize the middle class fascination with modernity. Louis Malle leads the movement of new French directors with the styl-

ish crime thriller, *Frantic,* also known as *Elevator to the Gallows,* starring Jeanne Moreau, with an intense jazz score by Miles Davis. Malle also shocked audiences with *The Lovers,* a sexually explicit film about a night of erotic love between a married woman and an archeology student. Starring Jeanne Moreau, the actress who would become most closely identified with the New Wave Movement, *The Lovers* was praised by Francois Truffaut as "the first night of love in the cinema." It won the Special Jury Prize at the Venice Film Festival, and was of course vigorously condemned by the Catholic Church.

Andre Bazin, considered the greatest and most influential critic of his era, dies of leukemia at the age of only forty in Paris. He was a contributor to *Cahiers du Cinéma,* the magazine he co-founded in 1951. Bazin formulated the concept of "objective reality," as opposed to Eisenstein's theory of montage, and championed such directors as William Wyler, Orson Welles, Jean Renoir, and Erich von Stroheim. Andre Bazin represented a brief time period when theories about the art and affect of cinema were debated with the same heated fever as international politics.

In Moscow, the second part of Eisenstein's *Ivan the Terrible* is shown. The epic film had been banned since 1946. From Warsaw, Poland, Andrzej Wajda completed his World War II trilogy with *Ashes and Diamonds,* the story of a political assassin whose life is changed by the chance meeting of a woman he falls in love with the night before he is to kill the new Communist district secretary. And from Sweden, Ingmar Bergman directed *The Magician,* starring Max Von Sydow, about a traveling troupe at the turn of the twentieth century that claims to provide miraculous cures but comes under suspicion by the local police and medical examiner in a small town. Bergman quite literally uses the metaphor of smoke and mirrors to explore the potential powers of the artist to play God.

From Japan, Akira Kurosawa directed *The Hidden Fortress,* a tale of two arguing petty thieves going through no-man's land in war-torn medieval Japan. With the belief they will be rewarded in great sums of gold, the bickering friends agree to help escort a mute woman and her ill-tempered male companion through enemy lines to safety. Not until late in their journey do they discover they are actually escorting a princess and her samurai general. George Lucas, a young fan of *The Hidden Fortress,* borrowed the structural skeleton of Kurosawa's plot and turned the two thieves into C-3PO and R2-D2, and transformed the arrogant, sharp-tongued women into Princess Leia in *Star Wars.* The samurai became the Jedi Warrior Obi-Wan Kenobi. This completed a cinematic cycle of East meets West, where cowboy movies influenced samurai epics and then these epics are transplanted to a galaxy far, far away. Lucas later repaid his debt to Kurosawa by being an executive producer on *Kagemusha* (1980).

1959

Changes in American Cinema

By 1959 foreign films had become a natural part of the average moviegoer's routine. The Hollywood Studios were struggling, still trying to figure what audiences wanted, but this turned out to be a red-letter year for American and foreign films. For a brief few years ticket sales for foreign features and studio releases were almost equal. This had never happened before, and would be sadly short lived, ending toward the late 1960s when, ironically, the directors of the New Hollywood began to make the equivalent of foreign influenced films within the crumbling walls of the Studio System. By the early 1980s this equal balance between foreign and American movies was becoming a distant memory,

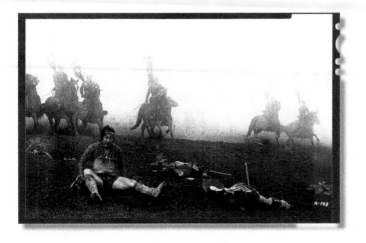

The Hidden Fortress (1958) directed by Akira Kurosawa, with Toshiro Mifune and Misa Uehara as Princess Yukihime. Played for comedy against an epic backdrop, two greedy, constantly bickering peasants agree to help a mysterious man and a mute woman across no-man's-land with the promise of gold. It turns out that the two strangers are a princess and her general stranded in enemy territory.

where today it is a minor miracle to see a single foreign feature in a sprawling Cineplex.

The revival cinema movement was in full-swing and it was not uncommon for large cities to have twenty or more theatres running the newest, controversial foreign films, retrospectives of outstanding directors, or a marathon of old Hollywood classics. International film festivals had brought attention to outstanding movies from all over the world. The critics of *Cahiers du Cinéma* heatedly argued the lifetime achievements of certain directors, many of whom could no longer find work in Hollywood. The Auteur Theory was discussed as much as Fidel Castro's recent coup d'etat in Cuba. The general public's expectation of foreign films was that they were provocative, sensual, violent, and unpredictable, and rarely was anyone disappointed with this assessment.

As an example of this balance of foreign and American films, the Academy Award nominations for original screenplays this year were *Pillow Talk, North by Northwest, Operation Petticoat, The 400 Blows* (France), and *Wild Strawberries* (Sweden). The winner was *Pillow Talk*. In 1960 the nominations were *The Facts of Life, The Apartment, The Angry Silence* (England), *Hiroshima, Mon Amour* (France), and *Never on Sunday* (Greece). The winner was *The Apartment*, by Austrian-born director Billy Wilder. And in 1961 the nominations

were *Lover Come Back, Splendor in the Grass, General Della Rovere* (Italy), *La Dolce Vita* (Italy), and *Ballad of a Soldier* (Russia). The winner was *Splendor in the Grass.*

It is inconceivable that back in 1939 people would come out of movies like *Mr. Smith Goes To Washington, Goodbye, Mr. Chips,* or *The Wizard of Oz* and talk about philosophical subversive messages, the use of handheld cameras, flash-forwards, dazzling editing techniques, the casting of non-professional actors, and the director's eye for unexpected camera angles. These were topics of discussion that suddenly became part of the foreign film invasion into America. This influence had now come full circle, from the 1930s when directors escaped from Europe during the rise of Nazism to the safety of Hollywood. And this was followed by the renaissance of European and Japanese directors who stayed home after the war and exported films to America that provided uniquely different viewpoints.

Hollywood had something for everyone this year, despite the fact that most of the films were shot elsewhere. MGM literally banked everything on *Ben-Hur,* giving audiences one of the greatest thrills ever with the brilliantly conceived chariot race. The profits pulled the studio out of the red ink and captured eleven Oscars in the process. The film was shot on location in Italy. Fred

Zinnemann made *The Nun's Story* with Audrey Hepburn, and shot it in Rome, Belgium, and the Congo jungle. Otto Preminger pushed the envelope of the Production Code with *Anatomy of a Murder,* starring James Stewart as a small-town lawyer in a controversial rape trial. The film was shot in Michigan. Howard Hawk's rip-roaring western, *Rio Bravo,* with John Wayne, was shot in Old Tucson. Billy Wilder's hugely successful sexy comedy *Some Like It Hot,* about a couple of Jazz Age musicians who dress up like women to escape from gangsters only to run into Marilyn Monroe, was shot mostly on Coronado Island. And Tennessee Williams' *The Fugitive Kind,* which teamed up acting legends Marlon Brando and Anna Magnani, cheated the look of the decadent modern south by shooting in Milton, forty miles from New York City.

The expansive studio back lots were now deserted most of the time, occasionally rented out for television shows. The significance of this is profound; it reflects the changing of the guard in Hollywood from a system that was overseen entirely by the producer to one where the director had the lion share of control. The director was now omnipotent and quite often on locations served in both roles. The total vision that directors had in Europe and Japan since the end of World War II was becoming commonplace in American features. There were still some films shot entirely within the studio, but the days when Louis B. Mayer or Jack Warner could stroll the studio grounds and check on every production were gone forever. Auteurism was no longer a theory but a reality.

Foreign Cinema

Outstanding films came out of almost every country this year. From England, Jack Clayton directed *Room at the Top,* the hard-knock story of a social climber, played by Lawrence Harvey, who sacrifices true love to marry the boss' daughter. The film broke new ground for its sexual candor, chipping away the base of the Production Code. *Room at the Top* was nominated for Best Picture and won Academy Awards for its screenplay. Simone Signoret won Best Actress for her role as the worldly but doomed mistress, becoming the only French actress to be so honored. John Osborne's hit play *Look Back in Anger* was brought to the screen by Tony Richardson. The character of Jimmy Porter, played by Richard Burton, began a rebellious phrase in English theatre with the "angry young man" character in what became know as "kitchen sink dramas" about the social lower class. The collaboration between Osborne and Richardson would continue the following year with *The Entertainer,* giving Laurence Olivier one of his greatest contemporary roles, and then three years later with *Tom Jones,* which earned both of them Oscars and also took home the statue for Best Picture.

From Italy came *Big Deal on Madonna Street* by director Mario Monicelli, a spoof of heist films like *Rififi* and *The Asphalt Jungle,* about a completely inept gang that tried to pull off a simple robbery of a pawnshop. Everything goes wrong, creating in the process a small comedy masterpiece that has inspired other bungling crime capers over the decades. One of the ill-fated gang members is played by Marcello Mastroianni, who would become an international heartthrob the following year in *La Dolce Vita.*

In India, the great director Satyajit Ray made *The World of Apu,* completing what became known as the "Apu Trilogy," which included *Pather Panchali* and *The Unvanquished.* Ray had been inspired by De Sica's *The Bicycle Thief* while he was visiting London and returned to his home in Calcutta to raise money for *Pather Panchali,* based on a book he had helped illustrate. Not able

to secure funding and encouraged by Jean Renoir who was making *The River* in India at the time, Ray risked everything he owned, including his wife's jewels, to make the film. At his lowest ebb, he had decided to abandon the film when the Bengal government unexpectedly offered to provide the funds to complete the project. *Pather Panchali* was enthusiastically received at the 1956 Cannes Film Festival and surprised critics when Ray won the special jury prize. Kuroshawa's *Rashomon* nine years before had opened the doors of Japanese cinema to Western culture. Satyajit Ray's *Pather Panchali,* and the other films of the "Apu Trilogy," did the same for the emerging Indian cinema. Today the Indian film industry makes thousands of films each year and has been given the nickname Bollywood.

From the German cinema came the powerful and deeply haunting anti-war film *The Bridge* by Bernhard Wicki. Ironically, one of the first films to come out of the German cinema in almost a decade, it showed the devastation of war when a group of young soldiers in their mid-teens were told to defend a bridge at all costs with disastrous results.

And from Russia a new series of films were being made after the death of Stalin. Grigori Chukhrai directed *The Ballad of a Soldier,* the story of a young man in the army on a four-day leave from the front during World War II. He travels on train, truck, and foot just to see his mother. During the long journey he visits with people who have been adversely affected by the long war, and by chance he meets a girl with whom he falls in love. Chukhrai created memorable visual images, like in his widescreen epic *The Cranes Are Flying,* shot two years before. In *The Ballad of a Soldier* he unfolds his story simply, without forcing the obvious hardships of the Russian people on the audience. He succeeds in presenting a touching re-creation of daily life that is caught in the middle of a great military con-

flict. This film obviously would never had been made if Stalin was alive.

The French New Wave, Francois Tuffaut, and 400 Blows

This was a landmark year in French cinema, arguably the most important ever. Jean Cocteau accompanied the "hot-heads" of the New Wave to the Cannes Film Festival in May of 1959. At the age of seventy, Cocteau had become the mentor of this passionate, out-spoken group who behaved like students who had just seized control of the school. The critics of *Cahiers du Cinéma* were there, including Jean-Luc Godard, Claude Chabrol, and Francois Truffaut, as well as Roger Vadim, Alain Resnais, and Marcel Camus. The New Wave had been a powerful force in film criticism. Now these critics began to practice what they preached and got behind the camera. As the New Wave took off, the neo-realism movement slowly came to an end, but it had started a revolution that could continue for another twenty years.

This was Truffaut's year. He had directed his first feature, *The 400 Blows,* and was given Best Director honors. *The 400 Blows* was an autobiographical film that follows the misadventures of a twelve-year-old boy in Paris. Antoine Doinel, played to heartbreaking perfection by Jean-Pierre Leaud, was neglected by his mother and stepfather. He played truant, got involved in a series of petty crimes, and ended up in reform school. From there he escaped and headed to the coast. The film concluded with the boy staring forlornly at the misty waves, possibly considering the repercussions of his new freedom. This final image was captured in a freeze frame, which was considered quite revolutionary and striking.

Jean-Pierre Leaud would play Antoine Doinel five times, including in *Stolen Kisses* and

The 400 Blows (1959) directed by Francois Truffaut, with Jean-Pierre Leaud as Antoine Doinel, is an autobiographical film about Truffaut's boyhood and his encounters with the law. It helped launch the French New Wave and showed that movies did not need to be based on popular books and plays, but could come from very personal stories.

Bed and Board, which can be looked upon as cinema chapters in Truffaut's own life. Federico Felllini would also tell parts of his life story on the screen using Marcello Mastroianni as his alter ego. Artists had written autobiographies, painted self-portraits, and even created fictional characters based on their personal lives, like Charles Dickens with *David Copperfield* and Ernest Hemingway's Nick Adam stories. For the artist to turn his life into a movie was something new and a breakthrough in cinema.

The freewheeling camerawork, combined with on location shooting and a story that was part of the director's memory, all became instrumental in defining the New Wave. The young French critics of *Cahiers du Cinéma* became movie directors, which had never happened before, and were the first to voice an opinion of what makes a great director and what the vital essence of film is. Because as critics they studied the shot-by-shot process of great films, they understood film technically and as an art form, unlike what evolved in later years when film was reviewed purely for its entertainment value. They argued that film was the ultimate expression of art, and these ideas were passionately gobbled up by a new generation of filmmakers growing up in America.

Alain Resnais' *Hiroshima, Mon Amour* is a film that is either declared a masterpiece or absolutely hated by audiences. It tells the story of a brief love affair between a young French actress and a Japanese architect, both with haunting memories from the past. Though much of the film is a long conversation between this complex couple, Resnais mixes past memories with the present, using montage images of the devastation of Hiroshima and the specter of a last love affair. *Hiroshima, Mon Amour* breaks from the orderly linear structure of Hollywood films and plays games with time, something that Resnais takes to extremes in his most famous film *Last Year at Marienbad* made two years later. Unlike the naturalistic approach to story in neorealism that does not intrude on the characters, the members of the New Wave symbolically burnt the filmmaking textbook and experimented with style on all levels.

Black Orpheus by Marcel Camus won the Golden Palm at Cannes this year. *Black Orpheus* was filmed on location in Rio de Janeiro using the carnival as a backdrop for the modern telling

of the Greek myth about Eurydice and Orpheus in the underworld. It is a magical tale, beautifully shot in rich Technicolor, with an all-Black cast. The music by Luiz Bonfa and Antonio Carlos Jobim is infectious, perfectly capturing the feeling of carnival and dance. The movie soundtrack became a huge international hit, one of the first movie albums to sell over a million copies, and the theme song "Carnival Time" was played for months on the radio. *Black Orpheus* became the most successful foreign film in the world, a distinction that was short-lived, losing this honor to *La Dolce Vita,* released the following year.

1960

Changes in American Cinema

If one year could be hailed as the fall of the old Studio System and the rise of the New Holly-wood, this would be that year. This was the year of *The Alamo, Sons and Lovers, Spartacus, Never on Sunday, Exodus, La Dolce Vita, The Misfits, The Sundowners, Psycho, Saturday Night and Sunday Morning, L'Avventura, The Apartment, Two Women, Elmer Gantry, The Virgin Spring, The Entertainer, Inherit the Wind, Breathless, Butterfield 8, Shoot the Piano Player,* and *The Magnificent Seven* (based on *Seven Samurai*). Of these films, only five were shot principally on Hollywood sound stages.

All of the directors that were nominated for the Academy Awards were foreigners, either living in a foreign country, like Jack Cardiff (*Sons and Lovers*), from England; Jules Dassin (*Never on Sunday*) who had gone into self-imposed exile during the blacklist and was living in Greece; or directors from a foreign country who had relocated to Hollywood, including Alfred Hitchcock (*Psycho*), Billy Wilder (*The Apartment*), and Fred Zinnemann (*The Sundowers*). Ingmar

Psycho *(1960) directed by Alfred Hitchcock is the most famous example of an American movie in this era that was heavily influenced by the revolutionary changes happening in world cinema.*

Bergman's *The Virgin Spring* won for Best Foreign Language Film.

Englishmen Freddie Frances won for his black-and-white cinematography on *Sons and Lovers,* and Peter Ustinov won for supporting actor on *Spartacus.* Laurence Olivier, who had directed and starred in *Henry V* in 1944, was nominated for Best Actor in *The Entertainer* and played Kirk Douglas' political and military foe in *Spartacus.* Also, in *Spartacus* was Charles Laughton, the first British actor to win the Academy Award and Jean Simmons who made her film debut in *Hamlet,* directed by Olivier. Trevor Howard, who achieved international fame from David Lean's *Brief Encounter,* was nominated as Best Actor for *Sons and Lovers.*

From Greece, composer Manos Hadjaidakis won for Best Song, "Never on Sunday," and Melina Mercouri was nominated for her role in that film. Two foreign language films that were made in 1960 but not released in America until the following year also received nominations and awards. *La Dolce Vita* was nominated for art direction, costume design, screenplay, and Federico Fellini as Best Director. And Sophia Loren won for Vittorio De Sica's *Two Women,* the only actress to win for a performance in a foreign language film.

Out of all these remarkable films, the one that created the biggest stir and the biggest box office success was Alfred Hitchcock's *Psycho.* Nominated for the fifth time, he lost to Billy Wilder for *The Apartment,* a cleverly done feature but lacking the ingenious touches of the Master of Suspense. "Always the bride's maid," Hitchcock would humorously lament, "never the bride." He lost to a director who was trained in German Expressionism, like he had been over thirty years before.

But there is even a greater irony associated with *Psycho* and this particular year. Hitchcock had never gotten over the reviews for Henri-Georges Clouzot's *Les Diaboliques,* which starred Simone Signoret, that impolitely referred to him as a has-been. He made *Vertigo* to show he could take a French novel and still scare the wits out of people. However, *Vertigo* failed at the box office. His next film was *North by Northwest,* the biggest hit of his career up to that point, but the old insult to his pride lingered. He continued to look for something to shoot cheaply in black-and-white with a major scare, like *Les Diaboliques* had with the bathroom sequence at the end of the film. In Clouzot's thriller, Paul Meurisse, the male lead, is killed off midway in the movie, or so the audiences assumed.

When Hitchcock read the galleys for Robert Bloch's novel *Psycho,* he knew he had found what he had been searching for. So, the biggest hit of 1960 was made by an English-born director, trained in Germany, moved to America, challenged by a French thriller, and who shot his movie in such an innovative fashion that it was declared a masterpiece by the young directors of the New Wave Movement. Hitchcock was sixty-one years old when he directed *Psycho* and shot it using the television crew from his popular program. Made for less than a million dollars, this one film became the signpost for a new era in Hollywood. There could be no better definition of the influence of foreign cinema on the Studio System than this.

By 1961, the next generation of directors that would reshape the movies began to take over. Most were trained in television or documentaries and raised on foreign cinema, like John Frankenheimer, Sidney Lumet, Norman Jewison, Richard Lester, Arthur Penn, Sam Peckinpah, Dennis Hopper, Peter Bogdanovich, William Friedkin, Hal Ashby, Clint Eastwood, and George Roy Hill. Roman Polanski would come to America, and Stanley Kubick would move to England.

Many of the foreign directors whose names became legendary continued to make important

films for decades. With the Italians, Federico Fellini would direct *8½, Juliet of the Spirits, Fellini's Satyricon,* and *Amarcord,* completing his twenty-fourth and last film in 1990, just four years before his death. Vittorio De Sica never returned to neorealism after *Two Women* but had international hits with *Yesterday, Today, and Tomorrow; Marriage Italian Style,* and *The Garden of the Finzi-Continis,* making his last film, *The Voyage,* in 1974, the year he died. Michelangelo Antonioni would make *Eclipse* and *Red Desert* in Italy, but he shot *Blow-Up* in England in 1966, which became a defining film of the 60s generation. By the late 1950s, Roberto Rossellini would direct mainly for television, no longer a force in the Italian cinema he helped create, and would have a minor success in 1966 when *The Rise of Louis XIV* was released in the theatres. Rossellini passed away in 1978.

For the French, Francois Truffaut would direct *Shoot the Piano Player, Jules and Jim, The Bride Wore Black* (an homage to Alfred Hitchcock), *The Wild Child,* and *Day for Night,* making twenty-six films before he died in 1984 at only fifty-two. As an indication of the fickleness of the short-term memory of cinema history, today he is best remembered for playing Claude Lacombe, the French scientist in Steven Spielberg's *Close Encounters of a Third Kind.* After the enormous success of *Breathless,* Jean-Luc Godard would never have another film that caused such an international sensation. Starting with *Pierrot le Fou* and *Weekend,* by the late 1960s his films became less structured and evolved as his own personal cinema essays on politics and the ills of society. He turned down many offers to direct in America, including *Bonnie and Clyde,* and remained in France. In 2004 Godard completed his eighty-eighth film, *Notre Musique.*

Akira Kurosawa would continue directing for thirty more years. *Yojimbo* was one of his biggest hits, remade by Sergio Leone as *A Fist Full of Dollars,* it spawned the "spaghetti western" genre. In 1970, after many aborted projects and the failure of *Dodes' Ka-den,* he attempted suicide. After his recovery, Kurosawa went to Russia and shot *Dersu Uzala,* a four-year effort shot mostly in Siberia, which won the Academy Award for Best Foreign Language Film. He continued his remarkable return to directing with *Kagemusha,* made with the support of George Lucas and Francis Ford Coppola as executive producers, and *Ran,* his adaptation of *King Lear.* Kurosawa died in 1998, leaving behind a legacy of films that had effected changes in international cinema unlike any other director.

Five of Ingmar Bergman's films, *The Virgin Spring, Through a Glass Darkly, Persona, Cries and Whispers,* and *Fanny and Alexander,* won Academy Awards as Best Foreign Language Films. His later films became almost obsessed with the metaphysical question of the existence of God and the isolation of the human spirit, reflected in *The Silence, Persona,* and *Shame.* With the television production of *After the Rehearsal* in 1984, Bergman retired from filmmaking but continued to write screenplays and direct in the theatre until 2004.

Foreign Cinema

Never in one single year did so many foreign films become enduring classics. In Italy, Vittorio De Sica made *Two Women,* his last film in the neorealism style, effectively marking the end of this movement. Unlike his earlier films, *Two Women* is set during World War II, instead of showing the hard aftermath that followed the war. It is the tragic tale of a mother and her teenage daughter that leave Rome to escape the bombardments, only to be brutally raped and abandoned by Moroccan allied soldiers inside a deserted church. Sophia Loren, who had been misused in a series of Hollywood comedies and

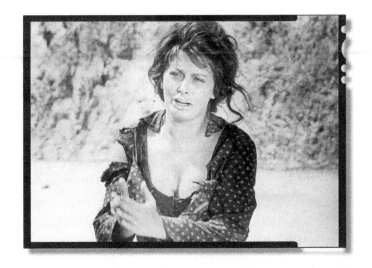

Two Women (1960) directed by Vittorio De Sica, Sophia Loren became the first actress in a foreign language film to win the Oscar. De Sica's realistic story of a mother and her 13-year-old daughter trying to escape the allied bombings of Rome has come to represent the last great film of Italian Neo-realism.

spectacles, gives one of the most powerful and realistic performances ever put on film. Under De Sica's inspired direction, *Two Women* is both harrowing and moving, ending remarkably with a promise of hope. The film stands as an emotional conclusion to a movement that began with *Open City* and *The Bicycle Thief.*

Never on Sunday, directed by exiled American Jules Dassin in Athens, turned Melina Mercouri into an international screen sensation. She played with delightful unbridled enthusiasm an unrepentant hooker who an American writer (played by Dassin) tries to unsuccessfully reform. *Never on Sunday* was shot mainly in English, with a musical score that makes the audience want to get up and dance, and is set in the picturesque port of Piraeus. The independent film was a huge hit and started a tourist stampede to Greece. Made the year the Hollywood blacklist came to an end, it undoubtedly gave Dassin enormous satisfaction to be nominated for his direction and writing, and for Mercouri (his wife) to receive an Oscar nod for her performance.

From England, came the most famous of the "angry young man" films, *Saturday Night and Sunday Morning,* directed by Karel Reisz, pro-

duced by Tony Richardson, and written by Alan Sillitoe, based on his best selling novel. This grim look at the blue-collar British factory town made a star out of Albert Finney. He plays the rough-edged nonconformist who treats everyone with equal disdain. Finney's performance was so strong and believable that David Lean asked him to star in *Lawrence of Arabia.* Finney went as far as getting his costumes fitted, but then turned down the role at the last moment to play instead the rowdy scoundrel in *Tom Jones,* directed by Richardson.

Ingmar Bergman's *The Virgin Spring* is the beautifully shot medieval folk legend of a beautiful young girl traveling through a forest to deliver candles for the church when she is viciously raped and murdered. Starring Max von Sydow as the vengeful father, *The Virgin Spring* is one of the few films that Bergman directed but did not write. However, it perfectly reflects his interest in the search for the meaning of God, and tells the emotionally inspiring story of a miracle born from despair and tragedy. *The Virgin Spring* became one of Bergman's most popular films and went on to win the Academy Award.

La Dolce Vita

Federico Fellini's *La Dolce Vita* ("The Sweet Life") opens with a helicopter transporting a large statue of Jesus followed by another helicopter with reporters and photographers, who temporarily break away from their pursuit to circle and try to get phone numbers from pretty women sunbathing on the rooftop. The film ends with a group of tired revelers after a wild all-night party, that strolls down to the sea to examine a strange creature, pulled from the water by fishermen, which has one eye that seems to stare at them with equal curiosity. *La Dolce Vita* is one of the most unforgettable, personal, and fascinating films ever made. As with many of Fellini's later films, it is told as a series of dramatic sequences revolving around the restless, misspent life of a reporter, Marcello, played to bewildering perfection by Marcello Mastroianni, and his persistent photographer sidekick, Paparazzo (the origin of the term "paparazzi"). Fellini's divine irony in *La Dolce Vita* is that while Marcello laments about the hollowness of his life, most people in the audience are envying his lifestyle, playing with the misfits of society. Underscored with Nino Rota's hauntingly playful jazz score, arguably one of the greatest every composed for the cinema, *La Dolce Vita* is a look at a bygone time in Rome that had the same fascination as Paris in the 1920s and New York in the early 50s.

Distributed by the legendary producer and presenter Joseph E. Levine, *La Dolce Vita* became the most famous and successful foreign film ever, a distinction it held for almost two decades, leaving a legacy of great movie moments, like Anita Ekberg wading in her black dress in the Trevi Fountain. A companion piece to Fellini's *I Vitelloni* (1953) that ends with the autobiographical character of Moraldo leaving his small village for the lights of Rome, *La Dolce Vita* follows Marcello, based on the young adventures of Fellini as a reporter before he turned to the movies. A recurring theme in films during these perplexing days of the Cold War was the question of "man alone" in a hostile world. *La Strada, La Dolce Vita,* and Truffaut's *The 400 Blows* all end with the protagonist gazing forlornly out to sea, an image that would later appear at the conclusion of *The Godfather, Part 2* with Al Pacino looking out at the still waters of the lake without an hint of emotion.

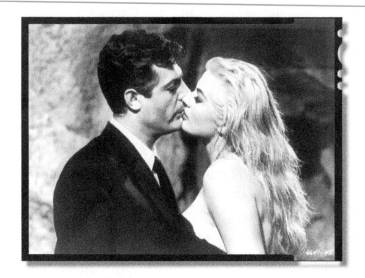

La Dolce Vita (1960) directed by Federico Fellini, with Marcello Mastroianni and Anita Ekberg, is about the misspent adventures of a capricious journalist in Rome, with his cameraman, Paparazzo, who tries to experience "the sweet life." Fellini's film about the divine decadence of Roman society became the first foreign blockbuster.

Michelangelo Antonioni and L' Avventura

L'Avventura was Michelangelo Antonioni's first international triumph and made a star out of actress Monica Vitti, who also appeared in *La Notte* and *L'Eclisse,* which comprise Antonioni's trilogy. *L'Avventura* caused a sensation and began a heated debate that continues in some circles today, as to whether or not Antonioni's film was a greater masterpiece than *La Dolce Vita, Breathless,* or *Seven Samurai. L'Avventura* created a hostile reaction at the Cannes Film Festival. Ultimately, when the furor settled down it was awarded a special jury prize for its remarkable contribution to the search for new cinematic language. *L'Avventura* had no strict story line. Three friends visit an uninhabited island for a brief vacation. After an argument with her boyfriend, one of the women disappears without a trace. The rest of the film is the search for her and the relationship between the surviving couple. *L'Avventura* seems to wander, has a slow pace, and at times is difficult to get through. But it is a film that lingers in the memory with almost dreamlike images. The honor it received at Cannes was very appropriate. *L'Avventura* is one of the most uniquely visual films ever made-one that seems to replay itself long after the theatre lights go up.

Jean-Luc Godard and Breathless

This was the year that the New Wave exploded on the screen. It had been building for several years, and Truffaut's *The 400 Blows* represents the first film of any significance that brought this movement to wide public attention. But it was *Breathless* by Jean-Luc Godard, the only critic of *Cahier's du Cinéma* who had not made a feature film, that hit an international chord. Everyone was talking about *Breathless,* and despite the fact that many other directors had used similar techniques, Godard's film became the lightning rod for a radically new cinema. *The 400 Blows* had been extremely popular in the art houses but there was something overwhelming about the reception *Breathless* received. *La Dolce Vita* and Breathless were the two MUST SEE films of the year, and the names of Jean-Paul Belmondo and Jean Seberg, the beautiful American actress who had been living in Paris, were whispered everywhere.

Breathless was inspired by Howard Hawks' *Scarface* and other Warner Bros. classic gangster

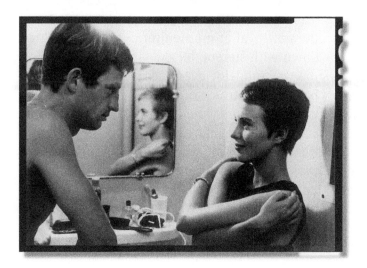

Breathless (1960) directed by Jean-Luc Godard, with Jean-Paul Belmondo and Jean Seberg, based on a true story, with Francois Truffaut, revolutionized filmmaking by deliberately breaking all of the established rules about editing and keeping the camera invisible. Godard's movie about love and murder was mostly improvised and shot entirely on locations around Paris.

movies, and was loosely based on the true story of a crime wave started by a man who killed a policeman. The impact of *Breathless* was the sheer brutality of its filmmaking style. Everything about it was done in defiance. Godard had made a film with no in between. If audiences liked it, then it was art, and if they don't, then to hell with 'em. It had brutal jump cuts-the kind of edits that were only seen in documentaries. While Belmondo is driving down a road there is an abrupt series of cuts that might be a second or two hours later. Godard broke the 180-degree line and at times left the audience without any orientation. The script was credited to Truffaut but it was really improvised on the spot by Belmondo, Seberg, and the other cast members. The sound was done on location with cheap microphones and would have been considered atrocious and amateurish by any studio chief. *Breathless* used flash-forwards and flashbacks. In fact, it used every possible cinematic technique imaginable. It was shot in close, cramped rooms with available light, and the camera was unsteady as the operator moved around trying to keep up with the action.

Breathless can be described as an elaborate home movie, and it changed the world as far as filmmaking. Its impact was the freedom of the camera and the idea that the director made the film the way he wanted without any apparent concern to play by the studio rules. While *La Dolce Vita* was the work of a master director with a very distinct style, *Breathless* gave the impression that anyone could be a director. This was not a put-down. *Breathless* made filmmaking seem accessible because suddenly it was not how slick the individual production elements were; instead it was all about personal expression.

Breathless paid homage to the old gangster films and film noir, which were as influential to Godard and many of the directors of the New Wave as Westerns had been to Kurosawa; but ultimately it was unique, a revisionist crime film.

As a kind of symbolic passing of the torch, at one point Belmondo goes up to a poster of Humphrey Bogart, stares at it, and then whispers under his breath "Bogie" in an almost sexual way, as if this rough faced icon was the one true god of the movies. The timing was perfect for Godard's done-on-the-quick crime film because people were looking for something new. *Breathless* is the film from this era that is cited over and over again by directors like William Friedkin, Arthur Penn, and Dennis Hopper. To them it blew the cobwebs off the old studio style and made the bold statement that the only rule was there are no rules.

MULTICULTURAL FILM AND WOMEN IN FILM

This era of foreign cinema eventually brought about a lasting change in the use of racial stereotypes, especially in American movies. Jean-Paul Belmondo, Simone Signoret, Yves Montand, Bridget Bardot, Anna Magnani, Sophia Loren, Marcello Mastrioianni, Jeanne Moreau, Toshiro Mifune, Harriet Andersson, and Max Von Sydow were all international stars, and they had been working with innovative directors in their own counties, making films about people in these countries. The casting practices in American films had changed enormously by 1960, and the portrayal of multicultural groups weighted down with stereotypical characteristics was on the way out. However, there were still drunken banditos, untrustworthy Arabs, and crime-loving Italians who would pop up from time to time.

The biggest factor that made these foreign films so representative of their cultures was the personal vision of directors that had not been trained in a movie factory environment. These directors had the opportunity to work closely for years at a time with the same writers and cinematographers. With only few exceptions, they re-

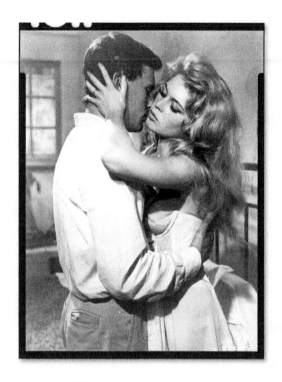

And God Created Woman *(1956) directed by Robert Vadim, made Brigitte Bardot an international sensation. While American movies were still in the grip of the Production Code, Bardot's unabashed sexuality was explosive to audiences where this kind of screen love-making had not been seen for twenty-some years. The term "sex kitten" is frowned upon today, but Brigitte Bardot's sense of womanhood lit the fuse to the Sexual Revolution in the 60s.*

mained in their own countries and made scores of films. During the silent era, most European directors headed to America for various reasons. And later in the 1970s and 80s, when directors from Australia, England, and Germany made reputations for themselves, most of them were lured to Hollywood to make bigger budget features.

The years from 1944 to 1960 are a unique chapter in film history, because foreign filmmakers stayed home and explored the changes, customs, and lives of the people around them. And since the timing was right, many of these films reached an international audience, creating a perception of these countries that still endures. This was the first time for an extended period that film became a positive influence on how people saw their world neighbors. The same was not true in the Hollywood system. The factor of ethnic directors making films about their individual heritage did not begin to happen in a significant way until the 1980s.

Most of the foreign films during this era did not deal with the subject of racial prejudice, like many of the American films did during these years. This form of prejudice was certainly not a theme that was unique to American society, but after almost half a century of terrible hatred and bloodshed in Europe and Asia, most foreign directors focused on different themes. Their subjects ranged from the difficulties of economic recovery facing the little person, like De Sica; the exploration of an ancient cultural heritage, like Bergman or Kurosawa; or simply the use film as cinematic autobiography, like they all eventually did. But most of these directors searched for reasons to celebrate life, either intellectually or emotionally, and to gain a greater understanding of human nature and its many foibles.

The examination of what makes people tick that was found in these foreign films was applied to the problems of prejudice and intolerance in America. This showed up immediately

on television. The quality programs like *Playhouse 90* would present a new story each week. This gradually became a natural forum to occasionally explore topics that were recently in the headlines, like flaws in the American Dream, juvenile delinquency, hate crimes, and other subjects that took years to find their way into the movies. Many of the young directors who were cutting their teeth on television, like Sidney Lumet, John Frankeneimer, Norman Jewison, Arthur Penn (and others who would become the driving forces in 60s Hollywood) were great admirers of foreign films and wanted to imitate them.

The growing number of Americans that went to foreign films and saw Toshiro Mifune in *Rashoman* or *Seven Samurai,* for example, soon found it inappropriate to have a non-Asian actor put on slanted eye makeup to play a Japanese man, like Mickey Rooney in his cameo appearance in *Breakfast at Tiffany's* (1961). And after *La Dolce Vita, The Seventh Seal, Breathless, Pather Panchali, Ashes and Diamonds,* and other international box office hits, audiences had a completely different perception of people from Italy, Sweden, Poland, France, India, and other countries—a perception that was finally based on truth.

No longer would an actor be able to use a fake, bigger-than-life foreign accent, with comic intonation, accompanied by stereotypical hand gestures, and have it be acceptable to audiences. The ancient tradition of suspended reality in the portrayal of ethnic characters was quickly disappearing. The appreciation of different ethnic cultures being something separate, special, fun, entertaining, and desirable began during this renaissance from 1944 to 1960.

Women in the majority of these foreign films, as simplistic as this may sound, were treated like women. Many of the major European directors focused their cameras on the woman's point-of-view in a film, which was not the case in America during this era. Women were treated as mysterious, unpredictable, nonsensical, treacherous, loving, violent, intelligent, two-timing, sexually insatiable, and willing to lie and cheat to get what they wanted. In other words, they were treated just like men. Women in foreign films were represented as equals to, and often more clever than their male counterparts, like they had been in Hollywood cinema during the Depression and War Years.

There was an obvious respect for women characters by directors like Bergman, Fellini, Antonioni, Truffaut, and De Sica and others in movies like *Wild Strawberries, Nights of Cabiria, L'Avventura, Jules and Jim, Two Women,* and *Room at the Top,* to name only a few. In these roles women had the freedom to express themselves and not be victims or mindless objectives of desire. This was another favorable by product of the foreign films of this era, leading the way for American actresses like Faye Dunaway, Jane Fonda, Barbra Streisand, Sissy Spacek, and Diane Keaton.

The Turbulent 1960s and the End of the Production Code

The 1960s started as a time of renewed hope in the American Dream and ended with the country violently polarized over war and government scandals. There was a change from the old guard in politics to the optimistic visions of a vigorous new frontier. In just eight years, the Cold War cooled off, men landed on the moon, rock 'n' roll literally began to change the world, an elderly African-American woman named Rosa Parks refused to move to the back of the bus, and peace was given a chance during the Summer of Love in 1967. By the end of the decade John F. Kennedy, Martin Luther King, Malcolm X, and Robert Kennedy had been assassinated, the death toll in Vietnam was rising, students had taken over university campuses in protest, and J. Edgar Hoover, the head of the FBI, declared that America was on the verge of a second Civil War.

Young, charismatic President John F. Kennedy excited the imagination of a new generation when, in his inaugural address, he spoke the words, "Ask not what your country can do for you, ask what you can do for your country." For perhaps the first time in American history young people felt they had a leader that spoke directly to them, someone with whom they could identify, and someone who was not an ancient relic looking out for big business, the military war machine, and the elite of society. The excitement of having Kennedy in the White House stirred up a positive energy in this country that had been absent since the early 1920s, in the carefree years before the Great Depression, World War II, McCarthyism, the Korean War, and the daily threat of The Bomb.

The first wave of baby-boomers had entered high school. These teenagers grew up with television, which was not a part of their parents' childhood experience. They were watching the old films from the Golden Age of Hollywood on tiny TV screens and catching the latest releases at the local theatre or drive-in. This generation saw without any preconceptions everything from the perfectly tuned melodramas of the 1930s to the new films that were shaking up audiences with thought-provoking themes, like racial prejudice in *The Defiant Ones* and the dark side of the psyche in Psycho. These baby-boomers grew up when television became the dominant force in the news, when each evening's broadcast showed increasingly more violent images from home and overseas. Presidential debates and conventions were televised. Audiences saw a relatively unknown John F. Kennedy with his movie

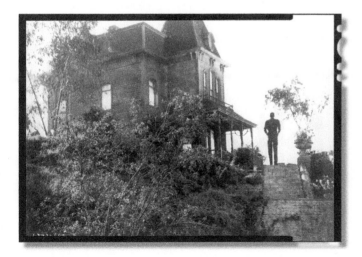

Psycho (1960) directed by Alfred Hitchcock, starring Anthony Perkins and Janet Leigh represents a major turning point in American cinema. Though the Production Code was still in place, its days were clearly numbered after Leigh's visit to the bathroom in the Bates Motel.

star looks next to Richard Nixon with his five-o'clock shadow, sweaty forehead, and nervous expressions-like someone out of a B-gangster film. These live images determined the course of the election for millions.

With extra spending money in their pockets, raised by mothers who constantly referred to Dr. Benjamin Spock's best selling *Baby and Child Care,* there was a naïve feeling of optimism mixed with arrogance that gave these "war babies" the false sense they could do or achieve anything. It can be argued they were the first generation to be raised as perpetual children. This won't-grow-up state of mind would be put to the test by the end of the decade, giving birth to the belief that no one over thirty could be trusted. Pauline Kael, the film critic for *New Yorker* magazine, would call them "the movie generation," which was true. These baby boomers, who grew from teenagers to university students during the 1960s, were in fact the first generation to be raised on the visual education of films, television, and comic books.

To a large extent, the polarization that happened in America during this era reflected the differences of what the young generation was seeing on the modern movie screen by daring new directors and what the older generation had *kept off* the screen for decades. For decades after World War II, the overwhelming carnage was never graphically enacted but presented as high adventure with bloodless battles, in the same style as Saturday matinee Westerns. Like kids taking apart an old alarm clock to see what made it tick, this was the first time a mass of young, curious moviegoers examined how films were made and argued about who the great directors were. The influence of foreign films had swept the county, and Hollywood classics that had been lost for years like *Citizen Kane,* Walt Disney's *Fantasia, Bringing Up Baby, Duck Soup, She Done Him Wrong, The Treasure of the Sierra Madre,* and many others were discovered in revival theatres. Faded stars like Mae West, W. C. Fields, the Marx Brothers, Buster Keaton, and Charles Chaplin were famous again, and Bogart was revered as the patron saint of tough guys.

By the end of the decade, the world would have seen the frame-by-frame images of President Kennedy being mortally wounded in Dallas, and his alleged assassin, Lee Harvey Oswald, shot down on live television by Jack Ruby, who may or may not have been part of a larger conspiracy. Thus began a tangled web of cover-ups and de-

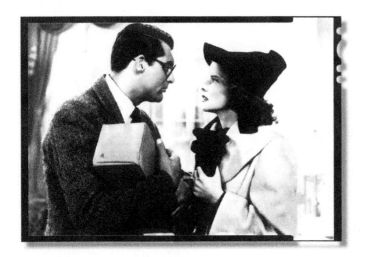

Bringing Up Baby (1938) directed by Howard Hawks, starring Katharine Hepburn and Cary Grant, is one of the many lost films of the Studio Era that were rediscovered when shown in revival theatres. Other movies include Citizen Kane, Walt Disney's Fantasia, and comedies by Mae West, W. C. Fields, and the Marx Brothers.

ceit that grew more complex over the decades. Then "the old troll" of politics (as he was referred to by the young generation), Lyndon B. Johnson became president. Despite the fact that Johnson pushed through most of Kennedy's legislation that was bogged-down in Congress, like the Civil Rights initiatives, and became the champion of the space program, he also reinstated the draft and dramatically escalated the military presence in Vietnam.

The struggle that ensued in the jungle battlefields of Vietnam and the passionate protests that spilled onto the American streets over this undeclared war, changed forever the blind faith in the United States government. Here began the conspiracy theories that have since been woven into hundreds of movies and television shows. In just eight years, the bright and shining image of Kennedy's Camelot eroded into a quagmire of an ignoble conflict half way around the world, shown on the nightly news with burning villages and G.I.s in body bags. Almost immediately, movies and music began to reflect this political maelstrom, and the favorite theme was that "the good die young." This was the complete reversal of the patriotism that sprung up in Hollywood features after the surprise attack on Pearl Harbor.

The 1960s were a time period of remarkable but humanly flawed political leaders, like ill-fated characters out of a Shakespearean tragedy, who tried to take America in a new positive direction and cure some of the ills of society. The fact that pushing a red button could set off nuclear mushrooms around the globe was beyond the control of everybody but two world leaders. The most ambitious and important issue that all citizens could get involved in was Civil Rights and the long, hard-fought efforts to put an end to racism, which sadly endured almost unchanged in many states since the end of the Civil War. This issue would generate many comparisons between the age of Lincoln and the unfinished business of

equal rights that came to a boil in America during this decade.

THE COLD WAR

History never fits itself neatly into decades; it spills over from one decade to the next. The so-called "happy days" of the 1950s really lasted until the assassination of Kennedy in 1963. The posters for *American Graffiti* ask, "Where were you in '62?" George Lucas' movie is a nostalgic look at a time when the biggest concerns of teenagers seemed to be who had the fastest hotrod, going steady, and cruising Main Street. In the years following Kennedy's death, the paranoia of the Cold War increased and was reaching a breaking point. The escalation of the war in Vietnam and the race riots in American cities brought in a whole new generation of filmmakers who used movies to show a world on the verge of complete, destructive madness. Prime Minister Khrushchev had emphatically said, "We will bury you," and with his wild, almost childlike temper, most people believed him. There was the unshakable belief that nuclear war between the Soviet Union and America, the Evil Empire vs. the Land of the Free, was nearing a showdown. Both countries had hydrogen bombs, which made the atomic bombs dropped on Hiroshima and Nagasaki look like previews for the main event. Just one hydrogen bomb equaled all the hundreds-of-thousands of bombs dropped during World War II.

In special documentaries, school children were taught how to jump under their desks if they saw a sudden white flash. What was not mentioned in these self-defense demonstrations was the fact that a few seconds later these cherub-faced kids would be blown to atoms. Audiences were constantly seeing newsreels in between movies of bombs being tested in

Nevada. In Las Vegas, at the height of these tests, the casino management would announce there was going to be a nuclear blast. The gambling would stop, and people would walk outside and watch the mushroom cloud only a few dozen miles away, completely oblivious to the effects of nuclear radiation.

The Cold War reached its height when missiles capable of carrying nuclear warheads were discovered in Cuba. For thirteen days, President Kennedy warned Americans on live television that war might be inevitable and that missiles could reach as far as Washington, D.C. and perhaps New York. Nuclear war was reflected in popular literature. Books like *Fail Safe* and *Red Alert* examined the cataclysmic consequences of technology gone wrong. And the best seller *Seven Days in May* predicted that the U.S. military might become impatient with a president soft on a nuclear buildup and forcibly remove him from command. After he read the novel, Kennedy commented that he was convinced this could happen to him.

BOND. JAMES BOND.

Today, it is almost impossible to understand the daily pressure of living with the threat that one fanatic's finger pressing a red button could end the world in less than 24 hours. The Cold War became a kind of invisible ceiling pressing down on people's emotions and hopes. There had been wars since the beginning of recorded time. Now the geniuses that had masterminded war weapons had created the perfect weapon to end all wars, because it would end all of mankind. No people, no more wars. This was the kind of ludicrous logic that appealed to the very nature of moviemaking. If one bigger-than-life villain could start a war, then one man under the right circumstances, with the

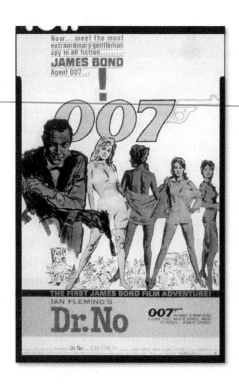

Dr. No (1962) directed by Terence Young, starring a little known actor named Sean Connery as .007 Agent James Bond, introduced audiences to the fact-paced action film that mixed violence with sexy repartee and the movies have not been the same since.

right weapons, would prevent him. It was time for Hollywood to come to the rescue with a superhero. The spy genre that Alfred Hitchcock had been instrumental in bringing to America with movies like *The Lady Vanishes, The Thirty-Nine Steps, Foreign Correspondent, Notorious* and *North by Northwest* was about to get a deluxe overhaul.

President Kennedy commented to the press that his favorite spy writer was Ian Fleming. Overnight, the James Bond thrillers about the British secret agent who had a .007 license to kill, were selling out in bookstores. Fleming had been writing about his ultra-cool, womanizing, undefeatable spy for years, but with Kennedy's endorsement paperback editions flew off the shelves and the movies came knocking. The James Bond films were the ideal action martini (shaken, not stirred, of course) that the public wanted and needed to get their collective minds off the Cold War. With secret agents like Bond, the world was a safer place. The gadgets Bond used to disarm the enemy were the kind of outrageous special effects that no one truly believed in but everyone *wanted to believe* existed. People would sleep better if they imagined agents were actually using these high-tech weapons to make the world a safer place.

Starting in 1962 with *Dr. No,* and over the next two years with *From Russia with Love* and *Goldfinger,* the James Bond series became England's greatest export. The trademark ingredients of these tongue-in-cheek thrillers became the blueprints of the modern day blockbuster. The Bond films took special effects out of the B-movie realm and made them the kingpin of the young franchise. Each new Bond film had to outdo its predecessor, from ejection seats in Astin-Martins to laser beams, to giant underwater battles and beautiful women with names that miraculously got past the censors, like Pussy Galore. The films opened with a "teaser" or a mini-adventure to instantly hook the audience.

This instant attention-getting story device over the years has become standard operating procedure for action films and television shows.

The stories in the Bond films hit the ground running. Films traditionally spent the first thirty minutes setting up the characters and the story situation, but, beginning with *From Russia with Love,* Bond was given an impossible assignment to undertake at the start of the movie, and a few minutes later he was in the midst of trouble and intrigue. Future action films became less concerned with character and cut to the chase as quickly as possible. Because the Bond films quickly became the most successful franchise in movie history, well surpassing the popular Andy Hardy and Thin Man series, audiences did not need lengthy character exposition scenes. One evil genius ready to take over the world and James Bond—what else was there to know?

The Bond films became a genre, with spin-off agents like Harry Palmer in *The Ipcress File,* with Michael Caine wearing big black-framed glasses; James Colburn in *Our Man Flint;* Dean Martin as Matt Helm in *The Silencers.* On television there was Robert Vaughn in *The Man From U.N.C.L.E.* and Don Adams in the madcap spoof *Get Smart,* just to name a few. Long after the Cold War has ended, the Bond films still generate giant box office returns, and the spin-offs keep flying, like *Austin Powers: International Man of Mystery* with Mike Myers as the swinging spy awakened from a cryogenic freeze. For better or worse, the action blockbuster began with *Dr. No,* directed by Terence Young, which originally was only released in drive-ins.

Also, James Bond is the father of Indiana Jones. When he first began to direct features, Steven Spielberg had always wanted to make a Bond film but was constantly refused. He lamented this to his friend George Lucas while on vacation in Hawaii, and George told him the rough plot of *Raiders of the Lost Ark.* The character of

Indiana Jones did not handle women as well as Bond, and often showed "the mileage" after a good fight, but definitely fell out of the Bond family tree. For *Raiders*, the opening teaser was designed to out-Bond the Bond films, with hundreds of spiders, poison darts, and a giant boulder. And as a touch of poetic justice, for the third installment, *Indiana Jones and the Last Crusade*, Sean Connery—the original Bond—played Indy's eccentric father.

DOOMSDAY MOVIES AND WASHINGTON POLITICS GO HOLLYWOOD

In 1964, two films came out about incidents that would drive the world to the edge of nuclear war. One was a suspense drama and the other was a black comedy. Stanley Kubrick's *Dr. Strangelove or How I Learned to Stop Worrying and Love the Bomb* and Sidney Lumet's *Fail Safe,* were in production in 1963 during the Cuban Missile Crisis. *Fail Safe* took the realistic approach to what happens if command communication is interrupted between the home front security headquarters and one of the bombers carrying atomic weapons to a target in the Soviet Union. In *Fail Safe,* the president, played by Henry Fonda, is forced to make a decision of trading the annihilation of New York after the destruction of Moscow, with knowledge that his family is there, and there is no way to warn them. According to producer, Max Youngstein, the U. S. Air Force stated that such a "slip up" could never really happen, and called the movie complete fiction, but permission to use any footage of military aircraft was denied. Lumet was able to find a three-second clip from an unclassified training documentary of one jet bomber taking off and used this image over and over to suggest a fleet of planes.

Dr. Strangelove took quite the opposite approach. Starting out as a serious movie based on Peter George's novel *Red Alert, Dr. Strangelove* slowly became one of the darkest comedies ever about the folly of war. It is impossible go back in time and hear the nervous laughter that was coming from audiences when this film was first released. *Dr. Strangelove* used vaudevillian humor to crack the shell of the public's fear of The Bomb and the threat of a real nuclear doomsday. Kubrick and his co-screenwriter Terry Southern, along

Dr. Strangelove or How I Learned to Stop Worrying and Love the Bomb (1964) *directed by Stanley Kubrick, written by Kubrick and Terry Southern, starring Peter Sellers, George C. Scott, Sterling Hayden, and Slim Pickens. Though the film was a farce, full of gallows humor and originally ending with a pie fight, Kubrick created such an authentic look to the War Room that President Reagan asked to see it after he was elected—only to be told that it only existed in the movies.*

with Peter Sellers' three roles and George C. Scott as a whacked-out general, make fun of a situation that had held grave repercussions in people's minds for years. Laughter began to diminish the fear of any real threat. Mel Brooks once commented that to ridicule Hitler, like he did in *The Producer,* turned the man into a joke, and this process lessened his powerful grip he had on people's imaginations. *Dr. Strangelove* played into the individual belief that all politicians and military leaders were complete, unadulterated idiots, and that the best medicine was laughter. Today, *Dr. Strangelove* remains a brilliant satire that still gets laughs, but in 1964 audiences were roaring at the absurdity, like it was a Marx Brothers movie.

Starting in the early 60s, Hollywood movies became political for the first time. Documentaries, especially during the war years, certainly had political subject matters that were intended to influence people's emotions. But there were only a few studio films that took a hard look at politics, and usually the films served as warnings about the corruption of power, like Robert Rosen's *All the King's Men,* a fictional account of Huey Long. And during the Red Scare of the 50s, writers stayed away from political tales as a form of self-preservation. However, in 1960 the Hollywood Blacklist ended and President Kennedy was narrowly elected, thanks in part to the high visibility brought to him by members of the "Rat Pack," including Frank Sinatra, Peter Lawford, Sammy Davis Jr., and others from Tinsel Town. Theodore H. White's *The Making of the President* about the presidential race between Kennedy and Richard Nixon became a best seller, and readers realized that raw politics was extremely dramatic and enormously entertaining.

Alan Drury's Pulitzer Prize winning novel, *Advice and Consent,* brought to the screen by Otto Preminger, can be argued as starting after there was Gore Vidal's play, *The Best Man, The Manchurian Candidate, Seven Days in May, The Ugly American,* and *The Battle of Algiers.* There were historical films that mirrored modern political situations, like David Lean's *Lawrence of Arabia,* Fred Zinneman's *A Man for All Seasons,* and Tony Richardson's *The Charge of the Light Brigade.* And there were many films, in different guises and genres, about the end of the world, including Franklin J. Shaffner's *Planet of the Apes* (with perhaps the best doomsday ending of any movie), Alfred Hitchcock's *The Birds,* Wolf Rilla's *Village of the Damned,* and George A. Romero's *Night of the Living Dead.* This theme even appeared in such diverse films as Roman Polanski's *Rosemary's Baby,* Ingmar Bergman's *Shame,* and the Beatles' animated feature, *Yellow Submarine,* where the Blue Meanies are trying to take over Pepperland and only love can save the world.

This kind of reflection on the flaws of the political system and the catastrophic consequences that might follow, had been in silent films like *Metropolis,* but for the next thirty years, Hollywood had painted everything in glossy optimism. In 1939, when Frank Capra made *Mr. Smith Goes to Washington,* real-life politicians were up in arms about how the Senate was portrayed, and Capra was accused of being un-American. During the second World War, there was nothing but positive images about our American soldiers and the good fight. Even in the Korean War, the few films that were made put a positive spin on that conflict. But slowly throughout the 50s there was new awareness of the good and bad in politics, because it was being seen on television. Joseph McCarthy reached a huge audience on early television, becoming a national hero, but ended up in total disgrace. Richard Nixon saved his political career on live television when accused of the misuse of public funds by joking about his dog Checkers.

American politics were seen daily in living rooms across the country, and common middle

class citizens became fascinated with how back-door negotiations could lead to the election of a President or the demise of a powerful political leader. Many of the new film directors coming from television, like John Frankenheimer, Sidney Lumet, Norman Jewison, and others made films that were celluloid editorials about the troubles looming over the globe at this time. They began to point fingers at world leaders, depicting them as flawed people who truly did not understand how to control the technology they had un-leashed like a nuclear Pandora's box, or were complete morons and fools like in Kubrick's fic-tional war room.

In the 60s, the public saw there were unde-niable elements of truth in these films and thus was born the relationship between Hollywood and politics, a fascination that has only grown larger over the decades. By the end of the decade the once unspiritual folktales of presidents and heroic politicians, which school children had been taught for over a 100 years, were withering away, and a revisionist look at American history was be-ginning. After all, how could anyone watch Peter Sellers, playing the president in *Dr. Strangelove*, as he jokes and negotiates on the telephone with a drunken Prime Minister of Russia about a nu-clear war, and still believe unquestionably in the purity of the democratic system?

ASSASSINATIONS AND CONSPIRACY THEORIES

One of the great curiosities of the 1960s is the number of movies that forecasted po-litical assassinations before the tragic string of assassinations actually happened in America. The book *The Manchurian Candidate* was made into a movie by John Frankenheimer the year before the assassination of John F. Kennedy, and had ironically been given the green light because of Kennedy's endorsement of the project (his only curiosity was who was going to play the mother). *Seven Days in May,* also di-rected by John Frankenheimer, looked at the pos-sibility that a high ranking general could create a secret army to enact a coup d'etat on the pres-ident of the United States, announcing the takeover to the American people on the three tel-evision networks. Kennedy commented after reading the novel, and before the movie was made, this was something that could realistically happen. This comment would fuel later conspir-acy theories, especially in light of the planned military build-up in Southeast Asia and the angry rumbling from outspoken members of the mili-tary industrial complex when Kennedy proposed a gradual withdrawal from Vietnam.

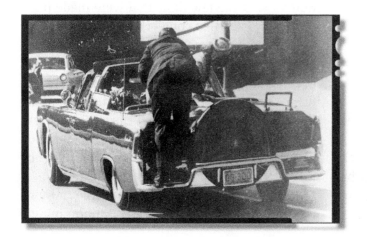

A news photo taken in Dallas, Texas on November 23, 1963, the day that President John F. Kennedy was assassinated. The tangled web of circumstances surrounding Kennedy's death changed the American people's perception of the U. S. Government and spun off conspiracy theories that have been the undercurrent of hundreds of movies and television programs.

Oliver Stone's *JFK* is the best known of the conspiracy films implicating the military in the assassination of Kennedy. Since that unforgettable day in Dallas, Texas, November 22, 1963, there have been many films made that explore the dark world of political conspiracies and government corruption. Most notable are Costa-Gravras' *Z,* Peter Yate's *Bullitt,* George Lucas' *THX-1138,* Stanley Kubrick's *A Clockwork Orange,* Alan J. Pakula's *The Parallax View,* Roman Polanski's *Chinatown,* Francis Ford Coppola's *The Godfather, Part II* and *The Conversation,* Sidney Lumet's *Serpico,* and more recently Wolfgang Petersen's *In the Line of Fire.* Even Woody Allen in *Annie Hall* finds a moment to talk about the possibility of a second gunman. But the biggest perpetuator of the conspiracy theme is television, mostly with programs in the guise of science fiction, including *The X-Files, Deep Space 9, Babylon 5,* and endless documentaries, like *The Men Who Killed Kennedy.*

The ultimate irony is that most of the conspiracy theories are fueled by a one-minute home movie by Abraham Zebruter, the only full account of President Kennedy being murdered. Something to eternally ponder is *what if* President Kennedy's assassination had not been captured on 8mm film that fateful day in Dallas? The world would never have seen Kennedy's physical reactions to being struck by the two bullets. The Zebruter film of Kennedy being hit in the throat and then in the head has been studied countless times by ballistic experts, journalists, and the general public. By all appearances, the second bullet seems to come from the front, perhaps by another gunman hidden somewhere on the infamous grassy knoll to catch the President in a crossfire. However, theorists and experts disagree, and undoubtedly this will remain an unsolved mystery.

What is certain is that without the Zebruter film American history might have played out very differently. With no visible evidence, and only conflicting first-hand reports, the Warren Commission might not have been formed, and the belief that Lee Harvey Oswald acted alone would have been generally accepted. This single event eventually caused many Americans to believe that the United States government was as deceitful as the Soviet Union, and that the CIA and FBI were corrupt, with rogue agents acting outside the law. This has inevitability led to the theory that there is a shadow government within the government that is keeping physical proof that aliens have landed on Earth. It may seem absurd to blame all this suspicion on one little bit of film, but it is also frightening to think about the course of events that might never have been brought to light if this film never existed.

REVISIONIST HISTORY

During the 1960s, non-fiction began to gradually outsell the fiction novel. A new breed of historians probed into the past and saw that American history à la Hollywood, especially the expansion of the West, was not like it was shown in John Ford films. Ford was raised on the oral tradition of Irish storytelling, where facts became bothersome stones in the path of a good tale. He brought this tradition to the movies, and for almost forty years he (and most other directors) glorified the quest of the Wild West. Ford created a thrilling history of America on film, brimming with bravery, sacrifices, noble deeds, and victory over ruthless savages. The soldiers in his cavalry films were fun loving, loyal, and for the most part honest men who only fought when necessary.

But books like *Bury My Heart at Wounded Knee* and *Black Elk Speaks* revealed a different west and a different image of the cavalry. In fact, there was undeniable proof of attempted genocide on many of the Native American tribes.

Fistful of Dollars *(1964) directed by Sergio Leone, starring a little known American television actor Clint Eastwood, gave birth to a new genre called the Spaghetti Western. This was the first of three violent shoot-'em-ups about the "Man with no Name" and introduced the anti-hero into Westerns. Two of the distinguishing features of these movies are Leone's playfully dramatic camerawork and Ennio Morricone's musical scores.*

Women and children were ignobly massacred, which, as timing would have it, seemed to correspond with what was happening in Vietnam with burning villages, the murder of innocents, and children screaming with pain from napalm. These books started a literary land rush to discover other dark facts about American history. Truman Capote's In Cold Blood introduced a new style of journalism, and suddenly the bare-knuckled truth became more exciting than fiction.

There seemed to be parallels and historical stones to overturn everywhere. Kennedy's assassination had a long list of similarities to Lincoln's assassination. J. Edgar Hoover, one of the most respected people in the world for decades (at least in the movies and newspaper headlines) suddenly came under suspicion when it was discovered he kept secret files and tape recordings to blacklist political leaders, like Martin Luther King. Cops in big cities were taking big payoffs and were more crooked than the criminals they were chasing. And famous gunfighters, whose gallant and fearless deeds were taught to elementary school children, were exposed as cheats, liars, and heartless murderers. Actually, the pendulum swung completely in the opposite direc-

tion, so for years (and still) everyone who was treated as a hero in the movies had dirt dug up on them. The old legends were debunked. Ford fell out of favor with young moviegoers.

But the history of the movies is one of perpetually charting new courses. All of the old genre films were revised. Within ten years Westerns reinvented themselves and went from John Ford's *The Man Who Shot Liberty Valance* and *How the West Was Won* to Sergio Leone's *A Fistful of Dollars* (the first of the "spaghetti Westerns") to George Roy Hill's *Butch Cassidy and the Sundance Kid,* then to Henry Hathaway's *True Grit* to Sam Peckinpah's *The Wild Bunch* and Arthur Penn's *Little Big Man.* Dennis Hopper claimed that *Easy Rider* was a Western on choppers, which is why his character wore spurs.

Film noir was reinvented in color in Roman Polanski's *Chinatown.* Warner Bros. gangster films like Mervyn LeRoy's *Little Caesar* became Francis Ford Coppola's *The Godfather,* and the morale building World War II action movie, such as John Farrow's *Wake Island,* turned into Robert Aldrich's *The Dirty Dozen.* The old MGM musical got a major makeover with Bob Fosse's *Cabaret.* Sam Spade, as played by Humphrey Bogart in the

Maltese Falcon, became Don Siegel's *Dirty Harry* with Clint Eastwood ("dirty" seemed to be a favorite word in movies during this era). The screwball comedies of Preston Sturges were transformed with the surreal Mike Nichols' comedy *The Graduate.* The Flash Gordon serials would have to wait until the late 70s to be reinvented as George Lucas' *Star Wars,* and the high adventure of George Stevens' *Gunga Din* would later be excavated as Steven Spielberg's *Raiders of the Lost Ark.* By the 1980s, none of the old genres looked the same.

CIVIL RIGHTS AND THE MOVIES

One hundred years had passed since Abraham Lincoln issued the Emancipation Proclamation in 1863, but there was still open prejudice in Southern states that gave the impression that time had stood still. African-Americans were forced to be separate and not treated as equals. They could not attend most colleges, they could not drink at the same water fountains as whites, and they had to eat in specially designated areas of restaurants—the ones they were allowed into. Despite the fact that in 1954 the Supreme Court overturned the old Jim Crow laws, based on the "equal protection of the laws" clause as found in the 14th Amendment, the spirit of segregation was still defiantly practiced. Congress finally passed the Civil Rights Act of 1965 and the Voting Rights Act of 1965; this legislation gave rights but could not eliminate the prejudice that many Americans had been raised with for generations. As the enforcement of Civil Rights began to explode, a few courageous producers, directors, and actors made a handful of films that managed to reach large audiences, and, most importantly, a new generation learned the hard truths of racial inequality from these movies.

D. W. Griffith's *The Birth of a Nation* had painted a degrading stereotype of the African-American and was responsible for the resurrection of the Ku Klux Klan. Griffith's film has become the most famous example of these negative images, but in actuality there were thousands of early films that depicted African-Americans as either contented slaves singing spirituals or frequent visitors to gin joints given to violent, unpredictable outbursts. Now, fifty years later, Hollywood would become instrumental in correcting these past indignities. When America entered World War II, the studios immediately began

To Kill a Mockingbird (1962) *directed by Robert Mulligan, screenplay by Horton Foote, based on the novel by Harper Lee, starring Gregory Peck, Mary Badham, Phillip Alford, Robert Duvall, and Brock Peters. Without preaching or being heavy-handed, this movie showed the wrongs of racial prejudice through the eyes of children. As proof of the film's continuing impact on audiences, Atticus Finch, played by Peck, was voted the greatest movie hero of all time by the American Film Institute.*

to produce films to show support in the effort to conquer the enemy. For the Civil Rights Movement, many studios once again used the power of cinema to expose the inhumane methods of the opposition, but, as political humorist Walt Kelly, creator of the long running Pogo comic strip, observed, this time the enemy was *us*.

This was not a war that could be won on a battlefield with bullets and tanks. The films that dealt with civil rights had to show the evils of racial intolerance festering in the minds of many American citizens. To do this, these films could not alienate the support of people who were yet uncommitted to the cause of equality. The challenge facing filmmakers was nothing less than to change how people thought, and in the course of this to transform hatred into respect, which at first was a seemingly impossible task. As in the past, Hollywood used its strongest weapons: compelling melodrama, laughter, and movie stars. With the rise of Nazism in Europe, studio moguls had been instructed not to stir up the political waters in fear of retaliation. On the issue of Civil Rights, a few filmmakers changed public opinion and forced the government to get involved.

As with so many events during the 60s, President Kennedy's one thousand days in office became the touchstone for the Civil Rights Movement. But building up to this there had been a series of films that sparked popular attention. They included Mark Robson's *Home of the Brave* (1949), based on Arthur Laurents' play and produced by Stanley Kramer; Joseph L. Mankiewicz's *No Way Out* (1950), which introduced Sidney Poitier, Ruby Dee, and Ossie Davis to the screen; and Richard Brooks' *Blackboard Jungle* (1955). Harry Belafonte starred in Otto Preminger's *Carmen Jones* (1955), with Dorothy Dandridge, who was nominated for the Academy Award as Best Actress, Robert Rossen's *Island in the Sun* (1957), and Robert Wise's *Odds Against Tomorrow* (1959). Stanley Kramer's *The Defiant Ones* (1958)

received eight Oscar nominations, including Best Picture and Poitier as Best Actor. This film was a big box office hit, and though today it might seem overly obvious in its symbolism of a white man and a black man who hate each other being chained together, it had an enormous impact on public awareness when it was released. By the early 60s, Poitier had become a major movie star, which meant that for the first time an African-American actor had an appeal that crossed racial barriers.

Television played a significant role in the advancement of the Civil Rights Movement, both on the nightly news and popular new programs. With television shows, viewers were seeing an uplifting and often fun image of the African-American. Bill Cosby became a household name from *I Spy*, and his live comedy records were sold by the millions. On *The Smothers Brothers Comedy Hour* and *Rowan & Martin's Laugh-In*, weekly black performers appeared in comedy sketches or showed up in cameo spots. Sammy Davis Jr., Nipsey Russell, Lena Horne, and Flip Wilson shot one-liners at the Establishment like, "Look that up in your Funk and Wagnalls" or "You bet your bippy." On these shows being African-American was cool, and the phrase "Black is beautiful" became part of the popular vernacular.

But on the news, the real events happening in cities were very different. In 1963, Governor George Wallace was seen coast-to-coast as he attempted to block black students from entering the University of Alabama. The National Guard had to be called out, a moment in history recreated in *Forrest Gump*, starring Tom Hanks. That same year in Birmingham, a bomb placed inside a church killed four little girls, creating a national outpouring of sympathy and outrage, galvanizing public opinion against the terrible hate crimes of the South. Civil rights leader Medgar Evers was shot down outside his home in Mississippi, and the following summer, three young civil rights

volunteer workers were murdered, the subject of Alan Parker's *Mississippi Burning.*

Within a single year, from 1963 to the summer of 1964, America lost a beloved president and then saw innocent children, young students, and dedicated civil rights leaders murdered because of the color of their skin. With the hope of a new age in government gone, the turbulent 60s began. Beginning in 1963, after his "I have a dream!" speech in Washington, D.C., Martin Luther King became the leader of the Civil Rights Movement, using the non-violent, civil disobedience tactics of Mohandas Gandhi. Many members of the Hollywood community united with King on his peaceful protests. Walking arm-in-arm were stars like Burt Lancaster, Marlon Brando, and Kirk Douglas, and directors like Stanley Kramer, Norman Jewison, and Sidney Lumet. The commitment to this cause became more and more apparent on the movie screens.

A film that had a profound impact on people's understanding of what had been happening in the South for decades under the segregation laws was *To Kill a Mockingbird* (1963), based on Harper Lee's best selling Pulitzer Prize winning novel. For much of the film the focus is on the bright, impressionable children of a poor, Southern lawyer named Atticus Finch, played flawlessly by Gregory Peck. Atticus is asked to defend a black man accused of raping and beating a white woman. He accepts with a passionate commitment to justice, knowing the potential dangers this might bring to his family and himself. During the trial, Atticus puts up a perfectly executed defense for his client, played by Brock Peters, closing by telling the all-white, male jury to "do your duty." But with all the evidence clearly in his favor, the black man is found guilty.

To Kill a Mockingbird is set in a small Southern town during the height of the Great Depression, but the message was that this kind of bigoted behavior was still going on thirty years

later. The power of the film is that it is shown through the point-of-view of the innocent children, who are forced to grow up during one violent summer. The unshakeable image of Atticus Finch is that one man standing up to the twisted face of injustice can make a difference. The American Film Institute named Atticus as the greatest hero in movies.

SIDNEY POITIER

Unquestionably, no actor has done more to change the negative stereotype of the African-American than Sidney Poitier. In her documentary about Poitier, actress and director Lee Grant refers to him as "one bright light." Born in 1924, into great poverty on Cat Island in the Bahamas, his first memory of seeing a movie was in a small theatre. The movie was about cowboys on a cattle drive. After the film was over, young Poitier went outside behind the theatre to find out where all the cattle were. At thirteen his father gave him a one-way ticket to Miami and told him not to return until he could help his family financially. Poitier wandered from job to job and eventually ended up in New York. By going through newspapers each day, he taught himself to read English and tried out for the prestigious American Negro Theatre. He made his Broadway debut in an all-Black production of *Lysistrata.*

Poiter's good looks and intelligent performances finally got him his first movie role in *No Way Out.* But his stardom did not happen overnight. Struggling throughout most of the 1950s, his role in *The Defiant Ones* made him the most sought after Black actor in the movies. But after a terrible experience on the Otto Preminger production of *Porgy and Bess* (1959), and two films that quickly disappeared, *All the Young Men* and *Virgin Island,* Poitier decided he wanted more

control over his movie roles, which, of course, was completely unheard of at this time. He returned to Broadway in Lorraine Hansbury's *A Raisin in the Sun,* which became the hit of the season. Controlling the movie rights, Poitier returned to Hollywood and starred in *A Raisin in the Sun,* directed by Daniel Petrie. The film was a box office success, and his career over the next six years was remarkable by any standards.

For the first time, a Black actor had directors develop movies especially for him. Poitier was fortunate to be part of a new movement of maverick directors who worked as independents outside the studio system. Between 1961 and 1967 he made twelve movies, including Ralph Nelson's *Lilies of the Field,* for which he received his second Oscar nomination and won for the delightful role of a laid-back handyman who is conned by a group of nuns into building a chapel. This was followed by Guy Green's *A Patch of Blue* and Sydney Pollack's *The Slender Thread.* But 1967 was Poitier's greatest year, and arguably the best year any star had. He made *To Sir with Love,* written and directed by James Clavell, who would later write the best sellers *King Rat* and *Shogun,* and featuring a hit song by the same title sung by Lulu. He also starred in two films nominated for Best Picture.

The first was Stanley Kramer's *Guess Who's Coming to Dinner,* a comedy about an interracial marriage, with Katharine Hepburn and Spencer Tracy in his last role. The film later came under attack by Black militant groups because Sidney's character was treated as part saint and part genius, and not a "typical Black man" in American society. But when it was released, *Guess Who's Coming to Dinner* found a huge crossover audience and served its purpose by making a lot of people think about the changing multicultural relationships that had already started to take place in the 60s.

The second, Norman's Jewison's *In the Heat of the Night,* won Best Picture and an Oscar for Rod Steiger, as a bigoted small town sheriff who meets his match with a big city detective by the name of Virgil Tibbs. *In the Heat of the Night* has a key moment when Tibbs, played by Poitier, decides he is going to bring down the fat cat on the hill, the white plantation owner who represents all of the evil done to the Black people. There is a moment when the condescending white plantation owner becomes incensed at Tibbs' questioning him about a murder and slaps him; then, without a beat, Tibbs slaps him back. Rod Steiger later recalls they could always tell how many white and black people were in the audience when the slap scene happened, because the whites in the audience would gasp in disbelief and the Blacks would cheer, "Give 'em hell, Sidney."

To see this image on the screen, a proud black man striking back against white authority, began a healing process for many African-Americans. The timing of *In the Heat of the Night* marked a turning point in films about African-Americans. The following year Martin Luther King would be assassinated, and the racial tension in the country would explode. In large cities, entire black neighborhoods would burn after violent protests and street rioting. One phase of the Civil Rights Movement had come to a bitter end. A new phase would begin, led by groups like the Black Panthers and influenced by the militant philosophy of Malcolm X, who was gunned down in 1965 during a meeting of the Organization of Afro-American Unity.

After 1967, films about African-Americans took on a harder edge and became openly critical of intolerance in American society. For the first time black directors got behind the camera like Ossie Davis with *Cotton Comes to Harlem* (1970) and *Gordon Parks Shaft* (1971). A new wave of angry actors appeared, like Jim Brown,

Godfrey Cambridge, Raymond St. Jacques, James Earl Jones, and Richard Roundtree. And Poiter was part of this change. He repeated his role from *In the Heat of the Night* in *They Call Me Mr. Tibbs* (1970) and *The Organization* (1972), and then turned to directing with *Buck and the Preacher* (1972), bringing his first childhood movie experience full circle by starring in a Western. In 1980, he directed *Stir Crazy* with Richard Pryor and Gene Wilder, which became the first movie by a black director to make over a hundred million dollars.

When Sidney Poitier started out, if his film was being shot on location, he would have to drive an extra thirty minutes or more each night to find a hotel that would accept African-Americans. This continued though films like *The Defiant Ones,* when he was recognized as a movie star. He has talked about walking onto studio lots in the 1950s and being the only African-American around, except for the old man shining shoes. He survived what he calls his "long journey" by being one of the greatest performers ever in the movies, then reinventing himself as a director and a writer. He lived to be honored by a new generation of actors, like Morgan Freeman; Louis Gossett, Jr.; Samuel L. Jackson; Ving Rhames; Cuba Gooding, Jr.; and Larry Fishbourne; then by seeing Denzel Washington and Halle Berry both win best acting Oscars in 2001.

THE VIETNAM WAR

In 1946, the Geneva Conference divided Vietnam into halves, drawing the borderline at the 17th parallel, between the Communists in the north and the Nationalists in the south. The French colonial government was left to defend South Vietnam, but like most international conflicts in the twentieth century, America was called in to support the increasing guerrilla ground war against the Vietcong, who were trained in North Vietnam and trained with Chinese backing. The original soldiers sent over by President Eisenhower were called "advisors" and part of a special military force that would eventually be known as the Green Berets. The conflict continued to escalate, and in 1963 Premier Ngo Dinh Diem was overthrown and President Kennedy, who had inherited this political nightmare, had to decide whether to increase America's presence in South Vietnam. Kennedy already had a terrible experience with the Bay of Pigs, the attempted coupe intended to overthrow Fidel Castro in Cuba, and had shaken up the CIA because of the faulty information he had received.

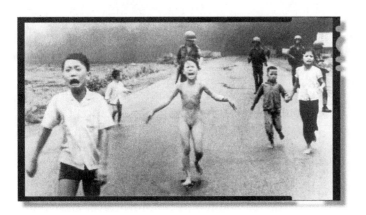

Kim Phuc at the age of eight on June 8, 1972, after being hit with napalm during the Vietnam conflict. This is one of hundreds of horrifying images people were seeing on television and in newspapers daily after President Johnson's escalated military operations in South Vietnam in April, 1964. Despite large and often bloody protests, the "undeclared war" would last until late April, 1975.

The country and the world, for that matter, had narrowly avoided a nuclear war with Russia in October the year before because of missiles found in Cuba. There was also the constant threat of major hostilities because of the Berlin Wall.

History is still divided on what Kennedy would have eventually done, but just before his assassination he announced that he was going to start withdrawing the American forces. Whether this would have ended the military stalemate which had torn the United States in half for twelve violent years, will never be known. Before Kennedy's funeral was over, President Johnson had signed an agreement to increase the military effort in South Vietnam. By 1968, there were nearly 550,000 troops involved in the conflict. Vietnam would be the first war (though it was never officially declared a war by Congress) to be seen nightly on television. For the first time, Americans saw bloody battles on television within a few hours after they took place. Because of the Production Code, which remained in force until 1966, people were seeing more graphic violence in their living rooms than in the movie theatres.

From the very beginning, Vietnam was looked upon as a bad war. Unlike Hollywood's rush to make motion pictures about the heroism and sacrifice of World War II, there was only one movie made about Vietnam during the long years of the actual conflict. That unfortunate film was *The Green Berets,* directed by and starring John Wayne, which critic Leonard Maltin lists as a "bomb" in his movie guide. Wayne tried to show how a handful of Americans could beat the enemy, like the 7th Cavalry in all his John Ford films, but audiences did not buy the gung-ho patriotism in 1968.

In many ways, by the mid-60s all the films coming out of Hollywood were about Vietnam, they were just disguised as Westerns, biker flicks, or gangster films. After the death of Kennedy and the buildup in Vietnam, realism in the movies meant that everyone died at the end, like a

Shakespearean tragedy. The Production Code by this time had lost most of its teeth, and there was no way to contain the foreign films that were exposing audiences to more and more violence, often very stylized and graphic. The anti-hero was the role of choice for a new crop of movie stars, who turned these rough-edged characters into likable folks, only to be killed off. With few exceptions, no serious film had a happy ending for almost fifteen years. This long stretch of self-imposed misery is a major reason why audiences went into hyper-space with delight when *Star Wars* came out.

But before then, Cool Hand Luke, Butch Cassidy, the Sundance Kid, Bonnie and Clyde, and the entire Wild Bunch all died bloody deaths. So did Dennis Hopper and Peter Fonda in *Easy Rider,* Sonny Corleone in *The Godfather,* Laurence Harvey in *The Manchurian Candidate,* and Ronny Cox in *Deliverance. They Shoot Horses, Don't They?; Midnight Cowboy; Five Easy Pieces; Clockwork Orange; McCable and Mrs. Miller; Dirty Harry; The French Connection; Nashville; Cabaret; Serpico; The Last Detail; Dog Day Afternoon; The Godfather, Part II; Chinatown; Taxi Driver;* and *One Flew over the Cuckoo's Nest* all had what became known as "downer endings." Even comedies and romances, like *Love Story, The Graduate, The Way We Were,* and *M*A*S*H* all ended on low notes. This perhaps explains why the few films with slightly upbeat endings did well at the box office, such as *The Sting, American Graffiti,* and *Saturday Night Fever.*

Films up until this time played an important part in keeping secrets about the horrors of war, but Vietnam opened the closet and let everything fly out onto the screen. The polarization between veterans of World War II and students protesting Vietnam was inevitable. The older generation had fought in Normandy, the Battle of the Bulge, and the South Pacific. They had seen things that were never talked about and certainly never shown on the screen during the war. It was not until *Saving*

Private Ryan, over fifty years after World War II ended that Baby Boomers saw what their parents endured. For the first time, they learned it was not a war as depicted in Hollywood high adventures, full of exciting suspense and easy deaths.

During the Vietnam era, the older generation became polarized against the "hippies" or "flower children" protesting the war. The members of the Peace Movement rightly felt that America was fighting some nebulous force and the Washington politicians were calling the shots. Soldiers that served in Vietnam and returned home were treated as "baby killers" and were never given time to emotionally heal. The feeling from the protesters was that anyone who did not run away to Canada or burn their draft card was the enemy. The headlines that erupted across the country and around the world after soldiers in the National Guard at Kent State University fired on and killed students were a tragic turning point in public opinion about Vietnam; bad feelings lingered until the fall of Saigon in 1975.

It took several more years before a major film was made about Vietnam. Michael Cimino's *The Deer Hunter* came out in 1978, winning the Academy Award for Best Picture, followed the next year by Francis Ford Coppola's *Apocalypse Now.* Oliver Stone's *Platoon* (1986) also took home the Best Picture Oscar, and Stanley Kubrick had a crack at Vietnam, which was strangely devoid of jungle scenery, in *Full Metal Jacket* (1987).

Then an odd thing happened-certain movies took the John Wayne approach to war, showing how a few determined Americans could pull off the impossible, including Chuck Norris in *Missing in Action* (1984) and Sylvester Stallone bringing back MIAs in *Rambo: First Blood, Part II* (1985). After this, the mentally tormented veteran who still sought dangerous professions became an almost stock character in movies and on television, like in *Predator* (1987) and *Magnum, P.I.*

(1980–88); which proves that in Hollywood, everything gets recycled.

THE RISE AND FALL OF THE HOLLYWOOD EPIC

There is a well-known poster of a cat clinging by his claws to a branch for dear life; the caption reads, "Hang in there!" By 1960, the old moguls were doing exactly that. One big gust of wind, and the studio system was ready to collapse. Executives were walking around in a daze. The only sure things were the big budget epics and musicals that got families out of their living rooms and away from that d*** television set. *The Robe* started this mass return to the theatres, plus made CinemaScope a must for any epic. The lavish tale of Christ brought in millions to 20th Century-Fox. *Ben-Hur* got MGM out of red ink, *The Ten Commandments* was a huge hit for Paramount, and *Spartacus* was a cash cow for Universal. Columbia had a corner on the action adventures with *The Bridge on the River Kwai* and *The Guns of Navarone.* And after a drop-off in the early 1950s, musicals were back. MGM's *Gigi* gathered six Academy Awards, and Robert Wise's *West Side Story,* released through United Artists, danced its way to ten Oscars. But each production had to be bigger and better than the studio next door, and, like a balloon stretched too far, an inevitable burst was about to happen.

Ben-Hur had all the right ingredients for an epic. It appealed to a large audience with its story of a Jew seeking revenge for the injustices done to his family, set against the story of Christ. *Ben-Hur* had a gigantic sea battle and chariot races, which are still some of the most exciting moments in any film ever made. The underlying strength of the movie was that it stayed faithful to Lew Wallace's classic novel, which had been a best seller since its first printing in 1880. *Ben-Hur* had

also been a hit for MGM back in 1925, so it had a track record combined with a time-proven story.

The Achilles heel of later big budget motion pictures was that instead of taking a lesson on the importance of epic storytelling they went for the epic look instead. The fatal flaw was that studio executives thought giant sets and international movie stars in elaborate costumes were all it took to fill seats. The lesson from D. W. Griffith's extravagantly produced *Intolerance* and the untold millions it lost had long since been forgotten. The first indication that the epic boom was living on borrowed time was *El Cid* (1961), starring Sophia Loren and Charlton Heston. *El Cid* was directed by Anthony Mann, who had been fired by Kirk Douglas from *Spartacus* and replaced with Stanley Kubrick. It was based on a famous tale of romance and conquest. But despite great battle scenes and close-ups of Sophia, it never caught the popular attention of audiences and struggled at the box office. Also, what studio executives did not take into proper consideration during this time was that epics like *El Cid* and *Ben-Hur* take a year or more to recoup their investments.

These epics opened the same way a touring Broadway show does, since only certain cities had movie houses with widescreens. People had to make reservations in advance for reserved seating, and since no other theatre could exhibit the film within a radius of one hundred miles or more, going to the movie was a major outing. Once there, people could buy large souvenir books full of glossy photographs, and sometimes the LP with the soundtrack was sold as the satisfied patrons exited. This was how films had been distributed since the silent era. But with epics, where millions of the studio's dollars were tied up, less than a hundred theatres nationally were generating ticket sales. Thus the financial return took several months, and if a studio was having production troubles on another film this was a formula for disaster.

LAWRENCE OF ARABIA

In 1962, the grand scale epics had reached a zenith with David Lean's *Lawrence of Arabia*. *Lawrence of Arabia* is one of the most breathtaking movies ever made for the widescreen, which is an experience that is probably impossible today. As with *The Bridge on the River Kwai*, even though it has a magnificent epic look, *Lawrence of Arabia* is a really a small story about one man's conflict with success and his own personal demons, set against the backdrop of World War I. Lean's movie inspired many future filmmakers, like Steven Spielberg and George Lucas, because it is a movie that obviously has a great director involved in every frame shot.

Lean; his cinematographer, Freddie Young; and his scenic designer, John Box; took days sometimes to get just a few seconds of film. Sometimes miles of desert were covered with paint to force the audience's focus on one spot. Brooms that looked more like giant powder puffs with handles were used to erase footsteps in the sand to make the scene look pristine and pure. *Lawrence of Arabia* is a remarkable feat of filmmaking on every level, and one of the best examples of what an epic can be. It serves as a reminder of a bygone era when it took a year to make a movie, and to manage the supply lines and build cities in the middle of a desert was like a major military maneuver. Not all epics were as fortunate to have a director like Lean behind then, who understood that spectacle came out of great storytelling and fascinating characters.

CLEOPATRA

When *Cleopatra* was finally released in 1963, after being in production for almost three years, it became the most expensive motion picture ever made, with a publicized budget of forty-four million dollars. The

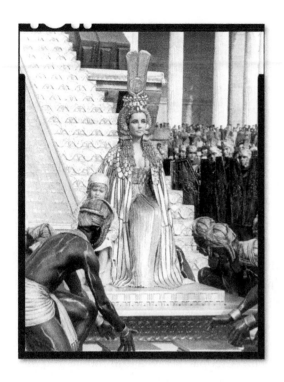

Cleopatra (1963) directed by Joseph L. Mankiewicz, starring Elizabeth Taylor, Richard Burton, Rex Harrison, and a cast of thousands. With its bloated budget, **Cleopatra** became the epic that almost toppled 20th Century-Fox. Escalating to $44 million dollars, it was the most expensive film ever made, grossing only $24 million during its first run. The affair between Taylor and Burton became such a hot news item it gave birth to the paparazzi frenzy that has stalked stars ever since.

reality of the actual budget was undoubtedly much greater, and these figures do not included the massive marketing costs. Recently the budget was revised to reflect today's dollars and the total exceeded the budget of James Cameron's *Titanic* (1987), which exceeded two hundred million. As a conservative estimate, a modern feature will cost at least six times more than it would have in 1963. *Titanic* proved a blockbuster and went on to become the most successful film of all time. Its primary advantage over *Cleopatra* was that it could play at over four thousand theatres at one time, where *Cleopatra* could only be shown in less than two hundred theatres worldwide.

Cleopatra was the movie that started the general public talking about budget overages and potential box office grosses. It also jump started the media's obsessive interest in behind-the-scene scandals. No movie since *Gone With the Wind* had so much advance publicity and excitement

about it. There were news stories almost daily. Elizabeth Taylor was given the astonishing price of one million dollars to star in the epic (the first actor to get this amount), and she was suddenly stricken with double pneumonia. She was not expected to live, and for days the only news story was about if she was going to pull through. Even the Pope prayed for her recovery. When she left the hospital to the cheers of her fans, the production shut down for almost half a year. Meanwhile the original director, Robert Momoulian, was fired (or resigned, depending on who told the story) and replaced with four-time Oscar winner, Joseph L. Mankiewicz, the writer and director of *All about Eve*. The decision was made to scrap all the sets in England and move the production to Italy. The two male leading roles were recast with Rex Harrison and Richard Burton.

Then the stories kicked into high gear. Taylor broke up with husband Eddie Fisher to have a very public fling with the hard-drinking,

quick-tempered Welshman Burton. Since the production was now shooting in Rome, the sizzling affair created a paparazzi paradise. To the dismay of celebrities ever since, *Cleopatra* made star-stalking an international past time. Photographs of the two lovebirds in their secret hideaways started bidding wars from newspapers and magazines for the exclusive rights. The affair was denounced on the floor of the U.S. Senate, and the Pope took back his blessing. 20th Century-Fox executives thought this scandal would harm the box office. Instead, Taylor became the figurehead of the sexual revolution that would explode in the late 60s with women burning their bras and advocating free love. Everywhere she went, fans chanted "Liz, Liz, Liz!"

To contend with the publicity produced by Elizabeth Taylor, Darryl F. Zanuck, former head of 20th Century-Fox, was brought back in to save the studio. In the middle of this financial bloodletting, Zanuck's war epic, *The Longest Day,* became an international box office sensation, and the cash flow was poured back into the bottomless pit of *Cleopatra*. Mankiewicz was a golden boy on the Fox lot, with films like *The Ghost and Mrs. Muir, A Letter to Three Wives,* and *Suddenly Last Summer,* the film Taylor had starred in with Katharine Hepburn before accepting the role of Cleopatra. But Mankiewicz had never shot a big epic picture. To complicate matters, he felt that he had to outdo George Bernard Shaw's classic play *Caesar and Cleopatra.* Many times he would be writing the dialogue for that day's shoot in longhand while a thousand or more extras and crew people waited. The original cut was almost eight hours long. Mankiewicz wanted to release the sprawling epic in two parts, so audiences would have to come on two different nights. Zanuck quickly axed this idea and started cutting the film down to its final release of 243 minutes. For years since, fans and film historians have tried to find the deleted scenes in the hope of restoring the epic to its full length.

Cleopatra opened with a gala premiere in the old Hollywood style, and was televised live for millions to watch. With all the publicity and marketing hype, *Cleopatra* should have easily recouped the fortune that went into the production cost, which would have been the ideal happy ending for 20th Century-Fox. It had everything-big stars, bigger sets, battles with thousands of extras on land and sea, and a legendary story that has endured through the ages. But *Cleopatra* had one thing going against it—the film was boring. Granted, expectations were so enormous that it could never live up to the excitement audiences were anticipating, but after *Lawrence of Arabia* and *Ben-Hur,* Cleopatra was a dull movie and audiences slowly waned. Eventually, it made back the investment, but 20th Century-Fox for a time let most of its staff go, and for a long time looked like a ghost town.

At the Academy Awards, *Cleopatra* won for cinematography, sets, costumes, and special effects, but lost Best Picture, directing, and writing to the amusing, naughty, madcap British production of *Tom Jones.* Sidney Poitier was voted Best Actor for *Lilies of the Field.* Both of these little films made sizable profits and cost less than Elizabeth Taylor's original salary of one million dollars. However, 20th Century-Fox did have its happy ending—in fact, one of the happiest endings ever seen on the big screen. In the midst of all the chaos, the studio had put a musical into production that had been quietly shooting in Salzburg, Austria. Robert Wise's *The Sound of Music,* starring Julie Andrews, who the year before won best actress for *Mary Poppins,* became an unexpected success.

THE QUICK REBIRTH AND RAPID FALL OF THE 60s MUSICAL

Long before *Jaws* and *Star Wars*, *The Sound of Music* created the audience phenomena known later as "repeat business." Unfairly maligned for its unadulterated optimism, *The Sound of Music* was shot entirely on location, unique for a musical, and on the giant widescreen it was a visual feat to behold for moviegoers. It had a first-run engagement in some cities for over a year, and eventually grossed over eighty million dollars, becoming the second most profitable film in history, next to *Gone With the Wind.* A record it held until it was broken by *The Godfather, The Exorcist,* and *Jaws,* which became the first movie to break a hundred million dollars.

The year before, *My Fair Lady* and *Mary Poppins* were competing with each other at the box office, and both did excellent business. Thus believing that the musical was the next box office golden goose, studios began to dump millions into lavish productions. This came at a time when the traditional Broadway musical was in decline, and rock musicals, like *Hair* and *Jesus Christ Superstar,* which were very anti-Rodgers and Hammerstein were attracting a younger audience who wanted to hear their music. The Beatles had scored two big hit movies with *A Hard Day's Night* and *Help!.* Rock 'n' roll was going through an incredibly rich period with Jimmy Hendricks; The Doors; The Rolling Stones; Donovan; Bob Dylan; Simon and Garfunkel; Jefferson Airplane; The Lovin' Spoonfuls; Buffalo Springfield; Cream; and Crosby, Stills, Nash, and Young.

But studios were still not aware of the untapped potential of the younger market, and most of the older executives disliked the rebellious new rock music. Instead they revisited the old fashioned musical well once too often and produced a series of musicals based on the old Hollywood and Broadway formula. One after another, these

*The Sound of Music (1965) directed by Robert Wise, starring Julie Andrews and Christopher Plummer, saved 20th Century-Fox after its near collapse from **Cleopatra.** The movie is often maligned for its sugary sweet nature, but what is overlooked today is the impact it had on audiences during its original release. **The Sound of Music** was beautifully shot on location, instead of sound stages as musicals had been since **The Jazz Singer,** and it provided an escape from news about Vietnam and political assassinations.*

overblown musicals went down in expensive flames at the box office, including *Lost Horizon, Thoroughly Modern Millie, Goodbye Mr. Chips, Paint Your Wagon, Chitty Chitty Bang Bang, On a Clear Day You Can See Forever, Doctor Dolittle,* and *Hello, Dolly!* Only Carol Reed's *Oliver!* and William Wyler's *Funny Girl,* both released in 1968, did respectable business, but nothing like *The Sound of Music* had done.

THE END OF THE EPICS (WELL, FOR 30 YEARS, ANYWAY)

In 1964, Anthony Mann's *The Fall of the Roman Empire,* with a title that invited criticism and poor box office turnout, went from first-run theatres to drive-ins within weeks. Despite the international cast and many truly exciting sequences, audiences seemed to collectively become tired of historical epics. And the following year, George Stevens' *The Greatest Story Ever Told,* even with one of the most star-studded casts since *Around the World in 80 Days,* proved to be a failure on almost a greater scale than *Cleopatra. The Greatest Story Ever Told* spared no expense, since the studio was banking on Stevens' old track recorded that included *Shane* and *Giant,* but the tale of Christ was ridiculed by critics and ignored by audiences. It never made back its large investment, and it ruined Stevens' career.

But just when it looked darkest for the epic, David Lean made *Doctor Zhivago,* based on Boris Pasternak's Nobel Prize-winning best-selling novel about the Russian Revolution. *Lawrence of Arabia* was a huge hit when it came out, but it pales in comparison to the success of *Doctor Zhivago.* As with all David Lean's films, *Doctor Zhivago* is absolutely gorgeous to view. One review suggested that Lean had a pact with God, thus explaining how he could capture certain natural elements exactly, unlike any other director ever had. This was long before computer-generated images. To photograph the breathtaking look of clouds, skylines, and endless landscapes was achieved purely by luck and great patience. *Doctor Zhivago* had everything going for it—romance, a lush score that produced a hit single, and Julie Christie, who won the Academy Award that same year for her memorable performance in *Darling.* It was also released during a period when books on the Russian Revolution were on best seller lists.

But even David Lean ultimately produced an epic that despite its gorgeous appearance, was a dud at the box office. To make ends meet, in 1970, MGM auctioned off hundreds of thousands of costumes and props from its glorious past, including the ruby slippers from *The Wizard of Oz.* Then most of the backlot, the most famous one in the world, was sold to developers. The greatest studio of the Golden Age was now desperate for a miracle.

Two movies were in production: Fred Zinnemann's *Man's Fate,* which had most of the sets built, and David Lean's *Ryan's Daughter.* One of them had to be cut for budget reasons, and Lean was the safe bet, with a string of successes over the last fifteen years. The sets for Zinnemann's film were torn down, and the future of MGM rested on *Ryan's Daughter,* like it had with *Ben-Hur* a decade before.

But the only safe bet in Hollywood is that there are no safe bets. In a year of great change, with movies like *Five Easy Pieces, M*A*S*H, Patton, Women in Love,* and Fellini's *Satyricon,* Lean's romantic tale set in revolutionary Ireland was a disappointment. With beautiful cinematography by Freddie Young, it was a throwback to a classical, symbolic style of filmmaking that was out of tune in a new age free from the restriction of the Production Code. *Ryan's Daughter* did moderately well at the box office, but was vi-

ciously attacked by critics, and, at the height of the free love movement, evoked laughter from audiences during some of the love scenes. To promote the film, Lean agreed to meet with some of the New York critics. At this gathering, Pauline Kael venomously ranted at Lean about how terrible his misconceived epic was. Deeply hurt by the comments, Lean did not make another movie for fourteen years—*Passage to India*, which would sadly be his last.

The failure of *Ryan's Daughter* brought an end to the large-scale epics, at least those that massively recreated ancient history. Lean's films were unique in this genre since he focused on major events of the twentieth century, but the scope of his movies fit the definition of what an epic was all about. The brief age when studios could lavish money on building a giant chariot arena, the Roman senate, or a city in the middle of the desert were gone. The inexpensive but skilled labor found in foreign countries after World War II gradually became unaffordable. It would take thirty years until computer graphic technology, which evolved from companies like George Lucas' Industrial Light and Magic, could render a view of the Coliseum that would fool the eye and appear completely lifelike on a large

screen. In 2000, the epic was reborn with Ridley Scott's *Gladiator* and Ang Lee's *Crouching Tiger, Hidden Dragon.* Quickly following these films were Peter Jackson's *The Lord of the Ring trilogy,* Wolfgang Petersen's *Troy,* Edward Zwich's *The Last Samurai,* and Oliver Stone's *Alexander.* With the ability to open in thousands of theatres around the world in a single day, combined with DVD sales and possible video game tie-ins, the risk of making back investments in the hundreds of millions is much safer today than it was during the time of *Cleopatra.* But it still takes only one box office disaster with a hefty price tag to financially cripple a studio, and film history always seems to repeat itself.

FILM SCHOOLS: FROM JOKES TO SERIOUS STUFF

Film schools were a joke to most people working in movie studios. From the very beginning, starting in the silent era, directors, cinematographers, designers, sound engineers, and other skilled tradespeople learned their craft by apprenticeships. Someone would master their craft by being an assistant and work up to a

*George Lucas directing his 15 minute student film **Electronic Labyrinth THX 1138 4EB** (1970). Film schools were generally considered a joke within the motion picture industry, because a degree provided no guarantee into the Hollywood Studio System. Then Francis Ford Coppola at UCLA made a small movie called **Finian's Rainbow** that got him a directing contract with Warner Bros. While filming he made Lucas, a student from USC, his production assistant. This ultimately lead to Lucas shooting a full-length version of **THE 1138.***

key position after several years. In cinematography, the most difficult and demanding of the movie professions to break into, a young person might start as a "gofer" to the cinematographer, then become an assistant cameraman. After this they might be given the responsibly of shooting second-unit footage, and then eventually allowed to be the cinematographer on B-features. Finally, after several years, and with luck, they would be given the opportunity to shoot A-features with stars. Just about everyone was under a long-term contract, so each day was a learning process.

Studios were their own universities, complete with acting schools where new talent took lessons from the best acting coaches available, plus had classes in movement, singing, dancing, sword fighting, and character accents. Most studios had small theatres where actors rehearsed scenes in front of audiences or comedians worked out new material. And the testing ground began with shorts, which most studios made until the late 1950s, then perhaps a few B-movies, and eventually small parts in A-features before getting a leading role, if an actor made it that far.

The idea that someone could get into the film Industry by going to a university to watch and analyze movies, and then going out and making ten-minute movies on war surplus cameras that would be shown in class was subject to great ridicule by insiders. This seemed equivalent to education by the "think system," which in *The Music Man* is how Prof. Harold Hill proposes the children will learn to make music on the instruments he hoodwinked the parents into buying. Then things began to change. Starting in the early 50s, studios began to cut back on personnel, so training opportunities began to disappear. This meant the only place to learn filmmaking was on television, a Roger Corman low-budget quickie feature, a film department at a university, or a combination of all three.

In the 60s there were only a few film departments at universities, since most institutions of higher learning consider film studies unimportant and an inferior art form—if it could even be considered an art form (a belief that amazingly still persists today in many major universities). These departments were primitive, often located in classrooms no one else wanted, and the equipment was mostly donated. Then a miracle happened-three students from three different universities somehow got films made and distributed.

These students were Francis Ford Coppola, who went to the University of California, Los Angeles (UCLA); George Lucas, who attended the University of Southern California (USC); and Martin Scorsese, who got a degree at New York University (NYU).

As an example of how long it took for film schools to be taken seriously, the University of Southern California (USC) was founded in 1929. The first film class began on February 6, and was titled "Introduction to the Photoplay." Some of the guest lecturers were Douglas Fairbanks, Mary Pickford, Cedric Gibbons, Ernst Lubitsch, D. W. Griffith, and Irving Thalberg. But thirty-five years later, when George Lucas attended, he recalls that the first thing the professor told the students was to get out if they were smart, because the only thing they could hope for was to perhaps make a few industrial films.

Eight years later, after *American Graffiti* was released, professors were telling students about the opportunities available in the motion picture industry. By the late 70s after the successes of *The Godfather, Star Wars,* and *Taxi Driver,* film schools had become the creative farms that studios watched carefully for new talent. Today, studios, production houses, equipment manufacturers, and software companies support film schools with equipment, and students are trained by instructors who are intimately familiar with the

business, which is proof that sometimes it takes just one person to make a difference.

ROGER CORMAN: FILMMAKING 101

Roger Corman produced over 340 films beginning in 1955 with *Five Guns West*. He hit a chord by making B-films that people loved to see and cuddle up to at the drive-ins—what Pauline Kael would call "movie trash" and later would be known as "popcorn films." Corman's low-budget quickies had such tantalizing titles as *It Conquered The World, Attack of the Crab Monsters, Naked Paradise, Teenage Doll, Sorority Girl, Rock All Night, Teenage Caveman, She Gods of Shark Reef, Machine Gun Kelly, Bucket of Blood,* and *The Wasp Woman*. Then, he began to make films that had a touch of class to them, usually using actor Vincent Price getting into Technicolor with *The House of Usher, The Pit and the Pendulum, The Premature Burial, Tales of Terror, The Tower of London,* and *The Raven*. He bragged about shooting *The Little Shop of Horrors* in three days, featuring a very young Jack Nicholson as the masochistic dental patient.

Although Corman's films will not be studied with the same reverence as independent films like John Cassavetes' *Faces* or Stanley Kubrick's *The Killing,* his most important contribution was that a by-product of his ultra-low budget features was that he created one of the most successful little film schools ever. He would welcome young students coming out of UCLA, USC, and NYU and give them a chance to make a feature movie. If they were lucky, they would have one month and roughly thirty-five thousand dollars. It was dizzyingly fast, highly stressful, and a training ground of the first order. Successful survivors and alumni from Corman's down-and-dirty school of filmmaking are Francis Ford Coppola, James Cameron, Jack Nicholson, Robert Towne, Martin Scorsese, Ron Howard, and many more.

Corman was a master at seeing the changes in trends, which were fast and furious during the 1960s, and tapping into them. Not many of his films will make it into the National Archives. He was not trying to make *The Seventh Seal* or

Vicent Price being directed by Roger Corman in one of the many low-budget gothic horror films they made together. Working on one of Corman's B-movies was considered a crash course in filmmaking. Graduates from this fast and lean production process include Jack Nicholson, Francis Ford Coppola, Robert Towne, Martin Scorsese, and James Cameron.

Bicycle Thief; he was giving people good, quick, cheap thrills. Within a few years he shifted from horror flicks like *The Man with the X-Ray Eyes* to biker films like *The Wild Angels.* These movies were targeted at a young teenage audience, which was ignored by mainstream Hollywood. In the late '30s Louis B. Mayer tapped into this market with the Andy Hardy series and in the early '60s Disney did it with *The Parent Trap* starring teen heartthrob Hayley Mills. But Corman saw that teenagers would not buy the sweet, whipped cream kids' movies anymore, but wanted something scary, tough, and a little sexy. He was right on the money. By the late 70s, this market would dominate the film industry.

THE END OF THE PRODUCTION CODE

The Hollywood Production Code officially ended in September of 1966, after being a watchdog on movie morality for thirty-six years. Recent films like Sidney Lumet's *The Pawnbroker* and Mike Nichols' *Who's Afraid of Virginia Woolf,* based on Edward Albee's controversial Broadway play, and even Roger Corman's *The Wild Angels* all contributed to the Code's final demise. The end had been coming for years, beginning with the flood of foreign films, the brutality shown on the nightly television news, sensational novels with no limits on language, and a raw, new freedom of expression in theatre. There had been a heated issue two years before over a proposed nude scene in Arthur Hiller's *The Americanization of Emily,* starring Julie Andrews. When the Code was first established, there were only eleven studios; now studios were made up of small production companies, and there were hundreds of other companies in Europe, Japan, and Hong Kong. There was no way to control them all.

Jack Valenti, the head of the Motion Picture Association of America (MPAA), who would hold this position until his retirement in 2004, issued an announcement about a more flexible code to replace the one Joseph Breen had overseen for decades: "a code of self-regulation." The statement said that, "Brutality, illicit sex, indecent exposure, vulgar or profane words and gestures,

***The Graduate** (1967) directed by Mike Nichols, starring Dustin Hoffman, Anne Bancroft, and Kathrine Ross, is an example of a film that never would have been made during the Production Code. The movie has nudity (very brief) and is about a student who has an affair with a married, older woman—and then her daughter! The Code was finally laid to rest the year before and Hollywood motion pictures literally changed overnight.*

and offensive treatment of religious and racial or national groups, are noted as subjects for restraint, but interpretation in all cases . . . including nudity, is left to the discretion of the administrations." Warning would be issued in advertisements that indicated if the film was "suitable for children" or "for adults only."

There were no taps played for the Production Code, it had served its purpose and much like a marathon runner, it was exhausted. The Code forced movies to be stripped of anything offensive, like in a research lab, which resulted in pure storytelling. The studios worked on the emotions of the audience through carefully constructed melodramas that were brought to life by a galaxy of new stars whose genuine personalities made audiences laugh and weep. This is what Hollywood did best through troubled times for three decades. The legacy of the Code is the pleasure of watching these old, clockwork films that established all the genres and compare how they continue to influence modern films in terms of story, character, and the casting of stars.

It is a sad but true observation that a certain amount of censorship has produced great art. This is not an encouragement to start imprisoning artists to see if their work improves. However, during the reign of the Czars and the dictatorship of Stalin, Russia was producing great literature and music. During the terrible days of debtors' prison and child labor, Dickens created his most memorable characters. And it can be argued that during the Production Code era, since writers and directors could not go for the easy four-letter word insult, and actors had to keep all their clothes on, the visual language of cinema expression was refined into a true art form.

1967—THE YEAR AFTER THE CODE

What is remarkable is to look at the films that came out in 1967, one year after the Production Code was retired. There was an instant and very distinct change. It was almost as if the movies had been stuck in school for thirty-six years, and then in just one year broke loose on a wild summer break. The sex and violence that were taboo under the Code were suddenly on the screen in startling ways. In one year there was Norman Jewison's *In the Heat of the Night*, Stuart Rosenberg's *Cool Hand Luke*, Roger Vadim's *Barbarella*, Richard Brooks's *In*

Bonnie and Clyde (1967) directed by Arthur Penn, starring Warren Beatty, Faye Dunaway, Gene Hackman, Michael J. Pollard, and Estelle Parson. Lately because of the Production Code, people had never seen graphic violence on screen—and in color. It is impossible now to imagine how shocking some of the scenes were to audiences. **Bonnie and Clyde** changed the way films were made, but it was also a final loss of innocence to moviegoers.

Cold Blood, Luis Bunuel's *Belle de Jour,* Jean-Luc Goddard's *Weekend,* John Boorman's *Point Blank,* Robert Aldrich's *The Dirty Dozen,* and Mark Rydell's *The Fox.*

Then there were two films that changed everything. Mike Nichols' *The Graduate* was about a young man just out of college who had a fling with Mrs. Robinson, an older married woman, then fell in love with her daughter. It was the first major film to use the contemporary music of the 60s. The movie's soundtrack featuring songs by Simon and Garfunkel sold in the millions. *The Graduate* also made a significant break from traditional casting. Legend has it that Nichols was going to cast Robert Redford in the lead role, then after Dustin Hoffman auditioned, he gave the part to him instead. This threw open the door to casting-against-type and ethnic casting, for what in the past would have been given to Cary Grant, Gregory Peck, or Burt Lancaster. By the '70s, the leading men were Al Pacino, Gene Hackman, Elliott Gould, Gene Wilder, Richard Pryor, Donald Sutherland, and Woody Allen.

The other film was Arthur Penn's *Bonnie and Clyde,* which broke almost every rule in the Code. The film opens with a nude scene of Faye Dunaway pacing her bedroom out of sexual frustration. Then there is a scene when a man rushes from a bank the couple just held up, and is shot in the face. The Code stated that in the same camera shot, a gun could not be fired and someone could not get struck. The fear was that this could encourage violent behavior. When the man from the bank is shot, the gun is clearly seen, and the man's face turns into a bloody mess. At the end of *Bonnie and Clyde,* the couple is brutally riddled with bullets, their bodies twitching in slow motion. Upon its release, the film was slammed by most reviewers, but a handful of critics, including Pauline Kael and Andrew Sarris, championed *Bonnie and Clyde,* defending the graphic violence by saying it marked the beginning of what

would become known as the New Hollywood. Another aspect of *Bonnie and Clyde* that critics objected to was that it combined slapstick comedy with scenes of vivid bloodshed. Today the blending of humor and violence is a standard feature of most action films, but at the time it was disturbing to many people in the audience.

Curiously, profanity, one of the forbidden sins of the Code, was not used in most films immediately. In 1939, David O. Selznick had to fight for Rhett Butler to tell Scarlett that, "Frankly, my dear, I don't give a damn." Colorful language, which is how it was described during the Studio System years, would become more commonplace in the mid-1970s after Martin Scorsese's *Mean Streets* and *Taxi Driver,* Hal Ashby's *The Last Detail,* and George Roy Hill's *Slap Shot.* But this is not too surprising, because 1967 was still the year of wholesome family entertainment, like the musicals *Doctor Dolittle, Camelot, Thoroughly Modern Millie,* and Walt Disney's *The Jungle Book.*

HOW TO SHOOT A HIPPIE

In 1967, the Summer of Love was a beautifully naive period when people wholeheartedly believed that the good vibes of peace and love could put an end to war. People were tripping out on LSD, and drugs were freely passed around at "happenings." And, yes, there really were hippies and flower children who flashed the peace sign, dressed in tie-dyed shirts, wore love beads, and went to army surplus stores to buy bell-bottom jeans and navy peacoats. It was a groovy, psychedelic time, when love children during the unrest and riots at the Chicago Democratic Convention put daisies in the barrel of an M-1 rifle held firmly by a soldier in the National Guard. The problem in Hollywood was how to make a movie that depicted this crazy time without it looking fake or silly.

A Hard Day's Night (1964) directed by Richard Lester, starring The Beatles: John Lennon, Paul McCartney, Ringo Starr, and George Harrison. This film was amazingly innovative when it came out. The fast-paced movie created a carefree, fun-loving image of John, Paul, Ringo, and George that has been fixed in the minds of fans ever since. It can be argued that the film had the first "music videos," over fifteen years before MTV. And, borrowing from the French New Wave, it was shot like a documentary, giving all the giddy madness a sense of reality.

The Summer of Love, which was actually a couple of years, depending on different parts of the country, has become part of the popular myth and it has never been successfully recreated. The whole era is like a zonked-out version of *Rashomon,* where everybody has a personal viewpoint of what was going on. The documentaries *Monterey Pop, Don't Look Back,* and *Woodstock* gave a real sense of this age through its music, which might be the only possible way to examine this unique period in history. Lawrence Kasdan tried to capture it in *The Big Chill.* There was a long flashback sequence about the hippie days, which was to be Kevin Costner's big break into the movies, but Kasdan cut it out because it seemed unbelievable. Milos Forman's version of the rock musical *Hair* has always gotten mixed reviews. Some feel he went too far, and others believe he didn't go far enough. It's that viewpoint thing again. But for a musical that takes place on a bare stage, Forman managed to opened up the story and give it a physical presence that at least gets the spirit of the era.

Stuart Hagmann attempted to have a serious look at the Peace Movement when students rioted at Columbia University, but the film The Strawberry Statement became fragmented in too many different directions. Hy Averbach came perhaps the closest with Peter Sellers in *I Love You, Alice B. Toklas,* written by Larry Tucker and Paul Mazursky, which has some truly funny scenes about the "head trips" people were having during this time. Mazursky later had fun with friends flirting with letting it all hang out and trying free love in *Bob & Carol & Ted & Alice.* Dennis Hopper's *Easy Rider* at times is more documentary than movie, but this blurred line gives a frightening look at America after the Summer of Love. Intentional or not, *Easy Rider* became the death knell for the innocence associated with the '60s youth culture trying, in the words of John Lennon, to "give peace a chance." And then there is Mel Brooks who played it strictly for laughs in *The Producer,* with Dick Shawn as a hippie Hitler, grooving during "Springtime for Hitler."

A Hard Day's Night and *Help!,* the two carefree movies that Richard Lester made with the Beatles, came out in 1964 and 1965, before the Summer of Love, but in their pleasantly madcap way set the ground rules for the peace and love

movement. Lester's fast-paced editing and camera tricks during the Beatles' songs became the forerunners of MTV music videos. Both films are make-believe documentaries, but they so cleverly developed the image of the Beatles as overgrown kids and perpetual practical jokers they have become inseparably linked to the legend of the Fab Four.

Perhaps the best movie about the Peace Movement is actually an animated feature, *Yellow Submarine,* based on the surreal artwork of Peter Max, and with some of the Beatles' best songs. *Yellow Submarine* perfectly captures the visual and emotional magic of those brief days, and since the characters are cartoons, there are no problems making the hippie image believable. Also, there was serious talk about the Beatles starring in a live-action movie version of *The Lord of the Rings,* with Ringo Starr as Frodo. Fortunately for Peter Jackson (and the rest of the world) this never happened.

KEVIN BROWNLOW

Film historians are never looked upon as important to the process of film history. If there is one single exception, it is a mild-mannered Englishman named Kevin Brownlow. Brownlow was a precocious adolescent, directing his first feature, *It Happened Here* (1956), at eighteen years old. Later he became an editor, working with Tony Richardson's company on *The Charge of the Light Brigade* (1967). His work on documentary shorts, and his childhood love of Abel Gance's masterpiece *Napoleon,* fostered a passionate interest in the silent era. He then began the tireless task of seeking out surviving pioneers of that distant era. Brownlow literally went from door to door in Hollywood, finding actors, directors, cinematographers, and others who were connected with silent movies. Most

had been forgotten for decades and never had an opportunity to talk about their experiences. The highlights of his numerous interviews were published with nostalgic illustrations as *The Parade's Gone By* in 1968.

Almost single-handedly, Brownlow's efforts created a long overdue curiosity to explore the silent era, which in turn brought to light how many of the innovations and movie traditions that are commonplace now were first discovered by these pioneers. This might sound like an obvious connection, but in the 50s and 60s film history mostly focused on the stars and scandals, not on the how and why of filmmaking. *The Parade's Gone By* opened up a world of early Hollywood that was the cinematic equivalent of finding King Tut's tomb. Within a few years after its publication, over half of the men and women he interviewed had passed away. If he had waited any longer, or had not conducted these interviews at all, there would be a large, empty hole in what is arguably the most exciting period in film history. It is astonishing how neglected the silent era was at this time, because it had all taken place just forty years before.

Ever since, Brownlow has dedicated himself almost exclusively to the research of the silent era. He spent years in the frame-by-frame restoration of Gance's five-hour epic *Napoleon* (1927), which had been considered lost after it was drastically cut during its original release. He made a thirteen-part documentary for the BBC simply called *Hollywood,* based on his book, *Hollywood: The Pioneers.* He worked closely with the Charles Chaplin estate and put together a three-part documentary, *The Unknown Chaplin,* with the only existing footage of this genius behind the camera. Then he did the same for the other comic genius of the silent era, with *Buster Keaton: A Hard Act to Follow.* Brownlow's documentary, *Cinema Europe: The Other Hollywood,* took over twelve years to make. In 1979, Brownlow was awarded

the Legion of Honor for his contributions to French cinema culture. If the Motion Picture Academy ever issues a film historian a special Oscar for a lifetime of research, then Kevin Brownlow should be the first to receive this award.

THE END OF LITERATURE, PART I

The observation that the 1960s were the last time there was a widespread interest in all forms of literature will certainly not be a popular viewpoint with English professors. But today the passionate debates on the green lawns of university campuses do not center around which is the greater novel, Dostoyevsky's *The Idiot* or Thomas Mann's *The Magic Mountain*. And when was the last time a production of Samuel Beckett's *Endgame* had standing room only and the run had to be extended? Or a reading of Dylan Thomas' poems had to be held in a large auditorium to accommodate an overflow audience?

Walking across a campus during this time, visiting the beach or a park, or even taking a bus downtown, Baby Boomers had their noses buried in Tolkien's *The Lord of the Rings,* Hermann Hesse's *Siddartha* or *Steppenwolf,* J. D. Salinger's *The Catcher in the Rye* (which they were reading for the eighth time), or Joseph Heller's *Catch 22.* There was an almost insatiable interest in all forms of art during the '60s, and cities like San Francisco, New York, Los Angeles, and many others had became modern mirrored images of Paris during the '20s. Perhaps there was a "lost" feeling among this generation because of Vietnam, the peace riots, assassinations, and the Civil Rights Movement, as Gertrude Stein called Hemingway and the other artists living in Europe in the years after World War II.

A connecting factor to this interest in literature were the revival theatres, where festivals of modern foreign films and the discovery of old classics seemed to foster the idea of film as art; this in turn began an overlapping influence in all art forms. The revival theatres or art houses in many cities were connected to bookstores and coffeehouses. There was the constant buzz about the possibility of great books being made into film by some of the new directors. Robert Altman wanted to adapt William Faulkner's *As I Lay Dying.* Altman's project never got made, but Mark Rydell brought *The Reivers* to the screen with Steve McQueen, based on Faulkner's Pulitzer-Prize-winning humorous novel. The most talked about literary work was *The Lord of the Rings,* but everyone agreed that it would be impossible to make into a movie.

Though it would take years to finally make, Joseph Conrad's *Heart of Darkness* was turned into a screenplay by USC student John Milus titled *Apocalypse Now,* which would later be co-written and directed by Francis Ford Coppola. Francois Truffaut made Ray Bradbury's *Fahrenheit 451,* Luchhino Visconi made Thomas Mann's *Death in Venice,* and Christopher Isherwood's *Berlin Stories* was turned into the musical *Cabaret,* then a motion picture, directed by Bob Fosse. However, a few adaptations of classics resulted in box office bombs, like Jack Clayton's *The Great Gatsby* and Peter Bogdanovich's *Daisy Miller.*

There was an interest in the theater, especially the plays by Samuel Beckett and Jean Genet, and the exciting staging innovations of Peter Brooks and what was happening with the Polish Theatre. During the late 60s, classics by William Faulkner, James Joyce, F. Scott Fritzgerald, Tennessee Williams, Eugene O'Neill, Ernest Hemingway, Joyce Cary, and many, many others were selling as many copies as Philip Roth's *Goodbye Columbus* and *The Teachings of*

Don Juan, a book on Native American mysticism. This was a period when the written word and the image on screen lived in complete harmony together.

It might be misleading to call it an intellectual age, but it was a time of great discovery where people talked about reading all of F. Scott Fitzgerald, or having made it through *Ulysses* with a clear understanding. And it was a great time for science fiction with Frank Herbert's *Dune,* Robert Heinlein's *Stranger in a Strange Land,* and Ray Bradbury's *Something Wicked This Way Comes,* all paperback best sellers with far-out artwork on the cover.

There was a popular new wave in painting. The pop artist was very in, with Andy Warhol's Campbell's Soup paintings and multi-tinted images of Marilyn Monroe. Peter Max caught the psychedelic spirit of the drug culture, and prints of the Impressionists were sold and talked about as if the artists were still alive. There was a great interest in philosophy. Books by Immanuel Kant, Friedrich Nietzsche, Auguste Comte, G. F. W. Hegel, Karl Marx, and Rene Descartes ("I think, therefore I am") were being read and zealously discussed. Woody Allen was giving spins on philosophical quotes in his comedy routines and getting big laughs. People were arguing whose philosophy hit the absolute truth and justified mankind's existence on this planet. And for womankind, the opposite sex was reading Gloria Steinem, and *The Feminine Mystique* was a runaway best seller.

There was a sense that innovative thoughts could change the course of the world, and the absorption of the works by great artists would produce a modern renaissance person. And there was a thrill when books were banned. Alan Ginsberg's *Howl,* Henry Miller's *Tropic of Cancer,* and Genet's *The Balcony* were considered forbidden reading by the Catholic Church and other religious organizations. When they were published by Grove Press, copies (which had literally been sold under the counter for years) flew off the shelves. D. H. *Lawrence's Lady Chatterley's Lover* and *Women In Love* had been banned in Boston since they were first published in the 1920s, so in the 1960s they became huge sellers. Jack Nicholson even does a toast to "good old D. H. Lawrence" in *Easy Rider.*

And this was the only time in television history when modern authors were sitting next to movie stars and politicians on talk shows like Dick Cavett. People would tune in to see Truman Capote and Gore Vidal argue, and everyone argued with Norman Mailer. This became a kind of last hurrah of the modern novel as a popular art form—of course, there might be a few who disagree with this.

THE GOLDEN AGE OF COMIC BOOKS

Yes, everything has a golden age, even comic books. This reached a zenith during the 1960s, with DC Comics and Marvel Comics introducing a new series of characters and revamping some of their legendary heroes. The Baby Boomers grew up with comic books. In every drug store, department store, or train and bus station, there were revolving comic book racks that were replenished each week with new titles.

Comic books and the movies have always had a kindred relationship. The Sunday funnies date back to the turn of the twentieth century when film was first getting started. DC Comics' *National Periodical* appeared in 1935, which eventually became *Detective Comics,* the longest comic book publication, continues today. The first characters were spin-offs from the funny papers, like Dick Tracy, Mandrake the Magician, and Flash Gordon. Then in 1938, DC released a new publication called *Action Comics* featuring a man in a

Superman was created by Jerry Siegel and Joe Schuster in 1933 as a villain with super powers. But in the summer of 1934 the duo revamped their comic book character into the ultimate flying hero, who pretends to be the mild-mannered reporter Clark Kent. For almost two-thirds of a century kids have been growing up reading comic books and getting caught up in the adventures of these super-heroes. The layout of these illustrated tales is exactly like storyboards for motion pictures, so it is not surprising that faster than a speeding bullet Hollywood began to make serials out of these bigger-than-life characters.

costume with a big "S" on it. Superman was pure comic book gold, but the following year DC stuck it rich again with a mysterious man who swung around skyscrapers on ropes called Batman, created by Bob Kane.

The layout art of a comic book is like stills from a movie, comprised of long shots, medium shots, and close-ups. Alfred Hitchcock became the first director to talk about storyboards, which he claimed he made for each of his films. A storyboard is a shot-by-shot illustration of every camera setup in a movie. It is invaluable to a director like Hitchcock who worked in montage and used dramatic camera angles. In the 70s, with the increase of special effects, it became essential for directors to storyboard their films during pre-production. With a storyboard, a cinematographer can see where to place the camera for each scene, the scenic and costume designers have visuals from which to work, and the director can plot the pace and editing of a sequence. So, while

these Baby Boomers were sneaking under the covers at night with a flashlight to read the latest *Tales of the Crypt,* they were actually learning the dynamics of filmmaking.

Marvel Comics and DC Comics, with an amazing lineup of superheroes, grew in popularity during World War II, with Captain America, whose archenemy was the Red Skull; the Flash; Green Lantern; Hawkman; and Captain Marvel, who was transformed with the magic word "Shazam!"

In 1942, a new hero was introduced, Donald Duck. In comic books, as created by Carl Banks, Donald is a different character than the unintelligible fussbudget in the cartoons. In the tales Banks cooked up for Donald, there was high adventure, like Tarzan or Errol Flynn films. In 1947, Banks introduced one of the greatest comic book characters of all times, Uncle Scrooge. The complicated adventures Uncle Scrooge would set out on each month, usually to ingeniously protect his

money from the Beagle Boys and Magica DeSpell, were very much in the style of *Raiders of the Lost Ark*. Banks wrote and drew over 500 duck tales, finally retiring (for the first time) in 1966. George Lucas and Steven Spielberg admit to being big Uncle Scrooge fans.

In 1950, EC Horror Comics introduced *The Tales of the Crypt* (with the crypt keeper introducing each grotesque tale) and *The Vault of Horror*. These comics were frightening, gruesome, and often diabolically deranged. Kids bought them by the tens of thousands. Other depraved titles included *Weird Science, From the Tomb, Weird Fantasy, Crime SuspenStories,* and *Tales of Terror*. By 1953, EC Horror Comics were selling close to 450,000 titles a month. That same year, the Senate Subcommittee to Investigate Juvenile Delinquency in the United States was formed and immediately targeted EC as a prime source of encouraging children toward violence. During this time, ACMP (Association of Comic Magazine Publishers) was formed, which is the comic version of the Hollywood Production Code. By the early '60s, most of the EC writers and artists were working on just one publication, *Mad Magazine*.

Classic Illustrated took a completely different approach, and turned great literature into comic books. They were remarkably faithful to the original stories and had some truly remarkable artwork that vividly brought the classic tales to life. In fact, students probably wrote more book reports after reading the *Classic Illustrated* versions of *Oliver Twist, 20,000 Leagues under the Sea* or *Crime and Punishment* than after actually reading the novel. Actually, it was discovered that *Classic Illustrated* did encourage students to read books, and that many students learned to read from these comic books. Thus they became the only comic books to be endorsed by many schools. Many of the directors and screenwriters of the New Hollywood era talk about how *Classic Illustrated* helped them understand story structure.

By the '60s, with the exception of EC Horror Comics, all of these comic books were at their peak. Superman and Batman, with his insanely clever foe, the Joker, were the most popular superheroes, but this was to quickly change. Starting in the early '60s, Marvel Comics introduced a batch of superheroes and for the first time outsold its chief competitor, DC Comics. The writer responsible for this was named Stan Lee, who originally joined Marvel at the age of sixteen years old, quickly becoming the youngest editor in the comic book business. He left to serve in the Signal Corps during the war and worked on Captain America, the Human Torch, and the Sub Mariner when he returned. Then in the '60s, Stan Lee went on a creative spree that has never been equaled in the comic book world, which is saying a lot. Out of his imagination came The X-Men, the Incredible Hulk, the Fantastic Four, Iron Man, Daredevil, Thor, Dr. Strange, the Avengers, and a confused student with girlfriend problems named Spiderman.

For two years, from 1966 to 1968, Batman, with Adam West and a slew of guest stars, including Vincent Price, Burgess Meredith, Julie Newmar, and Caesar Romero as the Joker, was the biggest hit on television. It was played for over-the-top, vaudevillian humor, with Op Art balloons popping up during fight scenes that read "Pow", "Bang", "Thud", and other funny paper exclamations. It was pure silliness, and nothing like the dark world where the comic book Batman lived. Tim Burton's *Batman* (1989), with Anton Furt's sets that perfectly captured the look of Gotham City, finally caught the feel, if not exactly the mood, of the Dark Knight comic books. It is no mystery then that by the early 1990s, with major leaps in special effects, the filmmakers who grew up with these superheroes were bringing

them to the screen with great regularity. In a remarkably short time, advancements in computer graphic imaging gave these fantasies a sense of ultra-reality, and fans rewarded *The X-Men* (2000) and *Spiderman* (2002) with record breaking box office returns. But the real blockbuster profits are in the computer game market, where people can interact with these superheroes, which is what they have been doing in their imaginations for decades.

WHY 1968?

All the other eras in film history fall neatly into significant turning points dictated by new innovations like sound, the enforcement of the Production Code, the War Years, the Hollywood Blacklist, and the influence of foreign cinema. The first year of President Kennedy's administration was hopeful, exciting, and full of great humor. It gave the appearance of a vigorous new decade. In complete contrast, 1968 was arguably the darkest year in twentieth-century American history. During these eight years, most of the old directors that created the movies were retired or were turning out inferior films, the Production Code was abandoned, and a new group of directors began creating a different kind of cinema, more in tune with the times.

Some of these new directors continue to have long careers, but many made only a few remarkable films and for whatever reasons never again reached the excellence of their early landmark efforts. Imaginary or not, after the Production Code was officially retired in 1966, there was a kind of delayed cinematic reaction. The films that reflected this complete freedom were strongly evident by 1969, the unofficial beginning of what became known as the New Hollywood and the start of a second great renaissance in American filmmaking. Significantly, the directors who would put an indelible mark on films in this next phase would almost all be new faces, creating a post-Production Code effect. These were the directors who were never conditioned to pull their punches with language, violence, or the depiction of sexual relationships.

In 1968, Martin Luther King was assassinated on the balcony of his motel in Memphis, and a few months later, Robert Kennedy, on the verge of his great victory in the California primary, was gunned down in the kitchen of the Ambassador Hotel in Los Angeles, just seconds after he said, "Now let's go on to Chicago and win." Riots broke out at the Democratic Convention in Chicago during that long hot summer and the National Guard was called out. Black neighborhoods went up in flames because of violent protests. President Johnson called up 100,000 more soldiers for Vietnam. The death toll in Vietnam was approaching 50,000 soldiers, and would become 100,000 before it was over. The peace movement was anything but that, with violence seemingly breaking out at each demonstration. And Richard Milhous Nixon was elected the thirty-seventh president of the United States, planting the seeds for the Watergate scandal that would topple a government. Most citizens were left with the hollow feeling that Robert Kennedy might have been elected and carried on the interrupted dream of Camelot. The words at his funeral resounded in people's thoughts, "I see things that never were and ask, 'Why not?'"

There are two other reasons why 1968 was a key turning point in cinema history. Rock had become the dominant force in music, with its hard poetry powerfully expressing the divisive topics of peace and equality. And in Stanley Kubrick's *2001: A Space Odyssey*, which introduced a new age for special effects, the "bad guy" was a computer named HAL-9000.

THE AUTEUR THEORY: HOLLYWOOD SUNSET

Many of the giants of the old movie system made films into their late seventies, long after they should have retired to their ranches. In 1962, John Ford directed *The Man Who Shot Liberty Valance,* with John Wayne and James Stewart, which was attacked by critics at the time, but has endured as one of his best Westerns. That same year, at the age of sixty-seven, he shot the Civil War sequence in *How the West Was Won.* What everyone had expected to be his long-anticipated epic about the plight of the Native Americans, *Cheyenne Autumn,* turned out to be a major box office disappointment; however, he still became the first recipient of the American Film Institute Lifetime Achievement Award.

Howard Hawks made the same movie three different times before his career came to a complete standstill. *Rio Bravo, El Dorado,* and *Rio Lobo* all starred John Wayne and were a trilogy of the rough-and-tumble Old West. Fun-loving in spirit, and intended as the last hurrah of the traditional Western, these films did not reflect the knack Hawks had in the 1930s and 1940s when he was the master of any movie genre, from adventure to screwball comedies to gangster dramas and eventually science fiction. *Rio Lobo* was his last film, made at the age of seventy-four.

George Stevens would make only one movie in this time, *The Greatest Story Ever Told,* which was plagued by constant weather problems, and the prolonged production literally began to take its toll on his health. David Lean stepped in to shoot parts of this epic on the life of Christ, but it turned out to be a major box office failure. Warren Beatty, who considered himself a protege of the legendary director, and Elizabeth Taylor, who had become a box office star because of *A Place in the Sun* and *Giant,* used their considerable influence to put together *The Only Game in Town,* which would be Stevens' last film.

Billy Wilder won Oscars for writing, directing, and producing *The Apartment,* only one year after his greatest success, *Some Like It Hot;* but in the years after these back-to-back hits, his films increasingly lost the daring originality that he had been identified with for decades. Wilder was one of the most versatile writers and directors to ever come out of the Hollywood system, mostly because his films defied the assembly line approach to entertainment. Until *The Apartment,* Wilder seemed almost infallible, even his few failures at the box office were still fascinating to watch, but

*Alfred Hitchcock had in his contract with actors that no one could object to his camera placement. The shower scene in **Psycho** (1960) is an excellent example of a camera shot that sets up expectations in the viewer's mind. The ideal composition for a single person shot is center screen, slightly to the audience's right. But Hitchcock has Janet Leigh down left in the shot —which makes the eye naturally go up to center right when a shadowy figure enters.*

Storyboards for the shower scene in **Psycho** *drawn by Saul Bass. Starting in the mid-50s, Bass designed opening credits for movies like* **The Man with the Golden Arm, Around the World in 80 Days, Vertigo, Anatomy of a Murder,** *and* **North by Northwest.** *He replaced the formal theatrical feel of Studio Era credits with hip, modern animations that that built up anticipation in the audience's mind.*

his later films gave the sensation they were almost from a different person entirely.

Irma la Douce was from a Broadway musical, but Wilder cut all the songs and kept the vivacious score. The film was successful but the sexual humor became a variation on the same note. Movies like *One, Two, Three; Kiss Me Stupid; The Private Life of Sherlock Holmes; Avanti!; The Front Page;* and *Buddy Buddy* left audiences cold. The Fortune Cookie teamed up Jack Lemmon for the first time with Walter Matthau, who won the Best Supporting Actor Oscar for his role as the ultimate sleaze-bag, ambulance-chasing lawyer. The great character actor Ray Walston said that for years critics accused him of destroying Wilder's career because of his performance in *Kiss Me, Stupid* (originally intended for Peter Sellers), simply because no one could believe that the writer-director of *Double Indemnity* and *Sunset Boulevard* could produce a terrible script.

Wilder seemed to be part of a curious phenomenon that befell many quality directors who worked under the strict guidelines of the Production Code for most of their careers. The freedom to express himself without the ball-and-chain of the Code, when he was forced to work around the system, appeared to diminish the cleverness that is associated with Wilder's earlier films. The result was a bland display of over-ripe humor that would have been forbidden by the censors in the past.

William Wyler, after winning his third directing Academy Award for *Ben-Hur,* also seemed to go from one production to the other without any of the spirit or exquisite preciseness of his early films. He remade *These Three,* this time with Lillian Hellman's original title *The Children's Hour,* but the film lacked the suspense and dramatic irony of the original. His adaptation of the best seller *The Collector* received critical praise but limited box office, and the stylish

heist comedy *How to Steal a Million* was a far cry from *Roman Holiday.* His last major film, *Funny Girl,* which introduced Barbra Streisand, would be plagued with behind-the-scenes battles over artistic decisions. His final film, *The Liberation of L.B. Jones,* was about racial prejudice in the modern South but proved to be out of tune with the times. The most nominated director in film history would spend his final years giving interviews and making home movies with an 8mm camera.

Two longtime studio directors with impeccable taste, George Cukor and Vincent Minnelli, would make several films that hit popular chords in the 1960s. Cukor directed *The Chapman Report;* the big-budget musical *My Fair Lady,* which finally won him an Academy Award; and *Travels with My Aunt,* adapted from Graham Greene's dark comedy best seller. He made his last film, appropriately titled *Rich and Famous,* at the age of eighty-two. Minnelli showed he still had the ability to make dramatically powerful films with A-list actors, like *Some Came Running,* with Frank Sinatra and Shirley MacLaine; *Home from the Hill* with Robert Mitchum; and *The Sandpiper* with Elizabeth Taylor and Richard Burton. He even added a touch of class to formula movies like *The Courtship of Eddie's Father* and *Goodbye Charlie,* and brought style to the misconceived *On a Clear Day You Can See Forever,* the only musical Jack Nicholson ever starred in.

After making *Psycho,* one of the most startling and talked about movies ever, Hitchcock never found another project that would challenge his unquestionable genius for suspense. His follow up film, *The Birds,* was highly popular with innovative special effects, but it lacked the tension of *Notorious* and the playful plot twists of *North by Northwest.* However, *The Birds* clearly suggested that if Hitchcock were alive today he would, without a shadow of a doubt, be having fun, along with Spielberg and Lucas, experimenting with computer graphic imaging (CGI) to enhance his movies. After the box office disappointments of *Marnie* and *Torn Curtain,* he made *Frenzy,* which showed moments of the old master's love of visual pranks. It was his last fully realized suspense thriller. Hitchcock's final movie, *Family Plot,* was an overplayed comedy with a title that proved a sad irony to the end of a great career.

A NEW GENERATION OF DIRECTORS

The 1960s were a fascinating time period, because many of the directors who started out at the beginning of the decade, dramatically changing the look of Hollywood films, had by the end of the decade, for the lack of a better term, burnt out. Many of them came from live television, where they made shows with provocative stories, but had to unofficially stick to the rules of the Production Code. It is possible that some of these directors could not make the transition from working within the restrictions of the Code to having total freedom of expression. Or perhaps they served as lightning rods for a turbulent age and then made way for the next generation of directors who had never experienced any rigid guidelines on what they could or could not do. Whatever the speculation is, within this brief window of time, several of them made masterpieces that have endured. As Orson Welles observed late in his career, "It takes just one film to be great."

John Frankenheimer came from television, having directed over 150 live performances. His use of multi-camera techniques and blocking in the camera all were evident in his earlier films. Frankenheimer worked with Burt Lancaster on three excellently crafted films, *Birdman of Alcatraz* (1962), *The Seven Days in May* (1964), and *The Train* (1964), each reflecting strong social and

political themes. *The Manchurian Candidate* (1962) is Frankenheimer's best film, famous for his surrealistic work on the nightmare sequences. Ironically, the film was made because of the endorsement of President John F. Kennedy. *The Manchurian Candidate* deals with the potential assassination of a presidential candidate and gave Frank Sinatra his most memorable role. The tragic events of this era are now forever linked with this superbly crafted thriller, which after Kennedy's death was pulled from distribution for almost twenty years.

Frankenheimer became a close friend and supporter of Robert Kennedy, who had stayed at his house the night before the California primary. The loss of Robert Kennedy devastated him for years, and as a director he never seemed to fully recover. His love for auto racing resulted in *Grand Prix* (1966), made for Cinerama, and *Seconds* (1966), about a man who is given the opportunity to live the life he has already dreamt about, only to see it go terribly wrong, has become a cult classic over the years. Frankenheimer's later work lacked the taut narrative style and imaginative experimentation associated with his earlier films. Perhaps the unsettling circumstances surrounding his political films about assassination and the military overthrow of the presidency took its creative toll on him.

Sidney Lumet would make interesting films until the mid-1980s, including several classics that have endured. Like many of his contemporaries, he came from television, making his debut as a film director with *Twelve Angry Men* (1957), starring Henry Fonda. This is a remarkable bit of filmmaking, considering that, except for the opening and closing scenes, all the action takes place in a very tight, cramped room. His variety of camera shots and editing technique makes *Twelve Angry Men* dramatically suspenseful throughout.

Based in New York, Lumet had a skill for working fast and getting great results on low budgets. Because of this, he was able to make a series of films that are closer akin to the directors of the neorealism movement or the New Wave, than to Hollywood directors. In the 1960s he made Tennessee Williams' *The Fugitive Kind* (1960), with Marlon Brando and Anna Magnani; Eugene O'Neill's *Long Day's Journey into Night* (1962), giving Katharine Hepburn one of her greatest roles; *Fail Safe* (1964), with Henry Fonda (the movie that went head-to-head with *Dr. Strangelove*); and *The Pawnbroker* (1965), one of the first films that showed the long-term effect of the Holocaust on survivors, giving Rod Steiger his most powerful role.

But Lumet's real impact as a director came in the 70s. After a series of misfires, he made a remarkable comeback with two films starring Al Pacino, *Serpico* (1973) and *Dog Day Afternoon* (1975). As a complete change of pace, he made the stylish adaptation of Agatha Christie's mystery *Murder on the Orient Express*, with truly an all-star cast, and *Network*, Paddy Chayefsky's dark comedy about television news that won Oscars for Faye Dunaway and Peter Finch and had people going around saying, "I'm mad as hell and I'm not going to take it anymore!"

Both John Cassavetes and Stanley Kubrick started out directing small films which they begged and borrowed to make. But Cassavetes has become known as the leader of the modern independent film movement in America, while Kubrick is looked upon as an independent force that defies being classified. Cassavetes was an actor's actor, who, like Orson Welles, accepted roles so he could make his own movies. His ultra-low budget films were quirky and shot with his friends, who improvised most of the dialogue and took turns operating the camera. He was looking for the essence of the moment, which is exactly what was happening in Italy and France at this time. Cassavetes' *Shadows* came out in 1959, the year before *Breathless*. *Shadows* is crudely made

by Hollywood standards, shot quickly in 16 mm for only $40,000, but it won the Critics Award at the Venice Film Festival. This led to studio contracts, but both *Too Late Blues* (1962) and *A Child Is Waiting* (1963) were panned by critics and lost money at the box office. Cassavetes returned to acting and got a supporting Oscar nomination for *The Dirty Dozen* (1967) and was the husband that sold his wife to Satan in Roman Polanski's *Rosemary's Baby* (1968).

He was able to make *Faces* in 1968, almost ten years after *Shadows,* which found a small, loyal audience and received a nomination for best screenplay. With his friends Peter Falk and Ben Gazzara, he made *Husbands* (1970), and with Falk and his wife Gina Rowlands, he made his best-known film, *A Woman under the Influence* (1974), for which he received his only nomination as a director. But Academy Awards were not what Cassavetes cared about. His films were personal, autobiographical, freewheeling, in your face, and more home movies than Hollywood. People either loved them or hated them, which is exactly the emotional reaction he wanted from audiences. Cassavetes passed away in 1989, at the age of 60. Today his maverick style of filmmaking is honored each year at the Independent Spirit Awards. The John Cassavetes Award goes to the Best Feature made for under $500,000.

Norman Jewison is a director who has had a long career. Occasionally he pulls the rabbit out of the hat and does something that is very memorable. He is someone who certainly knows how to spin a story and get the greatest effect out of it. Although he lacks a style that is immediately identifiable like Kubrick, Lean, Hitchcock, or even Sidney Lumet, he is a very consistent filmmaker who is able to tackle social issues, comedy, romance and musicals. Born in Canada, he got his start with BBC-TV in London. After directing live musical specials with Judy Garland and Harry Belafonte (he remembers that the night Belafonte's show aired, dozens of southern stations canceled their affiliation with CBS).

Jewison got into movies by cranking out traditional Hollywood comedy fare, mostly with Doris Day, in movies like *The Thrill of It All* (1963) and *Send Me No Flowers* (1965). He then teamed up with Steve McQueen on two films, *The Cincinnati Kid* (1965), also starring Edward G. Robinson, and *The Thomas Crown Affair* (1968), with Faye Dunaway. Following the example set by *Dr. Strangelove,* Jewison made Americans laugh at the Cold War with the slapstick satire The Russians Are Coming, *The Russians Are Coming* (1966) is about a Russian submarine that is grounded off a small island off Long Island and the panic it causes in the local residents, who eventually, in the spirit of detente, come to the aid of the stranded sailors.

In the Heat of the Night (1967) is a strong film about racial prejudice, involving a big city detective, played by Sidney Poitier, and a small, Southern town sheriff, played by Rod Steiger, who are forced to solve a murder together. Jewison balances the film perfectly with humor, fascinating characters, and suspense, and subtly that turns the story around to show that Blacks and Whites can work together if they try. *In the Heat of the Night* won Academy Awards for best picture, and Steiger won for best actor. Jewison then turned to musicals, with *Fiddler on the Roof* (1971) and *Jesus Christ Superstar* (1973), then switched gears for the futuristic *Rollerball* (1975), and the over-the-top courtroom drama . . .*And Justice for All,* with Al Pacino. He directed the lovely valentine to romance, opera, old traditions, and the Italian people in the comedy *Moonstruck* (1987), which won Cher her Oscar for best actress. And in 1999, he made the controversial *The Hurricane,* starring Denzel Washington, based on the true story of a black boxer wrongfully accused of murder.

Arthur Penn's career in Hollywood was brief, but during his years there he changed movies for-

ever. Penn also came from television, working on the legendary *Playhouse 90* and the *Philco Playhouse.* On Broadway, he directed *Two for the Seesaw,* which enjoyed a long run. Penn's first film was *The Left Handed Gun* (1958), with Paul Newman, which allegedly James Dean was going to star in before his death. The film failed at the box office, and Penn went back to Broadway to do *The Miracle Worker,* which he brought to the screen to great acclaim in 1962. He then had a disastrous time with Burt Lancaster on *The Train* and was replaced by John Frankenheimer. Then fortune smiled on him in a strange way. He made *Mickey One* (1965) with an unknown actor named Warren Beatty. The film disappeared almost overnight, but Beatty respected the way Penn worked with actors.

After another terrible experience on *The Chase* (1966), starring Marlon Brando, Jane Fonda, and Robert Redford (the film was supposed to make him a star), Penn had enough of movie politics and was ready to call it quits. Then he got a call from Beatty about a gangster film. *Bonnie and Clyde* was a script by David Newman and Robert Benton that had been floating around. It was inspired by Jean-Luc Godard's *Breathless.* In fact, Godard was originally going to direct the film, but backed out, leaving Beatty, who had put the deal together at Warner Bros., without a director. Penn loved the films of the French New Wave, and liked the way the directors used the camera, broke the old studio rules, and equated violence with sex,

Ultimately, *Bonnie and Clyde* is an American gangster film that pays homage to *Breathless* and the directors of the New Wave, who in turn were influenced by the old Warner Bros. gangster films, especially Howard Hawks' *Scarface. Bonnie and Clyde* was being made as the Production Code came to an end, thus allowing new films to have the freedom of violence that had been restricted for over thirty years. The ultimate irony was that these restrictions were a result of public outcry and the Church's negative reaction to the early gangster movies—mostly those made at Warner Bros. It all seemed to come full circle. After suffering several bad experiences, Penn had found the right project to suit his unique directing talents.

Next came *Alice's Restaurant* (1969) based on Arlo Guthrie's talking blues ballet (a style of folk singing popularized by his father Woody Guthrie) about flower children and the hippie movement. It is one of the few films of this era that captures the spirit of the flower children without mocking them. Penn followed this with *Little Big Man* (1970), starring Dustin Hoffman, Faye Dunaway, and Chief Dan George. *Little Big Man* is a movie that got lost in the revisionist shuffle of Hollywood and never received the respect it deserves.

John Ford's *Cheyenne Autumn* was the epic that people thought would fairly examine the White conquest of the West from the Native American point of view. Ford's film was a huge disappointment, but Penn got it right. Based on Thomas Berger's sprawling novel, *Little Big Man tells* of Jack Crabb who is raised both in White society and among the Native Americans. Through a strange quirk of fate, he becomes the only survivor of Custer's last stand. Penn only made a few films after this. His experiences with Marlon Brando's antics on *Missouri Breaks* (1976) caused him to retire from films for several years. In 2000, he became an executive producer for *Law and Order,* for which his son, Mathew, is one of the directors.

TRANSITIONAL DIRECTORS: PREMINGER, BROOKS, AND ZINNEMAN

Otto Preminger, Richard Brooks, and Fred Zinnemann were directors that began making films at the end of World War II,

during the twilight of the old Studio System, and effectively transitioned into a new era of filmmaking. Each of these directors did exceptional work in the 1960s. However, like Billy Wilder, after the Production Code was officially retired, the films they made lacked the hard edge and clarity of story that was associated with their early works. Otto Preminger had successfully challenged the Code with such landmark films as *The Man with the Golden Arm,* and *Anatomy of a Murder.* In 1960, he directed *Exodus,* based on Leon Uris' giant best seller about the founding of the state of Israel, written for the screen by blacklisted writer Dalton Trumbo. Certainly *Exodus* had a controversial theme, which Preminger had never shied away from in the past, but the film lacked any central energy and never generated the powerful impact audiences had expected. Some of the best scenes in the novel were left on the printed page, and it would be up to the television mini-series *Holocaust* (1978) and Steven Spielberg's *Schindler's List* (1993) to bring to life the terrible ordeal of the Jews during the war. Preminger's *Advise and Consent* (1962), came close to its marketing campaign of lifting up the capital dome and showing a true account of Washington politics. With an all-star cast, the last film made by Charles Laughton, *Advise and Consent* (1962), was one of the first Hollywood films to have the taboo subject of homosexuality as a key element in the story. After this, Preminger's films were interesting because of the international casts he put together, but movies like *The Cardinal, In Harm's Way, Bunny Lake is Missing,* and *Hurry Sundown,* were, to borrow from Shakespeare, much ado about nothing.

Richard Brooks made some of his finest and most exciting films during the '60s, starting with *Elmer Gantry* (1960), based on Sinclair Lewis' cynical look at organized religion. The highly successful film won Oscars for star Burt Lancaster, supporting actress Shirley Jones, and Brooks for best screenplay. He then brought Tennessee Williams' sexually charged *Sweet Bird of Youth* (1962) to the screen. After years of effort, Brooks made *Lord Jim* (1965), an epic on the scale of a David Lean film; but despite an excellent cast, the film disappointed critics and audiences. He then turned to the wild west with *The Professionals* (1966), and the result was one of the best Westerns ever made, straddling the line between the traditional and revisionism. The film is full of action, humor, and has some of Brooks' best hard-hitting dialogue. In *Cold Blood* (1976), his adaptation of Truman Capote's crime novel, based on a real story, is a very compelling study of the brutal murder of an entire family. The film was shot in black-and-white by Conrad Hall, one of Brooks' favorite cinematographers, during a period when most studio films had shifted to color. The result was a masterpiece of dramatic lighting that defined the characters and their dark world. Hall also shot *The Professionals,* which was shot in color and perfectly caught the hot, dry, dusty feel of the Mexican desert, a visual warm-up for his *Butch Cassidy and the Sundance Kid* two years later. Though Brooks continued directing until the late 1980s, his later films, though expertly made, seemed to be repeating old territory and were out of sync with the changing times. The exception was *Looking for Mr. Goodbar* (1977), which showed the nightmare side of free love.

Fred Zinnemann directed only three films in the 1960s, and two of them turned out to be classics. *The Sundowners* (1960) was one of the first major films to be shot on location in Australia and is a joyful valentine to the landscapes and odd creatures of the outback. With memorable performances by Robert Mitchum, Deborah Kerr, and scene-stealing Peter Ustinov, *The Sundowners* is full of rich humor and old fashioned charm. The movie introduces audiences to the traditions of Australia, a country that in the 1970s would have its own film renaissance.

Zinnemann made *A Man for All Seasons* (1966), based on Robert Bolt's drama about Sir Thomas Moore and his bitter spiritual battle with King Henry VIII over the subject of divorce and the rejection of the Catholic Church. Beautifully shot by Ted Moore (who made many of the early James Bond films), *A Man for All Seasons* became the surprise hit of the year, winning six Academy Awards, including cinematography and screenplay, Paul Scofield for best actor, and Zinnemann received his second for best director. Zinneman made only three more films in his career: *The Day of the Jackal* (1973), an expertly crafted thriller based on the best selling novel; *Julia* (1977), from Lillian Hellman's memoir of a close Jewish friend who became a victim of the Holocaust (Zinnemann received his seventh directing nomination for the film); and his final project was *Five Days One Summer* (1982).

THE UNIVERSE ACCORDING TO STANLEY KUBRICK

The 1960s could very well be called the Age of Kubrick, even though he only directed four films in this time period. On three he had total control, and on the other he would complain the he was "slave" to the producer. The latter film was the epic *Spartacus* (1960), and the producer was also the star, Kirk Douglas, who had worked with Kubrick three years before on the anti-war film *Paths of Glory*. No matter what his feelings were in retrospect, *Spartacus* put thirty-two year old Kubrick at the top of the Hollywood pyramid. He began his career with *Look* magazine, becoming a staff photographer at only seventeen. By 1950, he was making short documentaries, which he managed to sell to RKO for a small profit. Three years later he began the process that had since become a familiar routine by many independent directors. He borrowed from his relatives to make his first feature *Fear and Desire* and did what he would continue to do the rest of his life—he wrote the screenplay, directed, operated the camera, and edited the low-budget feature.

Completely self-trained, Kubrick became a master of cinematography and eventually of special effects. Kubrick's early films mirror young Quentin Tarantino. They both were attracted to film noir and each put their original mark on the genre. Kubrick made *Killer's Kiss* (1955) and then a year later started a production company with James B. Harris to make *The Killing*. For his lead, he got Sterling Hayden, who had starred in B-movie Westerns and the John Huston's film noir classic, *The Asphalt Jungle*. Hayden would work with Kubrick again as General Jack D. Ripper in *Dr. Strangelove*. *The Killing* became a minor art house hit and brought him to the attention of Kirk Douglas.

Douglas, along with Burt Lancaster, should be credited for the bravery with which they approached their film careers. They chose versatility in the roles they picked, breaking with the tradition of the leading man established during the Studio System, and took chances with new directors and controversial material. Douglas agreed to make *Paths of Glory* (1957), an unflinching look at the hypocrisy of the military during war, that examined the political games officers played to seize power, all at the expense of the expendable soldier. *Paths of Glory*, with its very dark and downbeat theme, was not successful at the box office. For two years Kubrick tried to put together another production, and then one day he got a phone call from Douglas, who had just fired Anthony Mann as the director for *Spartacus*.

Kubrick stepped into *Spartacus*, the most expensive movie that had ever been made at the time, without being part of the pre-production stage, and confronting an international cast of legends and large egos, including Laurence Olivier,

2001: A Space Odyssey (1968) directed by Stanley Kubrick, with Keir Dullea, Gary Lockwood, and Douglas Rain as the voice of HAL 9000. The impact of this motion picture, as originally seen on a Cinerama screen, was literally life-changing for many future filmmakers. Kubrick took special effects away from the B-drive-in movies and made them the star attraction in his leisurely and sometimes baffling journey through space. Made twenty years before CGI effects, *2001* set a standard for movie magic that films are still measured by.

Charles Laughton, Peter Ustinov, Jean Simmons, Tony Curtis, Herbert Lom, and Douglas, doing double duty as actor and producer. Kubrick immediately took control, and although some of the battles on the set over creative control were just as tumultuous as those staged in the movie, he was able to make *Spartacus* into a thinking man's epic. The success of *Spartacus* gave Kubrick the freedom that no other independent director had had up to this time. After developing the ill-fated Western, *One-Eyed Jacks* with Marlon Brando, he dropped out of the project and told Brando that he should direct the film himself. Wanting to get far away from the controlling atmosphere of Hollywood, Kubrick moved to England, where he lived the rest of his life.

His next project was the adaptation of Vladimir's Nabokov's scandalous best-selling novel *Lolita* (1962), about a middle-aged novelist who falls fatally in love with a fourteen year

old girl. *Lolita* was remade in 1997 by director Adrian Lyne and was turned down by every studio and major distributor simply because of its theme. As a reflection on how attitudes change over time, the marketing for Kubrick's version played off the potential objections to the film by asking "How did they ever make a movie of Lolita?" Kubrick and Nabokov (though it is disputed how much of Nabokov's screenplay was actually shot) filled the film with black humor, double entendres, and the veiled suggestion of forbidden sex. One of the reasons for *Lolita's* success with American audiences was because of the discovery of British comedian Peter Sellers, who in a supporting role plays Clare Quilty, but manages to steal the film from veteran actor James Mason.

Next Kubrick set out to make a serious film about a very serious subject, the annihilation of the human race because of nuclear war, but ended

up making an outrageous comedy instead. *Dr. Strangelove or How I Learned to Stop Worrying and Love the Bomb*, starred Peter Sellers, this time playing three different roles, and based on the novel by Peter George titled *Red Alert or Two Hours to Doom*. In *Paths of Glory*, Kubrick showed his pessimism and utter lack of faith in all matters involving the military and politicians, which he managed to pepper throughout *Spartacus*. While developing the screenplay for *Dr. Strangelove*, Kubrick and co-writer Terry Southern started thinking about generals, presidents, and prime ministers in the midst of life-and-death negotiations having to fulfill basic human functions. Thus the first scene with George C. Scott as Gen. "Buck" Turgidson is when he is taking care of business in the bathroom. After this image, Kubrick and Southern could not take anything seriously, and *Red Alert* turned into the dark, screwball comedy *Dr. Strangelove*.

The film opens with documentary footage of B-52 bombers being refueled in mid-air underscored by the romantic song "Try a Little Tenderness." Kubrick got his revenge on world leaders during the Cold War by turning them into vaudevillian clowns. A slapstick pie fight shot in the War Room was to be used as the final sequence of *Dr. Strangelove*, but Kubrick used a montage of Atomic Bomb explosions instead, underscored by "Until We Meet Again." The War Room designed by Ken Adams was so realistic in the film that when newly elected President Ronald Reagan took his first tour of the Pentagon he asked to see the room, but was told that it never existed.

2001: A Space Odyssey (1968) is probably the biggest home movie ever made. Though Kubrick enjoyed complete autonomy over the direction of *Lolita* and *Dr. Strangelove*, his science fiction film was a big budget film, especially for MGM, which was once again having financial woes. *Forbidden Planet* (1956) did moderately well at the box office for the studio, but up until this time the most successful science fiction movies were George Pal's *The War of the Worlds* (1953) and *The Time Machine* (1960), both remarkable in terms of special effects, considering the modest budgets with which they were made. Like young Orson Welles, Kubrick had total control over *2001: A Space Odyssey*. From the outset, this was not a Flash Gordon space adventure. Based on Arthur C. Clarke's novel, *2001* was more of a visual philosophical essay on the future of Mankind, the descent of killer apes, and his search for intelligence in space. Starting with *2001* and continuing with his later films, Kubrick showed almost a disdain for the audience at times. Like the defiant directors of the New Wave, *2001* was personal filmmaking on a giant Cinerama screen. Kubrick made a film to please him, and if the audience was bored at times or utterly confused—well, that was their fault.

2001: A Space Odyssey was lambasted by most critics when it opened, but word of mouth made it a must-see hit, especially with students and hippies, who found the special effects mind-blowing and intellectually challenging. *2001* ran in Los Angeles and other cities for three years. It became the touchstone of the next generation of moviemakers. Here was something huge, done through the studio system, but with the definite fingerprints of the Auteur Theory. It was a film that was so complex and baffling in its conclusion that no one truly understood what it meant. People talked and argued for hours about its meaning. As Kubrick said, "The feel of the experience is the important thing, not the ability to verbalize or analyze it."

What was clearly evident was that *2001* was a singular vision that was both overwhelming and completely unique. Kubrick, along with Douglas Trumbull and a small army of photographers and designers, transformed special effects in the movies from stop-motion monsters and

lifeless matte painting into a fully-realized environment. What is amazing about *2001* is that after more than thirty years, it still does not feel dated. The film raised the level of special effects to a tremendous new height and then stayed at the top of the visual heap ever since. When George Lucas was shooting *Star Wars* it was reported that he constantly asked if the effects were as good as Kubrick's. *2001* let loose the imagination of new filmmakers and proved to them that the impossible was a myth. It is also a film where the most interesting and fun character is a computer, named HAL 9000, who goes a little crazy and has to be given a lobotomy.

Kubrick directed only sixteen films in his career. After *2001: A Space Odyssey,* he made *A Clockwork Orange* (1971), *Barry Lyndon* (1975), *The Shining* (1980), *Full Metal Jacket* (1987), and *Eyes Wide Shut* (1999). Each of his films was distinct and his unique personal vision. Some of them had flaws, but even his flaws were fascinating. Once he was established, he was the first director who maintained complete control over his films until his death, just before *Eyes Wide Shut* premiered. His dream project was an epic based on the life of Napoleon, but regrettably the vision of that movie remained in his head and never made it to the screen.

MULTICULTURAL CHANGES

No decade brought about so many positive changes in the portrayal of multicultural groups. For centuries, actors had worn make-up and pretended to be Asian, African-American, Native American, Latino, or any other ethnic character. This caricaturing disappeared in the movies by the end of the 1960s. The directors, writers, and actors of this era were conscious and ashamed of the damage that so many earlier films had done in creating degrading stereotypes, often for providing comic relief or to establish an easily identifiable villain on the screen. The movement to cast actors in roles that matched their multicultural heritage began in the 1950s with films such as *Sayonara, The Blackboard Jungle,* and *The Defiant Ones.* Sidney Poitier became a movie star and swung open the door for the explosion of African-American films in the 1970s. In a time of turbulence and change in American society, the movies began to reeducate people on how they saw and thought about diversified cultures.

A fuse had been lit, and there was sentiment to strike back and protest against the defects in the American Dream, which had been a segregated concept for over two hundred years. This was a time when on the screen Americans were seeing racial equality, which in most of the Southern states, was far from reality. The fundamental idea that everyone should be treated equal was at the center of most Hollywood movies. Exactly how much some of these films altered the way people began to treat, sympathize, and ultimately respect each other can never be measured. But by sheer volume, and the fact that most films today are devoid of inappropriate casting practices, it can safely be said that these films had a powerful and lasting impact.

However, it was not a perfect, cure-all time period. While the casting of non-ethnic actors in ethnic roles almost disappeared in films, the stereotyping of some of these characters still lingered. The bandito and Mexican spitfire characters still persisted for another decade. The savage Indian character vanished, but the consequence was that for a long time there were no stories about Native Americans, and even today there are sadly few films about the contemporary lives and cultural changes of these people. In the '70s, the Native American reappeared in Westerns, this

The Good, the Bad, and the Ugly (1966) directed by Sergio Leone, starring Clint Eastwood, Eli Wallach, and Lee Van Cleef. Leone turned the traditional gunslinger standoff into almost a rock opera, with extreme close-ups underscored by electronic music. He was a far cry from John Ford and Howard Hawks with his approach to the genre, but he actually resurrected the dying Western, opening the trail for **Butch Cassidy and the Sundance Kid, The Wild Bunch,** and all those Eastwood outings.

time as a sympathetic character, and there was a genuine effort to depict their culture and show the injustices they had endured during the one-sided myth that became known as the "settlement of the West." There were very few Hollywood films with Asians during the '60s, and early in the decade there was some notorious casting, like Mickey Rooney as the ill-tempered Japanese neighbor in *Breakfast at Tiffany's* and Joseph Wiseman as Dr. No. The stereotypes of the Japanese maid and houseboy were seen on television with Academy Award winner Myoshi Umeki in *The Courtship of Eddie's Father*. The most ironic television example of this was Bruce Lee, who was the houseboy-chauffeur in *The Green Hornet* and played Kato in several episodes of *Batman*. Not able to get work in Hollywood, he made several low-budget Hong Kong martial arts movies, including *Fist of Fury* and *Enter the Dragon*, which became huge international hits and eventually changed the movie industry.

WOMEN IN FILMS IN THE 1960s

The 1960s represent the biggest change in the star system in Hollywood since the arrival of sound. By the end of the decade, Cary Grant, Greer Garson, Spencer Tracy, Deborah Kerr, Errol Flynn, Fredric March, and Bette Davis had retired or passed away. Katharine Hepburn and John Wayne were the only two major movie stars who continued to have productive careers throughout the 60s and 70s. Hepburn would win three more Oscars as best actress between 1967 and 1981 for *Guess Who's Coming to Dinner, The Lion in Winter,* and *On Golden Pond.* Wayne received his Oscar for *True Grit* (the same year *Midnight Cowboy* won for Best Picture) and continued making films until 1979, when he died of cancer.

The stars of the '60s were either newcomers or crossover stars established the decade before. They included Richard Burton, Lee Marvin, John

Mary Poppins (1964) directed by Robert Stevenson, starring Julie Andrews and Dick Van Dyke. In the early '60s Audrey Hepburn, Doris Day, and Sophia Loren were the top female box office stars. Andrews joined this list with **Mary Poppins** and **The Sound of Music** and was at the top for several years. But by the end of the decade, Hepburn and Day had effectively retired, Loren returned to Italy, and Andrews made three unsuccessful musicals in a row. When the Production Code was retired, it was time for a new kind of woman star to appear— but it took several years for it to happen.

Wayne, Peter O'Toole, Marlon Brando, Rod Steiger, Burt Lancaster, Kirk Douglas, Laurence Olivier, Paul Newman, Gregory Peck, Steve McQueen, Jack Lemmon, Albert Finney, Peter Sellers, Richard Harris, Charlton Heston, Michael Caine, Sean Connery, Omar Sharif, George C. Scott, Dirk Bogarde, Marcello Mastroianni, Sidney Poitier, and Clint Eastwood. By the end of the '60s there were Dustin Hoffman, Warren Beatty, Peter Fonda, and Robert Redford.

Of the women stars, there were Shirley MacLaine, Julie Andrews, Sophia Loren, Natalie Wood, Julie Christie, and Elizabeth Taylor. Both Doris Day and Audrey Hepburn started the '60s as top box office stars, but retired shortly after the Production Code was abolished. It is impossible to imagine either one of these ladies in a film like *Bonnie and Clyde* (though Doris Day was originally offered the role of Mrs. Robinson in *The Graduate,* but turned it down after reading half of the script). Actresses like Lee Remick, Capurcine, Tippi Hedren, Susannah York, Catherine Deneuve, and Claudia Cardinale were briefly in the stardom spotlight, but faded after a series of box office disappointments. And others, like Jane Fonda, Faye Dunaway, Barbra

Streisand, and Vanessa Redgrave, would be established late in this decade and become full-fledged stars in the '70s. With a few exceptions, the studio movies were dominated by male stars.

The warning signs of a major shift can be traced to two major movies: *Psycho* and *Dr. No* and the James Bond series. The "slasher" film would be born from Hitchcock's thriller and hit box office gold with low-budget franchises like *Night of the Living Dead, Halloween, Friday the 13th,* and hundreds of others. With each new James Bond action-adventure film, Playboy magazine would feature "the girls from Bond." These women were cast for their looks and measurements, with acting abilities running a distant second. As the Production Code began to crumble and then was abandoned, sex, which had been restricted by very limiting guidelines for over thirty years, was back on the screen, almost as if nothing had happened since the forbidden hollywood films of the pre-Code era.

The '60s became known for "free love," and women in movies became the objects of desire. There is no denying the fact that this is ancient history, and even during periods of censorship there were no laws or regulations that deterred

audience's interest in attractive women. The simple fact is there has never been a female movie star that is unpleasant to look at. Those who do not have appealing features are politely referred to as "character actresses." But in the '60s, the creation of the pill allowed women the same sexual freedom as men, and with the Code laid to rest, this freedom erupted on the screen unlike any other time in history.

Janet Leigh never made it past the first half of *Psycho,* because she is stabbed to death while naked in a shower. In *The Apartment,* Shirley MacLaine played an elevator operator who tries to commit suicide after an affair. MacLaine follows this with a series of roles where she is either a prostitute or an easy woman, in films like *Irma la Dolce, The Yellow Rolls-Royce, John Goldfarb, Please Come Home,* and *Sweet Charity.* Natalie Wood, the childhood star of *Miracle on 34th Street,* is driven to a nervous breakdown because of sex in *Splendor in the Grass* and ends up pregnant after a one-night stand in *Love with the Proper Stranger.* In *Darling,* Julie Christie wins an Oscar for playing a social climber who jumps from one affair to another, and in *Doctor Zhivago* she plays the other woman. After being Cleopatra, the greatest home-wrecker in history, Elizabeth Taylor is given her first Oscar for her role as an ill-fated call girl in *Butterfield 8.* In *The Hustler,* Piper Laurie is an easy pickup with low self-esteem who is driven to suicide. Jane Fonda does an outer space striptease in *Barbarella.* And even Audrey Hepburn plays a high society prostitute by the name of Holly Golightly in *Breakfast at Tiffany's.*

Complex, troubled sexual relationships brought Oscar nominations for Rachel Roberts in *The Sporting Life,* Leslie Caron in *The L-Shaped Room,* and Patricia O'Neal won for the housekeeper who got raped by Paul Newman in *Hud.* Roman Polanski created bizarre sex problems for many of his women. In *Repulsion,* Catherine Deneuve slips into madness and goes on a spree, viciously killing several men who made advances toward her. And in *Rosemary's Baby,* Mia Farrow is drugged so she will have sex with Satan. These films certainly did not possess the old time glamour like *The Philadelphia Story, Wuthering Heights,* or *Gone With the Wind.* The old fashioned woman's film was missing-in-action from the screen.

After *The Guns of Navarone,* the action-adventure film took off, and women were conspicuously absent from this genre. By the end of the '60s, the "buddy film" was selling tickets, like *Butch Cassidy and the Sundance Kid, The Wild Bunch,* and *Easy Rider.* The roles that many leading and highly talented actresses received (and were probably happy to get), often had them trading sex for favors, like Vanessa Redgrave in *Blow Up,* or they were treated roughly, like Claudia Cardinale in *The Professionals.* In low-budget drive-in movies such as Roger Corman's *The Wild Angels,* the "biker chicks" were presented as being uninhibited and out for a good time. In big-budget epics, including *Lawrence of Arabia* and *2001: A Space Odyssey,* there were just brief glimpses of women. In *Bullitt,* Jacqueline Bisset has only a few you-don't-love-me-anymore scenes with Steve McQueen. And in *Dirty Harry,* Clint Eastwood has very little time for romance, as a serial killer is loose shooting women.

The one actress who got the most interesting roles in the late '60s, and many of the remarkable roles of the 1970s, was Faye Dunaway. She has never really developed the following or respect that other Hollywood screen legends have, but her performance in *Bonnie and Clyde* is extraordinary, to the point it is almost impossible to imagine anyone else in that role. Dunaway then did a complete turnabout and played in the romantic heist film *The Thomas Crown Affair,* with Steve McQueen. But the '70s was Dunaway's decade, playing memorable

parts in *Little Big Man* and *The Three Musketeers.* She then landed three roles that became the stuff of legends: *Chinatown, Three Days of the Condor,* and *Network,* for which she won her only Academy Award.

Another star who has never received her full share of respect is Ida Lupino. Though she was exceptionally good in movies like *The Sea Wolf* and *High Sierra,* she was also one of the first successful women behind the camera. The movies she directed, starting in 1949, were usually film noir. She made one classic in this genre, *The Hitch-Hiker* (1953). By the mid-50s, Lupino was directing mainly for television on classic shows like *Alfred Hitchcock Presents, The Rifleman, 77 Sunset Strip, The Twilight Zone, The Untouchables, Thriller, The Dick Powell Show, The Virginian, The Fugitive, Bob Hope Presents Chrysler Theater,* *The Rogues, Bewitched, Gilligan's Island, Honey West,* and *The Ghost and Mrs. Muir.* Though she never won any major awards, Lupino inched open the door for other women to work as directors and producers. She never directed a film that became a blockbuster, like Penny Marshall, but she always received high marks from actors who worked with her. Lupino held her own in a male-dominated profession—quite an achievement in itself. She became the second woman to be admitted to the Director's Guild of America. Sadly, in later life she only made short guest appearances and fought problems with alcoholism. Unlike many stars who survived late into the twentieth century and were rediscovered, Lupino passed away almost unnoticed in 1995. Today, women in film groups are finally beginning to give her the credit she deserves.

A Second Golden Era— The New Hollywood

1969–1980

A REVERSAL OF FORTUNE

The years from 1969 to 1980 were a complete reversal of the previous era. The '60s began with great expectations, but within eight years, all of these dreams were in tatters because of the Vietnam conflict, the Civil Rights Movement, and a series of political assassinations. The following era inherited the overwhelming baggage of these events, plus in the years ahead came the Charles Manson murders, the Watergate scandal, the resignation of President Nixon, and the takeover of the American Embassy in Iran, resulting in a prolonged hostage crisis. But somehow by 1980 there was a new burst of prosperity, a partially revived faith in the government, and sense of new hope.

During these years a monumental battle took place in Hollywood that is not covered in history books. The significance of this battle may at first seem to pale in comparison to these major events; but the outcome of this unheralded conflict helped restore the emotional equilibrium of audiences around the world, which had for almost two decades been pushed toward a breaking point by a constant barrage of bad news.

The battle that ensued was between the old Hollywood style of escapist entertainment and a fresh batch of young filmmakers who were intent on bringing the undiluted hard knocks of life to the screen. This was the first time since the arrival of sound that all the directors and stars were new faces. These young filmmakers were a dramatic contrast to the old guard who dressed in suits and (for the most part) behaved like dignified celebrities in public. This new generation was full of rebels toting cameras—Baby Boomers who never took no for an answer, and were often referred to as "geniuses in tennis shoes."

Depending upon who was asked, the cinematic water glass was either half full or half empty at the end of this productive eleven-year period. Many believe that the renaissance in personal filmmaking reached its zenith during the 1970s and ended with the financial bloodbath of Michael Cimino's *Heaven's Gate* in 1980. But in the same year, popular public opinion championed the runaway, worldwide success of the most expensive independent film up to this time, George Lucas' *The Empire Strikes Back*.

Ironically, by the 1980s the old Hollywood traditions were still firmly intact, but what was

The Godfather (1972) directed by Francis Ford Coppola, screenplay by Coppola and Mario Puzo, based on his novel, starring Marlon Brando, Al Pacino, James Caan, Robert Duvall, Diane Keaton, Talia Shire, and Sofia Coppola as Michael Francis Rizzi. Made by a young director whose earlier films had all failed, a cinematographer that the studio did not like, a legendary actor who had been labeled box office poison, and a supporting cast of mostly unknowns, **The Godfather** has become known as the defining film of the New Hollywood.

once perceived as the "New Hollywood," following in the chic cinematic trends of the French New Wave and other foreign film influences, had almost disappeared. The innovative camera and editing methods of these landmark motion pictures were assimilated into the filmmaking techniques of mega-budget action blockbusters. The small, personal film became an endangered species for many years and would not reemerge until the independent film movement in the early 1990s.

But no matter how the end of this era is evaluated, these eleven years between 1969 and 1980 were extraordinary in terms of the sheer variety of motion pictures produced. This has been called a Second Golden Era, a renaissance in personal filmmaking, and the birth of the New Hollywood. All of these are accurate in describing the changes and the expansion of the visual language that took place in film in a remarkably short time. Only in the 1930s, during the Golden Era of the Studio System, did so many exceptional movies get made year after year. The major difference is that the films of this period were completely free of the Production Code. However, the art of great storytelling, identified with the Studio System, was not lost in this freewheeling revolution of filmmaking.

In the brief period known as the Pre-Production Code Era, from the introduction of sound in 1927 and the strict enforcement of the Code in 1934, movies examined such socially taboo subjects as free love for women, abortion, incest, drug addiction, divorce, and the seduction of violence. These movies were entertaining powder kegs, but highly melodramatic, presented like modern fables for grownups. Starting in 1969, three years after the abandonment of the Code and in the wake of the dynamic foreign films of the 1950s, the motion pictures that came out of Hollywood revisited these topics that had effectively been put in the deep freeze for over thirty years.

The results were films in all genres, often reinventing these genres or fusing different genres together, which have endured as masterpieces of contemporary cinema. In fact, these films so successfully set the standards for a contemporary viewpoint in cinema that they are still relevant today and will probably always be ground zero in defining a modern movement.

How this era began is a straightforward process of elimination. By 1969, the original studio moguls had retired or passed away, and with a few exceptions, so had the old guard of legendary directors and producers. The big-budget Hollywood epics and musicals were tanking at the box office, and the studios were on the verge of a financial abyss. To keep revenue coming in, most of the sound stages were now rented out to television production companies. No longer under contract, most of the stars of the Studio System, whose glamorous faces had appeared on the covers of *Photoplay* and *Silver Screen* for decades, had retired or had taken demeaning roles in drive-in horror movies, like Joan Crawford in *Strait-Jacket* or Ray Milland in *The Man with the X-Ray Eyes.*

Feature films were still being released in the same fashion they had been for fifty years, and the target audiences were either twelve-and-under, or adults in their 30s and 40s. The solution to studios' economic problems was in plain sight—the Baby Boomers, who were now teenagers and college students; but amazingly none of the studio heads seemed to recognize this potential gold mine. Roger Corman and others had tapped into this giant market, but most heads of major studios were in denial that musicals, Westerns, and overly cute comedies were not paying the bills like they had since the earliest days of motion pictures. Films like *The Graduate, Bonnie and Clyde,* and *Rosemary's Baby* forecasted the changes that were coming, but it took two independent sleepers to light the fuse.

THE FILMS THAT STARTED A REVOLUTION

Described as a "Z-budget shocker," George Romero's *The Night of the Living Dead* managed to combine flesh-eating zombies with an underlying political statement about the Cold War. As a footnote to film history, the ill-fated hero was played by Duane Jones, the first African-American to star in a horror movie. *The Night of the Living Dead* became a drive-in bonanza and an overnight cult classic. It was produced under the same circumstances that brought attention to the directors of the French New Wave.

The Night of the Living Dead was made in Pittsburgh, far outside the mainstream. Even Roger Corman and the other wizards of B-movies operated within shouting distance of the Hollywood studios. *The Night of the Living Dead* was a revisionist take on the Gothic horror movies from Universal Studios, and, like so many foreign films had, it broke the rules of old Hollywood's seamless filmmaking, thus giving the grizzly storyline an eerie documentary effect. Although Romero's thriller spawned a seemingly never-ending cycle of cheaply made, gruesomely real

horror movies, it was really part of the natural evolution of drive-in movies, including American International Pictures and Hammer Films, that kept pushing the limits of mass audience acceptance. *The Night of the Living Dead* is certainly not on the same artistic par as *Open City,* which began the neorealism movement, but most American films that capture the popular imagination and bring about change are entertainment first and serious works of art as a distant second. *The Night of the Living Dead* did not drastically alter the movie industry, but it was a wake-up call to the studios and a side show attraction for the main event.

The film that changed everything was *Easy Rider.* It shot the lock off what would become known as "the youth market" and threw open the gates to personal filmmaking. An offspring of *The Wild Angels,* this search for the "real America" by two hippie, drug-dealing bikers was produced by Peter Fonda, an alumnus of the Roger Corman school of low-budget filmmaking and the son of Henry Fonda. The director of *Easy Rider* and Fonda's co-star was Dennis Hopper, who allegedly behaved like his stoned-out character throughout the troubled shoot. Hopper's unpredictable temper resulted in a falling out

*Easy Rider (1969) directed by Dennis Hopper, starring Hopper and Peter Fonda, and written by Hopper, Fonda, and Terry Southern. Since the death of James Dean the major studios had avoided making films about rebellious youths. Independent filmmaker Roger Corman had tapped into the Baby Boomer culture, opening the doors for **Easy Rider,** a low-budget feature about drugs, sex, and rock 'n' roll that changed Hollywood.*

with actor Rip Torn, who was replaced by Jack Nicholson. The screenplay was co-written by Terry Southern, who had worked with Stanley Kubrick on *Dr. Strangelove* and had written *Barbarella* starring Peter's sister, Jane Fonda, just the year before.

Fourteen years before, Hopper appeared in *Rebel Without a Cause* and *Giant* with James Dean, and in the years that followed, he had minor roles in a string of forgettable Hollywood movies. Veteran director Henry Hathaway kicked him off the John Wayne Western *The Sons of Katie Elder* (1965) for arguing about a line reading. Because of his volatile nature and frequent substance abuse, Hopper became an outsider in the industry he grew up in. Reduced to bit parts, often with little or no dialogue, like in *Cool Hand Luke* (1967), *Hang 'Em High* (1968), and *True Grit* (1969), Hopper had become a bottom-feeder in Hollywood. Thus when the opportunity presented itself, there was no one better to direct *Easy Rider*, which became the ultimate high sign to the dying Studio System.

Everything about *Easy Rider* was a spit in the eye to the traditional suit-and-tie Hollywood. Jack Nicholson had, at this point in his career, given up hope of breaking into the mainstream of Hollywood stardom. His most recent films were *Hell's Angels on Wheels*, *The Shooting*, and *Psych-Out*, but his role as an ill-fated small Southern town lawyer who greets the morning with a shot of whiskey and a toast to "good old D. H. Lawrence" stole the film from Fonda and Hopper and landed him his first Academy Award nomination. Even cinematographer Laszlo Kovacs was an outsider, with earlier credits such as *The Incredibly Strange Creatures Who Stopped Living and Became Mixed-Up Zombies!* and *Mondo Mod*. He had met Nicholson on *Hell's Angels on Wheels*. Kovacs would go on to shoot *Five Easy Pieces*, *What's Up, Doc?*, *Shampoo*, and *Ghostbusters*.

Easy Rider was edited to rock 'n' roll music hot off the popular charts, including Hoyt Axton, Bob Dylan, Jimi Hendrix, Robbie Robertson and The Band, and Marx Bonfire ("Born To Be Bad"). There had been other movies about drugs in the '60s, like Roger Corman's *The Trip*, written by Nicholson and starring Peter Fonda, but *Easy Rider* became the film that turned on America, and ultimately the world. The film opens with a drug deal where Fonda and Hopper score a large quantity of cocaine. They next set out on their custom choppers to discover America, smoking grass with hippies in a New Mexico commune and later lighting up with Nicholson, who goes into a rant about UFOs. As an almost requirement of films during this era, *Easy Rider* ends in an unexpected tragedy, right after Fonda says, "We blew it." The two free spirits are shot to death on the open highway by a pair of redneck duck hunters. For years after this, the Hippie Generation had a deep-seated fear of traveling through the South.

Easy Rider exploded at the box office. Made for $400,000, it went on to gross $19 million in the United States and over $40 million worldwide. This was at a time when the average ticket was $1.50 and a movie was considered a success by bringing in seven to nine million. The vast majority of these tickets were sold to people twenty-five and younger, thus becoming the first runaway hit of the Baby Boomer generation. The studio pictures this year were *Hello, Dolly!*; *Anne of a Thousand Days*; the musical version of *Good-Bye, Mr. Chips*; *Paint Your Wagon*; and *Marooned*; all of which were major box office disappointments.

It might be difficult from today's perspective to understand why *Easy Rider* was such an international sensation in 1969, but this was the year of the Charles Manson Tate-La Bianca murders, Woodstock, the secret bombings in Cambodia, a massive anti-Vietnam war march on Washington, D.C., and the moon landing. *Easy Rider* caught

lightning in a jar, typifying to younger audiences everything that was both cool and bad in America at this time.

WATERGATE, POLITICS, AND THE MOVIES

In an age of increasingly fast-breaking new stories and the instantaneous coverage of an event from anywhere in the world, it is very possible that a minor break-in to campaign headquarters during an election might get lost and forgotten within a couple of days. But on June 18, 1972, the day after five burglars were caught attempting to steal documents from the Democratic headquarters at the Watergate hotel, two low-ranking reporters on the *Washington Post*, Carl Bernstein and Bob Woodward, began spending tedious months making hundreds of phone calls and running down dead-end leads until they were able to cast a wide net over the White House. With the help of a mysterious informant appropriately called "Deep Throat," they dethroned the first president in American history.

The notorious events that followed ripped to shreds the last vestiges of respect most people had for the office of the presidency and the integrity of the United States government. What were discovered under this large rock of political cover-ups were the misuse of campaign funds, smear tactics, illegal operations with former members of the CIA, lies told on national television by President Nixon, secret tapes, the Pentagon Papers, and conspiracies to use the Vietnam war for political gains. The unfortunate irony is that Nixon was elected to a second term by a historic landslide, but his personal paranoia led him to take petty, unnecessary chances to regain the presidency. The bitter lessons he learned from his campaign with John Kennedy, especially during the television debates, caused Nixon to

All the President's Men (1976) directed by Alan J. Pakula, starring Robert Redford and Dustin Hoffman. Many of the Hollywood elite had become politically involved during the Vietnam conflict and the Watergate years. Redford had approached Carl Bernstein and Bob Woodward to turn their Washington Post investigation into a book. The film focuses on their tedious, frustrating attempts to gather information, and builds up remarkable suspense despite the fact that the real scandal had been so highly publicized. The cinematography was by Gordon Willis.

rely on marketing people to sell his image, while he avoided interviews with the press and unscripted personal appearances.

During the Watergate scandal and investigation, Attorney General John Mitchell was forced to resign, and behind-the-scenes players like G. Gordon Liddy, James W. McCord Jr., John Dean, H. R. Haldeman, John Ehrlichman, and Alexander Haig became names that were constantly tossed around the news. Individuals like Senator Sam Ervin, the chairperson for the Watergate television hearings; Senator Howard Baker; and Judge John Sirica became media heroes. The most notable figure in the Watergate scandal was Secretary of State Henry Kissinger, who was both negotiating for peace in Vietnam and, as later evidence supports, was filling in the duties of a president who was on the verge of a breakdown. All of the foul entanglements that comprise a Shakespearean tragedy played out daily for over two years on television and in tens of thousands of newspaper and magazine headlines. Finally on August 8, 1974, Richard Nixon resigned. Vice President Gerald Ford became the new president, who would later jeopardize his own bid for a second term by granting Nixon a complete pardon.

There is an ironic twist to this dark moment in American history that leads straight to Hollywood. "Deep Throat" gave riddle-like clues to Woodward late at night in lonely parking structures, but there was no mention of this individual in the newspaper articles leading up to Nixon's resignation. Actor Robert Redford approached Woodward and Bernstein and encouraged them to turn the story of their tireless investigation into a book. However, the original draft of *All the President's Men* did not include "Deep Throat" and the clandestine rendezvous. The introduction of this individual appeared in a later draft. In Hollywood terms, it transformed the tedious footwork of reporting into something that was wrought with danger and suspense. Woodward and Bernstein had a best seller, and Redford had his movie.

All the President's Men was one of the first films that began to blur the line between fact and Hollywood. Redford's influence on the book was to treat the topic as a thriller. The reader would know the ending: The President turns out to be the bad guy. But by focusing on all the obstacles in their path, the reader, and later the movie audience, would be caught up in the moment and would believe that these two reporters would never crack the story. By sticking close to the true story, the film becomes the record of Watergate on which the majority of people today base their historical understanding. Truman Capote had tinted his reporting for *In Cold Blood* with a dramatic structure, which made it very easy to transfer to the screen. Gradually, during this era audiences turned away from the movies about real people being more make-believe than real, like *Hans Christian Anderson* or *Madame Curie.* Starting in the 1970s, people turned to movies as a kind of shorthand history lesson. *Z, Dog Day Afternoon,* and later *Raging Bull, Chariots of Fire, JFK, Schindler's List,* and hundreds of television dramas, all were looked upon as being faithful to the facts. In later years, movies like *Hurricane, A Beautiful Mind,* and *Alexander* came under critical attack for playing with the actual events, or for omitting unattractive details.

There can never be a true assessment of how much the avalanche of negative events during the 1960s and early '70s played on the psyche of people everywhere. It is important to understand that for more than 100 years, the backdoor intrigue of American politicians were considered off limits to news reporters. But with the Watergate investigation, the dirty laundry of politics played out like a prime-time soap opera. Whatever naïve beliefs the public had held about the honesty of government, the reliability of the legal system, and faith

that all people could treat each other equally vanished during these long years. This slow media blood-letting of assassinations, Vietnam, war protests, race riots, Watergate, evidence of police corruption, the Tate-La Bianca murders, and the troubles in Northern Ireland and the Middle East all conspired to create a cynicism in a new generation of filmmakers around the world.

The one golden rule of the Production Code was that crime does not pay. Criminals must get caught and be dispensed with. There were no ifs, ands, or buts about this particular rule. But this was contrary to what was happening in real life, as seen in shocking details on live television. The Code was now gone, and Watergate was the final custard pie in the face of the world public that put an end to the once cherished notion that there were heroes squeaky clean and pure in heart. Almost every film made in the 1970s had the theme of dirty politics at its core. There were many films that took place in the political arena (*The Candidate, All the President's Men, Z, Being There*), and films that had characters caught up in political manipulations (*A Clockwork Orange, The Conversation, Chinatown, Klute, Taxi Driver*).

But the "political agenda" of most filmmakers during this era was to show that authority itself was corrupt (a philosophy that has almost become a permanent fixture in movies ever since). The misuse of political power and the abuse of authority shows up in the criminal underworld (*The Godfather, Part I and II; The Sting*), the police department (*Bullitt, Dirty Harry, Shaft, The French Connection, Serpico*), the military (*Catch-22, M*A*S*H, The Last Detail, Coming Home, Apocalypse Now*), the media (*Dog Day Afternoon, Network*), the Old West (*The Wild Bunch, McCabe and Mrs. Miller, Little Big Man*), the CIA or a shadow government (*The Parallax View, Three Days of the Condor*), music (*Nashville*), religion (*The Exorcist, The Omen*), building construction (*The Towering Inferno*), entertainment (*Lenny*), Hollywood (*The Day of the Locust*), sports (*Downhill Racer*), mental institutions (*One Flew over the Cuckoo's Nest*), prisons (*Midnight Express*), atomic energy (*The China Syndrome*), and outer space (*Alien*).

The themes of politics and post-Watergate corruption even popped up in movies designed for mass audience enjoyment. In *Jaws* the local mayor is determined to open the beaches, despite graphic evidence of a really big shark in the water. In *Blazing Saddles,* no-good Gov. William J. LePetomaine sends a black sheriff into a town

Taxi Driver (1976) directed by Martin Scorsese, starring Robert De Niro, Jodie Foster, Harvey Keitel. De Niro's character, Travis Bickle, is a troubled Vietnam veteran that plans to kill a presidential candidate, but then turns his focus on saving a teenage hooker. *Taxi Driver* became a firestorm of controversy when John Hinckley admits to seeing the film fifteen times before he shot President Reagan.

full of bigots. In *Animal House* every student's fear comes true when it was discovered that the dean of the college is on a mission to expel the fun, party guys on campus. And Darth Vader in *Star Wars* takes politics to a new level with mind control.

Like the Mother Goose nursery rhyme of Humpty Dumpty, after Watergate and Vietnam, there was no way to put all the pieces of American politics back together again—especially in the movies. After decades of Indian attacks, desperate banditos, Fu Manchu, Nazis, communist agents, and femme fatales, movies had a new villain of infinite faces (or no face at all): The Government. Tied into this were lawyers, who during the Production Code were often treated as heroes, giving their time selflessly for the good of the community and the defender of the underdog (*Anatomy of a Murder, Judgment at Nuremberg, To Kill a Mockingbird*). In the post-Watergate years, they became stoic legal machines for hire, winning legal victories for the bad guys and twisting the intent of the law into a Gordian Knot (*The Godfather, Part I and II; Death Wish; All the President's Men*).

VIETNAM REVISITED

In 1969, in the months after the Tet Offensive, the number of United States ground forces in Vietnam grew to over 540,000. During his presidential campaign, Richard Nixon advocated "Vietnamization," which would allow American troops to be withdrawn as more South Vietnamese soldiers took responsibility for fighting the war. But once in office, Nixon began secret bombing campaigns into Cambodia, supposedly to destroy Communist supply lines. Once this violation of Cambodia's neutrality was discovered, the anti-war protests and the burning of draft cards increased on college campuses. On May 4, 1970, the National Guard was called upon by Governor James Rhodes to put down the unrest at Kent State. The result was an overzealous command to open fire, killing four students and injuring dozens more, thus becoming one of the darkest days of the Vietnam conflict.

After peace talks headed by Henry Kissinger collapsed in the spring of 1972, Hanoi and Haiphong were bombed nightly. The peace talks resumed in Paris, and by January, 1973, a pact was finally signed by the Vietcong, North and

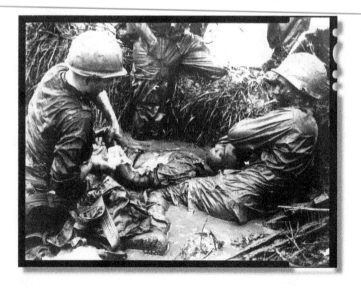

Unidentified soldiers after an attack in the Vietnam jungles. The ongoing conflict, combined with a series of high profile assassinations, has an effect on movies, where for years the heroes were killed off in the final scenes, like **Easy Rider, Butch Cassidy and the Sundance Kid, The Wild Bunch,** *and* **One Flew over the Cuckoo's Nest.**

South Vietnam, and the United States. The final American troops were pulled out as the Communist forces overran Saigon, forcing the military to push helicopters into the sea to make room on the ships. On April 30, 1975, the Saigon government officially surrendered to the Vietcong, bringing an end to a war that had escalated under President Johnson since August, 1964, when Congress gave him carte blanche to initiate troop movements into Vietnam.

After eleven years, the result was the loss of 58,000 American lives, over 350,000 casualties, and an undefined estimate of between one and two million Vietnamese deaths. It was the longest war in United States history, and the country still has not recovered. When armed forces invaded Iraq on March 20, 2003, to seize control from dictator Saddam Hussein, almost immediately the press began to speculate if this was "another Vietnam." Unlike World War II, Hollywood found no glory in the Vietnam conflict, with the single exception of John Wayne's misconceived *The Green Berets* (1968). The nightly news showed intensely violent images from battle zones that at the time were impossible to recreate in movies. Besides, for almost thirty-five years, Hollywood war movies had been depicted as high adventure, tear-jerker romances, and always fought against a handful of ruthless dictators and their armies who were intent on tearing down the democratic way of life. With Vietnam, the tables were suddenly turned. In popular public opinion, the bad guys were the American politicians, big business, and the military complex.

Though there were no films about Vietnam during the lengthy conflict, the graphic enactment of violence in movies grew rapidly. This reached a peak in 1969 when the Western became an unofficial metaphor for the senseless bloodshed in the jungles of Vietnam. Sergio Leone's *Once Upon a Time in the West* turned blue-eyed Henry Fonda into a cold-blooded murderer of women and children. George Roy Hill's *Butch Cassidy and the Sundance Kid* made audiences laugh at these two likable rascals, then blew them away in a hail of a thousand bullets. But it was Sam Peckinpah's *The Wild Bunch* that became a symphony to wholesale violence. The film ends with four over-the-hill cowboys slaughtering almost an entire army of Mexican soldiers. Peckinpah used every trick in the book, from slow motion to splattering blood squibs, to a sequence with over 100 camera setups showing scores of soldiers and women being mowed down with a machine gun.

Vietnam finally reached the screen in 1978, with Michael Cimino's *The Deer Hunter,* which took home Oscars for best picture and best director. The actual scenes in Vietnam are only about one-fourth of the epic picture. The three-hour film focuses on the friendship of three steelworkers and how the war changed their lives and the lives of the people who cared for them. The following year Francis Ford Coppola released *Apocalypse Now,* based loosely on Joseph Conrad's *Heart of Darkness.* This film is set entirely in Vietnam and uses the war as a backdrop to a slow descent into madness. Vittorio Storaro won an Academy Award for his amazing cinematography. When Coppola screened his movie (which took almost two years to make) as a work-in-progress at the Cannes Film Festival, he stated that *Apocalypse Now* was not about Vietnam, "it is Vietnam."

One of the casualties of the long Vietnam conflict was the Hollywood hero. In literature, the hero that must conquer his inner demons to achieve greatness goes back to Homer's *Illiad.* Sherlock Holmes is an example of a character who is driven to self-destructive excesses when his mind is not fully occupied on a mystery. When motion pictures came in, the line between good and bad became blurred. A star like James Cagney could do terrible things in *The Public*

Enemy but audiences still liked him, despite the flaws his character possessed. The star system was a perfect counterbalance to the extremes to which a character could go and still have the audience on his or her side. After World War II, the dark world of film noir allowed the anti-hero (usually someone who had dabbled in corruption like a private detective) to develop a more complex nature. But by the final reel of the movie, the anti-hero had ultimately taken action and became a true hero.

During the years of the Vietnam conflict, and after the cookie cutter demands of the Production Code were gone, the anti-hero was not obligated to perform this white-hat finale and wandered deep into the dark side. Vietnam produced no heroes, at least not in terms of an old time Hollywood star. Soldiers that served and performed their duties bravely were greeted with shouts of "baby-killers" when they returned home. The country was completely polarized. If a young man burnt his draft card or ran away to Canada to avoid the war they were called "draft dodgers" and worse. In Hollywood, the community that specialized in make-believe was split down the middle. The old guards were mostly "hawks" because of what they had experienced in World War II, and the new filmmakers were "doves" because they were witnessing a senseless war without merit or purpose, fought by soldiers their age or younger. The advantage of the young filmmakers was that they were making movies and the old-timers were on the sidelines.

The anti-heroes of this time period were the first real examples of true human beings in the movies since the Pre-Code Era in the early 1930s. These characters did not have to spin around on a dime at the climax of a film and suggest that forevermore they would do the right thing. These characters were now able to do something decent and worthwhile—perhaps even heroic—but the implication was that they would revert back to their old selves in the morning. They were real people. And audiences loved them. These newborn anti-heroes were a two-for-one deal. In one character there was an equal proportion of good and bad. The character might finally do the decent thing at the end, but the journey was rocky and unpredictable. What this did was radically change the look of the Hollywood Star System. Actors that in the old studio days would have played character parts or sidekicks became the leads in the movies of the 1970s.

THE SECOND GENERATION OF THE METHOD

The movies of the 1970s reflected how much the Method was accepted by movie actors in only a few years. This was the second generation—the symbolic children of Marlon Brando, James Dean, and Montgomery Clift. The Method's improvisational approach to finding the inner workings of a character created the ideal marriage with the increasingly realistic style of filmmaking in this era. Directors like Robert Altman, William Friedkin, Martin Scorsese, Woody Allen, Sidney Lumet, and Francis Ford Coppola wanted an atmosphere that was spontaneous for the actors to bring something new and unexpected to a scene. Sometimes this meant staying close to a screenplay, like *The Godfather*, but occasionally letting the actors have freedom to rephrase lines or improvise during the actual shooting. Sometimes this meant keeping the storyline of a screenplay but letting the actors completely improvise their dialogue, like in *M*A*S*H* and *The French Connection* (both won Oscars for best screenplays).

With *The Godfather* audiences were watching Brando, the actor identified with the birth of the Method, and his spiritual disciples, Al Pacino, James Caan, and Robert Duvall. One of the rea-

Dog Day Afternoon (1975) directed by Sidney Lumet, starring Al Pacino and John Cazale. Cinematographer Victor J. Kemper commented that the film was shot on "pure energy." Based on a true story, Lumet kept the camera in constant motion to create the immediacy of a documentary. This style of direction has been referred to as the Hollywood New Wave.

sons this film had an internal energy with all the actors is undoubtedly Brando's performance. Here was the legendary figure of *A Streetcar Named Desire* and *On the Waterfront* making what might be called the comeback of the century, after being labeled box office poison because of a long string of disappointing films. Brando took his role as Don Vito Corleone seriously and created one of the most memorable characters in the movies. To be in the presence of this level of acting inspired everyone involved, making the other performers dig deeper into their characters.

Martin Scorsese's relationship with actor Robert De Niro is unique in movies. James Stewart worked with Frank Capra many times, and John Wayne is forever associated with John Ford, but these performers built their characters from the old tradition of finding clues in the dialogue of carefully crafted screenplays. Scorsese allowed De Niro to improvise while the camera was rolling. During *Taxi Driver*, this process resulted in one of most quoted lines in films, when De Niro looks almost directly into the camera and says, "You talkin' to me?" With the right directors and actors, these moments in the movies be-

come extremely real and memorable. In *Dog Day Afternoon*, Sidney Lumet told Al Pacino to work the crowd of extras outside the bank into a high state of excitement. Pacino began to improvise and shouted, "Attica! Attica! Attica!", which almost caused a riot and achieved the desired effect for the scene.

THE STAR SYSTEM, TAKE 2

When Mike Nichols cast Dustin Hoffman instead of Robert Redford as Benjamin in *The Graduate*, it was the trigger effect that changed the look of lead men and women in the movies. To have predicted this 180-degree turnabout in the Star System would happen so quickly, or at all, probably was the furthest thought from Nichols' mind in 1967. But by the 1970s, the new stars were Hoffman, Robert De Niro, Al Pacino, Donald Sutherland, Barbra Streisand, Elliott Gould, Robert Duvall, Alan Arkin, James Earl Jones, Malcolm McDowell, Walter Matthau, Glenda Jackson, Richard Roundtree, Gene Hackman, Liza Minnelli, Gene Wilder, Pam Grier, Richard Dreyfuss, Richard

Butch Cassidy and the Sundance Kid (1969) directed by George Roy Hill, screenplay by William Goldman, and starring Paul Newman and Robert Redford. Many of the films associated with the New Hollywood are distinguishable by a radical change in cinematography. Conrad L. Hall, who won the first of his three Oscars for this popular revisionist Western, also shot **Cool Hand Luke, In Cold Blood, Fat City, The Day of the Locus,** and **The Marathon Man** during this era.

Pryor, John Travolta, Sylvester Stallone, Sissy Spacek, Diane Keaton, Christopher Walken, Eddie Murphy, Peter Sellers, John Belushi, and Woody Allen.

These new stars had one thing in common: If they were around during the Studio System of the 1930s and '40s they most likely would have played supporting character parts, been used for comic relief, or been the also-ran in a love triangle with the main star. Despite the amazing talent of each of these actors, it is doubtful any of them would have achieved name-above-the-title stardom before the '70s. They did not have the glamorous appearance of Cary Grant, Robert Taylor, Henry Fonda, Katharine Hepburn, John Wayne, Joan Crawford, Douglas Fairbanks Jr., Vivien Leigh, Errol Flynn, Laurence Olivier, Greer Garson, or other Hollywood legends. Of course, it can be argued that James Cagney, Humphrey Bogart, Bette Davis, Spencer Tracy, and even James Stewart were not the god-like personas typical of this era. But each of them made it on the sheer charm and energy of their performances, plus they struck a common chord with the general public.

The New Hollywood of the '70s became the great melting pot for actors. In fact, all areas of filmmaking—from directing, writing, and cinematography to producing talent—came from different countries and from different ethnic backgrounds. Instead of having just one African-American star, there were suddenly dozens starring in films. Many of the old studio moguls had concerns about actors being perceived as "too Jewish," as Jack Warner once remarked, so Emanuel Goldenberg became Edward G. Robinson and Jacob Julius Garfinkle became John Garfield. This vanished in the 70s when Dustin Hoffman, Barbra Streisand, Richard Dreyfuss, and Woody Allen all became superstars (Woody is the one exception, since he changed his name from Allen Stewart Konigsberg to better fit his comic image).

For some unexplainable reason, after Rudolph Valentino, there were no major Italian movie stars until the late 1940s, when Frank Sinatra began appearing in MGM musicals. Also during this time Richard Conte played supporting parts in war movies and film noirs (his most famous role is Emilio Barzini in *The Godfather*).

Perhaps there was some code of honor during the Studio Era where Italians did not play gangsters. In *Scarface,* based loosely on Al Capone, Paul Muni played Tony Camonte. Later, with the exception of Victor Mature (Maturi was his last name) there were no leading Italian actors in the CinemaScope epics, like *The Robe, Ben-Hur,* and *Spartacus,* giving the impression to audiences that people in Ancient Rome talked with proper English accents. Dean Martin became a star in movies like *Rio Bravo* and *Ocean's Eleven,* and Marcello Mastroianni became famous because of his films with Federico Fellini. Suddenly in the '70s, after *The Godfather,* being Italian was cool, and Al Pacino, John Travolta, Sylvester Stallone, and Robert De Niro became some of the hottest stars in Hollywood.

The traditional leading man and woman in movies did not become an endangered species in Hollywood during the '70s. Actors like Clint Eastwood, Paul Newman, Julie Christie, Robert Redford (who managed to find good roles after being passed over for *The Graduate*), Jane Fonda, Burt Reynolds, Faye Dunaway, Warren Beatty, Jon Voight, Harrison Ford, and to a lesser degree, Jack Lemmon, George C. Scott, David Carradine, and Jeff Bridges, all qualify in the category of movie idols. But there was a different emotional feeling that came off the screen from these actors. Perhaps it was because of the freedom of expression they experienced that was denied to the older generation of stars because of the Production Code. The subject matter of the films they appeared in was often darker, more complicated in terms of right and wrong, and thus permitted these actors to take greater chances. Many of them became masters of their own fate, developing and producing movies they wanted to appear in, like Clint Eastwood, Robert Redford, Jane Fonda, Warren Beatty, and later Harrison Ford.

Over the years, movie magazines often try to connect the past stars with the new faces in Hollywood. Clint Eastwood has been compared to John Wayne, Gene Hackman to Spencer Tracy, Jane Fonda to Bette Davis, and Al Pacino to James Cagney. As the years passed, this attempt to connect the past with the present has become a bitter-sweet exercise in nostalgia. Each generation of stars and character actors somehow instinctively reflects the mood of the time period in which they cast their shadows. Or perhaps the events of history allow certain actors the opportunity to become stars. If Fred Astaire was a Baby Boomer, then no matter how great his talent, it is unimaginable that he would have found fame in the Watergate Era. So, thank heavens he was born when he was and gave so many people enjoyment during the Depression Era.

If there was one actor that typified the New Hollywood of the '70s, it would have to be Jack Nicholson. This is not to claim he was the greatest actor of this era, though that certainly could be argued. Nor is it to suggest that his films were any more important than the hundreds of exceptional films that were made during these highly productive years. In truth, he made some of the best and some of the worst. What Nicholson had was attitude. He *was* the New Hollywood. He *was* the 1970s. No actor fit the time period better.

Brando is the actor most identified with the '50s, and in the '40s there was Bogart. At the tail end of the Studio System Nicholson could only find work in B-movies. After *Easy Rider* he never stopped working. He was not classically handsome, like Tyrone Power, Gregory Peck, or Clark Gable. His looks were boyish, closer to James Dean, and like Dean he carried the rebel persona.

Besides *Easy Rider,* Nicholson starred in three films that seemed to capture the conflicted nature of this era. In *Five Easy Pieces* (1970), directed by his close friend Bob Rafelson, he played a gifted concert pianist who turns his back on his elitist family and squanders his talent by working in oil fields with roughnecks. In Roman

One Flew over the Cuckoo's Nest (1975) directed by Milos Forman, starring Jack Nicholson, Louise Fletcher, and Brad Dourif, perhaps more than any other film, **One Flew over the Cuckoo's Nest** represents the frustration and deep-seated defeatism of many American people during these years of political scandals and an unpopular war. The idea that trying to change "The System" has destroyed some of the best and brightest is reflected in the conflict between Randle Patrick McMurphy and Nurse Ratched. No other actor represents this divided time period better than Nicholson, who finally won his first Oscar for the film.

Polanski's *Chinatown* (1974), written by his friend and fellow Roger Corman film school alumnus Robert Towne, he becomes involved in a murder investigation that exposes the corruption of all aspects of the Los Angeles government. In both of these films, he is defeated by overwhelming personal circumstances, leaving him bitter and confused.

But it was *One Flew over the Cuckoo's Nest* (1975), directed by Milos Forman, that became the unofficial anthem of this era. It is impossible to picture anyone else in these films, especially Nicholson's role as Randle Patrick McMurphy, who is crazy like a fox, and a perpetual free-spirit who figuratively and literally moons the Establishment. Like Brando and his character Terry Malloy in *On the Waterfront,* Nicholson will probably be forever associated with the ill-fated McMurphy, who became the "bull goose loony" of the asylum only to be crushed by the unfair rules of authority, as represented by the cold-hearted, by-the-numbers Nurse Ratched.

One Flew over the Cuckoo's Nest became a runaway box office hit, perhaps because it reflected the down mood of a nation that had

protested a war, but saw the bloody conflict continue for years, and who had endured a tedious investigation that revealed the President of the United States was a crook. People closely identified with McMurphy, because they felt that no matter what happened there was no way to defeat the Establishment. Frank Capra in the 1930s used the theme that one person could make a difference, and change the world around him, like in *Mr. Deed Goes to Town* and *Mr. Smith Goes to Washington.* But in the '70s there was the pervasive feeling that the individual could easily be crushed. After all, if it could happen to Jack Nicholson, it could happen to anyone.

TELEVISION IN THE 1970S

So many changes were happening in this era with politics, the Civil Rights Movement, and the Sexual Revolution that it was impossible for films to be up-to-date with current events. In the 1970s, television became the lightning rod for the rapid changes in society and what was happening in the pop culture scene. Like what was happening in motion pictures in

this era, many television shows took giant risks. And the best of these programs literally changed the nature of entertainment. In 1971, Norman Lear introduced millions of people to a character who arguably became the most beloved bigot of all times. His name was Archie Bunker, played brilliantly by Carroll O'Connor, and the long running show was *All in the Family*. It was a sitcom that the CBS producers were afraid would be torn apart by an avalanche of protest letters. Instead, it taught American audiences how to laugh at the sensitive issues of the time.

The genius of Archie Bunker's character was that people were amused by his open bigotry, but they did not want to be like him. Through Archie's black-and-white view of the world, the writers of *All in the Family* were able to explore not only racial problems, but political and even personal family problems, as seen through the myopic vision of a character who represented a side of America that had created so many past injustices.

By making people laugh at the narrow-minded quips of Archie Bunker, *All in the Family* was able to demonstrate the absurdity of prejudice. A spin-off of *All in the Family* was *The Jeffersons,* featuring George Jefferson, who was described as the black Archie Bunker. The Jeffersons were the neighbors to the Bunkers for many years. Then Norman Lear and Bud Yorkin created a show just for them, which aired in 1975, becoming one of three all-Black sitcoms in this era. The other shows were *Sanford and Son* and *Good Times,* also created by Lear.

Another unlikely hit was based on a wartime black comedy film called *M*A*S*H*. But the intelligent, wise-cracking humor of surgeons in the Korean War, based on the characters from the Robert Altman runaway hit, *M*A*S*H*, ran for eleven years. Another series that was an indirect spin-off of a successful movie was *Happy Days,* inspired by George Lucas' *American Graffiti.* From *Happy Days* would come the sitcom *Laverne*

*M*A*S*H (1970) directed by Robert Altman, starring Donald Sutherland and Elliott Gould, with a screenplay by blacklisted writer Ring Lardner Jr. Altman's approach to film directing was so unorthodox at the time that several members of the cast considered having him committed to an asylum. But the madness on the set resulted in a black anti-war comedy that broke box office records and made stars of Sutherland and Gould.*

& *Shirley,* both shows perpetuating the myth that the '50s were a time of fun-filled innocence. The first sitcom featuring a divorced woman was *The Mary Tyler Moore Show,* which, although hard to believe, was a sensitive subject in the early '70s.

There are many dramatic shows that are still running today or have been remade over the years. As for Westerns, which had dominated the networks in the '50s and '60s, *Gunsmoke* completed its twenty-year run in 1975, and *Bonanza* ended in 1973 after fourteen years. *Walt Disney Presents* would continue until 1990, and an unmatched run of thirty-six years. To keep up with the movies, this was an era of high-adventure shows, including *Hawaii Five-O, Charlie's Angels,* and *The Six Million Dollar Man.* For mysteries there was *Columbo, McCloud* (loosely based on Clint Eastwood's character in Coogan's Bluff), *McMillan and Wife,* and *Ironside.* One of the most popular and honored shows of the era was *The Waltons,* about a family in the Blue Ridge Mountains of rural Jefferson County, Virginia during the Depression. And in 1978, the prime-time soap opera was born with *Dallas,* quickly followed by *Knots Landing.*

MINISERIES

In 1924, legendary director Erich von Stroheim made *Greed,* based on the novel *McTeague* by Frank Norris. The film was a complete and faithful adaptation of the novel that came in at almost nine hours. Fearing a box office disaster, the film was ordered to be cut by Irving Thalberg. It was brutally and infamously trimmed down to roughly two hours. With this, the idea of the "cinematic novel" died for years. *Gone With the Wind* trimmed a thousand-page novel into four hours. Later Joseph Mankiewicz tried to release *Cleopatra* in two parts, each almost four-hours long. Then without great fan-

fare in 1969, the fledgling Public Broadcast Service (PBS) aired *The Forstyle Saga,* and television history was made. (This same year, *Sesame Street* became a morning regular.) Extending for twenty-six, hour-long, black-and-white episodes, this original BBC series took viewers by storm. A full novel was brought to the screen—the small screen. On January 10, 1971, *Masterpiece Theatre* premiered, hosted by Alistair Cooke, with the miniseries *The First Churchills.* This was followed by *The Six Wives of Henry VIII* and *Elizabeth R.* The most successful series was *I, Claudius* (1976), a thirteen-part look at the treachery and divine decadency of Ancient Rome, which had millions of loyal viewers tuning in each week.

The major television networks realized that little PBS was taking away significant audiences during prime-time hours. The network shows were primarily structured as single viewing episodes, a complete story that could be watched without having to know what went on the week before. But the miniseries on *Masterpiece Theatre* ended with small cliffhangers, hooking the audiences like old Saturday matinee serials. Producer Stan Margulies and executive producer David L. Wolper approached ABC about creating a miniseries based on Alex Haley's 1976 best seller *Roots: Saga of an American Family.* Haley spent twelve years researching *Roots,* which was a novel based on his own family's history as slaves. Twelve hours long and airing over six nights, starting on January 23, 1977, it became the most watched television dramatic series in history, seen by 130 million people. Shot as an epic motion picture, *Roots* is a mesmerizing piece of filmmaking.

The following year audiences got a terrifying look at the atrocities in Nazi Germany in the eight-hour miniseries *Holocaust,* the story of one Jewish family's struggle to survive extermination in the concentration camps. Among the excellent cast was a young Meryl Streep, who one year

later would win her first Academy Award as supporting actress in *Kramer vs. Kramer.* Other miniseries quickly followed, like *The Winds of War* (1983), based on Herman Wouk's giant novel. And it can be argued that these miniseries influenced the movies. Starting with *Star Wars* in 1977, trilogies and sequels became common in Hollywood, with *Back to the Future, Raiders of the Lost Ark,* and *Aliens,* ultimately resulting in *The Lord of the Rings,* perhaps the best example to date of a cinematic novel. Erich von Stroheim was just a half of century ahead of time.

SATURDAY NIGHT LIVE

After looking at the television programs that made such an impact on the 1970s like *Roots, All in the Family, The Mary Tyler Moore Show, The Waltons,* and dozens of others, the one show without question that had the biggest influence on Hollywood by the end of the decade was *Saturday Night Live.* First airing on October 11, 1975, the number of stars and superstars that have come out of *Saturday Night Live* has not been equaled since the glory days of vaudeville and burlesque. The format for the show, with comedy sketches and live music, was very similar to vaudeville, except updated for the college crowd of the '70s.

The first wave of SNL graduates to cross over into movies included John Belushi, Chevy Chase, Gilda Radner, Dan Aykroyd, Bill Murray, and Eddie Murphy. *Animal House* (1978), directed by John Landis, was shot for $2.5 million and made back almost fifty times its original budget. Overnight, John Belushi became one of the most sought after actors in Hollywood, and producers rushed to sign up other SNL talent. In just a few years, this handful of performers had starred in *Foul Play, The Blues Brothers, National Lampoon's Vacation, Caddyshack, Stripes,* and *48 Hours.*

To a younger generation that was hungry for humor that mirrored their disdain for authority and timeworn traditions, these movies were like minting money. Many of the films returned to the slapstick comedy of Buster Keaton or Laurel and Hardy, but with the Production Code a distant memory, the humor often went to extremes to gross out audiences. Gradually the humor in films like *Trading Places, Ghostbusters,* and *Beverly Hills Cop* became more sophisticated, still attacking sacred cows but with cerebral wit and borrowed parts from old screwball comedies. Over the years new faces from *Saturday Night Live,*

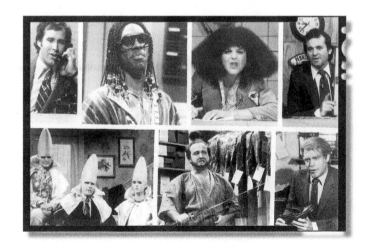

*The television phenomena **Saturday Night Live** (1975), created by Lorne Michaels, became the hip vaudeville of the '70s, launching the movie careers of many in the original cast, including John Belushi, Dan Aykroyd, Chevy Chase, Jane Curtain, Garrett Morris, Laraine Newman, and Gilda Radner.*

after paying their dues, went knocking on the doors of Hollywood and wound up making some of the most successful films or television shows ever. The alumni from SNL include Julia Louis-Dreyfus, Billy Crystal, Christopher Guest, Martin Short, Randy Quaid, Joan Cusack, Robert Downey, Dennis Miller, Dana Carvey, Phil Hartman, Mike Myers, Chris Farley, David Spade, Chris Rock, and Adam Sandler.

OPENING WIDE AND THE BIRTH OF THE BLOCKBUSTER

Worried that the three-hour length of *The Godfather* could potentially cut down on first-run revenues, Frank Yablans, head of distribution for Paramount Pictures in 1972, had an idea that would revolutionize the film industry. The average film was just under two hours long, thus it could play up to five times in one day. A three-hour film can only play three times in one day, maybe four with a mid-morning show on the weekends.

The traditional distribution pattern for an A-feature was to open at a prestige theatre, like Radio City Music Hall in New York or the National in Westwood, California, and let it run for several weeks or a month if it proved to be a crowd pleaser, then move it to a second-run theatre and eventually tour the drive-in circuit. The film would have an exclusive with a particular theatre in a community, which meant that no other theatre for fifty to a hundred miles could get the rights until the film went into its second run.

This is how it had been done since *The Birth of a Nation*, but Yablans posed a simple question: Why not open at several theatres in the same city at one time? There were two problems with the traditional release pattern: Each time the film moved to a new theatre there would have to be extra publicity money spent. The other problem—the biggest one—was that box-office revenue on

Jaws (1975) directed by Steven Spielberg, cinematography by Bill Butler, and starring Roy Scheider, Richard Dreyfuss, and Robert Shaw. Besides becoming the first motion picture to make $100 million, the Great White killer shark movie also won Oscars for John Williams and Verna ("Mother Cutter") Fields. Fields is a wonderful example how some of the experienced editors and cinematographers in the studio system took delight in helping the young directors of the New Hollywood. She also worked with Peter Bogdanovich on **What's Up, Doc?** *and* **Paper Moon,** *George Lucas on* **American Graffiti,** *and Spielberg on* **Sugarland Express.**

a film might be spread out for months or a year. Yablans' solution was to spend the budgeted amount of publicity money in New York, but he opened *The Godfather* in five theatres, staggering the playtimes. He also booked 316 theatres nationally, and then added 50 more over the next couple of weeks.

This was almost three times the number of theatre bookings for an A-feature. The process would later become known as "opening wide." Yablans' brainchild paid off in a big way. *The Godfather* went on to gross $86 million at the box office. The closest competition that year was *The Poseidon Adventure,* which brought in $42 million. But this strategy did not change Hollywood immediately. While opening at several prestige theatres for an A-feature was new, this practice had been used for "stinkers" in the past. The studios would release a film that was deemed a lemon at several second-run theatres, thus giving it a chance to stack up a few ticket sales before bad word of mouth killed it. It would take another A-feature to convert the studios to the practice of opening wide.

Jaws had a very long and troubled shoot. Anything that could go wrong did. For over half of the production the mechanical shark did not work, or as Steven Spielberg joked, "He refused to come out of his dressing room." Most of the action in the film takes place on water, and there were constant weather problems. Many of these setbacks caused almost daily rewrites on the screenplay. These revisions found ways for the giant eating machine's presence to be felt but not seen. The use of barrels let the audience know the shark was near the boat, plus demonstrated how extraordinarily powerful it was. This built up an escalating sense of suspense, which, when combined with John Williams' outstanding score, caused preview audiences to scream like they were on a thrill ride at Disneyland. Throughout all this, Steven Spielberg, who turned twenty-nine during the making of *Jaws,* remained calm, focused, and determined.

When Lew Wasserman saw a screening of *Jaws,* he knew he had something very special. Considered by many to be the last great mogul of the old Studio System, Wasserman was the CEO of Music Corporation of American (MCA), the parent company of Universal Studios, where Spielberg was under contract. Wasserman decided to make a summer event out of *Jaws* by opening wide, in conjunction with one other key element: television advertising. It is amazing that in 1975 this was still a relatively untried concept. Wasserman had negotiated the deal for *Alfred Hitchcock Presents,* which put the Master of Suspense on the air each week, thus stirring up anticipation for upcoming movies. But TV spots had only been used a few times. *The Golden Voyage of Sinbad* (1974) was promoted on local television stations. *Breakout* (1975), starring Charles Bronson, became the first film to be advertised nationally on the networks. *Breakout* was thought to be a disaster by the heads of Columbia, so they wanted to unload it quickly. Because of the television ads, the film broke even after just a few weeks. This was enough proof for Wasserman, who knew he had an exceptional film to sell.

Universal invested over $700,000 in half-minute TV spots on prime-time shows, which was considered an extravagant amount at this time. (Today a single spot during the Super Bowl would cost this or more.) After this television bombardment, *Jaws* opened in 409 theatres and immediately began to set box-office records. Instead of dropping off after the first weekend, a typical pattern for the vast majority of movies, *Jaws* kept climbing in attendance sales for weeks. This was the twilight of the drive-ins, and it was a common sight to see people on the hoods of their cars watching the movie and screaming in fear, laughing in unison when Roy Scheider sug-

gested they might need a bigger boat. *Jaws* went on to become the first film to break the hundred-million dollar mark, bringing in $129 million on its first release. *Jaws* held that record for two years, until *Star Wars* shattered it.

CINEMATOGRAPHERS

The influence of a new generation of cinematographers was extraordinary during this era. Not since the German Expressionist Movement had there been so much experimentation with light and the movement of the camera. If the films made during the late '60s and throughout the '70s are examined objectively, the line between director and cinematographer becomes blurred. The Auteur Theory puts the director at the center of a movie, but the cinematographer is ultimately responsible for the visual language and unforgettable images. In an ideal working relationship, the director will describe his vision of a scene, even storyboard it, and then the cinematographer will be given the time and freedom to light and arrange the various shots required. Many of the new directors of this era had a working knowledge of cinematog-raphy either from film schools, making low-budget features, or shooting documentaries. Thus the collaboration between director and cinematographer was based on trust, mutual respect, and an almost child-like sense of experimentation. There was an awareness that they were on the cutting edge of visual storytelling. The excitement must have been similar to what Orson Welles and Gregg Toland felt while making *Citizen Kane*.

Many of the new cinematographers were from Europe, thus seeing America during this turbulent time period affected them as artists. They were given the time needed to set the lights, lay down track, and arrange a sequence of shots. As the expression goes, they were literally "painting with light." Since the director was not bound by the Production Code, the stories that were being told were dynamic and had a sense of importance, like film could really change the world. This unquestionably inspired the cinematographer to take chances and to try to catch the visual soul of a story.

Starting in the '80s and continuing today, movie schedules became very tight in order to lower expenses, and much of a shoot is locked

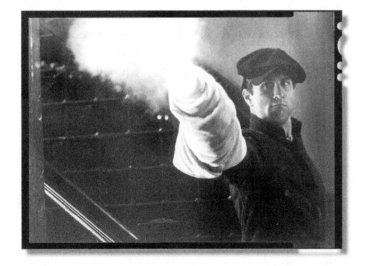

The Godfather, Part II (1974) *directed by Francis Ford Coppola, starring Al Pacino, Robert Duvall, Robert De Niro, Diane Keaton, John Cazal, Talia Shire, and Lee Strasberg. Many of old studio directors, like John Ford and Alfred Hitchcock, had little or no patience with Method Actors. Coppola had a background in theatre and felt very comfortable working with this new generation of actors, which contributed to the remarkable depth of characterizations in this sequel. Strasberg, who plays Hyman Roth, undoubtedly helped in this because of his presence. He was one of the founding members of the Group Theatre and the director of the Actor Studio during the '50s.*

down during pre-production. With rare exceptions, cinematographers are not given the extra hours to meticulously light scenes or develop alternative concepts for a director to look at. An epic film like *Lawrence of Arabia,* shot by Freddie Young, would be impossible to make today. However, because of the brilliant work done during the '70s, future cinematographers will always have a wealth of information and enduring images to study. The films by a few legendary cinematographers during these years have a feeling of presence and power that were unlike any films that came before. It is interesting to examine the work done by certain directors and see how the films they made with certain cinematographers are different from the films they made with other cinematographers. In most cases, the quality of the work by the cinematographer is more consistant than that of the director.

Of course, the generation of cinematographers in the '70s had "new toys" to play with, as Stephen H. Burum describes them. The Mitchell camera had served the film industry since 1921. With the coming of sound, the company made improvements allowing it to be quieter and easier to operate. The problem with the Mitchell was that it was heavy, weighing up to 200 pounds with a Panavision lens. As more films were shot on location, the demand for lighter-weight cameras increased. The Arriflex and Éclair are 16mm cameras, originally developed for documentary use, and could easily be handheld by a single operator. These cameras became the darlings of the French New Wave and independent filmmakers like John Cassavetes.

However, it was the 35mm Panavision Panaflex that changed the look of feature films. The Panaflex was less than half the size of the Mitchell, lightweight, and extremely easy to operate during location shooting. This meant saving time on camera setups, thus giving the director the opportunity to shoot faster and get more coverage. During the '70s, the Panaflex was preferred by most cinematographers, and the old, reliable Mitchell was gradually replaced. This is why the films of this era often have a freer style of camera movement and more shots edited into a sequence. The Panaflex could easily be put inside of a car or helicopter and roll with the action. The art of the montage, pure visual storytelling with very little dialogue, began to reappear. A film like *Jaws* would have been impossible to make with the heavy, cumbersome Mitchell. Instead it would have been shot in a giant water tank on the studio lot, like *Lifeboat* and *The Old Man and the Sea.*

The work of good cinematography is subtle. It should enhance the story, convey a sense of time and place, and not bring undue attention to the camerawork. All movies are make-believe. Even the most realistic films have elements of artificiality because of the use of actors and the manipulation of time. It is up to the cinematographer to turn this make-believe into reality, and if successful the audience will notice the hard work that went into this monumental effort. If the sound is turned down on a film, then the viewer should still be able to follow the action in the story without the dialogue. The cinematographer is always dealing in visual information, and a good film can be watched and understood like an old silent movie. Here are a few cinematographers from this era that were worth observing—with or without sound.

Conrad Hall's work was a perfect example of a cinematographer who liked to capture the mood of the action. In the 1960s, he worked with Richard Brooks on *The Professionals* and *In Cold Blood,* Stuart Rosenberg on *Cool Hand Luke,* and won his first of three Oscars for *Butch Cassidy and the Sundance Kid,* directed by George Roy Hill. During the 70s he shot *Fat City* for John Huston, and made *The Day of the Locust* and *The Marathon Man* with British director John Schlesinger. Hall would later

win Oscars for *American Beauty* and *Road to Perdition,* directed by Sam Mendes.

Many directors in this era enjoyed working with young or first-time directors, very much in the tradition of Welles and Toland. Haskell Wexler, Bill Butler, and Robert Surtees did some of their best work under these circumstances. Wexler won an Oscar for black-and-white cinematography on *Who's Afraid of Virginia Woolf?,* the first film directed by Mike Nichols, and was visual consultant for George Lucas's *American Graffiti.* He shot *One Flew over the Cuckoo's Nest* for director Milos Forman, and two films for Hal Ashby, *Coming Home* and *Bound for Glory,* for which Wexler won his second Oscar. Bill Butler pulled off the almost impossible as cinematographer for Steven Spielberg's *Jaws,* and shot *The Conversation* for Francis Ford Coppola. And Robert Surtees was behind the camera (at the age of sixty-one) for *The Graduate,* Mike Nichols' second film, Peter Bogdanovich's *The Last Picture Show,* and *The Sting,* directed by George Roy Hill. In his career, Surtees was nominated sixteen times and won three Oscars, one for *Ben-Hur.*

Gordon Willis and Owen Roizman learned their craft in New York, far away from the studio traditions, and both contributed to changing the look of films in the '70s. Willis enjoyed the freedom of working in New York and the ability to go with his gut instinct on films. Aside from Conrad Hall, no other cinematographer in this era put his personal touch on films like Willis. Nicknamed the "Prince of Darkness," he worked with Alan J. Pakula on *Klute, The Parallax View,* and *All the President's Men,* and shot eight of Woody Allen's films, including *Annie Hall* and *Manhattan.* But the films that made the greatest impact were *The Godfather* and *The Godfather, Part II* for Francis Ford Coppola. Astonishingly, he was not nominated for any of these films. On *The Godfather* movies he was criticized for his dark lighting and not showing the actors' faces. Today

these films are considered masterpieces and are studied by any aspiring young cinematographer.

Owen Roizman worked with William Friedkin on *The French Connection,* creating a gritty documentary look, then turned around and shot *The Exorcist* with its dark shadows and stylized backlighting. He then made a series of films that showed his amazing versatility as a cinematographer. Roizman shot *The Stepford Wives* for Bryon Forbes, *Three Days of the Condor* for Sydney Pollack, and *Network* for Sidney Lumet. He later worked with Pollack again on *Absence of Malice* and *Tootsie.*

Many of the major changes in cinematography were a result of Europeans who either worked mainly in their own countries with celebrated foreign directors, or left their homeland because of Communist dictatorship. Sven Nykvist's influence was enormous because of his work with Ingmar Bergman, including *Persona, Scenes from a Marriage, Cries and Whispers,* and *Fanny and Alexander.* Vilmos Zsigmond and Laszlo Kovacs were students in Hungary and in 1956 fled to America. They paid their dues on B-features until they were given the opportunity to work with some of the most innovative directors of the New Hollywood.

Zsigmond was responsible for the look of some of the most significant films of the 1970s. He shot *McCabe and Mrs. Miller* (considered by many as one of the most strikingly beautiful films of all time) and *The Long Goodbye* with Robert Altman. He made *Deliverance,* directed by John Boorman, and two films with Steven Spielberg, *Sugarland Express* and *Close Encounters of the Third Kind,* for which he won the Academy Award. His work with Michael Cimino resulted in a classic, *The Deer Hunter,* and a box office disaster, *Heaven's Gate* (his cinematography on this is without question the film's only saving grace). And his fellow countryman, Laszlo Kovacs was responsible for *Easy Rider,* directed by Dennis

Hopper; *Five Easy Pieces,* by Rob Rafelson; Peter Bogdanovich's *Paper Moon;* and Hal Ashby's *Shampoo.*

The two other important cinematographers from Europe are Nestor Almendros and Vittorio Storaro. Almendros collaborated with Francois Truffaut on many of his classic films, including *The Wild Child, Bed and Board,* and *The Story of Adele H.* With American director Terrance Malick, he made what many people consider the most beautiful film of the 1970s, *Days of Heaven,* shot almost entirely during the "golden hour," or that time just after the sun sets and there is a golden glow in the sky. He continued working mostly in Europe, especially with Truffaut and Eric Rohmer, but made *Kramer vs. Kramer* and *Places in the Heart* with Robert Benton and *Sophie's Choice* with Alan J. Pakula. Vittorio Storaro is associated with many of Bernardo Bertolucci's greatest films, including *The Conformist, Last Tango in Paris, 1900,* and *The Last Emperor,* for which he won his third Academy Award. He also won Oscars for Francis Ford Coppola's *Apocalypse Now,* and *Reds,* directed by Warren Beatty.

INTERNATIONAL CHANGES: EXODUS TO HOLLYWOOD, PART 2

The excitement of filmmaking in America in the 1970s mirrored what had begun a decade before in France, Italy, Sweden, England, Japan, and other countries. Directors like Ingmar Bergman, Federico Fellini, Francois Truffaut, and Akira Kurosawa stayed in their own countries, and the films they made influenced audiences and filmmakers halfway around the world. But in the late 1960s, a new generation of directors, cinematographers, and actors began a steady exodus from their countries to work in the American studios. Innovative directors like Roman Polanski, Milos Forman, John Schlesinger, and John Boorman came over because of lucrative offers and better equipment. Their unique twist on the tainted American Dream during these years of upheaval was reflected in films like *Chinatown, One Flew over the Cuckoo's Nest, Midnight Cowboy,* and *Deliverance.*

Roman Polanski and Milos Forman shared similar backgrounds. Polanski's parents were

Darling (1965) directed by John Schlesinger, screenplay by Frederic Raphael, and starring Julie Christie, Dirk Bogarde, and Laurence Harvey. Both Christie and Raphael won Oscars for their work. Schlesinger was one of several British directors that came cross the Atlantic to make provocative films about America. Four years later he made **Midnight Cowboy,** then **Day of the Locus** and **Marathon Man.** Karel Reisz shot **Who'll Stop the Rain,** and John Boorman did **Deliverance.**

sent to concentration camps during World War II, where his mother eventually died. As a child he managed to escape the Warsaw ghetto and survived the war by wandering the Polish countryside and living with various Catholic families. He put many of his experiences during this dark time into the film *The Pianist*. Polanski reigned as a filmmaker in the Lodz Film School, and received international acclaim in 1962 for *Knife in the Water*, which was nominated as best foreign language film. He worked briefly in France, and then moved to England and shot the post-*Psycho* shocker *Repulsion*, with Catherine Deneuve, and the horror comedy *The Fearless Vampire Killers*, co-starring screen beauty and future wife Sharon Tate. Robert Evans, the newly appointed head of production for Paramount, impressed with Polanski's work, brought him over to direct *Rosemary's Baby*.

Milos Forman's journey to Hollywood had a less auspicious beginning. His parents died in the Auschwitz concentration camp. Raised in Czechoslovakia, after the war he was able to study at the School of Cinema in Prague. Forman made several low-budget comedies that became the darlings of the art houses, including *Black Peter, The Fireman's Ball*, and *Loves of a Blonde*, which was nominated for best foreign language film. After the invasion of Prague by the Communists in 1968, he fled to America where he struggled as a filmmaker for seven years. His first feature, *Taking Off*, was a complete failure at the box office, despite good critical acclaim. Literally at a time when he was down to almost his last nickel, Forman received a phone call from Michael Douglas and Saul Zaentz to direct *One Flew over the Cuckoo's Nest*.

In the land down under, there began a movement that became known as the Australian New Wave with exciting, original young directors like Peter Weir, Gillian Armstrong, Bruce Beresford, George Miller, and Phillip Noyce. Very similar to

Picnic at Hanging Rock (1975) directed by Peter Weir, with Rachel Roberts, is one of the motion pictures that signaled a renaissance of filmmaking in the country down under, which has also been called the Australian New Wave. Weir also made **The Last Wave** and **Gallipoli**, George Miller did **Mad Max** and **Road Warrior**, Gillian Armstrong directed **My Brilliant Career**, Bruce Beresford did **Breaker Morant**, and Phillip Noyce made the thriller **Dead Calm**. All of these directors eventually made films in America.

the directors of the French New Wave and neo-realism, the films by these directors focused on the people and literature, and overlooked the history of their native homeland, and in turn created a showcase for the vast and singularly beautiful terrain of Australia. Films like *Picnic at Hanging Rock, My Brilliant Career, Breaker Morant, Mad Max,* and *Newsfront* captured the attention of American audiences and the heads of studios.

By the mid-1980s these directors would gradually be lured to Hollywood. Weir was nominated for the Academy Award as best director for *Witness, Dead Poet's Society, The Truman Show,* and *Master and Commander: The Far Side of the World.* Armstrong directed *Mrs. Soffel* and *Little Women.* Beresford made *Tender Mercies,* which won Robert Duvall the Oscar as best actor, and his *Driving Miss Daisy* won for best picture, despite the fact he was not nominated for his direction. Miller redefined the action genre with his post-apocalyptic Mad Max movies, making Mel Gibson an international star, then turned Jack Nicholson into the devil in *The Witches of Eastwick,* and was the producer of *Babe.* And Phillip Noyce scared audiences with *Dead Calm,* starring Nicole Kidman on her road to stardom; shot Tom Clancy's CIA thrillers *Patriot Games* and *A Clear and Present Danger* with Harrison Ford; then returned to Australia to make the superbly crafted *Rabbit-Proof Fence.*

Rainer Warner Fassbinder, Werner Herzog, Wim Wenders, and later Wolfgang Petersen became associated with the rebirth of the New German Cinema. This movement rose out of the ashes of what was once considered the greatest center of motion picture production in the world. There were many similarities to the French New Wave. All but Petersen stayed in Germany to make their films. These directors made highly personal films that were often dark, provocative, and occasionally experimental, reflecting back to Expressionism.

Fassbinder became the focus for this movement because of his incredible output, making forty-four films between 1966 and 1982, and his flamboyant, self-destructive lifestyle that ultimately led to his suicide. His most famous film was *The Marriage of Maria Braun,* which chronicled the difficult life of a German woman in the terrible aftermath of World War II. Fassbinder's obsession with work is illustrated in his ironic last moments, when after taking an overdose of sleeping pills and cocaine he continued to work on an unfinished screenplay until he died.

Herzog, Wenders, and Petersen are very different directors. Herzog's films, like Fritz Lang forty years before, took on giant subjects. *Aguirre, the Wrath of God* and *Fitzcarraldo* were shot on extreme locations and plagued with endless production problems. Herzog is linked with brilliant but eccentric actor Klaus Kinski, who starred in these films and *Nosferatu the Vampyre,* a haunting and at times weirdly amusing remake of F. W. Murnau's silent classic. Wenders was fascinated with the Americanization of the post-WWII German culture. His films caught the attention of Francis Ford Coppola, who brought him over to direct *Hammett,* but the relationship deteriorated into conflicts, and the film was re-shot and altered by Coppola. After the disillusionment of Hollywood, Wenders returned to Germany where he made two of his most memorable films, *Paris, Texas* and *Wings of Desire.* Petersen is not typically associated with this movement, since his projects were mostly made for television. His miniseries *Das Boot* was released as a feature and became an international hit. His epic tale about a WWII German submarine crew is one of the most powerful depictions of war, and its success brought him offers to work in America where he has made *In the Line of Fire, Air Force One, The Perfect Storm,* and *Troy.*

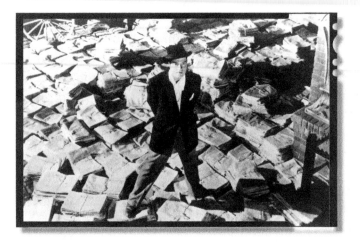

THE GHOST OF LEGENDARY DIRECTORS

The New Hollywood became divided between filmmakers who were influenced by a smorgasbord of innovations coming from foreign films and those who strove to keep alive the old traditions of Hollywood. What was fascinating about this era is that it was filled with the symbolic ghosts and spirits of great old-time directors who became mentors for this next generation. Peter Bogdanovich began his career running a revival theatre and writing about the men who made the movies. His documentary *Directed by John Ford* is an excellent tribute to the master filmmaker, despite Ford's characteristic refusal to talk about himself or look upon his movies as anything but pure entertainment. Bogdanovich has said *The Last Picture Show* was done in the spirit of a Ford film and that *What's Up, Doc?,* with Barbra Streisand, is his tribute to Howard Hawks and his great screwball comedies, like *Bringing Up Baby* and *His Girl Friday*. He became friends with many of these directors. Orson Welles often lived in Bogdanovich's guest house and recorded hundreds of hours of interviews for the young director.

William Friedkin claims to have taken *Citizen Kane* apart and then put it back together to get an understanding of the editing process on a great movie. And Warren Beatty considered George Stevens his champion. When making *Bonnie and Clyde* he remembered what Stevens had told him about the use of sound in *Shane*. Stevens would pump up the volume every time there was gunfire, so instead of sounding like a small firearm going off, it sounded like a cannon, which had a startling effect on the audience and heightened the sense of violence.

Steven Spielberg has said that he has found something of value in all of John Ford's films, especially how Ford depicts the traditions of family unity and the call of duty. Spielberg talks about how he was able to sneak on the set of Alfred Hitchcock's *Torn Curtain* and "watch the master at work." When *Duel* was released in Europe as a feature, David Lean called up Spielberg to compliment him on his directing. The two became friends over the years, and Spielberg credits Lean for encouraging him to make *Empire of the Sun*.

And Spielberg, George Lucas, and Francis Ford Coppola had many opportunities to meet and talk for hours with Akira Kurosawa.

George Cukor would regularly invite small groups of new directors up to his house and have dinner parties. At many of these get-togethers the new generation would mix with Hawks, Stevens, Ford, and other legends of the Old Studio System. Paul Mazursky recalls that at one of these afternoon dinner parties Cukor assigned him the duty that every time Ford got his wine glass refilled, Mazursky was to distract the stubborn old director and replace the glass with one that was half water.

The directors of the New Hollywood were looking for clues on what made films emotionally effective, as well as how to frame shots and how to create little magical special effects that appeared to happen naturally. They were anxious to tap into the vast mental encyclopedia of how other directors had solved problems. Because of this interest, many of the old directors talked for the first time about the tricks of the trade and told tales of filmmaking that sounded like high adventure to these young enthusiasts. Most of this past history might have been lost forever if it was not for the interest of the new generation of filmmakers.

During this time, production books were published highlighting all the films of great directors and actors. Directors like Frank Capra and William Wyler visited college campuses, screened films, and talked about how they were made. The Directors Guild of America began taping interviews with directors, realizing that a wealth of information was on the verge of extinction. On March 31, 1973, the American Film Institute gave its first Lifetime Achievement Award to John Ford. President Nixon attended the ceremony and presented the director of 146 motion pictures the

Liberty Medal, the country's highest civil award. Six months later Ford passed away.

THE AUTEUR THEORY YEAR-BY-YEAR

During the years that followed some of the great films of all time were made. It was an era when the American director had complete control for the first time, not only in the way films were shot, but in the freedom to explore any subject without a long list of restrictions. What is remarkable is the enormous variety of movies that were made, from *The Godfather* to *Animal House* and *Taxi Driver* to *Star Wars*. This has been described as a "decade under the influence" and what becomes sadly obvious by 1980 is that a large number of the directors that started this productive era by making a few exceptional films had lost that illusive magic touch somewhere along the way. They had simply run out of creative gasoline or were burnt out because of too much excessive living, and though many continued making movies for years afterward, they never recaptured the explosive vitality of their earlier films.

This era began with the small, personal film that had outperformed the big budget, prestigious studio motion picture and ended with big budget blockbusters like *Close Encounters of the Third Kind* and *The Empire Strikes Back* becoming kings at the box office. The influence of the French New Wave was very apparent in many of the classic films from these years, but by the end of the 1970s it was the reinvented, old-fashioned Hollywood crowd-pleaser that was left standing in the dust. Like the Golden Age of the Studio System, the era of the New Hollywood was bookended by historical events. It began during one of the low points in American history and ended with an

Steven Spielberg typifies the directors of what Pauline Kael has called the "Movie Generation." His love of old motion pictures, and his respect for directors like John Ford Frank Capra, George Stevens, Alfred Hitchcock, David Lean, and Akira Kurosawa, is evident in many of his films. He has said that he watches four films before he starts a new project: **The Searchers, Lawrence of Arabia, It's a Wonderful Life,** *and* **Seven Samurai.**

upswing in the economy and record attendance at movie theatres around the world. The decade that followed would be labeled the "Me Generation" by writer Tom Wolfe. Audiences no longer wanted downbeat endings with the dead bodies of likable heroes. The difference between *The Wild Bunch* and *Raiders of the Lost Ark* is that Indiana Jones survived to make sequels. It is believed by some that the Digital Age will allow for low-budget personal filmmaking to flourish once again, as in the '70s. Until that happens, we at least have the extraordinary films from this era.

1969

This could be called the last year of the Western, or at least the demise of the old traditional Western and the rise of the revisionist Western. Veteran director Henry Hathaway, who had made *The Lives of a Bengal Lancer* with Gary Cooper in 1935, directed John "the Duke" Wayne in *True Grit*. Meanwhile, Sergio Leone, the director associated with the "spaghetti Westerns," shot *Once Upon a Time in the West in Monument Valley,* a location forever linked with John Ford.

The Wild Bunch *(1969) directed by Sam Peckinpah, and starring William Holden, Ben Johnson, Ernest Borgnine, and Warren Oates. This might be the last great year for the Western and certainly the most diverse. Peckinpah's ode to the dying West featured four Oscar winning actors and the bloodiest shoot-out ever put on screen. Paul Newman and Robert Redford also went out shooting in* **Butch Cassidy and the Sundance Kid.** *Sergio Leone made* **Once Upon a Time in the West** *with Henry Fonda as a heartless bad guy. Peter Fonda and Dennis Hopper said their characters, Wyatt and Billy, in* **Easy Rider** *were cowboys on choppers, and Jon Voight was a* **Midnight Cowboy.** *And John Wayne won the Oscar as a one-eyed U.S. marshal in* **True Grit.**

But Leone sneaks up and puts a load of buckshot into the back of the hero-driven Ford Western by turning Henry Fonda, the star of *The Grapes of Wrath, My Darling Clementine,* and *Mr. Roberts,* into an icy, blue-eyed villain who shoots defenseless women and children.

The buddy Western was born this year with two films that were very different in style and action, but both concluded with the riddled bodies of the amiable anti-heroes. *Butch Cassidy and the Sundance Kid,* directed by George Roy Hill, is full of laughs, gorgeous cinematography, and light-hearted music right up to the end when a hundred rifles' reports are heard. And Sam Peckinpah's *The Wild Bunch* was a rapidly edited, slow motion bloodbath from start to finish. Peckinpah had learned his craft on dozens of television Westerns, like "Gunsmoke," "Zane Grey Theatre," "Trackdown," and "The Rifleman." His second feature, *Ride the High Country,* placed two old partners at the sunset of the old frontier hired to transport a gold shipment. Like in *The Wild Bunch,* the relationship between good and evil becomes a blur when greed plays a hand. *The Wild Bunch,* with its dusty, real-life characters and ultra-violent shootouts, completely transformed the genre. Every Western that followed was the stepchild of Peckinpah's bloody adventure.

Then there were two Westerns disguised in modern dress. Dennis Hopper has stated that *Easy Rider* is about two latter-day cowboys on choppers out searching for America. And *Midnight Cowboy,* directed by John Schlesinger, turned the pearl-white image of the cowboy into a wide-eyed male prostitute. Schlesinger was a director that liked flipping over stones to see what was underneath. In England he had made two films with Julie Christie, *Billy Liar,* where she is featured in a small but memorable role, and *Darling,* which made her an international star and won her the Academy Award as best actress.

Darling peeled the lid off of London society during the Swinging Sixties, and was considered shocking at the time for its open depiction of sexual freedom and homosexuality. *Darling* also paralleled the true life story of Grace Kelly, who had married Prince Rainier of Monaco, playing off the tabloid headlines that their seemingly fairy tale life might be plagued with personal problems. *Midnight Cowboy* was Schlesinger's first American feature, and perhaps being a stranger in a strange land gave him a greater sense of creative freedom. His explicit scenes of sexual acts, some bordering on the perverse, and the raw, documentary quality of the film cut to the core of American culture during a confusing time when old myths and honorable traditions were dying.

Midnight Cowboy was given an X-rating, but despite this went on to win the Oscar for best picture. Jon Voight and Dustin Hoffman were warned by friends that the movie would be perceived as pornographic and might destroy their careers. Instead they were rightfully acclaimed for two of the most powerful performances in movies up to this time. However, the Motion Picture Academy played it safe that year and gave the best actor award to John Wayne for his bigger-than-life role of Rooster Cogburn.

This was a year preoccupied with violence on and off screen. On August 9, in a villa in Benedict Canyon, Sharon Tate was brutally murdered, along with three of her guests, including coffee heiress Abigail Folger. Tate was in a state of advanced pregnancy with the child of director Roman Polanski. She was stabbed fifteen times, gruesomely killing her and the unborn child. On the walls in blood was written "Death to Pigs." The next night Rosemary and Leno LaBiaca were murdered in a similar fashion in their Hollywood home. Charles Manson and members of "The Family" would later be arrested and convicted of the crimes.

In complete contrast, less than a week later, on August 15, 16, and 17, 500,000 people gathered at Woodstock for a rock concert intended for a crowd only a fraction of this size. What happened over those rainy days was an idyllic celebration of peace, love, and great music, becoming the crowning moment of the Flower Children generation. One of the highlights of the concert was Jimi Hendrix playing the "Star Spangled Banner" on his electric guitar. Martin Scorsese worked on the documentary, *Woodstock,* as an editor and second unit director.

The incredible cavalcade of films from this year included *Women in Love,* directed by Ken Russell, based on D. H. Lawrence's often banned novel, which introduced the world to the outstanding actress Glenda Jackson. Constantin Costa-Gavras made the political thriller, *Z,* which he shot in a virtuoso documentary style. *Z* is about the murder of a popular leader of the pacifist opposition party in Greece and the investigation that follows, which reveals a conspiracy planned by the highest members of the military. The film invites comparisons to the assassination of President Kennedy and the murders of Martin Luther King and Robert Kennedy. From Italy, maestro Federico Fellini brought to life the decadence and wild orgies of ancient Rome in *Satyricon,* a visually stunning film that left critics and audiences torn down the middle. Paul Mazursky made his directing debut with *Bob & Carol & Ted & Alice,* a hip comedy about free love and couple swapping, starring Natalie Wood and Elliott Gould, who would hit it big the following year in *M*A*S*H.* And director Sydney Pollack looked beyond the glittering lights of 1930s marathon dancing in *They Shoot Horses, Don't They?,* giving Jane Fonda her first major dramatic role.

The big movies from the studios this year were *Marooned,* and the old warhorse musicals *Hello, Dolly; Paint Your Wagon; Sweet Charity;* and *Goodbye, Mr. Chips,* all of which were expensive failures. The only studio film that was truly successful at the box office was *The Love Bug,* from Walt Disney. This was the studio's first hit after the untimely death of Walt Disney three years before.

One film that slipped beneath of the radar for audiences but got noticed by a few influential critics was *The Rain People,* directed by Francis Ford Coppola. The low-budget film foreshadowed the future. It starred James Caan and Robert Duvall, who would team up again three years later for *The Godfather.* The assistant director was George Lucas, who also shot a documentary about the making of the movie. Just the year before, Coppola's big studio musical *Finian's Rainbow* was a disaster for Warner Bros., but the studio agreed to take a gamble and gave him development money to make small films under the banner American Zoetrope. Coppola and Lucas, along with John Milius, Philip Kaufman and other young, enthusiastic filmmakers opened an office in San Francisco to be far away from prying eyes of the studio bosses, a move which was considered radical and defiant at this time. One of the fortuitous outcomes of *The Rain People* was that Coppola got an offer from 20th Century-Fox to write a war movie called *Patton,* which he took to pay off a few bills.

1970

If the films of 1969 were dominated by Westerns, then 1970 was the year of the war movies. And like the Western, they came in two varieties: traditional and rebellious. The first category included *Patton* and *Tora! Tora! Tora!* The other films were unquestionably anti-war films, including Mike Nichols' adaptation of *Catch 22* and Robert Altman's *M*A*S*H.* The subject of war and the conquest of the Old West

*M*A*S*H* (1970) directed by Robert Altman, and starring Donald Sutherland, Elliott Gould, Tom Skerritt, Sally Kellerman, Jo Ann Pflug and Robert Duvall. Altman has said he was able to keep what was really happening on **M*A*S*H** under the radar because of the other big war movies 20th Century-Fox was making this year. **M*A*S*H** certainly reflected the rebellious attitudes of this time period. **Patton** writer (and Oscar winner) Francis Ford Coppola was told to bring out the rebel side of the general that constantly got him into trouble with the top brass. The other motion picture was **Tora! Tora! Tora!**, which proved to be one war film too many, performing poorly at the box office.

was the subject of Arthur Penn's *Little Big Man*, which gave Dustin Hoffman one of his best roles as Jack Crabb.

One of the subtitles for *Patton* was "A Salute to a Rebel." Darryl F. Zanuck, who had been reestablished as the head of Fox in the wake of the *Cleopatra* catastrophe, and director Frank J. Schaffner were concerned that a movie glorifying an American general during the Vietnam conflict would be a tough sale to audiences. This was one of the reasons Francis Ford Coppola was brought in; to highlight Patton's rebellious nature and his head-on conflicts with strict military authority. The first choice to play the role was actor Robert Mitchum, best known for his tough-guy film noir performances. Mitchum responded by acknowledging his respect for the cantankerous general, and said that if he took the role, the studio would just "run a bunch of tanks up and down the field in Spain and call it a movie." He suggested giving the role to George C. Scott, an actor who would fight for the integrity of the character. Indeed, the first thing that Scott did when he was cast was to insist on using Coppola's original screenplay, which had gone through several studio rewrites at this point. On Oscar night, *Patton* won for best picture, Schaffner got best

director, and Coppola took home the award for best screenplay. Scott also won for best actor but refused the honor, stating that the only way to judge the best actor was to let everyone play Hamlet then decide.

On the other side of the Fox lot, the real rebellious war film was being shot. When Robert Altman was given the chance to direct *M*A*S*H*, he had made a few routine studio B-movies; directed many television shows, including episodes of "Peter Gunn" and "Bonanza;" and had made a popular documentary called *The James Dean Story*. With studio heads concerned with the big budget war movies, including *Tora! Tora! Tora!*, Altman used the opportunity to cast *M*A*S*H* with unknown actors, like Elliott Gould, Donald Sutherland, Tom Skerritt, Sally Kellerman, and Robert Duvall. He kept the basic structure of the screenplay by Ring Lardner Jr., who had been one of the Hollywood Ten during the Hollywood Blacklist, and threw out all the dialogue. He then began to have the actors improvise their scenes, which changed day by day and sometimes hour by hour.

Altman made the operation scenes as realistic as possible, with blood squirting from wounds, and doctors working 24-hour shifts. Tossing out

an approved screenplay under an old-time mogul like Zanuck was unheard of, but no one cared about the little movie as long as things were kept on time and under budget. No one seemed to know what was going on, except Altman, and then everyone began to worry seriously about him. Altman was road testing what he became most identified for later on, creating an environment and mood on the set to capture a true sense of reality. Five years later, he would use this unorthodox method to create his masterpiece, *Nashville*. Altman did not care about story structure, he was after characters with depth of emotions, and, in the case of *M*A*S*H*, he wanted to convey a tone of insanity about the nature of war. It worked. The members of the cast at one point joined together to have Altman committed to an institution.

The problem was that no one knew how to piece the film together, so Altman remained and completed his black comedy that looked more like Vietnam than Korea, where the action supposedly takes place. When it was finished and a rough cut was assembled, there was still a continuity problem, which Altman fixed by adding the voice over the loud speaker, filling in certain story gaps. *M*A*S*H* used a style of humor that went back to the Marx Brothers. It was a time period when the old comedians had been rediscovered, like W.C. Fields, Mae West, and the Marx Brothers, with films like *Horse Feathers* and *Duck Soup*.

Also, the screwball comedies of Howard Hawks were constantly being shown in the revival theatres, like *His Girl Friday* and *Bringing Up Baby*. One of Hawks' trademarks was overlapping dialogue, scenes where everyone is talking at once, yet it all somehow makes sense. This is the touch that Altman brought to *M*A*S*H*, and audiences loved it. It went on to become the third highest money grossing film of the year (even beating out *Patton*), and more than any other film at this time. Since it was actually made

within a major studio, *M*A*S*H* became the flagship for change in Hollywood.

Like *Patton* and *M*A*S*H*, this was a year of contrasts. MGM Studio had bet on another box office hit by David Lean, but *Ryan's Daughter* almost bankrupted the studio, making back only $14 million. MGM never recovered from the loss. But the old-fashioned studio picture was not dead. At Universal, Arthur Hailey's novel *Airport* was brought to the screen, with an international cast, very much in the tradition of *Grand Hotel*. The formula worked, and *Airport* was a smash. Over at Paramount, head of production Robert Evans put together an unabashed five-handkerchief tearjerker titled *Love Story*. The gigantic success of the film, the top grossing film of the year, saved the studio from being shut down, plus provided the development money for *The Godfather*. (As an illustration of the strange forces that are sometimes in play in Hollywood, Erich Segal originally wrote *Love Story* as a screenplay, but all the studios turned it down for being too corny for modern audiences. Segal then turned the screenplay into a very short novel, which became a runaway best seller. He then turned the novel back into a screenplay and got an Oscar nomination.)

Some of the biggest films were small independent features. *Five Easy Pieces*, directed by Bob Rafelson and starring Jack Nicholson made back more than eight times its original budget, and went on to get an Oscar nomination for best picture. Ossie Davis' *Cotton Comes to Harlem* was popular, crossing over into audiences of all races. *The Prime of Miss Jean Brodie* ran for months in some theatres, winning little known British actress Maggie Smith the Academy Award as best actress. The documentary *Woodstock* had younger audiences rocking to the stereophonic music of The Who; Crosby, Stills and Nash; Country Joe and the Fish; Sly and the Family Stone; Joe Cocker; Joan Baez; and the amazing Jimi Hendrix. *Joe*, directed by John G. Avildsen, was a disturbing film that

struck a cord with blue-collar audiences, depicting a "typical American" who was a kind of violent Archie Bunker without humor or regrets. And John Cassavetes assembled his friends Peter Falk and John Ben Gazzara for *Husbands.*

The Motion Picture Academy gave Honorary Awards to actors: Lillian Gish "for superlative artistry and for distinguished contributions to the process of motion pictures," and Orson Welles "for superlative artistry and the versatility of creating motion pictures." In 1941, Welles had been booed when his name was mentioned for his three *Citizen Kane* nominations. Now, because of revival theatres and television, he had become a legend to young filmmakers and was finally given the recognition he deserved. Nevertheless, no studios stepped forward to offer him a directing contract, and he would spend the rest of his life acting in films and doing wine commercials for money to make his small films.

1971

The label of New Hollywood really began this year. It was a year of young directors making major films and swan songs for veterans. And it was a year that two flops, it can be argued, changed the direction of Hollywood forever. William Friedkin was thirty-six when he made *The French Connection;* Peter Bogdanovich was thirty-two when he directed *The Last Picture Show;* Steven Spielberg just turned twenty-five when he shot *Duel;* and George Lucas was twenty-seven when he directed *THX 1138.* On the opposite end, Alfred Hitchcock started directing *Frenzy* in London at the age of seventy-two, and Vittorio De Sica would win his fourth Academy Award for *The Garden of the Finzi-Continis* at sixty-nine years old.

The misfired were Dennis Hopper's *The Last Movie* and George Lucas' *THX 1138.* As a follow-up to *Easy Rider,* Hopper was given a large budget to shoot *The Last Movie* on location in Peru. The film went way over budget and over schedule, and rumors abounded about the craziness that was going on with the cast and crew. *The Last Movie* recouped only a fraction of its original budget, almost bringing to an end the investments by studios in films by young, unproven directors. Hopper would not have an opportunity to direct another feature until 1988 when he made *Colors* with Sean Penn.

THX 1138 was a remake of George Lucas's USC student film. Starring Robert Duvall, it was

*The French Connection (1971) directed by William Friedkin, cinematography by Owen Roizman, and starring Gene Hackman and Roy Scheider. Of all the New Hollywood directors, none of them were as influenced by the French New Wave than Friedkin. **The French Connection** almost feels like it was directed by Jean-Luc Godard, with jump cuts, shooting on cold locations in New York where many of the actual events happened, and almost all the dialogue improvised by Hackman and Scheider, who had spent weeks patrolling with detectives as they went on narcotic busts. Of course, the almost twenty-minute car chase, coordinated by stuntman Bill Hickman, is what really got the audience's blood flowing.*

a futuristic look at a time when people are controlled by mandatory drug use and the voice of God is prerecorded. It is a film almost devoid of humor, slowly paced, but intellectually charged with ideas, in much the same style as Aldous Huxley's *Brave New World.* The studio heads at Warner Bros. hated the film. They took it away from Lucas, cut over five minutes, and released it as a second feature on the drive-in circuit. What was worse is that Warner Bros. demanded all of the development money back from American Zoetrope. With only one feature, Coppola and Lucas' dream of an independent studio was over. With no other choice, Coppola agreed to direct a gangster film for Paramount. And thus began the process that led to *The Godfather,* and later resulted in a second opportunity for Lucas to direct.

Violence on the screen reached a new high with Stanley Kubrick's *A Clockwork Orange.* Based on Anthony Burgess' novel, which creates a new language used by young hoodlums in the future, the film was marketed with the following tagline: "Beginning the adventures of a young man whose principal interests are rape, ultra-violence, and Beethoven." One of the most disturbing scenes is when Alex, played to sadistic perfection by Malcolm McDowell, viciously rapes a woman, as her husband is forced to look on, while merrily choreographing the actions to "Singin' in the Rain." This was the first time Kubrick made a film without the restrictions of the Production Code, and he took the prospects of sex and violence in the movies to a new level. Because of all the protests and unfortunate copycat acts of violence, Kubrick put a self-imposed ban on *A Clockwork Orange* in England that lasted twenty-seven years.

Several of the films this year raised the level for filming action sequences, a result of smaller cameras, like the Panavision Panaflex, and faster ASA film speed. Don Siegel's *Dirty Harry* transformed Clint Eastwood from a cowboy to a hard-boiled San Francisco cop. In many ways, this film foreshadowed the slow death of the Western. For almost seventy years, chases on horseback and showdowns with the bad guys had thrilled audiences, especially young kids. *Dirty Harry,* along with Steve McQueen's *Bullitt* two years before, cranked up the excitement of a chase with cars literally flying over San Francisco hills. And with the image of Eastwood pointing a Magnum handgun directly at the camera lens, the old six-shooter seemed terribly out of date.

The French Connection, directed by William Friedkin, had everything that was touted for the New Hollywood. The story was contemporary, shot on real backstreet locations, with characters that almost redefined the term anti-hero, plus it had one of the best designed chases in any movie up to that time, and it still continues to exhilarate. Friedkin was drawn to movies after seeing Orson Welles' *Citizen Kane.* After graduating from high school, he went to work for WGN TV in Chicago where he made hundreds of documentaries and television shows. His documentary "The People vs. Paul Crump" was responsible for getting a man released from death row.

He went to Hollywood where he landed jobs in television, including "The Alfred Hitchcock Hour." His early movies reflected his training making documentaries, including Harold Pinter's *The Birthday Party* and Mart Crowley's *The Boys in the Man.* But his work on *The French Connection* represented a quantum leap as a director. The movie became a runaway hit. Made for less than $700,000, it grossed over $26 million. And that year at the Oscars, it took best picture, best actor for Gene Hackman, and Friedkin won for best director.

Pauline Kael compared Peter Bogdanovich's work on *The Last Picture Show* to Orson Welles' auspicious directorial debut on *Citizen Kane.* Based on Larry McMurtry's novel of life in a small Texas town, *The Last Picture Show* felt like

John Ford or Howard Hawks were peering over Bogdanovich's shoulder. With wonderful performances by the entire cast, especially Cloris Leachman, Ben Johnson, Timothy Bottoms, and young Jeff Bridges, *The Last Picture Show* was a counterbalance to *The French Connection.* Bogdanovich's film reflected the old seamless filmmaking of the Studio Era and Friedkin's work was very clearly in the spirit of the French New Wave.

Robert Altman made a minor masterpiece with the beautifully shot *McCabe and Mrs. Miller,* starring Warren Beatty and Julie Christie, with cinematography by Vilmos Zsigmond. John Schlesinger returned to England to make *Sunday, Bloody Sunday,* the story of a three-way relationship, but this time involving two men and a woman. Mike Nichols' *Carnal Knowledge,* from a screenplay by Jules Feiffer and starring Jack Nicholson, had some of the frankest conversations and depictions of sex on the screen up to this time, and still manages to shock many years later. Gordon Parks introduced his variation on *Dirty Harry,* with Richard Roundtree playing an ultra-cool Black private eye in Shaft. Woody Allen made what many consider his funniest film, *Bananas,* about a New York Jewish intellectual who winds up in a Castro-like revolution. And producer-turned-director Alan J. Pakula directed Jane Fonda to an Academy Award in *Klute,* co-starring Donald Sutherland, and photographed by Gordon Willis.

There were two other memorable directing debuts this year. Clint Eastwood got behind the camera in the scream shocker *Play Misty for Me,* about a casual fling that turned deadly. The film frightened some audiences so much it is reported that many bars in San Francisco were almost deserted for weeks after the movie opened. The other movie was *Duel,* a made-for-television special. Steven Spielberg, after working on TV shows like "Night Gallery" and "Columbo," was given the opportunity to direct a film about a giant tractor-trailer that pursues a hen-pecked business commuter. The special received such viewer attention that it was released in a slightly longer version in Europe as a feature. The remarkable aspect of *Duel* is that over half the film is without dialogue. Shot like a silent movie, *Duel* is a ninety-minute chase, which is very unusual for television, since most programs are non-stop talking. Spielberg takes what might have been a twenty-minute short, and with an incredible amount of camera movement, point-of-view shots, and variation of lens, he created for the highway sequences a continuous atmosphere of suspense. Three years later Spielberg would use this same formula for *Jaws,* but this time it would take place on the open sea.

1972

There are seemingly endless accounts regarding the difficulties of making *The Godfather.* The problems with casting, the criticism of the cinematography, and the daily threats to fire the director have all become a mythology swirling around what is now recognized as one of the greatest films ever made. Francis Ford Coppola presents one version, producer Robert Evans remembers something completely different, and Marlon Brando was infamously silent about everything. The fact is no one saw the success and glory of *The Godfather* coming. *The Godfather* was a moderately budgeted studio feature that gradually took on a life of its own. Evans had advanced Mario Puzo money to write the novel, thus Paramount owned the rights. The film went into production as the paperback sales of the novel climbed to the top of the charts and stayed there for months. This was the first real sign that the studio had something very special indeed.

Gangster films had gone out when the Production Code forced too many predicable

The Godfather (1972) directed by Francis Ford Coppola, came out in a transitional year for Paramount Pictures. The studio was founded in 1912 but was almost closed down in the late 60s because of a string of unsuccessful movies. Head of production Robert Evans, who had scored a success with **Rosemary's Baby,** filmed a carefully scripted appeal (directed by Mike Nichols) to the board of directors. Among the upcoming projects were two novels owned by the studio, **Love Story** and **The Godfather.** The board voted to keep production going a little longer and Evan's gamble played off, three years later Paramount was the highest grossing studio in Hollywood.

restrictions on the genre. The biggest one was that the gangster had to be caught and brought to justice, proving to audiences that crime did not pay. But when the Code was enforced, the gangster film was the most popular entertainment coming from the studios. For thirty years the genre was effectively put in the deep freeze until the Code was finally abolished. But recent gangster films had done poorly at the box office, like *The Brotherhood* (1968) with Kirk Douglas, so the studio had low expectations for *The Godfather.*

If the film has been slated as a major prestige picture, it is doubtful that Coppola would have been asked to direct. With an Oscar in hand for writing, Paramount was interested in him, plus since he was Italian-American there was the thought he might bring something new to the genre. His track record as a director up to this point had not been the stuff that impresses studio bosses. In fact, all of his films had lost money. Robert Evans claimed that he had a gut instinct that Coppola could turn Puzo's pulp fiction into something exceptional, which might have been the truth, but every step of the way Coppola was assaulted with problems and complaints from the front office.

Whatever transformed Francis Ford Coppola from a capable director to a brilliant one will probably never be known. All this adds to the legend of the film. Most likely the explanation is simple: He was the right person for the job. Something obviously inspired him, and that, coupled with the return of Brando in a great role, had a trickledown affect on everyone else in the cast and on the crew. When the heads of Paramount saw the final cut, they knew it was an outstanding film. From the very beginning, *The Godfather* and later *The Godfather, Part II,* have received the utmost respect from the critics and audiences. It has been compared to *Gone With the Wind,* and there is good reason for this. Both work on an epic scale, and the lead in each film is ruthless but somehow still very likable. And both films are part of the very fabric of American culture. It can be argued that *Gone With the Wind* is about America before World War II and that *The Godfather* represents the darker view of America after the war.

The significance of *The Godfather* in the early years of the New Hollywood is very great. It became the first film to open wide, bringing in an astounding $26 million in the first few days.

It told a complicated story, but audiences had no problems following the action. It was a showcase for gifted actors who would continue in the industry for decades to come. It became a galvanizing force on how the world believed the Mafia operated. But on another plain—one far less tangible—*The Godfather* became the catalyst for excellence in the New Hollywood. The film had raised the bar high in terms of character development, cinematic storytelling, truth in depicting an ethnic culture, intelligence in writing, and all the basics of production, including cinematography, acting, scenic design, and music, that other young filmmakers of this era strove to do the highest quality work.

This goes beyond mere speculation. There was an energized force in Hollywood at this time. Many directors relate that during these years there was the feeling that films could change the world. *Easy Rider, Bonnie and Clyde, M*A*S*H,* and *The French Connection* were testaments to this belief. It was an intoxicating concept, one ideally suited to a generation that was raised believing they could do anything. Like various times in world history—the Golden Age of Greece, the Italian Renaissance, Paris in the 1920s, Hollywood in the late 1930s, New York after World War II— what was happening in America cinema during these years was something exciting to experience.

There were many excellent films this year. Another English director visited America and put a new twist on the wilderness adventure tale. John Boorman had made two films with actor Lee Marvin, *Point Blank,* a tense crime thriller, and *Hell in the Pacific,* a war adventure about two mortal enemies. But these films did not prepare audiences for *Deliverance.* Based on the novel by James Dickey, *Deliverance* is a buddy story that goes terribly wrong. With cinematography by Vilmos Zsigmond, the film captures the damp feeling of the wilderness and turns Mother Nature into a bright green nightmare. On the heels of *Midnight Cowboy,* the film turned Jon Voight into a star, along with television actor and stunt man Burt Reynolds. The song "Dueling Banjos" played for months on the radio, but the scene in the movie is a brilliant job of tragic foreshadowing.

Bob Fosse had a remarkable year. As a director he would win the Tony Award for *Pippin,* an Emmy for *Liza with a Z,* and beat out Francis Ford Coppola for his direction on *Cabaret.* Fosse brought a new approach to the dying Hollywood musical, in much the same way that Busby Berkeley did in the 1930s. His camera movement during dance numbers and his editing to the tempo of the music made for an excitement akin to watching a live production. Instead of shooting the musical numbers as if the camera had been placed in the fifth row center of a theatre, Fosse took the camera into the chorus line. Fosse had choreographed several film musicals, including *Sweet Charity* and *Damn Yankees!,* but *Cabaret* was the first film he had total control over. He directed *Chicago* on Broadway and for years tried to make the film. When it was finally shot, director Rob Marshall acknowledged his debt to Fosse.

The big action film this year was *The Poseidon Adventure,* a special-effect feast by producer Irwin Allen. Michael Caine and Laurence Olivier pull off an acting tour de force in *Sleuth,* directed by Joseph Mankiewicz. Sydney Lument made his own wilderness movie, *Jeremiah Johnson,* starring Robert Redford. Peter Bogdanovich had his second hit in a row with *What's Up, Doc?,* a modern day screwball comedy with Barbra Streisand. Alfred Hitchcock got good reviews for *Frenzy,* and Charles Chaplin got terrible ones for *The Countess from Hong Kong.*

One-time blacklisted director, Martin Ritt, made an emotionally powerful film out of William H. Armstrong's novel *Sounder,* getting Oscar nominations for Cicely Tyson and Paul Winfield, the first time that two African-American actors

received this honor as leads in the same film. And as a curious footnote, for the only time in film history, a pornographic movie, *Deep Throat,* was listed in the top money-grossing movies of the year. It was just above *The Getaway,* directed by Sam Peckinpah and starring Steve McQueen.

1973

This was a year of extremes. Little films made huge killings at the box office. The depiction of violence was taken to a new level. Happy endings and nostalgia for the past resurfaced. Rough language entered the movie stream. The line between movie star and character actor became a blur. Big budget studio movies were overseen by a new generation of young producers. Legendary foreign directors made some of their most provocative and personal films. American directors made films that looked like they were shot by foreign directors, and two young directors returned to their childhood roots for films that became instrumental in the transformation of American cinema.

The list of directors nominated for the Academy Award this year reflected the many changes in filmmaking that were rapidly taking place. They were George Lucas for *American Graffiti,* Ingmar Bergman for *Cries and Whispers,* William Friedkin for *The Exorcist,* Bernardo Bertolucci for *Last Tango in Paris,* and the winner was George Roy Hill for *The Sting.* Francois Truffaut's valentine to moviemaking, *Day for Night,* won for best foreign language picture. Other notable films in this diverse year include Peter Bogdanovich's *Paper Moon,* Werner Herzog's *Aguirre, the Wrath of God,* Luis Bunuel's *The Discreet Charm of the Bourgeoisie,* Sidney Lumet's *Serpico,* Sydney Pollack's *The Way We Were,* Hal Ashby's *The Last Detail,* Fred Zinnemann's *The Day of the Jackal,* and Franklin J. Schaffner's *Papillon.*

American Graffiti (1973) directed by George Lucas, produced by Francis Ford Coppola, and starring Richard Dreyfuss, Ron Howard, Paul Le Mat, Charles Martin Smith, Candy Clark, Cindy Williams, Mackenzie Phillips, Wolfman Jack, and Harrison Ford. After the abysmal failure of **THX 1138** it looked like Lucas' career was over before it got started. But then Coppola scored big with **The Godfather** and said he would produce his friend's next film. Based on experiences growing up in Modesto, California, **American Graffiti** was made for $777,000, shot in sequence over 29 nights, and eventually grossed $115 million.

The little independent films that exploded at the box office were *Billy Jack,* directed by and starring Tom Laughlin (the film was shot three years before but because of contractual disputes the release was delayed); *Walking Tall,* directed by Phil Karlson; and *Enter the Dragon,* directed by Robert Clouse, and starring martial arts hero Bruce Lee. Each of these films have one common denominator: one man if pushed to the limit can single-handedly defeat overwhelming odds against corrupt adversaries. This was a complete reversal of the Frank Capra films in the 1930s where a good man with honesty and integrity can change society. Movies of this era reflected the cynicism that the American Dream had an exclusion clause, making many citizens ineligible to participate. The concept of the one-man vigilante became a new genre of film very popular with audiences.

Enter the Dragon reflected the influence of the James Bond movies, but earlier Bruce Lee films like *Fists of Fury* and *Return of the Dragon* are rugged examples of an individual who restores equilibrium through violence. In *Billy Jack* the lead character is portrayed as a half Indian who must finally take aggressive action against a gang of redneck troublemakers. For *Walking Tall* the tagline was "Take your best shot . . . 'cause it will probably be your last." The following year, Charles Bronson would take to the city streets with a gun in *Death Wish,* a violent movie that would start a popular franchise.

In the midst of this movie mayhem, one little film proved with big box office numbers that audiences had nostalgic feelings for less turbulent times. *American Graffiti* grossed more than $55 million, making it the most successful independent feature up to this point. George Lucas referred to his remembrances of small town life and street cruising as a musical, because old time rock 'n' roll songs are heard throughout the film, underscoring the action. Set in 1962, just eleven

years before, the unassuming events of street cruising and deciding where to go to college seemed like a lifetime ago to many people who watched the film. It was a film that almost did not get made.

After *THX 1138,* no studio was interested in a second film by young Lucas. He had become box office poison after one ill-fated feature. If his friend and mentor Francis Ford Coppola had not directed *The Godfather,* then it is very possible George Lucas might not have been given a second opportunity to direct, at least not so quickly. And if *American Graffiti* had not been made, potentially there could have been a vastly different Hollywood. Coppola agreed to be the executive producer on the low-budget film, and then encouraged his friend to try something a little more mainstream. In actuality, *American Graffiti* broke a lot of Hollywood traditions. It did not have a central character, but was an ensemble piece that followed the comic and romantic misadventures of several teenagers as they bid farewell to their high school days. The movie was a series of interconnecting episodes, or vignettes, without the strong plotline found in most studio films.

The cast was a bunch of young, unknown actors, with the exception of Ron Howard, who was trying to shake his image of little Opie from "The Andy Griffith Show." Richard Dreyfuss had small parts in *The Graduate* and *Dillinger,* and Harrison Ford had given up the idea of show business to become a professional carpenter. On top of all this, Lucas wanted to use songs that had fallen off the pop charts a decade before, something the executives at Universal Studios felt would not connect with contemporary audiences.

Despite a very positive reception for the preview of *American Graffiti,* representatives of the studio felt it was misconceived and wanted to cut scenes and reedit the film. Coppola stepped in and offered to buy the film outright, saying that they should be thankful to Lucas for saving their

careers. Still concerned, Universal give *American Graffiti* a limited first-run release, but after the second weekend, when word of mouth kicked in, the film took off at the box office, and the album of old rock 'n' roll songs quickly sold over a million copies.

The other young director that pulled from his roots to get on the New Hollywood map was Martin Scorsese. He had his baptism by fire on the Roger Corman quickie feature *Boxcar Bertha*, but the advice from his west coast friends, like John Milius, was that the commercial vehicle was the wrong fit for him. It was suggested that he return to New York and do something personal, something he had experienced. The film was *Mean Streets*, about small-time hoods in Little Italy, and the language was raw and believable. At the center of the film is a mesmerizing performance by Robert De Niro, who had also attracted wide-spread attention the same year as a dying ballplayer in *Bang the Drum Slowly*. *Mean Streets* gave Scorsese the chance to direct *Alice Doesn't Live Here Anymore*, which led to a project he felt uniquely qualified for, *Taxi Driver*, written by Paul Schrader. After watching a screening of *Mean Streets*, Francis Ford Coppola cast De Niro as young Vito Corleone in *The Godfather, Part II*.

Strong language in films had become an issue in 1966 with *Who's Afraid of Virginia Woolf?*, which became one of the final nails in the coffin for the Production Code. While sex and violence erupted on the screen almost immediately, the use of swear words did not become a factor in films for several years. In 1973, three films changed this in a major way: *Mean Streets*; *The Last Detail*, directed by Hal Ashby and starring Jack Nicholson as a swear-a-second Navy officer; and *The Exorcist*, where the most profane language was uttered by a little girl.

The Exorcist, which earned $89 million at the box office, marked a loss of innocence for movie audiences. No one had seen anything so terrifying in theatres before. *Psycho* frightened audiences and was a turning point in the depiction of violence, but the shocking effect of the shower scene in the Bates Motel was achieved through a clash of edited images, sometimes only a second long. In *The Exorcist* the scenes are graphically visual, and William Friedkin's documentary approach to the possession of young Regan heightens the sense of reality. Over the

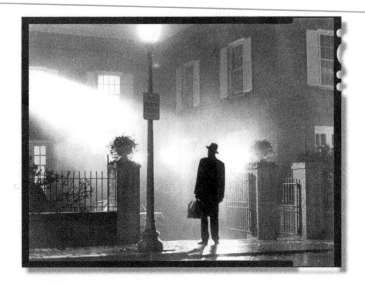

The Exorcist (1973) directed by William Friedkin, cinematography by Owen Roizman, and starring Ellen Burstyn, Jason Miller, Max von Sydow, and Linda Blair. The devil was enjoying a successful run at the box office during this era. Roman Polanski directed **Rosemary's Baby** (1968), based on Ira Levin novel, and Ken Russell made **The Devils** (1971), loosely adapted from Aldous Huxley's novel **The Devils of London.** But Friedkin's version of **The Exorcist,** from the runaway best seller by William Peter Blatty, was truly a horrifying experience, unlike anything that had been filmed before.

decades there has been a gradual numbing-down process for audiences toward extreme violence in the movies.

Today it is almost impossible to convey how emotionally engaging *The Exorcist* was when it was first released. There had never been a big budget horror film made by a studio. *King Kong* and *Frankenstein* scared audiences in the early years of sound, but as time marched on, these films are looked on more with amusement than terror. The horror genre was forbidden during the first years of World War II, and later the films were done on shoe-string budgets for the drive-ins. Friedkin's insistence on using refrigerators to drop the temperature on the set to the freezing point and spending hours to achieve the right look with make-up and special effects created something audiences had never seen before. *The Exorcist* went way over budget, and its original shooting schedule kept expanding, but within three weeks after its release the film had made back most of the studio's investment. It became a cinematic experience that was unique and has yet to be duplicated with the same degree of disturbing intensity.

This was a year when new producers began to operate within the studio system. Tony Bill, Michael Phillips, and Julia Phillips took home Oscars for producing *The Sting,* which teamed up Robert Redford and Paul Newman for a second time. Michael and Julia would go on to produce *Taxi Driver* and *Close Encounters of the Third Kind.* Francis Ford Coppola was executive producer for *American Graffiti,* and the following year he would produce two films that were nominated for Academy Awards, *The Godfather, Part II* and *The Conversation.* Richard Zanuck—after being fired as head of production at 20th Century-Fox by his father, Darryl Zanuck—with his partner David Brown, produced a forgettable film with the unfortunate title of *SSSSSSS,* but the following year they made *Sugarland Express*

and the year after that *Jaws.* Robert Evans became an independent producer and began development on *Chinatown.* As the decade continued, directors Sidney Lumet, Peter Bogdanovich, Bob Rafelson, Sydney Pollack, Steven Spielberg, and, of course, George Lucas, began producing.

In contrast to those individuals who grew up with movies and had first-hand knowledge of how films were made, a new breed of corporate executives began to fill offices once belonging to Louis B. Mayer, Harry Cohn, and Jack Warner. These corporate men (one of the few women executives at this time was Marcia Nasatir at United Artists) came into the film business after companies like Gulf & Western Industry purchased Paramount in 1966, and United Artists became a subsidiary of TransAmerica Corporation in 1967. The prevailing attitude of many Ivy League executives was that the film business could be managed from the top strictly in terms of green lighting a picture and strong marketing. The lack of experience in all aspects of film production would lead to several major disasters by the end of the decade, including *New York, New York; The Wiz;* and most notably *Heaven's Gate.*

1974

This was Francis Ford Coppola's year. His *Godfather, Part II* was hailed by critics as a greater achievement than *The Godfather.* Which film is superior is a lively debate that continues to this day. On many top ten lists the two films are listed side by side. It should be noted that once again cinematographer Gordon Willis was not nominated. However, *The Godfather, Part II* won six Academy Awards, including best picture, and three to Coppola for writing (shared with Mario Puzo), directing, and producing. This same year he was also nominated for producing and writing *The Conversation.* In addition, he

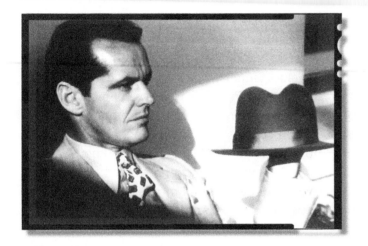

Chinatown (1974) directed by Roman Polanski, musical score by Jerry Goldsmith, screenplay by Robert Towne, and starring Jack Nicholson, John Huston, and Faye Dunaway. Polanski told cinematographer John A. Alonzo he wanted a period film noir with modern technology. Shot in widescreen Technicolor, the camera was two feet from the actors' face during close-ups. There was a lot of subtle handheld camerawork (which was still very new in American movies), to give the audience the sense that they are right behind Jack Nicholson as his character searches for clues.

was listed as the writer for *The Great Gatsby*, directed by Jack Clayton.

Coppola now turned his attention back to his first dream of developing American Zoetrope and producing his own films. As with any good Hollywood success story, the only direction from the top is straight down. Coppola's next film would take almost five years to make and be plagued with financial problems, a typhoon, location nightmares, and an overweight, temperamental movie legend. The film was *Apocalypse Now* and would prove to be a visually stunning accomplishment but a flawed masterpiece. Like Orson Welles, Coppola's later film career is overshadowed by his remarkable earlier achievements. But with just four films he defined the era of New Hollywood better than anyone else and raised the level of personal artistic achievement to a dizzying height.

Roman Polanski's original concept for *Chinatown* was to have the camera follow Jake Gittes, Jack Nicholson's private eye character, like it was trailing him on the murder case. John A. Alonzo, the cinematographer for the film, felt this was too much and would become distracting for the audience. Handheld camerawork had broken out in American films because of the New

Wave movement but never used as extensively as directors like Jean-Luc Godard and Francois Truffaut did. Though Polanski modified his approach, Alonzo later talked about how this technique of following the character, used very subtly, added a unique sense of suspense and first-person presence to the film. The camera was also used to intimidate. Chinatown was shot in widescreen with a Panavision Panaflex, which meant that for close shots the camera would be only a few feet from the actors. Alonzo remembers that Faye Dunaway's character was on the verge of breakdown for most of the film, and Polanski used the camera in extreme close-ups to create a true sense of nervous anxiety in the actress.

Writer Robert Towne won an Academy Award for *Chinatown*. He holds the distinction of being nominated for three consecutive years, starting in 1973 with *The Last Detail*, *Chinatown*, and *Shampoo*. Towne had a reputation as a script doctor on films like *Bonnie and Clyde* and *The Godfather* (the last scene between Al Pacino and Marlon Brando was written by him). His work on *Chinatown* has become the stuff of legends among aspiring screenwriters. Loosely based on true incidents of dirty politics and big city cor-

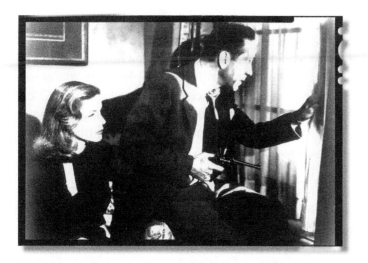

The Big Sleep (1945) directed by Howard Hawks, based on the novel by Raymond Chandler, screenplay by co-written by William Faulkner, and starring Humphrey Bogart and Lauren Bacall. It is a shame that Bogart did not live longer. By the late '60s, less than ten years after his death at the age of fifty-seven, his films were constantly being shown in revival cinemas, and there were many attempts at recreating his tough-guy film noirs. Jack Nicholson's character in **Chinatown,** Jake Gittes, is a close relation to Philip Marlowe and Sam Spade, played by Bogart. Since John Huston, who plays Noah Cross in the movie, directed six films with Bogart, the late actor's presence must have been felt on the set.

ruption that ultimately brought water to the valley in Los Angeles, Towne crafted a post-film noir murder mystery with surprises at every turn.

The first draft was almost 300 pages long (most screenplays are around 120 pages), and there are many opposing stories from Towne and director Roman Polanski about how the script got down to its final shooting version. Whatever happened, the end result was an example of clockwork perfection in character development and story structure. Jack Nicholson and Towne had become close friends during their Roger Corman days, and Towne tailor-made the character of Jake Gittes for Nicholson.

Almost immediately, Chinatown received enormous attention from students and lecturers, like Syd Field who analyzed the dramatic structure of the film in his *Screenplay: The Foundations of Screenwriting.* Ironically, it took until the 70s before the general public began to realize that good, memorable dialogue between characters did not just happen on the set, but was created (often painstakingly) by very clever writers, like Towne, William Goldman, Paddy Chayefsky, and Francis Ford Coppola.

This was also a year of big disasters. Disaster films, that is. In the successful wake of *The*

Poseidon Adventure, producer Irwin Allen, and director John Guillermin, put a bunch of movie stars into a skyscraper and set it on fire. *The Towering Inferno* had a who's who list of Hollywood, including Paul Newman, Steve McQueen, William Holden, Faye Dunaway, and Fred Astaire. The formula worked, and the film was a huge hit, even receiving a best picture nomination. Allen would later crash and burn with star-filled flops like *The Swarm* (1978) and *When Time Ran Out* (1980).

This was still the era of large-screen presentations, and audiences thrilled to these big-budget, special-effects wonders. There was a lot of competition this year. *Earthquake,* directed by Mark Robson, also had a stellar cast with Charlton Heston, Ava Gardner, George Kennedy, and Richard Roundtree. But the real star was a technology called Sensurround Sound, which made theatres rumble during the earthquakes. It was later revealed that several theatres had received structural damage because of the low bass sound effects. And there was *Airport 1975* about troubles on a 747 when the crew is killed, again starring Charlton Heston and George Kennedy.

These popcorn movies seem like rambling old relics from a contemporary perspective, but

audiences in 1974 were still in a stage of wonder and childish amazement at these disaster movies. In the 1930s, King Kong had torn up parts of New York, and San Francisco was laid to waste by an earthquake. For decades special effects that combined miniatures with trick photography were used for major moments in films, such as *The Ten Commandments* or *Ben-Hur*. Movies dominated by special effects, like science fiction or monster thrillers, were usually shot in black-and-white and made for drive-ins where audiences were not judgmental about what was up on the screen. By the early 70s the box office demands for bigger, louder, and more spectacular action pushed the art of movie magic unlike any time in cinema history.

The demands to create special effects that would look believable in full color on giant screens hastened the evolution of new technology. The advancements in this area of filmmaking are astonishing when studied year-by-year starting with *2001: A Space Odyssey* (1968). There is a steady progression of improvements and innovations. The disaster films and war movies like *Patton* and *Tora! Tora! Tora!* in the first half of the decade became the building blocks for *Star Wars*, *Close Encounters of the Third Kind*, *Alien*, and *The Empire Strikes Back* just a few short years later.

This year is almost like a cinematic tennis match, where audience experiences went back and forth between movies that were pure entertainment and those that approached high art. Mel Brooks had a red-letter year with the wildly funny, and unabashedly over-the-top comedies *Blazing Saddles* and *Young Frankenstein*. Federico Fellini reached back into his childhood experiences for *Amacord* ("I remember") about growing up during the years of fascism in Italy under the rule of Mussolini. Sidney Lumet brought Agatha Christie's *Murder on the Orient Express* to the screen with a cast that included Albert Finney as Hercule Poirot, Lauren Bacall, Sean Connery, Ingrid Bergman, and John Gielgud.

John Cassavetes put Gena Rowlands through the emotional ringer in *A Woman under the Influence*, for which he received his only Oscar nomination as best director. Veteran director Robert Aldrich scored a box office hit with *The Longest Yard*, a prison picture that features a very dirty game of football between the convicts and the guards. In *Lenny*, Bob Fosse explores the dark and tragic world of standup comedian Lenny Bruce, who took the concept of freedom of speech to a new level. And to punctuate what a diverse year it was, shot on 16 mm, and made for less than $100,000, Tobe Hooper directed *The Texas Chainsaw Massacre*, which was marketed with the tagline, "Who will survive and what will be left of them?" The film was loosely based on the gruesome true-life case of Ed Gein, a mass murderer known as the "Wisconsin Ghoul," who was also the nightmarish inspiration for *Psycho* and later *The Silence of the Lambs*.

1975

This year is often placed next to 1939 as one of Hollywood's greatest years. It was certainly the highpoint for the New Hollywood era with a wealth of films that include Milos Forman's *One Flew over the Cuckoo's Nest*, Robert Altman's *Nashville*, Sidney Lumet's *Dog Day Afternoon*, Steven Spielberg's *Jaws*, Stanley Kubrick's *Barry Lyndon*, Martin Scorsese's *Alice Doesn't Live Here Anymore*, Hal Ashby's *Shampoo*, Akira Kurosawa's *Derzu Uzala*, Peter Weir's *Picnic at Hanging Rock*, John Huston's *The Man Who Would Be King*, Francois Truffaut's *The Story of Adele H.*, Sydney Pollack's *Three Days of the Condor*, Woody Allen's *Love and Death*, John Schlesinger's *The Day of the Locust*, and Jim Sharman's *The Rocky Horror Picture Show*, the third highest grossing film of the year.

Monty Python and the Holy Gail (1975) *directed by Terry Gilliam and Terry Jones, and starring Jones, Graham Chapman, John Cleese, Eric Idle, and Michael Palin.* ***Monty Python's Flying Circus*** *had stopped production the year before and was only shown to American audiences on PBS. The spoof of King Arthur, with "Knight who say Ni," cost $400,000 and grossed over $5 million. After a decade of serious movies with bleak endings, this was a small sign that moviegoers wanted something different—and a little silly.*

One Flew over the Cuckoo's Nest became only the second film to win the five top Academy Awards. The first was *It Happened One Night* back in 1935. Jack Nicholson won (finally) as best actor, Louise Fletcher for her portrayal of Nurse Ratched (a role which had been turned down by both Jane Fonda and Faye Dunaway), Milos Forman as best director (who had been living day to day just a few months before), Lawrence Hauben and Bo Goldman for their screenplay, and the best picture honor went to producers Michael Douglas and Saul Zaentz. Zaentz would go on to win two more times for *Amadeus* (1984) and *The English Patient* (1996).

The cinematographers were Haskell Wexler and Bill Butler, who both had backgrounds in documentary filmmaking. Forman had studied filmmaking in Prague before coming to America and wanted a realistic tone for *One Flew over the Cuckoo's Nest*. This was achieved in part by shooting on location at the Oregon State Mental Hospital and using patients from the asylum as extras. The look of the film conveys the cold dampness of the Oregon weather, which seems to permeate the white walls of the asylum, and the actions of the characters are natural, as if being randomly caught in real situations.

One Flew over the Cuckoo's Nest over the years had fallen into what is known in Hollywood as "development hell," meaning there was interest in turning the book into a film, but for a multitude of compounding reasons, the project never got a green light. Kirk Douglas had optioned the rights to Ken Kesey's novel, and had later starred in a Broadway production adapted by Dale Wasserman. But even after the success of *Spartacus,* he could not find financial backing for a film version. The studios were afraid of its downer ending and pessimistic message. Kesey's psychedelic prose made *One Flew over the Cuckoo's Nest* a best selling paperback in the era of the Flower Children and continued to attract young readers into the '70s because of its nihilistic viewpoint of what was popularly perceived as the cold-hearted Establishment. This was represented by Nurse Ratched, the character everyone loved to hate.

Douglas passed the project on to his son, Michael, who in turn had the uneasy task of telling his father that he wanted Jack Nicholson

to play the role instead. The casting and the timing of the film were perfect. In the early 1960s, when the novel first came out, the tone of the film might have been too theatrical. By the mid-70s, with the new advancements in cinematography and the influence of foreign films, Forman made the decision to deliberately strip the film of all literary devices, giving it a contemporary feeling that captured the mood of an era slowly recovering from Vietnam, Watergate, and political upheaval.

In the four years after *M*A*S*H*, Robert Altman made six films, *Brewster McCloud, McCabe and Mrs. Miller, Images, The Long Goodbye, Thieves Like Us* and *California Split*. Each of these films experimented with directorial styles, cinematography, and especially improvisational acting. None of the films matched the critical and box-office success of *M*A*S*H*, which, of course, worried producers. Altman's greatest champion was *New Yorker* critic Pauline Kael, but the general public considered his films a little too avant garde. One of the great influences on Altman was director Jean Renoir, especially his film *The Rules of the Game,* which has no true primary character in the Hollywood tradition, but is an ensemble piece intertwining several different stories which are tied together at the end.

These films seemed to be building up to *Nashville,* Altman's acknowledged masterpiece. Nashville uses the country music scene as a metaphor for the rhinestone American Dream, following a cavalcade of characters, from the successful to the wannabes, over five days. Country music had exploded on the popular charts in the '70s. Even Bob Dylan was attracted to the grass-roots simplistic style of this music. Altman had each of his actors write their own songs to reflect the inner light of the characters they were playing. He then inter-cuts between twenty-four diverse characters as they try to earn a moment in the spotlight. At times *Nashville* seems completely chaotic, as unpredictable as real life, but then pulls together in the final tragic moments of the film. Sadly, *Nashville* foreshadows real events that became the downside of celebrityhood in the 1980s with deranged fans, assassinations, and the belief that the private lives of performers belonged to the public.

Sidney Lumet is the phoenix of American directors. Always taking chances, sometimes his efforts resulted in major failures, but he reemerged

*Nashville (1975) directed by Robert Altman is a standout cinematic achievement in a year that includes **Jaws, One Flew over the Cuckoo's Nest, Barry Lyndon, Dog Day Afternoon, Shampoo, The Man Who Would Be King,** and **Love and Death.** Using a large ensemble of character actors, Altman shot the film almost entirely in sequence, allowing the actors to improvise their dialogue and compose the songs they sang. Inter-cutting over a dozen different storylines, Altman created one of the most original films about America during this time, ending with the shooting of a musical star.*

each decade with exceptional films. He began his career in television during the early 50s by directing quality shows for *Studio One, You Are There,* and *Playhouse 90.* He made his film debut with *12 Angry Men* (1957), starring Henry Fonda. In the '60s Lumet made a series of remarkable small films, usually reflecting a strong social consciousness, like *Fail Safe, The Pawnbroker, The Hill, The Group,* and Eugene O'Neill's *A Long Day's Journey into Night.* Lumet hit his stride in the '70s with films that examined police corruption (*Serpico*), the unpredictable paths of corporate greed (*Network*), and even took time out from his movie muckraking to make the stylish *Murder on the Orient Express.* In the '80s and '90s, Lumet's films lost some dramatic intensity but still showed a mastery of different genres with *The Verdict, Deathtrap, The Morning After,* and *Running on Empty.*

In *Dog Day Afternoon,* Lumet teamed up for the second time with Al Pacino. Lumet's strength has always been working with actors. Over the years his direction has gotten Academy Award nominations and awards for Katharine Hepburn, Rod Steiger, William Holden, Faye Dunaway, Albert Finney, Ingrid Bergman, Paul Newman, Richard Burton, and Al Pacino. Lumet's strongest films explored the dark side of human nature, which was a recurring theme during this era.

Dog Day Afternoon is based on a true story about a bank robbery that goes wrong. During the standoff with police, the hostage negotiations with the small-time criminals are captured on live television and erupt into a media circus. It would be misleading to describe the characters as antiheroes, since they never do anything noble in the traditional sense during the entire film. The brilliance of the movie is that Lumet gives his actors the freedom to develop full-blown personalities for these idiosyncratic characters, then subtly manipulates the audience into identifying and rooting for them. Cinematographer Victor J. Kemper

said that *Dog Day Afternoon* was shot with "pure energy." Lumet's fluid camerawork is evident in every scene.

Hal Ashby might be the nicest and sweetest director ever in movies, which are two adjectives never associated with the vast majority of directors. By many reports from actors like Jon Voight, David Carradine, and Jack Nicholson, Ashby was a gentle soul who brought a quiet easiness to the sets. Working primarily with director Norman Jewison, Ashby was the editor on some of the most popular films of the '60s, including *The Cincinnati Kid; The Russians are Coming, the Russians are Coming; The Heat of the Night* (for which he won the Academy Award), and *The Thomas Crown Affair.* Taking the opportunity to direct, Ashby's second film was *Harold and Maude* (1971), about a 20-year-old boy obsessed with suicide and death who falls in love with an elderly woman. The offbeat comedy got very mixed reviews but quickly became a cult classic. Ashby's next film was *The Last Detail* (1973) with Jack Nicholson.

In 1975, Ashby made his most successful film, *Shampoo,* a bedroom farce about a modern-day Casanova who is a Beverly Hills hairdresser and seducer of wealthy, beautiful women. *Shampoo* stars Warren Beatty (who pokes fun at his own womanizing reputation), Julie Christie, Goldie Hawn, and Lee Grant (who won the best supporting actress Academy Award for the film, after being blacklisted for over fifteen years). The screenplay was by Robert Towne and Warren Beatty. Like Sidney Lumet, Ashby had a marvelous knack for getting outstanding performances out of actors.

The big movie of the year—and the one that marked the turning point for the New Hollywood—was *Jaws.* After seeing the film, veteran comedian George Burns allegedly remarked that Steven Spielberg "thinks like a camera." Whether this was meant to be compliment or a humorous

putdown, there is probably no better description of the young director. Spielberg grew up using a camera as both a hobby and an escape from the troubles of a family on the verge of separation. He took the vacation movies, structuring them like little travelogues, and then shot his own short films about alien encounters and World War II adventures, like "Escape to Nowhere." Since he had no formal training in filmmaking, he used his small Super 8 mm without the restrictions of traditional rules that might have been imposed on him if he had been an apprentice in a studio.

From the beginning, he moved the camera freely, not feeling the need to lock it down unless absolutely necessary. He was always searching for unusual angles to shoot scenes that seemed static to him, often giving the inanimate a point-of-view, like a giant tractor-trailer or a pier that had been pulled apart by a great white shark.

There is also the sense of being an outsider in his camera shots. His camera follows like a kid trying to keep up with the action, which gives the audience the sensation they are part of the drama. In *Jaws*, the way many of the scenes were shot gave people watching the film the illusion they were the fourth person on the small boat.

Spielberg has, on many occasions, paid homage to legendary directors. Most of them were masters of action sequences like John Ford, David Lean, and Akira Kurosawa. Growing up with the old classics, he developed a kind of visual encyclopedia in his mind, allowing him to become a chameleon that changed directing styles, depending on the nature of the film he was shooting. With the scenes near the shore in *Jaws*, Spielberg and his cinematographer Bill Butler kept the camera low to the water level, giving the uneasy feeling that something was watching from beneath the waves. Spielberg also introduced graphic violence into the adventure genre. In the past, movies like *Gunga Din* and *The Guns of Navarone* depicted death in a make-believe fash-ion. In *Jaws*, the deaths were bloody messes, like they would be in real life. It was like being on the "Pirates of the Caribbean" at Disneyland and actually seeing someone eaten by a crocodile.

Jaws gave audiences rollercoaster thrills like they had never experienced before, and it went on scaring up box office sales successfully around the world. It launched the blockbuster by earning more than $129 million domestically. The international box office typically amounted to half of the American domestic sales, but with *Jaws* the overseas revenues matched the domestic, which opened up huge possibilities for studios. In 1975, the average domestic box office take for a popular film was around $20 million. *Jaws* set the model for future marketing campaigns by opening wide, using television advertising and promoting heavily during the summer months.

This proved to be a wake-up call that personal films, like *Nashville* (which did not make it into the top fifteen grossing motion pictures of the year), might find it difficult to secure financial backing in the future. The other thing *Jaws* did was to forecast a change of mood in audiences during the mid-70s. Mainstream films since the early '60s had killed off their heroes or had what was popularly known as "downer" endings. This was certainly the case in 1975 with *One Flew over the Cuckoo's Nest, Dog Day Afternoon, The Man Who Would Be King, Barry Lyndon,* and *Nashville.* In *Jaws,* when Richard Dreyfuss (who everyone assumed was dead) pops out of the water in the aftermath of the great white shark's explosive demise, audiences began cheering. For once, instead of the heroes meeting a gruesome death at the end, they survived and dogpaddled happily to shore.

In 1975, the momentum of filmmaking began to shift. The near empty financial wells of 20th Century-Fox, Paramount, Warner Bros., and especially Universal had been replenished by a series of big box-office hits. Not since the last

years of World War II had the studios been so successful. But these wonder kids in tennis shoes had already suffered a few casualties. After three hits, Peter Bogdanovich made *Daisy Miller* (1974) and then attempted a musical, *At Long Last Love* (1975), both of which were attacked by critics and ignored by audiences. Bogdanovich continued to make occasional films but never topped his original successes. After the *Exorcist,* William Friedkin did not make another film for four years, and then spent over a year shooting a big-budget remake of *Wages of Fear,* titled *Sorcerer* (1977), which quickly disappeared at the box office. Friedkin also continued to make films, but never again generated the excitement of *The French Connection* and *The Exorcist.*

Sam Peckinpah had hits with *Straw Dogs* (1971) and *The Getaway* (1972), but never recovered from the misfire of *Pat Garrett and Billy the Kid* the following year. After *The Last Movie* (1971), Dennis Hopper returned to playing small parts in movies for many years. Francis Ford Coppola would eventually make *Apocalypse Now* (1979), but did not have another big success until *Bram Stoker's Dracula* (1992). His *Godfather, Part III* (1990) did well at the box office, but failed to match the critical or popular success of the original.

Roman Polanski fled to Europe shortly after *Chinatown* after being convicted of statutory rape. He would still make a few exceptional films over the years, like *Tess* (1979) and *The Pianist* (2002), for which he won the Academy Award for best director. And John Schlesinger received critical acclaim for *Sunday, Bloody Sunday* (1971), and after the failure of *The Day of the Locust* (1975) he would have very good luck with the suspense thriller *The Marathon Man* (1976). He continued to make small quality films with moderate success, like *The Falcon and the Snowman* (1985), *The Believers* (1987), and *Pacific Heights* (1990),

but, like many of the others, never matched his early successes.

Stanley Kubrick had planned for decades to make an epic film about the life and times of Napoleon, but the project never came together. After *A Clockwork Orange,* he made the exquisitely beautiful *Barry Lyndon* (1975), based on William Thackeray's eighteenth-century novel. The film received critical applause and four Academy Awards for music, cinematography, costume design, and art direction, but only did respectable business. His next film, *The Shining* (1980), would be his most financially successful. It was based on the Stephen King novel and starred Jack Nicholson. Milos Forman followed *One Flew over the Cuckoo's Nest* four years later with the adaptation of the rock musical *Hair.* He then directed *Ragtime* (1981) and won a second Academy Award for *Amadeus* (1984), also produced by Saul Zaentz.

The remainder of the era would be dominated by the international blockbuster movies of Steven Spielberg and George Lucas. But there are two other directors who would put their indelible mark on this era: Martin Scorsese and Michael Cimino. One will be identified with giving the personal film movement of the New Hollywood era its last great masterpiece. The other will be known for destroying the movement by self-indulgent excess.

1976

The years between 1969 and 1980 represented two different forces taking place simultaneously in motion pictures. There was a second Golden Era that reflected the personal filmmaking movement, or what has been referred to as the American New Wave; and there was the rise of the New Hollywood that unfolded over eleven years, where for the first time

since the coming of sound, American cinema was under the control of a completely new generation of stars and directors. The Second Golden Era was brief, lasting almost as long as the extraordinary years from 1934 to 1939 during the Studio System. This was the period of little films that made a big difference, the ones produced for less than a million dollars that reaped windfall profits. This movement began in 1969 with *Easy Rider* and *Midnight Cowboy,* and reached a peak in 1975 with *Dog Day Afternoon* and *One Flew over the Cuckoo's Nest.*

The rise and decline of the Vietnam conflict seemed to be the symbolic bookends to this era of low-budget personal filmmaking. Saigon fell on April 30, 1975. Afterwards there was an almost visible sigh of relief from the American and world public. Television news had shown soldiers and army personnel fleeing Saigon in overloaded helicopters, leaving behind terrified South Vietnam citizens. These were the last painful images of an undeclared war that divided public opinion. By the end, most people believed there were no heroes in Vietnam, only victims. And the movies had reflected this modern day Gotterdammerung. By the end of 1975, American citizens were experiencing the first year of peace since the early '60s. And considering that the Kennedy presidency was clouded by the Cold War and fears of nuclear weapons raining down, this was in reality the first prolonged peaceful period in the country's history since the beginning of World War II.

The tone of the movies began to change with this reversal of fortune. In 1976, the year of America's bicentennial, Hollywood motion pictures were split down the middle with films that showed the harsh realities of life and those that signaled the second phase of the New Hollywood that returned to the escapist films of the Studio System. Alan J. Pakula directed *All the President's Men,* a film project developed by Robert Redford, about uncovering the Watergate scandal. The film came out two years after President Nixon's resignation. Hal Ashby made a complete turnabout from *Shampoo* with *Bound for Glory,* based on the Depression-Era biography of folk singer and songwriter Woody Guthrie. Sidney Lumet turned Paddy Chayefsky's brilliantly satirical screenplay, *Network,* about the revolving-door politics of broadcast news, into a powerhouse movie that has remained remarkably contemporary over the

Network (1976) directed by Sidney Lumet, screenplay by Paddy Chaysfsky, and starring William Holden, Faye Dunaway, Peter Finch, Robert Duvall. Lumet is a director that has had made excellent movies since his first feature **12 Angry Men** *in 1957. In the '60s he made* **Long Day's Journey into Night, The Pawnbroker, Fail Safe,** *and* **The Hill** *back to back. But this seems to have been a warm up to the 70s when he directed* **Serpico, Murder on the Orient Express, Dog Day Afternoon,** *and* **Network.** *Nominated for five Oscars, he was given an honorary award in 2004.*

years. Peter Finch became the first actor to win the Academy Award posthumously. As the mad prophet Howard Beale, he has been immortalized with the frustrated outcry, "I'm mad as hell and I can't take it anymore!" But the most uncompromising film was Martin Scorsese's *Taxi Driver,* starting Robert De Niro.

Based on a screenplay by Paul Schrader, who said he wrote the dark psychological drama as a kind of therapy during a low ebb in his life, *Taxi Driver* introduces audiences to a character that at this time was unique, scary, and strangely fascinating. Travis Buckle was one of the first characters in movies to have his Vietnam experiences exposed as a reason for his unstable and potentially violent mental state. He was someone who, if people saw him on the street, they would quickly look away, not wanting to make eye contact. But Scorsese took the audience right into Travis' world, one that at times has a blurred line between reality and nightmare. With the exceptional work of cinematographer Michael Chapman, *Taxi Driver* becomes a journey into a state of obsessive madness that erupts into intensive violence.

Martin Scorsese seemed to find his identity as a director with *Taxi Driver.* Drawing on his own experiences of growing up on the mean streets of Little Italy, Scorsese depicts the senseless, unpredictable nature of violence unlike any director in this era. He is often like two people: A kid playing with complicated camera shots and a man who grew up surrounded by violence who uses film as a way to exorcise unpleasant images from his memory. As a sickly child, Scorsese escaped into movies, especially the B-films that often had a dark side to them, and sometimes a greater freedom in the visual styles.

There was an intense honesty about Scorsese's direction. He presents Travis, as portrayed by De Niro, as an unvarnished character who is racist and obsessed with violence. Travis stalks a political candidate to assassinate him and is attracted to a woman of external purity but does not know how to treat or talk with her. The brutal reality that Scorsese brings to the screen would have been impossible under the Production Code's extreme censorship. As a director, Scorsese never asks for pity or forgiveness for the people in his films, or preaches that they are a public menace, like in the 30s gangster movies, he just pulls back the curtain and lets the action unfold. Several directors in this era, including William Fredkin and John Schlesinger, would occasionally make films about characters from these dark streets, but Scorsese would do so throughout his career, with *Raging Bull, King of Comedy, After Hours, The Color of Money, Goodfellas,* and, in a historical perspective, *The Gangs of New York.*

Taxi Driver became the center of a controversy when John F. Hinckley, Jr., shot President Ronald Reagan. He had seen *Taxi Driver* fifteen times the summer it was released, and become obsessed with actress Jodie Foster, stalking her when she went to Yale University. Hinckley was a loner and identified with the character of Travis; and, like Travis, he fantasized about assassinating a political figure. On March 30, 1981, he left a note for Jodie Foster describing his plan to kill the President, concluding that he hoped this "historical deed" would impress her. At 1:30 P.M. he fired six shots at President Reagan, hitting him once in the left chest.

Once the media reported that Hinckley had a fixation on *Taxi Driver,* the oldest argument in film history remerged: films can teach people, especially children, bad behavior. In the movie, Travis ironically becomes a hero after his bloody showdown to rescue Jodie Foster's character from prostitution. Hinckley was possibly expecting a similar reaction after his attempt on the President's life. How much *Taxi Driver* truly affected Hinckley is impossible to determine, but some part of his irrational thinking processes

were obviously influenced by repeated viewing of the film. To many groups, this was proof that a new Production Code was needed, which would prevent such films from being made. This is an argument that will probably never go away, and has increased over the years because of children's access to the Internet and video games.

The influence of films seems to be perpetually examined with a double-standard. Films like *Mr. Smith Goes to Washington* and *To Kill a Mockingbird* can inspire people to take a positive course in life. If this is true, then logically a film like *Taxi Driver* can have the reverse affect. But there is still no method to determine the long-term influence of films, except on an individual basis, like with John Hinckley, Jr.

The motion pictures that signaled a return to escapist filmmaking in 1976 were decidedly hard-edged. John Schlesinger directed *Marathon Man,* a high-action thriller starring Dustin Hoffman, and a major leap from *Midnight Cowboy* and *Sunday, Bloody Sunday.* Schlesinger saw that the times were changing and successfully tried his hand at something with mass audience appeal. The scene when Laurence Olivier, as a chillingly sinister Nazi, tortures Hoffman by drilling into the cavities of his teeth is one of the most horrific scenes in any movie. Brain De Palma also tapped into audiences' basic fears in *Carrie,* the first Stephen King novel to be adapted to the screen. De Palma had worked his way up from low-budget, offbeat films that often showed the director's great admiration for Alfred Hitchcock work, like *Sisters* (1973) and *Obsession,* also in 1976. *Carrie* has the trademark tracking shots and Dutch angles that De Palma has become identified with over the years, and at times used multiple screens. Ultimately it is a very stylish horror film, but anchored in reality by a star-making performance by Sissy Spacek.

What is notable about these movies, and others like Richard Donner's *The Omen,* Nicholas Myers's *The Seven Percent Solution,* and Michael Anderson's *Logan's Run,* is that they are character driven. The action does not overshadow the development of relationships, which give them a stronger sense of basic human truth in how characters react to the situations they are put in. This in turns gives the audience an identification with the leads, which heightens the suspense at the climactic moments. The directors of this era grew up immersed in theatre and classic films, where fully drawn characters took on a reality that sometimes transcended the actors playing them. The most successful film of the year was a perfect example of the old studio style of character development.

John G. Avildsen's *Rocky,* starring sleep-eyed Sylvester Stallone, who also wrote the screenplay, is a modern Hollywood Cinderella story. Stallone was a down-on-his-luck actor who wrote a screenplay with the idea of playing the lead. He quickly found producers who wanted to make the film but did not want to take a chance on casting an unknown in the lead. At the time, Stallone was married with a newborn child and literally on the verge of being evicted from his apartment. But he gambled and said he would take a lesser fee for the screenplay if he could play Rocky. Boxing pictures had traditionally not done big box office. They were popular with male audiences but not the kind of pictures that would impress a date. The producers, after showing the screenplay to many movie stars, agreed to Stallone's terms and shot *Rocky* on a very low budget. What the producers had not foreseen was that *Rocky* was really an old-fashioned love story first and a boxing film second. Audiences fell in love with the not-too-bright contender, and *Rocky* became a runaway hit.

When *Rocky* came out, audiences were cheering during the heavyweight fight. At the time, these scenes were incredibly realistic to audiences, as if they were actually at ringside watching the

Rocky (1976) directed by John G. Avildsen, starring Sylvester Stallone (who also wrote the screenplay), Talia Shire, Burt Young, Carl Weathers, and Burgess Meredith. Because of the numerous and increasingly lackluster sequels, it is difficult to imagine how thrilling *Rocky* originally was to audiences. It was one of the first movies to use the Steadicam, which made the fight sequences seem so real that people were cheering. But the real enthusiasm for this little sleeper was that for the first time in many years there was an unabashed hero on the movie screen and crowds loved it.

bout. This was because of a revolutionary new piece of camera equipment called a steadicam. The steadicam is a portable unit that can be worn by an operator to get smooth, hand-held shots where tracks and dollies would be awkward or impossible to use. It was used this same year on *Bound for Glory* and *Marathon Man,* but the up-close fight scenes in *Rocky* established the steadicam in the movie industry. The brutally exciting fight scenes, combined with Bill Conti's infectious score, and a final scene with a bloody and battered Rocky yelling out for his girlfriend had audiences standing up and applauding during the credits. On a more speculative note, *Rocky* seemed to tie into the emotional mood of the public at this time. Here was a guy everyone had written off, but when the opportunity presented itself, Rocky proved he had the right stuff. If people could not find heroes in real life, they could still be found in the movies. *Rocky* was a turning point in the New Hollywood.

There were several films this year that were what can be best described as ambitious failures by notable directors. Federico Fellini's *Casanova* is eye candy, with its lavish costumes and scenic design, but is almost completely devoid of any narrative structure. After the failure of the film, Fellini would never again be given a large budget to work with, but the maestro still made six more little movies. Eliz Kazan made his final bow as a film director with the adaptation of F. Scott Fitzgerald's unfinished *The Last Tycoon,* loosely based on the life and times of Irving Thalberg. Kazan was able to work with Robert De Niro on the film but was contractually bound not to make changes to Harold Pinter's literal screenplay. The film suffers from the lack of improvisational touches for which the master of the Method was known.

Don Siegel made *The Shootist,* which would become John Wayne's last film. The Western about a dying gunfighter is somber and studied, lacking in the forceful energy that is Siegel's trademark in movies like *Coogan's Bluff* and *Dirty Harry,* both starring Clint Eastwood. Richard Lester turned the tale of Robin Hood into a revisionist take on the romantic adventure genre with *Robin and Marian,* starring Sean Connery and Audrey Hepburn. Lester is best known for his madcap Beatle comedies *A Hard Day's Night* and *Help!,* and the high-energy adaptation of *The Three Musketeers* (1973). *Robin and Marian* was considered mean-spirited by audiences when it

came out, but over the years has found an appreciative following. And Bob Rafelson made a small, offbeat comedy, *Stay Hungry,* which disappeared at the box office, but served as a launching pad into movies for a body builder named Arnold Schwarzenegger. Rafelson would have better luck five years later with the remake of *The Postman Always Rings Twice,* starring his good friend Jack Nicholson.

1977

There have only been a handful of films that have truly changed the nature of the motion picture business upon their original release. In fact, it can be argued there have been only been five: *The Birth of a Nation, The Jazz Singer, Gone With the Wind, Ben-Hur,* and *Star Wars. The Birth of a Nation* established the feature-length narrative film; *The Jazz Singer* introduced sound, *Gone With the Wind* became the first international blockbuster and is the defining movie that represents the Hollywood melodrama; *Ben-Hur* took the Hollywood epic to a new height; *Jaws* revolutionized marketing, creating the modern blockbuster; and *Star Wars* launched the era of special effects. To the generation that grew up after *Star Wars,* the film has come to represent the dividing line between old film history and the new. Like many of the movies in the 1970s, it is nearly impossible to convey the impact of *Star Wars* when it was first released.

During this era there was a "first-time effect" happening in movies. After the abandonment of the Production Code, and with the rise of realism and technology in filmmaking, audiences were exposed to innovations on the big screen that had never been seen before. *The Wild Bunch* brought violence to a new height; *The French Connection* introduced a new, gritty excitement to the cop drama; *The Godfather* turned the gangster film into high art; *Jaws* gave a new sense of realism and suspense to the adventure genre; *Taxi Driver* gave movies the ultimate anti-hero; and *Rocky* brought back the underdog hero. *Star Wars* took

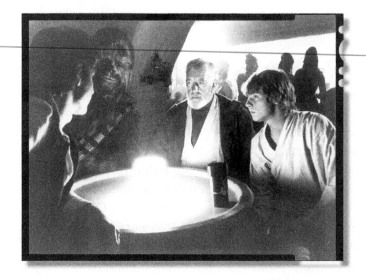

Star Wars (1977) written and directed by George Lucas, starring Alec Guinness, Mark Hamill, Carrie Fisher, Harrison Ford, and Peter Cushing. There is a debate among critics and historians that will probably never be solved, and that is if **Star Wars** ruined the New Hollywood or not. With every significant turning point in cinema there is one film that represents, for better or worse, the new trend. **The Jazz Singer, Gone With the Wind, Psycho,** and **Easy Rider** have had this dubious theoretical honor. But a look at the other films in 1977 will show that this trend in total escapism was already well underway before Luke Skywalker blew up the Death Star. Made this year were **Close Encounters of the Third Kind, The Spy that Loved Me, Smokey and the Bandit, Pete's Dragon, The Rescuers, Airport '77,** and **Oh, God!**

audiences to make-believe worlds that for the first time seemed to be completely real.

No one, not even George Lucas and his friend Steven Spielberg, expected such an intergalactic box office explosion when *Star Wars* opened. Lucas had hoped that his homage to old Hollywood serials, like Flash Gordon and Buck Rogers, would make around $17 million. This would give *Star Wars* roughly a $7 million profit and thus allow Lucas the opportunity to make another film. Spielberg was more optimistic and predicted the film would gross around $24 million. They were both considerably off. *Star Wars* grossed over $270 domestically, and, eventually with international ticket sales, climbed to almost one billion dollars. The merchandising sales reached twice this amount. *Star Wars* was the perfect movie for this moment in history. *Jaws* had shown that audiences were tired of downbeat films and wanted to return to old-fashioned adventure. *Rocky* proved that audiences would flock to see movies with old-fashioned heroes. *Star Wars* had both of these ingredients.

Star Wars (officially known as *Star Wars: Episode One—A New Hope* after its 1999 re-release) concludes with an elaborate ceremony where Luke Skywalker, Han Solo, and Chewbacca are awarded medals for heroism by Princess Leia. Three years before, with the Vietnam conflict still going on, this scene would have been laughed at in movie theatres. But when *Star Wars* opened, audiences wanted to pull the covers over their heads and return to old Hollywood escapism. *Star Wars* broke the bonds of Earth and all of its human problems and took audiences to galaxies far, far away. *2001: A Space Odyssey* had taken people on a similar special-effects journey nine years before, but Kubrick's movie did not have the fun and high-speed excitement found in Lucas' universe. *2001: A Space Odyssey* was science reality, whereas *Star Wars* was pure science fantasy.

After *THX-1138*, Lucas's movie career had looked like it was over, or at least sidelined indefinitely. His mentor, Francis Ford Coppola, made *The Godfather*, which in turn gave him the clout to green-light another low-budget feature for his friend. Coppola advised Lucas to make something personal, which turned into *American Graffiti*. The movie was a big hit and overnight restored Lucas' career. This led to *Star Wars*. It is hard to imagine another film that would have sparked such widespread attention. Steven Spielberg's *Close Encounters of the Third Kind* opened this same year, but it is more speculation on science fact, without high-action chases and battles with strange space creatures. Two years later Ridley Scott's *Alien* terrified audiences, but it is a film about a much sinister universe devoid of playful humor. There is no other movie that so clearly represents the advancements in film technology, yet *Star Wars* is a tribute to old Hollywood in terms of storytelling, character relationship, and pure entertainment value.

There are a lot of similarities between *American Graffiti* and *Star Wars*. The central characters come from small communities and want to break free from their family structures. Both characters have spiritual advisors in the form of mysterious older men who live aloof from others (and have beards). There are strong-willed women with sharp-edged wits. And there is the fascination with speed. Cinematographer Vittorio Storaro has said that "we are the sum of all our experiences." This is very true with George Lucas and *Star Wars*. Instead of science fact, he based his tale on ancient mythology, freeing the events in the story from any technical boundaries. The characters of R2-D2 and C-3PO were inspired by Akria Kurosawa's *The Hidden Fortress*. The attack on the Death Star is based on a famous mission in World War II, which was recreated in Michael Anderson's *The Dam Busters;* and the cliffhanger plot and perilous action comes from

Hopalong Cassidy Westerns and Saturday matinee serials.

What is completely unique about *Star Wars* is that it took the fun-loving spirit of these old B-movies and applied a revolutionary advance in special effects. There was a quaint artificiality to the Flash Gordon serials and the traditional Westerns, before the revisionist Westerns took over. They had a purity of action, including good guys vs. bad guys, chases on galloping horses, and a final showdown. But Lucas was a visionary with complete understanding of film technology. The two movies that won Oscars for visual effects in 1976 were the remake of *King Kong* and *Logan's Run*. *Star Wars* was a giant leap from what had been seen by audiences even the year before. With John C. Dykstra's Electronic Motion Control System—a camera that could repeat precise motions over and over again—the action scenes in *Star Wars* had multiple images matted into the same shot. In the past this would have created a "generation loss," meaning that each time a piece of film was exposed, the background image would fade a little because there was no way to completely control the ambient spill of light. With *Star Wars*, all the special effects scenes were rich in tone, without any fading.

The scenes that audiences most reacted to with cheers and applause were at the beginning and the end of *Star Wars*. The movie opens with a blast of composer John Williams' majestic score, which created immediate excitement in audiences. The first image was a small spaceship that raced deep into a star field, being shot at by laser blasts. Then Lucas used a process known as "breaking the frame" when a humongous spaceship appeared that seemed to continue for a mile. By filling the edges at the top of the screen with the giant spaceship, it forced the audiences to look up, giving the sensation that the craft was coming through the roof of the theatre. Within thirty seconds, Lucas had people hooked with excitement. No one had ever seen anything like this before.

The biggest thrill was at the end when X-wing fighters attempt to destroy the Death Star, and Luke Skywalker goes in at the last second to take a final shot. The feeling of speed in this famous sequence was, once again, something audiences had never experienced before. The process was as old as Georges Méliès' use of models and the under cranking of the camera in *Trip to the Moon* back in 1902, but the way Lucas shot the scenes to give the sensation of speed is astonishing to watch. A big part of the impact of this sequence and the overall success of *Star Wars* is because of the sound-effect editing and the musical score. Each of the spaceships had a distinctive sound. Darth Vader's ship sounds like a lion's roar. And R2-D2, which looks like an upside down garbage can on wheels with blinking lights, is given a complete personality with sound effects, becoming the single most endearing character in the movie.

John Williams' score is one of the true masterpieces in film music. He creates musical motifs for each of the major characters, musically revealing their personalities. Borrowing from the lush adventure scores of Erich Wolfgang Korngold and other composers of the Studio Era, Williams takes familiar movie themes that audiences have heard for decades and reinvents them. He taps into people's expectations, musically telling the viewer when danger abounds and when to cheer for the heroes. The other musical touch that Williams employs is to occasionally imitate the sound effects with a few notes, like with the swoosh of the light sabers or the mechanical problems aboard the Millennium Falcon.

Star Wars has been accused of ushering in the decline of the personal film movement in the 70s, but in fact this movement has already begun to fade away. The price tag on studio features had climbed enormously since the beginning of the

decade. Several directors that started out as the darlings of this movement had lost their way and made films that were attacked by critics and ignored by the public, like Sidney Lument's *Equus*. And other directors took advantage of their success and attempted big-budget projects that failed miserably at the box office. William Friedkin's *Sorcerer*, an overblown remake of the Henri-Georges Clouzot French classic *Wages of Fear*, is an example of this self-indulgent excess that would eventually destroy this movement.

The critical accusation that *Star Wars* singularly squashed the personal film movement proves to be unfounded when a list of the fifteen top moneymaking movies in 1977 is examined: Steven Spielberg's *Close Encounters of the Third Kind* was the second highest grossing film; followed by *Saturday Night Fever*, with new heart-throb John Travolta; *Smokey and the Bandit; The Goodbye Girl; Oh, God* with George Burns; *The Deep*, based on Robert Benchley's novel; Walt Disney's *The Rescuers;* the James Bond film *The Spy Who Loved Me;* the documentary *In Search of Noah's Ark; Semi-Tough; A Bridge Too Far;* the Mel Brooks spoof on Hitchcock's thrillers, *High Anxiety; The Other Side of Midnight;* and Woody Allen's *Annie Hall*.

Julia, a prestige film directed by Fred Zinnemann, and starring Jane Fonda, Vanessa Redgrave, and Jason Robards, won Academy Awards but only broke even at the box office. Sam Peckinpah's *Cross of Iron* and Robert Altman's *Three Women* ran only a few weeks in theatres. The biggest disappointment this year was Martin Scorsese's *New York, New York*, with Liza Minnelli and Robert De Niro. The movie showed the two sides of Scorsese—his love of old Hollywood films and his earnest desire to bring out the realistic truth in his characters.

The end result is that *New York, New York* is a highly stylized movie musical with dysfunctional characters. The musical numbers with Minnelli are highly entertaining, but the endless relationship problems offstage between her and De Niro did not settle well with audiences. Scorsese would later talk about losing his "artistic thread" during the making of the movie. The critics, expecting something daring and provocative after *Taxi Driver*, pounced on the movie; and audiences, likewise anticipating something along the lines of *Taxi Driver*, were disappointed. Scorsese was so devastated by the failure of his pet project that he did not direct another feature film for three years. De Niro finally talked him in to making a motion picture about prize fighter Jake LaMotta. The film would be *Raging Bull*.

The movie-going public in 1977 did not want to serve cinematic penance for the shortcomings of society. Audiences wanted to be entertained and to leave the troubles of the world outside the theatre. Ironically, in a year that seemed to be devoid of personal filmmaking, arguably the best film in this movement came out. Woody Allen's *Annie Hall* is partly autobiographical, following in the footsteps of Francois Truffaut's *The 400 Blows* and Federico Fellini's *8½*. It was a low-budget film that was innovative in its storytelling style. It had all the elements of this movement, except it was wildly funny and at the end no one died. *Annie Hall* broke the mold for personal filmmaking by proving that a film does not have to be tragic to be art.

Woody Allen had made six low-budget comedies before *Annie Hall* that played successfully to college audiences and the self-proclaimed intellectual crowd. The films were subtle, madcap satires about growing up Jewish (*Take the Money and Run*), revolution (*Bananas*), sex (*Everything You Wanted to Know about Sex But Were Afraid to Ask*), the future (*Sleeper*), and Russian novels (*Love and Death*). *Annie Hall* marked a surprise turning point in Allen's career. The humor evolved naturally from the characters, not in the punch line style of his earlier films,

Annie Hall (1977) directed by Woody Allen, screenplay by Allen and Marshall Brickman, and starring Allen, Diane Keaton, and Tony Roberts. Allen's remembrances of things past is a little like the comic version of Francois Truffaut's **The 400 Blows.** Both films are autobiographical in structure, but Allen one ups the French New Wave by breaking the "fourth wall" and talking directly to the audience. He mixes up time, creates absurdist situations, and revisits scenes with different actors. The love story is the one film genre that is common to all countries; however **Annie Hall** his unique among the thousands of films about lost love. The Writers Guild of America voted Allen and Brickman's screenplay among the top ten ever written, long with **Citizen Kane, Casablanca, The Godfather, Chinatown,** and **Some Like It Hot.**

and they were eccentric but absolutely real. *Annie Hall* also represented a minor miracle in movies; it is a love story that is unique in the bloated romantic genre.

The brilliance and appeal of *Annie Hall* is in the screenplay by Allen and co-writer Marshall Brickman. The screenplay is closer to *Citizen Kane* and *Last Year at Marienbad* because it has a non-linear structure that plays with time. Allen plays Alvy Singer and starts the movie by talking directly to the camera, thus making each member of the audience his personal confidant as he tells about the most unforgettable woman in his life—Annie Hall. He narrates his love story, making casual satirical comments about family and childhood friends, often breaking from the action in a scene to make comments directly to the camera. When Alvy Singer revisits his elementary school, a young actor portrays him, but then the scene turns about and the older Alvy Singer is suddenly in the midst of the children, who all

continue to behave as if everything is perfectly normal. Like in real life, Alvy's memory is constantly rearranging the order of actual events, sometimes improving on episodes or recasting scenes with different actors. It is a screenplay that has come to represent the freewheeling filmmaking style of this era. In 2001, *Annie Hall* was voted as one of the ten greatest screenplays by members of the Writers Guild of America.

1978

A look at the top movies of 1978 would first indicate that the personal filmmaking movement that dominated the start of this decade had all but vanished. The top moneymaker was the rock musical *Grease*, starring John Travolta hot off of his success in *Saturday Night Fever*. *Grease* earned over $96 million, making it the highest grossing musical at the time.

Animal House (1978) directed by John Landis, and starring John Belushi, Karen Allen, Tom Hulce, and Tim Matheson. This was the year of serious movies, including **The Deer Hunter, Coming Home, Days of Heaven, Interiors, Midnight Express,** and **An Unmarried Woman.** It was also a vintage year for comedies, musicals and other escapist flicks, like **Heaven Can Wait, Up in Smoke, The Cheap Detective, Grease, The Wiz, Halloween,** and **Superman.** But the most quoted line was from Belushi in **Animal House—"Food fight!"**

Next was *Superman* starring Christopher Reeve as Clark Kent. The movie set a record by reportedly paying Marlon Brando $4 million for one week of work to play Superman's father.

National Lampoon's Animal House, directed by John Landis was made for less than one million dollars and grossed over $70 million domestically. The overwhelming success of the crude and rude college life comedy with John Belushi flung open the doors to Hollywood for other alumni of *Saturday Night Live.*

The other box-office champs were *Every Which Way but Loose,* a truly wacky comedy with Clint Eastwood and Clyde the orangutan; *Jaws 2,* which had the tagline, "Just when you thought it was safe to go back in the water"; *Heaven Can Wait* starring Warren Beatty, a remake of *Here Comes Mr. Jordan* (1941); *Hooper* with Burt Reynolds; and *The Deer Hunter,* directed by Michael Cimino. *The Deer Hunter* is the only serious film on the list. The rest of the movies, with one exception, are all comedies: *California Suite;* Cheech Martin and Tommy Chong in *Up in Smoke; Foul Play; Revenge of the*

Pink Panther; The End; and *The Cheap Detective.* The exception was John Carpenter's *Halloween,* which introduced Jamie Lee Curtis.

There were many excellent films that addressed serious subjects this year, but audiences bought tickets to movies that made them laugh and feel good. There was Alan Parker's *Midnight Express,* with a screenplay by Oliver Stone, based on the true story of a young man's harrowing experiences in a Turkish prison for trying to smuggle drugs. The film was attacked for its racist stereotyping of the Turks. In 2004, Stone made a formal apology to the Turkish government for any damages that might have been caused by his screenplay.

Also this year was Hal Ashby's *Coming Home,* which won John Voight and Jane Fonda Academy Awards as best actors. The film unflinchingly examined the broken lives of Vietnam veterans who came home disabled. The film fared poorly with American audiences, who, it would appear, were still trying to forget the war. And there was Terrence Malick's *Days of Heaven,* one of the most beautiful films ever shot, with

cinematography by Nestor Almendros. Nestor won the Academy Award for his work but the film only had a limited release. Over the years, its reputation has continued to grow, and with VHS and DVD sales it has finally found the audience it deserves.

Sidney Lumet tried his hand at the musical *The Wiz,* the Black version of *The Wizard of Oz,* with Diana Ross and Michael Jackson. The ill-fated production became the biggest failure of the year. Other box-office disappointments included Woody Allen's *Interiors,* a film done in the spirit of Ingmar Bergman, which critics debated and audiences ignored, and Irwin Allen's *The Swarm,* an all-star disaster disaster film. After *Star Wars,* the unimaginative special effects in *The Swarm,* about an attack of killer bees, left audiences laughing instead of screaming. The big-budget disaster movies would disappear until *Independence Day* (1996), when state-of-the-art special effects and killer aliens would revive the genre.

1979

The personal film movement had one last great hurrah in 1979, a swan song to the innovative style of filmmaking this era has become noted for. With only a few exceptions, these movies were no longer million-dollar wonders. Many were big-budget features, but the best of them had the fingerprints of directors at the top of their form. This was the year of Francis Ford Coppola's *Apocalypse Now,* Ridley Scott's *Alien,* James Bridges' *The China Syndrome,* Robert Benton's *Kramer vs. Kramer,* Bob Fosse's *All That Jazz,* Hal Ashby's *Being There,* Roman Polanski's *Tess,* Woody Allen's *Manhattan,* Martin Ritt's *Norma Rae,* and Peter Yates' *Being There.*

Star Trek, directed by Robert Wise, made the long journey from television to the big screen, and despite poor reviews, it was the second highest grossing film of the year. A condemnation from the Catholic Church had curious people rushing to see *Monty Python's Life of Brian,* directed by Terry Jones. Teenager gang violence erupted after showings of Walter Hill's *The Warriors,* causing many theatres to cancel the movie. George Miller unleashed *Mad Max* onto the world, starring unknown actor Mel Gibson. And Germany had it greatest year of filmmaking in over forty-five years with Volker Schlondorff's *The Tin Drum,* Rainer Werner Fassbinder's *The Marriage of Maria Braun,* Werner Herzog's *Nosferatu,* and Wim Wender's *The American Friend.*

Following an emerging trend of directors that were given large budgets for projects after scoring a few successes at the box office, Steven Spielberg made the big ensemble cast comedy *1941,* starring Saturday Night Live alumni John Belushi and Dan Aykroyd. The humor was forced and over the top, and the film was eaten up by the critics. The story was loosely based on real fears that Los Angeles was going to be under attack after the bombing of Pearl Harbor, but the silliness and mayhem in *1941* was like an overblown screwball comedy out of control. Still, the film broke even at the box office, but the expectation was that it was going to be huge because of Spielberg's past record of *Jaws* and *Close Encounters of the Third Kind.* As *THX 1138* had been with George Lucas, *1941* was a wake-up call to Spielberg to examine himself as a filmmaker. For his next movie he teamed up with Lucas to make *Raiders of the Lost Ark* (1981), and continued with a run of blockbusters that include *E.T. the Extra-Terrestrial* and *Poltergeist,* both in 1982.

In 1979, movie legends John Wayne, studio mogul Darryl Zanuck, and director Jean Renoir passed away. Actress Jean Seberg, the beautiful star of Jean-Luc Godard's *Breathless,* committed suicide and was found in the backseat of a car,

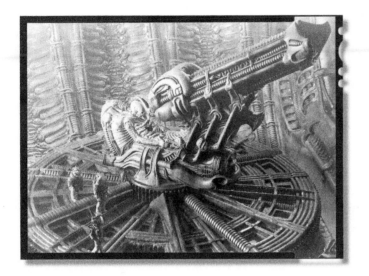

Alien (1979) directed by Ridley Scott, starring Tom Sherritt, Sigourney Weaver, John Hurt, Harry Dean Stanton, Ian Holm, and Veronica Cartwright. **Star Wars** and **Close Encounters of the Third Kind** changed the old B-movie tradition that showed aliens were terrible things. In Spielberg and Lucas's worlds they were kind, gentle, wise, and cute looking. But Scott zapped audiences back to the original concept when he had a nasty-looking alien pop out of Hurt's chest. With chillingly original art direction and visual effects, Scott made a film that stands as a landmark in suspense.

only a few blocks from where the landmark film of the French New Wave was shot.

1980—HEAVEN'S GATE AND THE DEATH OF PERSONAL FILMMAKING

This year is too often associated with the financial debacle of Michael Cimino's bloated Western *Heaven's Gate.* And since George Lucas' *The Empire Strikes Back,* directed in cooperation with Irvin Kershner, was a giant hit with audiences, the proximity effect of these two films gave rise to the theory that personal filmmaking was killed by the mindless, popcorn entertainment of the big, special-effects blockbusters. For many historians and critics, 1980 was a year when the cinema glass was half empty; to the movie-going public it was definitely half full. This was the most successful year Hollywood had experienced since the end of World War II.

The average box-office revenue of the top fifteen films in 1980 (not including *The Empire Strikes Back*) was around $34.5 million, almost

$15 million more per film than in 1975. The popular films this year were *9 to 5, Stir Crazy, Airplane!, Any Which Way You Can, Smokey and the Bandit II, Coal Miner's Daughter, Private Benjamin, The Blues Brothers, Caddyshack,* Stanley Kubrick's *The Shining, The Blue Lagoon,* Robert Altman's *Popeye, Urban Cowboy, Cheech and Chong's Next Movie;* and *Ordinary People,* directed by Robert Redford, which the Motion Picture Academy voted as the best film and director of the year. During the 70s movie genres had gone though a revisionist process, especially with Westerns and crime films. By 1980, genres began to overlap. The most popular this year was the action/comedy genre with movies like *Any Which Way You Can, Smokey and the Bandit II,* and *The Blues Brothers.*

As for personal filmmaking, this was the year of Martin Scorsese's comeback with the highly acclaimed *Raging Bull,* which many consider the highpoint of this era. Ten years later, *Raging Bull* would be voted the film of the 1980s. Other remarkable films this year included David Lynch's *The Elephant Man,* Richard Rush's *The Stunt Man,* Paul Schrader's *American Gigolo,* Jonathan Demme's *Melvin and Howard,* John

The Empire Strikes Back (1980) directed by Irvin Kershner, and starring Mark Hamill, Carrie Fisher, Harrison Ford, and the voice of Frank Oz as Yoda. It is very rare, and continues to be so, that sequels are as good (or better) than the original. **The Godfather, Part II** *and* **The Empire Strikes Back** *are notable exceptions. Many consider the second film (or Episode V) the most perfectly conceived science fiction fantasy ever made, and it is hard to argue against this.*

Cassavetes' *Gloria,* Bruce Beresford's *Breaker Morant,* Akira Kurosawa's *Kagemusha* (which was executive produced for the international version by Francis Ford Coppola and George Lucas), Louis Malle's *Atlantic City,* and Brian De Palma's *Dressed to Kill.*

De Palma was often referred to by many critics as the heir apparent to the filmmaking style of Alfred Hitchcock. *Dressed to Kill,* which is a unsettling and sometimes bizarre cross between *Vertigo* and *Psycho,* came out the year the Master of Suspense died at the age of ninety. Hitchcock had directed over sixty-five features and television shows and had unquestionably put a lasting mark on filmmaking. De Palma is just one of the many directors who have tried on the crown of the Hitchcockian tradition with measured degrees of success.

By 1980, the concept of the New Hollywood was already going through significant changes. Technology had rapidly enhanced the filmmaking process, which began to affect the ways movies were distributed. The days of the drive-ins were rapidly declining as cities grew and land became a premium, but new cinemas were being built or restored. One of the demands George Lucas put on cinema owners if they wanted to

show *The Empire Strikes Back* was that their sound systems had to be upgraded. Many theatres had sound equipment that was thirty years old and had been inexpensively adapted for Stereophonic Sound in the early 60s. Recognizing how critical music and sound effects where to the full enjoyment of visual effects, Lucas established Skywalker Sound, which in the 1980s revolutionized the movie experience.

The other sign that the times were changing was that many films were being made by relatively unknown directors. Colin Higgins, Buddy Van Horn, Michael Apted, Howard Zieff, Randal Kleiser, and James Bridges directed six of the most successful films of the year, which were *9 to 5, Any Which Way You Can, Coal Miner's Daughter, Private Benjamin, The Blue Lagoon,* and *Urban Cowboy,* respectively. Each of these directors would have other successful films, but none of them became as familiar to the public as John Ford, Howard Hawks, or George Cukor, or even, for that matter, as well-known over the years as William Friedkin, Peter Bogdanovich, or Sidney Lumet. Only three directors would emerge from the '70s and continue with long successful careers. They were Steven Spielberg, Martin Scorsese, and George Lucas. Lucas became better known as a

producer and innovator. Many other directors from this era would keep working over the decades, but would never climb back up to the heights of their earlier films.

The biggest change the failure of *Heaven's Gate* brought about was concerning the 70s concept that the director was the complete master of the ship. For many years, especially in the early part of the decade, the studio would essentially hand over the money, and the director would disappear for a few months, then return with a finished picture. When the bankroll was in the ballpark of a million dollars, not too much damage could be done. But as the costs for film production grew, and the old Hollywood philosophy of "bigger is better" returned to the movies, the downside became too great. *Heaven's Gate* pushed this process over the cliff. Since the film was a pet project for Michael Cimino, it came to represent the end of the personal filmmaking movement. This to a large degree is true. The producer began to supervise all stages of film production more, and in his or her eyes the natural enemy was the director, who, if left unchecked, would lavish money on scenes that were unimportant to the overall picture.

Movies had become a big business with television marketing, wide opening theatre bookings, revenue from foreign sales (which for the first time were matching or doubling domestic sales), multiple picture franchises, and spin-off rights that included merchandising and fast food tie ins. Movies have always been a business, but with the old moguls there was the sense that movies were like luxury cars. After the panic of *Heaven's Gate,* studios began to make mostly recreational vehicles: fun, entertaining films that large masses of people around the world would enjoy. Throughout most of the 1980s, the directors that wanted to work in this cinematic amusement factory were the ones that got green lights for projects. Spielberg was the only director from the New Hollywood era that continued to work uninterrupted over the next two decades.

Directors like Martin Scorsese, who did not have a natural interest in great white sharks and space creatures, had difficult times after the industry fallout over *Heaven's Gate.* After *Raging Bull,* his next film was to have been *Gangs of New York,* but this project was put on ice for twenty-two years. With the exception of *The Color of Money,* Scorsese made only a few low-budget films during the '80s. In 1990, he directed *Goodfellas,* followed by *Cape Fear* the following year, which again brought him back into the mainstream.

Film history is strewn with the carcasses of giant productions that bombed at the box office. There has been D. W. Griffith's *Intolerance,* Erich von Stroheim's *Greed,* David O. Selznick's *Duel in the Sun,* Joseph Mankiewicz's *Cleopatra,* and Michael Cimino's *Heaven's Gate.* Each of these big-budget failures took down the director or producer, but none of them stopped the flow of filmmaking in Hollywood—until *Heaven's Gate,* that is. Both *Intolerance* and *Greed* have since been heralded as masterpieces. Griffith went on to direct many more films, whereas von Stroheim's career in Hollywood was over. The determining factor between these two men is that Griffith was aristocracy by nature but still pleasant and entertaining to be around. These are important qualities in surviving in Hollywood, or any part of the movie business. On the other hand, von Stroheim was perpetually condescending and inflexible, which are considered the real reasons for his downfall.

While *Duel and in the Sun* and *Cleopatra* did not make back their original costs for years, they consistently made money and eventually broke even. *Citizen Kane* is not on this list because the film was made with a relatively low budget. Though *Citizen Kane* was an almost complete financial loss at the box office, the rumor that it almost bankrupted RKO was not true.

Reports were spread in the media to hurt Orson Welles, making him seem irresponsible with a budget. This also was not true, but the tide had turned on him, and he was labeled with these accusations for the rest of his career.

One of the reasons that large amounts of money are thrown at a production is that more often than not it works. David O. Selznick had been down this road once before with *Gone With the Wind*, which went on to make back its $3 million investment in a matter of weeks, then continued to reap in profits until it reached just under $200 million dollars, which in adjusted ticket sales today would be over $1.1 billion. *Snow White and the Seven Dwarfs* was called "Disney's Folly" until it opened and approximately one-third of America's population saw it. *Ben-Hur* was an all or nothing gamble for MGM, and the box-office returns kept the studio afloat for almost a decade. And more recently there was James Cameron's *Titanic* (1997) which went way over budget amidst speculation that it would sink at the box office. Instead it set new records and had a happy ending—for the investors.

Many films after *Heaven's Gate* lost even greater investments, like Kevin's Costner's *The Postman* (1997), *The Adventures of Pluto Nash* (2002) with Eddie Murphy, and Oliver Stone's *Alexander* (2004). Each of these films lost almost $100 million, but because of auxiliary rights, multiple picture deals, multiple investors, and tax write-offs, sometimes a loss can result in a long-term profit. Back in 1980, business arrangements were far less complicated, thus potentially more disastrous.

To understand the impact of the financial loss on United Artists because of *Heaven's Gate*, it is important to appreciate the circumstances that led up to the making of the film. In 1967, UA become a subsidiary of TransAmerican Corporation, which in theory gave the movie studio a protective financial net. Starting in 1975, the company set a record by winning the Academy Award for best picture three years in a row with *One Flew over the Cuckoo's Nest*, *Rocky*, and *Annie Hall*. UA had an exclusive agreement with Woody Allen, but the company's biggest asset was the James Bond franchise. In 1978, five of United Artists' top executives, who had been with the company for twenty-six years, left because of a policy disagreement and started Orion Pictures. In the coming years Orion would produce *Dances with Wolves* and *Silence of the Lambs.*

The new management of UA was suddenly desperate for projects and approached Michael Cimino, who had just won Oscars for *The Deer Hunter*. Cimino had a film he had been trying to get off the ground for years about the little known Johnson County War between the cattlemen and immigrant farmers. The cinematographer was going to be Vilmos Zsigmond, who had won an Oscar for *Close Encounters of the Third Kind*. The original budget was $2 million, but soon escalated to $7 million and then $11 million. But with Cimino hot off of *The Deer Hunter*, it still seemed like a smart deal to the new executives at United Artists, who in essence gave him a blank check to shoot up in Montana.

Within one month, Cimino was ten days behind schedule and had already spent $11 million. Like David O. Selznick and *Duel in the Sun*, Cimino was going to turn *Heaven's Gate* into the greatest Western epic ever made. The major problem was that Westerns by the end of the '70s were a dying genre. But once into the production, the UA executives saw no way out but to continue to throw money at the project and meet Cimino's increasing demands. There are reports that Cimino tore down sets and built new ones just to have a better look. He became obsessive about every detail, and eventually the budget grew to $40 million. Cimino then turned in a 4½ hour cut of the film.

The problem was that United Artists was forced to use production money for other films

to cover the overages on *Heaven's Gate* and had nothing to fall back on. TransAmerican Corporation refused to advance any more money for projects. When *Heaven's Gate* finally opened, after being cut down to 149 minutes, the thing that all the critics commented on was the expense of the film and all the production problems. Ultimately, *Heaven's Gate* made back less than $2 million, and UA was forced to declare bankruptcy. The following year, the new James Bond picture, *For Your Eyes Only,* saved the studio, but that same year TransAmerican sold United Artists to MGM, which became MGM/UA Entertainment.

After a series of expensive failures by directors, including Peter Bogdonovich's *Daisy Miller* and *At Long Last Love,* William Friedkin's *Sorcerer,* Martin Scorsese's *New York, New York,* Steven Spielberg's *1941,* and finally Cimino's *Heaven's Gate,* the studios decided that the director could not be trusted. It was a series of events that actually went back to David Lean's *Ryan's Daughter* and Dennis Hopper's *The Last Movie* that finally killed the era of personal filmmaking. There was a unique window of time between 1969 and 1980 that allowed for a freedom in directing, cinematography, acting, and screenwriting that had only existed before during the silent era, and, arguably, has not existed since 1980. Many of the films from this era have survived to impress a new generation of moviegoers, a testimony to the artistry and passion that went into making them. Even if *Heaven's Gate* had not been such as financial fiasco, the era of personal filmmaking had drawn to an end, replaced by high-concept blockbusters.

MULTICULTURAL FILMS

This era marked the biggest advancement in the history of motion pictures on how most ethnic groups were portrayed on the screen. It has taken almost seventy years for films to show Asians playing Asians in all the roles; for Native Americans to be a part of films that showed the truth about the conquest of the Old West; for Latino actors to be identified with other movie roles beside those of banditos, spitfires, and Latin lovers; and for African-Americans to star in and direct mainstream films.

ASIANS

The changes in the roles for Asian characters began after World War II with the films of Kurosawa, Teinosuke Kinugasa, and other Japanese directors. What became known as Samurai Films were very popular with audiences worldwide. These quality films of high artistic achievement were slowly overshadowed in the mass market by the Godzilla series and other B-monster drive-in movies. Following the huge success of the James Bond franchise, the next phase of Asian films took place in Hong Kong. Like many of the directors in the French New Wave, the young Hong Kong directors and stars enjoyed the Warner Bros. gangster films. These low-budget action movies became a hybrid of Bond spy adventures and streetwise mob films. The main attraction was that they cranked up the violence, but instead of Tommy guns the heroes had fists of fury.

Bruce Lee's influence is undeniable in turning the practice of martial arts into an international phenomenon. After a failed attempt in Hollywood, Lee went to Hong Kong in 1971, where he made four films in less than three years. They include *The Chinese Connection, Revenge of the Dragon, Fury of the Dragon,* and *Last Game of Death,* also known as *Goodbye Bruce Lee* because it was released after his death. Lee's movies started a new genre that was quickly labeled Kung Fu Films. The titles were often changed depending

Enter the Dragon *(1973) directed by Robert Clouse, starring Bruce Lee, started a revolution in movies that has continued to grow with each decade. The film brought attention to Hong Kong filmmakers and created an international interest in martial arts. Though he died suddenly three weeks before the film's premiere, Lee proved to Hollywood studios that an Asian actor could successfully play the lead in a movie. Jackie Chan played an uncredited role of a prison thug in the movie.*

on which country they were released in. For example, *Enter the Dragon* was also shown as *Operation Dragon* and *The Deadly Three*.

Lee's sudden death of a cerebral edema on July 20, 1973, at only thirty-two years old was as shocking to his fans in Asia as James Dean's fatal accident was to American teenagers. Myths arose about a sinister conspiracy to murder him. And the belief in a Bruce Lee curse was reinforced when his son, Brandon Lee, was killed because of a bizarre stunt accident on the set of *The Crow* (1993). Students of Bruce Lee included Steve McQueen and James Coburn. The popularity of his movies increased enormously after his death, and they were dubbed into dozens of languages without concern for matching any of the dialogue with lip movement. Audiences did not care about the technical quality of the films. People watched them for the action sequences. Besides, the most important language, the warlike sounds Lee

made as he prepared for battle, did not have to be translated and were imitated by fans in countries all over the world.

Making uncredited appearances in *Fist of Fury* and *Enter the Dragon* was Jackie Chan. By 1980 he had become the heir apparent to Bruce Lee. But this year he made a decision that changed the direction of the genre. Instead of living in the giant shadow of Lee, Chan decided to combine slapstick comedy with his carefully choreographed action sequences. A fan of silent comics Buster Keaton and Harold Lloyd, Chan made his directorial debut with *The Young Master,* which became the blueprint for his future martial arts films. Chan first tried his luck in Hollywood with *Cannonball Run* (1981), but quickly returned to Hong Kong. His big American breakthrough film was *Rumble in the Bronx,* made fourteen years later.

NATIVE AMERICANS

In 1970, Chief Dan George became the first Native American to be nominated for an Academy Award. It was for his supporting role in Arthur Penn's *Little Big Man,* starring Dustin Hoffman and Faye Dunaway, based on the epic novel by Thomas Berger. *Little Big Man* tells the story of white boy who is raised by the Indians and spends long periods of his life in both worlds. It is a definitive revision Western, especially in the depiction of the attempted genocide by the American cavalry and the half-mad portrayal of General George Armstrong Custer. The film was cast entirely with Native-American actors, unlike John Ford's *Cheyenne Autumn* (1964), which also attempted to show similar injustices. By the '70s, most Westerns were had stopped using Indian attacks as part of the storylines. Instead Westerns moved south of the border into Mexico, or focused on the rugged living in the wilderness or the misadventures of frontier life. The Native American slowly began to vanish from the screen. Chief Dan George only appeared in a few more movies in small roles,

including *The Outlaw Josey Wales* (1987), directed by Clint Eastwood.

The irony is that the last time Native Americans and settlers openly interacted was after the Civil War to the defeat of Sitting Bull and Crazy Horse following the Battle of Little Big Horn. By the 1880s, most Native Americans had been exiled to remote reservations. What was known as the Indian Wars was over. This separation of white and Native-American societies left a giant void as far as Hollywood movies were concerned. The many tribes became locked in time for movie audiences. Westerns were the original action genre, and showing the hardships and isolation of modern reservation life did not allow for chases and gunfights. But one film changed that.

Billy Jack (1971 and 1973), directed by and starring Tom Laughlin, is about an ex-Green Beret who is half-white and half-Indian who uses kung fu to teach the bigots and rednecks lessons in living peacefully. The film's tag line was, "You got due process, Mother's Day, supermarkets, the FBI, Medicare, air conditioning, AT&T, country clubs, Congress, a 2-car garage, state troopers, the Constitution, color television, and democracy.

Little Big Man (1970) directed by Arthur Penn, based on the novel by Thomas Berger, starring Dustin Hoffman, Faye Dunaway, Martin Balsam, Robert Mulligan, and Chief Dan George, this is one of the first films to use Native Americans in all the roles, not white actors in red make-up that had been the tradition in Hollywood since the silent era. A film that sadly had never gotten the full attention it deserves, *Little Big Man* is worth seeing for many reasons, but especially for the wonderful performance of Chief Dan George, the first Native American to be nominated for an Oscar.

They got *Billy Jack."* Made for less than $800,000, *Billy Jack* earned over $32 million at the box office. *The Trial of Billy Jack* (1974) did equally as well, but the third time was not a charm. *Billy Jack Goes to Washington* (1977) was a failure and became embroiled in legal problems. It would not be until 1990, with *Dances with Wolves,* directed by Kevin Costner, that a major film about Native Americans was made again.

LATINOS

The only character who did not really receive a complete overhaul was the Latino. In *The Wild Bunch,* director Sam Peckinpah cast all Mexican actors to play the drunken, two-timing Federales and prostitutes. This was a step forward from non-Latino actor Eli Wallach playing an over-the-top Mexican character in Sergio Leone's *The Good, The Bad, and The Ugly,* but it was also a step backwards, since the Mexican characters in Peckinpah's end-of-the-trail Western were stereotypes that went back to the early sound era with films, like *Viva Villa* with Wallace Berry. Plus the entire Mexican army was shot to pieces by only four over-the-hill bank robbers. Eli Wallach's character was at least smart, unintentionally humorous, and deliciously untrustworthy. Paul Newman had also played a conniving bandito-type character in *The Outrage* (1964), directed by Martin Ritt, which was a Wild West version of Akira Kurosawa's *Rashomon.*

In the 1960s, legendary animator Tex Avery had created the Frito Bandito, a perpetually grinning, singing, dancing, cartoon of a sombrero-wearing bandito. The campaign sold millions of bags of Fritos, but in the early '70s the Mexican-American community rightly protested this negative stereotype. Soon after, the Frito Bandito, who had become a marketing icon, disappeared from stores and television.

Stereotypes always distill an ethnic group down to its most recognizable common features. Every group has its stereotype, at least in Hollywood movies, but some are moderately acceptable as long as there are a variety of other characters from this ethnic background to balance out this stereotype. But with Mexican-Americans, the bandito characters became the sole stereotype in film and commercials. A similar outcry came about from the Italian-American community because of the films by Martin Scorsese, like *Goodfellas,* and later the HBO hit *The Sopranos.*

Change for the Mexican-American image was on its way. Luis Bunuel was the '70s' most famous Spanish filmmaker, who during this era lived in Mexico. In Spain, director Pedro Almodovar was making a series of short films, and by the 80s, his films like *Women on the Verge of a Nervous Breakdown* (1988), would turn Antonio Banderas into an international star. Also in the '70s, Edward James Olmos was beginning to be featured in films and would break out in *Zoot Suit* (1982) and receive an Academy Award nomination as best actor for *Stand and Deliver* (1988).

But in the '70s, the most offbeat Mexican characters were a pair of zonked-out buddies named Cheech and Chong. *Up in Smoke* (1978), directed by Lou Adler, starred Cheech Marin and Tommy Chong was a huge hit, and followed by *Cheech and Chong's Next Movie* (1980). These hilarious movies certainly introduced a new stereotype, but this time the real-life Cheech and Chong were writing and directing their own movies and having a great time making fools of all the non-Latinos they encountered on their delirious misadventures.

AFRICAN-AMERICANS—
BLAXPLOITATION FILMS

The work that Sidney Poitier had done to present a positive image on-screen of the African-American took a radical turn in the 1970s. After *Guess Who's Coming to Dinner* (1967), Poitier was criticized and deeply hurt by the comments he was a puppet for the movie industry and that his films were "sell outs" because they were not made by black filmmakers. It took years for Poitier to heal from these personal attacks. Fortunately he lived long enough to receive the tributes he rightfully deserved for opening up a path in Hollywood. What he is not given full credit for is being one of the first African-Americans to get behind the camera. In 1972, he made *Buck and the Preacher,* the first of nine films he directed.

The death of Martin Luther King, Jr. on April 4, 1968, created a schism in the black community. Many African-Americans felt that King's peaceful protests had only resulted in his assassination. Violence broke out, and during that long summer, cities burned all over the country. With the murder of Robert Kennedy three months later, there was the feeling among African-Americans that one of the few white politicians that fought honestly for the cause of civil rights was now gone. Within a few months, hope had turned into anger. New militant organizations began to appear in the news. The Black Panther Party with Billy Seale and Huey Long, and the Symbionese Liberation Army, who kidnapped newspaper heiress Patty Hearst, made the headlines and were involved in shoot-outs with police. *The Autobiography of Malcolm X: As Told to Alex Haley; Soul on Ice* by Eldridge Cleaver; and *The Wretched of the Earth* by Frantz Fanon became best sellers.

In 1969, Gordon Parks directed *The Learning Tree* and became the first African-American director to work in the Studio System. *The Learning Tree* is a sensitive, beautifully shot movie about growing up with prejudice in the South. It was a film that received good reviews, but was given a limited release and good reviews quickly disappeared. For his next film, Parks decided to set his story in the asphalt jungle of a modern metropolis. It was about a tough-as-nails, ultra cool, Black detective named John Shaft. *Shaft* (1971) was one of the most influential films of the era. This time

Shaft (1971) directed by Gordon Parks, starring Richard Roundtree, took the streetwise detective genre, that had done well for Humphrey Bogart, and gave it a new home in Harlem. With its rock score by Isaac Hayes, and proud, tough performance by Roundtree, **Shaft** help launched the Blaxploitation movement.

Parks' film found a large African-American audience that had been starved for entertainment and gave it a sense of cultural identity.

Shaft was shot on location on a very limited budget, and was really a variation on the Warner Bros. gangster films of the 1930s, but instead of James Cagney, Richard Roundtree was the star. *Shaft* has one of the most dynamic opening credit sequences in the movies. Parks creates a montage of Roundtree walking the city streets like he owns them. Pulsating underneath these images is Isaac Hayes' compelling music, which won the Oscar for best song that year. The powerful feeling that Shaft is his own man in a white man's world was immediate. What was important about *Shaft* is that it was a crossover film. First and foremost, Shaft was an action flick that everyone could enjoy. Other films quickly followed, including *Shaft's Big Score* (1972), and *Shaft Goes to Africa* (1973).

These low-budget films made by African-American directors and stars like Pam Grier, Ron O'Neal, Tamara Dobson, Godfrey Cambridge, Raymond St. Jacques, and later Richard Pryor, poured into the theatres and were hugely popular. They were labeled Black Exploitation Films and then "Films," and were also referred to as "badass movies." In this cinematic world, the black man and woman were in complete control and not going to play the games of "The Man." In fact, many of these films were openly hostile to the white dominated culture. Melvin Van Peebles' *Sweet Sweetback's Baad Asssss Song* (1971) is often credited as being the first film in this genre. It is an uncompromising tale of a radical on the run for shooting white cops. It is also a film of uninhibited sexual relationships and proudly advertised its triple-X rating when it was released.

The Mack (1973) is about an ex-con named Goldie who becomes the king pimp in Oakland. Director Michael Campus had to get permission from the Black Panthers to shoot on location. *The Mack* features Richard Pryor, who had already attracted wide public attention the year before in *Lady Sings the Blues,* starring Diana Ross. (Playing Billie Holiday, Ross had received an Academy Award nomination for best actress, becoming only the second African-American woman to receive this honor.) Pryor then co-starred in *Uptown Saturday Night,* directed by Sidney Poitier, stealing the film from Bill Cosby and Harry Belafonte. By the end of the decade, Pryor had become the most popular Black star in the movies, with major box office hits like *Silver Streak* and *Stir Crazy,* both with Gene Wilder.

Most of the films within the Blaxploitation Movement followed the traditional blueprint of tough detective tales. Ossie Davis made *Cotton Comes to Harlem* (1970) with the characters Gravedigger Jones and Coffin Ed Johnson. *Superfly* (1972) starred Ron O'Neal as Youngblood Priest, and was directed by Gordon Parks Jr., the son of Gordon Parks, who was tragically killed in a plane crash a few years later after making just four movies. Women got into the action in the Blaxploitation Films. Most famous is *Foxy Brown* (1974) with Pam Grier, directed by Jack Hill, about a woman who seeks (and gets) revenge for the murder of her government agent boyfriend. In *Coffy,* made the year before with Hill, she is a woman who administers vigilante justice on drug dealers, pimps, and mobsters who severely injured her younger sister. Quentin Tarantino was a great fan of Grier's movies, and cast her in the lead role of *Jackie Brown* thirty-five years later.

The other woman contender in this genre was Tamara Dobson, who starred in *Cleopatra Jones* (1973), directed by Jack Starrett. Dobson plays a United States Special Agent assigned to crack down on drug dealers, which she does by using kung-fu and dispensing with the bad guys with vicious kicks. The use of marshal arts in films had recently caught fire with audiences because of Bruce Lee's *Fury of the Dragon* (1972)

and *Enter the Dragon,* made the same year as *Cleopatra Jones.* As an example of how fast the kung-fu phenomena spread around the world, two years later Dobson revived her character in *Cleopatra Jones and the Casino of Gold,* which was set in Hong Kong.

WOMEN IN FILMS

In the years after the Production Code, women's films showed a lot of similarities to the controversial movies of the Pre-Code Era. Women once again used their sexuality and street smarts to climb to the top, and in many cases they stood nose-to-nose with men. In general, the women of the New Hollywood were "tough dames," which was a popular term during the Pre-Code Era. The legend most of these new stars were compared to was Bette Davis. Davis had fought for better scripts and better di-

rectors. This continued to be the battle cry for actresses like Jane Fonda, Faye Dunaway, and, by the end of the decade, Meryl Streep. There were many exceptional actresses during the 70s, but Fonda and Dunaway were the true contenders of this era.

It was a time period of new faces, and for a while, each one caught the attention of the public with remarkable performances in some standout films. There was Maggie Smith (*The Prime of Miss Jean Brodie*), Glenda Jackson (*Women in Love* and *Sunday, Bloody Sunday*), Liza Minnelli (*The Sterile Cuckoo* and *Cabaret*), Cicely Tyson (*Sounder*), Ellen Burstyn (*The Exorcist* and *Alice Doesn't Live Here Anymore*), Barbra Streisand (*The Way We Were*), Sissy Spacek (*Carrie* and *Coal Miner's Daughter*), Jill Clayburgh (*An Unmarried Woman*), Sally Field (*Norma Rae*), and Goldie Hawn (*Private Benjamin*).

But the first women asked for most roles were Fonda and Dunaway. Their screen personalities

Jane Fonda's Workout came out in 1982, as a follow up to her best seller, Jane Fonda's Workout Book. It became one of the most successful video tapes ever produced, and almost single-handedly jumpstarting the "fitness craze" that today is a multi-billion dollar industry. Fonda produced over twenty different exercise videos, which made her more money than all of her films. Nominated for seven Oscars, she won for Klute and Coming Home.

seem to typify this era of personal filmmaking. Fonda's roles reflected an actress who liked to take chances. She was a luckless marathon dancer in *They Shoot Horses, Don't They?* (1969), a prostitute stalked by a murderer in *Klute* (1971), a once affluent wife who turns to armed robbery with her husband to pay off debts in *Fun With Dick and Jane* (1977), playwright Lillian Hellman in *Julia* (1977), the wife of an army officer who falls in love with a paralyzed Vietnam veteran in *Coming Home* (1978), a reporter who stumbles on a story about a defective nuclear power plant in *China Syndrome* (1979), and a harassed office worker who decides not to take it anymore in *Nine to Five* (1980).

Fonda won her Oscars for *Klute* and *Coming Home*, which gave her the clout to put projects into production like *Julia, Coming Home, China Syndrome,* and *On Golden Pond* (1981), where she got to act opposite her father, Henry Fonda. She also single-handedly started the exercise craze in the '80s with her *Jane Fonda's Workout*. By the mid-80's she saw that her career had hit a dead end and walked away from the business— but for years she still appeared in living rooms with her exercise tapes.

Many of Faye Dunaway's films have become classics of the era, like *Bonnie and Clyde* (1967), *The Thomas Crown Affair* (1968), *Little Big Man* (1970), *The Three Musketeers* (1973), *Chinatown* (1974), *Three Days of the Condor* (1975), and *Network* (1976), for which she won a well-deserved Oscar for her pitch-perfect role of a totally heartless network executive who will stop at nothing, even murder, to get a hit program. Many of Dunaway's best characters were highly driven and sexually charged, something that American audiences had not seen on the screen with such an uninhibited attitude since the Pre-Code years with actresses like Joan Blondell, Ann Dvorak, and Jean Harlow. Dunaway continued to work steadily into the new millennium, but

has not had a string of critical successes like those amazing years in the 70s.

Meryl Streep was just beginning her remarkable career during this era, mostly in small character roles, like in *Julia* (1977), *The Deer Hunter* (1978), *Manhattan* (1979), and *Kramer vs. Kramer* (1979), for which she won her first Academy Award as best supporting actress. She made her strongest impression during these years on television in the highly acclaimed miniseries *Holocaust* (1978). Meryl Streep has talked about receiving a letter from Bette Davis congratulating her on her performance. She considered this a great inspiration, from one fighter to another. This was not uncommon during this era. There seemed to have been a connection, part real and part state of mind, between the new generation of actresses and the movie legends of the Golden Age like Davis, Katharine Hepburn, Olivia de Havilland, and Ginger Rogers, who actually went to battle with the moguls and ultimately got better women's roles.

But despite advancements, it still was not like the glorious heydays of the women films during the 30s and early 40s. With some wonderful exceptions, like *The Prime of Miss Jean Brodie, Carrie, Network, Women in Love,* and *Alice Doesn't Live Here Anymore,* most films were male dominated, and the women characters revolved around the conflicts that the men had to ultimately resolve. The Hollywood screenplay is linear, with few exceptions, and the principal character initiates the action. It is a deceptively simple format that has been used hundreds of thousands of times since the start of the star system.

The key to who drives the film depends on who is put in the driver's seat first, and typically it is the man. It can be argued that in films like *Carrie, Network,* and *Women in Love,* the men motivate the action. However, upon closer examination, in each of these films the women have the power to take control of the action and even-

tually they seize upon this opportunity because of the misspent efforts of the men around them. Since the vast majority of the writers and directors during this era were men, it is not surprising that most films would have male leads. In the past, in older movies like *The Thin Man, His Girl Friday,* and *Mr. Smith Goes to Washington,* the men and women were equally involved in the action. By the 70s, the buddy films took away this co-partnership and men played both roles, as in *Easy Rider, Butch Cassidy and the Sundance Kid, M*A*S*H,* and *The Sting.*

The singular reason for this was box office. Despite this resurgence in stronger women's roles, no single female star during the '70s was considered strong enough (meaning "bankable" enough) to carry a major motion picture. Paul Newman, Robert Redford, Clint Eastwood, Al Pacino, and Jack Nicholson were the big money stars. Jane Fonda and Faye Dunaway were in more films that failed at the box office than had been hits. Many of their films that received high acclaim did only moderate business and very few of them transferred successfully to the overseas market, where kung fu and disaster movies were what sold tickets. Faye Dunaway's only blockbuster was *Towering Inferno* (1974), and she was just one of the all-star casualties. Fonda's biggest film was *The China Syndrome,* which was really a disaster film with brains.

With the youth market (fourteen- to twenty-three-year-olds), what would become known as "the slasher film" was just getting started. The targets in these low-budget bloodbaths were women. In *Texas Chainsaw Massacre* (1974) and *Friday the 13th* (1980), young women were tortured and brutally dispatched, and despite the fact that Jamie Lee Curtis was the star of *Halloween* (1978), she spent the entire film escaping the evil clutches of psychotic Michael Myers. Also enormously popular with young audiences were movies starring the alumni of Saturday Night Live, like *Animal House* (1978), *Meatballs* (1970), and *Caddyshack* (1980), where women were usually the tantalizing objects of desire.

By the 1980s, the action movie had become king at the international box office. Going back to *Gunga Din* (1939), action-adventure films have been about men fighting overwhelming odds and returning victorious. With the advancements in special effects, this genre became supercharged and eventually went into outer space. If the old traditions of men only had prevailed, then women's roles might have become very meager during this time of big-budget action blockbusters. But because of the story structure of three different films, all of which had successful sequels, women became identified with this rough and tumble genre. The films were *Star Wars* (Princess Leia), *Alien* (Ripley), and 1984's *The Terminator* (Sarah Connor). With each of these films, the women characters became essential to the storyline of the sequels, and audiences never thought twice about it.

As a final note, in 1976, Lina Wertmuller, who was a protégé of Federico Fellini, became the first women to be nominated for the Academy Award as best director. She made the very dark Holocaust comedy *Seven Beauties,* which was declared by many critics as a masterpiece of modern surrealism. Wertmuller lost to John G. Avildsen for *Rocky.*

The Realism of the Impossible or Film History, Part II

1981–2005

One of the greatest conceived comic lines of all time is in *Wizard of Oz*. In 1939, audiences found themselves looking up at a movie screen showing flat, dusty Kansas fields shot in black-and-white with a hint of sepia tone. Then suddenly a tornado picks up the house with Dorothy inside (played perfectly by Judy Garland), spins it around and around, until it lands with a violent thud. Dorothy opens the door, holding her little dog Toto, and walks out into a Technicolor wonderland, with the whispering sounds of Munchkins hidden among the vividly colored plants. In awe Dorothy observes, "Toto . . . I have a feeling we're not in Kansas anymore."

Audiences exploded in laughter, because they too had never seen anything like this before. With the exception of *King Kong* (1933), this was the first big budgeted fantasy motion picture to come out of the Hollywood Dream Factory in the sound era. With the surprise transition to Technicolor, The *Wizard of Oz* was pure magic to people still in the grip of the Great Depression. Audiences were as transfixed as Dorothy was in the movie. It is a moment of film history that is impossible to duplicate. Like with *A Trip to the Moon* thirty-seven years before, people were seeing a strange new world, which before this was only possible through individual imagination.

However, during the 1980s audiences had come to expect large-scale special effects as a regular course to their movie diet. In what has become popularly known as the post-*Star War* era, movies like *Raiders of the Lost Ark, Time Bandits, E.T. the Extra Terrestrial, The Return of the Jedi, Blade Runner, Ghostbusters, The Terminator, Back to the Future, Top Gun, Robocop, Die Hard, Beetlejuice,* and *Batman* completely altered the process of filmmaking and revitalized Hollywood studios. The James Bond franchise, now with Roger Moore as Agent 007, kept raking in big profits in the international box office with *For Your Eyes Only, Octopussy,* and *A View to a Kill* (all light-years away from Ian Fleming's original novels). Sequels and trilogies abounded, building up anticipation with the enormous youth market during the long summer months. Audiences began keeping track of new films numerically with *Robocop 2, Jaws 3-D,* and *Back to the Future, Parts I, II* and *III*.

During the years following *Star Wars*, the art of special effects evolved as rapidly as the documentaries that showed Disneyland being built through time-lapse photography. The highly

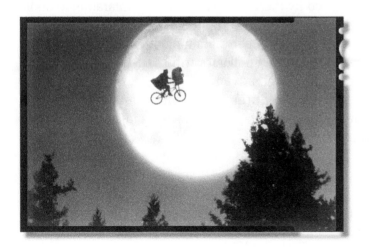

E. T. the Extra-Terrestrial (1982) *directed by Steven Spielberg, and starring Henry Thomas, Dee Wallace-Stone, Robert MacNaught, and Drew Barrymore. Spielberg recalls that during production for* **Close Encounters of the Third Kind** *he was encouraged by Francois Truffaut to make a film about children. When his "little movie" about a boy and an abandoned alien was released it was pure cinema magic to audiences. The film's greatest single asset was John Williams' Oscar winning score—his music made Carlo Rambaldi's big-eyed creature come alive.*

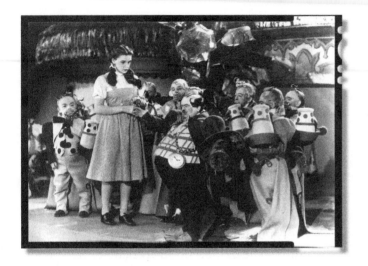

The Wizard of Oz (1939) directed by Victor Fleming, starring Judy Garland, represented the height of special effects during the Studio System, and continued to enchant audiences for the next fifty years. Today there are so many behind-the-scenes features on the technology of movie magic that there is concern future generations will not see the appeal of old classics.

promoted blockbuster, which did not officially exist until *Jaws,* became commonplace. And almost every genre was transformed by this renaissance in movie magic technology. The screwball comedies of the '30s were reinvented as *Ghostbusters.* The gritty crime films of the '50s became *Die Hard.* The old fashioned romance went supersonic with *Top Gun.* And the good guys with six-shooters in the Saturday matinee Westerns became Jedi knights with light sabers.

Old stories were given a special effects makeover until nearly every genre became, in essence, a fantasy film. The sense of dramatic reality that for decades had anchored character-driven movies to earth was jettisoned. During the '80s, a time period identified with corporate greed and the financial philosophy that bigger is truly better, the odds grew enormously against the new movie hero. Now he had to fight ten times the bad guys that Hopalong Cassidy once did. He might do battle with aliens in one movie and supernatural forces in the next. And *he* eventually became *she* in films like *Terminator 2: Judgment Day* and *Aliens.* The "action hero," a term once reserved for plastic toy figures, was born during this era. This movie action hero was an indestructible individual, usually molded from common clay, but who could stand up to whatever obstacles were thrown at him by the unbridled imagination of effect wizards and young directors specializing in these big-budget popcorn movies.

Looking back over this era, there is a sensation that overgrown kids were playing with shining new toys. The idea that a man or woman could make a good living building model space ships, and then blowing them up suddenly seemed a highly desired profession. Effects companies like George Lucas' Industrial Light and Magic and Richard Edlund's Boss Films became almost as well-known to a younger generation as General Motors was to their parents. And the films created by these companies were exhilarating to audiences. People around the world encouraged bigger and louder motion pictures by buying tens of millions of dollars worth of tickets.

High adventure and fantasy movies were popular during the silent years, especially with stars like Douglas Fairbanks and Lon Chaney. But when sound arrived, the stars changed overnight and there was a folk hero quality about them. It is hard to imagine James Stewart, Spencer Tracy, or Bette Davis trying to blow up a Death Star or chasing a T-1000 liquid metal Terminator on a motorcycle (though there is no doubt they would

have left their unique touches on these roles). This new era of adventure and fantasy films had action stars like Arnold Schwarzenegger, Mel Gibson, Bruce Willis, and Sigourney Weaver. With these films the history of movies begins to make a complete circle.

Perfectly timed with the new millennium, movies finally achieved the holy grail of special effects by turning fantasy into absolute reality with Peter Jackson's *Lord of the Rings* trilogy. The Land of Oz appeared remarkably real to audiences sixty years before, but to the modern eye, the elaborate stage sets, massive backdrops, and brightly colored artificial plants create a nostalgia for a bygone era, not a sense of genuine reality. However, Middle Earth is remarkably real in all its fantastical elements. With the smoke and mirrors of computer generated imaging (CGI), it has become nearly impossible for audiences to discern what is real and what is make believe. From 1902 to 2001, just shy of one hundred years,

movies have made a complete voyage, from Georges Méliès' fourteen-minute stop-action magic show, *A Trip to the Moon,* to Jackson's almost twelve-hour epic of Hobbits and monsters.

This symbolic connection neatly brings down the curtain on the first act of film history. With the impossible becoming everyday reality, the historical definition of film as an escapist art form has reached its zenith. The images on the screen now ingeniously fool the eye. And while audiences twenty years from now might see the subtle flaws of CGI technology in its infancy, the overall experience will still seem true-to-life. The next part of film history has already begun with digital cameras, complex computer games, live virtual reality shows, and CGI programs becoming available to everyone.

Ironically, "film" has already become an all-purpose word representing the media arts. In the future there might not be actual film, at least as it was known throughout the twentieth century.

Lord of the Rings: Two Towers (2002) directed by Peter Jackson, and the other films in this trilogy have taken special effect to the stage where the unreal is completely realistic. Movies made only twenty years ago now seem dated because of the available technology at the time to create effects. The recent advancements in CGI might signify the start of a new era where films do not visually show their age.

This next act in motion pictures will certainly be brimming with advances in technology—and who knows? Perhaps procedures found in *Total Recall* and *Eternal Sunshine of the Spotless Mind*, where the brain is reprogrammed, could become an everyday reality (hopefully with better results than in these movies). However, the technologies that follow will be variations on what has already been achieved. Like with an e-mail, it is impossible to send something any faster that arrives instantly.

There is one certainty: This next act of film history can never capture the wonderment of the last hundred years. When moving pictures were first seen in the twilight years of the nineteenth century, they were phenomenal. These flicking images seem crude six decades later, but originally they were stunningly real because of the collective imagination of the audiences. Today the secrets of movie magic are readily available in any bookstore or on hundreds of websites. But in the infant years of this lively art form, these images were pure magic.

Another certainty is that these hundred years will be revisited and researched forever. Like with the wealth of knowledge constantly being uncov-ered from ancient empires, all there is know about film, today and tomorrow, can be found in this past century. Over the span of these years, which is only a blink in the history of recorded time, a visual language was created that will be perpetually studied. This visual language was put together frame-by-frame by highly gifted directors, cinematographers, designers, actors, and producers. It is the most complex language in the world, and yet the most accessible.

The sole purpose of this visual language is storytelling. This is the one factor that is essential. All of the lights, sound equipment, props, editing consoles, and cameras are objects on an empty sound stage without a story. Stripping away all its technological achievements, the *Lord of the Rings* trilogy is the kind of breathtaking tale told around fires at the dawn of time. This need for a good story, with a good ending, never fades away. The advancements in movie technology from *Star Wars* to *Lord of the Rings* become the final entries in the massive dictionary of this visual language. And like the other major moments in motion pictures, this last phrase, leading up to the theoretical end of Film History, Part I, is subject to the tides of political events, changes in

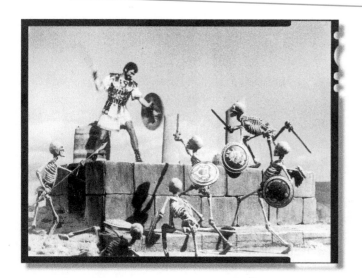

Jason and the Argonauts *(1963) directed by Don Chaffey; the warrior skeletons created by Ray Harryhausen stirred up the interest of future filmmaker on the unlimited possibilities of special effects. Harryhausen made these fantasy sequences working completely alone in a garage for months at a time. They were done by stop-action animation; the same process used by Georges Méliès sixty years before.*

world economics, and the influence of a handful of very imaginative filmmakers.

HISTORY AND FILM

A Generation of Peace

From April 30, 1975, when the last Marines flew out of Saigon, to the attacks on the World Trade Center and the Pentagon on September 11, 2001, was the longest era of peace in American history. Those were not uninterrupted years of peace. Several major military operations occurred during the presidencies of Jimmy Carter, Ronald Reagan, and Bill Clinton. In 1991, the Gulf War, known as Operation Desert Storm, under President George H. W. Bush, was over after only six weeks of aerial bombardment and four days of ground fighting.

The Gulf War was witnessed live on television and through digital cameras mounted on smart missiles. News commentators made constant references to the special effects in Hollywood movies. This brief war gave the illusion that military operations might have become so high-tech that the mere threat of using them would serve as a permanent deterrent to any future large-scale acts of hostility. But with the invasion of Iraq in 2003, under President George W. Bush, the fighting quickly ended up going house to house, giving a chilling reminder of the last months of World War II, a half century before.

In these twenty-six years, from the late 70s to the new millennium, a generation of children grew up in a nation of peace, and for the first time motion pictures were not directly influenced by long years of war, depression, social upheaval, blacklisting, and censorship. In 1981, Ronald Reagan became President. Looking back it should have not come as any great surprise that a movie actor would eventually be elected to the highest office in the world.

Motion pictures have depicted Presidents since *The Birth of a Nation,* and over the decades it has been suggested many times that James Stewart or Henry Fonda would have been elected if he had ever decided to run. Before movies grabbed the popular attention, the celebrities were heads of state, athletes, and the occasional

*Platoon (1987) written and directed by Oliver Stone, and starring Martin Sheen, Tom Berenger, Forest Whitaker, and Willem Dafoe. In his best work, Stone uses visual images like social reformist Upton Sinclair used his hard-edge prose, to wake people up to harsh realities that have been deliberately ignored. In **Platoon,** and films like **JFK, Wall Street, National Born Killers, Talk Radio,** and **Nixon,** Stone plays cat-and-mouse with true events. His goal was not to recreate history but to challenge people's perception of white-washed truths. He is one of the very few American directors that have used film this way, but like many reformists have experienced, his later films suggest he has run out of many sacred cows to exploit.*

writer, artist, or musical genius. After the overwhelming reaction to the death of Rudolph Valentino in 1926, it became immediately apparent that "common" movie actors had become better known and admired than kings and queens.

Movie Politics

Before turning his sights on the White House, Ronald Reagan had been the president of the Screen Actors Guild and then governor of California during the radical '60s. He was not the first actor to go to Washington. Song and dance man George Murphy was elected to the Senate in 1964 and served one term. Over the years movie stars were often seen with Presidents. Lauren Bacall was photographed on top of Harry Truman's piano, and Frank Sinatra and his Rat Pack showed young John Kennedy the ins and outs of Las Vegas. In the '60s and '70s, star power became important in political campaigns, and Paul Newman, Warren Beatty, Burt Lancaster, Jane Fonda, Robert Redford, Donald Sutherland, and others of the Hollywood elite were seen on both sides of the political lines. But no one played the real life role of President better than Ronald Reagan.

President Kennedy instinctively knew how to work a room full of press people. His short answers often ended with a touch of humor. In the years following his assassination, documentaries, television mini-series, and movies about him became almost annual events. The world public has seemingly never grown tired of the tragic fall of America's Camelot. On the other side, Richard Nixon was devastated by his early television debates. When Nixon ran for President eleven years later, he used TV advertising to launch his political attacks and stayed out of the public spotlight as much as possible.

Ronald Reagan was at his best in front of a live audience. He perfected the short, quotable reply to questions often referred to as "sound bytes," which were ideal fillers for nightly news reports. In 1980, the year Reagan was elected to office, Ted Turner and Reese Schonfeld introduced the Cable News Network (CNN), and though it was considered a folly at first by critics, viewers quickly became addicted to the twenty-four-hour news coverage. One of Reagan's defining moments as President, and the event that brought CNN to the attention of millions, was the Challenger disaster.

Somehow it was appropriate to have a movie star as President in the '80s, a time when the Hollywood motion picture industry had been revitalized and was enjoying its greatest box office sales in thirty years. The Cold War was still unofficially on, but "the Evil Empire," as Reagan referred to it, was slowly breaking into pieces. The faceless citizens behind the Iron Curtain were obviously more interested in food on the shelves of grocery stores and finding pairs of American Levis than in missions to space stations and May Day parades showing off rows of guided missiles. The collapsing Russian dictatorship gave Hollywood a new villain, the Russian Mafia. Reagan also borrowed from the movies when he proposed the Star Wars defense, the ultimate line of deterrent comprised of super satellites circling the Earth.

In the years since Reagan, Presidents have been made or broken by the endless scrutiny of television, and positive or negative depictions in movies and documentaries. President George H. W. Bush's popularity soared after the lightning success of the Gulf War, but during his reelection campaign against Bill Clinton, viewers found his television persona detached and humorless. Bush's promise of no tax increases in his "read my lips" speech came back to haunt him when this sound byte was played over and over during the campaign.

During his one term in office, Vice President Dan Quayle created a media stir when he attacked

the popular television sitcom "Murphy Brown" on the issue of family values. He was rebutted on a special episode of the show by the fictional character of Murphy Brown, as played by Candice Bergen, as millions of people watched. The line between political reality and make-believe politics had begun to blur. The worst media cut of all came when Quayle spelled "potato" with an "e" at the end. This three-second mistake plagued him for the remainder of his political career.

In complete contrast, Bill Clinton became the new Teflon President. Remarkably his popularity kept increasing despite highly publicized scandals and impeachment charges. Hollywood loved Clinton, and at his inauguration Barbra Streisand and an impressive lineup of stars celebrated his victory over President Bush. Clinton's eight years in office has been described as the ultimate primetime soap opera. Millions of people around the world tuned in almost daily to see if the latest scandal or sexual misconduct charge would dethrone him.

First Lady Hillary Clinton was presented as a real-life Lady Macbeth, and White House intern Monica Lewinsky went from bit player to superstar because of her late-night sexual performance in the Oval Office. During Clinton's time in office there were several movies with a fictional President at the center of the story, including *Murder at 1600* and *Absolute Power* where the President is suspected of homicide. In films by Wolfgang Petersen, the President is presented as an action hero in *Air Force One* and the target of an ingenious assassin in the high-profile thriller *In the Line of Fire.*

After the attacks on 9/11, President George W. Bush reached a height of popularity that only a few Presidents had ever known. Bush promised the American people retaliation for the deadly attacks, which resulted in the invasion of Iraq and the eventual capture of dictator Saddam Hussein. But when the war lingered on, with young American soldiers being killed daily by insurgents, and no weapons of mass destruction were discovered, Bush's popularity declined. The media became radically divided, arguably with greater personal bitterness than during the Vietnam War or the McCarthy era. There was also a widespread backlash against the stars and directors in the Hollywood community who spoke out against the war in Iraq.

The documentary, as pioneered in the last decade of the twentieth century by Ken Burns on PBS television and Michael Moore as part of the independent film movement, was enjoying a high degree of success for the first time since World War II. Moore had become known for his aggressive, one-sided approach to the documentary format in *Roger & Me* and *Bowling for Columbine.* For *Fahrenheit 9/11,* Moore used the documentary as a political weapon aimed at George W. Bush and his war on terrorism. The unquestionable intention of *Fahrenheit 9/11* was to persuade voters not to cast their ballots for Bush. *Fahrenheit 9/11* became the first documentary to make over $100 million. However, Moore's carefully crafted attack on the President cannot be accurately measured for its influence since Bush went on to win his second term.

Alfred Hitchcock once observed that he could turn James Stewart from a nice guy to a villain through the process of editing. If the image of an elderly lady is seen planting flowers and the next cut is Stewart watching her with a smile on his face, it implies that he is nice man who is respectful of old people. But if the first image shows a woman crying because her small pet dog has been poisoned, suddenly the same shot of Stewart smiling makes him a man without a heart who is amused by anguish of others.

By 2005, there were three around the clock cable news stations: CNN, MSNBC, and Fox News, and many cities had their own local twenty-four-hour news channels. At times each of these net-

works would edit similar images of a news incident to fit a particular take on the story, thus subtlety manipulating reality like a Hitchcock film. News and politics were gradually being altered like a director's cut on a DVD extra, and in a real sense the up-to-the-minute events of the world were taking the form of a perpetual movie.

THE STAR

Superstars and Action Heroes

In 1988, Bruce Willis was given $5 million to play John McClane in *Die Hard,* directed by John McTiernan. Willis at the time was in the popular television drama "Moonlighting" but his first two feature films had performed poorly at the box office. He certainly was not considered a major star in Hollywood. So the news of his big payday was greeted with outcries that the film business had gone mad. When *Die Hard* was a blockbuster hit,

Willis became a superstar overnight. Immediately other movie stars demanded bigger upfront salaries and ultimately a percentage of the gross receipts. Within less than ten years, Mel Gibson, Arnold Schwarzenegger, Sylvester Stallone, Tom Cruise, and Tom Hanks were demanding $20 million per film and getting it. Eventually Julia Roberts became the first woman to hit this magic mark, and Denzel Washington became the first African-American. The price tag, depending on the expectations of the film, eventually went up to $25 million and beyond.

A single film by one of these superstars was more money than Clark Gable, Henry Fonda, Spencer Tracy, Katharine Hepburn, Bette Davis, and Gary Cooper made in their combined lifetimes. For most of their careers these stars were contract players for major studios and made two or three films a year for a generous salary. But in the Studio Era, the mere suggestion that one of these stars should receive a percentage of the

Die Hard (1988) directed by John McTiernan, starring Bruce Willis, Bonnie Bedelia, Reginald VelJohns, and Alan Rickman, gave a new spin on disaster genre movies like **The Poseidon Adventure** and **The Towering Inferno.** In **Die Hard** the chaos was caused by super thieves that were willing to destroy a high-tech building to get what they wanted. Soon, with sequels and copycat thrillers, airports, trains, ships, New York City, and Air Force One *were not safe from terrorists and crooks.*

gross box office revenue would have been reason for Louis B. Mayer to throw them off the lot. Elizabeth Taylor became the first star to receive a million dollars for *Cleopatra.* However, before this, James Stewart, William Holden, Kirk Douglas, and Burt Lancaster had worked out deals that allowed them a percentage of the net profits if the film was successful. Holden negotiated one of the first contracts for gross profits and received an upfront salary of $250,000, plus ten percent of the gross for *The Bridge on the River Kwai,* for which he eventually received $50,000 a year for the remainder of his life.

In the 1980s, simply being a movie star was not enough. This was the era of corporate greed and outlandish deals, so a new category had to be created and the "superstar" was born. This title rarely had anything to do with talent. It was all about box office clout. These stars became identified with action blockbusters like *Top Gun, Predator, Rambo: First Blood Part 2, Terminator 2: Judgment Day,* and the *Lethal Weapon* and *Die Hard* series. Often these superstars, in between blockbusters, would take on serious acting roles in films like *The Color of Money, Rain Man, Pulp Fiction, Tequila Sunrise,* and even *Hamlet.* Tom Hanks received superstar status after a long series of successful movies that include *Big, A League of Their Own, Sleepless in Seattle, Forrest Gump, Toy Story,* and *Saving Private Ryan.* Julia Roberts would join this male dominated club seven years after *Pretty Woman* with a string of romantic hits that include *My Best Friend's Wedding, Stepmom, Notting Hill, Runaway Bride,* and *Erin Brockovich.*

The problem with superstar paychecks is that it does not guarantee box office success or that the film will be any good. For example, *The Last Action Hero, Mary Reilly, Hudson Hawk, Judge Dredd,* and *Far and Away* all failed at the box office, but the producers continue to gamble on the overall track records of certain stars. There have been several attempts to cut back on this big-budget spending, most notably with British producer David Puttman who was made head of production at Columbia in 1986 after the artistic and critically acclaimed hits *Chariots of Fire, Local Hero,* and *The Killing Fields.*

Puttnam tried to reform Hollywood by declaring that he refused to offer sky high salaries and would do away with expensive perks like new cars as gifts, personal chefs, and footing the bill for the small armies of personal attendants that accompanied many stars. He proposed that all Hollywood producers get back to the business of making serious movies with important themes—the kind of movies audiences *should* see. Puttnam's time inside the Hollywood movie industry was short-lived. His contract was terminated the following year, not because of his philosophy of moderation, which most people agreed with, but after committing the sin of green lighting a series of expensive box office failures.

The Star System—Ghosts from the Past

It is remarkable how many of the movie stars that got their start during the New Hollywood era of the 1970s are still active over thirty years later. This impressive list includes Dustin Hoffman, Gene Hackman, Meryl Streep, Clint Eastwood, Al Pacino, Robert De Niro, Jon Voight, Burt Reynolds, Harrison Ford, Jack Nicholson, Robert Redford, Richard Dreyfuss, Michael Caine, Goldie Hawn, Susan Sarandon, Shirley MacLaine, Woody Allen, Michael Douglas, Jodie Foster, Warren Beatty, Sally Fields, James Caan, Robert Duvall, Diane Keaton, Eddie Murphy, Sissy Spacek, Christopher Walken, and the seemingly unstoppable Paul Newman. The new millennium would find all these stars still making movies, and, if possible, becoming better with a touch of graceful age.

The Silence of the Lambs (1991) directed by Jonathan Demme, starring Jodie Foster, Anthony Hopkins, Scott Glenn, and Ted Levine is that rarity, an almost perfect film, and one of the most intelligent and best acted suspense thrillers ever made. But like all successful things in Hollywood, a stampede of imitators followed, producing more serial killers on screen than have ever existed in real life. A few spin-off films include **Se7en, Kiss the Girls, Copycat, The Stepfather, Scream, Taking Lives, Sleepy Hollow, Twisted,** and **Hannibal.** And this is not counting all the television movies and series.

A few of the leading ladies from the Studio System had long careers after the age of forty, including Katharine Hepburn, Marlene Dietrich, and Bette Davis, but there has always been a double standard between leading men and women in the movies. Romantic roles quickly disappear for women who have reached this mid-point in their lives. After this they either faded away like young Norma Desmonds or they made a transition into a limited category of parts ranging from idiot mothers, defiant older women, zany comic sidekicks, or the rare historical figure. Many of the A-list actresses from this era, such as Goldie Hawn, Susan Sarandon, Jodie Foster, and Sally Fields were able to have longer careers because they aggressively campaigned for roles or started their own production companies to develop films they wanted to make.

The key to longevity for both men and women who got their start in the 70s was, as the man says on Turner Classic Movies, they are "damn good actors." Meryl Streep proved this time and again with a string of artistic triumphs, including *The French Lieutenant's Woman, Sophie's Choice, Silkwood, Out of Africa, Ironweed, Postcards from the Edge,* and *The Hours.* Streep talks with pride about a letter she received early in her career from Bette Davis, who congratulated her on a performance, and then concluded with the wish that they do a film one day together. Unfortunately, this never happened, but from the way Streep told the story it was obvious that she deeply respected Davis as one of the women who put up a fight so that a later generation of actresses would have better roles to play.

In the following decade, the list of outstanding actors grew to include Tom Hanks, Denzel Washingston, Daniel Day Lewis, Julia Roberts, Robin Williams, Glenn Close, Michelle Pfeiffer, Kevin Coster, Richard Gere, Kathleen Turner, Geena Davis, Anthony Hopkins, Anjelica Huston,

Meg Ryan, Sigourney Weaver, Whoopi Goldberg, Morgan Freeman, Ben Kingsley, and Holly Hunter. There was a greater diversity of female and ethnic movie stars. What was once referred to as Women's Films was making a long overdue comeback, but these contemporary ladies were tough in unexpected ways. Not since the Pre-Production Code Era had women's issues been so frankly dealt with.

Julia Roberts was a happy and very shrewd hooker (*Pretty Woman*), Meg Ryan faked an organism in a deli (*When Harry Met Sally*), Glenn Close was a one-night stand that would not be ignored (*Fatal Attraction*), Kathleen Turner seduced her way to riches (*Body Heat*), and Anjelica Huston proved that a smart mother would do anything to survive, including killing her own son (*The Grifters*). Perhaps more significantly women were beginning to take over male roles. Sigourney Weaver incinerated ugly space monsters (*Aliens*), Holly Hunter was a smart TV producer (*Broadcast News*), and Geena Davis and Susan Sarandon became modern day outlaws in a feminine twist on the old buddy system (*Thelma and Louise*). After *Erin Brockovich,* the story of a mother with three children who topples a corporate giant, Julia Roberts became the first woman to receive $20 million per picture, a financial highpoint that had been dominated by her male counterparts.

Starting in the early '80s, women fought for greater artistic control as directors and producers. The American Film Institute started a program for women directors, and Lee Grant, who has been blacklisted for most of her career, became one of the leaders. Amy Heckerling directed the low-budget hits *Fast Times at Ridgemont High* (1982), *Look Who's Talking* (1989), and *Clueless* (1995). Martha Coolidge made *Valley Girl* (1983), *Rambling Rose* (1991), and *Introducing Dorothy Dandridge* (1999). Jodie Foster, after winning Academy Awards for *The Accused* (1988) and

Silence of the Lambs (1991), stepped behind the camera for *Little Man Tate* (1991) and *Home for the Holiday* (1995).

Penny Marshall began as an actress on the television sitcom "Laverne and Shirley," where she got the opportunity to direct. She then made a series of box office hits that have yet to be equaled by a woman director, including *Big* (1988), *Awakenings* (1990), and *A League of Their Own* (1992). She then turned to producing with *Cinderella Man* and *Bewitched* (both 2005). Dawn Steele became the head of production at Paramount, producing *Top Gun* and *Fatal Attraction*. She was removed from this position while in the hospital giving birth to her daughter. In 1987 she was made president of Columbia, the first woman to run a major studio, putting into production *When Harry Met Sally, Postcards from the Edge,* and *Awakenings.* Sherry Lansing was the producer of *Fatal Attraction, The Accused,* and *Black Rain,* then in 1990 became Chairman of Paramount Pictures, a position she held for fifteen years.

As the end of the millennium drew to a close there were a number of polls to acknowledge who were the greatest of the twentieth century. Humphrey Bogart, who died in 1957, won a close race with Cary Grant to become the male movie star, and Katharine Hepburn, with no competition, was voted the female star of the century. Hepburn passed away in 2003, at the age of ninety-four. Harrison Ford won the honor of being the box office champion because of the *Star Wars* trilogy, the *Indiana Jones* series, and such blockbusters as *The Fugitive, Air Force One,* and *Clear and Present Danger.* And Alfred Hitchcock, who never won an Oscar, was voted best director.

In a category that is uniquely his own, Tom Hanks holds the dubious honor as being the most unlikely superstar. His career started with the short-run television sitcom "Bosom Buddies" (1980), followed by a string of moderately suc-

cessful but mostly forgettable comedies, like *Splash, Volunteers, Bachelor Party, The Man with One Red Shoe, Volunteers,* and *The Money Pit.* In 1988, he landed the lead in *Big,* playing a confused boy who magically overnight grows into the body of an adult. Then in 1992, starting with *A League of Their Own,* he starred in an unprecedented series of films that topped the international $100 million mark, including *Sleepless in Seattle, Philadelphia, Forrest Gump, Apollo 13, Toy Story, Saving Private Ryan, You've Got Mail, The Green Mile, Toy Story 2, Cast Away, The Road to Perdition,* and *Catch Me If You Can.* Hanks became the only superstar of his era who did not achieve this status because of fast-paced action films, but, like James Stewart, to whom he is often compared, he got there by plain old great acting.

Undoubtedly for a long time to come there will be the temptation to compare current stars with the movie stars of the Studio Era, who were part of the original Star System. Like ghosts from the past, each new generation of stars are compared to Bette Davis, James Stewart, Katharine Hepburn, James Cagney, Spencer Tracy, Jean Harlow, Humphrey Bogart, Cary Grant, Gary Cooper, Clark Gable, John Wayne, and more recently Marlon Brando, James Dean, and Marilyn Monroe. These early stars were complete originals, and with the help of the old Hollywood publicity machine and a legacy of remarkable films they became true legends.

The comparison of modern stars to these "immortals of the cinema" has more to do with the types of films they made than similarities in general appearance. Hollywood studios mass produced genre films and it is the association with these films that endures. Though later in his career James Stewart played a few characters with dark souls, he is most identified with parts that were once considered All-American in nature—honest, forthright—not a lady's man but a good soul that ladies liked, someone that people enjoyed to be around (on and off screen), and who had a simple, folksy humor. One of Stewart's early hits was *The Shop Around the Corner* (1940), and when it was remade fifty-eight years later Tom Hanks was the ideal actor for the role.

James Cagney was short but tough as a bulldog. There was a special charm about Cagney, who could smash a grapefruit in Mae Clarke's face and still have audiences like him. The fearless attitude he brought to gangster movies in the 30s became a trademark of the genre, evident forty years later with Al Pacino in *The Godfather* and *Scarface.* Meryl Streep does not resemble Bette Davis, but Streep tenaciously latches onto roles where the character is flawed—the kind of roles Davis loved to play. If any studio is foolish enough to do a remake of *All About Eve,* then the only logical reason is because Streep might be available. And the list goes on. Gene Hackman has been compared to Spencer Tracy, Harrison Ford to Gary Cooper, and Michael Caine to Archibald Leach (also known as Cary Grant).

The genre films were created around certain stars and character actors. They naturally had the advantage of being there first, but they also put an indelible mark on these genres. Writers and directors found a good fit for certain stars and built around their real-life characteristics. And the studio moguls, who had complete control of their stars' careers, used them over and over again in certain genre pictures. Cagney played so many tough gangsters that when he got a chance to tap dance in *Yankee Doodle Dandy* the Academy gave him an Oscar.

The Star System—The Brat Pack

In the early '80s a series of low-budget motion pictures aimed at the youth market introduced a group of baby-faced actors who quickly became known as the "Brat Pack," a humorous pun on the "Rat Pack" with the ultra-cool Frank Sinatra,

Top Gun (1986) directed by Tony Scott, starring Tom Cruise, Kelly McGillis, Anthony Edwards, Vil Kilmer, and Tom Skerritt, produced by Jerry Bruckheimer and Don Simpson. Starting with **Flashdance,** this production team had tapped into the impact that MTV was having on young viewers with rapid-paced editing to the tempos of popular songs. Rock 'n' roll, sex, and jets made **Top Gun** a huge box office hit, but this dynamic use of music and editing was really a return to silent movies like **Potemkin** and **Wings.** After sound arrived, cameras became big and heavy, taking the mobility out of motion pictures. Starting in the 70s, cameras like the light-weight Panaflex allowed for faster setups and shooting in confined areas. This eventually brought back the kind of exciting filmmaking that had disappeared from the movies for fifty years.

Dean Martin, Sammy Davis Jr., and Peter Lawford. This new crop of actors was cool in a very different way. They reflected the aggressive, independent, and spoiled attitude of what would be labeled by writer Tom Wolfe as the "Me Decade." These children of social-climbing, status and money oriented parents (also referred to as Yuppies) became known as Generation X.

Taps (1981), directed by Harold Beckher, and *Fast Times at Ridgemont High* (1982), by Amy Heckerling, brought attention to Sean Penn, Timothy Hutton, Jennifer Jason Leigh, and Tom Cruise. In 1983, Francis Ford Coppola made two films based on the novels of S. E. Hinton, *The Outsiders* and *Rumble Fish,* that starred newcomers Matt Dillon, Patrick Swayze, Rob Lowe, Emillo Estevez, Nicholas Cage (Coppola's nephew), Mickey Rourke, Laurence Fishburne (who had been in *Apocalypse Now*), and Tom Cruise. Then in 1985, *The Breakfast Club,* directed by John Hughes, and *St. Elmo's Fire,* by Joel Schumacker, made overnight celebrities of Demi Moore, Judd Nelson, Ally Sheedy, Andie MacDowell, Andrew McCarthy, Anthony Michael Hall, and Molly Ringwald.

Out of this pack only Tom Cruise and Nicholas Cage emerged as superstars, in part because they became associated with the fast-action, thrill adventure films of Jerry Bruckheimer and Don Simpson (who passed away in 1996), like *Top Gun, Days of Thunder, The Rock* and *Con Air.* They balanced their careers by doing big-budget blockbusters mixed with small, personal films, much the same way the old Studio Moguls did for their stable of movie stars. Cruise is a good example of a model modern day movie star. He wears two hats, one as a chance taking actor in *Born on the Fourth of July, A Few Good Men, Interview with a Vampire, Jerry Maguire, Magnolia, Eyes Wide Shut,* and *Collateral,* and the other as a high-profile actor/producer with *Mission Impossible, Minority Report, The Last Samurai,* and *War of the Worlds.*

A continuing constant in the discovery of new, young talent was from *Saturday Night Live,* which, for three decades, produced an outstanding number of performers who went on to become major box office movie stars. The model for SLN was Sid Caeser's "Your Show of Shows," which was a fixture on Saturday nights during

the early years of television. The alumni from SLN is truly impressive, starting with Dan Aykroyd, Chevy Chase, John Belushi, Bill Murray, and in the following years by Eddie Murphy, Billy Crystal, Martin Short, Christopher Guest, Robert Downey, Jr., Dana Carvey, Phil Hartman, Dennis Miller, Chris Rock, Chris Farley, Mike Meyers, Adam Sandler, and Will Ferrell.

The Star System—The Actor as Producer

By the 1990s, major stars had become far more than internationally known actors. They were a corporation and production company, with a long line of agents, managers, media advisors, and lots of lawyers. With the exception of Cary Grant, movie stars during the '30s and '40s remained at one studio, signed to well-paying long-term contracts. This began to change in the '50s when stars like James Stewart, William Holden, and others negotiated percentages and backend deals for their acting services, but the thought of being a producer on a film was not of interest to them. With the studios in decline, producers spent every hour they were not asleep searching for money. A star might agree to a picture in advance to help the producer secure the necessary funding, but otherwise they would show up on the first day of shooting and be treated like royalty.

In 1957, Henry Fonda shared production credit on a little film made from a television drama called *12 Angry Men,* directed by Sidney Lumet, and written and co-produced by Reginald Rose. In later years, Fonda said he made more off this movie than all his others combined. Ten years later, Warren Beatty produced *Bonnie and Clyde,* followed by *Shampoo, Heaven Can Wait* and *Reds.* During the '70s, many of the studios had made financial comebacks and were offering actors picture deals where an actor would agree to make a certain number of films for a particular studio, which was really a long-term contract in disguise. This was a director's era, and since the average film was shot for less than a million dollars, the director often served as the producer.

During this time actors like Clint Eastwood and Warren Beatty began to step behind the camera and direct as well as act. Charles Chaplin and Buster Keaton had directed their own silent films, but sound offered a multitude of different problems. Orson Welles had done this with *Citizen*

Unforgiven (1992) directed by Clint Eastwood, starring Eastwood, Morgan Freeman, Gene Hackman, and Richard Harris, is a king of personal swan song to the American Western. Eastwood had kept David Webb Peoples screenplay under option for years, until he became the right age to play William Munny. There was a dramatic change in the Western genre starting in the '60s. Movies like **Fistful of Dollars** and **The Wild Bunch** turned away from the traditional "good guy" that had been associated with John Wayne, Hopalong Cassidy, Gene Autry, and Roy Rogers, and introduced the unpredictable anti-hero. With **Unforgiven,** Eastwood took his dark character to the extreme, where the obsession with killing had changed him into a force of violence.

Kane and *The Stranger,* Laurence Olivier with *Henry V* and *Hamlet,* and Robert Montgomery with several film noirs, including *Lady in the Lake* and *Ride the Pink Horse.* With the exception of *Henry V,* none of these films were particular successful.

In 1971, Clint Eastwood changed everything for actors working behind the camera when his first feature, *Play Misty for Me,* scared up huge box office returns. Beatty's first venture as a director also resulted in a box office hit with *Heaven Can Wait* (1978), but his next film, *Reds* (1981), which won him an Academy Award for Best Director, struggled at the box office. Beatty would direct only four films, whereas Eastwood played dual roles as actor and director over twenty-five times, including for *Unforgiven* (1992) and *Million Dollar Baby* (2004). Other stars like Tom Hanks, Jodie Foster, Kevin Costner, Robert Duvall, Denzel Washington, Al Pacino, and Paul Newman have tried their hand at directing. Besides Eastwood, the most successful actor-directors have been Woody Allen and Robert Redford. As Michael Caine once observed, a successful actor can make two and sometimes three films during the time a director makes only one—and for a lesser salary.

By the 90s and into the twenty-first century, the cost of production had increased by more than 300 percent since the eve of the New Hollywood. For example, *Play Misty for Me* was shot in twenty-one days for less than a half a million dollars. Thirty-three years later, *Million Dollar Baby* was shot over thirty-seven days and cost thirty million dollars. These skyrocketing costs have forced many stars to create production companies and develop their own motion picture projects. In the past if stars believed in a film, they would fight for it and make upfront concessions, like Sidney Poitier with *Lilies of the Field* or Nicholas Cage with *Leaving Las Vegas.* Today a star has to fight for almost every film. The process of moviemaking has slowed down be-

cause of soaring budgets, and it can take two or three years for a movie to go into production, even with a major star attached. After the giant success of *Titanic,* practically every producer in the world wanted to work with Leonardo DiCaprio, but it still took him seven years of constant pushing to get *The Aviator* made.

Stars like Cary Grant, James Stewart, Katharine Hepburn, James Cagney, John Wayne, and Bette Davis made sixty, seventy, or more films during their careers. Even Gene Hackman, Dustin Hoffman, Michael Caine, Susan Sarandon, and Clint Eastwood have made more than fifty movies, and are still working. These actors began at a time when it was still possible to make two and sometimes three feature films a year. In recent years the process of filmmaking for young movie stars is like walking a tightrope without a net. There is no studio mogul to give a new actor the old fashioned star treatment.

Many of the stars of the twenty-first century have almost become miniature studios. They employ large staffs to develop projects, hire writers, and woo A-list directors. Because of the high salaries, they have become corporations to avoid losing millions in taxes. These corporations can be development companies that literally sort through thousands of screenplays and pitches to find that next perfect motion picture, or they can be production companies actively involved in the entire filmmaking process. The current list of desirable stars includes Brad Pitt, Drew Barrymore, Johnny Depp, Jim Carrey, Will Smith, Kate Winslet, Sandra Bullock, Nichole Kidman, Leonardo DiCaprio, Kevin Bacon, Cate Blanchett, Russell Crowe, Gwyneth Paltrow, Antonio Banderas, Benicio Del Toro, Renee Zellweger, Naomi Watts, Jude Law, Reese Witherspoon, Angelina Jolie, Charlize Theron, Hilary Swank, and Uma Thurman.

Like at the end of Alfred Hitchcock's *Strangers on a Train,* many young stars feel like

they are on a merry-go-round that is out of control. A couple of unsuccessful films and their names quickly fall off the entertainment radar. Hilary Swank won an Academy Award for *Boys Don't Cry* but made nine films before scoring another critical knockout with *Million Dollar Baby* five years later. Charlize Theron was in twenty films and felt trapped and typecast as the pretty face in most of her underwritten parts. She then took a huge chance and made *Monster,* based on the true story of the very unglamorous serial killer Aileen Wuornos. Theron was one of the producers and her gamble paid off with a Best Actress Oscar. After this she was finally looked upon as a box office star and offered quality films. A good example of the unpredictable nature of modern stardom is Brad Pitt. The media immediately considered Pitt a star after his supporting role in *Thelma and Louise.* But despite playing leads in such cult hits as *Se7en, Twelve Monkeys, Fight Club,* and *Snatch,* he would make twenty-seven films before the motion picture industry acknowledged his superstar status because of the opening weekend box office returns on the big budgeted epic *Troy.*

Arnold Schwarzenegger in the 22nd Century!

In the Golden Era of the Studio System the movie star would shoot a motion picture for two or three months and then show up at the gala premiere in Hollywood or New York. But the contractual obligations of stars have changed dramatically, starting in the mid-80s. With the long post-production periods and the extensive use of computer generated imaging, actors are regularly called back for added shooting or pick-up months after a film production has wrapped. Movie contracts are now negotiated with agreements regarding commentaries and behind-the-scenes documentaries for DVD extras. Under the rules for the Screen Actors Guild (SAG), actors receive residuals when a film is shown on cable, network television, airlines, hotels, festivals, college campus, and clips from a movie are paid for by the foot for specials and documentaries.

The re-creation of a star's image has become a valuable commodity for merchandising, whether it is on a McDonald's Happy Meal or an action figure for *Lord of the Rings.* The estate of Charles Chaplin kept a careful guard on his likeness, rent-

*Terminator 2: Judgment Day (1991) directed by James Cameron, starring Arnold Schwarzenegger, Linda Hamilton, Edward Furlong, and Robert Patrick, took the use of CGI effects to the next level, making it possible for **Jurassic Park** two years later. Cameron stepped full-force into special effects action adventure films with The Terminator, eventually making **Aliens, The Abyss, T2, True Lies,** and **The Titanic.** In the Studio Era many directors made a film a year over three or four decades. With the complexity of modern films, and the time consuming task of finding funding, Cameron represents the new era where directors might make less than an dozen films in their careers.*

ing the use of his image out to corporations like IBM for millions of dollars. But for decades popular icons like Buster Keaton, Shirley Temple, Boris Karloff, and The Three Stooges never received a penny outside of the one-time-only salaries they received to appear in movies. They were under long-term contracts and legally the property of the studio. It was not until the nostalgia craze for Hollywood artifacts and memorabilia hit in the 1980s that senior stars or their estates realized that studios like Universal, 20th Century-Fox, Warner Bros., and MGM were making millions for the use of images that dated back forty years. In a landmark lawsuit, the families of The Three Stooges were able to gain control of the rights to license these images. As a sad irony, The Three Stooges and other deceased stars are making more money today than they did when alive.

What is rapidly becoming the most important and profitable market for stars outside the movies is computer games. The recreation of a star's likeness as a character in a film franchise can mean hundreds of thousands of dollars, and the price scale is constantly rising. Many games have live action sequences, which are actually carefully produced mini-movies, and stars are contracted to appear in these like they would in a feature film or television show. The sales of computer games are now out-grossing the yearly box office revenue of movies. With films like *The Matrix Reloaded* and *Matrix Revolutions,* the movies almost become long commercials to sell the computer games. To appear in these games a star will go through a process of laser sculpturing to get the exact dimensions of their facial features. These images can then be used in games or potentially appearances in motion pictures. As director James Cameron has suggested, Arnold Schwarzenegger could still be making action movies in the twenty-second century.

The Dark Side of the Star System

Federico Fellini's *La Dolce Vita* introduced the term "paparazzi," taken from the character Paparazzo. Considered by most stars as stalkers with cameras, these freelance photographers make a living catching a momentary glimpse into the private lives of the rich and famous. Since the silent era, movie stars have had to deal with fans and probing photographers. William Randolph Hearst was responsible for popularizing the term "yellow journalism" and quickly discovered that his readers could not get enough of stories about movie stars, especially if a scandal was involved. Eighty years later the public's appetite for juicy stories about movie stars has only compounded. A celebrity wedding becomes a swarm of helicopters. A female star who puts on a few pounds will find her posterior spread over the cover of magazines at checkout stands. And for over a year the lead story around the world was the O. J. Simpson trial.

After the murder of John Lennon in 1980, celebrities became frightened for their safety. In 1981, with John Hinkley Jr.'s assassination attempt on President Reagan that was, in a bizarre way, connected to Jodie Foster and the Martin Scorsese film *Taxi Driver*, this fear proved to be justifiable. Today stars have body guards around the clock. Despite this twenty-four-hour surveillance, an assailant broke into George Harrison's mansion and stabbed him. A woman who felt she was destined to become Brad Pitt's bride was found living in his Los Angeles home. And hiding outside Steven Spielberg's Pacific Palisades estate, a man was arrested and then confessed he was trying to kidnap and torture the famous director. There is the constant fear by most stars that some person is watching their image in a darkened theatre and will for some unknown reason make a deadly connection with them.

The personal identification with the light-and-shadow people on the large screen has intensified enormously over the decades. For many stars it has turned into a continuous and real film noir nightmare. After a hundred years, the original wonderment of watching flickering images on a screen has worn away. The sense of connection with stars is visually reinforced in almost every venue of American society and countries around the world.

Blockbuster action star Arnold Schwarzenegger was elected Governor (or "Governator") of California. Female stars are critically and sometimes harshly reviewed on what they wear to special ceremonies. Like small children with invisible friends, stars have become the imaginary companions to an increasingly large number of people. Most of these whimsical, long distance relationships are positive and harmless and actively promoted by the motion picture industry. Employees gathered around the water cooler will talk about Clint Eastwood like they were personal friends, or argue that Marty Scorsese should have won his Oscar for *Raging Bull* over *Ordinary People*.

With the population of the world exploding (there were less than one billion people on the planet at the start of the twentieth century), the movie star is the one glamorous profession that seems remotely obtainable to millions of people. Over the last century the royal families that once dominated history have almost disappeared, and the tragic death of Princess Diana seems to have brought this long chapter in history to a close as far as the public's curious fascination. The early motion picture industry was astonished when an unnamed actress given the nickname of "The Biograph Girl" was suddenly receiving thousands of fan letters. This love of movie icons has only intensified as it continues into the new millennium.

During an Academy Award ceremony, comedian Chris Rock joked that there are movie stars and then there are "very popular people." Part of the allure of the stars from the Studio System is that the real private lives of movie stars were kept a secret and a mysterious and sophisticated image was manufactured for the public in fan magazines. Starting in 1978, with the tell-tale book *Mommie Dearest* about Joan Crawford, which followed closely on the heels of *All the President's Men* detailing the fall of Richard Nixon, there was nothing sacred about public figures. With the passing of Katharine Hepburn, there are now no living legends from this Golden Era.

But the modern media machine builds up each new, young actress as if she were the successor to Hepburn or other screen luminaries, only to tear her down with an almost unrelenting search for anything that might hint at misbehavior. As a indication of the high pressure placed upon the chosen few that make it to leading roles on the big screen, eighteen-year-old Keira Knightley, who had stardom thrust upon her after the highly successful *Pirates of the Caribbean: The Curse of the Black Pearl* (2003), was considering retirement after only two years of being pursued by paparazzi headhunters and suffering a complete loss of privacy. Never has the price of fame taken such an exhausting personal toll on those that pursue the Hollywood dream, and the hunger to know all about the lives of people in the spotlight only seems to grow each year.

Major Changes in Film: Hollywood Sails On

In *The Wizard of Oz*, Dorothy and her friends are afraid of "lions and tigers and bears" in the dark forest. As unlikely as it might seem from today's vantage point, the film industry was frightened by the unknown forces of cable television and videotape. These nervous concerns mirrored the financial fears of Thomas Edison at the very dawn of motion pictures: The public would grow

Toy Story (1995) directed by John Lasseter, with the voices of Tom Hanks and Tim Allen. This is the feature that made computer animation, as Woody might say, a force to be reckoned with. **The Jungle Book,** released in 1967, was the last full-length animation production that Walt Disney was involved in. In the years following his death, animation had an uneven track record with audiences. Then in 1989, with the release of **The Little Mermaid,** under the new management at Disney, animation made a major comeback, continuing with **Beauty and the Beast** and **The Lion King.** But meanwhile, in 1985, John Lasseter had been part of the team at LucasFilm Ltd. that created the Stain Glass Knight for **Young Sherlock Holmes,** which was the first computer-generated animation. The following year Steve Jobs purchased the company and incorporated it under the name Pixar. The first short, directed by Lasseter was "Luxo, Jr.," followed by "Tin Toy," which won the Oscar as best animated short film. **Toy Story** would be given a special achievement Oscar. In 2001, the Motion Picture Academy created a category for animated feature film.

tired of seeing too many movies. This was the fear of projecting movies on a screen for large audiences, and it was the same fear when television captivated families in their own living rooms. It took the powerbrokers of Hollywood almost a century to finally realize that public's appetite for film was almost insatiable.

Starting in the late 1940s, for three decades people adjusted their lives around the three networks—ABC, NBC, and CBS—for news, movies, and popular television shows. Instead of destroying Hollywood, classic movies from the Studio Era became a vital part of the success of early television. These old movies filled in the late night hours, provided screams for the Friday evening creature features, and were a kind of surrogate babysitter for kids on Saturday mornings. Whenever a recently made film was premiered, it became a national event. By the '70s everything had turned around. More television shows were being shot on Hollywood sound stages than motion pictures. Studios were cutting back on film production and increasing production on sitcoms and hour-long dramas. Then, just as Hollywood executives felt like they had gotten the upper hand on network television, cable came rolling in.

Cable Television

The birth of cable television goes back to June 1948 when John Walson, a small town appliance store owner, had troubles selling television sets because of poor reception in the mountains of Pennsylvania. To get reception to these remote home he used coaxial cable and self-manufactured "boosters" or amplifiers to bring CATV (Community Antenna Television, as it was originally called) to people that bought televisions from his store. Later Milton Jerrold Shapp, who eventually became governor of Pennsylvania, developed an improved system known as MATV (one master antenna) that used boosters capable of carrying multiple signals.

However, it would not be until November 1972 that pay television was officially launched. Home Box Office, or HBO, became the first successful pay cable service in the United States. There were only a few hundred curious viewers in the early days, but through the support of Time, Inc., HBO's parent company, it became the first programming service to use a satellite for distribution. This allowed HBO's signal to be available to cable operators across North America. With this potentially wide financial base, HBO needed programming that would make it distinctive from the major networks. It went after newly released motion pictures, offering the studios lucrative deals to air these star-filled features first, thus putting the networks into second place. HBO's biggest advantage was that movies could be shown without commercial interruption. Television sets had become larger and all stations were now in color. Now by paying a few dollars each month, people could see movies from start to finish without, complete and uncut, a multitude of distracting advertisements.

Soon there was Showtime which was quickly followed by enterprising local stations that got on the cable bandwagon. Then in 1980 the Turner Broadcasting System launched CNN, the first twenty-four-hour all-news network. Originally called "Turner's folly," CNN soon had millions of viewer and changed the way the world got its news. But all this scared Hollywood. The old myth that people would get burnt out on movies was part of the concern. The biggest fear came from the motion picture guilds, especially the Screen Actors Guild that believed this was another way for producers and distributors to get rich and the actors to be cut out of profits. For years the industry was in turmoil over the wildfire expansion of cable television, but new contracts were negotiated that gave actors, writers, directors, and others a handsome percentage of this newfound money machine.

Originally most cable stations showed movies and reruns of televisions shows. A&E was primarily the mystery station, showing "Columbo" and other popular classics of the genre. Then once a week they had an hour-long biography of a famous person. Within a few years it became known as the Biography Channel with a new biography each night. This later spun off the History Channel. The SciFi Channel began the same way, showing reruns of "Star Trek" and "The Twilight Zone." Soon they began to produce their own miniseries and then series like "Farscape" and "Stargate" that drew new viewers by the millions. Instead of being the caretakers of old network television series, cable stations have become power producers of original programs, providing a wealth of opportunities for actors, writers, and directors—completely the opposite of what Hollywood was frightened of in the early days.

Videotape and DVDs

Videotapes caused the same fear cycle in Hollywood that cable did. Once again there was the concern that people would grow weary of movies. The concept that someone would purchase a tape and watch it over and over again seemed absurd. There was also the legitimate fear that people would record shows off of televisions, which the industry saw as outright theft. And, of course, there were the monetary concerns from the motion picture talent. Betamax was the first into this field, followed by VHS two years later, and thus began a high profile war of who would ultimately control this giant market. VHS soon surprised the Sony system, which use Beta tape, because of a lower price and longer recording capabilities. Despite the fact that Beta had a greater technical superiority, VHS took complete control of the commercial realm, leaving television news for Beta.

The first VHS tapes were as heavy as bricks and cost almost seventy dollars each. Soon rental businesses sprung up and Warehouse, Hollywood Video, Blockbuster, and little boutiques became fixtures for families on the weekends. But as popular as these outlets became, technology was changing at an amazing rate. In September 1995, Sony jointed nine other companies to create a single unified standard for the emerging DVD format. By 2005, VHS tapes were becoming almost extinct in stores, replaced by DVDs with letterbox format, hours of special features, and personal commentaries. And quickly out-grossing the rentals and sales of new movies are video and computer games, which have become a multi-billion dollar business since the start of the new millennium. But video stores are endangered with the rise of mail rental companies like Netflix and the inevitability of pay-per-view that will allow someone to watch any movie they want at anytime. With DVD sales providing the profits for most films, and more homes being converted into personal theatres with surround sound, the fear that people will burnout on watching movies seems to have been laid to rest.

THE AUTEUR THEORY REVISED

Defining the Independent Director

It is impossible to pinpoint when was the last day of the Old Hollywood System, or even the last year for that matter. The problem is defining what this System was, or still is, perhaps. If the System is looked upon as certain studios producing escapist movies in an assembly line fashion, then most of these studios still exist today, including Warner Bros., Fox, Universal, Columbia, and Paramount, and the goal of the movies from these legendary Dream Factories has not changed in almost one hundred years. If the long-term contract with internationally famous movie stars is the identifying factor, then Natalie Wood signed the last of these in the early 1950s; however, the Star System is stronger now than ever before. There has never a single period of time when the old fashioned glamour of movie stars vanished from the public's eye.

Movie moguls are now called CEOs, press agents are referred to as marketing directors, and cinematographers, production designers, character actors, composers, and overworked and underappreciated writers still make films in an assembly line fashion. The difference is they all have agents now and are selective about the movies they get involved with. The death of the Old Studio System might seem like a myth, since there was never a solitary chime at midnight that signaled the end of the old and the start of the New Hollywood. The only telltale signs of this massive but almost invisible transition is the changing role of the director. Not the duties of the director, but the *personal interest* of the director.

The Auteur Theory was formed during the 1950s, the final years when studios could still lock down talent with long-term contracts, and this included most directors. At their core, the prophets of this theory were incurable movie buffs and huge fans of Howard Hawks, John Ford, and Alfred Hitchcock. They admired the mavericks of the Studio System—those men who still put a personal mark on a film during an era when the producer was king. As a devil's advocate, director Sidney Lumet observed that the critics of the French New Wave, who forged the concept of the Auteur Theory, mostly wrote about popular Hollywood escapist trash (Lumet's actual words were much harsher). As Lumet points out, directors like Billy Wilder and William Wyler, whose films often reached the level of high art, were not seriously championed as part of this movement, perhaps because their styles seemed too European in nature.

The Player (1992) directed by Robert Altman, starring Tim Robbins, Greta Scacchi, Fred Ward, Whoppi Goldberg, and Peter Gallagher. After the failure of **Popeye** (1980), Altman spent the next decade making small independent films and directing for television. *The Player* was his triumphant return to Hollywood, despite the fact that it was a very black comedy about the wheeling and dealing of the movie business.

The common denominator of the Auteur Theory is that all these directors, and those of the Silent Era like Charles Chaplin, Buster Keaton, and Harold Lloyd, managed to achieve the freedom within the System to make films that interested them personally. Looking back, these directors were essentially making independent films with studio money. The American Heritage Dictionary defines "independent" as "free from the influence, guidance, or control of others; self-reliant." As long as the movies by these directors made money at the box office, then they were given their independence within the System. However, they were never "self-reliant," because each time they had a failure, like Hawks with *Bringing up Baby* or Hitchcock with *Rope,* they had to play the studio game all over again.

The start of the independent film movement in America is often credited to the low-budget features of John Cassavetes, who was greatly influenced by the directors of the Italian neorealism and the French New Wave. In this movement the word "independent" also means finding outside financing—a film made completely outside of the System. These films, like Cassavetes' *Shadows,* were made for the pure love of filmmaking with no expectation of a large profit. Over

the decades, a philosophical schism evolved as to the true nature of an independent director. Within this blurred, almost indefinable area, lies the true decline of the Old Studio System and the rise of the modern day movie industry.

If there is a date and physical personification of the end of the Old Hollywood, it is when Arthur Krim, Robert Benjamin, and three other top executives left United Artists in 1978 to form Orion Pictures Corporation. They departed over a dispute with parent company TransAmerica Corporation, after United Artists, under their management, had won the Academy Award for Best Picture three years in a row with *One Flew Over the Cuckoo's Nest, Rocky,* and *Annie Hall.* Krim and Benjamin, along with Max Youngstein, took over United Artists in 1950 and introduced a system of producing that immediately changed the movie industry. As Youngstein described it, "the studio would put up half the money, the outside production company would put up the other half, and both sides would split equally." This meant that directors, producers, and stars could make movies that interested them personally with almost complete independence. As long as the films made a modest profit, everyone could keep rolling the dice.

This is where the term "independent" gets its dual meaning. With United Artists, directors like John Huston, Fred Zinnemann, Stanley Kramer, Tony Richardson, Billy Wilder, Woody Allen, and Milos Forman chose the films they wanted to make, and many of these movies were critically acclaimed box office hits. Most of these films were in complete contrast to the big-budget musicals and melodramas coming out of the studios. However, today movies like *The African Queen, High Noon, Judgment at Nuremburg, Tom Jones, The Apartment, Anne Hall* and *One Flew Over the Cuckoo's Nest* are looked upon as financially successful films that set the standards for future films. But it is wrong to assume they were part of the mainstream studio productions. In fact, each of these motion pictures was high risk, shot on a limited budget, and considered a tough sale to audiences. But because they were made in association United Artists, which also produced the James Bond thrillers and action movies like *The Magnificent Seven* and *The Great Escape,* these films are often not considered part of the independent movement that began with Cassavetes.

The majority of films produced through United Artists from 1950 to 1978 were a high wire act over the commercially driven motion pictures from the major studios. They took on themes of prejudice, war crimes, and social reform, and reflected the turbulent times in which they were made more than films from any other studio. During these years United Artists was, to borrow from Gilbert and Sullivan, the very model of a modern major studio. In its relationship with directors, producers, and stars, United Artists was, in many ways, twenty years ahead of its time. By the 1970s, most of the major studios had begun to offer multi-picture deals with independent companies. Up until this time the major studios were often associated with a singular voice. The moguls that stayed in charge for twenty and thirty years gave their studios a look in terms of art

direction and cinematography, a lineup of stars that remained for decades, and specialty films ranging from musicals, comedies, film noir, Westerns, and epics. United Artists had many different voices, depending on who was producing and directing.

After the key executives left United Artists to form Orion Pictures, the new management quickly ran aground by over-spending on productions, which lead to the disaster of *Heaven's Gate.* And though Orion produced quality, award-winning films, including *Amadeus, Platoon, Dances with Wolves,* and *The Silence of the Lambs,* the company was forced into bankruptcy in 1991. A similar fate later happened to Miramax in 2005, a company modeled on United Artists, after the Weinstein brothers ventured away from the low-budget art features and invested in big productions like *Gangs of New York, Cold Mountain,* and *The Aviator,* that struggled to break even at the box office.

The reason it can be argued that the breakup of United Artists in 1978 was the symbolic end of the Old Studio System is because, despite the independent nature of the films, the driving force in these movies was old fashioned storytelling. There was still the tradition of entertaining the audience—the box office philosophy on which Hollywood was built. After the Production Code was replaced with the rating system, the films from United Artists foreshadowed the modern independent movement, especially the off-beat, free-style comedies of Woody Allen. This new movement is often credited with leading to the art house success of Steven Soderbergh's *Sex, Lies, and Videotape* and the rise of Miramax and the Sundance Film Festival.

While the other studios struggled during the 50s and 60s, selling off their back lots and film libraries, United Artists kept rolling along, since it had low overhead and worked in association with different production companies that shared

the risks. By 1978 the major studios that remained in operation after these rollercoaster years all looked like United Artists structurally. When Krim, Benjamin, and the others departed to form Orion Pictures, that was really the last of the old guard associated with the Hollywood Dream Factory.

During the 1980s, without the safety net of a studio like United Artists that straddled both the commercial and independent approaches to filmmaking, directors began to gravitate into three categories: the action directors who continually pushed the boundaries of special effects and stunt work; the directors, who, as George Lucas once described himself, had "earned the right to fail," meaning the studio would occasionally let them take chances because their track records were exceptional (these directors were in mind and spirit closely akin to the old studio directors); and the truly independent directors who struggled to find financing, struggled to get a film made, struggled to find a distributor, and who became associated with an anti-Hollywood style of moviemaking. This new generation of independent directors is debatably the last vestige of the Auteur Theory, adrift in a wide sea of hundred-million-dollar blockbusters.

Old Hollywood K.O.'s the New Wave

There are certain times when an artistic movement seems to explode and then mysteriously disappears. These rare but wonderful moments seem to happen for a variety of reasons that involve politics, social changes, and the right group of people that have merged together under unexplainable circumstances. The one factor can be that a certain city will be fortunate enough to be the home base for this gathering of artists. Athens was such a city in Ancient Greece; Florence during the Renaissance; Paris in the 20s; New York after World War II; and Hollywood in the '70s. However, this last era was a movable feast, as Ernest Hemingway described Paris, or a kind of international Hollywood state of mind. Exceptional filmmaking was happening around the world in the '70s, but the main centers were Hollywood and New York.

By the end of the decade, a battle over cinematic style had been waged. What resulted was an assimilation of the Old Hollywood high quality look combined with the experimental trends of foreign cinema. This gave birth to motion pictures like *Raiders of the Lost Ark, The Terminator,*

Titanic (1997) directed by James Cameron, starring Leonardo DiCaprio and Kate Winslet. At over $200 million, the epic is the most expensive film ever made, but with $1,845 million it is also the highest grossing movie of all time. In today's dollars, the original Titanic cost between $120–150 million to construct. **Titanic** *holds records for being number one on the box office for 15 straight weeks and being listed on the charts from December 19, 1997 to September 25, 1998.*

and *Top Gun* that carried forth the traditions of slick craftsmanship and star power from the Old Studio System but married it with mobile camerawork and rapid editing to give a heightened sense of reality. Compare *The Guns of Navarone* (1961) and *Aliens* (1986), both films about a small group of experts taking on an impossible mission, and it becomes obvious that all the innovations of directors like Jean-Luc Godard, Francois Truffaut, Akira Kurosawa and others have been freely borrowed from to make the ultimate, white-knuckle Hollywood blockbuster. A similar commingling of styles happened during the Silent Era when German Expression found its way into Universal gothic horror movies and later film noir.

Ironically, many of the leading American directors who championed the French New Wave and were heavily influenced by Italian neorealism and the Japanese cinema seemed to have lost their way after their early successes. What is both remarkable and curious is that most of them made movies into the twenty-first century, but never reclaimed that golden touch they possessed in the '70s. William Friedkin, Sidney Lumet, Peter Bogdanovich, John Schlesinger, Milos Forman, Francis Ford Coppola, Hal Ashby (who died in 1988), and even Stanley Kubrick, continued to work and each new film was looked at with hopeful anticipation by critics and fans. But whatever mysterious pixie-dust that might have been in the air during the start of the New Hollywood seemed to have evaporated. Their films were expertly crafted but there was a strange detached quality to them, almost like an old prize fighter boxing shadows to show he can still go the distance one more time.

Following *Apocalypse Now,* Coppola returned to the idea of creating his own studio using the banner of American Zoetrope, but he quickly ran into financial troubles with experimental films like *One from the Heart* and *Hammett.* He became a director for hire on disappointing movies like *The Cotton Club* and *Peggy Sue Got Married,* and when he was almost down and out, he turned to his old friend George Lucas to make the heartfelt *Tucker: The Man and His Dream.* Going against his basic instincts, Coppola wrote and directed *Godfather: Part III,* which has moments that live up to dark magic of the earlier films, and he scored a box office hit with *Bram Stoker's Dracula,* making enough money, he states, to buy another large section of prime land for his winery. In later years, he has served as executive producer on many films, including *The Virgin Suicides* and *Marie-Antoinette,* written and directed by his daughter Sofia Coppola, who has carried on in her father's tradition by winning an Academy Award for her screenplay *Lost in Translation.*

Kubrick made only two films after *The Shining. Full Metal Jacket* has an opening sequence in basic training that ranks as some of Kubrick's most provocative work. However, the remainder of the film is an uneven but fascinating exercise in style. Like most of his films, there are long moments of pure artistic self-indulgence, but the overall effect somehow lodges in the audience's mind for a long time. After spending over a year in production with Tom Cruise and Nicole Kidman, Kubrick died in 1999, shortly before his last motion picture, *Eyes Wide Shut,* was released. The sexually charged feature proved to be a perplexing farewell to moviegoers. He had often commented that he wanted to make a big-budget pornographic film, and *Eyes Wide Shut* suggests he was not kidding.

Kubrick had always enjoyed surprising audiences, so perhaps his greatest conjuring trick was to make a film after his death. For years he had been talking with Steven Spielberg, who considered Kubrick one of his mentors, about a project called *Artificial Intelligence: AI,* based on the short story "Supertoys Last All Summer Long" by Brian Aldiss. He even convinced Spielberg to

put a fax machine in his closet so he could wake up to new notes in the morning. After Kubrick's sudden death, Spielberg wrote and shot the film as a loving tribute to his old friend, based in part on this thick pile of nightly correspondence.

Allen and Scorsese: Carrying on the Auteur Tradition

These directors of the New Hollywood represented not only an exciting new generation of filmmakers, but they were the keepers of the flame for the legendary directors whose body of work formed the basis of the Auteur Theory. However, most of these young men's directorial efforts mirrored the meteor rise and slow decline of Orson Welles, who is best remembered for his early films, instead of John Ford or Alfred Hitchcock who made masterpieces over several decades. Like Welles, many of the movies these directors made at the beginning of their careers have so far endured the test of time. The question today is if any director just getting started can play the moviemaking game successfully enough to amass thirty or forty films that will eventually reflect a refinement of his or her artistic talents over several decades.

There are two directors from the '70s that have had long productive careers, and hopefully prove this longevity of creative fulfillment is possible. They are Woody Allen and Martin Scorsese. Their volume of work reflects a lot of similarities. Both are die-hard New Yorkers who have developed stories about the neighborhoods they grew up in (though obviously from different sides of town). They have a love for small, character-driven films, which appear to be colored by personal experiences and the people they have met over the years. And in many ways they are still kids with cameras, experimenting and approaching each new project with a slightly different style.

During the '80s these two filmmakers did not get mixed up in the special-effects craze, but, like many of the foreign directors after World War II, they stayed in their own little part of the world where they were comfortable and worked on personal projects with low budgets. Orson Welles once sadly observed that he made movies that the general public did not enjoy. Both Woody Allen and Martin Scorsese were fortunate to be critical favorites (most of the time) in an era when critics were influential on what moviegoers saw. Even the failures of these two filmmakers were more fascinating than the majority of the movies

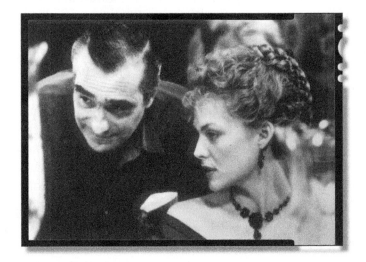

*Martin Scorsese on the set of **The Age of Innocence** (1993) discussing a scene with Michelle Pfeiffer. There have been few directors like Scorsese in American cinema that have managed to have careers of making personal films in a highly commercial industry, and none more successful. What has always been in his corner of the ring is that actors like Robert DeNiro, Daniel Day-Lewis, Leonardo DiCaprio, Paul Newman, Tom Cruise, Cate Blanchett, Sharon Stone, Nicolas Cage, Jodie Foster, and Ellen Burstyn all want to work with him.*

coming out of Hollywood during the Reagan era. And over the years they developed a loyal following and had the occasional breakaway hit. Both men seem to view film as an outlet for personal expression and an art form that requires a lifetime commitment.

After *Annie Hall* and *Manhattan,* Woody Allen made a series of films during the '80s and into the '90s that were playfully original—like he was a vaudevillian performer who pulled hats from a trunk and became different characters. The films ranged from melancholy intellectual comedies to the occasional (and often less successful) psychological dramas. His most notable achievements include *Stardust Memories, Zelig, Broadway Danny Rose, The Purple Rose of Cairo, Hannah and Her Sisters, Radio Days, Crimes and Misdemeanors,* and *Bullets over Broadway.* Allen has been referred to as a "darling" of the Motion Picture Academy, having received twelve nominations for writing, which ties him with Billy Wilder. By the mid-90s, Allen's films lost some of their creative edge, and at times he seemed desperate to rekindle his earlier slapstick comedies like *Small Time Crooks* and *Hollywood Ending.* But one of the things he has never had a problem with is finding a stellar cast to be in his upcoming (and usually untitled) features. Because of Allen's reputation with actors, he is one of the few directors that major stars are willing to work with for minimum scale salaries.

Martin Scorsese is also a director that stars get excited about making a movie with, except his films tear deeper into the human psyche. As a small kid growing up with asthma, he is lucky to have survived, especially if some of the neighborhoods he recreated in *Mean Streets, Raging Bull,* and *Goodfellas* were like his own. No other director has brought a sense of violence so realistically and compellingly to the screen. Sam Peckinpah turned violence into a symphonic bloodbath, and Arthur Penn and Francis Ford Coppola showed what real gunplay was like in a criminal world. But in Scorsese's films the violence erupts unexpectedly, and there is a certain madness about it that at times is both humorous and repulsive. He also brought a hard-edged street language to his films, introducing audiences to the raw way that the citizens of mean streets actually talk.

Where Woody Allen might occasionally stumble with a film, Scorsese falls flat on his face. As a filmmaker he gives the sense of a kid who visits a friend's house, breaks all the toys, and then goes down a block to see another friend. His films reflect a kind of controlled anarchy. His characters are often extraordinarily unlikable, the type a real person would cross to the other side of the street to avoid. And there has never been a clear line of where he was going from one movie to the next. Scorsese has gone from *Raging Bull* to *The King of Comedy* to *After Hours* to *The Color of Money* to *The Last Temptation of Christ* to *Goodfellas* to *Cape Fear* to *The Age of Innocence* to *Casino* to *Kundun* to *Gangs of New York* and to *The Aviator.*

But at the core of each film there is a certain undeniable truth: the kind of truth that used to be part of the daily vocabulary of artists, but has slipped away over the years, with public binge eating of too many formula movies. *Raging Bull,* a movie that only did moderate business at the box office when it was released, was voted the greatest film of the 1980s. And despite losing the Academy Award five times in a row, many critics have anointed Scorsese the greatest director to emerge from the New Hollywood—an honor he deserves if only for the extreme risks he takes as a filmmaker.

The Age of Spielberg

If there is one director that will be looked back upon in fifty years as the most influential of

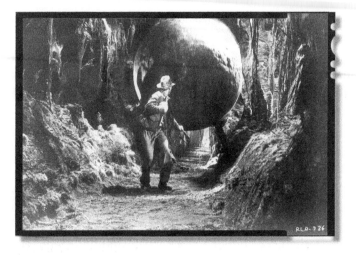

Raiders of the Lost Ark (1981) directed by Steven Spielberg, starring Harrison Ford and Karen Allen. Indiana Jones was an idea that George Lucas had developed from his love of old Saturday matinee serials. When his friend Spielberg was complaining that he wanted to direct a James Bond film, Lucas said he had a better idea, and thus a franchise was born. *Raiders of the Lost Ark* opens with a teaser, or mini-adventure, like the Bond films had become noted for. To out-do Bond, Spielberg and Lucas had Jones foil a murder plot on his life, get covered with spiders, dodge poison darts, out run a giant boulder, and escape from a tribe of spear-carrying natives. After this the James Bond teasers became more elaborate.

his time period, it will most likely be Steven Spielberg. He is one of those directors who has "earned the right to fail," not only because of his unequalled number of blockbuster films; even his films with serious themes have proved to be commercially successful. Spielberg has a common touch with the people. Like Hitchcock, he speaks of his childhood fears and has the ability to bring them to life on the screen; also like Hitchcock, he is very conscious of his audience. One of the reasons Hitchcock was not taken seriously as a great artist of the cinema until late in his life is because his basic instinct was to entertain the ticket buying public; but by building up a truth with audiences over many films, he was able to explore new values in his themes and delve deeper into the dark side of human nature. Spielberg is cut from the same cloth.

By the end of the '70s, there were really only two directors left standing that were ready for the rebirth of Hollywood as the focus of international filmmaking, like it was during the Studio Era—they were Spielberg and George Lucas. They were two self-confessed geeks during an era of drugs, sex, and rock 'n' roll moviemaking. Lucas had

made three feature films and received two Academy Award nominations as Best Director, but because of a dispute with the Directors Guild of America over delaying the credits until the end of the *Star Wars* and *The Empire Strikes Back*, he turned in his membership and focused all his attention to Industrial Light and Magic (ILM) and Skywalker Sound. But in many ways their two career paths combined to make one super director.

Not only did they work together on the Indiana Jones series, but for every film that Spielberg directed or produced, ILM and Skywalker Sound were the companies that provided the movie magic. Thus the high-speed evolution of special effects in the '80s was made possible because of Spielberg's remarkable output and Lucas' visionary technological advances. This lead to creative innovations in sound effects editing and a major leap forward in the art of computer generated imaging (CGI). Spielberg's production of *Young Sherlock Holmes* (1985) had the first extended use of a CGI character in the form of a stained glass knight that jumps out of its picture frame, and just eight years later *Jurassic Park* (1993) swung open the doors to the digital revo-

Jurassic Park (1993) directed by Steven Spielberg, starring Richard Attenborough, Sam Neill, Laura Dern, Jeff Goldblum, and Samuel L. Jackson. **King Kong** was made in 1933, shot frame-by-frame and hand manipulated by Willis H. O'Brien and his team. The film was looked upon as a marvel of special effects for the next seventy years. The achievement of **Jurassic Park,** with its amazingly realistic CGI dinosaurs, is no less a milestone in special effects. But this technical art form has developed so quickly that within only a decade it has become difficult to appreciating how jaw-dropping these effects are when first seen by audiences.

lution by fulfilling an ageless fantasy of bringing dinosaurs alive. Other Spielberg films that ILM created the special effects for were *E. T. the Extra-Terrestrial, Poltergeist, Who Framed Roger Rabbit?, the Back to the Future* trilogy, *Men in Black, Artificial Intelligence: A.I.,* and *War of the Worlds.*

A vitally important partner to the young team of Spielberg and Lucas is composer John Williams, almost fifteen years their senior. Spielberg has commented many times that 50 percent of the success of his films was because of Williams' scores. Just watch the scenes on the water in *Jaws,* the chase sequence in *Raiders of the Lost Ark,* or the opening of *Star Wars* without sound, and then turn the sound up and watch them again. Spielberg's praise for Williams will be immediately obvious. Williams' career goes back to television shows like "Playhouse 90," "Wagon Train," and "Lost in Space," and he had created the musical scores for *The Poseidon Adventure, Earthquake,* and *The Towering Inferno*

before he worked with Spielberg on *The Sugarland Express.* After *Jaws,* Spielberg recommended him to Lucas for *Star Wars.* It is nearly impossible to imagine the films of Spielberg and Lucas without the rich underscoring of John Williams' music. With the exception of Nina Rota, who composed the distinctive and haunting scores for Federico Fellini's movies for almost thirty years, no other composer has had such a long-term relationship with two directors. Bernard Herrmann is identified with Alfred Hitchcock, but they made only seven films together over nine years

The term "movie generation" perfectly applies to Spielberg, perhaps more so than any other director of the New Hollywood. Though he would use the innovations from the New Wave directors to remarkable effect in *Schindler's List* and *Saving Private Ryan,* Spielberg was a loyalist to the Old Hollywood. Before each movie he directs, he talks about watching Frank Capra's *It's a Wonderful Life,* John Ford's *The Searchers,*

David Lean's *Lawrence of Arabia,* and Akira Kurosawa's *The Seven Samurai.* Spielberg memorizes movie sequences like sports fans do stats on players. This gives him a kind of mental encyclopedia of film language to pull from when shooting. *Raiders of the Lost Ark* resembles an old '30s adventure films, like George Stevens' *Gunga Din; Empire of the Sun* has echoes of a David Lean film (who was interested in directing the project at one time); and *Schindler's List* has the appearance of World War II documentaries.

This creative sampling from different directors is part of the linear flow of filmmaking. Every modern director learned by watching the movies of Ford, Hitchcock, Lean and other greats. Spielberg grew up watching these directors solve problems in visual storytelling, and when it became Spielberg's turn, he made these borrowed movie moments distinctively his own. Though his early films were pure bucket-buttered popcorn entertainment that fit the formula of old fashion genres, his later films proved that he was not only one of the exceptional artists of the cinema, but two of his films literally brought powerful new insights to critical moments in world history. *Schindler's List* was a gateway into the horrors of the holocaust that had never been seen

before on the screen in such graphic detail. And *Saving Private Ryan,* for the first time, truly captured the nightmare of the D-Day invasion.

During the 1940s, war movies were meant to be comforting and hopeful, like *A Guy Named Joe* or *Mrs. Miniver,* and later high adventure dramas such as *The Guns of Navarone* or *The Dirty Dozen.* Almost half of Spielberg's movies take place during the war years, and many fall into the cliffhanger excitement of Saturday matinee serials. So audiences for almost fifty years only knew the battles and terror of World War II with movies that deliberately avoided the realism of human sacrifice to save families and loved ones the pain of seeing these moments graphically played out on the screen. While films like *The Deer Hunter* and *Platoon* revealed the brutality of Vietnam, the Great War was still being depicted as action adventure.

Schindler's List and *Saving Private Ryan* brought the hard reality of the war to audiences around the world. Because of these films, there was a renewed interest in the victims of the Holocaust and the citizen soldiers that defeated two of the greatest war machines in military history. The remarkable aspect of the films is the directing style, which seems almost invisible, as

Schindler's List (1993) directed by Steven Spielberg, screenplay by Steven Zaillian, cinematography by Janusz Kaminski, starring Liam Neeson, Ben Kingsley, and Ralph Fiennes. There have been many motion pictures about the victims of the Holocaust, including **The Juggler, Judgment at Nuremberg, Exodus, The Pawnbroker,** and **Sophie's Choice.** But as powerful as these movies are they do not capture the callous brutality of Nazi atrocities towards the Jewish which Spielberg is able to recreate.

it much of the action was talking place as it was unfolding. This is what film is capable of achieving (as many of the directors of the '70s passionately believed)—to change people's thoughts and actions in a profound way.

Without a doubt, there will always be detractors as to Spielberg's style of directing and accomplishments, which thematically are very close to Frank Capra's belief that one individual can make a significant difference. This argument falls into two separate areas of film criticism: the academic side that tends to champion small films that have had only been seen by a limited number of people over the decades, such as *The Bicycle Thief;* and those movies that have been popular with the mass public, like *Saving Private Ryan.* Lillian Gish spoke about the disrespect that theatre people had toward the flickers during the Silent Era, and it is evident that these feelings of artistic pedigree are still floating around after a full century. To rephrase a line from John Huston, old buildings and box office directors become respectable with age. The only way to know what films will be the critical darlings in the future—is to tune in fifty years from now.

Sound Effects Editing and Other Technical Advancements

In the Studio Era, the action directors were Michael Curtiz, William Wellman, George Stevens, John Ford, Howard Hawks, Raoul Walsh, and Henry Hathaway. In what might be called The New Hollywood, Part 2: The Blockbuster Years, it was John Woo, George Miller, Richard Donner, Ridley Scott, John McTiernam, Tony Scott, James Cameron, Steven Spielberg, Clint Eastwood, Oliver Stone, and Quentin Tarantino. After the huge box-office returns on *Jaws, Star Wars, Alien,* and *The Empire Strikes Back,* the studios lost interest in the small personal films that had been the trademark of the 70s and turned to big-budget

special effects movies. In actuality, the studios returned what they had always done best, which was making lavish entertainment motion pictures. Except this was the first time the studios mass produced movies that were almost exclusively high acceleration action stories whose basic ingredients were non-stop stunt scenes and complex visual effects.

In the early '70s, Irwin Allen updated the genre to modern times with *The Poseidon Adventure* and *The Towering Inferno.* Though spectacular when they were released, they are slow paced in comparison to *Jaws* and *Stars Wars,* made only a few years later. One of the most notable differences with these early special effects films is the coverage in the action sequences. Because the cameras were bulky and the lighting time consuming, most of the action scenes in adventure films were shot in masters, meaning the camera was placed several yards away from the action so the actors and stunt people were captured full figure as they moved through the scene. This gave a slightly detached sensation to the drama of the moment. Most war films were shot in black-and-white so actual battle footage could be cut into sequences that filmed on sound stages.

In the '60s and '70s, revival theatres were showing Sergei Eisenstein's *The Battleship Potemkin,* Abel Gance's *Napoleon,* and other silent classics. The rapidly edited action montages in these motion pictures, made almost forty years before, were astonishing compared to contemporary standards. The other important factor in these silent movies was how music underscored the cross-cutting in the battle sequences. A sudden change in the musical mood would instantly alert the audience to new developments and points-of-view so the action choreography was never confusing to the people watching. By the mid-80s a new cable channel called MTV was cutting music videos to the tempos of rock songs,

*Titanic (1997) combined historical events with a love story, which audiences had not seen on an epic scale since David Lean's **Doctor Zhivago**. During the Studio System love stories usually took home the top prize, like **Grand Hotel, It Happened One Night, Gone With the Wind, Rebecca, Mrs. Miniver, Casablanca, An American in Paris, Marty, Around the World in 80 Days, Gigi, The Apartment, West Side Story, My Fair Lady,** and **The Sound of Music**. Then after the mid-60s, for whatever reason, the honor fell on only a few such romantic movies, including **Rocky, Annie Hall,** and **Forrest Gump**. James Cameron must have instinctively known that the loss of true love was just as important as all the special effects to make his film work.*

in much the same fashion that musical scores were composed to highlight the dramatic scenes in silent movies. By the '90s, young viewers were seeing 200 cuts or more during a three-minute song by Duran Duran, Bon Jovi, Michael Jackson, or Madonna, which is almost the number of edits in an entire motion picture made during the Studio Era.

The biggest change in shooting action sequences was the arrival of the Panaflex camera in the '70s. This lightweight camera, with its fast lens, could be put in a canoe for *Deliverance,* a small fishing boat in *Jaws,* or a speeding truck in *Raiders of the Lost Ark.* This allowed for faster turn around on shots, which meant there could be two or three times more coverage on action sequences. More than ever there needed to be an audio guide for audiences to prevent confusion. Music set the tone of the action and let the people watching know when things looked bleak for the hero and when things turn around in favor or the hero. But music alone would serve to heighten the melodramatic aspects of the sequence, not give a resounding sense of realism, and realism was ultra-important to this new breed of action films.

In 1975, the Motion Picture Academy gave a special award for Sound Effects Editing to *The Hindenburg.* Over the next seven years this was handed out only as a special award, not part of the existing nominated categories, and not every year. In 1977, *Close Encounters of the Third Kind* won, in 1979 *The Black Stallion,* and in 1981 *Raiders of the Lost Ark.* Starting in 1982 this became a separate category, the year that *E. T. The Extra-Terrestrial* took home the award. Up until this point the audio in film was usually mixed on four channels, blending in voice, music, sound, and effects noises. This gave a very limited range to what the audience was hearing. Usually there was a master sound track that gave a point of orientation in a scene. For example, on a train, the clicking of the metal wheels over the tracks was used as the background sound to establish where the action was taking place.

With advanced sound mixing that evolved because of studio music recording in the '70s, there were more channels to create complex sound effects. This increased the realism during a particular moment in a sequence. Now audiences were hearing the clicking of the wheels, the squeaking of the cars, dishes clattering, peo-

ple muttering, outside whistles, whisking sounds as the train passed buildings or bridges, and dozens of other noises that subtly blended into the mix. Add music to this, and audiences were experiencing a heightened reality that could not be found in real life, but only in a theatre. And with the advancements of Dolby sound systems and THX surround sound (developed for the release of *Return of the Jedi* in 1982), audiences were finally submerged in a complete audio environment when they watched the action on the screen. Considering that sound was introduced in 1927 with *The Jazz Singer*, this process took forty-plus years to achieve, just in time for a whole new group of directors to experiment with.

From James Bond to Indiana Jones: The Effects of Raiders of the Lost Ark

If there was one motion picture that could be called the father of the modern action film it would be *Raiders of the Lost Ark.* Indiana Jones came about because of George Lucas' love of seeing Saturday morning serials as a kid, which were usually done as twelve episodes that ended in a cliffhanger each week. As contemporary legend has it, one day on a beach in Hawaii, after the success of *Star Wars* and *Close Encounters of the Third Kind,* Lucas listened as his friend Steven Spielberg bemoaned how he had always wanted to direct a James Bond thriller but had been constantly refused by the owners of the unprecedented franchise. Lucas listened and then calmly said that he had a better idea for a series. Thus Indiana Jones became the grandchild of 007 (which is the reason that Sean Connery was cast as Indy's dad in *The Last Crusade*).

There are subtle differences between Bond and Indiana Jones. Bond fights Cold War villains, and Indy fights Nazis and other bad guys during the World War II era. Bond has a natural gift with women, but Indy is uneasy and confrontational with women. Bond is fearless, but Indy has a terror of snakes. The one feature that was unique to the Bond series was the opening action sequence, or "the teaser" as it would have been called in burlesque. For *Raiders of the Lost Ark* the idea was to outdo the Bond teaser, which resulted in hundreds of spiders, gold treasure, poison darts, traitors (or double agents as Bond would have called them), a giant boulder, and a

Indiana Jones and the Last Crusade (1989) directed by Steven Spielberg, starring Harrison Ford and Sean Connery. Since James Bond gave birth to the Indiana Jones movies, when it came time to introduce Jones' dad, the perfect actor for the role naturally was Connery.

race-against-death ending. But Spielberg and Lucas added a new twist that would affect future action adventure movies.

Even more than *Star Wars, Raiders of the Lost Ark* was designed structurally on twenty-minute serials that always resolved one death-defying situation only to end the chapter in the middle of another, even more deadly situation. Like clockwork, Indy is running from spear-throwing natives, fighting Nazi henchmen in a remote tavern, chasing after the kidnappers of his female companion, finding the lost ark only to be sealed in an ancient tomb with thousands of poisonous snakes. This was a kid's dream. Instead of returning week after week, all of the cliffhanging adventures were back-to-back in one action-packed motion picture.

The Bond movies had cliffhangers peppered throughout, but the main course of the action always built up to one final epic showdown with the bad guys. *Raiders of the Lost Ark* was one dramatic climax after another, just like at the end of each chapter of a Flash Gordon or Don Windslow serial. Even the Bond films adapted this formula after the success of *Raiders,* especially after *Raiders* became one of the top grossing films of all time in a matter of weeks after it opened. Also, in past adventures films, like *Twelve O'Clock High, The Guns of Navarone, The Dirty Dozen,* and *The Towering Inferno,* the first thirty minutes were spent on exposition and establishing the characters, a standard way of writing almost any Hollywood screenplay.

In *Raiders,* after Indiana Jones returns home after one adventure, ten minutes later he is flying away on a secret mission. All the audience had to know was who the hero was, and the better known the star, the quicker they figured it out (something that Alfred Hitchcock had always talked about). The complexity of the characters' psychological construction became apparent during the non-stop journey. After all, these were stock characters that audiences had grown up with since the days of "The Perils of Pauline" in the silent era. This was truly a movie rollercoaster ride. And with the advancements in lightweight cameras, faster film stock, realistic special effects, and state-of-the-art sound editing, *Raiders of the Lost Ark* became that oddity that only happens a few times in motion picture history. All future action films began to imitate its perpetual motion structure and refer to it as the singular example of old-fashioned adventure films.

Raiders of the Lost Ark was lovingly crafted from actual childhood experiences of going to perhaps hundreds of old B-westerns and serials, growing up with the Tarzan movies, and watching *King Kong* every time it was on television. In *Raiders* there are moments of homage to *Stagecoach, Tarzan and His Mate, Gunga Din, North by Northwest, 20,000 Leagues Under the Sea,* and *The Guns of Navarone,* which was the first big modern special effects film to use the Nazis as the villains, just to list a few. And there are tributes to classic Warner Bros. actors like Peter Lorre, and tough, no-nonsense women from Howard Hawks' Westerns and gangster movies.

Within a few years after *Raiders,* most of these old motion pictures and serials that influenced the basis of the storyline were effectively forgotten. This was because revival theatres began to rapidly disappear, and Saturday morning children's television no longer pulled from the studio libraries of old films but created new shows. The few that were released on early VHS tapes were not restored, turning off potential new audiences because of pale images and poor sound. And even if they were restored, these B-westerns and serials were shot quickly on tiny budgets; thus people watching them today would never understand how real they must have seemed to kids in the '40s and '50s that had nothing to compare them to, especially a movie as elaborate as *Raiders of the Lost Ark.*

The remarkable achievement of *Raiders* and *Star Wars* is that these films captured the child-like nostalgia for the old cliffhangers for future audiences. Within a few years other movies began to reflect the cut-to-the-chase style of *Raiders,* including *48 Hours, First Blood, Road Warrior, Conan the Barbarian, Romancing the Stone, Ghostbusters, The Terminator, Beverly Hills Cop, Top Gun,* and *Die Hard.* These tightly wound movies were very much like amusement rides for international audiences. They were streamlined with the bare necessity in dialogue, twenty-minute chase montages, eye-popping explosions and crashes, ultra-realistic sound effects, and bigger-than-life characters. The need for speed had taken over Hollywood.

Kings of Action: The Directors and Changes in Filmmaking

Two directors that put a new spin on the action motion pictures are Terence Young and Guy Hamilton, the directors of the early James Bond films. Young made *Doctor No, From Russia with Love,* and *Thunderball,* and Hamilton added a new kick to the series with *Goldfinger, Diamonds Are Forever, Live and Let Die,* and *The Man with the Golden Gun.* The pacing in action films has changed considerably since the early Bond thrillers were released. These movies seemed to fly by for audiences in the '60s, which only illustrates how super-charged action films have become over the decades. *Die Another Day,* the first Bond adventure of the twenty-first century, directed by Lee Tamahori, has more than three times the number of edited shots with twice the complexity of the storyline as *Doctor No.*

This means that modern audiences are now absorbing the same amount of information when they watch one feature that forty years earlier they would have gotten by seeing two or three movies. It is no wonder that movies made before *Raiders of the Lost Ark* and *Star Wars* seem to move at a slower pace, which on a purely technical level, they do. The editing is faster, and the music and sound accelerates the perception of speed in the visual images. The characters are developed less through the traditional use of dialogue (which up to this point had been the natural custom in theatre and Studio Era films), and instead achieved this development with the careful pre-planned manipulation of lighting, scenic design, make-up, and costuming. Thus "The Word" was literally being replaced by visual information. With the

Goldfinger (1964) directed by Guy Hamilton, starring Sean Connery, Gert Frobe as Goldfinger, Harold Sakata as Oddjob, and Honor Blackman as Pussy Galore. The early James Bond films were comprised of one impossible situation after another, very much like a serial that continued on to the next cliffhanger without making the audience wait a week. They seem to move by at a frantic pace to audiences at the time. As an example of how accelerated the action has become in movies over the last forty years, watch **Goldfinger** *and then* **Die Another Day.**

need for almost instantaneous recognition of character types by audiences, smart casting choices have become a major factor in the success of a movie. The star and supporting players were all components in the international visual language.

The directors that mastered and advanced this rapid-fire style of filmmaking are John Woo, George Miller, Richard Donner, John McTiernan, Tony Scott, and James Cameron. These directors effectively took the formula of the old Western genre, that of an individual or handful of courageous men or women deliberately confronting overwhelming odds, and turned it into contemporary (or futuristic) legend making. For almost two decades, Hollywood movies had killed off heroes, or was obsessed with the dark side of the anti-hero. By the early '80s the hero had returned, but now possessed almost super-human powers of survival, like John McClane in *Die Hard* or Ripley in *Alien*. It would have been unthinkable to have one of these characters killed off in the final reel, especially in an industry that had just learned about the power of the franchise from George Lucas. Other directors like Ridley Scott, Oliver Stone, Quentin Tarantino, and Clint Eastwood are a slightly different breed. Their films tended to be about characters who would rather avoid violence but then get swept up in it.

What becomes increasingly difficult is recognizing a sense of style from some of the action directors. Each has a particular trademark: John Woo with his extended use of slow motion and white doves in the midst of action sequences, or Tony Scott with his occasional use of surrealistic colors. And most new directors had an unabashed kinship with directors from the Hong Kong cinema of the '60s and '70s, and "the Spaghetti Westerns" of Sergio Leone. Quentin Tarantino was especially influenced by these radically different styles.

During the '80s, any original approach to an action montage was quickly assimilated by directors around the world. This wholesale borrowing of cinematic ideas evolved so rapidly that within a decade, an action sequence in any motion picture might have touches of Woo, Leone, Don Siegel, Bond movies, and dozens of others influences. As an example of this almost instantaneous incorporation of innovative concepts, in 1998, Steven Spielberg made *Saving Private Ryan,* with cinematographer Janusz Kaminski, and brought an unnerving new vision to the D-Day invasion. Within months, other war movies, action films, and television shows were copying the techniques used in Saving Private Ryan battle sequences. Thus in modern world cinema an innovative breakthrough is seized upon so quickly there is no time gap between the event and the assimilation.

Many exceptional directors came out of Australia during the late '70s and early '80s. The country down under was going though its own film renaissance, dubbed the "Australian New Wave," during the years of the New Hollywood. Most of the motion pictures were made on exceedingly meager budgets with the support of the South Australian Film Corporation. Almost immediately after the auspicious debuts of these directors, many were lured to Hollywood with the prospects of bigger budgets, stars, and better equipment. Peter Weir received international attention for *Picnic at Hanging Rock* (1975) and two films with young Mel Gibson, *Gallipoli* (1981) and *The Year of Living Dangerously* (1982). Weir has continued to make outstanding films, including *Witness* (1985), *Dead Poets Society* (1989), *The Truman Show* (1998), and *Master and Commander: The Far Side of the World* (2003).

Bruce Beresford was highly acclaimed for *Breaker Morant* (1980), based on a true story about military injustice that is as emotionally powerful as Stanley Kubrick's *The Paths of Glory.* Beresford's *Tender Mercies* (1983) won Robert Duvall a long overdue Academy Award as Best

Actor and his *Driving Miss Daisy* (1989) won for best picture. Philip Noyce made the excellent *Newsfront* (1978) and the thriller *Dead Calm* (1989), which started Nicole Kidman on the road to stardom. Noyce has managed to juggle blockbuster entertainment, like *Patriot Games* (1992) and *Clear and Present Danger* (1994) with Harrison Ford, and small artistically satisfying films, such as *Rabbit-Proof Fence* and *The Quiet American,* both in 2002.

During these formative years of the Australian film industry, no motion pictures were as internationally successful as George Miller's Mad Max trilogy, *Mad Max* (1979), *Mad Max 2: The Road Warrior* (1981), and *Mad Max Beyond Thunderdome* (1985), all starring Mel Gibson as the mythical post-apocalyptic rebel. *Mad Max* was shot on an extremely low budget, but full of innovative action photography. Miller then redefined the concept of the action genre with *The Roar Warrior,* which ended with thirty-minute non-stop chase sequence that gave a bizarre new spin on what the future might hold.

In America, Mel Gibson teamed up with director Richard Donner to make the enormously popular *Lethal Weapon* (1987), which generated three sequels. Donner already had a successful box-office track record with *The Omen* (1976), *Superman* (1978), and the Steven Spielberg produced *The Goonies* (1985), but *Lethal Weapon* became hits. The four *Lethal Weapon* movies took the gritty, big city detective genre and infused it with touches of screwball comedy. Donner also gave a fresh spin to the buddy picture by teaming a white man and an African American as reluctant partners. Danny Glover is the older, down-to-earth officer who plays counterpoint to Gibson's unpredictable and sometimes suicidal antics.

John McTiernan made three films early in his career that were highly original and quickly became highly imitated. In *Predator* (1987), Arnold Schwarzenegger is the head of a group of fearless commandos who are slowly eliminated by a shape-changing alien from another world. The movie takes the concept of the Rambo character, the Vietnam vet who still craves life-and-death adventure, and expands this theme into a multicultural band of misfits. The following year, McTiernan directed the action-packed thriller *Die Hard,* starring Bruce Willis, which borrows the perfect heist scenario from film noir and places it in a high-tech office building seized by criminal masterminds. The story is pure lone cowboy versus heavily armed bad guys; except the hero is a

Mad Max 2: The Road Warrior *(1981) directed by George Miller, starring Mel Gibson and Bruce Spence. One of the reasons Westerns were so popular is because most of them ended with a chase and a shootout. With **Bullitt, The French Connection,** and **The Seven-Ups,** all staged by legendary stuntman Bill Hickman, the big city replaced the Wild West for chases. Miller took the chase back to the desert in the most expensive Australian film at the time. But the investors did not need to worry, the massively complex chase for almost the last half hour of the movie insured its success in countries around the world—and made Gibson a star.*

Predator (1987) directed by John McTiernan, starring Arnold Schwarzenegger, was a film designed for foreign markets. There was more action than dialogue, the cast was multi-ethnic, there were humorous one-liners, lots of loud gunfire, and the villain was a nearly undefeatable alien. Under McTiernan's tight direction all this studio packaging worked like gangbusters. His next two films were **Die Hard** and **The Hunt for Red October.**

persistent New York cop and the ingenious villains are ruthless professionals from around the world. And in 1990, McTiernan brought *The Hunt for Red October* to the screen, the first of the Tom Clancy political thrillers.

Tony Scott is the younger brother of director Ridley Scott and began his career by making thousands of commercials. His films reflect his early training with the use of rich and vibrant production designs. He teamed up with producers Don Simpson and Jerry Bruckheimer on several movies that reflect the influence of MTV, with rapid kinetic editing to rock music. *Top Gun* (1986) was the breakthrough film for both Scott and Tom Cruise. The film was a throwback to the hotshot flyboy movies of the 1930s and became an international hit. The appeal of *Top Gun* is largely due to the thrill-ride action montages made up of several hundred individual shots, many taken from inside supersonic jets. This reflects a return to the energetic camerawork that was familiar to audiences during the Silent Era, before sound swept the movie industry, with *The Battleship Potemkin, The Big Parade,* and *Wings.* Scott is a solid director with a very distinctive style, who often works with high profile movie stars, but he rarely ventures outside the action genre, preferring to make movies like *Days of Thunder* (1990), *Crimson Tide* (1995), *Enemy of the State* (1998), and *Man on Fire* (2004).

During the Studio Era, certain directors were called "Ten Year Men" or "Ten Year Wonders," meaning that in a brief time period they had made many exceptional motion pictures and then seemed to loose their instinctive Midas touch. Most directors are at the mercy of finding the screenplay, and this is especially true of directors that specialize in the action genre. The one major exception is James Cameron, who is both a highly skilled writer and director. Cameron got his start as an art director and miniature-set builder on Roger Corman's *Battle Beyond the Stars* (1980), and is credited with the direction of *Pirahna Part Two: The Spawning* (1981). After this inauspicious beginning, so the contemporary legend goes, he set up three typewriters, each with a different screenplay in progress, and wrote *The Terminator, Rambo: First Blood Part II,* and *Aliens.*

The Terminator (1984) and *Aliens* (1986) took the science fiction genre into a new realm of audience involvement. Cameron was able to transfer his screenplays into exciting new visual experiences, becoming the first director in the post-70s era of high tech action-adventure films

to control his vision from script to screen. Along with Steven Spielberg, Cameron represents the modern day director that was raised on a steady diet of motion pictures and aggressively cultivated an extensive knowledge of special effects, editing techniques, and production design. He also might be highly typical of future directors, since he spent years developing a limited number of films that he wanted to make. Where directors like John Ford, Michael Curtiz, Howard Hawks, William Wellman, and Alfred Hitchcock turned out an average of one film a year, Cameron has made six feature motion pictures from *The Terminator* (1984) to *Titanic* (1997).

Each of these films became a major undertaking, which in terms of past productions is comparable to making *Ben-Hur* a half-dozen times in a row. *The Abyss* (1989), *Terminator 2: Judgment Day* (1991) and *Titanic* pushed the art of Computer Generated Imagining (CGI), each winning an Academy Awards for visual effect. *Titanic* became the extreme movie-going experience, creating a sense of heightened reality through the use of sight and sound so that audiences around the world almost felt as if they were among the doomed passengers on the giant ship. The epic disaster film made over $1,835 million worldwide and tied the record of winning eleven Academy Awards set by *Ben-Hur*. Cameron is one of the few directors that played an important part in the transition from the old, traditional methods of special effects, dating back to *A Trip to the Moon* in 1902, to the new era of CGI effects. And in the process changed audience's expectations of what a motion picture was all about.

Mavericks: The Independent Directors

In 2005, the top twenty-five grossing motion pictures were *Titanic, The Return of the King, Harry Potter, The Phantom Menace, The Two Towers, Jurassic Park, Harry Potter 2, Fellowship of the Rings, Finding Nemo, Independence Day, Spider-Man, Star Wars, The Lion King, E.T. The Extra-Terrestrial, The Matrix Reloaded, Shrek 2, Forrest*

Do the Right Thing *(1989) written and directed by Spike Lee, cinematographer by Ernest R. Dickerson, starring Lee, Danny Aiello, Ossie Davis, Ruby Dee, Richard Edson, Bill Nunn, Giancarlo Esposito, and John Turturro.* ***Do the Right Thing*** *is loosely based on an incident that happened to Black youths in Howard Beach in New York, but the film's purpose is much greater than a reenactment of a news headline. Lee takes the audience into a Black neighborhood, over a 24-hour period, and shows through a series of seemingly unrelated scenes the everyday life of a wide assortment of splendidly developed characters. But throughout the film he is leading the viewer into a cleverly designed trap, where the events of the day boil up into an act of violence. The film's gut punch comes from the smooth interplay of the ensemble cast, who, without exception, are excellent.*

Gump, The Sixth Sense, Pirates of the Caribbean, Attack of the Clones, Harry Potter 3, The Lost World: Jurassic Park, The Passion of the Christ, Men in Black, and *Return of the Jedi.* With the exception of *Star Wars* (1977), all of these movies were made after 1980. (In adjusted dollars, *Gone With the Wind* would also be on this list, being the sole motion picture from the Studio Era.)

Three of these are feature length animations: *The Lion King* is the only animation done in the old traditional Disney style, whereas *Finding Nemo* and *Shrek 2* are both computer-animated, which effectively began with *Toy Story* in 1995. Of the live action films, only *The Sixth Sense* and *The Passion of the Christ* were made with a minimum of special effects. And it can be argued that The Passion of the Christ is the only serious drama on this list and the only film that reflects the spirit of independent filmmaking.

Starting in the 1980s, the concept of an "independent director" really had two meanings. These were directors who had the power to make a variety of different styles of motion pictures, from big-budget action adventures to small dramas. Or they were the maverick directors who worked outside the New Hollywood system and found the money to make highly personal films. Of this first group, only Ridley Scott and Clint Eastwood fit this mold. Their films are produced by major studios, but because of their track records, they have the clout to change gears on occasions and make films that examine what can be described as the modern human experience. The second group is far more unwieldy to characterize, since their films often deliberately defy any kind of transitional definition, thus making them the ultimate mavericks. This varied group includes Oliver Stone, Quentin Tarantino, Tim Burton, John Hughes, John Sayles, David Lynch, David Cronenberg, Spike Lee, John Singleton, Kevin Smith, David Ficher, Sam Raimi, Joel and Ethan Coen, Ang Lee, Chris Eyre, Robert Rodriguez, Michael Moore, and Peter Jackson.

All of these directors work in the shadow of the Studio Era directors, in the sense that most are proficient in different genres and all developed their own distinctive styles. Sayles has been compared to John Ford because of the way he chronicles the American experience in his films. The Coen brothers, Tarantino, and Rodriguez have put a hard new spin on film noir. Stone almost single-handedly revised the social issue films to examine the effects of the Vietnam War on American society. Films by Burton, Cronenberg, and Lynch often contain moments of surrealism that mirror the influences of Federico Fellini, Jean Cocteau, and Luis Bunuel. And Moore dusted off the old search-and-destroy techniques of muckraking journalism and transferred them to the feature-length documentary.

Perhaps the single most important aspect of the films by Spike Lee, Singleton, Ang Lee, Eyre, and Rodriguez is the strong sense of cultural identity they bring to their motion pictures. These are highly gifted directors who are proud of their ethnic heritage. Spike Lee and Singleton shattered the narrow doorway of the American cinema that had taken decades to slowly open, revealing the humor and raw emotions of modern urban life for African Americans. Rodriguez and eventually Ang Lee took the action-adventure genre and reinvented it to fit their own cultural backgrounds, in a similar fashion to what Serigo Leone did with the American Western.

The New Hollywood, Part II

Ridley Scott and Clint Eastwood joined Steven Spielberg, Martin Scorsese, and George Lucas as the handful of directors from the New Hollywood of the '70s that have continued to make exceptional films into the third act of their careers. The other directors in this second phase of the New Hollywood began their careers in the '80s and seemed to be a separate breed from their predecessors, al-

most as if they had advanced to the next stage of the Hollywood evolution. This metaphor is more real than fanciful, since most of these directors learned to survive by eventually turning to big-budget features and working with popular movie stars. Part of this transition from shoe-string independent to blockbuster director might be the natural result of what happened to several independent companies that got started in the '80s, in particular New Line Cinema and Miramax. In order to survive the inevitable box office failure that could cripple a small company, these independents turned to the shelter of financially fat entertainment conglomerates, which in the case of these two companies was Time Warner and Disney.

The one indisputable fact about the motion picture business is that it is just as hard to make a small film as it is to make a big one. If a small film hits, then the profits are like a wildcat oil well that come in, but the losses will not inflect that much damage if the film misfires. The risks for a big-budget feature are naturally greater. However, by the mid-80s, with the new formula of opening wide, an expanding international box office, and the skyrocketing sales and rentals of videotapes, even a movie that performed poorly on its opening release could turn a profit in time. In this era of Hollywood, it was easier to raise millions of dollars for a high-concept feature as opposed to scrounging for one million dollars to shoot a movie that would be an uphill battle to make and distribute. Many of the directors that got started in the '80s by making small independent features quickly realized this and were lured to the opposite end of the spectrum.

Another possible reason for this new wave of young directors following in the footsteps of Spielberg and Lucas, as opposed to the many socially oriented directors of the '60s and '70s, was because of a major shift in world events. Most of these directors were children when President Kennedy was assassinated and teenagers during the final years of the Vietnam conflict. They grew up in a time of peace, learning the alphabet from Sesame Street. Their heroes were Spider-Man and the Incredible Hulk, who started out as average guys and then had the responsibly of superpowers thrust upon them. These directors were part of the dynamic shift in motion picture technology that allowed the seemingly impossible to become commonplace reality. And the movie stars for this generation were not Humphrey Bogart, John Wayne, and Cary Grant, who had dominated the public's imagination for over three decades, but younger actors like Al Pacino, Mel Gibson, and Harrison Ford.

The New Durables

There is a short list of directors that have earned the right to play by their own rules and make films that have a commercial shell with a maverick underbelly. These directors followed in the footsteps of some of the legendary directors because they seem to fully understand how to assemble a clockwork film that has the visual and emotional events to entertain, but also frontload their features with strong themes. Directors like Quentin Tarantino, Tim Burton, and Joel and Ethan Coen have favorite genres they like to explore and occasionally reinvent. Directors like Clint Eastwood and Ridley Scott started out making a reputation in a certain genre and then expanded their scope to take on diverse cinematic styles. And then there is Peter Jackson who either represents the new movement in twenty-first century directors, or he is the last exceptional director of the first phrase of film history.

Quentin Tarantino broke new ground for violence with *Reservoir Dogs* (1992) and *Pulp Fiction* (1994), but what became his early trademark was the casual chitchat between gangsters and hitmen that turned into off-the-wall, philosophical

Pulp Fiction (1994) directed by Quentin Tarantino, screenplay by Tarantino and Roger Avary, starring John Travolta, Samuel L. Jackson, Bruce Wills, Ving Rhames, Tim Roth, and Amanda Plummber. It has always been hard to find a movie star willing to gamble with his career and play a hired killer. Even in the 70s when the anti-hero took over the screen, stars would be drug addicts, male prostitutes, or corrupt cops, but draw the line at murder—with the notable exception of Michael Corleone. John Woo made films about hit men, but that was on the other side of the world from Hollywood. Tarantino found the secret—language. In crime movies and film noir that characters can talk in streetwise metaphors, with a touch of might be called urban poetry. Humphrey Bogart talked this way, and so did Robert Mitchum. It is Tarantino's gift for bigger-than-life dialogue that makes it cool for stars to be bad.

discussions about Big Macs and divine intervention. Tarantino's output as a director has been limitless. His movies since *Pulp Fiction* include *Jackie Brown* (1997), *Kill Bill: Vol. 1* (2003), and *Kill Bill Vol. 2* (2004). But he has a strong following and a new generation uses his non-linear narrative style and black humor dialogue as the benchmark for the crime genre.

Tim Burton seems to possess the playful spirit of Federico Fellini's movies. His best films are a blend of bizarre fantasy and a self-confessed fondness for old gothic horror movies, especially those featuring his childhood idol Vincent Price. His talent as an artist (he worked briefly as an animator for Walt Disney's *The Fox and the Hound* and the *Black Cauldron*) is reflected in his films, which have strong visual styles that propel audiences into strange, new worlds. Burton has carved his own niche in post-New Hollywood with *Pee-wee's Big Adventure* (1985), *Beetlejuice* (1988), *Batman*

Batman (1989) directed by Tim Burton, starring Jack Nicholson, Michael Keaton, and Kim Basinger. Burton, with his gift for the abstract, seemed the ideal director to bring the Dark Knight alive. His strong point is the visual design of his movies, which often compensates for stories that go astray midway. Burton is constantly picking strange lands to take audiences to, like **Sleepy Hollow,** the **Planet of the Apes,** that town where Beetlejuice lives, and a magical Chocolate Factory. He is also fortunate to have exceptional actors join him on these journeys.

(1989), and films starring Johnny Depp, including *Edward Scissorhands* (1990), *Ed Wood* (1994), *Sleepy Hollow* (1999) and *Charlie and the Chocolate Factory* (2005), all of which are counterpoint to mainstream action movies.

Joel and Ethan Coen have redefined the image of independent filmmakers. Their films are noted for brilliantly conceived and executed camerawork and post-noir tales with dark-soul characters that feel like they are infused with large doses of screwball comedy. According to the credits, Joel directs, Ethan produces, and both write and edit their movies, but on the set they become the equal embodiment of a "total filmmaker." Their early efforts were low budget, but the extraordinary visual style of *Blood Simple* (1984), *Raising Arizona* (1987), *Miller's Crossing* (1990), and *Barton Fink* (1991) won critical raves and devoted fans. In the era of the high-concept blockbuster, the expertly crafted, cinematic gems of the Coen Brothers became the rallying point for independent filmmakers. Sometimes their efforts, such as *The Hudsucker Proxy* (1994), *The Big Lebowsky* (1998), and *O Brother, Where Art Thou?* (2002) are like idiosyncratic experimental home movies that hint at perpetually arrested childhoods. But their completely original masterpiece, *Fargo* (1996), about a small crime that goes terribly awry, has earned them a rare respect.

Clint Eastwood learned the directing craft from two masters, to whom he dedicated his dark Western masterpiece *Unforgiven* (1992), Sergio Leone and Don Siegel. His directing debut was *Play Misty for Me* (1971), a simply made horror thriller that proved he had learned his lessons well. When he returned to Hollywood from his years in Europe he was a movie star, but in a time period when Hollywood was chasing its own tail, he decide that controlling his films gave him a better chance at survival. As a director, his most successful films plowed new ground for Westerns, with *High Plains Drifter* (1973), *The Outlaw Josey Wales* (1976) (which he took over from the original director, Philip Kaufman), and *Pale Rider* (1985). Then he made a complete turnabout. Influenced by his lifelong love of jazz, Eastwood made *Bird* (1988) about the troubled life of legendary musician, Charlie "Bird" Parker.

After this Eastwood balanced his career with appearing in popular action movies and direct-

Fargo (1996) directed by Joel Coen, written by Joel and Ethan Coen, starring Frances McDormand, William H. Macy, Harve Presnell, Steve Buscemi, and Peter Stormare. The Coen brothers have gotten away with murder, kidnapped children, and stuffed a man in a wood chipper. With these qualifications, they can be acknowledged as two of the most original filmmakers—ever. Their movies have a distinctive style about them, in an age when style has become a lost art. Just watching one of their films for a few minutes, the viewer will know there is something different going on. They are obviously fans of film noir and cannot get enough of black comedy. They are among the very few filmmakers that people eagerly anticipate their next venture. And even the stuff that occasionally misses the mark is better than most of the movies being made.

ing offbeat films that interested him. In two amazing years he made *Mystic River* (2003) and *Million Dollar Baby* (2004), for which he won his second Oscar for directing, at the age of seventy-three. There is an almost sublime touch of irony about Eastwood as a director. During the 1970s, one of the great times when directors took on provocative subjects, he was making Westerns and all-out action movies. Then late in his career he became one of the very few directors who kept the personal filmmaking spirit of the '70s alive.

Ridley Scott has one of the most distinct visual styles of any director, either past or present. Born in England, he studied art and film at the Royal College of Arts in London, and spent years as a director of television commercials, a field where every foot of film is designed for maximum effect. After directing the critically acclaimed *The Duellists* (1977), he changed the science fiction horror genre forever with *Alien* (1979). In the feel-good-about-space years following *Star Wars* and *Close Encounters of the Third Kind,* Scott's gory creature encounter terrorized audiences, giving birth to the marketing catchphrase, "No one can hear you scream in outer space." His next effort, *Blade Runner* (1982), a cyberpunk film noir set in Los Angeles during the year 2019, based on a novel by Philip K. Dick, is celebrated as a masterpiece of futuristic production design.

After this remarkable beginning, many of Scott's later films lacked a strong, engaging storyline to match the high gloss visual effects that has become his trademark. A notable exception was *Thelma & Louise* (1991), a spin on the good ol' boy buddy movies—this time about two women on the lam from the law. Then in a stunning tour de force of directing, he resurrected the motion picture epic with *Gladiator* (2000), an opulent genre that had vanished from movie screens in the mid-60s. Very few directors have had such a richly productive second act to their

careers. With a seemingly new bust of creative energy, Scott made the harrowing *Black Hawk Down* (2001), based on a true story of a military operation that ends in disaster, and *Kingdom of Heaven* (2005), a spectacular depiction of the twelfth century Crusades.

Only time will tell if Peter Jackson's name belongs on this list of "durables" or if he should be listed first on a new list that starts the next cycle. Born in Pukerua Bay, North Island, New Zealand, Jackson grew up on the other side of the world from Hollywood. Nevertheless, he grew up fascinated by the magic of movies and remembers the overpowering affect that *Star Wars* had on him at the age of fifteen. He made his first feature ten years later, appropriately titled *Bad Taste* (1987), a gore-fest about aliens dining on human flesh. This very non-Orson Wellesian debut was followed by *Meet the Feebles* (1989) and *Brain Dead* (1992). Then in 1994 he directed *Heavenly Creatures,* based on the tragic true story about two girls who develop such an intense fantasy life that their parents separate them, igniting a bloody revenge against one of the mothers. Jackson's original screenplay, co-written by Fran Walsh, was nominated for an Oscar.

His next effort was a 53-minute mockumentary, *Forgotten Silver* (1995), about a "lost" filmmaker by the name of Colin McKenzie. This was followed with what was intended to be his Hollywood blockbuster, *The Frighteners* (1996), about a psychic private detective that consorts with death, but, due in part to an ill-timed distribution campaign, the film failed to set off box-office fireworks. So, with his diverse motion picture track record, and his most successful film being a modest art house hit about two disturbed teenage girls, Jackson's name was certainly not on the Hollywood A-list for directors to make three of the most ambitious features in movie history.

If there is truly divine destiny in the motion picture business, Jackson is proof of it. Despite

The Lord of the Rings: The Return of the King (2003) *directed by Peter Jackson, starring Elijah Wood, Sean Astin, Ian McKellen, Billy Boyd, Dominic Monaghan, Orlando Bloom, Cate Blanchett, Ian Holm, John Rhys-Davies, Liv Tyler, Christopher Lee, Miranda Otto, and Viggo Mortensen. There are several things that are nearly impossible to imagine. Infinity is one. Life on another planet is another. And how did Peter Jackson, with* **Bad Taste, Meet the Feebles, Braindead, Heavenly Creatures,** *and* **The Frighteners** *to his credit, pull off one of the most remarkable feats of filmmaking ever? Perhaps the most amazing part of this is how he anticipated the technology curve to create the effects for the films, deliberately escalating the number of specialty shots for each film. And he did this while directing all three films at the same time. In 2005, the Britain's Empire movie magazine listed Jackson as one of the top ten directors of all time. This might be premature, but judging from what he has done so far, it might very well be true.*

the fact he grew up out of the mainstream of Hollywood, he had in essence spent his life preparing for the grand opportunity of turning J. R. R. Tolkien's *Lord of the Rings* into three exceptional epic films. With an encyclopedia-like knowledge of visual effects, coupled with a passionate devotion to Tolkien's legendary trilogy, Jackson convinced executives at New Line Cinema that he was the right director to take on this daunting, almost superhuman assignment. The major factor in Jackson's favor was that *Lord of the Rings* resulted in failure for every filmmaker that had attempted it in the past. *The Hobbit* (1977) was turned into an overly sentimentalized, simplistic 77-minute cartoon by Jules Bass and Arthur Rankin, Jr. In 1978, director Ralph Bakshi tried to squeeze *The Lord of the Rings* down to 132-minutes, resulting in a mishmash of animation. Even Tolkien had stated that his beloved books were not filmable. It took the commitment of a small ambitious studio, along with Computer Generated Imaging to finally catch up with pure fantasy filmmaking, to create the perfect opportunity for Jackson.

The Lord of the Rings: The Fellowship of the Ring (2001), *The Lord of the Rings: The Two Towers* (2002), and *The Lord of the Rings: The Return of the King* (2003) are excellent examples of ingenious filmmaking that stays faithful to great writing. In a symbolic sense, these three films, that grossed over three billion dollars worldwide and won seventeen Academy Awards, represent the close of the first act of motion picture history and the start of the next long phrase. The novel reached a height of excellence in the twentieth century, and J. R. R. Tolkien's fantasy novels have been acknowledged as being among the handful of books at the apex of this great artistic tradition. But the ability to turn these books into a completely realistic cinematic vision took one hundred years of motion picture technology to achieve.

Jackson was a director that grew up by self-educating himself in the technical art of filmmaking, but who was also a devoted student of the literary arts. By mutually respecting these two forms, he brought an in-depth style of storytelling to the screen at the start of the twenty-first century,

which exhibits the complexity of the novel and the visual pageantry of motion pictures. He is in both appearance and action a kind of Renaissance man with a movie camera, representing the close of one age and the start of a new adventure in moviemaking.

In the Shadow of Orson Welles

There are a number of exceptional directors in this era that have made one or two films that stand out, but whose other films seem to pale in comparison. The outstanding films from these directors have often caused an immediate sensation or have been rediscovered as modern classics because of video and DVD sales. This could be called the Orson Welles syndrome, because, like this legendary director, the reputation of these directors is based on a limited number of films that continue to shine.

At the top of this list is Frank Darabont, who directed *The Shawshank Redemption* (1994) based on a Stephen King short story. This dark but optimistic film about an innocent man sent to prison did only moderate business on its the-atrical release, and received a few award nominations. But since then it has found a large following, which has ranked it among the best films of all time. Darbont has made other expertly crafted films, like *The Green Mile* (1999), also based on a story by Stephen King; but *The Shawshank Redemption* has proven to be one of those rare experiences, a near perfect movie.

Another director is Adrian Lyne, whose film *Fatal Attraction* (1987) caused a flood of controversy that seems almost unimaginable twenty years later. What has been referred to as the ultimate anti-pickup movie, *Fatal Attraction* tapped into the nervous psyche of the mass public during the twilight of the "Me Generation." Glenn Close plays the character of Alex Forrestt with such obsessive vengeance that preview audiences sent up an outcry when she was allowed to commit suicide instead of being violently blown away for her actions. Thus a new ending was added that satisfied this mass blood-lust. This second version changed the rules on how villains die. The character of Alex appears to have drowned in the bathtub after an intense struggle, but suddenly she pops out of the water swinging a kitchen knife and

The Shawshank Redemption (1994) directed by Frank Darabont, starring Tim Robbins and Morgan Freeman. It could also be called The Shawshank Resurrection, since this nearly perfect film was ignored at the box office, overshadowed by **Forrest Gump** and **Pulp Fiction**—or perhaps because no one could remember or say its title. It was nominated for seven Oscars, including best picture, but went home empty handed. There was not much fanfare when it came out on VHS, because by this time it has been painfully written off by everyone involved. Then people began to rent it—and rent it—and rent it. Until on the Internet Movie Database it ended up as #2, right under **The Godfather,** and there it stayed for years. So, this is proof that there is life after death.

has to be shot to end her rampage. After this, the adverse character in movies tended to spring alive for a second or third round of cinema carnage.

There are three directors with the name of David whose films meet the criterion for this distinctive category. David Lynch, who has been referred to as the Jean Cocteau of American cinema, shocked and bewildered audiences with *Blue Velvet* (1986), and later with *Mulholland Dr.* (2001). David Cronenberg redefined the horror-science fiction genre with the ultra-intense and nightmarish *Scanners* (1981) and *The Fly* (1986). And David Fichner created a dark and very dangerous post-noir world in *Se7en* (1995) and played mind games, laced with black humor, on audiences with *Fight Club* (1999). All of these films have their own cult following.

AMERICAN MULTICULTURAL FILMS

The Rise of the Action Hero

Unfortunately, it is probably impossible for negative stereotypes to completely disappear from the movies. The vast majority of films are two hours long, thus the story has to be compacted into this short period of time. With the accelerated pace of modern movies, there is almost twice the amount of story being stampeded across the screen during these two hours than audiences were accustomed to just three decades before. If a stage play tried to maintain this pace, the actors would drop from exhaustion after the first act. But more storytelling being forced into a compressed time means there is a greater need for quick recognition of who is good or bad.

The stories in these movies, with rare exceptions, are linear in structure and demand an encounter with an adversarial force to propel the action forward. It is estimated that the average American under the age of thirty-five sees roughly 190 films or hour-long television shows each year. So, it is absolutely astounding that audiences have never grown tired of this routine narrative structure.

The single largest issue facing the film industry today is the wholesale piracy of newly released motion pictures. It is estimated that the industry is loosing billions of dollars each year to Russia, China, India, and other countries where black market DVDs are sold by the millions, often before a film even opens. But this is happening primarily to the special-effect blockbusters like *Spider-Man*, *The Return of the King*, *Troy* and *Finding Nemo*. There is not the same outcry from the industry about the piracy of *Sideways*, *Mystic River*, or *Vera Drake*. Audiences around the world cannot get enough of the fast-paced Hollywood action movies, and these films need a kind of visual shorthand to keep a story hurtling along.

Early motion pictures made an attempt at realism, in the sense they pulled from historical events for the backdrop of these stories, which then dictated the ethnic appearance of the adversarial characters. The Westerns had Indian attacks and later bad dealings with untrustworthy banditos. From Asia, once known to movie audiences as the Orient, there was the evil genius Fu Manchu. After the discovery of King Tut's tomb, there were sinister Egyptians in gothic Universal horror films that brought mummies back from the dead to kidnap unsuspecting women. During World War II, the Nazis and Japanese were the villains, and in recent years Arabs have been cast in the role of terrorist bombers. But starting with the action films of the '80s, Hollywood began to break the mold of the traditional adversaries.

The rapid and sophisticated advancements in special effects during the '80s kept upping the ante for audience expectations. The old villains became dated, because they were too easily eliminated, and, in the brave new age of warp-speed,

Lethal Weapon (1987) directed by Richard Donner, screenplay by Shane Black, starring Mel Gibson and Danny Glover. There have been comedy teams since the silent era, but after Lewis and Martin broke up this began to fade away. Then this old vaudeville tradition resurfaced in Westerns but now it was called buddy movies. Then writer Shane Black got the idea of teaming up two mismatched detectives. Gibson and Glover played off of each other like fine tuned instruments, which is the real reason there were four sequels.

too slow. Whatever the new action stars went up against had to be *almost* invincible. The one aspect of the Vietnam conflict that Hollywood movies finally championed was the Special Forces units. These select groups of highly trained and motivated soldiers were perfect for the new action films.

On screen, these small groups were multicultural in their configuration, eventually including women that stood toe-to-toe with the cigar-chomping men. Their mission: To eradicate aliens and villains with superpowers. Of course, not all the groups were a true reflection of the Special Forces; many were simply a mishmash of humanity that quarreled and blundered but pulled together at the critical moment. Most of these movies, like *Predator, Ghostbusters,* and *Aliens,* had one common denominator: In the future there is no prejudice.

Closely related to these films are the "buddy movies," which became highly popular after

Butch Cassidy and the Sundance Kid and *The Sting.* Partners in films have always been a mismatch, like Stan Laurel and Oliver Hardy, or Bob Hope and Bing Crosby. By the '80s, this genre was ideal to reinvent for "buddies" of different ethnic backgrounds. *48 Hours* teamed up Eddie Murphy and Nick Nolte (plus the sequel *Another 48 Hours*); *Lethal Weapon* starred Mel Gibson and Danny Glover (this time with three sequels); and in the late '90s, Jackie Chan and Chris Tucker proved the old formula still worked with *Rush Hour* (and a sequel, with talk of several more). In *Die Hard* and *Die Hard 2: Die Harder,* Bruce Wills put his trust in Reginald VelJohnson, and in *Die Hard: With a Vengeance,* he became good buddies (eventually) with Samuel L. Jackson.

African-Americans

The image of African Americans in movies has without question come the longest distance, from

Glory (1989) directed by Edward Zwich, starring Denzel Washington, Morgan Freeman, Matthew Broderick and Cary Elwes. The story about the Civil War's first all-black volunteer company had been a footnote until this powerful film, with beautiful cinematography by Freddie Young and a haunting score by James Horner. At the core of it are inspired performances by the entire ensemble, but Washington's angry performance as Pvt. Trip was a standout, winning him his first Oscar.

the degrading stereotypes in *Birth of a Nation* to stars Halle Berry (*Monster's Ball*), Denzel Washington (*Training Day*), Jamie Foxx (*Ray*), and Morgan Freeman (*Million Dollar Baby*) winning Academy Awards between 2001 and 2004. Washington became the first African American to win two acting Oscars, having already won the supporting actor award for *Glory,* which co-starred Morgan Freeman. Washington had also been nominated for *Cry Freedom* (supporting); *Malcolm X,* directed by Spike Lee; and *Hurricane,* directed by Norman Jewison (who had made *In*

Glory is an example that any film is better if Morgan Freeman is in it. He makes acting seem so effortless, because there is always a sense of genuine truth and honesty in whatever he says. Nominated four times, he finally won for **Million Dollar Baby.**

the Heat of the Night with Sidney Poitier). Like his mentor Sidney Poitier, Washington started a directing career with his feature *Antwone Fisher.*

Freeman had been nominated for *Street Smart* (supporting), *Driving Miss Daisy,* and *The Shawshank Redemption.* In a touch of bittersweet irony, Halle Berry won an Emmy for her performance in *Introducing Dorothy Dandridge,* a television biography about the tragic life of the first African-American actress to be nominated for an Academy Award. Perhaps more than any other ethnic group, the Oscar became a sign of growing respect for African Americans. After Dorothy Dandridge's nomination in 1954 for *Carman Jones,* and Sidney Poiter's nomination for *The Defiant Ones* in 1958 and his win for *Lilies of the Field* in 1963, no African-American actor was nominated again until Rupert Crosse was supporting actor for *The Reivers* in 1969, and then no nominations throughout the New Hollywood years of the '70s. This long dry spell

changed in the 1980s with a long string of Supporting Actor nominations, starting with Howard E. Rollins, Jr. for *Ragtime* in 1981. Louis Gossett, Jr. won for *Officer and a Gentleman* in 1982. Then in 1985, Oprah Winfrey and Margaret Avery were nominated for *The Color Purple,* followed five years later with Whoopie Goldberg winning for *Ghost.*

But in Hollywood it is never the serious dramatic roles that ultimately change public perception, it is the breakout performance that crosses the preconceived boundaries of all audiences and blurs the perception of race. Eddie Murphy became the first African-American superstar because of his hilarious work on "Saturday Night Live" starting in 1980, and then in 1982 with three comedy films over two years, *48 Hours, Trading Places,* and *Beverly Hills Cop.* Murphy had a cocky, ultra-cool, bad boy attitude that made audiences everywhere laugh. Richard Pryor undeniably had this same gift, but Pryor never had the

Beverly Hills Cop (1984), directed by Martin Brest, could have been a one-note movie about a misfit cop from Detroit nosing around the chic establishments of Beverly Hills. But Eddie Murphy's bad boy screen charm and his multi-million smile took a B-movie idea and turned it into a blockbuster.

luck of picking films that exploded at the box of-fice. Murphy did. And it is a fitting twist of fate that his biggest film of the '80s, *Beverly Hills Cop*, was originally written for Sylvester Stallone who left the production over creative differences. Murphy stepped in and turned the character of Axel Foley into his own outrageous creation.

Perhaps the most important changes in films about African Americans happened because of director Spike Lee. During the '70s, most of the directors of the "Blackploitation" films took tra-ditional genres, usually about urban crime, and put a new spin on them with black actors. With the exception of Melvin Van Peeble and *Sweet Sweetback's BaadAsssss Song* in 1971, these films did not attempt to explore the true inner conflict and anger of most African-American people. Spike Lee stepped away from the formula of genre movies and made films that reflected real people in black, urban society.

From 1986 to 1992, he made a series of films that are arguably the first motion pictures to show an honest portrayal of African Americans, sever-al of them with Denzel Washington. Starting with the low-budget comedy, *She Gotta Have It*, Lee followed with *School Daze*, and then made what many consider his masterpiece, *Do the Right Thing*, for which he was nominated as writer but not director. Lee was a true total filmmaker who was able to put a complete personal vision on screen for world audiences to see. He was gifted with a visual style, that at times was almost im-provisational like jazz music, but what is most distinctive about Lee is his fearlessness as a writer and storyteller. After *Do the Right Thing*, he made *Mo' Better Blues, Jungle Fever*, and *Malcolm X*, his heartfelt epic tribute to the fallen black civil rights leader.

The only African-American director to be nominated is John Singleton, who in 1991 wrote and directed *Boyz n the Hood*, and at the age of twenty-four became the youngest person ever nominated as Best Director. His directing efforts have been uneven at times, going from *Poetic Justice* to *Higher Learning* and the historical drama *Rosewood*. The '80s seemed to be a pres-sure cooker for young directors like Lee and Singleton. Their later work seems to have lost some of the dramatic punch and social purpose as their earlier materials. But perhaps this is be-cause the films they made earlier were directed with such passion that their vision of African-American society finally woke up audiences of all colors to what was happening in America. Singleton put a symbolic closure on the Black-ploitation film movement by directing the remake of *Shaft* in 2000. And Lee has continued to direct films with a dramatic edge, ranging from satires like *Bamboozled* to dramas like *25th Hour* to doc-umentaries, including *4 Little Girls* to *Jim Brown All American*.

Asian Americans

Undeniably, winning an Academy Award for act-ing carries a double meaning for many ethnic ac-tors. The award serves as recognition for an out-standing performance and a nod to the actor's cultural heritage. In light of this, it is extremely ironic that the first Asian role to win a best ac-tress award went to Luise Rainer in *The Good Earth* in 1937. Rainer, who won her second Oscar in a row with this film, was born in Germany of Jewish heritage. It is unquestionably a great per-formance, but it would not be until 1957 that an Asian was nominated. In the same year Sessue Hayakawa was nominated for *The Bridge on the River Kwai* and Myoshi Umeki won in the sup-porting category for *Sayonara*. After this it would be 1984 before another Asian actor was nomi-nated, Haing S. Ngor for *The Killing Fields*, for which he took home the Best Supporting Oscar. In 2003, Ken Watanabe was nominated for *The Last Samurai*.

Crouching Tiger, Hidden Dragon (2000) directed by Ang Lee, starring Yun-Fat Chow, Michelle Yeoh, and Ziyi Zhang. Watching this majestic epic makes it seem like films with non-Asian actors playing the leads was part of the medieval ages, but it was only a few decades ago. Yun-Fat Chow has made over 80 films, including U.S. hits **The Replacement Killers** and **Bulletproof Monk**. Ziyi Zhang has become an international star because of films like **House of Flying Daggers** and **Memoirs of a Geisha**.

The most honored Asian is director Akira Kurosawa, who had four of his motion pictures win the Best Foreign Language Oscar, and he was given an Honorary Award in 1989 for "accomplishments that have inspired, delighted, enriched, and entertained audiences and influenced filmmakers throughout the world." The significant difference in how Asians are portrayed in movies toward the end of the twentieth century has everything to do with the popularity of films coming out of Japan and Hong Kong with American audiences. African Americans and Native Americans are in a sense landlocked; they are part of American history and their struggles in a predominately white society have created a recurring theme for most films made about them. This is true to a lesser extent with the modern Mexican-American character, but the Latino culture also extends to Spain and Central and South American.

The evolution of Asians in Hollywood movies has been achieved almost entirely from the outside in, meaning that the changes are because of Asian films that have been successfully imported for American audiences. Certainly the Samurai epics of Kurosawa, Miyamoto Musaschi, and Teinosuke Kinugasa had a tremendous effect on popular culture. In Hollywood, the samurai eventually found himself in galaxies far away, renamed Jedi warriors. Debatably this merger with the fantasy genre is reflected in samurai films made in the twenty-first century. In Ang Lee's *Crouching Tiger, Hidden Dragon,* the samurai warrior can leap great distances and battle on the top branches of trees. In *Hero* and *House of Flying Daggers,* directed by Yimou Zhang, the feats of the samurai have become truly superhuman. The opulent beauty of these films reflects the dynamic use of color found in the early Technicolor movies, and the attention to details in these films has lifted them into incredible works of cinematic art.

Bruce Lee had no idea what a filmmaking revolution he would start when he return to Hong Kong in 1972 to make *Return of the Dragon.* The martial arts or Kung Fu movie hit at the same time as the Blackploitation film was reaching its height of popularity. The difference was that Kung Fu movies hit a popular cord with audiences around the world, especially with teenage boys. Westerns were in decline, and gritty films about city violence and maverick cops, like *Bullitt, Dirty Harry,* and *The French Connection* were cleaning up at the box office. Since all big cities look alike when

it comes to dark alleys and criminal dominated neighborhoods, Hong Kong became the new domain for the post-noir anti-hero.

For several years after Lee's untimely death, Jackie Chan followed in his footsteps, playing his roles with utmost seriousness. Then he decided to create his own persona on screen and began to lace his characters with humor, until his later films became almost a mix of martial arts and Buster Keaton. Chan's mission was to break into the American market. His breakout movie was *Rumble in the Bronx* in 1996, but it would take another two years before he had a real box-office smash. *Rush Hour* is a film that that would have been unimaginable a decade before. The two unlikely buddies were an Asian and an African American. It certain was not a socially important film like *In the Heat of the Night,* but *Rush Hour* in its slap-stick fashion signaled a new age of racial equality in the movies. Following in Chan's success, and the enduring legend of Bruce Lee, by the end of the twentieth century actors like Chow Yun-Fat, Jett Li, and Michelle Yeoh were movie stars known to audiences worldwide.

By the early '90s, director John Woo had made over thirty movies in Hong Kong which caught the attention of Jean-Claude Van Damme, Quentin Tarantino, John Travolta, Tom Cruise,

and others in the Hollywood community. There was something mesmerizing—almost lyrical—about his camera work in action scenes. His early films were translated into English titles like *Hand of Death, To Hell with the Devil,* and *Heroes Shed No Tears.* Two films he made with Asian matinee idol Chow Yun-Fat became cult classics in America. *The Killer* (1989) and *Hard-Boiled* (1989) had scenes of pure carnage on the scale of grand opera, with guns that never ran out of bullets and editing that pounded audiences with hundreds of bits of information. A favorite stand-off motif of Woo's is having two rivals stand with automatic pistols pointed between each other's eyes (a slick bit of drama that Tarantino borrowed for *Reservoir Dogs*).

Woo was lured to America to direct *Hard Target* (1993) with kung fu star Jean-Claude Van Damme. Over the next ten years he make *Broken Arrow, Face/Off, Mission: Impossible II* (a remake of *Notorious,* though this is not acknowledged in the credits), *Windtalkers,* and *Paycheck,* plus a short film, "The Hire: Hostage," that has a freedom of style most of his Hollywood films are missing. In Hong Kong, Woo had been well known for shooting without a finished script, a practice he was forced to abandon with his big-budget Hollywood features. Like Alfred Hitchcock, for Woo

Rush Hour (1998) directed by Brett Ratner, starring Chris Tucker and Jackie Chan, had a worldwide gross of $245 million. *Rush Hour 2* made $347 million. Chan has made over 90 movies, many by his own production company, and because of his almost life-defying stunt work, he is considered a star in almost every country. What is unique about his appeal, especial for someone who does mainly action pictures, is that women enjoy him as much as men.

the reality of a story often got in the way of a brilliantly conceived action sequence. The plots of many of his American films are preposterous, but, like a jazz musician, he makes it all worthwhile with moments of pure bravada.

Anime

What has been described as the Asian invasion of America began quietly on Saturday morning television for kids. Japanese Animation, or "Anime" as it has become popularly known, got its start as far back as 1917 with one-reelers. During the 1920s the number of cartoons increased, growing into three reels, and dramatizing Asian folk tales in the tradition of Japanese art. In the 1930s, the style of these cartoons changed; they became faster paced and were heavily influenced by Walt Disney. Then during the late '30s and throughout World War II, to get approval of government censors, the cartoons became part of the military propaganda machine. Slow to recover after the collapsed economy following the war, it was not until 1958, with the release of feature *Panda and the Magic Serpent,* did Anime begin to attract international attention.

In 1960, *Alakazam the Great,* based on popular comic books by Osamu Tezuka, became an unexpected sensation. The feature used Tezuka's plot and visual style, and he was hired as a consultant. Tezuka was enormously popular in Japan for his comic strips and books during the 1950s, but with the success of *Alakazam the Great* he switched his attention to animation. Influenced by the Hanna-Barbera television cartoons, Tezuka focused his attention on Japan's first TV animated studio, Mushi Productions, and he began by adapting his comic book character *Astro Boy* into a series. The studio was soon mass producing science fiction and action adventure for a new generation of children growing up on television animation.

In the '50s, cartoons like Mighty Mouse and Heckle and Jeckle dominated Saturday morning children's shows. When Hanna-Barbera broke into early evening television with *The Flintstones* and *Johnny Quest,* this swung open the doors for Anime to make a major entry into American television. Soon kids were watching *Speed Racer* and robot series like *Mazinger Z.* After the success of *Star Wars,* Leiji Matsumoto's *Space Ship Yamato* became a hit, spinning off other series in this genre, which lead to the highly popular *Dragon Ball Z.* Anime was mainly produced for television for almost two decades, until Hayao Miyazaki and Isao Takahata, through Studio Ghibli, returned to feature animation with *Laputa: The Castle in the Sky* (1986) and *Pom Poko* (1994). The success of these features resulted in Katsuhiro Otomo's cyberpunk thriller *Akira* and Mamoru Oshii's adaptation of the manga novel *Ghost in the Shell* (1995). In 2002, Miyazaki's *Spirited Away* became the first Anime feature to win the Academy Award.

The violence in these features became more intense, reflecting the possible influence of Sergio Leone's styled violence, and very sexual, almost at times pornographic in nature. In 1984, there was a emergence into the home-video market, which resulted in OAV, for Original Anime Video. *Crying Freedom* (1988) is a good example of the ultra-violent, sexually explicit features that broke away from the restrictive nature of children's television. The influence of Anime is just beginning to be reflected in motion pictures. The most notable example is *The Matrix* (1999), written and directed by Andy and Larry Wachowski, who worked closely with Anime artists to create the scenic design and special effects for *The Matrix* and its two sequels, *The Matrix Reloaded* and *The Matrix Revolutions.*

Perhaps the biggest change to come about because of the highly stylized Anime artwork is found in modern comic books and graphic novels. The old frame-by-frame layout of DC and

Marvel comics has changed radically over the last decade, with illustrations that break the frames, a sense of fluid dramatic movement, and an intensification of violence. This is another example of how early Hollywood influenced the filmmaking (in this case the animation) in foreign countries, and in turn these countries spun out a new variations on genres and visual language that ultimately influenced the young directors of the New Hollywood.

Latinos

Being a Latino in the movies underwent a major transformation starting in the 1980s. For decades the focus was on Mexico, a country dramatized with poor peasants, corrupt officials, romantic music, and beautiful women. But with a revival in foreign cinema, exceptional films from Spain and South America began to change this image and widen the scope of the Latino heritage in cinema. Luis Bunuel, who was born in Spain but lived his later years making films in Mexico City, began this change of perception with art house films like *That Obscure Object of Desire* (1977) and *The Discreet Charms of the Bourgeoisie* (1972). In 1979, *Bye Bye Brazil*, directed by Carlos Deigues, became the most successful foreign film up to that time. *The Official Story*, directed by Luis Puenzo, won the Oscar for best foreign language film in 1985.

In Spain, Pedro Almodovar wrote and directed a series of films that found a large international following, including *Matador* (1986), *Women on the Verge of a Nervous Breakdown* (1988), *Tie Me Up! Tie Me Down* (1990), *All About My Mother* (1999), and *Talk to Her* (2002). Almodovar's frequent leading man was Antonio Banderas, whose good looks and easy charm attracted the attention of Hollywood. Banderas made *The Mambo Kings* (1992) when he could barely speak English, but within a year he landed a small role that would begin his assent to stardom. The film was

Stand and Deliver *(1988) directed by Ramon Menendez, starring Edward James Olmos and Lou Diamond Phillip. Olmos received an Oscar nomination for his role as high school math teacher Jamie Escalante. By this time he had already made* **Wolfen** *with Albert Finney,* **Zoot Suit** *and* **Blade Runner.** *Since then he has appeared in more than 35 films and television movies. One of the most in demand actors in Hollywood, Olmos has played Lt. Castillo in* **Miami Vice** *and Commander Williams in* **Battlestar Galactica.**

Philadelphia and in it he played Tom Hank's devoted lover. After this he was cast opposite Tom Cruise and Brad Pitt in *Interview with a Vampire* (1994) and then with Madonna in *Evita* (1996).

By the time he made *The Mark of Zorro* (1998), Banderas had become the most famous Latino movie star in the world. Taking more control of his films, he began to break the old stereotypes of the Latino character. Banderas brought his own sense of humor to the role of Zorro (becoming the first Spaniard to play the masked outlaw), and he had fun mocking the old Hollywood image of the dashing Latino lover in *Shrek 2* (2004). In 1995, Banderas accepted the lead in a low-budget film by a young director named Robert Rodriguez. The movie was *Desperado*, a remake of *El Mariachi* (1992), which was shot for just seven thousand dollars. Both movies have become cult favorites.

This started an ongoing collaboration with Rodriguez on a series of Latino themed films, including *Spy Kids* (2001), *Spy Kids 2: Island of Lost Dreams* (2002), *Spy Kids 3-D: Game Over* (2003) and *Once Upon a Time in Mexico*, made the same year. Rodriguez is one of the smart, independent rebels that selects to workout outside the Hollywood system. Aware that big-budget features inevitably cause a director to become a prisoner to the purse strings of large studios, he prides himself that each *Spy Kid* feature came in on a progressively lower budget. In 2005, Rodriguez shot *Sin City*, based on the graphic novels of Frank Miller, entirely against a green screen in his small studio based in Texas. Since he was using Miller's drawing as his storyboards, he proposed to the Directors Guild of American that Miller be listed as co-director on the film. The DGA turned down his proposal, so Rodriguez resigned from the Guild.

In 1988, Edward James Olmos received an Oscar nomination for his standout performance in *Stand and Deliver*, based on a true story about a dedicated teacher. The last Latino to be nominated in this category was Anthony Quinn in 1964, for, ironically, his robust performance as *Zorba the Greek*. Co-starring with Olmos was Lou Diamond Phillips, who the year before played Ritchie Valens in the sleeper hit *La Bamba*, directed by Luis Valdez. These films presented a positive view on Latinos in the American culture. One of the complaints has been that too many movies about Latinos focus on youth gangs or violence within communities. *Zoot Suit* (1981), starring Olmos and directed by Valdez, is about the notorious "zoot suit riots" in Los Angeles during the 1940s. Olmos powerfully directed and starred in *American Me* (1992), which is about thirty years of Chicano gang life in Los Angeles. *Colors* (1988) directed by Dennis Hopper, starring Sean Penn and Robert Duvall, is about gang violence in East Los Angeles.

As a hopeful sign of positive change, since the turn of the new century more Latino men are appearing in major films. Benicio Del Toro won a supporting Oscar for *Traffic* (2000), playing a good cop who is battling nearly overwhelming odds to stop drug smuggling in Mexico. Del Toro had become popular with audiences for his funny, offbeat characterizations in *The Usual Suspects* (1995), *Snatch* (2000), and *Sin City* (2005), and proved his dramatic range in *21 Grams* (2003), for which he received a second nomination. Gael Garcia Bernal made a striking impression in *The Motorcycle Diaries* (2004), directed by Walter Salles, about revolutionary legend Che Guevara's youthful adventures in South America. That same year Javier Bardem impressed audiences everywhere with his performance in *The Sea Inside*, directed by Alejandro Amenabar.

Latina women have made it into the Hollywood mainstream, many of which have used their newfound status to fight for strong meaningful roles. Salma Hayek received a nomination for *Frida* (2002), based on the life of artist Frida

The Usual Suspects (1995) directed by Bryan Singer, starring Kevin Spacey, Benicio Del Toro, Steven Baldwin, Gabriel Byrne, and Kevin Pollak. Starting out as Duke the Dog-Faced Boy in **Big Top Pee-wee**, Del Toro came a long way to finally win an Oscar for **Traffic** and to be nominated for **12 Grams**. He studied with the legendary Stella Adler, but became known for taking big chances with his characters. As Fred Fenster in **The Usual Suspects** he is almost completely inarticulate—and steals every scene he is in.

Kahlo, an act of love for which she also served as one of the producers. Hayek has emerged as one of the most popular actresses in Hollywood, working with Robert Rodriguez on *Desperado* and *From Dusk to Dawn* (1996) and *Once Upon a Time in Mexico.* Jennifer Lopez won raves for her performance as *Selena* (1997), the true story of the ill-fated pop singer, and has been on the A-list since her breakout performance in *Out of Sight* (1998), directed by Steven Soderbergh. In 2004, Catalina Sandino Moreno was nominated as Best Actress for her breathtaking performance in *Maria Full of Grace,* directed by Joshua Marston.

Native Americans

Not all cultural groups have made large strides in movies since the 1980s. Many Native Americans have been described as "strangers in their own land." As has been exhibited over and over, the stereotypes of different ethnic groups are not started by small films but by films that reach large audiences, and most of these films in the past have been pure popular entertainment that are fueled by the quick recognition of characters. In the same respect, it often takes popular films with a new viewpoint that being to heal ancient wounds. For the Native Americans, *Little Big*

Man (1970) and *Dances with Wolves* (1990) were important films that fairly depicted the unjust hardships endured as part of the waning of the West in the late nineteenth century. Each of these films had Native Americans nominated for Best Supporting Actor, Chief Dan George in *Little Big Man* and Graham Greene for *Dances with Wolves.* Greene has continued an active career in both film and television with dozens of roles, including *Thunderheart* (1992), *Die Hard: With a Vengeance* (1995), and the mini-series *Into the West* (2005).

But *Little Big Man* and *Dances with Wolves* also made the end of the Hollywood Western. It is inconceivable that filmmakers will ever want to revisit the old cowboys and Indians action movies that were enormously popular for over fifty years. But when these films ended so did the public's awareness of modern-day Native Americans. They have become almost invisible on movie screens. There are Native-American film festivals around the country, but sadly these features, shorts, and documentaries are seen by only selective audiences.

One of the most successful Native-American filmmakers is Chris Eyre. *Smoke Signals* (1998) is perhaps his best known movie and deals with modern reservation life. It is the heartfelt story of a son coming to terms with the memories of

Smoke Signals (1998) directed by Chris Eyre, starring Adam Beach and Evan Adams, was one of the few breakaway films by a Native American that reached a mainstream audience. But this appears to be changing. There are over 30 film and video festivals around the country, media arts is being taught in many of the schools, and there is a growing awareness that movies can used to reverse the negative stereotypes that have been presented since the first Westerns were made. As is the case with many ethnic groups, it just takes one film to begin to alter mass perception.

his dead father and is full of delightful, amusing characters. It took Eyre four years to find the funding for his next film, *Skins* (2002), which stars Graham Greene in a powerful story of two brothers who have lead very different lives. Unfortunately *Skins* received a very limited release. Eyre has had more success with his television production of Tony Hillerman's mysteries *Skinwalkers* (2002) and *A Thief of Time* (2004).

Lost Cultures: The Invisible Multicultural Groups

Native Americans are not the only ethnic groups that are lost in modern motion pictures. There are many cultures that have had very little attention paid to them in Hollywood movies. For each of them there have been movies that presented a stereotype and in some cases the movies have shown a very positive viewpoint. But with African Americans, Asians, Latinos, and Native Ameri-

cans up until the 1980s, there have been a wealth of films that have reached audiences worldwide, and by tracking these films, a pattern of change and social understanding can be observed. Most importantly, with the exception of Native Americans, entertaining and often meaningful films are perpetually being made that explore deeper into the traditions of these cultures.

This does not mean these other cultural groups are not actively making films, but the vast majority of these films never pass the boundaries of the countries in which they are made. The most notable void is the Arab cultures. There are the epics *Lawrence of Arabia* (1962) and *Lion of the Desert* (1981), each with Anthony Quinn playing historical Arab roles, and action adventures like *Executive Decision* (1996), where Arab terrorists highjack a 747 and demand to land in Washington, D.C. The subject of terrorism is also part of television dramas and miniseries, including *MI-5* and *The Grid*, both in 2004.

Motion pictures about Arabs tend to fall into these two categories: historical melodramas and modern political thrillers. Part of the reason for this absence of Arab films goes to the heart of the ancient Muslim religion. Many believers feel that the dramatization of holy events should be forbidden. This is in complete contrast to the Christian and Jewish religions that welcomed motion pictures based on Biblical tales, going back to the silent era and recently demonstrated by the phenomenal success of Mel Gibson's *The Passion of the Christ* (2004), a success story that completely took Hollywood by surprise.

Locations were an important factor in making motion pictures and remote desert lands are difficult to shoot in and many places are restricted because they are considered sacred. There are many other issues, ranging from the depiction of women, to the fundamental difference in customs, costumes, and life styles. But perhaps the biggest reason is the most obvious: Arab cultures have not grown up with film as part of everyday life. From the earliest days of the silent movies, to the enforcement of the Production Code, religious organizations have been the watchdogs of acceptable social conduct in the movies. But only a handful of them forbid the viewing of movies as part of their religious beliefs. Instead the members of the Catholic Church and other organizations attended movies regularly. It was this steady flow of business that saved the studios during the dark years of the Depression.

However, this does not explain why there are not more films coming out of Hollywood about East Indians. India loves movies and has a huge film production, which is often referred to as Bollywood. *Gandhi* (1982) won the Best Picture Oscar and *Bend It Like Beckham* (2002) was a runaway hit. Yet neither one of these films generated more movies about Indian history or its people. Like the Native Americans, to Hollywood India is also stuck back in another time period,

in this case the romantic days of Rudyard Kipling tales like *The Man Who Would Be King* and *The Jungle Book*. Debatably the most famous India director is M. Night Shyamalan, but his movies do not deal with his cultural background.

Perhaps this is because movies have become the Great Equalizer, gradually ironing out the wrinkles in all cultures. Early sound films were a glorious hodgepodge of characters with different accents and slang terms. With three little words, audiences could tell if someone was from Chicago, the Deep South, Texas, Oklahoma, Maine, or even which neighborhood in New York they came from. Nowadays there seems to be a common vernacular that has been debugged of any idiosyncrasies. In the age of political correctness, it is probably considered a social taboo to label or make fun of someone because of an accent. So, there are fewer characters with exaggerated Jewish, Irish, or Swedish accents. But, naturally, there are always exceptions. Even today there are very few films about Italians that are not mob or crime related. Thus in the movies and on television, Italians still tend to talk with a tough-guy accent that echoes back to *Scarface* in the early 1930s.

Another reason certain countries are not used more as locations might reflect the destructive power of a single film to poison the image of a country. After almost thirty years the Turkish government complains that *Midnight Express* has cast an unfavorable impression on the entire nation and its people. Even a great film like *City of God* might give tourists a nervous hesitation about visiting Rio de Janeiro. But whatever the numerous factors are that might play into why a country or a cultural group is not used regularly in films, there is one factor that has proven true over and over again: It takes just one filmmaker to create a passionate image of a country or a race of people to change in a positive way the perception of the entire world.

WOMEN IN FILM

There will probably never be another era for women's movies like there was during the Studio Era of the 1930s. But since 1980 there have been changes that were never possible during the decades of the studio moguls. By the mid-30s, the few women filmmakers that existed, like Francis Marion and Dorothy Arzner, had been pushed aside in the male-dominated system. The films about women during these years often had the female sex as equal to the male animal, but mostly the movies were "weepers" about sacrifice and enduring hardships. The delightful exceptions were screwball comedies and movies directed by Frank Capra, Howard Hawks, George Stevens, or John Ford, who liked strong women characters in their features.

After World War II, these comedies and true love melodramas faded away. Women had been a vital part in building the American War machine, but when the war was over, they were asked to become happy housewives in utopian kitchens, and the movies reflected this domestic image. Of course, the femme fatale in film noirs could operate in the tough man's world, but they rarely got to be part of the climactic shootout. Because of the Production Code, these scheming women usually caught a bullet before the final reel. When musicals proved to be expensive flops in the early '70s, and stars like Audrey Hepburn and Doris Day retired, women in films were represented by only a few stars, like Faye Dunaway, Natalie Wood, and Jane Fonda.

The old-fashioned women's film never disappeared; instead the scenarios from many of these classic movies became part of the daily fabric on television comedies and dramas. On TV women could be cops, news reporters, doctors, and the kind of villains the vast public loves to hate. Mary Tyler Moore, Joan Collins, Linda Evans, and Heather Locklear became superstars, despite the fact they made very few successful

Chicago (2002) directed by Rob Marshall, starring Catherine Zeta-Jones, Renee Zellweger, John C. Reilly, and Richard Gere. Zeta-Jones danced and sang her way to an Oscar as Velma Kelly in this hit musical, and Zellweger, as Roxie Hart, proved she could be just as rotten and manipulative as any man. Zellweger is not a classic Hollywood beauty, but she lights up the screen in the right role, like in **Jerry Maguire, Nurse Betty, Bridget Jones's Diary, Cold Mountain** (for which she won her Oscar), and **Cinderella Man.**

A League of Their Own (1992) directed by Penny Marshall, starring Tom Hanks, Geena Davis, Madonna, Rosie O'Donnell and Lori Petty. Marshall started directing on her television show **Laverne & Shirley,** and made her film debut with **Jumpin' Jack Flash.** She then had three major hits in a row, **Big, Awakenings,** and **A League of Their Own.** Changing hats again, she produced **Cinderella Man** and **Bewitched.**

movies. But in films, with the rising popularity of buddy movies and loud action features, women were back being prostitutes, unhappy housewives, the occasional over-the-top, tough-as-nails boss, or the sharp-tongued object of desire that had to be rescued. Women were suddenly back to the kind of roles available to them in the early '30s, and then only a few years later were forbidden to play, when the Production Code settled in. But a few films starting in the '80s changed this cycle.

Sigourney Weaver, being the only survivor in *Alien* (along with her cat), was brought back to fight the acid-for-blood creatures in *Aliens,* and then found herself in two more sequels. Weaver also held her own against evil spirits in *Ghostbusters.* Then Linda Hamilton became the

Aliens (1986) directed by James Cameron, starring Sigourney Weaver, Michael Biehn, Bill Paxton, Lance Henriksen, and Paul Reiser. As a bit of sweet irony, Weaver has done something no male actor has achieved, she received an Oscar nomination in a science fiction adventure film—**Aliens.** She played Ripley in the original **Alien** and three sequels, almost single-handedly changing the macho concept that an action hero had to be a man. A versatile actress, she has starred in everything from **Ghostbusters** to **Working Girl** to **Gorillas in the Mist: The Story of Dian Fossey.**

ultimate commando mom in *The Terminator* and *Terminator 2: Judgment Day*. James Cameron was the director of *Aliens* and the *Terminator* movies, and like Hawks, he liked women that were not afraid of a little firefight. But also behind the camera was Gale Anne Hurd who co-wrote *The Terminator* and was the producer for the film.

Hurd also served as producer or executive producer on *Aliens, Alien Nation, The Abyss, Tremors, Terminator 2: Judgment Day, The Relic, Armageddon, Hulk,* and *Terminator 3: Rise of the Machines.* By the mid-80s it was becoming almost commonplace to see women's names as producers. Sherry Lansing was behind *Fatal Attraction, The Accused, Black Rain, School Ties,* and *Indecent Exposure.* Marcia Nasatir made *The Big Chill, Hamburger Hill,* and *Ironweed.* Linda Obst has been involved with *Flashdance, Fisher King, Sleepless in Seattle, Contact, Hope Floats,* and *How to Lose a Guy in Ten Days.* And Niki Malvin produced *The Shawshank Redemption.*

Starting in the early '80s, by working on low-budget features, with smart, current stories, usually involving the humorous perplexities of Generation X, women finally got a foothold in film directing. Amy Heckerling caused a sensation with *Fast Times at Ridgemont High,* which started a trend in teen high school movies. She followed this with *National Lampoon's European Vacation* and *Look Who's Talking,* and hit box office gold with *Clueless.* Starting almost at the same time in the 80s was Martha Coolidge, who directed *Valley Girl, Real Genius, Rambling Rose, Lost in Yonkers,* and has also directed for the hit series "Sex in the City." And Barbra Streisand used her star power to direct *Yentl, The Prince of Tides,* and *The Mirror Has Two Faces.*

Two of the most successful directors are Penny Marshall and writer-director Nora Ephron. Marshall became the first women director to make movies that made over one-hundred million dollars. Ephron wrote *Silkwood, Heartburn,* and *When Harry Met Sally* before she got the opportunity to direct her first movie, *Sleepless in Seattle,* which she also wrote. Other films she has written and directed include *Michael, You've Got Mail,* and *Bewitched.*

Today's movie stars like Julia Roberts, Sandra Bullock, Drew Barrymore, Reese Witherspoon, Cameron Diaz, Jodie Foster, and Meg Ryan have their own production companies and develop films they want to make and star in. This was almost unheard of as late as the mid-90s, but then

When Harry Met Sally (1989) directed by Rob Reiner, written by Nora Ephron, starring Meg Ryan and Billy Crystal, and Carrie Fisher. Ephron has a knack for turning adversity into good fortune. After her divorce from Watergate journalist Carl Bernstein, she wrote the novel *Heartburn,* which was made into a film with Meryl Streep starring as her. Ephron got the first of her three Oscar nominations for co-writing *Silkwood,* then *When Harry Met Sally* and *Sleepless in Seattle,* which is also directed.

Lost in Translation (2003) directed by Sofia Coppola, starring Bill Murphy and Scarlett Johansson. Following in her father's famous footsteps, Sofia Coppola is multitalented as a writer and director. Born during the production of **The Godfather,** she directed her first feature, **The Virgin Suicides,** when she was twenty-eight. With **Lost in Translation** she became the first American woman to receive an Oscar nomination as best director, and won the award for best original screenplay.

each of these actresses appeared in movies that were so successful, that studios quickly gave them special development deals. During the Studio Era, only Katharine Hepburn made a deal like this. With the help of Howard Hughes, she had acquired the rights to the hit Broadway play, *The Philadelphia Story,* and then negotiated with Louis B. Mayer to make the movie—a deal that did well for both of them.

Francis Ford Coppola once mused that someday a little girl with a camera would make a picture that would change everything, the same way that Orson Welles did. It is doubtful that he anticipated his own daughter, Sofia, who was not even ten when he made this remark, might be that girl. In 1999, Sofia Coppola wrote and directed her first feature, *The Virgin Suicides,* at the age of twenty-eight. Four years later she received nominations for writing, directing and producing the highly successful *Lost in Translation,* and won the Oscar for her original screenplay that year. This became the first time that a father and daughter each won Academy Awards for writing. For her next film Sofia took on nothing less than the French Revolution and made *Marie-Antoinette.*

It has taken almost one hundred years for women to finally be able to call the shots, but finally the exception to the rule is becoming commonplace.

Afterword

SOME FINAL OBSERVATIONS AND A SNEAK PREVIEW OF THINGS TO COME

To follow the "trigger effect" in film can be both enlightening and discouraging. What becomes clear is that almost every aspect of film as it is known today was pioneered within thirty years of Edison's *Fred Ott's Sneeze* in 1894. By the end of the silent era film genres were established, so it is possible to trace, for example, Westerns from *The Great Train Robbery* to *Stagecoach* to *A Fistful of Dollars* to *Butch Cassidy and the Sundance Kid* to *Unforgiven*. Or study the advancements in stop-action animation from *A Trip to the Moon* to *King Kong* to *Jason and the Argonauts* to *The Empire Strikes Back*. Film is the only art form where every innovation can be traced back to the year, and often the very day, it occurred. So, to follow the key events in film will reveal changes in directing styles, refinements of cinematography, and the influences of popular public tastes over the decades.

The disadvantage of studying film in this fashion is that remarkable men and women are left out because their contributions might not have profoundly changed the process of motion pictures. These individuals did quality work, and are personal favorites of many film enthusiasts and scholars, but because so much has happened in this lively art form during the twentieth century the information becomes overwhelming. It is evident that future generations will literally not have the time to become familiar with all the important people. To have an understanding of the key movements in film creates stepping stones into the past and hopefully this journey generates interest for more research.

The members of the New Hollywood were raised at a time when film was just fifty years old, and it was possible to see all the movies of John Ford, Frank Capra, or Alfred Hitchcock, plus be well-versed in William Wellman, Henry Hathaway, and George Cukor. But today with more than 18,000 movies on video and DVD this task becomes daunting. The directors of the New Hollywood are now studied but the directors that influenced them are literally fading away. The irony is that young filmmakers who are learning from Steven Spielberg or Martin Scorsese are actually learning from a long list of earlier directors.

The other possible downside of examining film in this fashion is that all the small innovations and personal low-budget movies of the past seem to eventually merge into a highly commercial commodity as time goes on. This is why film is such a conundrum to teach. A bad painting or piece of music might be experienced by only a few people, but a bad movie is seen by millions—potentially forever. The fact there is a multitude of camp horror movies but only one *Seven Samurai* has been a major stumbling block in having film embraced in the academic world as a respectable field of study.

Early motion pictures were cranked out daily to keep up with popular demand. With the Studio System there was an attempt to produce

Lord of the Rings: The Return of the King (2003) directed by Peter Jackson, with Andy Serkis as Gollum. This exceptional motion picture trilogy debatably takes the history of cinema full circle. The first narrative movie was the 14 minute **A Trip to the Moon** by Georges Méliès, which introduced the art of movie magic. Starting with **Jurassic Park** and culminating with Jackson's epic adventures, CGI has allowed filmmakers to create completely realistic worlds and the creatures that inhabit them. The fantasy and science fiction movies that lead up to this point have had an artificial quality to the special effects. Though the achievements have been astonishing at times, and have created countless nostalgic memories, audiences were required to use their collective imagines to enhance a giant gorilla, a creature from the Black Lagoon, or even E. T. Now a character like Gollum (half human and half computer generated) appears absolutely real. With this final leap in technology a chapter in movie history seems to be closing. But whatever lies ahead will still owe an enormous debt to the first one hundred years.

prestige features with stars, a team of good writers, and smart directors. But even during this era there were B-movies, shorts, newsreels, cartoons and serials that were not as carefully overseen for quality. There were undoubtedly B-artists during the Impressionism movement, but thankfully they have been lost in time. When television began, the demand for entertainment was so enormous that that shows were being turned out weekly, almost at the same pace two-reelers were made in the silent era. In this giant mix, the prestige film became a rare event instead of common occurrence. But just when it appeared that great or provocative movies were an endangered species along came *The Usual Suspects, L. A. Confidential, American History X, American Beauty, The Matrix, Memento, Spirited Away, Amelie, The Lord of the Rings* trilogy, or *City of God* by Brazilian director Ferando Meirelles, one of the most remarkable films ever made.

Film is very young. The other arts are well established in ancient civilizations. For film, this is the start of a very long journey full of changes. Unquestionably the biggest potential change in film is the possibility there might not be *film* in the future. Though there is a tug-a-war now between the use of film and digital cameras to make motion pictures, the end result, in this increasingly expensive art, will be money. What is certain is that digital cameras have sparked a growing revolution in highly imaginative low-budget features and shorts. A period of personal filmmaking appears to be unfolding and the young filmmakers involved are part of a generation that grew up not only with movies and television but interactive video games, expensive digital cameras, computer editing systems, CGI software, and the Internet.

What follows is a brief look at some changes that could significantly affect the future of the

motion picture industry, plus some insights on the influence of film in people's daily lives.

FILM PRESERVATION AND STUDIO ERA DIRECTORS

Because of individuals like Kevin Brownlow and Martin Scorsese, and organizations such as The American Film Institution (AFI), The Museum of Modern Art, UCLA Film and Television Archive, Turner Classic Movies (TCM) and The National Film Preservation Foundation, a large portion of our sound film heritage is being saved from certain extinction. Because of careless or deliberate acts, it is estimated that over 85 percent of the silent films have been lost. AFI has been very successful in televising the results of different 100-lists, including the "Greatest American Movies of All Time" and "Heroes & Villains."

However, in a symbolic sense most of the motion pictures prior to 1960 (some would say 1977) are vanishing, not from lack of effort to preserve them but because there is not a popular outlet for younger generations to watch them. As revival cinemas began to disappear in the 1980s, and the number of cable channels grew into the hundreds, new audiences began to simply overlook this wealth of film heritage for new programs. No longer are there just three networks and the Friday night classic movie is seen by millions of people. Those days are gone forever. TMC is the only twenty-four hour channel that shows these movies without interruption. But without a way to make these films part of every school's curriculum then there is a very real chance they will be lost to future generations.

As an example of how quickly films made before 1960 have become invisible to young people, the only director from this early era that is still well-known is Alfred Hitchcock. This is largely due to the enduring legacy of *Psycho* and the slasher genre that grew out of the film's success. Also, Hitchcock's name is synonymous with thrillers and horror films, and his name has become a genre unto itself. There are constantly references to "like a Hitchcock movie" in review for modern films. But he is the last director standing from the Old Studio System as far as mass public identification.

Most people think of Charles Chaplin and Buster Keaton as silent comics, not directors. And Frank Capra's name appears every Christmas because of *It's a Wonderful Life,* and school children might have seen *Mr. Smith Goes to Washington* in class, but because Capra did not use the visual tricks associated with Hitchcock, so ironically he is not thought of as being a director in the contemporary definition. This means that Billy Wilder, George Stevens, William Wyler, Victor Fleming, Michael Curtiz, George Curkor, William Wellman, and foreign directors Ingmar Bergman, Federico Fellini, Vittorio De Sica, Jean-Luc Godard, Akira Kurosawa, and dozens of other directors who literally made the movies are unknown to a young generation that has not taken a film history class. And regrettably many of these individuals are sometimes omitted from the course study.

FILM EDUCATION

Film is sadly neglected in the education process, especially in area of film appreciation. Most students do not see a movie from the classic canon until they take a special study course in college. This means that the first eighty years of motion pictures production is unknown to them. Consequently their first viewing of silent movies and the films of the 1930s, '40s and '50s are met with resistance because of black-and-

white cinematography, slower editing techniques, longer story developments, less camera movements, and movie stars that they are unfamiliar with. The visual language of film is used more than the written alphabet. Everyone is exposed to it daily for hours at a time, but there are no general courses on this vital subject. Film should be taught in elementary school where students could learn to appreciate Charles Chaplin, Buster Keaton and the silent comics. And because of the Production Code, the movies from the Golden Age of the Studio System are all G-rated, which means these movies can be shown to young audiences without concerns of controversy.

There are hundreds of films from this era with enduring stories, marvelous acting, and no offensive language or actions. They are ideal to use as teaching tools for young children—before they grow up and develop attitudes about the lack of color or leisurely paced editing. These motion pictures were put together with a carefully crafted style that is often associated with individual studios, so it is easy to study them and appreciate the gradual development of a universal visual language. And these films are portholes to the past that reveal changes in ethnic relationships, the role of women in society, and fun history lessons on what things were like before cell phones, DVDs, and jet airplanes.

DEAR MR. SPIELBERG . . .

Teaching film at any level, even after a hundred years, is still a thorn of contention in the world of education. As an example, there is a story that after he directed *E. T. the Extra-Terrestrial*, a university, which will remain unnamed, approached Steven Spielberg about the possibility of him lending support in an effort to create a film school. However, when the theatre department of the university found out about this proposal they objected vehemently. Several of the professors stated flatly that Mr. Spielberg's work, and his films in general, were not worthy of being associated with the towering works and achievements in the theatre arts. Ironically, this is the same objective to motion pictures that Lillian Gish remembers happening during the early days of the flickers, when stage actors used to change names to keep their excursion into this low art form a secret. Not surprisingly, after this unflattering reception, Mr. Spielberg gave his support to the USC Film School instead.

FUTURE SHOCK

Frankenstein terrified audiences in the early 1930s, but seventy years later the big monster is more amusing than frightening. The shower scene in *Psycho* left people numb with fear, but the "slasher" films that followed, like *Halloween, Friday the 13th* and *Scream*, were far more explicit in gory details. *Bonnie and Clyde* and *The Wild Bunch* took screen violence to a new level, and *Mean Streets* and *Taxi Diver* brought rough language to audiences. Each of these films in a real sense was a loss of innocence to moviegoers. A Production Code is impossible in the twenty-first century because there is no way to control the hundreds of production companies, the Internet, and cable television. During the Pre-Code Production Era violence was noisy in gangster movies, but not graphically realistic, like James Caan's death in *The Godfather*.

The shock of seeing Dennis Hopper and Peter Fonda blown away at the end of *Easy Rider*, or the sickening horror of Tom Hanks making his way through a blood soaked battlefield in *Saving Private Ryan*, will probably never be duplicated

again. The violence and language in some computer games is non-stop, to the point that the grotesque becomes almost commonplace. In Rome and other ancient civilizations public deaths became popular weekend entertainment events, but there has never been a time when people watched bloody, make-believe violence thirty feet high while eating buttered popcorn. There is no way to measure the long-term impact of all this ultra-realism, complete with surround sound, because this vivid movie experience did not begin until the late '60s. The only certainty is that Bela Lugosi as Dracula is not going to cause young children to lose sleep anymore.

RUNAWAY PRODUCTION

Runaway production was originally a term used by Hollywood studios about films that were shot in other states like Arizona, Texas, Florida, and, for many years, even New York. Today the term is used for films shot outside the United States, in countries like Canada, Australia, New Zealand, England, the Czech Republic, and numerous other countries. Film Commissions began to flourish in the 1980s all around the world, because film is a "clean business" and has a spin-off factor of sometimes ten-to-one, meaning that for every dollar worth of foreign currency spent on the production, there are ten other dollars spent on hotels, car rentals, restaurants, hardware stores, clothing stores, souvenir shops, and other local businesses. This is a huge windfall to the revenue of towns and cities around a major film production.

The Lord of the Rings trilogy was shot in New Zealand, not only because it was the ideal location but primarily because New Line Cinema saved almost 30 percent on the total budget by shooting outside the United States. It can be ar-gued that runaway production really started after World War II when European countries were so impoverished that the American dollar was at its high point. Italy, Yugoslavia, Spain, and England became the locations for big-budgeted epics like *Ben-Hur, Cleopatra, El Cid,* and *Doctor Zhivago.* Once studios kept the majority of film production on sound stages and back lots, now production is scattered all over the world, and it is hurting the economy not only in Hollywood but in dozens of states throughout the country that were the home for film production for decades. Some states like Arizona, Texas, Louisiana, and North Carolina offer tax incentives, but this still does not attract the mega budget productions like Peter Jackson's *King Kong,* the *Mission Impossible* series, or even *Cold Mountain,* which is about the American Civil War.

But technology might bring it all back home for the studios. Movies like *Captain Sky and the World of Tomorrow* and *Sin City* were shot almost entirely against green screens, and then all the locations and effects were then digitally added. There is a sequence in *Wild, Wild West* that takes place in Monument Valley, but the only shooting on this location was the special second-unit photography to create the background effects—meanwhile the actors were on sound stages acting out their parts. With the advancement of this technology films could once again be shot entirely on sound stages.

THE CRITIC: PAULINE, SISKEL, EBERT AND YOU

At one time film critics had enormous power over what audiences saw. Not so much with the popular popcorn movies, these have always been relatively bulletproof and at the whim of word-of-mouth promotion,

but with serious films that had a deeper purpose than to just entertain. In the 1950s, James Agee was one of the first American critics that treated movies like art, and, like members of the French New Wave, he successfully entered the motion picture business by writing the screenplays for *The African Queen* and *The Night of the Hunter*. During the 1970s critics like Pauline Kael, Andrew Sarris, Penelope Gilliatt, and Molly Haskell were widely read and their opinions were highly respected. They would champion new directors like Robert Altman, Peter Bogdanovich, William Friedkin, and Bernardo Bertolucci and their in-depth criticism could turn a film into an art house hit.

Then in 1975 Gene Siskel and Roger Ebert went on television with "Sneak Previews" and like modern Roman emperors they showed their approval or disapproval with thumbs up or thumbs down. As the glory years of the New Hollywood faded away, the balance between serious films and popcorn movies became very lopsided. Columns of analytical film criticism was soon reduced to short reviews of new films, but the influential factors became which way the thumbs were pointed and the number of stars a movie got. Then the Internet arrived and websites like rottentomatoes.com and imdb.com (The Internet Movie Database) made *everyone* a critic, or more accurately a reviewer with an attitude or personal agenda.

There are no job descriptions that demand critics must have a vast knowledge of film history, but without this complete understanding of movies, reviews over the years have melted down to two critical points: A *personal* like or dislike of the film that has just been seen. This reduces the cinematic experience of watching a film to the ground floor evaluation of whether it provided a pleasurable two hours. *Metropolis, Grand Illusion, The Bicycle Thief, Ikiru, Jules and Jim, Aguirre: the Wrath of God, Chinatown,* and *Mean Streets* are not uplifting experiences to sit through —but they are life changing experiences for many people. The equilibrium between pure adrenalin entertainment and cinema that works on multiple layers, including the intellectual, has almost vanished since the 1970s. Today a multitude of reviewers give rapid-fire one-to-four star opinions in hundreds of newspapers, magazines, television programs, and on Internet sites. All this has the effect of sending too many mixed messages to filmmakers. For ever reviewer that hates a film, two more enjoyed it. And now that anyone can log in and share a personal opinion (which might be read by millions), it begins to dilute the whole process of insightful criticism.

THE ATTACK OF THE OVERLY DEVELOPED MARKETPLACE

One of the biggest fears in the movie industry is the steadily declining box office. This is the cause and effect of building a better mousetrap, but finding that the mouse has gotten bored and gone away. When *Jaws* hit the magic $100 million mark, and then two years later *Star Wars* shattered this record, the financial virtues of opening wide were immediately apparent to all the studio heads. The fast turnaround became king. As multiplexes popped up around the world there became an obsession of breaking records over the first weekend of a new release. With only a few exceptions, what were once affectionately called "the little films" got lost in the stampede of blockbusters going for the full monty.

Marketing for a big-budget feature begins with an elaborate website giving updates, sneak previews, and chat rooms. Then there are previews in theatres six months in advance, followed by the faces of the stars smiling on magazine covers, and then caught up in a whirlwind of tabloid

articles. This leads up to the all-important opening weekend. For years, moviegoers have unconsciously been part of a mass international training program to respond to the first days of a new release. There is a certain thrill of seeing the movie with a packed theatre, it gives the impression the individual is part of something really big—important, perhaps. And then there are all the chat and verbal reviews that people who have seen the movie participate in. But if someone has not seen the movie they are made to feel out of the loop by their peers, who did the right thing by catching it over the first weekend.

To capitalize on the marketing momentum of a successful movie, the time between the first run and the arrival of the VHS and DVD dwindled down from a year to sometimes less than six months. And this had unexpected repercussions on the movie industry. A mind-fix began to develop that if someone missed the opening weekend, and then the next couple of weekends, they would simply decide to wait for the DVD with all the extras. In fact, it has been learned that people, during the marketing blitz for a new movie, will have decided if they want to see it in a theatre or wait for the DVD.

The sales of widescreen televisions and surround sound units have soared and an increasingly large number of homes now have rooms that are mini-theatres. And this is as ideal environment. No parking problems. No lines. No one talking during the main feature, unless it's friends who are invited. And the refrigerator is supplied with food and beverages, plus microwave popcorn costs less than a dollar a bag. It's movie heaven. The individual is in complete control. This is a flashback to the early days of television when studios were hurting because people were staying home and watching the small screen. Now people are waiting for the DVD to watch the movie at home.

STORY

From the very beginning, film was a big business, which responded to the ebb and flow of technological changes, hard times, war, social upheaval, and politics. But the chief commodity of this business was creating emotions, i.e., storytelling. Movies made people laugh, cry, get scared, want to break into song, and cheer for the forces of good. Ironically the greatest periods of creativity in film were often during the poorest economic times for the industry.

The Great Depression produced the Golden Age of the Studio System, but during these years most of the studios were on the verge of bankruptcy. Nevertheless, Hollywood turned out hundreds of movies with uplifting stories that amused audiences. The bleak years in Europe after World War II resulted in the films of Italian Neo-realism and the French New Wave. And in the late '60s and early '70s, when the studios were selling off their back lots and producing one bloated flop after another, the Baby Boomers broke in and made small films that launched the New Hollywood.

The search for exciting stories is the one common denominator to every era of film. A great story is truly timeless, and this is the one factor that people are gambling on when they shell out the price of admission time and again. Through the decades people remember the first time they saw *It Happened One Night, Gone With the Wind, The Best Years of Our Lives, On the Waterfront, Lawrence of Arabia, The Godfather, Star Wars,* or *Saving Private Ryan.* The great paradox about the motion picture industry is that a film with a wonderful story can be made on a shoe-string budget, like *La Strata,* or for $200 million, like *Titanic.* A case can be made that even the awareness of having a really good story seems to inspire everyone involved in the filmmaking process, so all levels of production reach a high

plain, like *The Shawshank Redemption, The Usual Suspects,* and *Shakespeare in Love.*

It should come as no great surprise to discover that film is a very inconsistent art form. Anything that costs $30, $60, or $100 million should represent the top of the line, the Rolls-Royce of cinema experience, where every detail is accomplished with impeccable taste. It is unimaginable to think that a building could be constructed for this amount of money, and then topple over during the grand opening just because no one bothered to prove a complete set of blueprints. But this happens with movies regularly. The ideal ending for a book on film is to observe that after a hundred years of practice, all movies are uniformly marvelous. But this is unfortunately not true—and it is not true because of the lack of good, *well-developed* stories.

DISAPPOINTING ENDINGS AND REALITY TV

Another possible reason for the declining box office is the increasing disappointment with the ending of movies. There has always been the belief by studio heads that happy endings sell more tickets. But during different eras this formula was mixed up, so that audiences did not always know if Bette Davis, James Cagney, or Humphrey Bogart were going to be alive at the end of the picture or not. During the Vietnam conflict heroes usually met violent ends, and if they did survive the ordeal their experiences had radically changed them, like in *The Godfather* or *Dog Day Afternoon.* As the stakes got higher for movies, and in order to appease a large public, endings started to become overly predictable.

An ending to a moviegoer is a sacred thing. A bad ending will destroy all the good qualities of a movie. When *The Sixth Sense* came there was a kind of gleeful delirium that happened with audiences. It had an unpredictable ending. And the film went on to gross over $293 million. A good ending, whether it is Rhett Butler telling Scarlett, "Frankly, my dear, I don't give a damn," or the Terminator giving the thumbs up as he lowered into a vault of molten steel, gets people excited. In a sporting event no one knows the winner until the last second. And this search for a good ending might be the reason for so many reality shows. A viewer can watch *Survivor* and only speculate on the outcome, and even if the winner is not someone they liked, or were cheering for, the outcome was unexpected, and therefore it was satisfying.

Television shows originally ended each episode with a dramatic conclusion, like a short story. Then *The Fugitive* proved that an "open end" to a show, as Dr. Richard Kimble searched for the real murderer of his wife, added a continuing suspense to the series. The producers for *Hill Street Blues* were originally worried that the ongoing storyline, much the old serials, would hurt the series by confusing the audience, or perhaps prevent the series from being sold into syndication. Now most television shows are designed this way, from *Friends* to *The Sopranos,* leaving audiences guessing a little bit about what will happen. This touch of mystery gives these shows a greater sense of reality. But movies have become stuck in a formula that audiences have caught on to years ago, especially with the Hollywood blockbusters.

GAMES

Video and computer games are gradually beginning to transform movies, potentially giving them a greater freedom to break

away from stale, cookie-cutter endings. Games now generate greater gross revenues than motion pictures. In a single day a new game has sold over $100 million. The human likeness in games is uncannily real, and acting for games is extremely lucrative. A game can take fifteen or more hours to complete, the equivalent of watching seven movies. Recently, several universities, including USC, began offering degrees in game design and writing. Two generations have now grown up on games, and games appeal to all ages, races, and are popular around the world.

A well-designed game is more like complex novel with multiple subplots. The story will take many surprise turns before it eventually arrives at the climax or the "showdown." The journey often looks like a series of crazy 8's instead of a straight path. The big appeal is that games are interactive and the player can make dozens of decisions about where he or she wants to go next. This is the equivalent to standing up in a movie theatre and shouting directions to the actors—and they listen and obey. The power of controlling this virtual world—and after centuries of being a spectator in the traditional storytelling process, there is a very real sense of power involved—is both exhilarating and mentally challenging.

There has been joking speculation that movies are becoming long commercials for games. Andy and Larry Wachowski designed games for *The Matrix Reloaded* and *The Matrix Revolutions* that followed the adventures of secondary characters, expanding new elements of the story, so that when people saw the movies they would have a greater knowledge of the events taking place on screen. Whether or not this was successful is debatable, but it does provide a sneak preview into the future. Film and games are going to become increasingly more interconnected. The abilities to tell a carefully constructed story, with surprises and well orchestrated suspense, still cannot be equaled. An excellent story is experienced over and over again, because the viewer enjoys the journey and takes pleasure in the company of the characters. But as games become even more realistic and absorbing, the impatience with movies that simply "round up the usual plot points" will increase.

WATCHING MOVIES

It is estimated that the average American watches 190 movies a year. This includes going to the cinema, renting new or old releases, and watching a combination of television programs that are an hour or longer. This does not include half-hour shows, twenty-four-hour news, MTV, sports, or searching the Internet. Thus the average person in the early years of the twenty-first century is engaged in some form of visual entertainment 3.5 hours per day, 24.5 hours per week, for a total of 1,274 hours each year. When computer games are added into this mix, these numbers go up higher. The current statistics estimates that this same average American reads a book every 60 days, goes to sporting events 5 times a year, buys tickets to concert performances 3 times a year (not classical), attends a musical or theatrical production once a year, and sees a dance event once every 4.5 years (this number would be lower if *The Nutcracker* was not included). Nothing fills in the hours between work and sleep more than films, but still the true dynamics of this revolutionary art form remains a mystery to most people.

The Motion Picture Production Code of 1930 (Hays Code)

If motion pictures present stories that will affect lives for the better, they can become the most powerful force for the improvement of mankind

A Code to Govern the Making of Talking, Synchronized and Silent Motion Pictures. Formulated and formally adopted by The Association of Motion Picture Producers, Inc. and The Motion Picture Producers and Distributors of America, Inc. in March 1930.

Motion picture producers recognize the high trust and confidence which have been placed in them by the people of the world and which have made motion pictures a universal form of entertainment.

They recognize their responsibility to the public because of this trust and because entertainment and art are important influences in the life of a nation.

Hence, though regarding motion pictures primarily as entertainment without any explicit purpose of teaching or propaganda, they know that the motion picture within its own field of entertainment may be directly responsible for spiritual or moral progress, for higher types of social life, and for much correct thinking.

During the rapid transition from silent to talking pictures they have realized the necessity and the opportunity of subscribing to a Code to govern the production of talking pictures and of re-acknowledging this responsibility.

On their part, they ask from the public and from public leaders a sympathetic understanding of their purposes and problems and a spirit of cooperation that will allow them the freedom and opportunity necessary to bring the motion picture to a still higher level of wholesome entertainment for all the people.

GENERAL PRINCIPLES

1. No picture shall be produced that will lower the moral standards of those who see it. Hence the sympathy of the audience should never be thrown to the side of crime, wrongdoing, evil or sin.
2. Correct standards of life, subject only to the requirements of drama and entertainment, shall be presented.
3. Law, natural or human, shall not be ridiculed, nor shall sympathy be created for its violation.

PARTICULAR APPLICATIONS

I. Crimes Against the Law

These shall never be presented in such a way as to throw sympathy with the crime as against law and justice or to inspire others with a desire for imitation.

1. Murder
 a. The technique of murder must be presented in a way that will not inspire imitation.
 b. Brutal killings are not to be presented in detail.
 c. Revenge in modern times shall not be justified.

2. Methods of Crime should not be explicitly presented.
 a. Theft, robbery, safe-cracking, and dynamiting of trains, mines, buildings, etc., should not be detailed in method.
 b. Arson must subject to the same safeguards.
 c. The use of firearms should be restricted to the essentials.
 d. Methods of smuggling should not be presented.

3. Illegal drug traffic must never be presented.

4. The use of liquor in American life, when not required by the plot or for proper characterization, will not be shown.

II. Sex

The sanctity of the institution of marriage and the home shall be upheld. Pictures shall not infer that low forms of sex relationship are the accepted or common thing.

1. Adultery, sometimes necessary plot material, must not be explicitly treated, or justified, or presented attractively.

2. Scenes of Passion
 a. They should not be introduced when not essential to the plot.
 b. Excessive and lustful kissing, lustful embraces, suggestive postures and gestures, are not to be shown.
 c. In general passion should so be treated that these scenes do not stimulate the lower and baser element.

3. Seduction or Rape
 a. They should never be more than suggested, and only when essential for the plot, and even then never shown by explicit method.
 b. They are never the proper subject for comedy.

4. Sex perversion or any inference to it is forbidden.

5. White slavery shall not be treated.

6. Miscegenation (sex relationships between the white and black races) is forbidden.

7. Sex hygiene and venereal diseases are not subjects for motion pictures.

8. Scenes of actual child birth, in fact or in silhouette, are never to be presented.

9. Children's sex organs are never to be exposed.

III. Vulgarity

The treatment of low, disgusting, unpleasant, though not necessarily evil, subjects should always be subject to the dictates of good taste and a regard for the sensibilities of the audience.

IV. Obscenity

Obscenity in word, gesture, reference, song, joke, or by suggestion (even when likely to be understood only by part of the audience) is forbidden.

V. Profanity

Pointed profanity (this includes the words, God, Lord, Jesus, Christ—unless used reverently—Hell, S.O.B., damn, Gawd), or every other profane or vulgar expression however used, is forbidden.

VI. Costume

1. Complete nudity is never permitted. This includes nudity in fact or in silhouette, or any lecherous or licentious notice thereof by other characters in the picture.
2. Undressing scenes should be avoided, and never used save where essential to the plot.
3. Indecent or undue exposure is forbidden.
4. Dancing or costumes intended to permit undue exposure or indecent movements in the dance are forbidden.

VII. Dances

1. Dances suggesting or representing sexual actions or indecent passions are forbidden.
2. Dances which emphasize indecent movements are to be regarded as obscene.

VIII. Religion

1. No film or episode may throw ridicule on any religious faith.
2. Ministers of religion in their character as ministers of religion should not be used as comic characters or as villains.
3. Ceremonies of any definite religion should be carefully and respectfully handled.

IX. Locations

The treatment of bedrooms must be governed by good taste and delicacy.

X. National Feelings

1. The use of the Flag shall be consistently respectful.
2. The history, institutions, prominent people and citizenry of other nations shall be represented fairly.

XI. Titles

Salacious, indecent, or obscene titles shall not be used.

XII. Repellent Subjects

The following subjects must be treated within the careful limits of good taste:
1. Actual hangings or electrocutions as legal punishments for crime.
2. Third degree methods.
3. Brutality and possible gruesomeness.
4. Branding of people or animals.

5. Apparent cruelty to children or animals.
6. The sale of women, or a woman selling her virtue.
7. Surgical operations.

REASONS SUPPORTING THE PREAMBLE OF THE CODE

I. **Theatrical motion pictures, that is, pictures intended for the theatre as distinct from pictures intended for churches, schools, lecture halls, educational movements, social reform movements, etc., are primarily to be regarded as ENTERTAINMENT.**

Mankind has always recognized the importance of entertainment and its value in rebuilding the bodies and souls of human beings.

But it has always recognized that entertainment can be a character either HELPFUL or HARMFUL to the human race, and in consequence has clearly distinguished between:

a. Entertainment which tends to improve the race, or at least to re-create and rebuild human beings exhausted with the realities of life; and

b. Entertainment which tends to degrade human beings, or to lower their standards of life and living.

Hence the MORAL IMPORTANCE of entertainment is something which has been universally recognized. It enters intimately into the lives of men and women and affects them closely; it occupies their minds and affections during leisure hours; and ultimately touches the whole of their lives. A man may be judged by his standard of entertainment as easily as by the standard of his work.

So correct entertainment raises the whole standard of a nation.

Wrong entertainment lowers the whole living conditions and moral ideals of a race.

Note, for example, the healthy reactions to healthful sports, like baseball, golf; the unhealthy reactions to sports like cockfighting, bullfighting, bear baiting, etc.

Note, too, the effect on ancient nations of gladiatorial combats, the obscene plays of Roman times, etc.

II. **Motion pictures are very important as ART.**

Though a new art, possibly a combination art, it has the same object as the other arts, the presentation of human thought, emotion, and experience, in terms of an appeal to the soul through the senses.

Here, as in entertainment,

Art enters intimately into the lives of human beings.

Art can be morally good, lifting men to higher levels. This has been done through good music, great painting, authentic fiction, poetry, drama.

Art can be morally evil it its effects. This is the case clearly enough with unclean art, indecent books, suggestive drama. The effect on the lives of men and women are obvious.

Note: It has often been argued that art itself is unmoral, neither good nor bad. This is true of the THING which is music, painting, poetry, etc. But the THING is the PRODUCT of some person's mind, and the intention of that mind was either good or bad morally when it produced the thing. Besides, the thing has its EFFECT upon those who come into contact with it. In both these ways, that is, as a product of a mind and as the cause of definite effects, it has a deep moral significance and unmistakable moral quality.

Hence: The motion pictures, which are the most popular of modern arts for the masses, have their moral quality from the intention of the minds which produce them and from their effects on the moral lives and reactions of their audiences. This gives them a most important morality.

1. They reproduce the morality of the men who use the pictures as a medium for the expression of their ideas and ideals.
2. They affect the moral standards of those who, through the screen, take in these ideas and ideals.

In the case of motion pictures, the effect may be particularly emphasized because no art has so quick and so widespread an appeal to the masses. It has become in an incredibly short period the art of the multitudes.

III. **The motion picture, because of its importance as entertainment and because of the trust placed in it by the peoples of the world, has special MORAL OBLIGATIONS:**

A. Most arts appeal to the mature. This art appeals at once to every class, mature, immature, developed, undeveloped, law abiding, criminal. Music has its grades for different classes; so has literature and drama. This art of the motion picture, combining as it does the two fundamental appeals of looking at a picture and listening to a story, at once reaches every class of society.

B. By reason of the mobility of film and the ease of picture distribution, and because the possibility of duplicating positives in large quantities, this art reaches places unpenetrated by other forms of art.

C. Because of these two facts, it is difficult to produce films intended for only certain classes of people. The exhibitors' theatres are built for the masses, for the cultivated and the rude, the mature and the immature, the self-respecting and the criminal. Films, unlike books and music, can with difficulty be confined to certain selected groups.

D. The latitude given to film material cannot, in consequence, be as wide as the latitude given to book material. In addition:

 a. A book describes; a film vividly presents. One presents on a cold page; the other by apparently living people.
 b. A book reaches the mind through words merely; a film reaches the eyes and ears through the reproduction of actual events.
 c. The reaction of a reader to a book depends largely on the keenness of the reader's imagination; the reaction to a film depends on the vividness of presentation.

Hence many things which might be described or suggested in a book could not possibly be presented in a film.

E. This is also true when comparing the film with the newspaper.

 a. Newspapers present by description, films by actual presentation.

 b. Newspapers are after the fact and present things as having taken place; the film gives the events in the process of enactment and with apparent reality of life.

F. Everything possible in a play is not possible in a film:

 a. Because of the larger audience of the film, and its consequential mixed character. Psychologically, the larger the audience, the lower the moral mass resistance to suggestion.

 b. Because through light, enlargement of character, presentation, scenic emphasis, etc., the screen story is brought closer to the audience than the play.

 c. The enthusiasm for and interest in the film actors and actresses, developed beyond anything of the sort in history, makes the audience largely sympathetic toward the characters they portray and the stories in which they figure. Hence the audience is more ready to confuse actor and actress and the characters they portray, and it is most receptive of the emotions and ideals presented by the favorite stars.

G. Small communities, remote from sophistication and from the hardening process which often takes place in the ethical and moral standards of larger cities, are easily and readily reached by any sort of film.

H. The grandeur of mass settings, large action, spectacular features, etc., affects and arouses more intensely the emotional side of the audience.

In general, the mobility, popularity, accessibility, emotional appeal, vividness, straightforward presentation of fact in the film make for more intimate contact with a larger audience and for greater emotional appeal.

Hence the larger moral responsibilities of the motion pictures.

REASONS UNDERLYING THE GENERAL PRINCIPLES

I. **No picture shall be produced which will lower the moral standards of those who see it.** Hence the sympathy of the audience should never be thrown to the side of crime, wrong-doing, evil or sin.

This is done:

1. When evil is made to appear attractive and alluring, and good is made to appear unattractive.

2. When the sympathy of the audience is thrown on the side of crime, wrongdoing, evil, sin. The same is true of a film that would thrown sympathy against goodness, honor, innocence, purity or honesty.

 Note: Sympathy with a person who sins is not the same as sympathy with the sin or crime of which he is guilty. We may feel sorry for the plight of the murderer or even understand the

circumstances which led him to his crime: we may not feel sympathy with the wrong which he has done. The presentation of evil is often essential for art or fiction or drama. This in itself is not wrong provided:

a. That evil is not presented alluringly. Even if later in the film the evil is condemned or punished, it must not be allowed to appear so attractive that the audience's emotions are drawn to desire or approve so strongly that later the condemnation is forgotten and only the apparent joy of sin is remembered.

b. That throughout, the audience feels sure that evil is wrong and good is right.

II. Correct standards of life shall, as far as possible, be presented.

A wide knowledge of life and of living is made possible through the film. When right standards are consistently presented, the motion picture exercises the most powerful influences. It builds character, develops right ideals, inculcates correct principles, and all this in attractive story form.

If motion pictures consistently hold up for admiration high types of characters and present stories that will affect lives for the better, they can become the most powerful force for the improvement of mankind.

III. Law, natural or human, shall not be ridiculed, nor shall sympathy be created for its violation.

By natural law is understood the law which is written in the hearts of all mankind, the greater underlying principles of right and justice dictated by conscience.

By human law is understood the law written by civilized nations.

1. The presentation of crimes against the law is often necessary for the carrying out of the plot. But the presentation must not throw sympathy with the crime as against the law nor with the criminal as against those who punish him.

2. The courts of the land should not be presented as unjust. This does not mean that a single court may not be presented as unjust, much less that a single court official must not be presented this way. But the court system of the country must not suffer as a result of this presentation.

REASONS UNDERLYING THE PARTICULAR APPLICATIONS

I. Sin and evil enter into the story of human beings and hence in themselves are valid dramatic material.

II. In the use of this material, it must be distinguished between sin which repels by it very nature, and sins which often attract.

a. In the first class come murder, most theft, many legal crimes, lying, hypocrisy, cruelty, etc.

b. In the second class come sex sins, sins and crimes of apparent heroism, such as banditry, daring thefts, leadership in evil, organized crime, revenge, etc.

The first class needs less care in treatment, as sins and crimes of this class are naturally unattractive. The audience instinctively condemns all such and is repelled.

Hence the important objective must be to avoid the hardening of the audience, especially of those who are young and impressionable, to the thought and fact of crime. People can become accustomed even to murder, cruelty, brutality, and repellent crimes, if these are too frequently repeated.

The second class needs great care in handling, as the response of human nature to their appeal is obvious. This is treated more fully below.

III. **A careful distinction can be made between films intended for general distribution, and films intended for use in theatres restricted to a limited audience.** Themes and plots quite appropriate for the latter would be altogether out of place and dangerous in the former.

Note: The practice of using a general theatre and limiting its patronage to "Adults Only" is not completely satisfactory and is only partially effective.

However, maturer minds may easily understand and accept without harm subject matter in plots which do younger people positive harm.

Hence: If there should be created a special type of theatre, catering exclusively to an adult audience, for plays of this character (plays with problem themes, difficult discussions and maturer treatment) it would seem to afford an outlet, which does not now exist, for pictures unsuitable for general distribution but permissible for exhibitions to a restricted audience.

I. **Crimes Against the Law**

The treatment of crimes against the law must not:

1. Teach methods of crime.
2. Inspire potential criminals with a desire for imitation.
3. Make criminals seem heroic and justified.

Revenge in modern times shall not be justified. In lands and ages of less developed civilization and moral principles, revenge may sometimes be presented. This would be the case especially in places where no law exists to cover the crime because of which revenge is committed.

Because of its evil consequences, the drug traffic should not be presented in any form. The existence of the trade should not be brought to the attention of audiences.

The use of liquor should never be excessively presented. In scenes from American life, the necessities of plot and proper characterization alone justify its use. And in this case, it should be shown with moderation.

II. **Sex**

Out of a regard for the sanctity of marriage and the home, the triangle, that is, the love of a third party for one already married, needs careful handling. The treatment should not throw sympathy against marriage as an institution.

Scenes of passion must be treated with an honest acknowledgement of human nature and its normal reactions. Many scenes cannot be presented without arousing dangerous emotions on the part of the immature, the young or the criminal classes.

Even within the limits of pure love, certain facts have been universally regarded by lawmakers as outside the limits of safe presentation.

In the case of impure love, the love which society has always regarded as wrong and which has been banned by divine law, the following are important:

1. Impure love must not be presented as attractive and beautiful.

2. It must not be the subject of comedy or farce, or treated as material for laughter.

3. It must not be presented in such a way to arouse passion or morbid curiosity on the part of the audience.

4. It must not be made to seem right and permissible.

5. It general, it must not be detailed in method and manner.

III. Vulgarity; IV. Obscenity; V. Profanity; hardly need further explanation than is contained in the Code.

VI. Costume

General Principles:

1. The effect of nudity or semi-nudity upon the normal man or woman, and much more upon the young and upon immature persons, has been honestly recognized by all lawmakers and moralists.

2. Hence the fact that the nude or semi-nude body may be beautiful does not make its use in the films moral. For, in addition to its beauty, the effect of the nude or semi-nude body on the normal individual must be taken into consideration.

3. Nudity or semi-nudity used simply to put a "punch" into a picture comes under the head of immoral actions. It is immoral in its effect on the average audience.

4. Nudity can never be permitted as being necessary for the plot. Semi-nudity must not result in undue or indecent exposures.

5. Transparent or translucent materials and silhouette are frequently more suggestive than actual exposure.

VII. Dances

Dancing in general is recognized as an art and as a beautiful form of expressing human emotions.

But dances which suggest or represent sexual actions, whether performed solo or with two or more; dances intended to excite the emotional reaction of an audience; dances with movement of the breasts, excessive body movements while the feet are stationary, violate decency and are wrong.

VIII. Religion

The reason why ministers of religion may not be comic characters or villains is simply because the attitude taken toward them may easily become the attitude taken toward religion in general. Religion is lowered in the minds of the audience because of the lowering of the audience's respect for a minister.

IX. Locations

Certain places are so closely and thoroughly associated with sexual life or with sexual sin that their use must be carefully limited.

X. National Feelings

The just rights, history, and feelings of any nation are entitled to most careful consideration and respectful treatment.

XI. Titles

As the title of a picture is the brand on that particular type of goods, it must conform to the ethical practices of all such honest business.

XII. Repellent Subjects

Such subjects are occasionally necessary for the plot. Their treatment must never offend good taste nor injure the sensibilities of an audience.

130 Movies That Changed the World

1. Muybridge's Horse Running at Full Gallop [serial photography] (1878)
2. The Arrival of a Train at La Ciotat (1895)
3. The Kiss (1896)
4. Trip to the Moon (1902)
5. The Great Train Robbery (1903)
6. Rescued by Rover (1905)
7. Tillie's Punctured Romance (1914)
8. Birth of a Nation (1915)
9. The Poor Little Rich Girl (1917)
10. The Cabinet of Dr. Caligari (1920)
11. Way Down East (1920)
12. The Four Horsemen of the Apocalypse (1921)
13. Nosferatu (1922)
14. Safety Last (1923)
15. Sherlock, Jr. (1924)
16. Greed (1924)
17. The Thief of Bagdad (1924)
18. The Gold Rush (1925)
19. The Battleship Potemkin (1925)
20. Flesh and the Devil (1926)
21. Napoleon (1927)
22. Metropolis (1927)
23. Sunrise (1927)
24. The Jazz Singer (1927)
25. Steamboat Willie (1928)
26. Un Chien Andalou (1929)
27. Pandora's Box (1929)
28. The Blue Angel (1930)
29. All Quiet on the Western Front (1930)
30. M (1931)
31. Dracula (1931)
32. Frankenstein (1931)
33. The Public Enemy (1931)
34. City Lights (1931)
35. Red-Headed Woman (1932)
36. 42nd Street (1933)
37. Flying Down to Rio (1933)
38. Duck Soup (1933)
39. King Kong (1933)
40. It Happened One Night (1934)
41. The Thin Man (1934)
42. The 39 Steps (1935)
43. Triumph of the Will (1935)
44. Snow White and the 7 Dwarfs (1937)
45. Gone With the Wind (1939)
46. The Wizard of Oz (1939)
47. Stagecoach (1939)
48. The Grapes of Wrath (1940)
49. Citizen Kane (1941)
50. Maltese Falcon (1941)
51. Casablanca (1942)
52. Double Indemnity (1944)
53. Notorious (1946)
54. The Best Years of Our Lives (1946)
55. The Bicycle Thief (1948)
56. Rashomon (1950)
57. Sunset Blvd. (1950)
58. The Day the Earth Stood Still (1951)
59. High Noon (1952)
60. Shane (1953)

61. Gentlemen Prefer Blondes (1953)
62. From Here to Eternity (1953)
63. Seven Samurai (1954)
64. La Strada (1954)
65. On the Waterfront (1954)
66. Marty (1955)
67. Rebel Without a Cause (1955)
68. The Searchers (1956)
69. The Ten Commandments (1956)
70. The Bridge on the River Kwai (1957)
71. The Seventh Seal (1957)
72. Anatomy of a Murder (1959)
73. The Defiant Ones (1959)
74. Ben-Hur (1959)
75. Psycho (1960)
76. Breathless (1960)
77. La Dolce Vita (1960)
78. West Side Story (1961)
79. Doctor No (1962)
80. Lawrence of Arabia (1962)
81. Tom Jones (1963)
82. Zapruder Film of Kennedy Assassination (1963)
83. A Hard Day's Night (1964)
84. A Fistful of Dollars (1964)
85. Dr. Strangelove or: How I Learned to Stop Worrying and Love the Bomb (1964)
86. Bonnie & Clyde (1967)
87. The Graduate (1967)
88. 2001: A Space Odyssey (1968)
89. Easy Rider (1969)
90. Butch Cassidy and the Sundance Kid (1969)
91. The Wild Bunch (1969)
92. M*A*S*H (1970)
93. The French Connection (1971)
94. A Clockwork Orange (1971)
95. Dirty Harry (1971)

96. The Godfather (1972)
97. Enter the Dragon (1973)
98. The Exorcist (1973)
99. Chinatown (1974)
100. Jaws (1975)
101. Breakout [TV spot] (1975)
102. The Rocky Horror Picture Show (1975)
103. Taxi Driver (1976)
104. Rocky (1976)
105. Annie Hall (1977)
106. Star Wars (1977)
107. Deep Throat (1977)
108. Animal House (1978)
109. Alien (1979)
110. China Syndrome (1979)
111. Heaven's Gate (1980)
112. Raiders of the Lost Ark (1981)
113. The Road Warrior (1981)
114. Das Boot (1981)
115. E.T. the Extra-Terrestrial (1982)
116. Jane Fonda's Workout [self-improvement video] (1982)
117. The Terminator (1984)
118. Top Gun (1986)
119. Goodfellas (1990)
120. Silence of the Lamb (1991)
121. Unforgiven (1992)
122. The Crying Game (1992)
123. Jurassic Park (1993)
124. Pulp Fiction (1994)
125. Toy Story (1995)
126. Titanic (1997)
127. Saving Private Ryan (1998)
128. There's Something About Mary (1998)
129. The Blair Witch Project [web site] (1999)
130. Lord of the Rings: The Fellowship of the Ring (2001)

Glossary
Motion Picture Terms

$100,000,000 Club: A term used for any motion picture that reaches $100 million in domestic box office sales. *Jaws* was the first movie to break this mark, though in today's dollars *Gone With the Wind* would have had this distinction.

Above-the-line-costs: The expenses negotiated separately by high profile movie stars, and certain directors and producers, that is considerably higher than the normal rate given to most actors in a production. Under special circumstances story rights, screenwriters and cinematographers can also be part of these arrangements.

Art Director: *See* **Production Designer.**

ASC: Stands for American Society of Cinematographers. These letters often follow the name of the guild member in the screen credits. In England a member would be identified with the letters **BSC** for British Society of Cinematographers.

Associate Producer: The individual that performs a limited number of functions on as delegated by producer; often in charge of the daily operations of a production.

Auteur Theory: A term this is associated with the rise of the French New Wave, which declares that the director is the "author" of a production, meaning that certain directors leave a recognizable mark on the films they make. *Notorious* by Alfred Hitchcock is a notable example of the Auteur Theory.

Below-the-line-costs: The general expenses for a production that includes set construction, camera supplies, equipment rental, travel, meals, film processing, and crew members and most performers that work under salaries established by different guilds or unions. Certain individuals can negotiate for salaries greater than the fixed minimum, but not in terms of the millions of dollars received by those in the above-the-live-costs.

Best boy: A term that goes back to the early days of film production given to first assistant to the key electrician or gaffer. The term is all inclusive; there are no "best girls."

Blockbuster: A movie that is a runaway hit. The term originates from the nickname given to large bombs used by the Royal Air Force and the United States Air Force that could demolish extensive areas, like a city block.

Blocking a scene: This is the process of arranging all the key elements in a given shot, from the camera movement to the choreography (or blocking) of the performers.

Bomb: The complete opposite of a blockbuster; this is a movie that fails to generate expected box office revenue.

Box Office: The revenue generated by a movie. The term originates from the small, often glass enclosed structure located in front of older theatres where patrons purchased tickets for a show.

Breakeven: The point where the box office revenue on a movie equals the production costs. The marketing budget and studio overhead expenses are generally not figured into the breakeven amount, thus the actual expense of a movie could be much greater. This gets into an area that is sarcastically referred as "creative accounting."

Casting Director: The individual responsible for locating the best performers to appear in a movie or television production. This individual works closely with the director and producer during the audition process to find the right personalities to fit each role. Other duties include checking for schedule conflicts and the guild status of each performer.

Cinema verite: A term associated with the filmmaking style of the French New Wave, where the "truth" or of a moment was the primary objective. This artistic process attempts to capture the rough, unadorned look of documentaries; often the actors improvise the dialogue and the camerawork is handheld to create this in-the-moment effect.

Cinematographer: Also known as the Director of Photography or DP, evolving from the early cinema term cinema photographer. The individual oversees the use of the camera, lighting equipment, and electrical and grip work on a production. The cinematographer coordinates with the director the use of filters and film stock, and is involved in all steps of film development. Cinematographers, like the great artists, have defined the look and mood of the twentieth century through the process of "painting with light."

Composer: The individual responsible for creating the musical underscore of a movie. A composer will work closely with one or more arrangers on the full orchestration.

Co-Stars: The performers that share top billing with the movie star whose names often appear immediately under the title.

Costume Designer: The individual responsible for the design and construction (or rental) or the costumes for the principle players and the supporting cast. The Costume Designer works closely with the Production Designer on the use of color, texture, embodiment, and hand props for each costume or group of costumes.

Development: The process of taking a story or concept from the germ of an idea to a fully realized project ready to be green lighted for production. A development package often includes a completed screenplay (for the moment), a director, producer(s), one or more stars, and potentially a production designer. The term "production hell" is given to a project that is stuck in the development process because of endless changes to the screenplay or other key elements, often imposed by studio heads.

DGA: The Directors Guild of America, the union that represents directors, assistant directors and production managers.

Digital Revolution: The catchphrase given to the widespread use of inexpensive cameras, computers and software for editing and CGI effects. It also relates to the rapid changes in technology and the impact this has on society.

Director's Cut: The edited version of a movie prepared by the director. As the history of motion pictures shows, this is not always the same as the *release print,* which is controlled by the producers. Directors who have seen their cut version taken away from them and drastically altered include Erich von Stroheim, Orson Welles, and Sam Peckinpah.

Distribution: The process of rental, shipping, marketing, and selling the properties of a completed film for theatrical market.

Domestic box office: The revenue made by a motion picture in North America on its original release.

Documentaries: A process of capturing life as it happens and editing the footage down to a short or feature length presentation. This process is also known a nonfiction film. Robert J. Flaherty is considered the father of the modern documentary.

Executive producer: The credit given the person (or persons) that has been influential in arranging of production funds, and sometime above-the-line talent, for a movie. In motion pictures the executive producer normally does not have a hands-on role in the production; however in television he or she can be very involved in the day-to-day activities.

Expressionism, or German Expressionism: Derived from the early twentieth century art movement that quickly found its way into early silent films. This cinematic style attempts to depict the inner psychology of a character through exaggerated mood lighting, scenic design, and unusual or subjective camera placement and movement. *The Cabinet of Doctor Caligari* is the most famous film of the Expressionism movement, but directors like Fritz Lang and Alfred Hitchcock use the basic principles of Expression in their films.

Extras: Actors that have brief appearances in movies, usually with little or no dialogue, that are used in scenes ranging from background people in an elevator to large crowd sequences.

Film Noir: Literally translated as "black film," this genre is associated with urban crime thrillers of hard-edged realism that often take place in the dead of night. Film Noir was highly popular during the mid-1940s and 50s, and is identified by low-key, high contract lighting. Classic noir films include *Double Indemnity, Out of the Past,* and *The Asphalt Jungle;* post-noir films including *Chinatown, The Usual Suspects,* and *L. A. Confidential.*

Gaffer: The chief electrician on a movie or television set, also know as key electrician; a "best boy" is the assistant to this position.

Genre: Early motion picture studios quickly began to put movies into groups, identified by subject matter or a common cinematic look, like Westerns, Crime, Adventure, Musicals, Film Noir, and other short-hand definitions. Putting movies into categories is useful in the film industry since it is an easy way to market new releases, allowing audiences to know what to expect when the lights go down; plus genres gives the studios a way to tract the popularity of certain kinds of movies around the world.

Grip: A stagehand that is assigned to several different tasks on a set, often demanding physical strength.

Gross: The total revenue generated by a movie before production and distribution expenses are deducted.

Home Box Office or HBO; it is also a general term used for movies and special events that generate money from pay-per-view television.

International Box Office: The realm outside of the domestic box office, i.e., the rest of the world.

Line Producer: The man or woman that is responsible for the day-to-day demands of the production during the weeks of shooting; among many duties, this invaluable individual is the direct link between the director and the producers.

Location Scout: A person who travels to different states or countries to seek out ideal locations that are right for the visual demands of a motion picture.

Marketing: The process of creating favorable "hype" or publicity for the release of a new motion picture. An effective marketing campaign can begin a year in advance of a premiere with sneak previews in theatres and well-placed articles in magazines and newspapers. Today marketing includes the use of websites, advertising tie-ins, television spots, print ads, press junkets, exclusive interviews, and the coordination of hundreds of local advertising agencies around the world.

Merchandising: Closely tied in with marketing campaigns, merchandising is the licensing of a movie's visual and story elements to corporations to create special products, which can include special permissions for the likeness of stars and character actors. The first successful merchandising sales are associated with the Western character Hopalong Cassidy, but *Star Wars* set the standard for modern wide-spread merchandising that includes computer games, toys, food items, clothing, jewelry, CDs, books, and numerous other items.

Mise-en-scene: A French term borrowed from the theatre for "placing into a scene;" in film this refers to the artistic arrangement and physical staging of actors, set pieces and props within the frame.

Narrative film: A motion picture that tells a story in a traditional three-act structure, usually in a linear format; this is the style of storytelling that is associated with the vast majority of Hollywood features, from *The Birth of a Nation* to Steven Spielberg's *War of the Worlds.*

Neo-realism, or Italian Neo-realism, is a movement that broke from the escapist Hollywood motion pictures to show slices of unvarnished human drama, usually involving the personal tragedies of common people. The directors of this movement shot on real locations, often using available light, with non-professional actors, to create an immediate sense of realism associated with documentary filmmaking. This movement lasted roughly from 1945 to 1960; or from the productions of *Open City* to *Two Women.*

New Wave, or French New Wave, is a movement that paralleled the finals years of Neo-realism. The New Wave is associated with a group of French film critics turned directors who set out to deliberately break the Hollywood traditions of the "invisible camera" and linear storytelling. The movies had a freedom of camera movement that had not been seen in cinema since the final years of silent films, and the stories unfold naturally, with dialogue often improvised by the actors, avoiding the melodramatic structure of studio pictures. The French New Wave exploded on the scene with *The 400 Blows* and *Breathless,* ushering in an era of what became known as "personal filmmaking."

Persistence of vision: This is the human phenomenon that gives the illusion of continuous motion when people are watching movies. When a single frame is brightly projected on a movie screen, a split second image is retained by the eye, thus creating a natural progression from one image to the next, 24-times a second.

Post Production: The steps after principal photography to complete a motion picture for release, including editing, music scoring, sound effects editing, sound mixing, and special effects.

Pre-production: The process of preparing a motion picture for production, which involves a working screenplay, scenic and costume designs, storyboards, location scouting, and casting.

Producer: The person or group in charge of a film production from development to final release. The prime duty of a producer is to obtain

funding and hire the small army of individuals to create the motion picture. A good producer is familiar with all the elements of filmmaking and is involved in each step of a production.

Production: The process of shooting a motion picture, from location work to sound stages to green or blue screen special effects photography.

Production Designer: Also referred to as **Art Director** during the Studio Era, is the person, along with the director and producer(s), who creates the physical look of a motion picture through extensive drawings, sketches, and models. This individual oversees the coordination of color design, costumes and other visual elements. William Cameron Menzies is often credited as being the first production designer.

Property: A term given to a book, short story, article, comic book, or original screenplay that is optioned or bought with the intension of making a motion picture.

Scene: A piece of action shot in one location. A scene can consist of one camera shot, but normally is a series of shots that advances the dramatic tension of a motion picture.

Sequence: Usually comprised of several scenes, a sequence is like a short story within a motion picture, unifying similar elements of action. Examples of sequences are the chase in *The French Connection,* the attack on the Death Star in *Star Wars,* and Gandalf's arrival at the beginning of *Lord of the Rings: The Fellowship of the Ring.*

Set dressing: Objects that are placed on a set to give it the favor of location and/or personality. This can range from chairs, curtains and pictures on a wall in a living room to garbage cans and trash in an alley. The trick of good set dressing is to have the audience belief that a character actually lives or works in a certain house or office.

Shooting permits: Contractual permissions granting the right to shoot in certain locations. This can range from closing off a street for an action scene to filming inside a public building to using a famous landmark in a sequence. With these permits, release forms are often required from people that serve as background extras in a shot.

Shooting script: This is the final screenplay used for production, often with detailed shot descriptions and numbers corresponding to panels on a storyboard. A shooting script will invariably go through many writing changes during the course of a production.

Sneak preview: The showing of a new motion picture to invited audiences to get reactions before the scheduled opening date. Producers will "test" a film at previews to see if it needs additional cutting or if the ending works as anticipated.

Social Realism: A spin-off of the Neo-realism movement closely associated with American films shot on locations using a documentary approach. Many of these films became associated with strong social themes like anti-Semitism, racial prejudice, and the need for reform. Though elements of this movement continues to appear in films like *The Gangs of New York* and *Mystic River,* the height of social realism was from 1947 to 1959, or from *Gentleman's Agreement* to *The Defiant Ones.*

Sound design: The comprehensive and integrated steps taken to create a complete environment of sound for a motion picture, including dialogue, music, and sound effects.

Special effects (**SPFX** or **SFX**): An all inclusive term given to mechanical, optical, or digital effects that have to be created during post production to seamlessly blend in with footage shot during the production phrase.

Stars: The popular term given to actors that have achieved an enduring affection or admiration from audiences. Starting the in 1980s being a star was not enough for certain celebrities and the term "super star" was given to performers like Arnold Schwarzenegger, Tom Cruise, Julia Roberts, and Tom Hanks.

Stop motion animation, or **stop action animation:** The frame-by-frame process of adjusting an objective in almost imperceptible degrees and photographing it to create the illusion of motion once the scene or sequence is completed. The most famous early use of this time consuming technique is the 1933 version of *King Kong*. Though modern movies use computer-generated imagery (CGI) instead of small scale models, the actual process remains the same.

Storyboard: The process of envisioning a motion picture by drawing the camera setup, or "what the camera sees" for each individual shot. In a modern motion picture this could amount to over two thousand separate sketches. Alfred Hitchcock is the first director associated with the storyboard process.

Supporting Players: Actors that have secondary leads in a motion picture, usually with dialogue and multiple scenes, a status that separates them from extras. These performers have also been referred to as "character actors" and "sidekicks" in Westerns.

Visual Language or **Visual Grammar:** The ability to express complex dramatic actions visually without the reinforcement of words or dialogue. Visual language can be as simple as a still photograph or a complicated sequence edited together with long shots, medium shots and close-ups. Each frame conveys information resulting from the interaction or deliberate contracting of costumes, sets, color design, cinematography, and the blocking of actors. Once all these elements are put into motion they pass on hundreds of bits of information each second. Though the basic building blocks of visual language is comprised of a limited number of camera setups, each director puts a personal imprint on this universal art form through a multitude of creative selections he or she makes.

Index

Future cinematic trends *(continued)*
 film education and, 543–544
 film preservation, studio era
 directors and, 542–543
 marketplace trends and, 546
 movie-watching, extent of, 549
 runaway production, international
 locations and, 544–545
 storytelling styles and, 546–547
 ultra-realism, shock value and,
 544

G

Gable, Clark, 64, 144, 145, 146, 147,
 148, 150, 156, 159, 161, 162,
 168, 177, 178, 195, 196, 258,
 413, 488
Gahdhi, Mohandas, 361
Gainsborough Pictures, 83
Gallagher, Peter, 498
Gallipoli (1981), 424, 512
Gance, Abel, 69, 118, 264, 378, 507
Gandhi (1982), 329, 535
The Gang's All Here (1943), 117, 198,
 199
The Gangs of New York, 451, 463,
 499, 503
Gangster films, 66, 99
 anti-Nazi film, 142–143
 The Musketeers of Pig Alley, 53
 Production Code and, 78, 99
 Prohibition and, 101–102
 Public Enemy, 130, 170
 See also Hollywood Rebel persona
Garbo, Greta, 64, 101, 109, 110, 136,
 137, 143, 145, 159, 161, 171,
 177, 182, 221, 280, 300
The Garden of Allah, 165
The Garden of the Finzi-Continis, 340,
 433
Gardner, Ava, 222, 227, 443
Garfield, John, 177, 252, 412
Garland, Judy, 64, 116, 141, 144, 145,
 146, 170, 171, 182, 257, 388,
 478
Garner, James, 276
Garson, Greer, 150, 182, 189, 197,
 227, 301, 395, 412
Gate of Hell (1954), 322

The Gay Divorcee (1934), 156
Gazzara, Ben, 388, 433
Geer, Will, 252
Gein, Ed, 444
The General (1927), 71
General Della Rovere (1959), 334
Generation X, 489, 538
Genet, Jean, 379, 380
Geneva Conference, 363
Genocide
 Native American populations and,
 357–358
 Vietnam conflict and, 358
Genre films, 98–99
 audience research/box office
 popularity and, 99
 costume dramas, 99
 detective/cop dramas, 99
 epic films, 40, 41, 55, 64, 99
 fantasy films, 25, 28, 99
 film noir, 99
 gangster films, 53, 66, 78, 99,
 101–103
 horror films, 65, 85, 98, 99
 marketing of, 99
 mixed-genre films, 99, 461
 musicals, 65, 66, 94–95, 99
 psychological thrillers, 99
 romance films, 99
 science fiction genre, 84–86, 99
 slasher films, 99
 spaghetti westerns, 358
 spy thrillers, 118
 television programming and, 99
 Westerns, 31, 32–33, 62, 79, 99
Gentleman's Agreement, 268, 309
Gentlemen Prefer Blondes (1953),
 259, 260, 319
George, Chief Dan, 278, 389, 467, 533
George, Peter, 354, 393
Gere, Richard, 486, 536
German cinema, 79, 80–83, 109,
 117–119
German expressionism, 45, 80,
 81–82, 83, 96, 119, 121, 126,
 145, 174, 219, 323, 331, 339
Germany Year Zero (1948), 305
Germi, Pietro, 299
Gershwin, George, 94, 145

Gershwin, Ira, 94, 145
Get Smart, 353
The Getaway (1972), 449
Ghost, 526
The Ghost and Mrs. Muir, 368, 398
Ghost Breakers (1940), 179
The Ghost Goes West, 152
Ghost in the Shell (1995), 530
Ghostbusters, 404, 417, 477, 478, 511,
 524, 537
Giant (1956), 258, 370, 384, 404
Gibbons, Cedric, 372
Gibson, Hoot, 129, 133
Gibson, Mel, 105, 258, 425, 460, 479,
 484, 512, 513, 524, 535
Gielgud, Sir John, 192, 297, 444
Gigi (1958), 331, 365, 508
Gilbert, John, 110, 159
Gilda (1946), 227
Gillette, William, 14
Gilliam, Terry, 445
Gilliatt, Penelope, 545
Gilligan's Island, 398
Ginsberg, Alan, 380
Gish, Dorothy, 39, 52
Gish, Lillian, 39, 47, 50, 52, 53, 56,
 57, 58, 59, 61, 112, 161, 323,
 433, 507, 544
Gladiator (2000), 371, 520
The Glass Menagerie, 242
Glenn, Scott, 486
Glennon, Burt, 125
Global documentaries, 22–23, 28, 121
Gloria (1980), 462
Glory (1989), 55, 525
Glover, Danny, 513, 524
Go, 206
And God Created Woman (1956), 326
Godard, Jean-Luc, 224, 287, 289, 292,
 293, 294, 314, 315, 336, 340,
 343–344, 376, 389, 433, 442,
 460, 501, 543
Goddard, Paulette, 177
Godfather (1972), 107, 170, 256, 257,
 268, 294, 306, 358, 364, 369,
 372, 401, 410, 412, 413, 419,
 422, 430, 432, 435–437, 438,
 439, 442, 454, 455, 458, 488,
 544, 547

Radio-Keith-Orpheum Corporation, 66–67

Radner, Gilda, 417

Rafelson, Bob, 413, 423, 432, 441, 454

Raff, Norman, 18, 21, 23

Raft, George, 66, 145, 272

Raging Bull (1980), 294, 406, 451, 457, 461, 463, 503

Ragtime (1981), 449, 526

Raiders of the Lost Ark (1981), 217, 353–354, 359, 417, 427, 460, 477, 500, 504, 505, 506, 508, 509–511

Raimi, Sam, 516

Rain, Douglas, 392

Rain Man, 485

The Rain People, 430

Rainer, Louise, 111, 180, 181, 527

Rains, Claude, 150, 164, 165, 199, 207, 208, 209, 211, 212

Raintree County, 254

A Raisin in the Sun (1961), 261, 262, 362

Raising Arizona (1987), 519

Rambling Rose (1991), 487, 538

Rambo: First Blood, Part II (1985), 365, 485, 514

Ran, 340

Random Harvest, 149, 161, 197, 301

Rank, J. Arthur, 303, 309

Rankin, Arthur, Jr., 521

Raphael, Federic, 423

Raphaelson, Samson, 123

Rappe, Virginia, 74

Rapper, Irving, 182

Rashomon (1950), 206, 277, 314, 315, 321, 322, 336, 346, 377, 468

Rat Pack, 355, 482, 488–489

Rathbone, Basil, 149, 164, 165

Rating system, 499

Ratner, Brett, 529

The Raven, 373

Ray, 525

Ray, Nicholas, 253, 257, 258

Ray, Satyajit, 335–336

Reagan, Ronald, 393, 451, 481, 482, 493

Real Geuius, 538

Reality
bonds of, 3
global documentaries and, 22–23
illusion of motion and, 4
inatimates in motion and, 3–4, 22
melodramas and, 31
narrative motion pictures, illusion in, 24–30
New Wave Movement and, 216
time and, 10, 24, 314
See also Contemporary film; Hollywood Rebel persona; Italian neo-realism movement

Realto theatre, 67

Real-world characters, 31, 252

Rear projection footage, 113, 121

Rear Window (1954), 49, 126, 194, 213, 272, 320, 325

Rebecca, 150, 178, 193, 195, 197, 508

Rebecca of Sunnybrook Farm, 74

Rebel persona, 243, 253–262, 430, 431, 432

Rebel Without a Cause (1955), 243, 254, 257, 258, 300, 323, 404

Red Alert, 352, 354, 393

The Red Badge of Courage, 269

The Red Balloon (1956), 326

Red Channels, 250

Red Desert, 340

Red Dust (1932), 161, 177, 259

Red Menace, 233–234, 246, 355

Red River, 218, 223, 254

Red Scare, 233–234, 246, 355

The Red Shoes (1948), 303, 308, 316

Reds (1981), 423, 490, 491

Redford, Robert, 376, 389, 396, 405, 406, 411, 412, 413, 428, 437, 441, 450, 461, 473, 485, 491

Redgrave, Michael, 152

Redgrave, Vanessa, 223, 396, 397, 457

Red-Headed Woman (1932), 105, 155, 161, 259, 326

Reed, Carol, 152, 288, 304–305, 310, 311, 312, 328, 370

Reed, Donna, 241, 254

Reeve, Christopher, 459

Reichenvace, Henry M., 14

Reid, Wallace, 75

Reilly, John C., 536

Reimann, Walter, 82–83

Reiner, Rob, 538

Reiser, Paul, 537

Reisz, Karel, 341

The Reivers (1969), 379, 526

The Relic, 538

Rembrandt, 3

Remick, Lee, 396

Rennie, Michael, 247

Renoir, Jean, 151, 152, 288, 299, 323, 333, 336, 446, 460

Repeat business phenomenon, 369

The Replacement Killers, 528

The Republic, 3

Republic studio, 155, 172, 238

Repulsion, 397, 424

Requiem for a Dream, 294

Requiem for a Heavyweight, 239

Rescued by Rover (1904/1905), 34–36, 50
animal actors and, 34
blocking in the camera technique, 35
cutting-to-the-chase editing and, 35–36
180° rule and, 36
planned sequence shots, 34–35
shooting out of continuity and, 36

Rescued from the Eagle's Nest, 48

The Rescuers (1977), 454, 457

Reservoir Dogs (1992), 314, 517, 529

Resnais, Alain, 336, 337

The Return of Jesse James, 221

Return of the Dragon, 439, 528

The Return of the Jedi (1982), 477, 509, 516

The Return of the King, 515, 523

Revenge incentive, 65

Revenge of the Dragon, 465

Revenge of the Pink Panther (1978), 459

Revere, Anne, 252

Revisionist history, 356, 357–359, 461
See also Turbulent 60s

Revival theatres, 112, 235, 350, 379, 426, 432, 433, 507, 510

Revue du Cinéma magazine, 316

Rex Pictures, 64

Yung, Victor Sen, 180, 225
Yuppies, 489

Z

Z (1969), 357, 406, 407, 430
Zaentz, Saul, 424, 445, 449
Zaillian, Steven, 506
Zampa, Luigi, 299, 370
Zane Grey Theatre, 429
Zanuck, Darryl F., 63, 65, 146, 158,
 196, 264, 368, 431, 441, 460
Zapata, 134
Zapruder film, 217

Zavattini, Cesare, 285, 306, 318
Zebruter, Abraham, 357
Zeffirelli, Franco, 297
Zelig, 49, 503
Zellweger, Renee, 491, 536
Zeta-Jones, Catherine, 536
Zhang, Ziyi, 528
Zieff, Howard, 462
Zinnemann, Fred, 80, 219, 222–223,
 234, 253, 254, 269, 269–270,
 287, 317, 319, 328, 335, 338,
 355, 370, 389, 390–391, 438,
 457, 499

Zoetropes, 6, 11
Zoopraxiscopes, 11, 15
Zoot Suit (19812), 468, 531, 532
Zorba the Greek, 278, 532
Zorro, 242
Zsigmond, Vilmos, 95, 422, 435, 437,
 464
Zukor, Adolph, 38, 40, 56, 62, 63–64,
 65, 145
Zwich, Edward, 371, 525
Zworykin, Vladimir, 236